DISCIPLINARITY AND DISSENT IN CULTURAL STUDIES

D1462367

DISCIPLINARITY AND DISSENT IN CULTURAL STUDIES

edited by

CARY NELSON

and

DILIP PARAMESHWAR GAONKAR

Routledge
New York & London

Published in 1996 by
Routledge
29 West 35th Street
New York, NY 10001

Published in Great Britain by
Routledge
11 New Fetter Lane
London EC4P 4EE

Copyright © 1996 by Routledge

Printed in the United States of America on acid-free paper.

All rights reserved. No part of this book may be reprinted or reproduced or utilized in any form or by any electronic, mechanical or other means, now known or hereafter invented, including photocopying and recording, or in any information storage or retrieval system, without permission in writing from the publisher.

Library of Congress Cataloging-in-Publication Data

Disciplinarity and dissent in cultural studies / edited by Cary Nelson & Dilip
 Parameshwar Gaonkar.
 p. cm.
Includes bibliographical references.
ISBN 0-415-91371-3. — ISBN 0-415-91372-1 (pbk.)
1. Popular culture—United States—History—20th century. 2. United States—
 Intellectual life—20th century. 3. Culture—Study and teaching (Higher)—United
 States. 4. Culture. I. Nelson, Cary. II. Gaonkar, Dilip Parameshwar, 1945– .

E169.04D568 1996 96-893
306'.097—dc20 CIP

CONTENTS

Cary Nelson and Dilip Parameshwar Gaonkar

CULTURAL STUDIES AND THE POLITICS OF DISCIPLINARITY: AN INTRODUCTION

It was over thirty years ago—in what now seems almost the dark beginnings and abysm of cultural time and certainly in the pre-historic era of what we ordinarily think of as American cultural studies—that an English department faculty member became fascinated with modern physics and the creation of the atomic bomb.[1] He couldn't let go of the topic and eventually decided to do something like an institutional and interpersonal cultural history of the work at Los Alamos and Livermore. To do so he had to acquire informally and unofficially the equivalent of the working knowledge of a physics Ph.D.[2] Over a period of time, auditing courses, talking with Physics professors, and doing independent reading, he did just that. Meanwhile, he travelled across the country to interview about a hundred veterans of Livermore Labs, the Manhattan project, and related physics enterprises and began to think and write. The book that came of all this work, *Lawrence and Oppenheimer* (1968) by Nuel Pharr Davis, made something of a splash. It was reviewed positively on the front page of the *New York Times Book Review*, the only book by a member of his department ever to find its way there. Soon there was a British edition, and before long *Lawrence and Oppenheimer* was translated into French, German, Japanese, and Spanish.

When asked years later why he decided to write the book, Davis replied that

2 those who have facility with language, including English professors, have a responsibility to record and analyze the great events of their time for the benefit of future generations. The development of the bomb, he allowed, was surely an event of that magnitude.[3] The notion that facility with language, as a discipline's central skill and power, might give that discipline a special social, cultural, and historical responsibility offers a rather different notion of disciplinarity than the one English professors know best. Yet it anticipates a comment Stuart Hall made about cultural studies many years after Davis did his research. The topic this time was AIDS, and Hall characterized it as a central crisis of our time:

> It's a site at which not only people will die, but desire and pleasure will also die if certain metaphors do not survive, or survive in the wrong way. Unless we operate in this tension, we don't know what cultural studies can do, can't, can never do; but also, what it has to do, what it alone has a privileged capacity to do. It has to analyze certain things about the constitutive and political nature of representation itself, about its complexities, about the effects of language, about textuality as a site of life and death. Those are the things cultural studies can address. (Hall 1992: 285)

Between Hiroshima and AIDS, catastrophes for different times and generations, fall decades of cultural change. Yet certain parallels are striking. Davis was addressing the social and disciplinary responsibilities an English professor might feel, Hall the social and multidisciplinary or postdisciplinary responsibilities a cultural studies specialist might confront. Both point to the duties and ethical pressures facility in language brings with it, and both think of academic specialization in terms of its larger social implications. Far from antihumanist assaults, these reflections about responsibility for witnessing, about the social meaning of language, and about responsibility toward the public sphere, reflect humanist commitments with far older histories than modern disciplines have.

In recognizing that cultural studies has—in both its research and its pedagogy—abandoned a narrow, circumscribed professionalism in preference for a broad, politically reflective cultivation of a cosmopolitan self, Arjun Appadurai in the opening essay of this text gives a contemporary inflection to a much older humanities commitment. What all these projects linking politics, public life, and the humanities violate, of course, is the unwritten and unsigned pact post World War II disciplines made with state power. It was a McCarthy-era pact guaranteeing silence and irrelevance from the humanities and collaboration from the social sciences, a pact disguised by (and structured in terms of) the proprieties of disciplinarity and its proper boundaries, limits, and conduct. In solitary dissent from that pact Davis wrote a book many years ago; in collective dissent cultural studies has formed itself as an arena of research, writing, and political engagement.

Davis did his work in the heyday of the 1960s. Among the young was a belief—almost axiomatic in their popular culture, an article of faith from coast to coast—that anything was possible, anything permissible. Soon to come from France was the news that you could not do what you could not think of doing. For many traditional academics, ideologically positioned to believe they are barely restrained by

the laws of physics Davis studied, let alone by the mere habits of such disciplines Davis chose to ignore, ideas like this seem rather fanciful. But that is how disciplines police their boundaries, by training their members to internalize them, naturalize them, and then fancy themselves free as birds. In some sectors of the culture, in any case, the unthinkable and undoable could be named and cast out when necessary. One of those sectors was the academy, and its disciplines would discipline unruliness whenever it arose. Anything may have seemed permissible on the streets of San Francisco, but not as a rule in the halls of academe.

The author of *Lawrence and Oppenheimer*, then an Associate Professor of English at the University of Illinois, inquired about whether the book might be recognized with a promotion in rank to a full professorship. It was his second book, the first having been a rather more securely disciplinary literary biography of Wilkie Collins, and the department both then and later regularly gave full professorships to far less accomplished colleagues. The department's senior faculty debated the question, but disciplinary reason prevailed. It was not an appropriate book for an English professor to have written. No imaginable map of the discipline, no matter how generously enlarged and redrawn, reached out so far as to encompass Los Alamos. No actual penalty would be assessed, no fine levied (after all, the senior faculty were gentlemen), but a promotion was out of the question. It was fine for Davis to take on physics as a hobby, but it could not be professionally recognized. Physics was in a different building, past the remnants of another sort of disciplinary blindness—the stumps of Elm trees clustered together on the campus's central square in unthinking, vulnerable, and, as it happened, entirely mortal, monoculture.

In writing this book Davis had of course broached the division between the two cultures, science and the humanities; it is a division Andrew Ross in the pages that follow will urge cultural studies to broach again, one that Paula Treichler has overridden repeatedly in a decade's work on AIDS, and one that Constance Penley transgresses in her paper when she reports presenting NASA and the Jet Propulsion Laboratory with a cultural studies analysis of space exploration. It is hard not to imagine that some among Davis's colleagues would have felt his transgression particularly unseemly, a decisive fall from aesthetic transcendence into the laws of sheer matter. The review in the *New York Times Book Review* would have reinforced that sense of a descent from spirit into matter; indeed, public attention would have confirmed the book's relevance to the most perilous sort of matter, the masses of ordinary people. Davis had violated the most important disciplinary boundary of all during the cold war, the one surrounding and containing the campus as a whole. Finally, whatever his colleagues felt, it would surely as well have been underwritten by the categorical faith every academic discipline seems to possess—that it alone has the only truly impeccable standards, the only true key to god and country.

The disciplinary guardians of that day are gone, retired or dead. We need not wonder how they would respond to the work English department students and faculty are doing in the 1990s. In 1996, Jane Juffer, one of the graduate students in

4 Davis's former department, published her first article—on the lingerie catalogs issued by the Victoria's Secret company. Another graduate student completed a dissertation on British music halls in which literary texts were not often on stage at all, let alone on center stage. Whether Davis's colleagues would have seen such undertakings as so absurd they could only be taken as pranks or so vulgar and outrageous they warranted the excommunication of their authors hardly matters. What is obvious is that in discipline after discipline forms of cultural studies analysis are routinely under way that would have been wholly unimaginable but two decades ago.

More, perhaps, than the incomprehensibility of contemporary theory—were it to be displaced, anachronistically, into the past—would be the savage impropriety of object choice that would seem so thoroughly to outrage disciplinarity. The move from Keats to physics is a comprehensible confusion of realms and boundaries, the move from Pater to panties an epistemological impossibility, a violation exceeding anything a 1960s or 1970s disciplinary imagination could call upon to fear or lampoon.

The risk for both of these students is no longer their own department's policing mechanisms. What is now permissible, at least for many doctoral committees, is very broad indeed. But few English departments have entries for lingerie or music halls in their course catalogues. The job market, not the dissertation committee or the promotion committee, now serves as the discipline's de facto arbiter of the possible and the permissible. Indeed, whatever intellectual largesse underwrites the regulation of dissertation topics is virtually rendered moot by the job market, since a dissertation committee cannot effectively police entry into a discipline that has no jobs. Hostility to new developments like cultural studies is thus more likely to be mobilized at the critical point of entry into the discipline—the hiring process.

In that sphere the music hall dissertation seemed to play no winning tunes in 1994 or 1995. In the publishing world, as it happens, boundaries are more fluid. Our advice to Barry Faulk, the author of *Aesthetics and Authority: Literary Intellectuals in London Music-Halls*: revise the dissertation, publish it as a book and perhaps win disciplinary tolerance (and a job) that way. For many young cultural studies students, inspired by the more freewheeling world of publishing, animated by what they read, the links between disciplines and their traditional objects of study are increasingly irrelevant. The author of the music hall dissertation was, oddly enough, in a position not unlike Davis's thirty years earlier. He could publish his book, but the discipline might close its doors in response. Were he up for promotion or tenure in the 1990s a crisis or a trial for witchcraft, however, might be avoidable. He would by then have taught more traditional courses and have proven himself a dutiful child of his discipline in that respect. Many departments, though not all, would make the tenure case on its exceptional grounds, gesturing toward a wild disciplinary future of kaleidoscopic object choice they secretly hope will never come to pass. The job market, especially in an extended era of fiscal crisis, is another matter. For in a time of budget cuts and

retrenchment many departments look first to protect their more traditional investments and object choices.

It is hardly news that the leading edges of a discipline are not necessarily replicated in the recidivist reaches of every reactionary department. But the current situation in cultural studies, in which disciplinary cultural studies degree recipients and departmental hiring committees march to such different drummers, is distinctive and alarming. It presents young intellectuals with impossible and equally hopeless alternatives—abandon your passions to become more palatable or devote yourself to what matters whatever the consequences. We always give the latter advice, but it is far from harmless.

Although our contributors are quite concerned with the politics of disciplinary encounters, most do not comment explicitly on such real-world conditions for the academic pursuit of cultural studies projects. But we want to make our readers aware that there are significant consequences to the intellectual commitments people make. The disciplinary and transdisciplinary differences detailed in the pages that follow often have painful bearing on people's lives and their careers. The public sphere consequences will be clear, among other essays here, in Valaskakis's paper on the discursive construction of Native American culture, in Paula Treichler's account of the real and symbolic struggles over the meaning of condom usage in the age of AIDS, in Lauren Berlant's analysis of conflicts over immigration and national identity, in Michael Hanchard's summary of the complexities of black public intellectual life, and in David Hirsch's analysis of the complex displacements of homophobia in American culture. One of the purposes of this introduction is to urge people to keep such contexts and consequences in mind throughout the book.

So cultural studies in the 1990s finds itself being textually inscribed and politically positioned in a time of financial crisis. It was only a few years ago that many of us wondered how cultural studies would be institutionalized in America and across the world, perhaps imagining an explosion of subdisciplinary programs and interdisciplinary institutes. Some of our contributors still anticipate that sort of growth, but for the most part institutionalization is on hold. For the occasional college dean who seeks approval for a cultural studies degree program, it is as likely as not to be conceived as a holding company for the remnants of eviscerated humanities departments. Yet on two other fronts—the work of individual scholars and the conceptual struggles within existing disciplines—cultural studies is alive and well, holding its ever-changing ground. It is to tracking these recent developments that *Disciplinarity and Dissent in Cultural Studies* is dedicated.

The first section of the book, "Disciplinarity and Its Discontents," opens with Arjun Appadurai's effort to set the recent public and university debates about cultural studies in the context of the continuing struggle between professional and more broadly humanist conceptions of disciplinarity. He offers the emerging marriage of cultural studies with area studies as a way out of this impasse that is also focused on the increasingly global nature of cultural interchanges. The next group of essays records the sometimes unhappy and always deferred marriages between

6 cultural studies and a series of more traditional disciplines. Throughout these essays a sense of difficulty shares space with a sense of possibility. If traditional disciplines have been wary toward cultural studies and cultural studies sometimes nervously condescending toward them, the authors of all these comparative essays—Dominguez on anthropology and cultural studies, Nelson on literature and cultural studies, Steinberg on history and cultural studies, Grossberg on communications and cultural studies—nonetheless see potential futures of mutual critique and transformation. Neither cultural studies nor the disciplines they would be in dialogue with would remain the same in the process. Indeed, the implication here is that, while traditional disciplines need the cultural studies difference, cultural studies also needs the critique and challenge of disciplinarity.

In her essay Gail Guthrie Valaskakis reviews the long history of Native American studies by way of a case study of its competing and intertwined discourses about the land. A department or program in a number of universities, Native American studies has been a research tradition for a century but a political, religious, legal, and imaginative discourse for much longer than that. A cultural studies approach to those traditions shows them to be deeply implicated in one another. Following this essay Andrew Ross summarizes the recent debates growing out of continuing cultural studies inquiry into the cultural construction of scientific knowledge. Finally, in the concluding essay of the book's opening section, Bruce Robbins mounts a basic philosophical inquiry into the relations between disciplinarity, disciplinarity's human agents, and their objects of study. He concludes that one sign of a discipline's health is its admission of its inability, finally, to fully master the objects it studies. He also depicts a crisis that cultural studies has—to some degree—overcome, since cultural studies is realized *dis*continuously both across the globe and through time. Unlike traditional disciplines, cultural studies responds consciously to immediate political problems and counts its success—its pertinent progress— partly in terms of its success at interpreting, analyzing, and intervening in local conditions. It does not need a myth of unbroken disciplinary continuity to prop up its current self-confidence. Its long-term traditions, on the other hand, reflect not only methodological continuities but also a general progressive telos. Its object choices, however, are often variable and sometimes replaceable.

The second section, "Going Public, Going Global, Going Historical: Cultural Studies in Transition," identifies three major transformative movements in cultural studies in the 1990s. Led by the opening essays by Herman Gray and Benjamin Lee, which diagnose the current state of cultural studies across a series of multidisciplinary and multinational terrains, the contributors give special emphasis to the efforts a number of cultural studies scholars are making either to address multiple disciplines or to reach audiences outside the academy. The essays by Gray, Benjamin, Penley, Hanchard, and Denning all take up aspects of the problems and challenges of cultural studies in the public sphere. They deal not just with the benefits of entering into various public spheres but with its multiple difficulties in a variety of cultures. Hanchard and Lee make it clear that many Americans lack the comparative models they need of how public intellectuals function in other

cultures. Penley recounts a series of partly failed efforts not only to *write* for nonacademic audiences, which is the narrow model of public action many academics cling to, but actually to interact with a variety of nonacademic institutions. The experience led her to suggest, only half whimsically—and perhaps ringing a contemporary change on Karl Mannheim's notion of the free-floating intellectual—that we drop the term "public intellectuals" and instead speak of "free range intellectuals," thereby evoking "those chickens that get to run around in an open space instead of being confined to a cage before they're slaughtered."[4] Ben Lee tackles the challenges of a global cultural studies in dialogue with area studies programs now breaking with their cold war histories. Michael Denning, on the other hand, goes back in time to test contemporary cultural theory against a key alliance discourse of the past—the far more public, rather than academic, popular front criticism of the 1930s.

The book's last section, "Toward Wild Culture," suggests a movement toward unhoused and unhousable essays, essays assignable to no familiar discipline, multidisciplinary essays entangled instead with the discourses of the public world. As its conclusion, then, *Disciplinarity and Dissent in Cultural Studies* offers a glimpse of one version of what a radical cultural studies future might entail. It opens with Ackbar Abbas's effort to read the social, political, and cultural reality of contemporary Hong Kong by way of an unconventional mix of aesthetic and popular objects; it proceeds with Lynn Spigel's conflation of two typically wholly distinct cultural domains, television and the fine arts; and concludes with essays by Paula Treichler, Lauren Berlant, and David Hirsch that press still further the objects and domains that cultural studies critics feel empowered to juxtapose and interrogate. Throughout this section the difficulty inherent in postdisciplinary object choice steadily intensifies. With Treichler's essay, moreover, which shows how cultural studies can use a condom politically and conceptually, it becomes particularly clear that a single object can prove the intersection of a great many competing discourses and political interests. The Berlant and Hirsch essays also bring to a conclusion a concern with citizenship and the construction of national identity that occupies all of the contributors and is perhaps one of the inevitable orientations of an intellectual tradition that grows out of a sense of cultural crisis. Given the contemporary sources of that sense of crisis, however, one of the surprising things about the book to some readers will be its inclusion of two essays—Nelson's and Denning's—about the modern decade, the 1930s, when citizenship was most notoriously public. By the time we get to Berlant's essay we enter the world of the 80s and 90s when the media are collaborating to reinstall a wholly privatized, intimate notion of citizenship. Media analysis here is thus devoted to deconstructing the sort of public spaces and valorized identities popular culture creates and promotes. But throughout the book and throughout cultural studies, whether it is literary texts or movies that are receiving critical attention, a deep concern with how objects, discourses, and practices contruct possibilities for and constraints on citizenship is one of cultural studies's primary differences from more narrowly construed academic disciplines.

8 Cultural studies has often been ridiculed for applying sophisticated theory to mass media and popular culture and thus producing an improbable and incongruous conflation of the high and the low. As Spigel's title suggests, however, such juxtapositions—even interanimations—of high and low are already present in the culture. Indeed, with a certain impassioned ruthlessness these essays track the interdependency and rearticulation—if you will, the mongrelization—of domains academics and others often prefer to keep separate. Metadiscourse is here set against the most raw of public discourses. And in the end, in Hirsch's experimental, collage-like essay, the mutual implication of idealization and violence leads to a powerful and disturbing critique of how our culture constructs its values and its dichotomies. That leads us back as well, in Hirsch's essay, to important reflections on the problematics of disciplinary object choice.

The three-part structure of the book thus has an obvious inherent linearity: beginning with disciplinary discontent, the book moves outward toward the public sphere and concludes in terrain belonging to no existing academic specialization. That journey is not an inevitable one, however, nor is it irreversible. Many of the authors remain involved in their disciplines and some do more than one kind of writing, addressing some work to their disciplinary colleagues, some to academics from multiple disciplines, and some to educated readers outside academia. Some cultural studies advocates in fact have been writing different pieces for these different audiences for years.

We have not, we should add, tried to be exhaustive in any of these sections but rather to be representative. We have not invited essays on all relevant disciplines and issues but rather on some of the more charged and suggestive ones. Omissions, unfortunately, often signal our sense of the sometimes hopeless character of the present debates. Sociology would be the foremost of those, where the homicidal confrontation between quantitative and qualitative methodologies made it inevitable that cultural studies would be positioned as yet one more opportunity for mid afternoon plotting and late night murders. Cultural studies scholars in most American sociology departments—specialists, as Herman Gray points out in his summary of the history of cultural studies and sociology, in areas like symbolic interaction—are marginalized, disempowered, and sometimes actively harassed. The positivist, quantitative bias that dominates most American sociology departments relegates cultural studies there—at least in institutional and programmatic terms—to little more than a new terrain for the fratricidal struggles that have all but broken some sociology departments in two. Consider the following remarks from a review three sociologists wrote of the massive *Cultural Studies* anthology: "this is nothing less than an attempt to put a definitive stamp on the empirical study of culture itself.... Institutionalized social structures are hierarchical and oppressive.... Culture is not merely related to power but is intertwined with [it].... This is nothing other than the cultural Marxism of CCCS [Birmingham's Centre for Contemporary Cultural Studies] in a more contemporary form" (Sherwood 1993: 370–71).

Amidst the ruins of the Berlin wall, hoping to erect one last red-baiting barrier

to difference and the threat of theory, the authors imagine cultural studies to be communism's last gasp. Few people would be more surprised than some of the apolitical and opportunistic American scholars marching toward tenure under a cultural studies umbrella. So we saw no clear reason for sociology to bear its general disciplinary wounds more fully in this context, though there does need to be testimony from sociologists doing cultural studies work about what it is like to function under siege.

On the other hand, there are fruitful essays yet to be written on disciplinary interchanges yet to be realized. Regrettably still hypothetical is an essay on the history of rhetorical analysis in cultural studies and the interchanges between cultural studies acolytes and traditional rhetoricians. There is more than adequate warrant for such an essay and such an interchange, even if the interchange has not yet taken place. For from Raymond Williams's and Richard Hoggart's earliest work through the watershed Birmingham volume *Policing the Crisis* and beyond, cultural studies has been deeply, if broadly, textual and rhetorical in its methodology. Discourses have not been its only objects of inquiry, but they have been central evidence; and neither a structure of feeling nor a subculture is critically available except as a linguistic simulacrum. Even Lawrence Grossberg, who among our contributors has perhaps the most wary attitude toward discourse-oriented cultural studies analysis, insists that discourse is the primary form in which culture survives and that discourse analysis is a necessary moment in any cultural studies project. One need only read through the present volume to see how many kinds of linguistic evidence cultural studies uses—here it includes congressional testimony, news stories, headlines, song lyrics, television and film scripts, radio broadcasts, literary texts, scientific papers, interpretive theory, interview transcripts, popular nonfiction, personal letters, speeches, captions, banners, jokes, and rumors. These essays also make it clear how crucial various kinds of discourse analysis are to various cultural studies projects and thus make it possible to estimate the potential of a working relationship between rhetoric and cultural studies. Perhaps this book will encourage such projects; that is certainly one of our aims. Meanwhile, the recent history of disciplinary, interdisciplinary, and transdisciplinary interchanges with cultural studies has been rich enough to warrant more than one such thick description. Some of them are offered here.

These essays are representative in more than one sense. Not only do they take up key disciplines; they also represent quite different takes on the cultural studies/disciplinarity problematic. Virginia Dominguez has collated the actual debates in anthropology and extracted their epistemological assumptions and ambitions. She adds to this a statistical analysis of publication practices in cultural studies and anthropology. At its deepest level, however, her essay is a sometimes poignant recreation of a uniquely fraternal confrontation, one in which the differences between cultural studies and anthropology cannot be wholly segregated from their similarities. At that point her method blends with Michael Steinberg's, which is a meditation on the results of making history and cultural studies confront one another through both their errors and their triumphs. Cary Nelson, on the other

hand, juxtaposes a theoretical polemic with an extended case study in his interrogation of the relationship between literature and cultural studies. Lawrence Grossberg combines a history of the interchanges between cultural studies and communications with a sharp critique of the legacy they have offered scholars throughout the humanities and social sciences.

These methodological and strategic choices could easily be interchanged. One could easily take up the anthropology/cultural studies debate by way of an extended case study. One could expand Dominguez's comments on the mutual implication of cultural studies and anthropology in similar value systems and political commitments so as to resemble Steinberg's study of cultural studies and cultural history. In effect, the reader is urged to do exactly that. Thus someone particularly interested in the confrontation between cultural studies and literature should benefit from testing his or her knowledge of that relationship against all the essays in the book. In that way something like a sufficient account of cultural studies's disciplinary encounters can be taken collaboratively from the entire run of essays we have commissioned. Indeed, even people affiliated with disciplines not treated here at all will frequently find their own experiences mirrored in several contributions.

If these essays about disciplinarity and its cultural studies discontents are foregrounded by the book's title and their placement at the book's opening, much as they are at the center of the contemporary university, they are also positioned, historicized, problematized and in some ways undone by the essays in the following two sections. There the overall nature and conditions of disciplinarity are interrogated and sometimes overthrown. If we cannot use cultural studies to see our general historical status by way of the diverse disciplinary objects we study, as all these authors implicitly argue, it is finally of little use to us. Nor is cultural studies of much use if it does not do away with our disciplinary inhibitions about what objects merit being placed side by side in the discursive space of analysis. That imperative will be substantially fulfilled by the Abbas, Spigel, Treichler, Berlant, and Hirsch essays in the book's concluding section. But before we get there, the existing grounds of disciplinary work will have to be radically overhauled.

In the intensifying debates over cultural studies's nature and place in the academy, however, it is increasingly clear that not only the present status of disciplines but also their past history needs to be rethought. American academics, notably, are little more inclined than their nonacademic counterparts to recall and reflect on their histories. Academic institutions generally are surprisingly little interested in thinking about their past history and asking what it tells them about their present condition. British cultural studies, certainly, was an exception to this rule, being inclined continually to restate and revise its account of its origin and history. Many recent American cultural studies converts, however, have assumed their general cultural warrant—to have no history ready to hand—applies to membership in this new field as well.

Yet the contest over cultural studies's contemporary identity is also inevitably a struggle over what texts and traditions are central to its history and what their bearing on the present might be. For a discipline like anthropology, which wants to

incorporate and internalize cultural studies, the centrality of its theorists and prac-
titioners to any history of cultural studies is a central point of contention. In liter-
ary studies, on the other hand, comparisons between cultural studies and past
literary historiography are often a way of willfully disavowing any meaningful cul-
tural studies difference. Much the same is often true of historians, for whom the
cry "we have always done cultural studies" is supposed to end the conversation.

More than most of us are eager to admit, the history of American cultural stud-
ies is a history yet to be told, its texts yet to be found, its meanings yet to be rearti-
culated to contemporary needs. In the decade to come, past texts will fall in and
out of cultural studies in an ongoing struggle over which histories can win pur-
chase over current work. Michael Denning makes an unusual effort here to give
American cultural studies a usable past, a past that cultural studies is in some ways
especially well equipped to recover, a moment of public interpretive work that can
retroactively be seen as a viable predecessor to cultural studies. A series of inter-
pretive books are shown to be part of a relational historical configuration, a project
that can now be viewed as collective and mutually implicated as we analyze a his-
torical moment from a significant distance. Michael Hanchard's paper is partly
devoted to exactly the same project, though in a different cultural context and with
a different list of progenitors and models. Denning recovers among his forgotten
tutors several people doing popular cultural criticism in the U.S. in the 1930s.
Hanchard instead looks to Latin America and the Caribbean for critics who
embraced a New World hybridity and an ethnically inflected criticism long before
it became so urgent in North America. The result makes clear how much we lose
in the way of intellectual tutelage and inspiration by our ignorance about cultural
history throughout the Americas. Much more of this sort of effort needs to be
made, in multiple American versions of Williams's *The Long Revolution*.

Hanchard's and Denning's papers are, of course, partly efforts to persuade other
critics either to embrace these alternative pasts or to make comparable efforts of
their own. Indeed, for more than a decade it has been standard practice for many
in the humanities and social sciences to assemble their personal dossier of relevant
theoreticians, to cobble together and identify with an intellectual lineage that may
be partly idiosyncratic and certainly generally attuned to the individual scholar's
particular interests and preoccupations. Such individually designed theoretical lin-
eages are often constructed alongside disciplinary training that may be more con-
ventional. At that point one may be the product at once of consensual disciplinarity
and designer theory. But many cultural studies critics eventually do work almost
entirely unrelated to their disciplinary training.

Constance Penley was trained in rhetoric and film studies and now writes much
more broadly about popular culture. Andrew Ross completed an English Ph.D.,
wrote his first book about modern poetry, and then went on to write about popu-
lar music, cold war intellectuals, pornography, ecology, science debates, and other
topics. Both felt the need—to different degrees—to work up other topics before
writing about them, familiarizing themselves with new bodies of academic schol-
arship and even doing some ethnographic research. But neither put the years of

work into learning a new discipline or research tradition that Nuel Davis did in order to master physics. Each, in effect, had to work out a personal ethic and comfort level with a new subject area or discipline; their loyalty, clearly, was not to the discipline's credentialing processes but rather to their own sense of what felt right, to a strategic sense of historical grounding and intellectual sufficiency. It is at that point, of course, that some more traditional academics become incensed.

But the intense specialization of postwar academia—linking the right to speak with a narrow credentialing process—is increasingly apparent as a highly politicized compact between knowledge and power. Moreover, it is a compact in which academics cede almost all public power to specialists and to the agencies that fund and promote them. It also helps encourage a wider undemocratic notion of disempowered and broadly silenced citizenship. There are still among us some who believe that only the experts with appropriate work experience or degrees have the right to decide whether the rest of us should give our health or our lives to the state on one occasion or another. But cultural studies scholars are usually not among that group. And cultural studies scholars are often willing to write something like educated, academically inflected journalism for an audience outside their core discipline.

Is disciplinarity, then, a necessary prerequisite for academic writing? Or could one familiarize oneself with a group of texts in pure theory and then proceed to write on any topic under the sun? Since all our contributors have had some version of conventional disciplinary training, they and we may be ill equipped to estimate the possibility of working in its absence. Certainly, at the very minimum, detailed acquaintance with one research tradition prepares one to have some idea of what is entailed in acquiring a new one. And cultural studies scholars have regularly been able to bring fresh questions and perspectives to a discipline that those long involved in its study would have been hard pressed to achieve.

At the very least, what is clear throughout this book is the complete disavowal of the common notion that cultural studies has no interest in history, that it idolizes contemporary popular culture and little else. All these contributors are deeply committed to mastering and reinterpreting the history of the disciplines or areas of study with which they are involved. In various ways most of them believe the past powerfully shapes and determines the present, that those who fail to study it are not only culturally impoverished but also substantially disempowered. Those contributors here who study contemporary culture tend to honor and value the politically informed work of colleagues studying earlier periods. The book includes both detailed interrogations of disciplinary histories and close readings of specific cultural moments in American history. Even areas of popular culture, Spigel's paper on the early history of television will force reluctant readers to concede, are necessarily subject to historical recovery and analysis.

Of course there are philistine members of the cultural studies community who argue otherwise. Some cultural studies scholars and students routinely dismiss historically based cultural studies projects—especially work done by historians and literary critics—as hopelessly text-obsessed, as mistakenly "obsessed with the sig-

nifier." Cultural studies, they argue with facile self-importance, has gone beyond such concerns and such evidence. One young student, possessed by a similar cultural studies ethic, worried that such efforts "privilege history" or "privilege literature," as if the history of relatively autonomous cultural domains should now be forgotten in pride of ignorance. All we can say in response is that here are a group of accomplished cultural studies scholars—veteran students of the history of jazz, film, literature, politics, music, medicine, criticism, rhetoric, and a wide variety of historical periods—who feel differently.

Almost as strong as the call for historical depth in cultural studies work here is the call for an increasingly *comparative* cultural studies, advice very much against the grain of a good deal of both American and European cultural studies. Indeed, if the call for a more historically informed cultural studies reinforces long-standing traditions—think, for example, of E. P. Thompson's 1963 *The Making of the English Working Class* and Williams's 1961 *The Long Revolution* and his 1973 *The Country and the City*—traditions only recently ignored in some American work, the plea for a comparative cultural studies represents something of a break with the past. That call, running from Denning's and Nelson's work on the 1930s through Hanchard's and Lee's on the 1990s, also runs counter to the dominant disciplinary heritage in American universities. This demand for more comparative work may fairly be identified as a product of the confrontation and mutual interchange between disciplines and cultural studies.

Yet all our contributors have gained at least some of their expertise (and some of this set of cultural convictions) through disciplinary training. Once again, however, the question of whether to make a particular disciplinary investment in a given time and place is not usually so generalizable. For many, the question is whether it would be useful to study a given discipline on a particular campus. For someone interested in sociology and cultural studies, for example, it would not be helpful to study sociology at the University of Illinois at Urbana-Champaign or at the University of Wisconsin, but it might well be helpful to study it at the University of California at Santa Barbara. In the abstract, to take another example, it might seem that someone interested in studying the history of painting and sculpture from the perspective of cultural studies and recent theory generally ought to be able to join almost any art history department. In practice, that is not the case; many art history departments are uniformly antagonistic to the intellectual currents of the past few decades. So there are numerous contexts, then, when it might be completely counterproductive to study a particular discipline. Many cultural studies scholars, however, have found a critical and ambivalent but also passionately committed relationship to an academic discipline intellectually productive.

The picture, then, is far more complex than one might suppose, and any overly confident rule about the necessity of disciplinary training as a foundation for cultural studies work is sure to run up against real world exceptions. But some generalizations can be made with reasonable confidence. First, it seems clear that detailed knowledge of both an appropriate intellectual tradition and the history of at least one relatively autonomous cultural domain are essential to good cultural studies

work. Either a traditional or more recent academic discipline in many cases can fulfill this need. Second, disciplinarity should not be wielded as a condition for speech or a prohibition against it. While many cultural studies advocates would resist the opportunistic and exceptionalist implications of the currently popular "public intellectual" designation, many also seek a more public role for university intellectuals. Disciplinarity and official expertise are often mostly a bar to more open public debate on critical issues. Third, cultural studies is committed to the ongoing critique of disciplinarity and to the redefinition and recombination of disciplines in response to new or newly recognized historical realities.

Just how complex and overdetermined these principles are will become clear if we take up just one—the increasing interest among cultural studies advocates in intellectuals' functions in the public sphere—for further discussion. In the United States the primary component here is no doubt the mounting sense of disenfranchisement progressive intellectuals feel after more than a decade of public debate dominated by Reagan, Bush, Gingrich, and their allies. The capacity of American cultural studies scholars to understand these developments—from the New Right's ability to rearticulate a variety of popular beliefs and values to its agenda, to conservative politicians' success at persuading working-class people to vote against their own interests—has benefitted considerably from the efforts Stuart Hall and others have made to theorize similar developments in Britain under Thatcherism. Both British and American cultural studies scholars, in short, have acted out of necessity. They have felt impelled not only to venture into the public sphere but also to make more elaborate efforts to analyze and understand it.

Meanwhile, a series of diaspora intellectuals from the Far East have come to prominence in cultural studies, among them Arjun Appadurai in the present volume, in part because of the increasing power, pertinence, and sophistication of postcolonial theory, a body of work now central to cultural studies that had relatively little general influence fifteen years ago. As it happens, the barriers between university intellectual life and the public sphere are much more permeable in many other places in the world, from Latin and South America to India. The relative autonomy of the university—reinforced by structural, cultural, and financial barriers—is largely an American and European phenomenon. But as the work of these postcolonial intellectuals has become more visible, it brings with it their very different senses of the relations between disciplinarity and public discourse. Meanwhile, as American universities have become more dependent on corporate funding, their own sense of independence comes increasingly under question. Finally, African-American scholars like Michael Hanchard have an even stronger inducement to reflect on public activity by activists and intellectuals, for few African-American leaders have the sort of political or economic power that comes with direct control over public life.

For university intellectuals to take up the question of how various discourses fare in the public sphere is inevitably to take on a more reflective relation to their disciplines, since the public sphere necessarily involves engagement with the translation and rearticulation of any disciplinary conversation. Nor is simple popular

advocacy, especially for cultural studies scholars, an easy alternative. For one thing cultural studies is already widely under attack by conservative commentators. For another, cultural studies has its own traditions of respect for popular culture and popular wisdom. So cultural studies scholars are less likely to see the public sphere only opportunistically. Involvement with issues of public representation, then, brings with it yet one more basis for critical distance from disciplinarity.

Perhaps no one among our contributors, inevitably, is more ambivalent toward the discourse of her discipline, Native American studies, than Gail Guthrie Valaskakis. Raised on a Native American reservation, with a father who was an enrolled Chippewa, she now contributes to a conflicted, public, interpretive tradition that was contaminated by violence, genocide, desire, and misrepresentation from the outset. Its multidisciplinary textual history has been religious, political, literary, and anthropological. It combines special pleading by colonists and testimony from the Native American "subjects" of the discipline. The truths she urges cultural studies to seek must honor the inventive and mystical Native American retellings of that history as much as the recoverable conventional "facts" of the history as it would be cast in other disciplines. In the case study she presents here about discourse and the land, it is clear that Native American studies embraces not only contemporary academics but also writers of every sort. And in Valaskakis's account of its paradoxes, it opens questions about the palimpsestic textual history all disciplines carry with them.

In varied ways, in fact, most of our contributors are effectively dissenters from the discipline in which they were trained. One, Paula Treichler, trained in linguistics, has been a postdisciplinary writer throughout her career and has never had a full-time appointment in a single traditional discipline. Some, like Steinberg, Dominguez, and Nelson, return from cultural studies reading and reflection to import a set of differences into the home discipline. Each would insist that a revised set of objects—typically plausible extensions of the discipline's traditional object choices—merit continuing attention. The mix of objects differs, the questions are sometimes new, but the discipline's ideals, now renewed and transformed, still merit a certain devotion. Others of our contributors—among them Berlant, Hirsch, and Ross—have gone on a postdisciplinary journey without plans to return. If Steinberg, Dominguez, and Nelson would in some of their work install themselves within a renewed and politically challenged discipline, Berlant and Ross are permanent and willing disciplinary exiles. They now live elsewhere, though Berlant does so within an English Department and Ross does so as chair of an American studies program.

Both Berlant and Ross of course won their first tenure-track jobs and later tenure itself on the basis of projects of unambiguously literary interpretation. By the time he came up for tenure Ross had made the turn toward cultural studies, but he also had his book on modern poetry and was still publishing occasional essays on literature. Could either have won beginning jobs in English departments purely on the basis of the work they do now? It seems unlikely, at least if broad departmental consensus was a requirement of the hiring process. A small search

16 committee committed to hiring at the leading edges of cultural studies work might
have hired them, but it would have been difficult to sell their candidacies to depart-
mental traditionalists. At a senior level, where national reputations are at issue, it
would be another matter. However fleeting fame may be in academia—fleeting
because it is conferred upon those who are doing the best work in the areas cur-
rently in greatest demand—departments will purchase it when the opportunity
arises, and even conservative colleagues will sometimes accept increased national
visibility as a rationale for an appointment they might otherwise reject.

But if you eliminated Berlant's book on Hawthorne and Ross's on modern
poetry from their records what department would they join? It is partly a ques-
tion, of course, of which departments want to lay claim to the sort of work they
do and expand the discipline's reach as a result. Like a number of new intellectu-
al enterprises, cultural studies is, in effect, temporarily, if only partially, available
for strategic poaching or colonization by opportunistic disciplines. If the disci-
plinary distribution of avowed cultural studies specialists were eventually to
harden in place, such opportunities would diminish. Enterprising departments
would then cry out "But at Penn and Berkeley all the cultural studies people are in
Folklore. Harvard doesn't have Folklore. That's why they don't do cultural stud-
ies. So we in Folklore want to be the center of cultural studies on campus."

Some of our more omnivorous contributors, it is worth noting, including Ross
and Berlant, could potentially lodge their current work in numerous disciplines.
Treichler already does. The old rule that the discipline granting the Ph.D. remains
a scholar's home thereafter is no longer so decisive. In fact, were higher education
financially healthy, that rule would already be widely broken because of the shifting
disciplinary identifications of cultural studies scholars.

For beginning scholars it is another matter. Some new cultural studies Ph.D.s
apply for jobs to several disciplines, but successes outside the primary discipline
are relatively few. And without some clear disciplinary focus to a dissertation—
either in reality or through careful packaging—jobs may be difficult to find. So it is
one thing for a graduate student to admire the exemplars of wild culture here, quite
another to imitate them. Successful mimesis may be professionally fatal.

Nor is it just a matter of gradually winning disciplinary recognition for new
trends and methods. As late as the mid-1980s established scholars were warning
young academics not to publish in feminist journals for fear the work would not
count as much at tenure time. Yet feminist object choice was often categorically
consistent with the discipline's history. A feminist literary critic or art historian
might substitute novels or paintings by women for the discipline's previously all-
male canon of revered objects, but at least the very nature of the objects at stake
was not in question. Even feminist critiques of patriarchal bias in traditional
objects could be uneasily incorporated as yet one new interpretive perspective.
Once feminist political and philosophical views became widespread, new inter-
pretations of familiar objects (and the journals specializing in them) could be
accepted and given full prestige value. Feminist critiques of professional behavior

and academic institutions were another matter; those were often a genuine threat. So were demands to attend to new classes of objects, such as the pressure to balance national diplomatic, political, and economic history with studies of ordinary people and everyday life.

With cultural studies the problems are sometimes much more severe, since both the methods and the objects incorporated may be unfamiliar, and the epistemological challenges to the discipline substantial; indeed the most ambitious wild culture essays often have no secure disciplinary referent. It is possible in general to map a discipline's response to cultural studies according to how the discipline's core assumptions are challenged by the cultural studies initiative. Despite its long period of confidence in its grand narratives, history has always had a self-consciously dialectical relationship with its object; the past is always inescapably other. Even more so with anthropology, whose uneasiness about its relationship with supposedly primitive cultures has been a major subject of reflection throughout much of its history. English, on the other hand, has had an unshakably religious attitude toward its objects of study for decades; moreover, it has imagined that the relationship is enacted in a timeless aesthetic realm outside history. So cultural historians and anthropologists will feel they have already taken up many of cultural studies's challenges and may resent the suggestion that it represents anything more than a complication of an existing internal debate. English, alternatively, may either feel no challenge at all—if it can only hear cultural studies as a call to incorporate new and different objects and decides to respond opportunistically—or as an absolute one, if it hears the challenge to contextualize as threatening the constitution of its objects and the multiplication of viable object choices as heretical.

The only real threat to English, then, is to the special sacralizing relation the discipline maintains with its traditional objects. In its most decontextualized and ahistorical form, it seems at first that any object can fill the eucharistic structural role of the literary text. That opportunistic, imperialist quest for new interpretive commodities, so Appadurai has suggested, has sometimes led English to be perceived as the disciplinary equivalent of contemporary Japan.[5] But frequent substitutions in fact end by undermining the idealized status of the aesthetic object and by provoking a crisis across the discipline as a whole. Conservative critics are justified in suspecting cultural studies presents a threat to the discipline's elitist sources of prestige. Reverence toward Shakespeare is easier to muster than reverence toward Madonna. And the atomic bomb, to recall the projects we discussed at the outset, wields more cultural power than lingerie.

But the most kaleidoscopic cultural studies essays present a further and still more radical challenge to disciplinarity. We have no firm notions of where they belong in the university—who should be writing or teaching them, what training or expertise they entail, what disciplinary future they anticipate. Should people be trained to emulate Meagan Morris (1992) or Donna Haraway (1992) or Lauren Berlant or David Hirsch in their most radical styles, in essays that seem at once deeply fragmented and stunningly synthetic? Is it the duty of the new generations of acade-

mics to move freely across the cultural field taking up any and all issues and objects in an interpretive politics with no limits? Clearly one answer within cultural studies—though not necessarily an exclusive one—is yes.

That affirmative answer is implicit in all these essays, whether their object choices seem relatively constrained or unconstrained, for nowhere in this collection are we given secure, stable objects whose meaning and nature is established beforehand by disciplinary conventions. While it is obvious that no existing discipline could constitute the body parts featured in Jeffrey Dahmer's story, it is equally true that the antifascist poems of the Spanish Civil War are not familiar disciplinary objects either. To a considerable degree these essays constitute the objects they study through their terms of analysis; in the process they cast up simulacra of the larger culture as well.

Inherent in such essays is a dissent not only from anything even vaguely resembling disciplinarity as we know it but also a dissent from both the internal organization and the cultural positioning of the contemporary university. Most of the intimate power over the professional lives of students and faculty is wielded at the departmental (or local disciplinary) level; as disciplinary loyalties are weakened and academics' identities fragmented, that power has the potential to be unsettled. Disciplines, furthermore, are not merely arrayed equally on a level playing field but arrayed hierarchically according to local strengths and weaknesses and according to the prestige and power and economic status awarded differentially to disciplines both within the university and outside it. As academics invade one another's turf with social and political commentary and evaluation, not only will disciplines' exclusive power to represent themselves to the public be undermined but also the institution's overall ability to manage the relative hierarchization of its components be threatened.

The modern university represents its knowledge and expertise to the public primarily in disciplinary terms. But cultural studies now would speak to the world about the nation and the planet from the vantage point of educated citizenship, not only the circumscribed and contained expertise of disciplinarity. If that is to be one function of the university of the future, then the university will not be the sort of place it has been for decades. In that transformation cultural studies would be at once irritant and inspiration.

Notes

1 This book is based partly on a lecture series of the same title organized by the editors and held at the University of Illinois at Urbana-Champaign during the 1994–95 academic year. We thank those units that funded the series: the College of Liberal Arts and Sciences, the Department of Speech Communication, the English Department, and the Unit for Criticism and Interpretive Theory. The Unit for Criticism and Interpretive Theory has provided continuing support during the production of the book.

2 Such was the opinion of two scientists (who knew Davis and his book) with whom Cary Nelson spoke shortly after arriving on campus in 1970.

3 Cary Nelson, interview with Nuel Davis, November 18, 1995.

4 Constance Penley, in the opening remarks to her paper when she presented it at the University of Illinois at Urbana-Champaign in 1995.

5 Arjun Appadurai, in the draft of his essay presented as a 1994 lecture at the University of Illinois at Urbana-Champaign.

References

Davis, Nuel Pharr (1968) *Lawrence and Oppenheimer*. New York: Simon and Schuster.

Juffer, Jane (1996) "A Pornographic Femininity?: Telling and Selling Victoria's (Dirty) Secrets." *Social Text* (forthcoming 1996).

Hall, Stuart (1992) "Cultural Studies and Its Theoretical Legacies." In *Cultural Studies*, ed. Lawrence Grossberg, Cary Nelson, and Paula Treichler. New York: Routledge.

Haraway, Donna (1992) "The Promises of Monsters: A Regenerative Politics for Inappropriated Others." In *Cultural Studies*, ed. Grossberg, Nelson, and Treichler.

Morris, Meaghan (1992) "On the Beach." In *Cultural Studies*, ed. Grossberg, Nelson, and Treichler.

Sherwood, Steven Jay, Philip Smith, and Jeffrey C. Alexander (1993) "The British Are Coming…Again! The Hidden Agenda of Cultural Studies." *Contemporary Sociology* (May 1993): 370-75.

Thompson, E. P. (1963; rpt. 1966) *The Making of the English Working Class*. New York: Vintage.

Williams, Raymond (1961) *The Long Revolution*. New York: Columbia University Press.

——— (1973) *The Country and the City*. New York: Oxford.

DISCIPLINARITY AND ITS DISCONTENTS

Arjun Appadurai

1

DIVERSITY AND DISCIPLINARITY AS CULTURAL ARTIFACTS

Introduction

There is an implicit economy that informs us when we think of diversity and disciplinarity. Diversity suggests plenitude, an infinity of possibilities, and limitless variation. Disciplinarity suggests scarcity, rationing, and policing. They thus seem to be naturally opposed principles. I argue here that they need not be opposed and that it is important that they be brought into a certain sort of interaction in the American research university. The question is: what sort of interaction?

My observations have a background. First, I take as my context the research university in the United States, as well as those undergraduate colleges whose faculty were trained at research universities. In treating diversity as a cultural artifact, I have in mind the debate of the last decade or so over multiculturalism, political correctness, and affirmative action, which shows no signs of abating, even as it grows more sterile. I am also concerned with diversity as a slogan for the peculiarly American investment in cultural pluralism. I aim to return to the idea of diversity something of the technical sense it has in anthropology.

Images of Diversity

Even without recourse to the dictionary, it is possible to see that diversity is a tricky word. I began by suggesting that it suggests plenitude, an infinity of possibilities.

24 There is something to this implication, even if the dictionary will not directly sustain it. Today, diversity is a word that contains all the force, all the contradictions, and all the anxieties of a specifically American utopianism. Let us call this a utopianism of the plural. To my knowledge the story of how the idea of "pluralism" enters American social, political, and academic thought has yet to be told. Briefly, I believe it is a twentieth-century idea, not really a part of the founding principles of the United States. It is a co-optative reaction to the great migrations from Europe of the late nineteenth and early twentieth century, and the fact that it has since become a central aspect of American society, civics, and political science is one of the interesting puzzles of the cultural history of this century. Be that as it may, today "diversity" as a slogan encompasses the strong fascination with the plural, and the even stranger idea that plurality and equality are deeply intertwined in a democratic society. The folk view that biological diversity is a good thing (which has become naturalized in American thought in the same way that the Oedipus complex and germ theory have become naturalized) creates a good part of the energy that animates debates about multiculturalism.

In spite of this utopian subtext, which suggests that diversity means the infinite multiplication of difference, there is an uneasy sense among all participants in the debate about diversity, particularly in the academy, that it is not an infinitely elastic principle. This intuition is culturally and technically justified. If nothing else, it reflects the sense that even American wealth is not infinitely available to subsidize American dreams. The current discourse of the deficit, played out with remarkable uniformity in corporations, in the government, and in the university, certainly makes it difficult to sustain the idea of the plural as infinite.

When we speak of diversity, whatever our position in these debates, we all know that we are not speaking of just plurality, or variety, or difference. Diversity is a particular organization of difference. The question is: what kind of organization? The issue that does not seem to be engaged in much of the debate about diversity is not whether it is somehow organized (that is, rationed, policed, limited, and reproduced) but how it should be organized. In the wider society of the United States, this is the unspoken issue in debates about immigration, bilingualism, and citizenship. But my concerns here are with the academy, and in the academy the central problem is the reluctance to recognize that the economy of diversity is also a managed economy. If it is in the wider sense a managed economy, how then is it or could it be managed in the academy? What is at stake in its management?

There are many ways in which diversity could be managed in the academy, notably by the wholesale application or extension of larger principles, mechanisms, and ideas from outside the academy, such as quotas, censuses, and entitlements. These approaches tend to generate affirmative action babies, human and technical, whether we like them or not. Much of the official discourse of the University, notably in matters of recruitment, retention, and promotion, is premised on the assumption that diversity is a mechanical good, the aggregate outcome of good intentions applied case by case. By refusing to recognize that diversity requires more deliberation and more organization, universities allow the unfree play of the

market—in students, in staff, and in faculty—to determine actual demographic outcomes. Furthermore, actual outcomes—specific statistical profiles about the presence of students of color, faculty of minority background, and a vaguely international milieu are used as marketing tools by many colleges and universities to seek further diversity in their populations.

What is lacking is a sustained effort to examine the links between intellectual and cultural diversity. One way to approach diversity in the university is to see it as a particular organization of difference, in which intellectual and cultural diversity are interactive and mutually interlocutory. If we miss this link, the last vestiges of difference between the academy and other corporate organizational forms will disappear and the university will become just another workplace. This is not to deny that the university is *also* a workplace (involving issues of class, wages, safety, discrimination, mobility, and productivity) but to recall that it is a special sort of workplace concerned with thinking, with training, with ideas, and with knowledge.

One symptom of the current lack of critical thought about diversity in the academy is to be found in the canon debate. While much has been said in and about this debate, one feature of the debate is worthy of remark. There is a peculiar anxiety about quantity that characterizes much of it. This emerges in arguments over the form and shape of the canon—in particular of classic or "great" books in the undergraduate curriculum. In this debate of the last decade, there is a strange slippage between issues of quantity and quality. On the face of it, the debate is about the sort of standards that ought to govern the selection of classic books to be read by undergraduates—*prima facie* a question about quality. But this issue invariably tends to slip into a zero-sum discourse in which the addition of new sorts of classic works—by women and people from other societies and traditions, for example—is seen as unseating and eliminating a list, even if imaginary, of already time-tested classics. The debate often implies that for books to be truly great, they must belong to a closed and short list.

In one sense, this view reflects the deep and widespread idea that lists of the great, the rare, and the precious tend to be short and overlapping, with books as with other sorts of commodities. More salient is the fact that the issue of classic works involves a small fraction of the thirty or so courses that most American undergraduates take in their four or five years in college. In this sense, the list is finite, not by its nature but because the formal pedagogical opportunities to tell students what is really great about some books are relatively few. The true scarcity is not of great books—an odd idea—but of opportunities to impress upon students the right norms of quality-control.

Given this unconsciously apprehended scarcity of pedagogical opportunities to communicate ideas about great texts in the average college curriculum, it is no surprise that the sense of scarcity—and thus of urgency and of competition—tends to blur the line between the admission of books into various kinds of lists and the admission of students (and, to some extent, of faculty and of staff) into the social world of the university. There is a vague political intuition, shared by all sides in campus debates, that the demography of great books and the demography of stu-

26 dents and faculty are somehow related. One aspect of this relationship, which has been widely noted, is that new kinds of students ("multicultural") tend to demand new kinds of books, but the sense of demographic anxiety runs deeper than this factor alone. It also reflects unease about the lack of principles with which to regulate intake in any of these lists. With human beings as with texts there is a sense that issues of quality (a.k.a. "standards") and issues of quantity are connected, but there are few explicit efforts to engage this connection.

Tied to the general absence of engagement with the links between intellectual and cultural diversity is another absence: the lack of any effort to distinguish between cultural diversity and the culture of diversity. By this I mean that the commitment to cultural diversity is dominated by numerical and categorical strategies that fundamentally involve addition and extension. A more serious effort to create a culture of diversity requires more than new categories and added numbers of people and books conceived to be different. What is required is a sustained effort to create a climate that is actually hospitable to diversity: one which puts diversity at the center of the curriculum and the demographics of the university, rather than at its statistical or conceptual margins. Affirmative action—in the narrow sense of entitlement by quota—is good neither for books nor for people. What is wrong with the narrow sense of affirmation is that addition of numbers—though good in itself—says little about the organization of the new or the transformation of what already exists by what is new. Put simply, the demographic and textual core of the university remains untouched if affirmative action is seen as a matter of a few more books, a few more courses, and a few more students and faculty of color.

More may be better, but it is not good enough. It is not good enough *for the university* unless the commitment to diversity transforms the way in which knowledge is sought and transmitted. That is, without a conscious commitment to the mutual value of intellectual and cultural diversity—which is really what I mean by a culture of diversity—the core mission of the university remains insulated from the commitment to diversity. Though the American academy has to some extent managed to put into practice a minimal commitment to cultural diversity, it has a long way to go before it can truly claim to have instantiated a culture of diversity. While the American university has managed to put into its official life (job advertisements, faculty and student recruitment, and courses of study) the principle that more difference is better, it has not succeeded in creating a habitus where diversity is at the heart of the apparatus itself. To deepen this appreciation requires a critical approach to the problem of disciplinarity, since it is in and through various kinds of discipline that the American university pursues its pedagogical and research projects.

The Idea of Disciplinarity

There has been much serious writing on the history of disciplines and disciplinarity, and an even larger literature about particular scholarly disciplines, their history and organization. There is also a substantial literature about the way in which the American research university adapted late nineteenth century German mod-

els, which accounts for a good deal of the morphology of departments and disciplines, for the ideology about teaching in relation to research, and for the value of research training. The "liberal arts" college is a more peculiarly American thing, which combines elements of the Oxbridge model of undergraduate life with the European model of disciplinary research. Notice that in neither European model (the British or the German) is there the slightest interest in diversity, especially in its social and cultural sense. That is an American preoccupation of this century, as I have already suggested. I am not going to engage this complicated set of literatures. Rather, I am going to propose a naive anthropology of the idea of disciplinarity as a cultural artifact.

One place to begin such an anthropology is the tension between historicity and authority. At least since the publication of Thomas Kuhn's *The Structure of Scientific Revolutions*, there has developed a broad consensus that the historicity of certain forms of inquiry is not the enemy of their productivity but perhaps its guarantee. This idea has leaked into various fields, institutions, and disciplinary cultures unevenly, but it seems clear that a simple model of accumulation and expansion no longer governs, even in such fields as philology, psychology, or musicology. Nevertheless, the virtues of historicity (or at least its undeniability) do not seem to blunt the rhetoric of permanence in many disciplinary contexts. This rhetoric usually underwrites the conservative discourse of standards, canons, taste, and anti-fashion that is most visible in public debates about the humanities, but in a quieter way appears in the social sciences and even in the natural sciences. The issue tends to show up in the invocation of quality and permanence—typically humanist tropes—in fields dominated by reading and interpretation. In the social and natural sciences the rhetoric of permanence relies on images of reliability and objectivism. It is thus also invoked in regard to ethnic identities, nationalist histories and the like, and often deployed against critiques couched in the idioms of invented traditions and constructed realities. The battle over trendiness, fashion, and the tradition of the new in the humanities seems to be fought largely at the annual meetings of the MLA and in cultural studies settings, but it is present throughout the academy.

One crucial question is why the humanities have become the site for the displacement and enactment of these large academic and social anxieties. I would suggest that this implosion into the humanities of issues of general cultural import reflects the peculiar status of the humanities and, at the college level, of the liberal arts, in an educational atmosphere increasingly driven by mega-science, corporate sponsorship of research, the rollback of federal support for big research, and the continuing scramble for professional and pre-professional credentials among American students. Thus while many colleges and universities have increasingly become factories for specialized research, applied interests, and professional credentialing, the humanities have become the critical site for the idea that the University is also about thought and reflection, cultivation and conscience, disinterest and abstraction, literacy and cosmopolitanism. Since the humanities are simultaneously badly funded and seen to be infected by dangerous fashions—in

art, literary theory, popular culture and the like—they are a serious site for cultural warfare. On their survival rests the image of the academy as being *independent* of wider social pressures, whether from science, state, or industry, and of the university as being the critical bastion, in modern American society, of the *cosmopolitan*.

In addition, there is the anxiety about quantity and quality that I alluded to in an earlier section of this essay and a widespread presumption that the four years of undergraduate life (when most students are roughly between eighteen and twenty-two years of age) constitute the crucial window for instilling cultural literacy. Before that age, students are seen as inadequately mature and after that, as given over to the full-time worship of Mammon. Whatever the reasons, we have a peculiar political economy behind the debates over the canon that assumes that ten or fifteen books, read in two or three courses, in a few thousand colleges and universities, in four years of the life-cycle of a modest number of Americans, are the decisive stage for the battle over literacy, standards, and cosmopolitanism. Is it expected that people will never read again? Or that they will never again read in a proper pedagogic setting? Whatever the reasons, the humanities have been elected for the role of hosting a series of dramas and debates about what constitutes cultural literacy for the educated elite. This implosion of large issues into a small and underfunded area of the American academy may well reflect the ambivalence about disinterested learning, passionate reading, and serendipitous discovery among those who hold power in American society as much as it reflects the left-wing discovery that the humanities are the place where existing ideas of the good, the true, and the beautiful are most easily exposed and challenged.

Debates about cultural studies—seen variously as an area, a field, a program, a discipline, or a conspiracy—reveal an overdetermined landscape of anxieties about the humanities. Two existing disciplinary fields that have much to lose (and also to gain) from the growth of cultural studies in the last decade are anthropology and English and American literature. In general, English departments have been the spaces within which cultural studies has grown and thrived. Recalling the origins of cultural studies in England in the work of Richard Hoggart and Raymond Williams (both students of literature), this is perhaps understandable. It was also doubtless inevitable that it would be in the space of English that Matthew Arnold's sense of culture (as civilizing process) would encounter the revenge of popular culture as a subject fit for literary study. As literary critics widened their lens to include all forms of representation, it was natural that the visual would enter their interests, with its accompanying cinematic, scopic, and feminist critiques. Exported to the colonies, English created many minor literatures, particularly of the "Commonwealth" variety, again rich materials for contesting the "white" canon. To all this must be added the seductions of theory (a.k.a. French post-structuralist thought) the special bête-noire of the literary neo-conservatives. A heady mix, mediated by a peculiar mixture of high formalisms (rightly traced back to the cold-bloodedness of New Criticism) and of low formalisms (feminism, music theory, rap, and consumer culture).

Of course, what looks like a vast and unruly expansion of the subject matter of

literary studies in the United States (annually celebrated in the MLA fiesta and demonized by the National Association of Scholars and other conservative organizations) hardly passed without remark within English departments themselves, where scholars of Byron and Chaucer, of Joyce and of Whitman, did not greet this new imperialism of cultural studies without notable alarm and aggressive resistance.

But from the outside, in such fields as anthropology, cultural studies looked like a high-consensus conspiracy by literary scholars to steal CULTURE, or worse, to turn the study of cultural forms into a literary exercise. At this point, the protectionist wing of anthropology joined forces with the literary conservatives to decry, with the usual disregard for detail—all forms of the "postmodern," meaning all forms of cultural theory which emerged after they stopped reading. This war over culture (tied indirectly to the more publicly discussed "culture wars") takes on a special displaced force in anthropology, where the last few years have witnessed a growing anxiety about whether and why anthropology should remain the unified home of the "four fields"—socio-cultural anthropology, linguistic anthropology, biological anthropology, and archaeology.

In England and Europe, these fields are largely separate, but in the United States, because of the Boasian heritage, the special concern with cultural relativism, and the intense battle against racism in social science, anthropology retained the vision of a grand discourse on all forms of human variation, a vision sustained by explicit reference to evolutionary theory. For reasons that lie outside the scope of this essay, this foundation for normal interaction across the four fields has fallen on hard times lately and sustains uneven serious traffic. What is left is market niches, university politics, and shrinking budgets as the main motivations for holding the four fields together. In short, current arguments for holding the four fields together are grounded in calls to disciplinary patriotism rather than in high frequency, vibrant intra-disciplinary exchanges. The anxiety about holding the four fields together is tied up with a wish for a sort of general paradigm that is now plainly lacking. Since these matters are highly contingent, it is quite possible that such an integrating discourse—built around new understandings of material life: the body, work, space, death, warfare—may well emerge again, but calls to disciplinary arms have never been the best ways to hasten the progress of intellectual history.

At any rate, for anthropologists the threat from cultural studies comes just at the time when the center (at least in terms of the issue of the four fields) is seen as weak. Thus, although there is a healthy traffic on the borders of the two disciplines between groups who are happy to work in the gray economies typical of disciplinary borders, conservatives in both spaces have drawn the battle lines and are engaged in a vigorous tug-of-war about who really owns the study of culture. Of course, this is not helped by the fact that a whole slew of other fields, ranging from sociology and communication studies to romance languages and musicology are happily grabbing pieces of the market.

One way in which the attack on cultural studies is formulated—by opponents from both anthropology and from literary studies—is to portray it as promiscu-

30 ous in its choices of topic, loose and opportunistic in its methods, lax and consumerist in its pursuit of "trends." The charge of being victims of "trend" or "fashion" (hardly the first in the history of Western intellectual life) is levelled at cultural studies scholars as an omnibus characterization about its "theory" (too French), its topics (too popular), its style (too glitzy), its jargon (too hybrid), its politics (too postcolonial), its constituency (too multicultural). All this is usually accompanied by charges, both implicit and explicit, that the whole business of cultural studies is somehow not really scholarly, not truly disciplined, not about "real" research, and not about genuine knowledge. To see why cultural studies excites this anxiety about genuine scholarship, it is necessary to look more closely at some ambiguities that characterize ideas about discipline and disciplinarity, especially in the humanities.

Just as in regard to diversity there has been little thought about how to get from cultural diversity to a culture of diversity, likewise there is an aporia—or break—in thinking about disciplinarity in its two main senses: (a) care, cultivation, habit and (b) field, method, subject matter. The relationship between these two senses of discipline and of disciplinarity remains obscure in much debate, for example, about interdisciplinarity. The general contradiction in this sphere can be put something like this: much thinking about undergraduate curricula in the American academy presumes that care and cultivation—as expressed in habits of clear thinking, writing, and argumentation—must be divorced from the limitations of any single subject or field. This is what is liberal about the liberal arts. But graduate teaching (which is often and rightly described as training) presumes just the opposite, namely that discipline in the primary sense (care, cultivation, rigor, order) can only be formed in the context of special subjects, fields, and disciplinary departments. Caught in this contradiction is the idea of the undergraduate major (a messy creature) as well as the host of initiatives that multiply today under the rubric of the interdisciplinary (humanities institutes, interdisciplinary programs, interdepartmental colloquia and so forth.) All of these are efforts to restore the sense that discipline in the first—scholarly and critical—sense should be the conscience of disciplines in the second or departmental sense.

By and large, the political economy of the American university over the last fifty years or so (substantially driven by the needs for fiscal and bureaucratic accountability associated with large funds from the state and from industry) has resulted in the reverse situation: one in which departments (especially those defined by old and naturalized core disciplines, i.e. English, history, mathematics, physics) become the conscience and gatekeepers of discipline in the primary sense of care, cultivation, and habit. Yet scholarly discipline itself has a bifurcated history that is worth remarking.

There seem to be two senses of scholarly discipline, in the history of words and in the history of intellectual practices and institutions. On first glance, discipline in the sense of "care, cultivation, and habit" may appear to be best exemplified and institutionalized in the British ideal of the gentleman-scholar or amateur. This anti-professional sense of "discipline" (not unlike Hans-Georg Gadamer's sense of

bildung in *Truth and Method*) may appear to be deeply antithetical to the sense of discipline (tied up with specialized techniques, standards, and interests) defining the vocation of the scholar. These two senses of scholarly discipline are the roots of what is now the very different, even opposed, milieus of graduate school and undergraduate learning, especially in the humanities. Graduate training, with its intense bias towards the vocational, the professional, and the specialized appears directly contradictory to the idea of self-cultivation and liberality associated with the undergraduate ideology of the liberal arts.

The roots and implications of this tension between graduate school and college, between training and teaching, between teaching and scholarship, between the cultivation of a liberal self and the production of a professional scholar, has much to do with the archaeology of the idea of "research" in the Western academy. Briefly, I would like to suggest that sometime in the middle of the nineteenth century in Europe, the interest in discovery, reflection, observation, inquiry, and debate gave way to the idea of something radically new—the idea of research, the systematic pursuit of the not-yet-known. Research, in this sense, represents an inherently collective, replicable, and professionalized mode of inquiry into the world, first institutionalized in the natural sciences, then in history and the fledgling human sciences, all the way from philology to sociology. By the latter part of the nineteenth century, we get the idea of the research university, born in Germany and then taken up elsewhere in the world, including the United States.

This story is in many ways well studied and well documented. What I wish to highlight here is a matter I intend to take up in greater detail elsewhere—the newness and cultural strangeness of the idea of research itself. The main tension is not between teaching and research, or between teaching and training, or between professionals and amateurs, or even between two very different senses of the cultivated self which developed among academics in Europe in the course of the nineteenth century. Each of these tensions follows from a deeper institutional and epistemological change that occurs in Western Europe sometime during the nineteenth century, a change reflected in the emergence of the idea of research as the only legitimate way in which knowledge could be created in the framework of the modern university. Once this break occurs, the rest of the contradictions follow, one of which involves the tension between scholarly discipline and departmental disciplinarity. The latter reflects all the properties identified by Max Weber and others with the emergence of professional scholars, whereas the former harks back to an earlier, more broad ideal of knowledge associated with the formation of a cultivated self. This break is what, to pick one example among many, makes Goethe's treatise on color appear, in retrospect, as bad physics. If we can agree that the idea of research is both what is newest, strangest, and most interesting about the epistemology of the modern Western university, then the challenge is to establish whether there can be any coherent shared space between these two senses of scholarly discipline. Put another way, can liberal arts education and research co-exist to each other's benefit? This question might seem frivolous, in view of the fact that

both in the United States and in Europe, as well as in many other parts of the world, they are encompassed either in the same institutions or in the same system of institutions. But does that mean they actually nurture each other?

In the folklore of the American academy the tension between teaching and research is frequently seen as a simple matter of faculty priorities and interests, with teaching represented as a chore and research as desirable and prestigious. There may be some truth to this perspective and to the increased pressure on faculty to do more justice to the classroom (and to the paying undergraduate consumer) and less to their research. But the issue is not just one of contradictions between faculty and student interests, or of different scales of prestige and reward associated with these activities for college and university teachers, or even of their apparently opposite budgetary properties: teaching pays the bills whereas research is often costly (especially in an era of shrinking federal support for research).

What is really at issue are the very different ideas of knowledge involved in the two kinds of discipline. The idea of discipline in the liberal arts aims to cultivate a certain sort of cosmopolitan liberal self among students. The idea of discipline that underpins the practice of research has very little to do—normatively—with any morally weighted sense of a liberal self, and has everything to do with the means and techniques for scrutinizing the world and producing knowledge that is both new and valid. The doing of research does, of course, involve certain ideals of ethics, vocation, and purpose but these ideals are means to the reliable pursuit of the not-yet-known. In the liberal arts ethos of discipline, by contrast, the formation of a certain sort of self is indeed the end, the telos of the activity.

What does this discussion of the idea of research have to do with disciplinarity and diversity? Departmental disciplinarity frequently advances its interests by invoking its special status in the fostering and protection of research. At the same time, when departments argue their interests (in matters of curriculum, certification, hiring, and budgets) against other departments or organized fields of study, they not only invoke the aura of research, but also imply that discipline in the prime sense of "care, cultivation, and habit" (the hallmark of the liberal arts and the building of cosmopolitan selves) is somehow an extension of the ideal of research. In fact, both conceptually and historically, just the reverse is true. Thus the first step towards articulating a more fruitful relationship between disciplinarity and diversity is to recognize the suture that the ideal of research permits between the discourse of departmental disciplinarity and the more general liberal ideal of scholarly discipline.

There is no easy solution to the co-existence of research and the formation of a cosmopolitan self as twin goals of the modern university. Yet one crucial step towards providing a moral basis for the pursuit of diversity (in both the intellectual and cultural senses) in the academy is by recourse to the more general, and historically prior, logic of the liberal arts, which was tied up with the production of a certain sort of liberal self.

How could this primary sense of "discipline" help to create what I earlier called a culture of diversity in the modern American university? Here I return to the idea

of the liberal arts as quintessentially cosmopolitan: they were intended, that is, to widen the horizons, broaden the mental experiences, expand the imagination, and stretch the moral worlds of those exposed to them. To be sure, this sort of cosmopolitan ideal is also tied up with a particular bourgeois liberal conception of the self, with elite European conceptions of self and other, and with the many European imperialisms of the last four hundred years, as a key component of the civilizing of European elites. Yet, it also contains the kernels of the idea that the key to self-formation is a disciplined encounter with the other. Gadamer, again, argues for the importance of the study of the classics of Greece and Rome because of their strangeness and their role in the dialectic of self-formation. Today, in the heat of the canon wars, it is hard to see Greek and Roman texts as truly "other," but the argument, in principle, is compelling.

The cosmopolitan self which is the object of humanistic pedagogy is tied up with a series of political, cultural, and social assumptions that might cause unease among some of us in an era in which liberalism has to be critically reconstructed and not just passively enjoyed. Yet there is no denying that in most of its Anglo-European variants, liberal education contains the germ of the sense of the cosmopolitan. This germ is often obscured by the other associations of liberal pedagogy, with democratic virtues, with class prerogatives, and with various forms of civilizing rhetoric. Yet it certainly contains the principle of self-expansion through engagements with the other. It is this principle that links the classic liberal sense of discipline with the values of diversity. Cosmopolitanism today, without a serious engagement with diversity, must degenerate either into tourism or into aestheticism, which are linked pursuits that can hardly advance the democratic potential of the modern university.

Diversity and Disciplinarity

In the context of the American research university as I have described it, and bearing in mind the artifactual and historical qualities of both diversity and disciplinarity, I suggest that diversity in all its senses poses a threat to departmentalized disciplines, both at their centers and at their boundaries. The canon wars, on which much ink has been spilt, are an excellent illustration of anxieties at the center: will Shakespeare be on the chopping block if Toni Morrison gets in? As regards the threat at the boundaries, there are numerous examples: anthropologists view English as a threat, just as political scientists worry that anthropologists are poaching on the nation-state; sociologists are moving to the Third World as media students begin to occupy domestic space in the United States; film scholars worry about members of the English department who have started teaching about film; and everyone is worried that cultural studies will take over the world.

Departmental disciplines operate increasingly like antagonistic nation-states, with much policing of boundaries, arcane loyalty tests, and rampant intellectual protectionism. Stimulated by ever-shrinking job markets and ever-growing budget cuts, there is much anxiety about disciplinary markets, and rhetorics of allegiance, mobilization, and interdisciplinary warfare are rife in the large universities.

This sort of border warfare (between disciplines-as-nation-states) usually indicates major internal problems, in the academy as in the wider social world. Debates within disciplinary departments typically ignore the fact that relations between fields and sub-fields cannot be legislated by economic externalities or by a misplaced sense of political solidarity in the budget wars. Such debates frequently betray the fraying relationship between departments and disciplines. This latter slippage, increasingly observable across the university, affects the entire tenor of debates about interdisciplinarity and indeed about diversity.

One potentially fruitful way to look at the relationship between diversity and disciplinarity is through the lens of "minors," "minorities," and "minor literatures." In a brilliant essay entitled "What is a Minor Literature?", Felix Guattari has shown that the key issue about minor literatures is that they expose the historicity of the majority of "major" literatures. This argument could be applied to literatures and knowledges across the entire terrain of the American academy, perhaps including the natural sciences, but certainly including the humanities and social sciences.

Today, calls for intellectual diversity in the curriculum (rather than just social diversity in the academy) are typically associated with calls for greater voice for "minor" texts. In more radicalized settings, advocates of "minor" literatures seek not just to add but to destabilize majority literatures (the textual foundation of all departmental disciplinarities). In even more radical cases, they seek to destabilize the very "majoritarianism" that underlies disciplinary authority. That Allen Bloom has now been followed by Harold Bloom in the debate about great books suggests that these efforts are successful as provocations in the academic world and the publishing world, even if they are hardly as powerful as they are sometimes made out to be. The regular flowering of Blooms suggests that the voice of the minor remains unsettling.

In the current dispensation of the culture of diversity and disciplinarity in the American academy, diversity is typically the voice of the "minor" whereas disciplines claim, generally successfully, the voice of the major (in all the senses of the senior, the larger, the more important). Here is where the tension between historicity and authority comes in. The idea of the minor can be used to explore the historicities that constitute the relationship between majority and minority in the history of disciplines. By extension, we can open up a serious way to interrogate the relationship between departmental disciplinarity and scholarly discipline in the life of the academy, since "minority" voices and texts can be the trojan horse both of the border in the center and a place to link intellectual to cultural diversity. It is with this last issue, tying "minor" to "minority" and intellectual to cultural diversity that I would like to close.

One way to think about the links between diversity, the cosmopolitan, and the minor in the life of the academy is to consider the problems and potentials of area studies. By area studies I mean the particular organization of funds, centers, and pedagogical methods developed in the United States after 1945 to study those large areas of the world—Africa, Asia, Latin America, and the Middle East—considered both strategic for United States global interests and civilization. The debate over

the future of area studies is now active and is deeply caught up with the effort of scholars, policy-makers, and funders to find a new way for American universities to internationalize themselves and participate in the making of a new world order. The question is: does the peace dividend have implications for how we study the rest of the world, as that world changes rapidly and in unexpected ways? This is not the place for an extended discussion of this topic, but a few observations might be helpful.

If the liberal arts (in the primary sense of the cultivation of a liberal self) have always involved a cosmopolitan agenda, then area studies—especially in the emerging cultural studies inflected forms that are gaining visibility—is surely one way to carry forward the cosmopolitan ideal without engaging in tourism or simple elite self-cultivation in the American college and university. Further, given that area studies remains both minor and endangered in most American universities and colleges (largely because of the steady decrease in government funds at the graduate level), it retains the value of the minor in unsettling the authority of disciplines. Often seen as dangerously anti-disciplinary (and thus as formless) area studies is simultaneously intensely demanding (especially as regards language training) and is inherently international, thus cosmopolitan, in its potential for American students and faculty. In current debates about the future of area studies, it has been shown that it contains the potential for a new, and critical, internationalism (Lee 1995). The critical revitalization of the cultural study of other parts of the world (area studies) is thus at least one way in which to restore the primacy of the liberal-cosmopolitan ideal of discipline over the later, research-driven ideal of disciplinarity.

Intellectual and Cultural Diversity

The major question originally proposed concerns how the interaction between disciplinarity and diversity could best be organized. A sub-question is: how can diversity be managed, assuming that there is an economy of diversity? A further question, which brings us to the matter of disciplinarity, is: how should intellectual and cultural diversity be linked in the academy?

An effective strategy for dealing with these questions runs something like this. Let us insist on the mutual interlocution of historicity and authority in the organization of disciplines and recognize that one entailment of this mutual interlocution is to resist the hegemony of departmental disciplinarity (tied to the dominance of the ideal of "research") over the more general disciplines of reading, writing, and argumentation. In so doing, let us invoke the minor and minority in the landscape of disciplines, not just as part of a program of distributive or affirmative reform, but as a way to destabilize the authority and establish the historicity of the "major" in whatever textual and interpretive world we inhabit.

This critical approach to the majoritarian thrust in departmental disciplinarity will ensure the constant historicizing of disciplinarity. It will also provide a principled, scholarly, textual, properly academic way to assure that the question of plurality—that is, cultural diversity—is driven by the academy rather than by

36 electoral politics at large. In this strategy, intellectual diversity could drive cultural diversity within the academy, and could provide a critical basis for its organization. This should not be taken as a recipe for the isolation of the academy from politics, but as a proposal for the productive regulation of the ways in which politics-at-large enters the logic of cultural diversity in the academy.

Since questions of minority, historicity, and authority with respect to the disciplines inevitably invite an understanding of histories larger than those of the academy, the door might thus be opened for a genuinely dialectical relationship between the authority of disciplines and the diversity of texts and of readings. One result of this dialectical process could be to provide a way to assure that the plurality of readings and the plurality of readers (teachers and students) will drive each other while providing realistic constraints, in any given real university or college, on the actualization of the other. In this way, cultural diversity can create cultures of diversity not by fiat or by politics-as-usual but by a form of politics that is properly academic, that is, one that is disciplined without being merely disciplinary. This is a utopia whose thinking does not depend on the prior admission of its impossibility.

Notes

This essay took shape before audiences at Bryn Mawr College, at Rutgers, and at the University of Illinois. The last of these was the most recent, and led to its publication in the present form. I am grateful for comments and suggestions made on all these occasions, particularly by Michael Bérubé, Dilip Gaonkar, George Levine, Cary Nelson, and Judith Shapiro. I am particularly grateful for suggestions about the penultimate draft from Dilip Gaonkar, who alerted me to the relevance of some of Gadamer's ideas to my arguments. This essay is part of a larger project that explores the anthropology of the modern American university. Many topics dealt with cursorily here await fuller treatment in that larger project. These include: the wider economy of debate about immigration, citizenship, and democracy that affect debates about diversity in the American university; the future of area studies as a distinctive knowledge form through which the American university grasps the world; and the genealogy of contemporary American practices and discourses surrounding "research." Because of the preliminary nature of this essay, the citation of other relevant work is minimal, though my reliance on a wider literature, especially on the canon wars, should be apparent to the reader.

References

Gadamer, H.G. (1990) *Truth and Method.* Trans. Joel Weinsheimer and Donald G. Marshall. New York: Crossroad Publishing Corporation.

Guattari, F. (1990) "What is a Minor Literature?" In R. Ferguson et al., eds. *Out There: Marginalization and Contemporary Cultures,* 59–69.

Lee, Benjamin (1995) "Critical Internationalism," *Public Culture* 7 (3), (Spring 1995): 559–92.

Virginia R. Dominguez

2

DISCIPLINING
ANTHROPOLOGY

Five years ago I would undoubtedly have written a different essay. Then the image of "anthropology" among non-anthropologists energized by the intellectual agendas and practices associated with "Cultural Studies" was not good, to put it mildly. Clifford and Marcus's *Writing Culture* (1986) had become a canonical citation in critical depictions of anthropological tropes of realism, Marcus's own anthropological training, affiliation, and location notwithstanding. Counterethnographic filmmakers, like Trinh Minh-Ha, were not shy about their antagonism. And while individuals like James Clifford and Janice Radway had made strategic sympathetic uses of anthropological debates and research techniques in print in *The Predicament of Culture* (1988) and *Reading the Romance* (1984) respectively, there were few degree-certified anthropologists in 1990 who did not feel that "Cultural Studies" was overwhelmingly critical of anthropology and full of stereotypes about anthropology and anthropologists.

Indeed the defining moments, sponsors, and journals had few, if any, anthropologists in visible positions. Authors identifying themselves as anthropologists (or with an institutional affiliation with anthropology) were almost non-existent in the first 3 volumes (1987, 1988, 1989) of the then new journal called *Cultural Studies*. The same went for invited speakers at the now famous conference entitled

38 "Cultural Studies Now and in the Future," held at the University of Illinois at Urbana-Champaign in April 1990, which is widely regarded today as a defining moment in the development of "Cultural Studies" in the U.S. Organized by Cary Nelson, Paula Treichler, and Larry Grossberg through the Unit for Criticism and Interpretive Theory on that campus, it drew an interdisciplinary audience of about 900 and featured speakers from a range of anglophone countries and disciplines as varied as art history, communications, English, and sociology. The organizers considered the conference international and interdisciplinary and promoted the resulting book, *Cultural Studies* (1992), as such. Yet of the 45 scholars with essays in the book, only one, Emily Martin, was an anthropologist either by training or institutional location.

An essay on "anthropology" in relation to "Cultural Studies" in 1990 could not have avoided questioning or, more importantly, theorizing the apparent absence of anthropologists through selective exclusion or self-alienation, the consequential silencing of anthropologists, and the arguable fashionable dismissal of anthropology and anthropologists. The task would have simultaneously been intellectually easier and politically riskier than it is today.

Changes on both "sides" have led, in the past few years, to more contact, more public declarations of the possibility of learning from each named scholarly "community" (whether or not officially disciplinary), more visibility of a named "Cultural Studies" within anthropological ranks, and a greater presence of degree-certified anthropologists in named "Cultural Studies" activities. But these openings remain constrained—both by anthropology's own disciplining practices and by the majority/minority frame through which the numerical majority that identifies itself as "Cultural Studies"—and is overwhelmingly trained in literature, aesthetic, or textual media analysis—approaches the idea of anthropology, the history of anthropology, the rhetoric of anthropology, the practice of anthropology, and the scholarly publications of anthropologists.

Anthropologists remain very much a numerical minority in some of the most visible scholarly journals friendly to "Cultural Studies." For example, between 1990 and (January) 1995, the journal *Cultural Studies* published 129 full-length articles. Only 4 of these authors are identified as anthropologists in the biographical information about authors (See table 1). One article during this period dealt with anthropology directly. Entitled "From Gesture to Activity: Dislocating the Anthropological Scriptorium" and authored by David Tomas (who teaches Visual Arts at the University of Ottawa), it discussed Clifford and Marcus's critiques of ethnographies as texts and argued that ethnographic methods should include visual arts and not just written texts. During this five year period, no known anthropologist was cited more than 8 times (and that was Clifford Geertz), whereas at least 6 scholars from other disciplines were cited in numerous articles: Stuart Hall (32 times), Pierre Bourdieu (25 times), Raymond Williams (20 times), Michel Foucault (17 times), Edward Said (15 times), and Benedict Anderson (10 times). Over the same five-year period, the proportions are similar in both *Cultural Critique* and *Social Text*. Only 4 authors in the issues of *Cultural Critique* we examined list anthropol-

TABLE 1
Cultural Studies, 1990–1995 (Vol. 4, No. 1–Vol. 9, No. 1)
Biographical Information about Authors

Authors' Fields of Study:	
Media/Film/Communications	33
English/Linguistics/Rhetoric/Literature	25
Cultural Studies	13
Sociology	9
Humanities	9
Political Science/Government/Public Policy	5
Language/Area Studies	5
Women's Studies	5
Education	5
Social Science	5
Anthropology	4
Art History/Art	3
Other	15
(Indigenous Studies-1, Geography-2, Music-3, Health Research-1, Design-1, Critical Studies-1, Social Theory-1, American Civilization-1, History-3, Child Research-1)	
Non-Academic	7
Information Not Provided	15
Total	158

ogy as an academic affiliation (see table 2), and cited anthropologists are fewer than in *Cultural Studies* (the journal) over the same period of time, with Geertz here—still the most cited anthropologist—being cited only 5 times. In contrast, Foucault is cited in 27 articles, Jameson in 23, Said in 19, Spivak in 18, Derrida in 17, Lyotard in 16, Freud in 15, Bourdieu in 14, Lacan and Benjamin in 13, Althusser and Barthes in 11, and Stuart Hall in 10. Only 8 authors (out of 209) who published 195 articles in Volumes 8 through 12 of *Social Text,* spanning a period of nearly six years since 1989, are identified as anthropologists (see table 3). And cited anthropologists are no more numerous in *Social Text* than in *Cultural Studies* or *Cultural Critique*: Appadurai, cited in 10 articles, is followed by G. Marcus with 5; R. Rosaldo with 4; and M. Fischer, C. Lévi-Strauss, and P. Rabinow each with 3. In contrast, all of the following non-anthropologists were cited at least 10 times: Jameson (21), Said (20), Foucault (18), Spivak (18), R. Williams (18), Benjamin (17), Habermas (14), Marx (14), S. Hall (12), J. Clifford (11), Laclau (11), Derrida (10), Bhabha (10). Somewhat different intellectual agendas among these journals can be gleaned from who gets cited more and less frequently —Hall, Bourdieu, and Williams proportionately more in *Cultural Studies*; Foucault, Jameson, and Said more in *Cultural Critique*; and a combination of those two in *Social Text*. But one thing holds for all three, even in the 1990s: anthropologists are included as authors to publish and cite but only in very small numbers.

Seen in this light, it is obvious that anthropology as an institutionalized disci-

TABLE 2

Cultural Critique, 1990–1995 (No. 15, Spring 1990–No. 30, Spring 1995)
Biographical Information about Authors

Authors' Academic Departments	
English/Literature	65
Language/Area Studies	10
Women's Studies	10
Sociology	5
African-American Studies	4
Anthropology	4
Cultural Studies	4
Philosophy	3
History	2
Law	2
Political Science/Government	2
Other	5
(American Studies-1, Education-1, Germanic Studies-1, Performance Studies-1, Speech/Communication-1)	
Information Not Provided	16
Total	132

pline is not currently merging with a named and identifiable, if not equally "disciplined," Cultural Studies. Nor, contrary to some perceptions in literature circles sympathetic to Cultural Studies, is there much tangible evidence that anthropologists are really being read and discussed—at least in leading Cultural Studies journals. A certain palpable distance continues to exist and to be reproduced. Since a relationship of greater fluidity, exchange, and mutual influence is far superior to what currently exists, we should be asking ourselves what is at stake for those who do, and those who don't, want the antagonism to continue.

For example, a conciliatory message is evident in Tony Bennett and Valda Blundell's statement in their Introduction to the January 1995 Special Issue of *Cultural Studies*, which focuses on "First Peoples: Cultures, Policies, Politics." Specifying their desire to establish closer links between Cultural Studies and the reforming currents within anthropology and archeology, these guest editors wrote that the "development of such closer links will help CS to develop a more cautious and critical account of its own history [and] that the use of ethnographic methods within CS has, of course, always been an area in which anthropology and CS have intersected and criticisms of traditional ethnographic techniques of inquiry are now influential within both areas of work" (Vol. 9, No. 1).

From the other side, interest in cross-dialogue is equally evident, as is suggested by comments made by the Contributing Editors of the American Ethnological Society and the Society for Cultural Anthropology within the past two years. Consider two such examples. The first, from the September 1994 issue of the *Anthropology Newsletter*, are comments made by Joan Gross in her capacity as Contributing Editor of the American Ethnological Society Section News:

TABLE 3

Social Text, 1989–1994 (Nos. 22–41)

Biographical Information about 169 Authors with listed academic affiliations

Academic Authors' Fields of Study (including 33 authors' multiple affiliations):

Area Studies	
Afro/African-American Studies	9
American Studies/American Civilization	3
Latin American/Caribbean Studies	5
Near Eastern Studies	4
South Asian Studies	2
Victorian Studies	1
Anthropology	8
Art/Art History	4
Biology	2
Communication Studies	2
Cinema/Film/Television	9
Community Studies/Development	1
Comparative Literature	9
Cultural Studies	9
Culture of Imperialism	1
Visual and Cultural Studies	1
Economics	2
Education	2
English	50
French	2
Gender/Women's Studies	12
General Studies	1
Geography	2
German	3
History	4
History of Consciousness	1
International Studies	2
Japanese	1
Lesbian/Gay Cultural Studies	1
Philosophy	5
Politics/Political Science/Government	11
Popular Culture	2
Psychology	3
Religion	3
Sociology	21
Spanish and Portugese	2
Total	200
Percent in Literature departments	33.5%
Percent in Social Science departments	26.0%

TABLE 3 *(continued)*

Social Text, 1989–1994 (Nos. 22–41)

Biographical Information about other Authors

Non-Academic/Professional	15	8.1%
Journalist	1	
Producer	2	
Psychotherapist	1	
Researcher	1	
Sex Worker	3	
Shop Steward	1	
Writer (Essayist, Novelist, Poet)	6	
Information Not Provided	25	12.0%
Total Number of Authors	209	

Author's Location of Employment		
United States	171	81.8%
Great Britain	4	1.9%
Germany	3	1.4%
Puerto Rico	3	1.3%
Canada	2	1.0%
France	1	0.5%
Ireland	1	0.5%
U.S.S.R./Russia	1	0.5%
Unidentified	23	11.0%

At the moment I am a participant in an NEH seminar, "The Image of the Nation in Interwar France," run by Dudley Andrew (Communication Studies) and Steve Ungar (Comparative Literature) at the University of Iowa. The deployment of racial categories in the construction of the "True French" is a persistent theme. I am the only anthropologist in the group, but anthropology regularly comes up in our discussions. *"Culture," after all, is being wondered about by everyone these days, and we do have some prior claim to its analysis. It is, for instance, far easier for an anthropologist to not allow intellectual discourse and elite entertainment forms to stand in for culture.* In other disciplines some people still have to struggle against this. Of course, as history has shown, it might be less pernicious to elide culture with elite products than it is to elide it with race. Anthropologists in both Europe and the US, unfortunately, were instrumental in making the second elision, which is why it is so important to address this topic at AES meetings (emphasis added).

The second example comes from Marilyn Ivy's comments as Contributing Editor of the Society for Cultural Anthropology's Section News and echoes an even greater interest in moving towards Cultural Studies:

The Society for Cultural Anthropology is organizing a special session, "Culture at Large: *Cultural Studies and Ethnography in the US*," at the 1993 AAA meeting. The session reflects

on *the ongoing exchange between anthropology and cultural studies. Papers are by anthropologists doing research on the US who have abandoned the traditional pursuit of stable, unitary and bounded cultures and are contributing to an ethnographic practice in which the cultural objects represented appear as partly derivative and mutually entangled.*[1] (Anthropology Newsletter, Society for Cultural Anthropology Section News, November 1993, emphasis added)

But it would be a mistake to ignore the many less sanguine comments appearing side by side in the *Anthropology Newsletter* and the *American Anthropologist* over the same 5 year period examined. Three such examples should suffice: (1) From a letter to the *Anthropology Newsletter,* January 1993,

> Anyone can study culture. In fact, almost everyone seems to be doing so today. And, there are no standards which will lead deans inevitably to the conclusion that anthropologists do a better job of it than literary critics in culture studies or English departments. Those who would continue to deemphasize holism and imitate the single-minded approach of other disciplines need to be prepared for the challenges they will face in the academic marketplace. (Andrew Miracle, Texas Christian University, on "Holism and the Future of Anthropology")

(2) From Barbara and Dennis Tedlock, in a note ("From the Editors") about their editorial philosophy, published just as they were taking over as new coeditors of the *American Anthropologist,*

> There are terrific tensions in anthropology, and we want the *Anthropologist* to be a place where they can be worked out in a constructive fashion, not in a shoot-out. As A. L. Kroeber pointed out long ago, anthropology has a dual rather than a unilineal ancestry, with the natural sciences on one side and the humanities on the other. More recently, Eric Wolf called anthropology "the most scientific of the humanities and the most humanist of the sciences." It is no coincidence that anthropologists get grants from both the National Science Foundation and the National Endowment for the Humanities, sometimes for different aspects of the same larger project. But while we have been fighting with one another about what kind of discipline anthropology really is, *our neighbors in other disciplines*, whether scientific or humanistic, have reached new levels of sophistication in theory and method and *have begun to make claims in areas that were once ours to research and teach*. It is time we stopped fighting and got on with the work of showing our neighbors on both sides that they haven't even begun to deal with the full range of human diversity and that no one knows how to do that better than anthropologists. (September 1994, *American Anthropologist*, Vol. 96, No. 3, 521; emphasis added)

(3) From an essay by Renato Rosaldo, published in September 1994 in the *American Anthropologist* but originally prepar d for, and delivered at, the December 1992 meetings of the Modern Languages Association in a forum entitled "Cultural Studies and the Disciplines: Are There Any Boundaries Left?"

> The present audience would probably be surprised to hear the reactions to cultural stud-

ies voiced by senior anthropologists. One often hears laments about exclusion: "They've shut us out," "We're being silenced," and the like. Humanists most broadly and literary critics in particular play the villains in these melodramas (as they do in not unrelated anthropological melodramas about multiculturalism). Yes, literary scholars, whatever their self-perceptions, are the all-powerful, hegemonic, exclusionary group. Despite all the talk about interdisciplinarity, a large number of senior anthropologists feel that cultural studies is just another name for literary studies. They feel downright bad because they have not been invited to the party.

The feelings of exclusion predictably engender other recognizable feelings: "If I can't come to the party, then I'm going to take my toys and go home." In public discourse, such feelings usually are encoded as something like: "Cultural studies does nothing that anthropology hasn't done long ago. These literary critics would do well to read Franz Boas or to take an introductory anthropology course." Now there is a grain of truth in the anthropologist's lament. An introductory anthropology course would probably do little damage. And one could probably learn that culture in the anthropological sense (How many literary scholars sneer as they say "culture in the anthropological sense"?) is neither high nor low; it is all-pervasive. (Rosaldo, 1994, 526)

A Framework for Analysis

Nelson, Treichler, and Grossberg told us in *Cultural Studies* (the book) that "disciplines stake out their territories and theoretical paradigms mark their difference" (1992, 1) and that they do so "by claiming a particular domain of objects, by developing a unique set of methodological practices, and by carrying forward a founding tradition and lexicon" (ibid.). When what is at stake is significant enough to practitioners, "different" gets invoked to mean "better," and "distinctive" gets invoked to mean "bounded." When what is at stake is a desired bearing on life outside the academy, commitments to particular claims of analytic difference loom larger and potential articulations of other claims—such as claims of analytic sameness or observations about shared sameness-claims—fail to materialize or, at most, stay in the woodwork.

In a sociohistorical era that a few of us (e.g. V. Dominguez, Naoki Sakai, Geoffrey White) have increasingly begun to characterize as widely *culturalist*, it is both noteworthy and unremarkable that more than one intellectual constellation of scholars in the US should invoke "culture" and "the cultural" as defining tropes. Proliferation of an objectification of "the cultural" is, after all, one of the characteristics of what I have termed global and societal culturalism (cf. Dominguez, 1992). The UN participates and promotes a form of it; multicultural governmental and non-governmental discourses exemplify another highly visible form of it; and numerous Fourth World nationalist movements, staking out claims in the midst of those political environments, have likewise embraced the widespread contemporary practice of making arguments in terms of "culture" (e.g. Jackson, 1989; Keesing, 1994).

Skeptics may think that this is window-dressing, that fashionable terms come

and go, and that little shared referentiality accompanies this proliferation of invocations of "culture" and "the cultural." Some scholars are fond of citing evidence of the numerous ways "culture" is used both in and out of the academy: whether it is Kroeber and Kluckhohn whose 1952 collection of over 150 definitions of culture (1963) is cited, or it is Geertz whose 1973 semiotic definition is quoted, or it is Raymond Williams whose *Keywords* discussion of three "broad active categories of [modern] usage" (1976; see, e.g. Tomlinson, 1991, 5) gets referred to, evidence of referential proliferation is not hard to come by. But I want to echo Nelson, Treichler, and Grossberg's assertion that, despite Stuart Hall's often-quoted statement that "cultural studies is not one thing [and] that it has never been one thing" (1990, 11), it does matter to practitioners how cultural studies is defined and conceptualized (Nelson, et al., 1992, 3). Many of the referents of "culture"/"the cultural" in actual usage are incommensurable with each other, but this is not because everyone is simply loose and casual about invoking "culture." In fact, there is a high degree of specificity in the *invocation(s)* of culture as a sociopolitical act.

It is this mutual, coeval invocation of "culture" and "the cultural" in support of oppositional stances—either at "home" or "abroad"—that is important to both "Cultural Studies" and "cultural anthropology." It is also, I will argue, what underlies many of their samenesses and ironically many of their mutually suspicious, and at times downright antagonistic, stances towards each other.

Consider the following sets of commonalities between "anthropology" and "Cultural Studies":

(1) "Anthropology" and "Cultural Studies" both name constellations of scholars, partly overlapping and typically working within institutions of higher education and producing "products" according to the practices and habits of those institutions—typically books and articles for scholarly readerships, courses and lectures for students enrolled in university degree programs, and non-commercial films and videos distributed through universities and colleges, public access channels and public broadcast stations, and specialty distributors.

(2) "Anthropology" and "Cultural Studies" were officially "born" (i.e. named, flagged, and at least partly institutionally recognized) about a century apart—Anthropology in the late 19th century, Cultural Studies in the late 20th century—but both in the context of industrial capitalist states located in the North Atlantic and heavily invested politically and economically in much of the rest of the world.

(3) "Anthropology" and "Cultural Studies" are both self-identifying labels employed by university students, former students, and faculty members who see themselves as willfully standing in opposition to particular social, political, and cultural ideologies, structures, and practices they perceive as powerful, dominant, and hegemonic.

(4) "Anthropology" and "Cultural Studies" both individually and together actively critique the dominant philosophies and practices of a number of other "disciplined" units of knowledge, especially smugly universalizing and persistently Eurocentric scholarly circles in literature, art history, philosophy, sociology, economics, political science, and psychology.

(5) "Anthropology" and "Cultural Studies" both name a commitment to fight racism and promote a positive affirmation of difference.

(6) "Anthropology" and "Cultural Studies" both signal a scholarly activity that appears fuzzy to outsiders and wonderfully multi/inter/cross/anti-disciplinary to those for whom they are self-labels.

(7) "Anthropology" and "Cultural Studies" both index scholarly circles that are far less multi/inter/cross/anti-disciplinary than the typical insider rhetoric suggests—when one examines citationary practices, canon-making practices, attendance at conferences and conventions, book series and journal submissions as well as selections, scholarly methodologies, and criteria of scholarly merit evident in peer reviews of manuscripts and grant proposals.

(8) "Anthropology" and "Cultural Studies" are both populist or anti-elitist in ideological orientation but entangled in structures, habits, and positions that are both class-specific and geopolitically specific.

(9) "Anthropology" and "Cultural Studies" attract and repel potential audiences because of their ambitions, which make them both broadly encompassing, paradoxically totalizing, and typically committed to the application of analytic frames deeply rooted in the modern and modernist history of the North Atlantic—and invoked through the literal canonization of culture, race, class, gender, identity, nationalism, and sexuality.

(10) "Anthropology" and "Cultural Studies" are non-neutral terms to most scholars for whom these are terms of identification.

Yet these commonalities are rarely the ones in the spotlight when discussions arise about the relationship of the discipline of anthropology to the still less "disciplined" but named intellectual phenomenon we call Cultural Studies. More evident, on the anthropological side is a common presumption that Cultural Studies is "other" to anthropology.

Specifically, I want us to consider the following: (1) the fact that any "Cultural Studies" claim to non-disciplinarity, anti-disciplinarity, or multidisciplinarity looks suspect to many anthropologists, (2) that topically and ideologically a great deal of sociocultural anthropology currently being published looks very much like "Cultural Studies" (easily fitting under at least a few of the descriptions given or suggested by the editors or contributors to Grossberg, Nelson, and Treichler's *Cultural Studies*, for example), (3) that "Cultural Studies" is, nonetheless, being publicly resisted on both generational and philosophical grounds by noticeable numbers of anthropologists, and (4) that an ideological commitment to oppositional politics and some legacy of Marxism has long been prevalent in the certified anthropological community as it is these days among self-labelled "Cultural Studies" scholars.

A Framework for Thinking about Their Inequalities

I have found it increasingly useful to examine anthropologists' public rhetoric next to and, at times, in opposition to anthropologists' publishing practices and political commitments. I have already established that "Cultural Studies" makes many

holders of Ph.D.s in anthropology nervous, and that U.S. anthropologists typical-
ly feel proprietary about a non-arts-based concept of culture.

Issues of size and position are relevant here. Huge differences in the number of
people who read, teach, study, and write "literature" and those who read, teach,
study, and write "anthropology" create enormous differences in the markets for
scholarly writings produced and promoted by literature scholars and those pro-
duced and promoted by anthropology scholars. The adoption of key terms and
issues outside anthropology circles typically surprises most institution-based
anthropologists who are used to educational institutions' processing of anthropol-
ogy as fascinating but neither necessary nor a core discipline. But the promotion
of a not-necessarily-elite and not-necessarily-artistic concept of culture (along with
a theorizing of difference) in the much larger markets for products associated with
"literature"-training and scholarship is, as I have already noted and documented,
typically accompanied by little citation of works by anthropologists and little inclu-
sion of books and essays by contemporary scholars who identify themselves as
anthropologists. So the sense that something is being appropriated by people in far
more visible and powerful positions in the academy, who stand to benefit, is logical
and understandable. A cross-over effect results from the simultaneous silencing,
appropriation, and, at best, token acknowledgement of hundreds of thousands of
articles, essays, and books produced amidst internal debates and struggles in a cen-
tury of scholarly production on, through, against, and because of a parallel canon-
ization of "culture" in the institutional discipline of anthropology. Reactions to
marginalization and non-acknowledgement among established degree-certified
anthropologists parallel those of other marginalized and minoritized populations:
(a) in some quarters, the result is blanket dismissal [in this case of named "Cultural
Studies"] on the grounds that their appropriation is shallow and the quality, hence,
questionable; (b) in other quarters, the result is active resentment of the greater
marketing success of the form that has gone "mainstream"; (c) in related quarters,
there is a move towards turf protection and border patrol, coupled with a defen-
sive intensification of a discourse on its own "disciplined" value; and (d) in certain
circles, typically among those established but not yet heavily invested in decades of
group-defining activity, the result is a visible fleeing toward the "mainstream" and
a self-distancing from the practices and rhetoric of the marginalized/minoritized
population.

Reactions to marginalization and non-acknowledgement among students and
other not-yet-established anthropologists also parallels those of other similarly
positioned younger members of marginalized and minoritized populations—
many drawn to the seemingly "new" and demographically more visible and more
energized discourse communities that, in topics and political/ideological concerns,
so significantly coincide with their own issues of research and analysis. Under these
circumstances, what does not "cross-over" gets noticed and, where it is integral to
the key working concepts of anthropology, gets re-examined and revalued.
Examples of this include a range of analytic questions, processes, and issues
addressed by many anthropologists and not yet even touched on in "Cultural

Studies"; a methodology that requires "fieldwork," meaning multiple and exten-
sive "testing," rethinking, and reformulating through activities that persistently put
the researcher in situations outside the academy, outside elite art settings, outside
governmental institutions and in settings in which one's scholarly assumptions
typically fail to hold up and where non-scholarly "takes" seriously cause us to
rethink our agendas and interpretations; a commitment to knowledge from people
outside our social class and countries of residence (and origin).

As in other minority/majority situations, some individuals travel and cross "dis-
ciplined" borders much as in Fredrik Barth's (1969) conception of individuals
crossing the boundaries of "ethnic groups." But the sense of distinctiveness and dif-
ference of the "group" does not disappear because of these "crossings." Barth's
analysis of personnel crossings, like the more recent analysis of "borders" in
Cultural Studies, stresses the paradoxes of "group boundaries" in social, economic,
and political settings in which insiders and outsiders have a stake in maintaining a
visible boundary. It is this paradoxical (non)boundedness that I am reminded of
when examining the relationship of "anthropology" and "Cultural Studies." Some
anthropologists get hyperprivileged among non-anthropological Cultural Studies
practitioners, and some non-anthropologists in Cultural Studies circles get hyper-
privileged as well. They are the ones who get cited in publications by "outsiders."

Cultural Studies-friendly anthropologists also join forces to put together ses-
sions in conferences, to set policy for a journal, or to train graduate students. When
they do so *within* anthropological organizations and units, they are open to charges
that they have stopped being anthropologists (a charge that insists on the validity
and worth of the boundary). Ironically, they also put themselves in the position of
being little noticed by non-anthropologists in Cultural Studies circles (because of
the othering of anthropology that remains a common practice in demographical-
ly dominant Cultural Studies circles).

Boundary maintenance is evident in perceptions of complicity in "the other's"
choice of oppositional politics. Anthropologists typically *see (and critique)* the con-
tinued rootedness of "Cultural Studies" in sites of canonized aestheticized privi-
lege (literature programs, book series, and conferences and their filial, generated, or
colonized disciplines such as film studies and non-quantitative communication
studies) as well as the continued dominance of writings on bounded products still
typically, if unintentionally, defined as meriting scholarly attention and analysis by
the extension and hence democratic derivation of their value from elite canonized
aestheticized forms—of literature, music, and art. This occurs even if now the
bounded products examined and theorized are graffiti, the Book-of-the-Month
Club, World Beat, MTV, and Disney theme parks. Complicity is noted in the con-
tinued reliance on bourgeois criteria for defining cultural sites and cultural forms.

"Cultural Studies" proponents, not among the individual anthropologists who
travel across the border, typically *see and critique* the continued rootedness of
anthropology in particularist claims to knowledge that typically keep anthropolo-
gists from promoting transcultural and transspatial theories, and even produce an
anthropological prevalence for attacking others' theories on particularist grounds

(i.e. that evidence they have gathered in particular places in the world undermine the universalist claims of those theories). They also *see and critique* the continued prevalence of anthropological research and writing on parts of the world to which European and American anthropologists would not have had access had it not been for EuroAmerican conquest, colonization, pacification, economic penetration, and control. Complicity is noted in the continued reliance on otherizing practices by which a subject matter is created, maintained, and strategically and selectively incorporated by definition outside dominant Euroamerican theories. The bottom line is that, despite a shared, largely leftist, intellectual and political position vis-a-vis the society in which they live, those vested in boundary maintenance see in each other a rejected form of oppositional intellectual activity.

A Question of "Data"?

These are wide-ranging statements, but they are not unsupported ones. With the help of research assistants, I have surveyed, examined, and compared the publications of 5 scholarly journals over a 5 year period, as well as the 9 issues per year of the U.S. anthropological profession's monthly newsletter, the *Anthropology Newsletter*. Two of the journals chosen (the *American Ethnologist* and *Cultural Anthropology)* are premier journals in anthropology, published by the main contemporary organizations of social/cultural anthropology in the U.S.—the American Ethnological Society and the Society for Cultural Anthropology. Three of the journals (*Cultural Studies, Social Text,* and *Cultural Critique*), discussed earlier in this essay, are respected, though relatively recent, interdisciplinary sites for publishing "Cultural Studies" pieces.

I have wanted to be specific about the "evidence," because appearances are often deceptive. For example, about a sixth of the out-of-towners participating in an international self-labelled Cultural Studies conference in December of 1994 in Honolulu were degree-certified anthropologists, and half had at least one formal institutional base in an academic department of anthropology. While degree-certified literature scholars made up at least a third of the out-of-towners at the same conference, in many named "Cultural Studies" meetings they constitute a far greater percentage of the participants. Three Ph.D.s in anthropology were actually instrumental in thinking up the December conference and the two formal organizers themselves were both degree-certified anthropologists with continued membership in the American Anthropological Association. On the other hand, neither organizer was at the time housed in a department of anthropology nor actively participating in the pedagogical task of reproducing "disciplined" anthropological knowledge. Anthropology was both more and less present than I had initially presumed.

Similarly, a survey of academic journals published by and for anthropologists in the U.S. shows that the 2 leading journals for sociocultural anthropology (constituting more than two-thirds of the field of anthropology) are quite "Cultural Studies" friendly (and the flagship four-field journal of U.S. anthropology, the *American Anthropologist,* is apparently becoming increasingly so through decisions

of its most immediate past editor, Janet Dixon-Keller, from the University of Illinois at Urbana-Champaign, and the humanistic leanings of the new co-editors, Barbara and Dennis Tedlock). While *Ethnology* and the *Journal of Anthropological Research* retain a decidedly quantitative, positivistic mission, vision, and editorial policy not sympathetic to much named contemporary "Cultural Studies" work, they have far smaller subscriptions than at least the *American Ethnologist* and the *American Anthropologist*. They are also counter-balanced by the existence of more humanistic, less quantitative, and definitely more "Cultural Studies" friendly journals that, though far newer on the scene than *Ethnology* and the *Journal of Anthropological Research,* operate on similar levels of subscriptions and national visibility, journals such as the *Anthropology and Humanism Quarterly* and *Anthropological Quarterly.*

Of the premier journals at the present time, *Cultural Anthropology,* founded in the mid-1980s by the Society for Cultural Anthropology, is the most openly "Cultural Studies" friendly. Its opening line in "Information for Contributors" says that "*Cultural Anthropology,* the journal of the Society for Cultural Anthropology, welcomes contributions of relevance to cultural studies broadly conceived." While it is important to note that the phrase cultural studies is not capitalized here, it is equally important to note that the journal chooses to identify with at least a broad conception of cultural studies. Moreover, both its founding editor, George Marcus, and its succeeding editors, Fred Myers and Dan Segal, travel frequently in named "Cultural Studies" circles, while simultaneously chairing or administering their respective departments of anthropology (at Rice, NYU, and Pitzer College in California). Likewise, its editorial board has included numerous visible figures in named "Cultural Studies" circles—both degree-certified anthropologists and non-anthropologists—for example, Talal Asad, Dipesh Chakrabarty, Jim Clifford, Mike Fischer, Barbara Kirshenblatt-Gimblett, Catherine Lutz, V. Y. Mudimbe, Renato Rosaldo, Gayatri Spivak, Susan Stewart, Sylvia Yanagisako, and Brackette Williams.

The May 1991 issue (Vol. 6, No. 2), which I randomly pulled off my shelves when I began writing an earlier draft of this essay, is quite typical. Its seven articles are entitled:

"Rachel, Mary, and Fatima" (by Susan Sered)

"Tactility and Distraction" (by Michael Taussig)

"Consuming Desires: Strategies of Selfhood and Appropriation" (by Jonathan Friedman)

"Fictions that Save: Migrants' Performance and Basotho National Culture" (by David B. Coplan)

"Cultural Pastiches: Intertextualities in the Moncrabeau Liars' Festival Narratives" (by Vera Mark)

"The Embodiment of Paradox: Yoruba Kingship and Female Power" (by Andrew Apter)

"Sexuality and Cargo Cults: The Politics of Gender and Procreation in West New Britain" (by Andrew Lattas)

Some of these authors have anthropological institutional affiliation, but not all do. They include: Sociology and Anthropology, Bar-Ilan University in Israel; Performance Studies, New York University; Anthropology, Lund, Sweden; Comparative Humanities, SUNY-College at Old Westbury; French, Penn. State University; Anthropology, University of Chicago; and Anthropology, University of Sydney, Australia.

Note, more importantly, that the topics and analytic frames highlight textualities, gender, sexuality, performativity, politics, and appropriation. Note as well, however, that 4 of the 7 situate their sources and analytic discussion visibly (in either title or subtitle) with reference to a named (though not quite taken for granted) "peoplehood," a named geographic region, or a named nation(alist) claim to cultural boundedness. Note that 2 of these 4 are contributions from scholars institutionally located in humanities departments (rather than departments of anthropology), that one of these concerns a festival in France and not a ritual in a historically primitivized or minoritized world setting, and that 3 of the 7 articles in the issue have deliberately shifting, superimposed, non-particularistic, or non-identified forms of spatial (or cultural/geographic) groundedness. While cognitive anthropologists, more psychologically-trained anthropologists, and sociolinguists are members of the Society for Cultural Anthropology and have even served as officers of the organization in the past, it is clear that the Society's journal, many of the Society's Invited Sessions at the annual meetings of the American Anthropological Association, most of the Society's own annual meetings, and at least half of its visible elected officers read, travel through, and write with a contemporary U.S. (and less frequently British) named Cultural Studies network in mind.

The *American Ethnologist*, founded in the mid-1970s by the American Ethnological Society, is rhetorically not at all committed to a U.S. or U.K. contemporary "Cultural Studies" agenda but, in its editorial *practices*, has increasingly developed a topical and issue orientation that overlaps greatly with U.S. and U.K. "Cultural Studies" agendas. Its self-description—dating from the 1970s and appearing on the inside cover of every issue—says that

> the *American Ethnologist* is a quarterly journal concerned with "ethnology" in the broadest sense of the term. The Editor welcomes topical papers in areas such as ecology, economy, social organization, ethnicity, politics, ideology, personality, cognition, ritual, symbolism, or cosmology focused on any human group or society. Papers that cut across specific topical areas, and that deal with culture diachronically as well as synchronically, are especially welcome.

Relevant here are (1) the coded, but explicit, shift towards soliciting articles within anthropological scholarship that offer more temporal or historical analysis of materials; (2) the equally coded, but equally explicit, solicitation of articles that are less spatially or culturally particularistic; (3) the identification of this journal as explicitly NOT a four-field journal, thereby breaking with the century-old traditions of the *American Anthropologist*, the more international *Current Anthro-*

pology, and the *Journal for Anthropological Research* (originally named *Southwestern Journal of Anthropology*) of publishing articles on and by physical/biological anthropologists, anthropological linguists, and anthropological archaeologists as well as sociocultural anthropologists; and (4) the inclusion in the list of acceptable topics and, hence, the valuing of then non-traditional and more clearly oppositional and politicized topics such as "ethnicity" and "ideology" alongside the long-standing, pre-1960s, frequently canonized topics such as "social organization," "ritual," and "personality."

A Marxist, political economy, or history background and orientation characterized at least two of the four 1970s/1980s editors-in-chief—Richard Fox (now editor-in-chief of *Current Anthropology*) and Shirley Lindenbaum. The two most recent editors—Don Brenneis, immediate past editor, and Michael Herzfeld, current editor—are more oriented towards questions of discourse, narrative, public culture, and performance than their predecessors, hence, more attuned to literature, film, and performance studies while continuing to value historicizing moves.

Their editorial boards look "Cultural Studies" friendly, and include scholars who serve and/or have served on the editorial board of *Cultural Anthropology*. Serving under Brenneis, for example, were Lila Abu-Lughod (NYU), Arjun Appadurai (Chicago), Steven Feld (Texas-Austin), Richard Handler (Virginia), Michael Herzfeld (Harvard), Fred Myers (NYU), Renato Rosaldo (Stanford), Daniel Segal (Pitzer), Ann Stoler (Michigan), and Brackette Williams (Arizona). Herzfeld's Editorial Board is different in names but not theoretical orientation, and I am currently a member of it. Lindenbaum's political economy grounding led to Editorial Board positions then for Bill Roseberry (New School for Social Research), Jane Schneider (CUNY Graduate School), and (I presume at the time) John Comaroff (Chicago) but the Board, at the time much smaller than under Brenneis, also included James Clifford (University of California at Santa Cruz), James W. Fernandez (then at Princeton, now Chicago), and Louise Lamphere (first at Brown University, now at the University of New Mexico).

The ill-fit between the mid-1970s mission statement and the actual publishing practices of the *American Ethnologist* is most evident with regard to gender and feminist criticism. Throughout the 1980s, though "gender" and "sexuality" were never added to the mission statement as welcome topics for submitted articles, articles highlighting feminist questions and gender issues began appearing in large numbers. By the 1990s, "gender" had become the most consistently visible topic or frame for the *American Ethnologist*. A check on keywords attached to articles published in the *AE* over the past 5 years revealed that "gender" was a chosen keyword for 27% of the 190 articles—winning, in the words of my research assistant Sasha Welland, "the prize for overwhelmingly being the one [topic] most frequently listed." Among the articles included during this period was Catherine Lutz's November 1990 article entitled "The Erasure of Women's Writing in Sociocultural Anthropology," which chose a quantitative strategy to argue that a deeply gendered citationary practice is rampant in anthropological writing and that it is not a phenomenon that can be explained by simple reference to differential numbers of arti-

cles published by men versus those published by women in the premier disciplinary journals, including the *American Ethnologist* itself.

Frequency of articles "on gender" does not, of course, a "Cultural Studies" journal make. In fact, the journal *Cultural Studies* in its 8 years of publishing has published only 13 articles "on gender," feminism, or women. Feminist perspectives shape the arguments in articles on other things, which predominate in this flagship journal. Numerous takes "on gender" are also, of course, possible and the objectification or topicalization of "gender" need not automatically be critical, or theoretically aimed.

But what accompanies this privileging of "gender" during these past 5 years of the *American Ethnologist* tells a clearer story. The fact is that gender is not the only privileged "Cultural Studies" issue to be highly visible in the journal. While 52 articles had chosen gender (or feminism, women, masculinity, men's experience, reproductive politics, and fertility) as a keyword, 46 articles (i.e. almost a quarter) were identified as dealing with hierarchies or differentiations based on physically or culturally collectivizing formations—namely race, racism, or racialism; ethnic identity, ethnicity, ethnic conflict, or interethnic relations; minorities (including Afro-American history, Latino Studies, marginality, and multiculturalism); and nation, nationalism, transnationalism, and the national. Sixteen articles keyed in on "colonialism" or "postcoloniality," and 27 (about 15%) highlighted "resistance," "hegemony," "the discourse of subalternity," "rebellion," "inequality," or "power relations". Note the distribution of other related terms and issues, in the accompanying table (table 4) on the *American Ethnologist*, 1989-1994: 9 articles on "bodies," 6 on "sexuality," 8 on public culture, the arts, popular culture, and TV, and 6 on "cultural politics," "the invention of tradition," "identity," "the past," and "imagined communities."

Likewise, three "Special Sections" were published by the *AE* over this period, and all three inflect issues of empire, coloniality, and postcoloniality with questions of cultural politics, the problematizing of historicity, and the paradoxes of imagined identities: Vol. 16, No.4 (November 1989)= "Tensions of Empire"; Vol. 18, No.3, (August 1991)= "Representations of Europe: Transforming State, Society, and Identity"; Vol. 19, No.4 (November 1992)= "Imagining Identities: Nation, Culture, and the Past." "Tensions of Empire" included articles by historians and anthropologists selected from a Wenner-Gren Foundation conference in November 1988 in Mijas, Spain, to which they were invited to "rethink what frameworks and themes the anthropology of colonialism should entail," "to refocus attention on the tensions *among* colonizers *and* them and the colonized," and to "look at the agency of the agents of colonization as well as at that of the colonized." "Imagining Identities" included numerous references to Hobsbawm and Ranger's *The Invention of Tradition* (1983), Roy Wagner's *The Invention of Culture* (1980), Benedict Anderson's *Imagined Communities* (1983), and several of Richard Handler's articles on nationalism and cultural politics in Quebec.

Add to these the inclusion over the past 5 years of articles on tribal self-representation in Jordan (Layne 1989), ethnic tourism (Volkman 1990), the Polish

54 TABLE 4
American Ethnologist, 1989–1994 (Vol. 16, No. 1–Vol. 21, No. 3)
Survey of Keywords Related to Cultural Studies

Keyword	Times Attached to Articles
Cultural Studies	0
Gender (+subcategories)	37 (52)
Feminism	3
Women	6
Masculinity	1
Men's experience	1
Reproductive politics	3
Fertility	1
Sexuality (+subcategories)	4 (6)
Virginity	1
Transvestism	1
Colonialism or Postcolonialism	14
(6 from Vol. 16, No. 4)	
Race/Racism/Racialism	4
Ethnic Identity/Ethnicity/Ethnic Conflict/ Interethnic Relations	10
Politics of Representation (+subcategories)	6 (32)
Minorities	
(including Afro-American History/Communities-4,	
Latino Studies-1, Marginality-1, Multiculturalism-1)	9
Nation/National/Nationalist	14
Transnational	2
Personhood	1
Bodies	9
Public Culture Issues and/or Events (+ subcategories)	2 (8)
Aesthetics/Arts	3
Popular Culture (festivals, rodeo)	2
TV	1
Youth Culture(s)	0
Resistance (+subcategories)	9 }19 (27)
Hegemony	10
Discourse of Subalternity	1
Inequality	4
Power Relations	2
Rebellion	1

TABLE 4 *(continued)*
American Ethnologist, 1989–1994 (Vol. 16, No. 1–Vol. 21, No. 3)
Survey of Keywords Related to Cultural Studies

Keyword	Times Attached to Articles
Other	
Cultural Politics	1
Cultural Change	3
Cultural Identity	1
Social Identity	1
Cultural Relativism	1
Historical Consciousness	1
Invention of Identity or Tradition/ Imagined Communities	4
Interpretation of the Past	1

Solidarity movement's use of historical representation (Nov. 1992), Occidentalism (Feb. 1992), and the representation of Spanish peasants in their relationship with state authorities (Bauer 1992); or note what a quite randomly selected recent issue looks like, such as the August 1993 issue with the following Table of Contents:

The Selling of San Juan: The Performance of History in an Afro-Venezuelan Community (David M. Guss)

Poetics and Politics of Tongan Laments and Eulogies (Adrienne Kaeppler)

Nationalizing the Local Past in Sri Lanka: Histories of Nation and Development in a Sinhalese Village (Michael D. Woost)

Gender, Power, and Legal Pluralism: Rajasthan, India (Erin P. Moore)

National Texts and Gendered Lives: An Ethnography of Television Viewers in a North Indian City (Purnima Mankekar)

Power and Transcendence in the Ma Tsu Pilgrimages of Taiwan (P. Steven Sangren)

Chicano Indianism: A Historical Account of Racial Repression in the United States (Martha Menchaca)

The Wizard from Oz Meets the Wicked Witch of the East: Freeman, Mead, and Ethnographic Authority (Mac Marshall)

Review Article

Questioning Jews (Virginia R. Dominguez)

Now compare how the organizers of the deliberately and decidedly interdisciplinary international Cultural Studies conference that was held in December of 1994 in Honolulu identified the rationale for the conference. The organizers wrote: "The emergence of cultural studies in academic institutions throughout North America and in parts of Asia and the Pacific reflects the emergence of new interdisciplinary approaches to problems that affect everyone in the region, particularly concerning issues of race, ethnicity, nationalism, and gender as these are affected by the globalization of media and politics." By such standards, the *American Ethnologist* is then regularly and primarily publishing contributions in and to "Cultural Studies."

Now consider the fact that *not even one of these 190 articles chose Cultural Studies as a keyword*, and my research assistant charged with the task of looking for overt references to "Cultural Studies" found none. Instead of finding discussions of territorial fights between disciplines or explicit discussion of "Cultural Studies," she found several articles that touched upon anthropology specifically and on its direction as a discipline but without overt reference to a named "Cultural Studies." One such example was Arturo Escobar's "Anthropology and the Development Encounter: the Making and Marketing of Development Anthropology" (November 1991) in which he criticizes the growing number of anthropologists who have taken applied positions as "cultural experts" in development activities, arguing that "these practitioners disturbingly recycle, in the name of cultural sensitivity and local knowledge, conventional views of modernization, social change, and the Third World."

There is indeed a public discourse concerning "Cultural Studies" within the degree-certified anthropological community, but it has been Cultural Studies-related *work* rather than talk about Cultural Studies that has been published in the *American Ethnologist*. In fact, a visible difference has existed until very recently between the scholarly journals published by anthropological organizations and the more informal newsletters and exchanges among anthropologists. Until the past year, only one published essay had appeared in official anthropological journals on the "Cultural Studies" work, network, movement, or phenomenon, and that article, "Coming of Age in Birmingham: Cultural Studies and Conceptions of Subjectivity" (by Jean Lave, Paul Duguid, and Nadine Fernandez from Berkeley and Erik Axel from Copenhagen) published in 1992 in the *Annual Review of Anthropology* was an analytic description and chronological summary of the Birmingham circle and its scholarship over three decades. Little direct reflection on its relationship to anthropology, its potential implications for anthropology, or its perceptions among anthropologists was included.

More direct in tackling these issues have been two recent essays both published in the *American Anthropologist* (a December 1993 review essay by Richard Handler on *Cultural Studies*, edited by L. Grossberg, C. Nelson, and P. Treichler and a September 1994 essay entitled "Whose Cultural Studies?" originally delivered by Renato Rosaldo—not insignificantly as an invited speech at the Modern Languages Association annual meeting in 1992 and quoted at the beginning of this essay). Like Rosaldo, quoted earlier, Handler sees merit in non-anthropologists' Cultural Studies work but also validates the fears, reactions, and doubts articulated by many of his colleagues in anthropology, especially with regard to (1) fears of being left behind by a larger and more visible movement, (2) a century of anthropological claims to ownership of a non-elitist concept of culture, and (3) the drawbacks to limiting one's methods to textual analysis.

"Faced with the growing prominence of cultural studies in the American academy," Handler writes unabashedly about fears of being left behind,

anthropologists have exhibited two rather different reactions. The first, the ostrich-in-

the-sand stance, has been to ignore cultural studies in hopes that it will go away. A growing number among us are coming to reject this tactic, having watched in bewilderment as literature departments try to capture the culture concept as their own disciplinary property. The second, the jump-on-the-bandwagon approach, is perhaps more in line with the theoretical eclecticism that Robert Murphy once described as "the one characteristic of social anthropology that makes it adaptive to its subject matter, and that also makes it an amiable way of life" (1971: 209). A scanning of current anthropological jargon is enough to suggest that the trajectory of anthropology is being inflected by cultural studies; or, at least, that both disciplines are drawing on the same terms and concepts: "hegemony," "resistance," "race, gender, and class," "difference," "embodiment," "empowerment," "voice," "space". (1993, 991)

"With respect to theory," he goes on to state for an anthropological readership, "anthropology has much to learn from cultural studies about the analysis of modern systems of power and how these intersect with categorizations of persons and with social class" (1993, 992). But a caveat is important to him, nonetheless, especially with respect to the concept of culture invoked or deployed. "The cultural studies represented in *Cultural Studies* [1992]," he explains,

is hardly broad-ranging when it comes to culture theory. Many issues that have preoccupied anthropologists for generations—questions about origins, diffusion, and the relationships between biology and culture, social structure and culture, norms and action, and "deep structures" and "secondary rationalizations"—seem to have little relevance to the contributors to the present volume. Nor do they display much interest in the history of the culture concept, beyond an occasional reference to [Raymond] Williams' *Culture and Society*. The work of George Stocking (1968), for example, or Kroeber and Kluckhohn's "critical review" of definitions of culture (1963)—or, indeed, most of the anthropological literature on culture theory—goes unnoticed in the present volume. Given these lacunae, [Stuart] Hall's proclamation of cultural studies' "astonishing theoretical fluency" seems rather fatuous. (ibid., 993)

Clear and emphatic are Handler's points as well about methodologies. "Ethnography," he acknowledges,

is the anthropologist's trump card. Cultural studies practitioners claim they would like to learn to play that card, even though they seem (in this collection, at least) mostly to avoid touching it (cf. Lave et al. 1992: 273). Only a few of the authors in *Cultural Studies* base their contributions on anything like field research, and most of this work concerns audience research—that is, it stems from questions about how people respond to various mass-marketed cultural products....

In the end, the modus operandi of cultural studies remains textual analysis. This is a fine technique (we use it frequently ourselves), but anthropologists browsing through *Cultural Studies* are going to wonder repeatedly about the relationship between the texts under discussion and social situations beyond the text. This is particularly the case when the topic is (as it so often is in cultural studies) hegemony and resistance.... Needless to

say, ethnographic research is no panacea.... But ethnographic research at least has the chance to engage human beings in a range of settings much more vast than those encompassed within the elite, textualized circuits to which most humanistic scholarship (including cultural studies) confines itself. (1993, 993)

It is, however, not in explicit academic articles but, rather, in the pages of the monthly *Anthropology Newsletter* of the American Anthropological Association that one finds the most explicit discussion, the most overt references, and the most mixed signals about "Cultural Studies" of any of the venues. I have labelled these interventions: (a) supportive or participatory, (b) border-noting, (c) anxious, (d) defensive, (e) critical of anthropological defensiveness, and (f) aggressively critical. They appear side by side, all with enough frequency to make it impossible to imagine articulating one position as modal or hegemonic.

Supportive or Participatory:

—[Re] The border zones between anthropology and other disciplines. What have been the yield—advantages and disadvantages—of the border excursions between anthropology and literary criticism, anthropology and social history? *Where is anthropology situated in relation to that "trans-border" phenomenon, cultural studies?* (Jose Limon, AES Committee Program Chair, Sept. 1994, AES Section News, *Anthropology Newsletter*. Emphasis added.)

—Contributions sought for a multidisciplinary text on women in the 20th century Caribbean (and in "exile communities"). *Of special interest are essays in cultural studies, criminal justice issues, women in religion, health and feminist movements.* (Consuelo Lopez Springfield, Cooperation Column, *Anthropology Newsletter*, April 1994, vol. 35, no. 4. Emphasis added.)

—Developments in literary theory, geography, history or sociology may be much more important to social/cultural anthropology than what our colleagues in the other fields work on. The four-field focus seems sometimes to be an excuse to hide from the interdisciplinarity which seems to be the future of academia, and within which anthropology would seem to have many potential "competitive advantages," if we can discard the crises of confidence that tempt us into subdisciplinary and parochial niches in which we feel safe as "big fishes in small ponds." (A Comment from Alan Smart [Calgary], "Continuing Debate on the Scope of Urban Anthropology," Society for Urban Anthropology Section News, *Anthropology Newsletter*, September 1993. Emphasis added)

Border-Noting:

—The inexorable growth and specialization of knowledge, and the cross-fertilization of ideas with other fields, does make anthropology's center or core seem more elusive. *Ironically, this loss of integration occurs at a time when anthropology is becoming a potent source of ideas for others.* One need only track the recent permutations and refractions of familiar concepts like "ethnography" and "culture" in business, communications, edu-

cation and other fields. (Robert Jarvenpa, SUNY-Albany, "Four Fields and the Field" January 1993, Correspondence Section, *Anthropology Newsletter.* Emphasis added)

Anxious:

Is anthropology a discipline?

Is anthropology a discipline, a loosely knit field, or, as viewed by Clifford Geertz, a temporary holding company that will disappear as its parts migrate to more permanent locations? How that question is answered will determine the future of both the discipline and the Association.

—*Concepts and methodologies basic to cultural anthropology are being used, for better or worse, by other disciplines, often without involvement of anthropologists.* (Annette Weiner, President, and James Peacock, President-elect, AAA, Sept. 1993, *Anthropology Newsletter*, 68)

Defensive:

—Anthropology has been multidisciplinary in America since the early 1800s—*150 years before "interdisciplinary" became a fashion.* (David Givens, Editor, and Susan Skomal, Press Officer, in article entitled "The Four Fields: Myth or Reality," *Anthropology Newsletter*, October 1992, 17. Emphasis added.)

Critical of Anthropological Defensiveness:

—Panels like this—and the general pattern of exclusion within anthropology of self-identified lesbian and gay anthropologists, and discourse on subjects like homosexuality—are a major reason *why anthropology has been left behind by the multicultural movement, why it continues to be seen as irrelevant and suspect not only by the communities we would study but by our fellow scholars in other disciplines.* It is panels like this that reveal why anthropology is a shrinking discipline and why a last-ditch attempt to reassert the traditional four-field structure—purging the AAA of its minority-based units in a nostalgic desire for a master discourse—is certain to fail. (Will Roscoe, "AAA and HIV," May 1993, Correspondence Section, *Anthropology Newsletter.* Emphasis added)

Aggressively Critical:

—*As for the proliferation of "cultural studies" programs,* I have for a quarter of a century associated with those people who today are calling themselves "inter-culturalists." *I have been and continue to be appalled by their lack of knowledge.* Some are outright charlatans, far more are well meaning and self-deluded. With a career base in some other field, a stimulating experience in another cultural environment, a reading of Robert Hall, some of Margaret Mead's more popular works and perhaps *Chrysanthemum and the Sword* they presume to discuss human culture without any real knowledge of the history and development of the concept and how the various elements of human life interact. (James F. Downs, International Bridge Inc. [Tokyo], "Utility of the Four Fields," April 1993, Commentary, *Anthropology Newsletter*). Emphasis added)

60 A Disciplined Response

A critical analytic history of the discipline of anthropology can put these reactions in a larger intellectual, material, and institutional context. The fact is that anthropology has never been considered a core discipline, that it has both been other-ized by allegedly core disciplines over the past century and been complicitous (and even often proud) of its relative independence.

Not until after World War II did it grow sizably in numbers and departments, and most of that growth took place in the 1960s and 1970s. In 1969-70 when I was a freshman at Yale taking Sidney Mintz's introductory anthropology course, some 630 students were enrolled in what turned out to be the largest single course at Yale University at the time. Those were "boom" years. Funding, faculty positions, graduate student enrollments, and even some anthropological publications gained the field a different level of legitimacy, a kind of mainstreaming never before experienced by the discipline. Energy, jobs, and productivity maintained the momentum.

But the heavy criticism of anthropology from both inside and outside the discipline over the past 8-10 years deflated the "modernist" sense of certainty and transparent value that had accompanied the "boom." No longer sure of its higher moral and intellectual ground, anthropology finds itself noting, at times fearing, at times admiring, at times copying, and at times critiquing this new intellectual movement that is like it enough in politics and subject matter to worry it. No longer sure that it will just go away, growing numbers of anthropologists may be changing their strategies and participating in venues, publication projects, and conferences still dominated by colleagues in literature and film/video studies. What is not yet known is whether the flow of ideas, publications, and personnel will be two-sided, or whether the majority/minority frame that causes cross-overs to work in only one acknowledged direction will hold for this case as it has typically done in the past.

Notes

1 The rest of the column details the papers and the panel's participants. "Steven Gregory (Wesleyan)," she writes, "critically analyzes the discursive practices that construct the urban poor as a 'ghetto underclass;' Catherine Lutz (North Carolina-Chapel Hill) explores contradictions in the visual representation of war to 20th century American audiences, commenting on the powers and limits of cultural studies models; Roger Rouse (Michigan) examines approaches to popular culture which are shaped by the concept of 'transnationalism' and considers their implications for the relationship between ethnography and cultural studies. Kathleen Stewart (Texas-Austin) uses an unexpected conjunction between her fieldwork in 'Appalachian' coal mining camps and in Las Vegas to address processes of displaced agency and deterritorialized meaning in American working-class discourses. Session organizer Elizabeth Traube (Wesleyan) maps the recent turn toward ethnographic approaches to media audiences and criticizes a tendency to construct 'popular' pleasure as autonomous of producing institutions and textual constraints. Judith Stacey (Sociology, California-Davis), author of Brave New Families, will be the discussant. The 'Culture at Large' format will be repeated in future years with other themes" (Marilyn Ivy, Contributing Editor, Society for Cultural Anthropology, November 1993).

References

Anderson, Benedict (1983) *Imagined Communities*. London: Verso.

Barth, Fredrik (1969) "Introduction." In F. Barth, ed. (1969) *Ethnic Groups and Boundaries*. Boston: Little Brown.

Bennett, Tony and Valda Blundell (1995) "Introduction." Special Issue of *Cultural Studies* focusing on "First Peoples: Cultures, Policies, Politics." (January).

Clifford, James (1988) *The Predicament of Culture*. Cambridge: Harvard University Press.

Clifford, James and George Marcus (1986) *Writing Culture*. Berkeley: University of California Press.

Dominguez, Virginia (1992) "Invoking Culture: The Messy Side of 'Cultural Politics,'" *South Atlantic Quarterly* 91: 19-42.

Escobar, Arturo (1991) "Anthropology and the Development Encounter: the Making and Marketing of Development Anthropology." *American Ethnologist* 18, No. 4.

Geertz, Clifford (1973) *The Interpretation of Culture*. New York: Basic Books.

Hall, Stuart (1990) "The Emergence of Cultural Studies and the Crisis of the Humanities." *October*, 53: 11-90

Handler, Richard (1993) "Anthropology Is Dead! Long Live Anthropology!" *American Anthropologist* 95: 991-995 [review article on L. Grossberg, C. Nelson, and P. Treichler, eds. *Cultural Studies*, New York: Routledge, 1992].

Hobsbawm, Eric and Terence Ranger (1983) *The Invention of Tradition*. Cambridge: Cambridge University Press.

Jackson, Jean (1989) "Is There a Way to Talk about Making Culture without Making Enemies? *Dialectical Anthropology* 14: 127-43.

Keesing, Roger (1994), "Theories of Culture Revisited." In R. Borofsky, ed. (1994) *Assessing Cultural Anthropology*. New York: McGraw-Hill, 301-10.

Kroeber, Alfred and Clyde Kluckhohn (1963) *Culture: A Critical Review of Concepts and Definitions*. New York: Random House.

Lave, Jean, Paul Duguid, and Nadine Fernandez (1992) "Coming of Age in Birmingham: Cultural Studies and Conceptions of Subjectivity." *Annual Review of Anthropology*, 21: 257-82.

Lutz, Catherine (1990) "The Erasure of Women's Writing in Sociocultural Anthropology." *American Ethnologist*, 17, No.4.

Nelson, Cary, Paula Treichler, and Lawrence Grossberg (1992) "Cultural Studies: An Introduction." In Grossberg, et al., ed. (1992) *Cultural Studies*. New York: Routledge.

Radway, Janice (1984) *Reading the Romance*. Chapel Hill: University of North Carolina Press.

Rosaldo, Renato (1994) "Whose Cultural Studies?" *American Anthropologist*, 96: 524-29.

Tedlock, Barbara and Dennis Tedlock (1994) "From the Editors." *American Anthropologist*, 96: 521

Tomlinson, John (1991) *Cultural Imperialism*. London: Printer Publishers.

Wagner, Roy (1980) *The Invention of Culture*. Chicago: University of Chicago Press, Revised Edition.

Williams, Raymond (1976) *Keywords*. London: Fontana.

Cary Nelson

3

LITERATURE AS CULTURAL STUDIES

"AMERICAN" POETRY OF THE SPANISH CIVIL WAR

I want to explore—by way of a particularly instructive example—how the discipline of English might transform itself into cultural studies and how in the process one national literature, American literature, would be internationally repositioned. Despite many opportunistic efforts to expand into cultural studies and claim its territory for the discipline, there have been few systematic efforts to reflect on what is entailed by this change and to lay out its key principles. In an earlier essay (Nelson 1994) I list some sixteen features of a fully realized cultural studies project. With those principles in mind, I begin here with some general points and move on to an extended historical analysis. Even though it is necessarily a unique example, both some of its historical contingencies and some of the methods they call forth will prove exemplary. It is fair to say that only by combining theoretical argument with specific case studies can we proceed effectively, for as a discipline we have as yet not even the most shadowy consensus about what it might mean to *do* cultural studies. In response to that lack of consensus—and to a certain ignorance about the history of cultural studies that helps sustain it—I open with some strategic rudenesses:

PROPOSITION 1: If you come to literature with an unshaken belief in the ultimate auton-

omy of the work of art, you cannot do cultural studies. If, in a parallel conviction, you believe the nature and meaning of literary objects cannot be radically altered by their historical context, you cannot do cultural studies.

PROPOSITION 2: If you work entirely within the confines of one nation state, bringing to bear upon a literary corpus only the knowledge of one nation's history, traditions, and practices, you cannot do cultural studies.

PROPOSITION 3: If you know only one discipline—whether it is literary studies, sociology, history, art history, or communications, among others—intimately, and you operate securely within its ethos and principles, you cannot do cultural studies.

As this essay proceeds into its case study, it will quickly become clear that the working conditions these propositions challenge—working conditions typical of literary studies for decades—are not merely problematic but actually disabling. This list could easily be expanded, but I pause to propose a still more radical constraint, offered as a counter claim in the midst of all the self-declared cultural studies projects crowding the academic marketplace: *no one* can "do" cultural studies. This pronouncement cuts two ways. First of all, cultural studies is always a collective historical phenomenon, even when its practitioners write in the solitude of their studies and even when many of them are unaware of each other's work. In other words, cultural studies is necessarily constituted as a field of practices within a particular historical context. To speak of cultural studies is properly to address a range of texts and disciplinary and national traditions and to examine their explicit or implicit interrelations and social effects. Thus no one person can carry through a cultural studies project whose ultimate meaning is independent and self-contained. Second, the full relational complexity of any cultural moment must always vastly exceed any of our efforts to record and analyze it. Years ago, working with a home-grown variety of structuralism, Northrop Frye suggested that a full interpretation of any literary work would eventually have to mark its similarities and differences with every other literary work ever written. It was a task, needless to say, that no one could ever accomplish. Now, more historically based, more focused on active mutual determination, and committed of course to tracking a far wider field of cultural forms and practices, cultural studies seeks an equally impossible goal: within a particular historical frame (a frame whose dimensions will vary) it tries to understand how *everything* is related to everything else. If tracking relationality across the whole cultural field is ideally what cultural studies entails, then no one has yet or ever will "do" cultural studies, or at least no one will ever mount much more than an exemplary, representative, heuristic, and partial cultural studies project. Far from cultural studies hyperbole, I think this should be the humbling warrant within which all of us work. That means reflexively marking the differences, the gaps, between the writing we are doing and the larger aims of a more comprehensive form of cultural studies analysis. Indeed, if these two limiting conditions—the historical relationality of individual projects and the impossibly wide contextualization required for an authoritive account of cultural phenome-

na—are added to my opening propositions, we begin to get a sense of the difficulties attendant upon cultural studies work generally and upon the effort to transform literary studies into cultural studies.

For literary studies, at the outset, cultural studies means giving up the hierarchizing cultural memory that has dominated the field throughout the century. The search for masterworks has to be replaced with an effort to understand literary texts as part of wider discursive formations. That entails deriving their meaning primarily from an analysis of those relations rather than from an ahistorical and largely immanent formalism or thematics. The challenge this presents to many people in the field—the puzzlement, anger, or dismissiveness they will display as the implications of giving up autonomous, transcendent works of art become clear—should not be underestimated.

However, as I shall attempt to show in a representative historical analysis to follow, that does not mean denying literature—and even individual genres—specific social roles at specific historical moments. Rather it means establishing the specificity of those roles. The Spanish Civil War poetry I analyze here is not independent of literary traditions; rather it comes into being at the intersection of certain literary traditions and the politics of antifascism. These poems are objects without transcendental guarantees, without indeed any guarantee of meaning outside their historical conjuncture. But within that conjuncture their power is considerable.

A culturally specific analysis also does not mean refusing to ask what particular writers contributed to a discursive formation, despite how overdetermined their contributions will have been. I hold to a notion of *relative* autonomy without which no cultural practices could be justifiably isolated for analysis. It is not only literature but also popular music, political speeches, architecture, science, religious belief, military conflict, and so forth that require a model of relative autonomy for cultural studies attention to be warranted. I would not therefore join my long-term cultural studies coworker in giddily proclaiming "Down with literature!" to any and all willing to listen. As for literature professors, as opposed to literature, well, there my affection is more qualified.

For the institution that produces literature professors builds into them no few inhibitions to cultural studies. It is axiomatic, for example, that some estrangement by way of comparative analysis is necessary if we are to see the specificity of cultural practices as historically constituted rather than natural. To take an example from the Spanish Civil War, which is the context about to be addressed, until one knows that the Spanish government regularly invested money printing poetry broadsides and dropped broadside poems from airplanes onto enemy troops as a way of convincing them to change sides, one may not have imagined that as a use for literature. Americans, in particular, may be unlikely to consider poems an alternative to napalm. So it is difficult to see a culture's practices as choices from among a series of alternatives if one only knows one's own culture's history, if one has no idea what possible alternatives exist. And the institution of literary studies—not just in the United States but across much of the world—gives primacy to national literatures, which is a handicap under which many of us labor. Equally problemat-

ic is the discipline's decontextualizing and phantasmatic search for literary excellence and its unwillingness to grant primacy to literature's social and political meaning, both tendencies cultural studies must reverse. On the second point, cultural studies is of course not alone; it has learned much from Marxism and feminism. The first point is another matter; we have precious few signposts there. This essay will provide some.

The focus here will be on the poetry of the 1936-39 Spanish Civil War, and especially that written by Americans, and it begins with a couple of anecdotes widely separated in time. The first is an account—written on October 23rd, 1937—of a poetry reading Langston Hughes gave in Spain the day before. It is from an unpublished letter written by Fred Lutz, an American who had volunteered for service in the Abraham Lincoln Battalion and became a Political Commissar in Spain:

> Heard Langston Hughes last night; he spoke at one of our nearby units—the Autoparque, which means the place where our Brigade trucks and cars are kept and repaired. It was a most astonishing meeting; he read a number of his poems; explained what he had in mind when he wrote each particular poem and asked for criticism. I thought to myself before the thing started "Good God how will anything like poetry go off with these hard-boiled chauffeurs and mechanics, and what sort of criticism can they offer?" Well it astonished me as I said. The most remarkable speeches on the subject of poetry were made by the comrades. And some said that they had never liked poetry before and had scorned the people who read it and wrote it but they had been moved by Hughes's reading. There was talk of "Love" and "Hate" and "Tears"; everyone was deeply affected and seemed to bare his heart at the meeting, and the most reticent (not including me) spoke of their innermost feelings. I suppose it was because the life of a soldier in wartime is so unnatural and emotionally starved that they were moved the way they were. (Nelson and Hendricks, eds. [1996], 116)

It is a remarkable story, as poetry for a moment becomes an occasion for a working-class oral community—not, as literary studies has often held it to be, the sign of an isolated and self-contained subjectivity but a discourse opening a space for sharing experiences. Exactly what poems Hughes read the letter does not say, but it is fairly safe to assume he would have read the poems about the war he had only just written. But part of the meaning of those texts derives from their performance before audiences like these "hard-boiled chauffeurs and mechanics," hardly the sort of audience literature professors would ordinarily count as either significant or relevant. Indeed, we might not think of these fellows as qualified to judge the poems, though apparently Hughes did. Despite some pioneering work on the uses popular audiences have for literature and other cultural forms, many academics still assume that professionally trained audiences are the ones most qualified to read literature properly and fully. That is a disciplinary bias cultural studies has to overturn.

Fourteen years forward in time, in 1951, while he was in federal prison as one of the Hollywood Ten, Alvah Bessie wrote a series of political poems, which he assembled into a book. I came across the manuscript of the book amongst his private

papers in the course of a search for the repressed poetry of the 1950s. Novelist, screenwriter, and Veteran of the Abraham Lincoln Brigade (the name given to the group of Americans who volunteered to fight in Spain), Bessie was not known as a poet. But for a moment, behind bars for the offense of standing up for his constitutional rights, in a country that had demonized most of the commitments that mattered to him, poetry seemed the right form to use to call forth the mixed emotions he felt: anger at the present madness and faith in an earlier cause. There was no place to publish a book of such poems at the time, but several of the poems appeared in *Masses and Mainstream* and *The National Guardian* over the next two years. Two of the poems he published were about Spain, a country he had left at the end of 1938 when the International Brigades were disbanded. A few months later Franco was victorious, and Spain entered its decades-long night of fascism.

There are many Spains we remember, many we have forgotten. Some of them overlap and some seem to have almost no points of correspondence. The Loyalist Spain of 1951, however, twelve years after the fall of the Republic, the Spain preserved within the American inquisition as counterpointing resource and reference point, that Spain we have largely forgotten. Indeed, as a culture we never knew its existence; it was real only for the subculture of the embattled Left. That Spain is at the end of the story I want to tell, but I want to foreshadow the end. Here is Bessie's 1951 poem to his fellow American volunteer Aaron Lopoff, mortally wounded in the struggle for hill 666 in the Ebro campaign of the summer of 1938:

For My Dead Brother
 The moon was full that night in Aragon...
 we sat in the black velvet shadow
 of the hazel (called *avellano* there);
 the men lay sleeping, sprawled on the packed earth
 in their blankets (like the dead)....

 With dawn we'd move in double files
 down to the Ebro, cross in boats,
 and many lying there relaxed
 would lie relaxed across the river
 (but without their blankets).

 He said "You started something, baby—"
 (I was thirty-four; he ten years less;
 he was my captain; I his adjutant)
 "—you started something, baby," Aaron said,
 "when you came to Spain."

 Across the yellow river
 there was a night loud with machine guns
 and the harmless popcorn crackle

of hand grenades bursting pink and green,
and he was gone and somehow Sam found me in the dark,
bringing Aaron's pistol, wet with blood.
He said:
> "The last thing Aaron said
> was, 'Did we take the hill?'
> I told him, 'Sure.'"

Aaron, we did not take the hill.
We lost in Spain, Aaron,
I know, finally, what you meant that night
under the black shadow of the *avellano*,
sitting here in prison twelve years later.
We did not take the hill, *mi commandante*,
but o! the plains that we have taken
and the mountains, rivers, cities,
deserts, flowing valleys, seas!
You may sleep…sleep, my brother, sleep.

The "we" of Bessie's poem is, of course, the we of the Lincoln Battalion, the International Brigades, and the we that was Loyalist Spain and those of its allies who joined the army in the years 1936-38. In a larger sense, however, that "we" also refers to the popular front of 1936-1939, a popular front that might effectively have taken the hill if it had succeeded in persuading the allied governments to sanction arms shipments to Spain and if it had been able to hold the various factions in the Spanish Republic in a workable alliance. Many still believe that arms sufficient to balance more fully the men and weapons Hitler and Mussolini provided Franco would have been enough support to turn the war in favor of the elected government and insure a defeat, rather than a victory, for fascism in 1939. We will never know for certain. But the Loyalists did not take the hill; that much we do know. By extension, then, the vast literature of support for Spain—poems, plays, journalism, novels, broadsides, letters, essays, speeches—that swept the West for those few years failed as well. At least it failed in achieving the practical political effect that was one of its inescapable aims. Did it succeed, however, in other ways? Did it give to successive generations a resource worth drawing on and thus potentially still vital today? That is one, but only one, of the questions cultural studies can ask today, though it is also one that it must ask, that all its traditions urge it to pose: what is our interest in a past we recover now. Yet cultural studies may also ask what the literature of the Spanish Civil War, and specifically its poetry, offered to its own time. The present essay is not an attempt at a full survey of Spanish Civil War poetry, something not even a book-length manuscript could hope to achieve. The main aim is rather to begin describing the collective and almost choral nature of the poetry of the Spanish Civil War. In the process the poems a few representative American poets wrote on the subject will

be highlighted and put in their proper international context. Establishing that context will lead to a new choral paradigm for understanding the poetry of this watershed moment in twentieth-century history.[1]

The outpouring of support for the people of Spain and the working alliances it made possible for those few years of 1936-1939 are one of the hallmarks of internationalism and of coalition politics in our century. It was a politics that embodied both losses and gains. One of the most obvious losses was that of the more thoroughgoing revolutionary spirit of the first half of the 1930s. The broad alliance against fascism, however necessary it was—and it would be irrational to claim we did *not* need such an alliance in the late 30s—displaced the more aggressively class-conscious revolutionary art and politics of the preceding seven or so years, though it also facilitated broad public support for the U.S. effort once we finally entered the Second World War. Yet that same broad alliance disintegrated in the face of the anticommunist hysteria of the postwar decade, so whatever resources we feel it may offer now need to be critiqued in the light of how little it did for the Left in the late 1940s and throughout the 1950s. On the other hand, Alvah Bessie's poem, and the poem "To Spain" by Olga Cabral that is printed next to it in the June 1953 issue of *Masses and Mainstream,* may be seen in part as late flowerings of popular front politics. Only a year before, in fact, the Veterans of the Abraham Lincoln Brigade brought out their anthology *Heart of Spain* in an effort to revive the alliances of the 1930s when they were most needed. The dominant culture's most succinct response came on June 19, 1953 when Julius and Ethel Rosenberg were executed. For those in power in America, the hard revolutionary Communist stance of the Third Period and the more liberal democratic policies of the Popular Front were not worth distinguishing.

None of these issues has much impact on the stories told most often about modern literature. Canonical American modernism has its international moments, to be sure, most notably when Pound and Eliot were in England or when various American expatriates were in Paris in the 1920s. Those international moments are comfortable to recall for a number of reasons. First, they involve many of the canonical figures of modern art and literature. Second, they seem reassuringly aesthetic and personal episodes. Even the sense of distaste for American culture that led many writers to Europe seems individually inflected, a generational phenomenon that has to be understood in terms of personal temperament. No problematic political issues seem centrally at stake in those decisions to travel abroad. Of course a considerable number of writers from the United States and elsewhere travelled to the Soviet Union in a far more politically charged cultural interaction in the same decade, but we tend not to retell those stories. Spain was, however, the focus of one of the more remarkable international literary interchanges in our history. The case of Spain also suggests that the effort to move beyond the limitations imposed by studying national literatures in isolation—an effort that must be built into the cultural studies project—might well begin by working less with broad generalizations than with specific historical conjunctures; indeed we might first open our eyes to the key sites of internationalization we have long ignored.

 The literary component of the Spanish Civil War is so deeply and intricately international in fact that any effort to read it exclusively in national terms seems seriously misguided. We can properly ask how writers from a given country responded, what contributions a given national literature made to this global conversation, and even what place Spain played in individual careers. It was British and American poets, not Spanish poets, for example, who were most likely to attack the hypocritical nonintervention policy pursued by the allies. Certainly we can also try to discover what impact writers hoped to have on the particular audiences reached by the books and journals they published in, audiences that were sometimes but not always focused on a particular country. But any sense of the rhetoric of particular poems, any effort to read them closely or to identify related poems that particular writers were responding to, certainly requires looking widely at the international literature of the war and perhaps necessitates recasting our sense of what a national literature means. For several modern American poets, the period of the Spanish Civil War was a period when they were no longer primarily *American* writers; they were part of an international political struggle and an international community of writers. Part of what is important about American poets' contributions to the dialogue about Spain, therefore, is that a number of them figuratively gave up nationhood as the ground of their being. It is thus the very reverse of projects like Hart Crane's poem sequence *The Bridge* (1930) and William Carlos Williams's critical book *In the American Grain* (1925). If a number of American poets had earlier wondered how to give modernist experimentalism an American inflection, how to interleave collage with American sights and sounds, how to construct a myth that would enable uniquely American identities, now in the shadow of fascism the challenge was to enter the international arena seamlessly.

 The collective, interactive, and international rhetoric, identity, and motivation of Spanish Civil War poetry does not exhaust its meaning. But it is part of what brought the poems into existence and established and sustained their historical identity. For too long we have thought of these poems exclusively as separate *responses* to shared historical conditions. Whatever commonality of experience, conviction, intention, and meaning is pertinent, or so we imagine, precedes the poem and somehow drops out of contention once the poem itself is under way. Even when we acknowledge that the historical context is central to each poem's meaning, we tend to treat the history as "background" and to assume that various poems' relations to one another and to other cultural forces are at best a minor part of their meaning. Here, therefore, is a case where the difference between literary studies as we have practiced it for decades and cultural studies is particularly clear: cultural studies properly takes everything that the discipline backgrounded and puts it in the foreground.

 The Spanish Civil War is not simply an historical context that enriches and complicates the poems written under its influence. It is an historical conjuncture that reshapes the very activity of reading and writing poetry, making poems into something they had not been before and would not again be afterwards. Our twin habits of treating history as background and of reading poems in radical isolation from

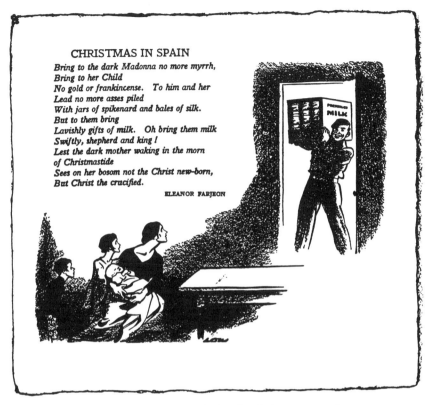

Fig. 1. A poem card distributed in Britain during the Christmas season in 1937. Author's collection.

one another prevent us from understanding how these poems came to be and how they functioned in their historical moment. That does not make immanent formal or rhetorical analysis of the poems illicit but it does make such analysis impoverished and misguided when it is taken to be a sufficient mode of understanding. Certainly any account with claims to being an historically grounded cultural studies has to take up the collective nature of what has, perhaps deceptively, been called the "literary response" to the war. When Loyalist poets read their work aloud in the trenches, when Republican planes scattered poems over enemy troops, when soldiers from numerous countries tacked their poems up on battlefield or training area wall newspapers, when editors put poems into political journals here or battalion newspapers in Spain, when Americans read translations of Spanish wartime romances to audiences here and helped build support for the Republic, they were not *responding* to the war; they were part of it. When poets wrote or translated poems for collective projects they were not engaged only in solitary creation but rather in group activity.

The poetry of the war, moreover, saw multiple means of distribution and reproduction. Both cultural studies and any literary historiography worthy of the name

should be interested in all these material forms, in the multiple forms in which particular texts were produced and in the variety of uses to which they were put. Not only books and pamphlets but also broadsides and cards were common means of reproduction. Poems cards were typically issued to commemorate special occasions, while broadsides helped build public consensus and strengthen convictions. Thus the International Brigades printed a stanza by British volunteer Miles Tomalin—written at the battle of Brunete—on their 1937 Christmas card, which was then mailed throughout the English-speaking world; in Britain, an illustrated card with Eleanor Farjeon's poem "Christmas in Spain" reminded people of the Republic's needs (fig. 1); the government of Catalonia issued a series of nine-by-twelve inch poetry broadsides, with an illustration on one side and a poem on the other (Rafael Alberti's "*Defensa de Madrid*" is number forty-one in the series); and when the International Brigades marched through Barcelona in October of 1938 a series of commemorative three-by-six-inch poem cards—including Miguel Hernández's "*Al soldado internacional caído en España*" (fig. 2)—were distributed amongst the crowds. Meanwhile, not only literary journals but also mass circulation newspapers in Spain, Britain, and the United States published Civil War poetry. And in all these countries people often heard poems read aloud before they were published anywhere. In Britain Jack Lindsay's "On Guard for Spain!—A Poem for Mass Recitation" was given group performances throughout the country. Some 346-365 lines in its longest versions, it was apparently shortened on some occasions. One three-page version that has survived from the 1930s—typed in red and annotated for performance in pencil—is cut to 132 lines. There were at least five people scheduled to read the text, with some passages marked for one, two, or three voices and some marked "all."[2] "The effect," wrote Lindsay later, "of a multiple set of individual voices, now and then brought together in a collective outburst, was given a dramatic effect by continual movement among the group—again a movement of individuals which at moment[s] came together in a collective pattern."[3] Recalling one such wartime performance in a 1943 essay, R. Vernon Beste writes that when the name of Malaga was called out from the stage "it was a deep growl of fury rather than a name, not just a place in Southern Spain, but a word to give vengeance a sharper meaning, a banner rallying the defenseless and shaming the cynical."[4] Meanwhile, foreign visitors to Spain were astounded by mass poetry readings attended by soldiers and working people.

Perhaps the most obvious forms that this international poetic activity took, however, were in translation, in international anthologies, and in the broad exchange of the wide range of poems about the Civil War. There were literally dozens of journals in Britain, France, Spain, Latin America, and the United States publishing poems about the war, and many of these journals issued translations of poems from other countries as well. Some were then collected in books and pamphlets. Indeed, the most obvious evidence that these poems should be grouped together and read in relation to one another and to their historical moment is the large number of times they have been (and continue to be) anthologized in Civil War collections. Although most North American academic modern poetry spe-

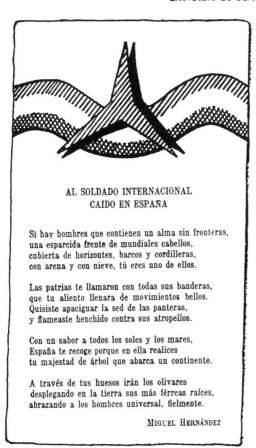

AL SOLDADO INTERNACIONAL
CAÍDO EN ESPAÑA

Si hay hombres que contienen un alma sin fronteras,
una esparcida frente de mundiales cabellos,
cubierta de horizontes, barcos y cordilleras,
con arena y con nieve, tú eres uno de ellos.

Las patrias te llamaron con todas sus banderas,
que tu aliento llenara de movimientos bellos.
Quisiste apaciguar la sed de las panteras,
y flameaste henchido contra sus atropellos.

Con un sabor a todos los soles y los mares,
España te recoge porque en ella realices
tu majestad de árbol que abarca un continente.

A través de tus huesos irán los olivares
desplegando en la tierra sus más férreas raíces,
abrazando a los hombres universal, fielmente.

MIGUEL HERNÁNDEZ

Fig. 2. One of several poem cards distributed in Barcelona in October of 1938 to honor the International Brigades on the eve of their departure from Spain. Brought back from Spain by American poet and Abraham Lincoln Battalion member Edwin Rolfe.

cialists have no more knowledge of them than they do, say, of lunar geography, anthologies devoted all or in part to Spanish Civil War poetry were important during the war and repeatedly in the decades since. Thus American poets like Edna St. Vincent Millay, Muriel Rukeyser, Genevieve Taggard, Ruth Lechlitner, and William Carlos Williams realized that one of the more important things they could do was to give Spanish poets a voice in English and a broad American audience; all were among the writers who contributed translations to the 1937 New York anthology …*And Spain Sings: Fifty Loyalist Ballads.* Across the ocean Stephen Spender and John Lehman's 1939 anthology *Poems for Spain* mixed original poems with translations, many of which had already been published in newspapers and journals.[5] As Peter Monteath (1994) astutely puts its, "In effect these anthologies were the Popular Front in aesthetic form" (p. 78). Meanwhile a number of Spanish poets wrote poems about the international volunteers who had come to the aid of their country. Some were published in journals, some printed as cards and broadsides

for mass distribution, and a small anthology of them, *Homenaje de despedida a las Brigadas Internacionales*, was issued in Barcelona in the final months of the war. English translations of collections of works by individual poets—from Alberti to García Lorca—were also published throughout the war years. And from 1937 to 1938 the English language magazine of the International Brigades, *Volunteer for Liberty*, published in Madrid and Barcelona and distributed both in Europe and the United States, regularly printed both poems translated from the Spanish and original poems in English, most of them written in Spain.

Of course most of the English language poems written about the war were composed in England and the United States. For a variety of reasons it was not easy, especially for American poets or novelists at this distance, to write about Spain. Some of those who did—Hemingway being the most famous case—spent substantial time there and made the commitment to Spain a central fact of their lives thereafter. Others had at least some Spanish experience and combined that with long histories on the Left to make a coherent and specific stand possible. Genevieve Taggard spent a year in Spain before the war on a Guggenheim fellowship and thus retained strong images of the Spanish people and Spain's landscape and culture. Muriel Rukeyser was there at the opening of the war in 1936 to cover the antifascist Olympics and was among those foreign nationals evacuated from Barcelona at the time. Her long poem "Mediterranean" is a collage of images from the first days of the war, with an undercurrent of concern about what role poetry should serve in the conflict. It regularly violates grammatical rules within apparent syntactic units to force shifts in perspective that make the collage both material and perspectival.[6] Langston Hughes spent half a year there in 1937 visiting troops, talking with people in Madrid, and acquiring extensive wartime knowledge. His wartime poem "Letter from Spain," published in *Volunteer for Liberty* in November 1937, is a splendid example of the way he uses colloquial language to put the struggle between democracy and fascism in Spain in a broad context of international racism and imperialism:

Dear Brother at home:

We captured a wounded Moor today.
He was just as dark as me.
I said, Boy, what you been doin' here
Fightin' against the free?

He answered in a language
I couldn't understand.
But somebody told me he was sayin'
They nabbed him in his land

And made him join the fascist army
And come across to Spain.

And he said he had a feelin'
He'd never get back home again.

He said he had a feelin'
This whole thing wasn't right.
He said he didn't know
The folks he had to fight.

And as he lay there dying
In a village we had taken,
I looked across to Africa
And seed foundations shakin'.

Cause if a free Spain wins this war,
The colonies, too, are free—
Then something wonderful'll happen
To them Moors as dark as me.

I said, I guess that's why old England
And I reckon Italy, too,
Is afraid to let a workers' Spain
Be too good to me and you—

Cause they got slaves in Africa—
And they don't want `em to be free.
Listen, Moorish prisoner, hell!
Here, shake hands with me!

I knelt down there beside him,
And I took his hand—
But the wounded Moor was dyin'
And he didn't understand.

Hughes's biographer Arnold Rampersad (1986), representing the dominant values of the English profession, describes this as "a maudlin dialect poem in ballad-epistle form" and says it is typical of the sort of "proletarian doggerel" Hughes wrote in the 1930s and 1940s (351). Rampersad also reports, apparently echoing Hughes's account in *I Wonder as I Wander*, the second volume of his autobiography, that some of the American soldiers objected to Hughes's use of dialect, since most of the black volunteers were educated.[7] Since the poem adopts the voice and persona of a black volunteer in the Lincoln Battalion, it is understandable that some Americans felt the use of dialect misrepresented their comrades, but it is equally easy to imagine that others among the Lincolns would have understood why Hughes put the poem in what is actually a rather mild form of dialect—not simply

to appeal to common people, as Rampersad suggests, but to make a specific political point: that the common sense of oppressed people gives them an appropriate experiential basis for understanding international politics. For all their fabled ferocity, the Moors were partly there as canon fodder, expendable because they were black. The view from Alabama therefore had the potential to clarify fascism's racist character—to link Franco's use of Moorish troops with Mussolini's conquest of Ethiopia, for example—and to identify imperialism as a form of international racism. The relative universality of working-class interests, moreover, also made for a vantage point from which it was possible to understand why British industrialists and financiers supported Franco; a progressive Spain threatened not only one source of potential profit but also, by its example, many others. A fairly complex set of political relationships are thus condensed into a brief poem in ordinary language, and the ordinary language asserts more clearly than any other kind of language might that expertise in international politics need not be restricted to those in power and authority. Indeed, one of the notable things about the volunteers in Spain was the diversity of their class background. Political understanding is thus not an elite, moneyed, high cultural capacity; it is in some ways the clarity that comes when some of that obfuscation is swept away. The use of dialect in the poem makes possible the material instanciation of some of those insights. Thus when the speaker looks across to Africa, makes the appropriate connections between his Spanish experience and global racial and financial relationships, the moment of recognition makes it possible to envision the existing structures of power undone, to "seed foundations shakin.'" "Seed," an improper usage quite proper to dialect, is actually a pun: it is a moment of sight and insight which is also the fertile seed of radical change. The proffered handshake is an offer of alliance politics, a simple gesture of solidarity dependent on nothing less than a different understanding of the world. Yet the difficulty of reaching such understanding, the power national cultures have to impede such knowledge, is apparent in the Moor's failure to recognize the speaker's offer.

These interrelationships are foregrounded and heightened in the republication of the poem in the January 23, 1938, issue of *The Daily Worker* (fig. 3).[8] There three of Hughes's poems in the voice of the black volunteer Johnny, "Dear Folks at Home," "Love Letter From Spain," and "Dear Brother at Home," are printed as a dramatic double-page poster bordered with illustrations that blur the distinction between the Spanish peasant and the American worker. The sombrero-clad peasant plowing a field behind a horse in Spain is substantially interchangeable with an American sharecropper. The farmer taking a hoe to the land before his modest home could easily be either here or in Spain; indeed, the industrial strikers just below him carry signs in English. The Republican soldiers in the images clearly stand guard over their mutual interests. Grouped together this way, the poems also reinforce these connections. "Folks over here don't treat me / Like white bosses used to do," Hughes writes in the first poem; those who might are on the other side: "Fascists is Jim Crow peoples, honey— / And here we shoot 'em down."

Hughes, of course, was in Spain when he wrote "Dear Brother at Home" and

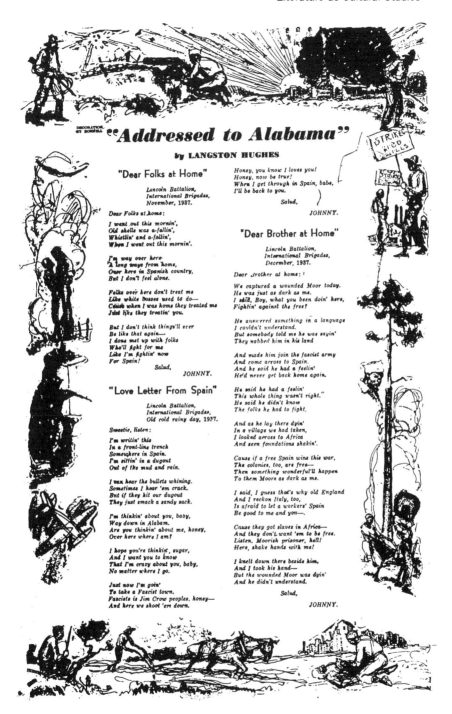

Fig. 3. A full-page poem broadside published in the January 23, 1938, issue of *The Daily Worker* (New York).

gave it to Edwin Rolfe in Madrid at International Brigades headquarters to publish in the *Volunteer*.[9] Matters were somewhat different for those who remained in the United States. For many of those who remained here the vivid visual images coming out of Spain and the powerful reports from those returning were enough to put them securely on the loyalist side but not enough to generate their most important writing. Near the end of the war, for example, Kenneth Rexroth demonstrates in two poems published in Alan Calmer's 1938 anthology *Salud!: Poems, Stories and Sketches of Spain by American Writers*, that his only real subject is his radical distance from the reality in Spain: "I am caught in a nightmare, the dead flesh/ Mounting over half the world presses against me."[10] In safety in California he hears a plane overhead at night:

> As the sound departs I am chilled and grow sick
> With the thought that has come over me, I see Spain
> Under the black windy sky, the snow stirring faintly,
> Glittering and moving over the pallid upland,
> And men waiting, clutched with cold and huddled together,
> As an unknown plane goes over them.

This passage helps make for a successful poem, because Rexroth is able to write about his own cultural positioning, a positioning that many other American readers will share. That results in a politically relevant poem, one that will help readers understand and articulate their own relationship to the war. Rexroth is less effective when he writes about life in the International Brigades, which he does not know about directly and cannot yet learn about from the detailed accounts that will begin to be published in 1939. The cliche that one had to be there to write productively about the war is thus only partly warranted; being there made a difference, often a critical one, but it did not constitute the only reality worth articulating.

Even being in Spain, where experiential claims might seem most straightforward, could make for more complex arguments than some critics have been able to recognize. Thus when Rolfe in "City of Anguish" recites his catalogue of war's immediacies—"No man knows war / who never has crouched in a foxhole, hearing the bullets an inch from his head, nor the zoom of / planes like a ferris wheel strafing the trenches"—he is not quite reporting his own experiences, but rather honoring his comrades at the front. When Rolfe wrote the poem he was editing *Volunteer for Liberty* in Madrid, and while he regularly visited the Lincolns he is not likely to have been strafed in the trenches. As much as anything else, it is his troubled separation from the front that drives that part of the poem. It testifies not, as one critic has assumed, to a wartime belief in unmediated experience, but testifies rather at one anguished remove, and thus the poem points to the impossibility of direct testimony at the same time as it demands it.[11] The image of the ferris wheel, more a retrospective visual analogue than a figure that would have been ready to hand in the trenches themselves, suggests the inevitability of literary medi-

ation. Yet Rolfe also wants to emphasize that those who have been in battle do have unique experiences the rest of us cannot quite share.

The more historically-specific problems noncombatant writers faced were not experiential ones but social and political ones. The first problem was to reveal the specific social and political understanding Spain required. Hughes's success at that is one reason why Rampersad's willingness to collapse "Letter from Spain" into a nonexistent universal 1930s poem is so inadequate and unfair. The second problem was one of commitment, of the demand that Spain and all it stood for placed on people everywhere. Something of that problem is evoked in a short but very striking poem that Mike Quin published in the August 8, 1937 issue of *The Daily Worker*:

> *How Much For Spain?*
>> The long collection speech is done
>>> And now the felt hat goes
>> From hand to hand its solemn way
>>> Along the restless rows.
>> In purse and pocket, fingers feel
>>> And count the coins by touch.
>> Minds ponder what they can afford
>>> And hesitate … how much?
>> In that brief, jostled moment when
>>> The battered hat arrives,
>> Try, brother, to remember that
>>> Some men put in their lives.

There were, of course, frequent collections of funds for Spanish relief. Early on, the Nationalist forces had captured major food production areas, and thus basic necessities were in short supply everywhere in Loyalist Spain. So Quin's poem is partly a fund raising device, a reminder of just how much (and how much more than money) some had already given to the cause. But Quin's poem also reminds us implicitly of how unqualified justice was on the side of the Republic. The narrow self-interest involved in secretly counting coins invokes all the hesitation built into deciding how much to give to Spain. And the counting of coins is, of course, not only personal but also political and institutional; it mimics the calculations Western business was making about which victor would be a better ideological ally. Nonetheless, on the left, for a while, it was possible to argue that seeing Spain clearly meant being willing to give everything. Holding back suggested more than cowardice or small mindedness; it suggested a kind of social, political, and moral blindness. Quin's poem made its way to Spain, in fact, as did many others. One American volunteer in the field, Frances Feingersh (later Frank Lister), copied "How Much For Spain?" onto two postcards and sent it to his mother in America (fig. 4). The poem thus travelled back and forth across the Atlantic because it was

Fig. 4. In the fall of 1937, after being wounded at the battle of Brunete, American volunteer Frances Feingersh copied out a poem by Michael Quin on two color postcards and sent them to his mother in the United States. Frank Lister Archive, Rare Book Room and Special Collections Library, University of Illinois at Urbana-Champaign.

a fitting vehicle at once for self-expression and political commitment. When Feingersh wrote it out in holograph in the fall of 1937, of course, it became a somewhat different poem than it was when Quin wrote it in safety in the United States; wounded at Brunete, Feingersh had taken the risk of putting in his life. To send it back in his own hand was to make it partly his own poem, or at least to put it in his

own voice, and thus simultaneously to comment on his own commitment and to give Quin's question to noncombatant Americans singular moral and political urgency.

The problem for a poet, then, was not so much whether to volunteer for service. For one thing not every poet was young enough or healthy enough to serve. And getting to Spain to fight was far from easy, since U.S. passports were invalid for Spanish travel except for correspondents. The challenge, rather, or at least one challenge, was to discover how to give everything *in a poem*. How does a poet, in other words, put in his or her life? Spain demanded that a poet put everything at risk, wager everything on the poem that was yet to be written. Those who could not do that—and relatively few could—in some ways failed. Others succeeded because they understood the special character of Spanish Civil War writing—its collective antifascist and international identity. It was a distinctive historical necessity that set the Spanish Civil War apart and made its poetry potentially different from other war poetry. Nevertheless, the historical forces bearing on the decision to write about Spain were considerable: In the brief moment when the battered hat—symbol of Spain's arrival in your life—appears, remember that some have already given everything to a cause worthy of nothing less. Now, with all that in mind, with all that is at stake in the politics of the occasion, write.

For poets outside Spain, moreover, the war arrived already significantly spoken for—in the dozens, eventually thousands, of poems Spanish nationals wrote during the course of the conflict. Just how quickly poetry took a significant place in the war remains startling even today. The rebellion began on July 18th, 1936. On August 27th the first issue of *El Mono Azul* appeared with a two-page poster-sized spread of illustrated poems under the heading "*Romancero de la Guerra Civil*."[12] The format would be maintained for eleven issues, after which the journal adopted a larger page with a poem under the masthead. By October, copies of the journal were arriving in the United States. The poems generally followed the traditional form of the Spanish romance—epic narratives restricted to an eight syllable line (employing assonance instead of full rhyme in every second line) that was well suited to oral delivery and memorization. Indeed, many of *El Mono Azul*'s poems were read aloud in the trenches around Madrid before being published and some in fact were written there. American translations of some of these poems were read to groups in east coast cities in 1937. A separate collection devoted entirely to poems by soldier poets appeared in Madrid under the title *Poesia en las trincheras*.[13] The poems built solidarity and morale, celebrated new heroes, and in a very real sense gave combatants a sense of their historical mission. Moving all these issues so rapidly into poetry also lent the war a sense of epic scale—not only its larger outcomes but also its daily progress. The poems gave soldiers and civilians alike a common mode of recitation, remembrance, and recognition. Like the songs sung everywhere on the Loyalist side, the poems were a shared language, a communal speech, a social text strengthened in every reading and recitation. And they were rapidly gathered into books, translated into other languages, and distributed around the world. The collection *Romancero de la*

Guerra Civil was issued in November of 1936 and included thirty-five poems from *El Mono Azul*. The Fifth Regiment's cultural wing issued *Poesías de Guerra* near the end of the year, using poems from *El Mono Azul* and other sources. *Poetas en la España Leal* appeared in July of 1937, drawing most heavily on poems previously published in the journal *Hora de España*; a number of copies of the book were sent to people in the United States. As visitor and volunteer poets arriving in Spain and poets in other countries began to write about the war, they did so against the background of this accessible and rapidly disseminated group of existing texts. American poets Hughes and Rolfe, among others, read the Spanish romances when they were in Spain and spent a good deal of time with the editors of *El Mono Azul*. To a significant degree, then, the wartime poetry written by American and British poets took its first inspiration from the work of Spanish poets. Inevitably, poets from other countries adopted forms, themes, and metaphors from their front-line Spanish compatriots. The International Brigades published *Romancero de los Voluntarios de la Libertad* in October of 1937; it included poems by foreign volunteers in Spanish, French, Polish, and English and it was regularly mailed to countries in both hemispheres. Suddenly, modern poetry had a distinctly international configuration. Its first subject, inevitably, was the heroic defense of the city of Madrid.

From 1936 to 1939 there erupted something like a chorus of voices calling back and forth to each other about the besieged capital of Spain. In poem after poem in country after country the name Madrid is used as a rallying cry and an incantation, sometimes with and sometimes without an exclamation mark. The poems echo one another across time and space and national or political difference, ring changes on the suffering and courage of the Madrileños, and establish in print, in voice, and in dream and nightmare the point of articulation of an antifascist politics for its time.

This international poetic dialogue began, as it happens, not with a poem but with a series of proclamations and slogans that captured people's imaginations immediately after the war began. "Madrid is the heart of our Republic, of our country," declared La Pasionaria in the pages of *Mundo Obrero* on September 25th, two months into the war (1938: 31). Soon that claim was supplemented with a special rallying cry—"Madrid will be the tomb of fascism"—and with a proclamation on Madrid radio. On the night of November 8, 1936, with Madrid under assault by fascist troops, Fernando Valera, a Republican deputy, read this statement over the air:

> Here in Madrid is the universal frontier that separates Liberty and slavery. It is here in Madrid that two incompatible civilizations undertake their great struggle: love against hate, peace against war, the fraternity of Christ against the tyranny of the Church ... This is Madrid. It is fighting for Spain, for humanity, for justice, and, with the mantle of its blood, it shelters all human beings! Madrid! Madrid![14]

By then, numerous poems were already published and more followed. Norman Rosten inserted a slogan between each stanza of "The March" and ended the poem

with the words "Madrid—*Madrid*—MADRID!"[15] In Spain Frances Fuentes wrote "Revolutionary Madrid"; Manuel Altolaguirre wrote "Madrid"; Jose Vila wrote "Madrid Front."[16] The October 29th issue of *El Mono Azul* had included Rafael Alberti's "*Defensa de Madrid*," Manuel Bolin's "*Alerta los madrileños*," Luis Perez Infante's "*A Madrid*," and Manuel Altologuirre's "*Arenga*," which declared the city the capital of Europe. In France Jacques Romain answered with "Madrid," Paul Eluard with "November 1936." In Britain Richard Church answered with "The Madrid Defenders," Elisabeth Cluer with "Analogy in Madrid." Among Americans, Joy Davidman wrote "Snow in Madrid," Langston Hughes wrote "Madrid—1937," and Ben Maddow in "The Defenses" cried out "Madrid, Madrid! …your great trenches hold/Death back from love"; Norman Rosten hailed "Madrid!/Burning in the night…but still standing" and turned the famous slogan into a command: "Make Madrid the tomb of Fascism"; "Madrid awoke," wrote Sol Funaroff in "The Bull in the Olive Field," a "toreador in overalls…people poured like rain/upon the face of the streets."[17]

Part of what is notable about the poetry focused on Madrid is its uncanny mixture of sloganeering and invention. "Greetings, Madrid, heart of the country," wrote Luis de Tapia in "Salud"; Alberti called the city "heart of Spain,/heart of earth"; "Madrid is the heart," Auden wrote in "Spain," echoing La Pasionaria. "Pasionaria speaks," wrote Rosten "and the silence/is greater than the soaring of birds"; he opened "Invocation" with this stanza:

Spain, the body,
and in its center
calmly beating
the great heart, Madrid.

Stanley Richardson addressed Madrid as "Life's glorious capital." George Barker, on the other hand, said the city was "like a live eye in the Iberian mask," while José Moreno Villa described the besieged city in winter as "an island tomb, / Alone, in an asphalt sky" and Eluard said it was a "city as if at the base of the ocean made of only one saved drop of water." Like the more broadly revolutionary poetry of the 1930s, this poetry is partly echolailic, with poet after poet deploying some of the same images and phrases in a choral literary project of political commitment.[18] In a 1935 essay in *Partisan Review* Edwin Rolfe simultaneously expressed his doubts about the place of slogans in poetry and defended their potential in certain contexts, an argument that is as much anticipatory as it is pertinent to the revolutionary poetry that preceded Spain. Years later, no longer able to place himself within the culture of the Left, Malcolm Cowley would recall Rolfe's point from a conversation and note the willingness to use slogans in poetry with incredulity. In fact the sloganeering in the poetry of 1928-1936 was often more implicit than explicit, with thematic and imagistic repetition, reinforcement, and counterpointing far more common than the repetition of full sentences or explicit slogans. There were, to be sure, instances of recurring slogans, like the line "All Power to the Soviets!" in Sol

Funaroff's poem "What the Thunder Said: A Fire Sermon" that also appears in Richard Wright's poem "I am a Red Slogan." It is a slogan with a complex history in the USSR and one that appears in other American documents as well. But for the most part the explicit reoccurrence of full slogans is uncommon in American poetry of the early years of the depression.

The rhetorical differences between the poetry of the first and second half of the decade have their roots in political and historical realities. In the first half of the 1930s the poetics of revolution had sufficient support to achieve a relative degree of autonomy, an autonomy in turn that gave its utopian vision some considerable intertextual force. But there were always all the while competing political positions and competing poetries on the national scene. A commitment to the broadly revolutionary intertext was not quite the same as the specific communist commitment implied in the use of the slogan "All Power to the Soviets!" Poets could commit themselves to the red revolution and still feel their politics to be flexibly revolutionary; after all, the red flag had been raised by American socialists and the Industrial Workers of the World and other partly home-grown groups as well as the Communist Party. There was a remarkable revolutionary intertext that overcame these political differences, but it had shared subjects, images, convictions, developmental structures, and aspirations, rather than fixed slogans, at its disposal. Spain was another matter.

With the advent of the Spanish Civil War the range of pertinent literary topics did not dramatically narrow but a limited number of topics did gain a special international authenticity; outside Spain, the awareness of contesting Left political positions and the significance of contesting poetries temporarily receded into the background as well. The Comintern, or Communist International, had begun to support broadly democratic antifascist alliances in 1935 and by July 1936 and the opening of the Spanish Civil War these views had become widely shared among progressive constituencies. Now, with Madrid under assault, an antifascist alliance politics had its historical imperatives and its universal slogans, and the slogans rapidly made their way into the poetry of the war.

Patently sloganeering discourse—at least in the form of explicit quotation or adaptation of familiar, preexisting slogans—does not make up a major portion of many Republican poems. Yet there are hortatory poems urging action and solidarity that effectively invent slogans of their own, and the quoted slogan is a notable part of many poems otherwise devoted to lyrical and rhetorical invention of the sort we expect from poetic language. Moreover, even though many Civil War poems do not have explicit hortatory moments—overt calls to arms, slogans, calls for commitment—enough of them do so that the will to international political solidarity is part of the implied context of any poem about the war. The most inward looking and reflective Civil War poems, then, cannot be wholly separated from the most straightforwardly militant. The poems written at the front, the poems written behind the lines, are part of the same discursive field. In reading one poem you read others by implication. So we need to ask whether the slogans that are the most striking points of similarity between these poems are central or peripheral. Are they a

fatal flaw that undermines the rest of the text? An aberration forgivable in the context of the historical pressures these poets faced? Or are they pivot points for Spanish Civil War poems, providing at once a grounding in material politics and the links in a chain of verbal correspondences that connect poem to poem and poet to poet and poet to soldier across the world? I believe the last explanation brings us closest to the historical reality in which the poems were forged. Indeed, one Spanish scholar, Serge Salaün (1975), suggests it is necessary to understand all the Civil War romances on behalf of the Republic—more than ten thousand of them, many of them anonymous—as one vast poem, a huge intertext. But the full text of this final 1930s metapoem is not Spanish alone. It is also American, British, Canadian, French, German, Italian, and Russian. Into its journey from defiance to lamentation are integrated texts from throughout Europe and all of the Americas. At that point we have left behind any mode of understanding typical of literary studies as we know it.

For with the outbreak of the war the significance of slogans in poetry changed. There is now a more constrained—or at least more focused—semiosis at work in these repetitions and verbal clusters than there was in the revolutionary poetry of the early 30s. The constraint, of course, is fascism's threat and Spain's peril, which gave wartime writers and readers the precise political pressure they felt. The revolutionary intertext of the early 30s reflected wide social dislocation and diverse aspirations for change. But victory for worldwide socialism was a far more abstract and hypothetical goal than the defeat of fascism. The popular front poetry about Spain confronted a specific enemy on confined terrain. In that context the *highest calling for a single voice* was to choose to echo the slogan signifying solidarity with the defenders of Madrid, to step forward and speak the words that kept the signifying chain alive, that carried it forward in time and sustained its spread across the globe. But the use of slogans in this poetry has yet an added dimension. For the slogans circulate from street and newspaper into poems and back to the street again. There is thus a transit through poetry for critical pieces of universal public rhetoric. In the process the slogans are infused with all the values poetry itself has historically acquired, and the slogans become not merely instrumental but also literary, lyrical signposts of a history already eternal and monumentalized. And their deployment in the street thereafter has the feel of poetry at work in public life. From the traditional disciplinary perspective, clear evidence of rhetorical interchanges between literature and the public sphere is evidence of a failure of literariness, of its fatal contamination. Such contamination by the public sphere denies literature access to transcendence. From a cultural studies perspective, there is no such transcendence, except as a cultural value itself deployed in time. Moreover, such intertextual transpositions—across relatively autonomous discursive domains—are exactly what cultural studies expects to find in any historical context. Tracking this sort of rearticulation of rhetorical segments to different cultural domains is one of cultural studies's key analytic procedures.

The war produced a small number of highly focused topics—the defense of Madrid, the murder of the poet Federico García Lorca, the role of the internation-

als who came to fight for the Republic—that were unlike anything in the poetry of the first half of the decade. No single Depression setting had the real and symbolic force of Madrid under siege. Poverty in London was readily understandable from the vantage point of poverty in New York, but few could confidently have proclaimed either city the "heart of the world." For a few years that is exactly how people did describe Madrid. Indeed, that figure reflected the beliefs of a broad international constituency. From Paris to Edinborough to Boston to Mexico City every person sympathetic to the Left held Madrid in special honor. It was the focus of a Manichean conflict that might shape not only Spain's destiny but also that of the entire West.

As the fascist troops worked to encircle the city and Hitler's planes bombed civilian neighborhoods, it seemed increasingly likely Madrid would fall. Embassies closed, newspaper headlines proclaimed the city's imminent loss; even the Spanish government abandoned its capital and moved to Valencia. Then, against every reasonable assessment, the people recruited their own militias, built barricades, raided military depots, and—with the dramatic and inspiring entrance of the International Brigades—held their city by the power of their collective will. The presence of the International Brigades, in which ordinary British and French citizens stood with their Spanish comrades—in Battalions whose names honored their national origins—made the conflict one with which almost every nation could easily identify. And it gave people across the world symbolic agency in the battle. When an American volunteer Ben Leider took his plane aloft to battle Hitler's air force, he was every progressive American's agent in the clouds.

In this context so central and productive were the slogans of the war that we hear them echoed and embroidered even when they are not explicitly quoted. On July 19th, the day after the rebellion started, La Pasionaria gave her first speech on Madrid radio, calling on Spaniards to resist the generals. "*No pasaran!*" she declared, echoing Verdun, they shall not pass. The phrase would be repeated again and again over the next months. La Pasionaria adapted it herself in a speech delivered before 100,000 people at Mestal Stadium in Valencia and published in *Mundo Obrero* in August. The fascists will not pass, she cried out, "whenever they pass they sow death and desolation." "*No Pasaran!*" appeared on banners stretched across Madrid streets; soon audiences would call out the slogan together in response to La Pasionaria's speeches. In September another of her slogans was set to work: "Better die standing, than live kneeling!" "Better to die on your feet than to submit on your knees," was another version (1938: 7-21). "Much worse to be alive and bend/ a slave's knee in the living," wrote the Cuban poet Nicholas Guillén in his poem sequence *España*, first published in Madrid. "Listen, revolutionary Spaniards," wrote León Felipe in "The Insignia," "Don't kneel down before anyone/Kneel down before yourselves." Miguel Hernández in "The Winds of the People," repeatedly published in Spain and issued in Britain and the United States in a variety of translations, put the slogan in his own words: "If I must die may I/with my head held high at least." When Jose Herrera Petere closes "*El día que no vendrá*" with his promise that the day shall never dawn on that night when the fascist dream of tak-

ing Madrid is realized, we hear it as a version of the slogan "No Pasaran!"[19]

But the slogan also occurs unchanged or in fresh contexts. Félix V. Ramos titled one of his poems in *Poesias de Guerra* "No Pasaran!" "We, the men of the fields," writes Francis Fuentes, "shout out like a word of command/our slogan: They shall not pass!" George Barker, answering from England, imagines blood soaked "stones that rise and call/tall as any man, 'No pasaran!'" A. S. Knowland ends his poem "Guernica" with the cry "*They shall not pass to ruin Spain!*" and Jack Lindsay recalls "the voice that cried out over Spain:/They shall not pass!"[20]

In the decades since World War II came to end, American academics have taken the use of slogans in poetry as the surest sign of the disavowal of poetry's essential character. The use of slogans is invoked as self-evident proof that poetry has given way to politics, that the aims of self-expression and linguistic invention have both been subverted by prefabricated rhetoric. But for a moment in the 1930s verbal creativity and political slogans were considered poetic partners. As the war proceeded, the slogans chanted in poem after poem were trumpet calls and calls to arms. Like bricks in the barricades constructed in Madrid streets in the summer of 1936, the poems mounted serially to build consensus and solidarity across the world.

Indeed, whatever the intricacies of diction, whatever the metaphoric invention, nothing takes us away from the poetry's representational aims. The most striking metaphors invade representation to heighten and reshape it, to make what we see, what we believe must be done, more vivid and compelling. Whatever their aesthetic aims, these are poems of political action. Though the political and the aesthetic are relational forces here, they are not in stark conflict. For the commitment to Spain sweeps up many of the cultural values historically articulated to aesthetics, from transcendentalizing images of what is just to transformative images of unsettling beauty. The gift of one's will, one's desire, one's fear and hope and anger to Spain and antifascism is now the beautiful thing that must be done.

In echoing and counterpointing one another—even when the poets themselves are not aware of all existing parallel passages—and in accumulating a field of potential correspondences for future poems, the poems of the Spanish Civil War do something more than contribute to a growing international intertext. They hail one another—and their writers and readers—with extraordinary directness and intensity. To be hailed in that way is to be positioned as an international political subject—and to experience that cultural positioning with pathos, anguish, pride, and anger. The effects of varied lines on similar subjects, then, are not simply additive, complicating our view, say, of how civilians suffered under fascist bombing, or how Madrid withstood fascist assault. A sense of strong linkage, of shared necessity, of centripetal focus on the heart of Spain, coalesces in each of the metaphors, phrases, and topics that recur in the worldwide poems about the war.

When Auden writes in "Epitaph on a Tyrant" that, "when he cried, the little children died in the streets," we see the pictures of dead children lined up on Republican sidewalks that were widely distributed after Franco's air attacks on civilian populations, an element of modern war first experienced in Spain.[21] George Barker had one of those photographs—a powerful image of a young girl killed in a

Barcelona bombing raid—printed carefully on coated paper and tipped in like an art photograph across from the opening stanza of his 1939 *Elegy on Spain*:

> O ecstatic is this head of five-year-joy—
> Captured its butterfly rapture on a paper:
> And not the rupture of the right eye may
> Make any less this prettier than a picture.
> O now, my minor moon, dead as meat
> Slapped on a negative plate, I hold
> The crime of the bloody time in my hand.

We are forced by this device to take the description both literally and figuratively, for we hold the girl's image in our hands as we read. Barker's stanza, meanwhile, anticipates Jacques Roumain's comparable image: "On the torn and bloodied face of that child / A smile; like a pomegranate crushed under the tramp of a heel." And both poems echo the opening lines of Herbert Read's "Bombing Casualties in Spain": "Doll's faces are rosier but these were children / their eyes not glass but gleaming gristle." "Spanish suns at Badajoz," writes Somhairle Macalastair, "are bleaching baby bones." "A hundred children in one street, / Their little hands and guts and feet," reports *Left Review* editor Edgell Rickword, are "scattered where they'd been playing ball."[22]

Each new metaphor, each comparable passage, some strikingly graphic, reanimates and reinforces the same space of political recognition. Each metaphor that evokes memory of lines in other poems casts out a net to gather together the experience of Spain. The repetition and variation of slogans is thus only the first instance of the pervasive political and rhetorical unity of these poems. As others have noted, the poems are linked by their anger and hope, by their explicit antifascism, by the places and events they cite repeatedly, and by the blood that soaks so many passages worldwide. Indeed, in the poetry of Spain's Civil War the red dawn of revolution that was so frequent a binding element in the Left poetry of the early 1930s is mostly exchanged for the blood of victims or for the red rags tied around wounds, emblems of violence that unify these poems rather differently.[23] Even such patterns as the recurrent references to the olive trees of Spain help bind the poems to a common enterprise. Finally, as poet after poet comes forward to list Spain's cities and provinces that are sites of battle, of heroism and terror, the lists at once overlay one another and make up a continuing intertextual recitation spread out in time and space. The lists, in effect, are at once deeply additive and simultaneous. And the one difference that matters most here is the stark moral difference between a just cause and an unjust one, between democracy and the gathering forces of evil.

This is, of course, partly a collective emotion, a mass emotion if you will, and such impulses were widely demonized after the Second World War. In reflecting on the 1930s many liberal intellectuals were effectively able to collapse the radical Left into the radical Right and thus equate all recent collective claims on our ideals. Collective action of all kinds seemed unseemly, corrosive, and antithetical to any

notion of individual identity. When British poet Richard Church wrote in "The Madrid Defenders" that "our love is another;/much greater than one/For husband, for mother," declaring his own and his compatriots' love for "the People, the One," he was in one way citing a familiar 30s conviction—that the individual self should find its realization in the common good. Before the war the notion of "the people" was sometimes an abstraction. In Spain, however, sustained worldwide attention was focused on the imperiled defenders of Madrid—from its already legendary leaders to the masses of ordinary men, women, and children facing daily bombardment. One of the cultural legacies of the poetry of the Spanish Civil War—in the wake of a full century when English and American poetry were repeatedly linked with lyrical self-expression—is a record of how lyricism could be marshalled for collective aims and how subjectivity could be realized in public action. Given that such impulses run counter to every dominant model within professional literary studies, recovering the cultural context of Spanish Civil War poetry amounts to acquiring an anti-disciplinary knowledge.

Because the confrontation between democracy and fascism literally took on a global character when the Second World War began, the lesson of Spain retained its urgency for some years despite Franco's victory in the spring of 1939. The antifascist anthologies that appeared over the next several years—notably *War Poems of the United Nations* (1943) and *Seven Poets in Search of an Answer* (1944) in the U.S.—included a substantial number of poems about the Spanish Civil War. Once the Second World War came to an end, however, the pattern changed. The ruling emotion then for those focused on the Spanish experience changed. Franco's Spanish supporters had issued a series of celebratory poetry anthologies in 1939, and the few poets elsewhere in the world who stood with fascism—most notably the South African poet Roy Campbell—could cling to their one great victory. But the poets of the Republic were either dead, in prison, or in exile. Antonio Machado died shortly after crossing the French border in 1939. Miguel Hernández, an Alicante goatherd as a child, later a soldier and poet in the Fifth Regiment, was captured trying to leave Spain and died in a Franco prison of untreated tuberculosis.

For the others who were still alive, scattered across the world, Spaniards, volunteers in the International Brigades and international sympathizers alike, a new category of experience took over their work. Surprisingly, Rukeyser anticipated the focus early on in "Mediterranean." Reflecting on the way memory seemed so quickly to magnify and clarify the experience of the war after she left Spain abruptly, she grasped what would be a hallmark of Republican experience for decades—exile. In the aftermath of the war, as exile, elegy, and loss took over Spanish Civil War discourse, then, a different kind of choral pattern emerged from poetry written throughout the Americas and Europe. Millay's "Say That We Saw Spain Die" would prove one of the signature poems of this new mood in the United States. As dust settled on blasted stone, as blood soaked into the land, the parallel metaphors in different poems acquired a mutual transparency, a palimpsestic quality of shared and layered memory. Poet after poet remained haunted by Spain, and that haunting was less personal than historical and generational. It was a shared experience

and those who gave witness to it in their poetry constituted a far-flung chorus amidst the ruins of memory. Those modern poets of the Left who survived the modern period took with them this experience of international solidarity and subsequent disaster. It haunted their work far more powerfully than did the memory of the purported giants of modern poetry. "What was left to be done," one critic, in effect, reports a series of postmodern poets asking, looking back on the achievements of Pound, Eliot, and Yeats.[24] "What more was to be done," others sometimes asked—among them Rolfe and Rukeyser in the United States, Neruda in Chile, MacDiarmid in Scotland, Altolaguirre in exile in Mexico—"now that we have lost Spain?"

What was to be done, of course, was to keep the memory alive, to maintain witness through the years. That did not require abandoning all the central topics of the war itself. The militant *romanceros* written during the defense of Madrid were now unwriteable, but the image of the city itself still held its power. "Madrid Madrid Madrid," Rolfe wrote in 1948, "I call your name endlessly, savor it like a lover." "Ten irretrievable years have exploded," he reports, "since last I slept/in your arms of tenderness and wounded granite." In the last phrase we can hear an echo of Rolfe's own wartime observation about people strolling in the *paseo* in Madrid: "In the candle-light their faces were granite," along with echoes of Neruda's wartime image of the city's "eyes still wounded by dream,/with carbine and stone, freshly wounded Madrid," as well as his celebration of the International's "ardent brigade of stone." In the fall of 1937 Charles Donnelly, an Irish volunteer who was killed in Spain, had called out to Spain "Your flag is public over granite."[25]

One other more specific topic held its power through the years as well, in part because it was about loss, betrayal, longing, and death from the outset—the murder of Federico García Lorca. The poetic memorial service for García Lorca started almost immediately after his death in August at the outset of the Spanish Civil War and continued for more than a decade. *El Mono Azul* dedicated its September 17, 1936, two-page spread of poems to García Lorca and opened with Emilio Prados's elegy. The July 1937 anthology *Poetas en la España Leal* opens with Antonio Machado's poem about Lorca. By the time *Poems for Spain* was published in 1939, elegies for Lorca were among the central and inescapable categories used to construct the war's intelligibility and its continuing power in the experience and memory of the Left. The Spender/ Lehman anthology is divided into six thematic categories—"Action," "Death," "The Map," "Satire," "Romances," and finally, bringing the text full circle back to the war's opening months and to its core poetics of anguish, "Lorca." Among the poems devoted to him in books and magazines and broadsides are Rafael Alberti's "*Elegía a un poeta que no tuvo muerte*," Manuel Altolaguirre's "*Elegía a nuestro poeta*," J. Bronowski's "The Death of García Lorca," Oscar Castro's "*Responso a García Lorca*," Louis Cernuda's "*Elegía a un poeta muerto*," Joy Davidman's "Elegy for García Lorca," Sol Funaroff's "To Federico García Lorca," Eldon Grier's "In Memory of García Lorca," Miguel Hernández's "*Elegía primera*," Aaron Kramer's "García Lorca," Raúl Gonzalez Tuñón's "*Muerte del poeta*," Jorge Guillén's "Federico García Lorca," Nicolás Guillén's "Anguish Number

Four: Federico," Claudia Lars's "*Romance de romancero gitano*," Pedro García de
Lorca's "*Romance a Federico*," Leopoldo de Luis's "*Romancero a la muerte de
Federico García Lorca*," Hugh MacDiarmid's "In Memoriam García Lorca," Antonio
Machado's "The Crime Took Place in Granada: To Federico García Lorca," Martha
Millet's, "Song for Federico García Lorca," Vincius de Moraes's "*La muerte de
madrugada*," Leopoldo Panero's "*España hasta los huesos*," Geoffrey Parsons's
"Lorca," Pablo Neruda's "Ode to Federico García Lorca," Emilio Prados's "The
Arrival," Alfonso Reyes's "*Cantata en la tumba de Federico García Lorca*," Edwin
Rolfe's "A Federico García Lorca," Norman Rosten's "To Federico García Lorca,"
Héctor Suanes's "*Romance de los cuatro gitanos*," and Leopoldo Urrutia's
"*Romancero a la muerte de Federico García Lorca*." Prose tributes came, among oth-
ers, from Vicente Aleixandre, Pablo Neruda, and William Carlos Williams. Of these,
González Tuñón was Argentinian, Lars was Salvadoran, Moraes was Brazilian,
Reyes was Mexican, Nicolás Guillén was Cuban, MacDiarmid was Scottish, and
Castro, Neruda, and Suanes were Chilean, though only nominally so in this con-
text. Davidman, Funaroff, Kramer, Millet, Rolfe, Rosten, and Williams were
Americans, though in this context, again, only nominally so.[26]

The poems, prose poems, and statements that make up this extended interna-
tional wake are almost impossible to think about only as discrete texts, for they
make up a kind of reflexive Lorca cantata whose music is the sound of war and
lamentation. Among the distinctive and sometimes uncanny continuities in these
elegies to García Lorca are the number of times poets address him directly and the
affectionate, plaintive, and often rather childlike calls to him many poets issued:
"Federico, wait for me! Wait!/I must talk with you! Look! …I have so much to tell
you, Federico!" (Prados); "I cry in pain, 'Oh, Federico! Federico!' …where does a
gypsy go to die?/Where do his eyes change to silver frost? …Where will Federico
be,/where will he be that he won't be back?" (Guillén); "Ay, Federico García,/How
swiftly death, dagger in hand, draws nigh! …Ay, Federico García,/Death is here, is
here!" (Urrutia); "O this is your end, your end, your end…. You joked with the
dead: did you not hear/their voices lower year by year?" (Bronowski); "We used to
see him walk alone with her,/Unfearful of her sickle…. And Federico, in his cour-
teous way,/Would talk with Death and she would listen" (Machado); "Were there
stars in the sky, Federico,/when the fascist rifles struck you down?" (Rosten); "What
is the power of words against flight of bullets? …A poet dies easily, easily as a babe"
(Parsons); "Federico, do you remember/under the ground,/do you remember my
house with balconies where/the light of June was drowning flowers in your mouth"
(Neruda); "Lorca, you who were the morning song of Spain,/the song is on the lips
of the people!" (Funaroff).[27] More powerfully than in any single poem, this collec-
tive elegy makes García Lorca a figure for the Republic as a utopian return to a
prelapsarian cultural moment. It would be a moment when difference—so often
fatal in Spain and throughout the modern world—was merely polymorphous
diversity, when every impulse and desire was purified of worldly corruption. In
some fundamental way, then, Lorca's death demonstrated that it was at once inno-
cence and poetry itself the fascists sought to kill. Lorca was not primarily a political

poet—though his lines attacking the Guardia Civil were hardly neutral and hardly likely to prove harmless in the fatal world of Spanish politics—but he was to a remarkable degree a people's poet. His work was known to many working people; his books were everywhere; his poems could be quoted throughout the country. Lorca's death was thus a figure for the will to kill the people's soul. It was, more-over, as if every progressive poet thereby felt himself or herself (and every value he or she held dear) under a murderous gaze, under a potential death sentence to be carried out immediately if Franco, Hitler, and Mussolini had their way.

The special poignancy of poets' relationships to García Lorca—both real and imaginary—were underlined both during the Civil War and after. In 1938, when the Duchess of Atholl was to be presented with a portfolio of texts and paintings in appreciation for her help for the Republic, Bernardo Clariana's prose tribute to García Lorca was copied out in holograph on parchment and hand illuminated as part of the gift.[28] When Manuel Altolaguirre reached Cuba shortly after the war, one of the first things he did was issue a miniature anthology of García Lorca's poems. "This gathering of poems does not," he pointed out in the introduction, "emphasize his best verses, something I do not like to calculate, but those I heard frequently from his own lips."[29]

The Spanish writers in exile, the foreign writers who fought in Spain or visited it during the war, were among those for whom the memory was strongest. The experience of exile touched all of these writers, moreover, not just the Spanish nationals. In the United States, however, the memory of Spain acquired a special inflection, for supporting the Spanish Republic became a hallmark of politically unacceptable beliefs and commitments. Genevieve Taggard wrote and published a poem in 1941, "To the Veterans of the Abraham Lincoln Brigade," that captured the gathering demonizing of Spain and all it stood for; it was published on the front page of the postwar Veterans' magazine, *Volunteer for Liberty*:

> Say of them
> They knew no Spanish
> At first, and nothing of the arts of war
> At first,
> how to shoot, how to attack, how to retreat
> How to kill, how to meet killing
> At first
> Say they kept the air blue
> Grousing and griping,
> Arid words and harsh faces. Say
> They were young;
> The haggard in a trench, the dead on the olive slope
> All young. And the thin, the ill and the shattered,
> Sightless, in hospitals, all young.

Say of them they were young, there was much they did not know,
They were human. Say it all; it is true. Now say
When the eminent, the great, the easy, the old,
And the men on the make
Were busy bickering and selling,
Betraying, conniving, transacting, splitting hairs,
Writing bad articles, signing bad papers,
Passing bad bills,
Bribing, blackmailing,
Whimpering, meaching, garroting,—they
Knew and acted
 understood and died.

Or if they did not die came home to peace
That is not peace.
Say of them
They are no longer young, they never learned
The arts, the stealth of peace, this peace, the tricks of fear;
And what they knew, they know.
And what they dared, they dare.

By the time Taggard wrote this poem, one that reaches powerfully for the complex human reality of the volunteers, the Vets had already been through their first round of testimony before the House UnAmerican Activities Committee. There their loyalty was questioned and they defended themselves aggressively, as they would have to again throughout the 1950s. Under remission during the Second World War, antipathy toward the Spanish Republic rose again during the postwar inquisition. By then, it was no longer necessary to have fought in Spain to be marked as subversive. Merely having signed a petition or contributed funds was enough to get you fired and blacklisted. During those dark years the commitment to Spain remained a kind of beacon with which to read the betrayals of the decades to follow. Thus many of those who suffered because of their devotion to Spanish democracy also found the memory a powerful resource amidst oppression.

In the United States, a number of poets on the Left who had worked through the radical 30s and made a commitment to Spain never quite outlived that period of unique intensity. Those who held to their beliefs through the long postwar inquisition of the 1940s and 1950s—the widespread purge of the Left from both public and private employment that culminated in the McCarthy period—could hardly forget that earlier moment of alliance politics when the Left at least seemed able to mount an organized resistance to fascism. When Edwin Rolfe, a veteran of the Lincoln Battalion in Spain, turned to write of García Lorca one last time in 1948, then, he was, in effect, recalling not only the martyred poet but also the whole imperiled coalition that stood with the Spanish republic:

A Federico García Lorca
>Ten years have passed since I found in a book shop
>>in Albacete,
>The case of jewels which I treasure still, the book
>>*Romancero Gitano.*
>And turned to the first poem, the "Romance de la Luna,
>>Luna,"
>And read and found fabulous peace in the midst of the war.
>
>Later, in Madrid, the lads of the guerrilleros
>Crossed the midnight lines from madness to the light of
>>the Casa de Alianza.
>And told us (Langston was there, and Rafael, and Maria Teresa)
>That they came from the choked south, from your buried
>>city, Granada.
>
>And they told how they met in the streets the people who
>>told them in whispers
>Of the way you died, with surprise in your eyes,
>>as you recognized your assassins,
>The men with the patent-leather hats and souls of patent-leather.[30]

In the last lines of the poem Rolfe imagines the moment of García Lorca's death and in so doing cements its relation to the moment of the poem's composition. The men with the souls of patent leather, first named in García Lorca's "Ballad of the Spanish Civil Guard," were abroad in the land again, this time in America as well as Spain. García Lorca *recognizes* his assassins, a recognition that is preeminently political but also—because of the force of the verb—unstably personal and familial as well. The Guardia Civil represent members of the lethal family of Spanish politics. They are among the agents tearing apart Spain's body politic. So too are the agents of the American inquisition at once neighbors and representatives of recognizable political institutions. That is also why Alvah Bessie, whose poem "For My Dead Brother" I quoted at the outset, turned to write of Spain as well when he was in Federal prison for asserting his First Amendment rights. There is a strong suggestion that no less than everything is at stake in Bessie's poem. For the plains and seas that the International Brigades took, despite losing the war, are terrains of principle and witness, ranges of value, cities of history. It is a geography of honor and things done, not simply a geography of contested lands. Nearly a thousand Americans lost their lives in Spain, a country that was not their own, but whose cause they made individual decisions to support. Though as a larger culture we have largely forgotten that commitment; it has echoed through the Left and through American poetry ever since.

Yet the story of when and how some of these poems were published is a complex and troubled one. The case that sets the standard for the postwar experience,

arguably, occurred near the Civil War's end. Manuel Altolaguirre had set up a printing press on the eastern front in an old monastery and set about printing Neruda's *España en el corazón*. Neruda tells the story himself in his *Memoirs*:

> The soldiers at the front learned to set type. But there was no paper. They found an old mill and decided to make it there. A strange mixture was concocted, between one falling bomb and the next, in the middle of the fighting. They threw everything they could get their hands on into the mill, from an enemy flag to a Moorish soldier's bloodstained tunic…. My book had just been printed and bound when the Republic's defeat was suddenly upon us…. Among those lines of people going into exile were the survivors of the eastern front, and with them Manuel Altolaguirre and the soldiers who had made the paper and printed *España en el corazón*. My book was the pride of these men who had worked to bring out my poetry in the face of death…. Many carried copies of the book in their sacks, instead of their own food and clothing…. The endless column walking to exile was bombed hundreds of times. Soldiers fell and the books were spilled on the highway…. The last copies of this impassioned book that was born and perished in the midst of fierce fighting were immolated in a bonfire (125–26)

Neruda, of course, saw his book reprinted and translated numerous times. Rolfe, however, could find no one to publish his 1948 poem "Elegia" until Altolaguirre issued a Spanish translation in Mexico City, and Rolfe died in 1954 without publishing his poem to García Lorca; I published Rolfe's poem thirty-nine years later (Rolfe 1993: 50-51). Walter Snow, a friend of Rolfe's in the 30s who helped publish Jack Conroy's radical magazine *Anvil*, turned against the Left in the 1950s. A decade later he had second thoughts, sought out those of his friends on the Left who were still alive, and gave thought to publishing his long poem "Spain—The Modern Phoenix," completed during the war but abandoned in his papers. Finally, he wrote a prologue to it, briefly suggesting why young readers today might still care about a war over for decades, along with a brief conclusion, and issued it shortly before his death in his self-published book of poems, *The Glory and the Shame* (1973: 67–68). The original opening of the poem, now section two, was a long tribute to the International Brigades. Here is its first stanza:

> They came with the four great winds in their leaf-green youth.
> They were students with quicksilver minds, more footloose,
> more sensitive to the barometer of history than
> tenured teachers. They were the disillusioned
> unemployed, frayed victims
> of the Great Depression, deciding it was time to act.
> They were the young colts of the prairies, the dreamers who still
> read poetry
> instead of doping Daily Doubles and Three-Horse Parlays;
> the tailors from sweatshops who still bled at the prick of needles;
> belt-line assembly robots from Detroit who rebelled
> at obsolescence planned in chrome-plated coffins.

They were miners long accustomed to coughing out their lungs and
 protesting
but willing to be jolted now in cattleboats five thousand miles
to set off dynamite blasts for a better world.

Whether Snow meant these Whitmanesque lines that way or not, they may also stand for many of the young poets, some of them volunteers as well, who began to write of Spain in 1936 or 1937 and continued doing so through the modern era and as far into the century as their lives reached. Rukeyser wrote of the Spanish Civil War in *U.S.1* (1938), *A Turning Wind* (1939), *Beast in View* (1944), and, in her last book, *The Gates* (1976), called Spain "that core of all our lives,/The long defeat that brings us what we know."[31]

All this gives us at least a glimpse of literature as lived history and culture, embedded both in the discourses and politics of its own time and in the cultural politics in which our own memories are forged. Indeed, this second half of the cultural studies coin—the politics of our own memory—is wholly inescapable in the story I have told. That is because it is preeminently a popular-front story and thus a story about communism, socialism, anarchism, and their brief (and widely forgotten) flirtation with democratic liberalism. It is not a story the discipline of English has been inclined to tell. In the last twenty years English has gradually confronted the fact that it is a sexist discipline and begun to recognize that it is a racist one. But only a handful of people are dealing substantially with the knowledge that it is also fundamentally a Cold War discipline. That is a critique and an investigation that cultural studies must have a share in undertaking.

While the Left held onto the memory of Spain and drew on it repeatedly during the long night of McCarthyism, and the Right, conversely, regarded any commitment to the Spanish Republic as proof that the person so committed should be cast out of social life, the literary establishment went about suppressing the entire episode. In the 1950s, when the canon of modern poetry began to be solidified, it was clear to any academic who wanted to keep his job that the whole communal, contrapuntal, and choral radical project of a decade could have no place in any general literary history of modern poetry. In the process, we lost not only a singular instance of internationalism in our literary history but also the record of a poetry reaching for an alliance politics. At a moment when few, if any, discourses about the common good seem able to win much purchase in the public sphere, the memory of the alliance politics of the 1930s—in both its successes and failures—can at least be instructive. Indeed, the suppression of such memories may be counted, to borrow Michael Denning's apt deployment of a 1930s phrase, as among the "origins of the present crisis."

If cultural studies, as Denning argues, is always about the origin of the present crisis, then its contemporary focus must include a gaze cast backward. That helps counter and complicate the widespread conviction that cultural studies can only be about the contemporary world. We cannot understand the constitution of the present unless we seek to know its history. Moreover, if cultural studies in America

adopts a casual dismissal of history, it makes two additional regrettable moves: first, it makes common cause with those too young to credit the historical roots of contemporary culture; second, it leaves history to the Right. And it leaves cultural studies with a present whose readability is either assumed to be transparent or available without constraint. That naiveté is arguably a common feature of recent cultural studies writing. In testing the possibility of a cultural studies analysis against a moment half a century in our past, I hope to have put all these assumptions in doubt.

But the example of Spain puts other common cultural studies assumptions in crisis as well. Among the challenges at issue in the question of whether literary studies can become cultural studies, for example, is a challenge about whether it *should*. From the Right, the question is whether literature would thereby lose its special high cultural character. From the Left come suspicions about literature's elitism and thus doubts about its inherent class politics. Both these concerns, alas, are grounded in widespread ignorance about literature's material conditions at key moments in the past. As the example of Spain shows, there were moments when literature had a broad audience that cut across class lines. To traverse the field of Spanish Civil War poetry is to find few signposts clearly marked for high and low culture. There are, to be sure, poems that would be easier for mass audiences to read than others, but the political and cultural similarities override the differences. To divide this body of work into elite and popular segments would be to import a perspective hostile to every central aim in Spanish Civil War poetry. It would be equally misguided to sort through this literature in search of the "best" Spanish Civil War poems. I have talked about certain poems in detail because I find them interesting, but I have no idea whether they are better than other Spanish Civil War poems. And I do not care. To conduct an aesthetic contest among these poems and then forget the losers would be to abandon the whole historical meaning of this work.

I have tried to read a body of poems as social and political, as well as rhetorical, documents, not as efforts to reach for transcendence. And I have read them partly as a collective international phenomenon, not simply as unique objects. To a significant degree, both these aims go against the grain of assumptions that have dominated the discipline for many years. But they are not unknown impulses. Moreover, I would not want to claim that any of the specific elements of the sort of historiography I am practicing here is unheard of; in one representative location or another from among the historiographic practices of our century all these techniques are available. Putting them all together and giving them a cultural studies inflection does, however, mark a collective difference from the discipline we have inherited.[32] Case by case, context by context, we can begin to establish the cultural studies difference. Some of the cases, as with the case of Spain, will well reward the effort. That is what I have tried to show here.

In 1936, 1937, and 1938 "No Pasaran!" was a newspaper headline and the lettering on banners stretched across Spanish streets, a rallying cry from a charismatic speaker and a choral response from a crowd, the caption on posters and leaflets to

98 be found in nearly every free city on earth. One particularly famous photograph of a Madrid street, the "No Pasaran!" banner hung high above, was published throughout the world. Yet some graphic artists wanted more than just the original image. They wanted to feel the words enacted in the sinews of their drawing hand, so they redrew the photograph in a variety of styles, illustrating books or articles. "No Pasaran!" was also the title of a song sung on behalf of the Spanish Republic and the closing line in letter after letter sent home by American volunteers on battlefields in Spain. It was the title of a novel by Upton Sinclair and a memoir by Ilya Ehrenburg. And it was at the same time a title for poems, the substance of stanzas, and a line renewed in poem after poem wherever poets were world citizens. And it figured in a dance called a poem, and it was the sound of a mass chant. As a result, banners became poems and poems became posters and poetic speech became the people's common cry. For a moment a certain dream of possible poetries had taken form before mounting terror. Poetry was the language of history and the story of ordinary lives. It was one of the indisputable terms in which history burnt its name into the living flesh of its time. Then night came, fascism spread over Europe, and it was over. But no one who had been part of it would ever forget.

Notes

1 There are a number of interesting critical books on the international literature of the Spanish Civil War, including several that devote space to British and American poetry. See Hugh D. Ford (1965), John M. Muste (1966), Marilyn Rosenthal (1975), and Stanley Weintraub (1968). All these books are heavily influenced by American New Critical assumptions; thus they concentrate on evaluating the achievements of individual poets who wrote about the Spanish Civil War. Given when the books were written, that bias was inevitable. Nonetheless, it slights the collective and interactive nature of the literature and, in many cases, misses possibilities for valuing particular poems in that light.

2 The unpublished manuscript of the shortened manuscript of "On Guard for Spain!" is in the author's collection.

3 Jack Lindsay, letter to Valentine Cunningham, quoted in Cunningham, ed. (1980). "On Guard for Spain!" was published both in a separate pamphlet and in *New Left Review* in March of 1937. Cunningham's notes (478–79) include an additional unpublished passage added for some performances, though not in the typed version in my possession.

4 R. Vernon Beste (1943), quoted in Cunningham, ed. (1980), 45–6.

5 See M. J. Benardete and Rolfe Humphries, eds. (1937) and Stephen Spender and John Lehman, eds. (1939).

6 Muriel Rukeyser (1978), "Mediterranean," 136–43. The poem was first collected in Rukeyser's *U.S. 1* (1938).

7 As Hughes (1956/1993) makes clear, it was actually *white* American volunteers who wondered whether the use of dialect "might mistakenly be aiding in perpetuating a stereotype" (378). Hughes defended the poem during the war and stood by it twenty years later. It is one of the few poems he reprints in *I Wonder as I Wander* (353–54).

8 Langston Hughes, "Addressed to Alabama."

9 For information on Hughes's interactions with Rolfe in Spain see Cary Nelson and Jefferson Hendricks, eds. (1990).

10 Kenneth Rexroth, "Two Poems", in Alan Calmer, ed. (1938), 28–29. Rexroth's poems are untitled.

11 See Alan Filreis (1994: 42) for his comments on "City of Anguish."

12 *El Mono Azul* was reprinted by Kraus in 1975. It is part of a series that also reprints *Hora de España*.

13 *Poesia en las trincheras*. Sixty-three pages long, the paperbound book included an introduction and thirty-three poems.

14 Valera, a republican deputy, was subsecretary of communications. He was one of only two under-secretaries left in Madrid. The government as a whole had decided to evacuate on November 6. See Hugh Thomas (1977), 475, 481.

15 Norman Rosten, "The March," in Calmer, ed. (1938), 31.

16 In citing Spanish wartime romances I have placed some titles in English to signal poems that were available in English translation during the war. Some American poets, however, also read the poems in Spanish. The titles I mention are only a tiny fraction of the Spanish romances written about Madrid. A recent anthology, Salaün (1982), includes 143 poems, and it is far from comprehensive. Recent English translations include Carlos Bauer (1984) and Michael Rossman (1986).

17 Richard Church, "The Madrid Defenders," *New Statesman* (December 5, 1936): 886; Elisabeth Cluer, "Analogy in Madrid," *New Statesman* (April 8, 1939): 536; Joy Davidman (1938), "Snow in Madrid," 40; Sol Funaroff (1943), "The Bull in the Olive Field," 47–49; Langston Hughes, "Madrid—1937," in Faith Berry, ed. (1973), 104–106; Norman Rosten, "Invocation," in Thomas Yoseloff, ed. (1944), 100–101; Jacques Roumain, "Madrid," trans. Nancy Cunard *Left Review* (April 1938): 909–10; David Wolff (Ben Maddow), "The Defenses," in Calmer, ed. (1938), 14–15. The poems by Church, Cluer, and Roumain are reprinted in Cunningham, ed. (1980).

18 Rafael Alberti, "Defense of Madrid," trans. Millen Brand in Spender and Lehman, eds. (1939), 22–23; Stanley Richardson, "To a Certain Priest," *Spain at War*, no. 3 (June 1938); Luis de Tapia, "Salud," trans. Isidor Schneider in *International Literature* No. 10–11 (1937): 191; José Moreno Villa, "Madrid Front," trans. Stanley Richardson in *New Writing*, new series, 1 (Autumn 1938): 34–35.

19 León Felipe, "The Insignia," in Rosenthal (1975), 266–83; Miguel Hernández, "Winds of the People," trans. A. L. Lloyd in Spender and Lehman, eds. (1939), 37–9; trans. Willard Maas in Benardete and Humphries, eds. (1937), 51–52; José Herrera Petere, "*El día que no vendré*," trans. Sylvia Townsend Warner in Cunningham, ed. (1980), 291–92.

20 Francis Fuentes, "Revolutionary Madrid," trans. Sylvia Townsend Warner in Cunningham, ed. (1980), 279–80; A. S. Knowland, "Guernica," *Spain at War*, No. 8 (November 1938): 307; Felix V. Ramos, "No Pasaran!" in *Poesías de Guerra*, 24.

21 W. H. Auden, "Epitaph on a Tyrant," *New Statesman* (January 21, 1939): 81.

22 Herbert Read, "Bombing Casualties in Spain," in Spender and Lehman, eds. (1939), 41–2; Somhairle Macalastair, "Ballyseedy Befriends Badajoz," *Left Review*, II, No. 15 (December 1936), 817; Edgell Rickword, "To the Wife of Any Non-Intervention Statesman," *Left Review*, III, No. 14 (March 1938): 834–36; Jacques Roumain, "Madrid," in Cunningham, ed. (1980), 164.

23 Valentine Cunningham (1989) gathers together a broad sample of blood images in Spanish Civil War poetry. See his last two chapters, "Spanish Front" and "Too Innocent a Voyage," for his often challenging comments on the literature and politics of commitment. The discussion of blood imagery is on 425–27.

24 See James E. B. Breslin's (1984) summary of the belatedness of the contemporary in his opening chapter.

25 Charles Donnelly, "Poem," *Ireland Today* II, No. 1 (January 1937): 48–49; Pablo Neruda, "Spain Within My Heart," trans. Lloyd Mallan in Davidman, ed. (1943), 237–42; Edwin Rolfe (1993), "Elegia," "City of Anguish," 186–89, 131–35.

26 See Héctor Suanes (1977) for an introductory essay and a selection of seventeen Spanish language elegies about García Lorca. Also see the following edited collections for poems about García Lorca and other Spanish Civil War subjects: Alvarez Rodríguez and López Ortega (1986), Bessie (1952), Spender and Lehman (1939), Cunningham (1980), and Yoseoff (1944).

27 J. Bronowski, "The Death of García Lorca," in Spender and Lehman, eds. (1939), 104–105; Funaroff (1943) "To Federico García Lorca," 46; Nicolas Guillén, "Spain (A Poem in Four Anguishes and One Hope)," trans. Lloyd Mallan in Davidman, ed. (1943), 252–56; Antonio Machado, "The Crime Took Place at Granada," trans. Rolfe Humphries in Benardete and Humphries, eds. (1937), 62–63; Pablo Neruda, "I Explain Some Things," in Rosenthal (1975), 294–96; Geoffrey Parsons, "Lorca," in Spender and Lehman, eds., 103–104; Emilio Prados, "The Arrival (To Federico García Lorca)," trans. Edna St. Vincent Millay in Benardete and Humphries, eds, 57–61; Norman Rosten, "To Federico García Lorca," in Yoseloff, ed. (1943), 101–103; Leopoldo Urrutia, "Lorca," trans. Sylvia Townsend Warner in Spender and Lehman, eds., 107–108.

28 Two or three copies of the portfolio of paintings and illuminated holograph manuscripts were made in Spain during the war. One was given to the Duchess of Atholl, whose work included the widely read pro-Republican *Searchlight on Spain*. One copy is now in the Rare Books and Special Collections Library at the University of Illinois at Urbana-Champaign.

29 See Manuel Altolaguirre's one-page introduction to *Poemas escogidos de Federico García Lorca*. It is a miniature book sixty pages in length.

30 Rafael and María Teresa refer to Rafael Alberti and María Teresa Leon, both Spanish writers, who were married to each other. The poem is set in Madrid in the fall of 1937, when Langston Hughes was often in the city and spent a number of days with Rolfe. The Casa de Alianza was the headquarters of the Alliance of Antifascist Intellectuals, where all these writers often met and worked.

31 Muriel Rukeyser (1978), "Neruda, The Wine," 554. In the poem, it is Neruda "in the hall of students / Speaking at last of Spain," who occasions Rukeyser's characterization of the war's lasting impact, but she is clearly speaking not only for both of them but also for this "link deep in our peoples."

32 One question I was regularly asked when presenting oral versions of the paper is whether it could be fairly classified as an exercise in comparative literature. Historically, of course, comparative literature has been as elitist as English as a discipline, with its own canon of most highly valued works. I believe I have broken with that tradition. More serious still is my effort to read the poems in a historical and political context and in terms of their historical and political meaning, not in terms of purportedly transcendent aesthetic values. Finally, comparative literature has shown little disciplinary interest in the notion of collective poems composed of numerous texts by different authors. An international Lorca cantata is not the sort of text the discipline has urged us to consider. Nonetheless, I am happy to identify with a revitalized comparative literature enterprise, just as I would urge that both English and cultural studies must become substantially more comparative in their outlook and methodology.

References

Alvarez Rodríguez, Román and Ramón López Ortega (1986) *Poesía Anglo-Norteamericana de la Guerra Civil España: antología bilingüe.* Salamanca: Consejería de Educación y Cultura.

Bauer, Carlos (1984) *Cries from a Wounded Madrid: Poetry of the Spanish Civil War*. Athens, Ohio: Swallow.

Benardete, M.J. and Rolfe Humphries, eds. (1937) *…And Spain Sings: 50 Loyalist Ballads*. New York: Vanguard.

Berry, Faith, ed. (1973) *Good Morning Revolution: Uncollected Social Protest Writings by Langston Hughes*. Westport, Connecticut: Lawrence Hill.

Bessie, Alvah, ed. (1952) *Heart of Spain*. New York: Veterans of the Abraham Lincoln Brigade.

Best, R. Vernon (1943) "On Mass Declamations." *Our Time*, 11, No. 11 (May 1943).

Breslin, James E. B. (1984) *From Modern to Contemporary: American Poetry, 1945-1965*. Chicago: University of Chicago Press.

Calmer, Alan, ed. (1938) *Salud!: Poems, Stories, and Sketches of Spain by American Writers*. New York: International.

Cunningham, Valentine, ed. (1980) *The Penguin Book of Spanish Civil War Verse*. Harmondsworth, England: Penguin.

Cunningham, Valentine (1989) *British Writers of the Thirties*. New York: Oxford.

Davidman, Joy (1938) *Letter to a Comrade*. New Haven: Yale University Press.

Davidman, Joy, ed. (1943) *War Poems of the United Nations*. New York: Dial.

Filreis, Alan (1994) *Modernism From Right to Left: Wallace Stevens, the Thirties, and Literary Radicalism*. New York: Cambridge.

Ford, Hugh D. (1965) *A Poets' War: British Poets and the Spanish Civil War*. Philadelphia: University of Pennsylvania Press.

Funaroff, Sol (1943) *Exile from a Future Time*. New York: Dynamo.

García Lorca, Federico (1939) *Poemas escoqidos de Federico García Lorca*, ed. Manuel Altolaguirre. Havana.

Hughes, Langston (1938) "Addressed to Alabama." *The Daily Worker* (January 23) sec. 2: 8.

Hughes, Langston (1956/1993) *I Wonder as I Wander*. New York: Hill and Wang.

Ibarrurri, Dolores (1938) *Speeches and Articles: 1936-1938*. Sydney: Modern.

Monteath, Peter (1994) *Writing the Good Fight: Political Commitment in the International Literature of the Spanish Civil War*. Westport, Connecticut: Greenwood Press.

Muste, John M. (1966) *Say That We Saw Spain Die: Literary Consequences of the Spanish Civil War*. Seattle: University of Washington Press.

Nelson, Cary and Jefferson Hendricks, eds. (1990) *Edwin Rolfe: A Biographical Essay and Guide to the Rolfe Archive at the University of Illinois at Urbana-Champaign*. Urbana: University of Illinois Press.

Nelson, Cary (1994) "Always Already Cultural Studies: Academic Conferences and a Manifesto." In Isaiah Smithson and Nancy Ruff, eds. *English Studies/Culture Studies: Institutionalizing Dissent*. Urbana: University of Illinois Press.

Nelson, Cary and Jefferson Hendricks, ed. (1996) *Madrid 1937: Letters of the Abraham Lincoln Brigade from the Spanish Civil War*. New York: Routledge.

Neruda, Pablo (1977) *Memoirs*. Trans. Hardie St. Martin. New York: Farrar, Straus, and Giroux.

Poesía en las trincheras. (1937) Madrid: Publicaiones del Subcomisariado de Agitación, Prensa y Propaganda del Comisariado General de Guerra.

Poesías de Guerra. (1937) Madrid: Ediciones 5 Regimento.

Poetas en la España Leal. (1937) Madrid / Valencia: Ediciones Españolas.

Rampersad, Arnold (1986) *The Life of Langston Hughes—Volume 1: 1902-1941—I, Too, Sing America*. New York: Oxford.

Rolfe, Edwin (1935) "Poetry." *Partisan Review* 2, no. 7 (April-May): 32-42.

Rolfe, Edwin (1993) *Collected Poems*, ed. Cary Nelson and Jefferson Hendricks. Urbana: University of Illinois Press.

102 *Romancero de los voluntarios de la libertad.* (1937) Madrid: Ediciones del Comisariado de Las Brigadas Internacionales.

Rosenthal, Marilyn (1975) *Poetry of the Spanish Civil War.* New York: New York University Press.

Rossman, Michael (1986) *Winds of the People: The Poetry of the Spanish Civil War.* Berkeley: Privately published.

Rukeyser, Muriel (1978) *The Collected Poems.* New York: McGraw-Hill.

Salaün, Serge (1975) "*L'expression poétique pendant la guerre d'Espagne.*" In Marc Hanrez, ed. *Les écrivains et la guerre d'Espagne.* Paris: Pantheon Press.

Salaün, Serge (1982) *Romancero de la defensa de Madrid.* Barcelona: Ibérico.

Snow, Walter (1973) *The Glory and the Shame.* Coventry, Connecticut: Pequot Press.

Spender, Stephen and John Lehman (1939) *Poems for Spain.* London: Hogarth.

Suanes, Héctor (1977) *Llanto por Federico García Lorca.* Buenos Aires, Argentina: Ediciones del Libertador.

Thomas, Hugh (1977) *The Spanish Civil War.* Revised and Enlarged Edition. New York: Harper.

Yoseloff, Thomas, ed. (1944) *Seven Poets in Search of an Answer.* New York: Bernard Ackerman.

Michael P. Steinberg

4

CULTURAL HISTORY AND CULTURAL STUDIES

1. Disruptive History

Should the farmer and the cowhand be friends? The question is asked in Rodgers and Hammerstein's musical *Oklahoma!* and proves relevant to a number of dubious professional alliances. As an academic metaphor, the antagonism between farmer and cowhand conjures the conflict between energies of cultivation and preservation on the one side; energies of disruption and subversion on the other. In current American debates about trends in the study of culture, this dichotomy is manifest in the rivalry between traditional disciplines and post-disciplinary formations. The farmer-disciplinarians want to cultivate their gardens, and they often worry that the disruptive cowhands will first trample their flowers and then move their markets to far-away, greener pastures. The cowhands disrupt out of necessity, conviction, and justice, but find themselves vulnerable to the accusation that the undermining of cultivation may portend withering harvests for everyone.[1]

One such tension exists between History and Cultural Studies. The discipline of History is of course the root discipline of newer ones such as political science, anthropology, and sociology. To the extent that historical study is a dimension of the humanities in general, it is also a root of such practices as literary studies, art history, music history, and so forth. History is younger than philosophy and the-

ology, both of which have become more marginal to the study of culture. History is the study of the past and also a discipline formed in the past. It is a nineteenth-century discipline, formed in the joint age of professionalization, nationalism, and various forms of domestic and foreign colonization. Its consistent fallacy has been its desire to provide a narrative of How We Got To Where We Are Now—professionally, nationally, and otherwise. In other words, the professional study of history often fails to account for itself in relation to its status in the present. It fails to ask "Who Are We In Relation To How We Say We Got Here?"

This same question, and the necessity of asking it, are relevant to Cultural Studies. The decisive rupture in the late twentieth-century worldly context of Cultural Studies is the advent of post-coloniality, which accompanies a degree of post-nationalism but NOT post-capitalism and therefore NOT post-professionalism. Since Cultural Studies wants to further the post-colonial alteration of the condition of Where We Are Now—and who's We, anyway?—the two modes of cultural knowledge often meet but rarely communicate. Cultural historians tend to see cultural studies types as plunderers—especially when they "do" history. Cultural studies scholars see cultural historians as antiquarians and/or ideologues who hide a more vicious form of presentism, instrumental reason, and indeed neo-coloniality under their antiquarian innocence. When self-proclaiming poohbahs of the two practices do meet to talk about their differences, the dispute will make itself known first as one of dress style: tweed versus latex, let's say, the display of emblems of the contemplative mind (pocket watches and pipes) or of the subversive body (safety pins without diapers); of respectability or of subversion; of gentility and up-classing or of subculture and down-classing. The semiotic suggestion: History is the site of traditional knowledge and the civilizing process, while Cultural Studies is the site of disruption and subversion.

Where, in all this, is Disruptive History? In this essay, I want to argue for such a different encoding of this disruptive element in the study of culture. Disruption is a dimension of historical record and of historical knowledge. I want therefore to argue for the potential cooperation of History and Cultural Studies, as indeed for the cooperation of disciplinarity and dissent. I want to argue that this mutual inflection can potentially create an epistemologically and ethically valid alliance in what remains the basic conflict in the making of cultural knowledge: that between, on the one hand, modes of critical and self-critical knowledge and, on the other, modes of normal science, ideologically produced.

The history of cultural history (like that of other disciplines) offers examples of both critical and normal science. The dominant narrative in the history of historiography is that of the evolution of a normal science, but that does not certify such practice as the best history. The history of cultural studies—a much shorter story, of course—is, to be sure, a history of disciplinary disruption. But cultural studies also shows signs of routinization and normal science. Cultural history's most insidious potential is the production of closed narratives of cultural dominance and authenticity: the production of the museum as the agent of empire. Cultural studies's most disturbing potential is the denial of historicity and temporality, of exis-

tential subtlety, overdetermination, and the subsequent production of a uniform cynicism, all in the service of the alleged liberation from history: the production of global shopping malls.[2] I leave it to the reader to judge the character of Cultural History/Cultural Studies hybrid I will argue for here: whether it is a museum store, an exhibition in a shopping mall, both, or neither.

In 1986, in the first autumn of my first job as the new European intellectual and cultural historian at a semi-small, semi-elite, semi-liberal arts college in the American northeast, I unwittingly contradicted the apparent semiotics of my grey tweed jacket. I did this by voting for the appointment to the history department of an African-Americanist whose teaching load would include the standard course on the Civil War and Reconstruction, and who would thereby be likely to upset the exceptionalist grand narrative that had marked the department's American history curriculum. (In this narrative, long discarded by most American historians, slavery and racism were of course condemned but Reconstruction was still understood as a triumphant emergence from them.) Several minutes after the end of that department meeting, one of the departmental elders slipped into my office and closed the door behind him. He told me to "be advised" (1) that my function as the European intellectual and cultural historian was to serve as the guardian of intellectual and hence curricular tradition; (2) that I should resist at all costs the insidious slide from the party of scholarship to the party of ideology; and (3) that if I persisted in tipping the scales of the department from tradition to experimentation and from scholarship to ideology, I would be digging my own grave insofar as my own, traditionally defined position would be the most likely one to face elimination by a newly politicized institution.

I realized immediately that I had been blackmailed and that—due to this particular patriarch's credibility problem—the threat was empty (so much for No. 3); but Nos. 1 and 2 gave me pause. Self-righteously appalled as I was, I didn't entirely disagree that my role was to transmit a tradition. But I defined that tradition as one of interpretation, contestation, and critique rather than as one of authority, linearity, or evolution. I saw my epistemological and ethical choice not as one between tradition and innovation or between objective and ideological scholarship, but between the tradition of ideologically marked "normal" science and the tradition of critical thinking and, most specifically, of the critique of ideology. Consequently, I was—the point will be obvious to a sympathetic reader—loath to accept the scholar/ideologue distinction because of its kneejerk acceptance of the myth of objectivity.

As a scholar of culture and history, I hold myself responsible to the existence and exigencies of an object-world that is morally, materially, linguistically, and culturally constituted. The positing of this object world has nothing to with the claim of its empirical epistemological availability. Duty to the object-world cannot be considered an alternative norm to the norm of "objectivity." In current American professional historical practice, both among adherents and opponents of the so-called "linguistic turn," the term "objectivity" seems to me to refer to an epistemo-

106 logical norm alone. It means being careful, being scrupulous. By "duty to the object-world" I strive for a hermeneutic able to retain epistemology by combining it with ethics. I want to retain criteria of epistemology because I want to retain forms of knowledge that involve the marking of objects: facts, events, dates, languages, grammars. I want then to combine, indeed to sublate this epistemology into a hermeneutic capable of questioning subject position in relation to structures and claims of knowledge. Through such a process, objects of knowledge (languages, people) become subjects of knowledge. As argued toward the end of this essay, this hermeneutic can be understood through metaphors of hearing: having an ear; listening.

The failure to develop and continue to question the theoretical and practical distinction between these modes is a basic American intellectual problem—endemic to the historical profession—that results from the crippled legs of much founding American social science. It emerges in the classical tendency to invoke Max Weber's "fact/value distinction" while getting it exactly backwards. For Max Weber—tortured, fin-de-siècle Wilhelmine that he was—the point was that scholarship must eternally agonize over the desire to separate fact from value but must recognize the futility of the wish and the subsequent certainty of the obsolescence and revision of knowledge. Everyday American social science often simply assumes the performativity of the fact/value distinction. The sociology of knowledge, generated out the widespread and diverse fin-de-siècle insistence that knowledge become self-conscious, became "the sociology of knowledge"—just another game within normal social science. The same trajectory holds for the British and American analyticization of philosophy and medicalization of psychoanalysis. The source paradigms rested on too much pain for their breezy American epigones. Thus, the same generation that gave us the provincialism of Woodrow Wilson's Fourteen Points looked at the agonized will of European social theory to distinguish critical from ideological thinking and shrugged, "What's the problem?"

Another example of the same knotty problem. The cultural historian Aby Warburg (1866-1929), who liked mottoes, had a favorite: "Athens always wants to be reconquered from Alexandria." For "Athens" read "the West," "rationality," "fact." For "Alexandria" read "the Orient," "the irrational," "value." Warburg's own, quirky German reads: "*Athen will eben immer wieder neu aus Alexandrien zurückerobert sein.*" His principal biographer, E. H. Gombrich, has chosen to translate the line as "Athens must always be conquered anew from Alexandria." Do you see what happens in the difference? What Warburg addressed in the mode of a Weberian, fin-de-siècle agony—namely, the desire to engender a self-aware rationality out of an inescapable dimension of cultural pain—is transmuted into an allegedly disinterested epistemological and emotional confidence that rationality and pain, reason and desire, can be separated. But science (knowledge) is not a thing; it is a cultural desire as well as a cultural necessity. Knowledge is a form of desire: the wrestling, in Aby Warburg's formulation, with cultural demons.

Such positivistic naiveté has been very detrimental to historical scholarship in America. The position set forth here is distinguished from one of reverse provin-

cialism because it does not favor Europe to America but favors, rather, both places' epistemological and political cosmopolitanisms to forms of nationalism or provincialism. When disciplinary ascendancy gives way to "normal science," the illusion of transparent facticity can take over to the detriment of critical thinking. The ascendancy of the historical profession—in Europe in the nineteenth century and in America in the twentieth—clearly produced modes of normal science that became instruments of national ideologies. But from the same sources came powerful voices of internal critique.

A mode of culturally and ideologically critical cultural history did indeed emerge to question the normal science of professionally and nationally sanctioned historiographical paradigms. This mode is often marginal or entirely external to the evolution of the historical profession. Such is the case with Walter Benjamin. Even more importantly, it often characterizes the dark side of the work of a figure who in other modes might well be identified with mainstream disciplinary formation and practice. Such is the case with Max Weber. Moreover, this kind of critical and self-critical historical consciousness, grounded in principles of specificity, dialogicity, materiality, must be understood as an ongoing, necessary dimension to the developing practices of cultural studies.

The roles of cultural history as a sub-discipline are very different on both sides of the Atlantic. In nineteenth-century Europe—especially in Germany, where the historical profession enjoyed unparalleled cultural prestige—the function of historical scholarship was to provide a narrative of the nation in its uniqueness and, often, superiority. In Germany, national exceptionalism was constituted, by Herder and the Romantics, in terms of language. Until 1848, German nationalism can reliably be characterized as *expressive* nationalism: the desire for national legitimacy and autonomy. After 1848 nationalism became oppressive, representing Germany as the site of authenticity and superiority. Accordingly, the dominant mode of historical scholarship and narrative—the narrative of state- and nation-building exemplified by the Prussian school of Ranke, Droysen, Treitschke, Mommsen, and the early Max Weber—was complemented by an explicitly cultural (and usually non-Prussian) historiography that concentrated on language, religion, and style: Burckhardt, Usener, Lamprecht, Wöllflin, Riegl, Warburg. Toward the end of the nineteenth century, scholars in both the political and cultural areas were under increasing pressure to define their position with regard to the category and the narratives of the nation. With the exception of Trietschke, the historians mentioned above became increasingly critical and self-critical with regard to the conflicting pressures both to reproduce and to criticize the evolutionary narrative of the German nation. This ambivalence is reinforced by terminology. "Cultural History" here is reliably the translation of *Kulturgeschichte*, by which a triumphalist account of a coherent culture's unfolding is usually intended.

Triumphalist accounts did not go internally uncontested. In both political and cultural history, the symbiotic rise of nationalism and normal science encountered internal resistance of great integrity. Thus, in 1879 the Roman historian Theodor

Mommsen fought to preserve a certain pluralistic liberalism against Heinrich von Treitschke, who sought to fix the definition of nationhood by fixing the cultural boundaries of Germanness, which meant most fundamentally that Germans were Christians. Their public clash in Berlin in 1879 became the watershed through which illiberal and neo-liberal currents in history, philosophy, and emerging disciplines such as sociology divided. Of course one can argue that the Mommsen-Treitschke clash is the clash of one triumphalist narrative (liberalism) against another (nationalism). But such a structure is insidiously anti-historical, as Mommsen's liberalism was not the representative of a fixed position but a plea for social justice.

In nineteenth-century France, history had not nearly the cultural and professional prestige and national importance that it did in Germany. The memories of sacred monarchy and of revolution, the cornerstones of French national identity, preceded modern historical narrative. Nonetheless, nineteenth-century French historiography focused on the narrative of the nation, conceived alternatively as the political, revolutionary nation of 1789 or as a cultural nation of a meta-political, quasi-religious character more in tune with the century's repeated royal and religious revivals. French historiography became the theology of revolution, or of counterrevolution. It largely remains in this inconvenient position today.[3] Jules Michelet may be most famously identified apostle of the people; Hippolyte Taine the most famous Cardinal Richelieu of the national memory.

In twentieth-century France, specifically after 1918, everything changes. With the victory in the Great War attributed to the courage of the common man, a neo-Micheletian history of the people was inaugurated that was explicitly anti-German on both political and historiographical grounds. Culturally oriented, the practice of the so-called "Annales" school and its working definition of culture have been local and anthropological in focus rather than, as in Germany, national and aesthetic. The culturalist agenda of the new history was perhaps most thoroughly laid out in Lucien Febvre's 1925 *The Problem of Unbelief in the Sixteenth Century*, in which he argued that atheism was culturally impossible in the early modern world.

In Germany, historiography after 1900 sought to remove itself from the Mommsen-Treitschke, liberalism-nationalism opposition. It did so by making itself more "scientific"; it claimed scientific status by removing its object-worlds of study and its own methods from the contingencies of temporality. Thus history became sociology; the specificity of the historical moment became the ideal type. The largest Luther of this reformation was Max Weber.

After 1918, German historiography had to confront national defeat rather than, as in France, the cultural ambiguities of victory. Thus the fin-de-siècle dichotomy of illiberalism and neo-liberalism remained in place in historians' confrontations with republican history in relation to the Weimar Republic. The illiberal, national exceptionalist voice was discredited following the Nazi period, and the neo-liberal strand achieved dominance as a new social and political history, modeled now on a neo-Weberian social science model reimported from the United States and hence, ironically, hermeneutically impoverished. In the 1970s and 80s, a belated arrival of

Annales methods helped to produce a hybrid and ideologically troubling new social and cultural history, referred to as *Alltagsgeschichte* or the history of everyday life. Under this rubric, the cultural and social history of the Nazi period began to be addressed. But whereas the French mode of the history of everyday life—as begun by Febvre and Marc Bloch and recuperated in the 1960s and 70s by Michel de Certeau and others—sought locality and difference, *Alltagsgeschichte* often easily fell into the trap of taking the Nazi constitution of the German people—the *Volksgemeinschaft*—for granted. The history of everyday life could easily ignore the fact that everyday life was not available to the persecuted. The history of everyday life potentially and functionally served the delusionary wish to escape retroactively from history and from social and political responsibility.

In America, the tropology of the nation is older than in modern Germany and older than one of the two national tropologies of France. But the professions are younger. In the American historical profession—self-designated as such in 1884 on the founding of the American Historical Association with the Mosaic blessing of the near-ninety-year-old Leopold von Ranke—American national exceptionalism could not rest on linguistic distinction, and for this reason cultural history did not take off with the same ideological or professional authority that it had in Germany. The American nation could not be defined as a cultural nation (a *Kulturnation*). The American exceptionalist narrative had to be defined differently. The British, Whiggish model was more appropriate to a national history defined by political and constitutional Prometheanism.

American exceptionalist political history was challenged from the left by social history. Roots of this challenge can be found as early as 1913 in the guise of Charles Beard's milestone *Economic Interpretation of the American Constitution*, which offset the Olympian profile of the Founding Fathers with a portrait of them as a self-interested agrarian elite. As Peter Novick has recounted in his study of the American historical profession, Beard's challenge to the cult of objectivity was succeeded a generation later by that of Carl Becker, the historian of the French Enlightenment (Novick, 1988). But the Second World War regrounded America in an epistemological as well as a political triumphalism. In the 1950s, "objective" grand narrative reigned in America as a stealth narrative of national triumph, just as it had in the 1850s in Prussia. Its most lasting American product was the "Western Civilization" curriculum, with its well known sobriquet "from Plato to NATO." The social and class-based challenge to American historiography took off decisively only in the 1960s, in the context of serious political questioning of American exceptionalism.

The rise and professional authority of cultural history in the United States is an even later phenomenon and the mark of American scholarship's belated and ever controversial internationalization. The dominance of cultural history is, first of all, a product of the 1980s and, equally important, a result of new critical demands brought from within the profession and focused primarily on the psychoanalytic, structuralist, and deconstructive principle of the non-transparency of language and on the Foucauldian principle of mutual imbrication of knowledge and power.

The so-called "new cultural history" in America has been largely imported from Europe by American scholars who have identified intellectually more with European intellectual models than with their teachers at home. The new cultural history has a certain confidence but only marginal institutional success as undergraduate enrollments in history courses and majors are down in general, and European history enrollments are down in particular.

Cultural history as a practice has had continually to renew and revindicate itself to resist the collusion of normal science and dominant ideology. Its challenge has been to chart cultural constructions of identity and meaning through the formation of inhabited particularities defined autonomously from the nation-state: race, religion, and class and, more recently, gender and sexuality. In American society and culture, and in that realm of marketed learning called the university course, the past is of marginal use or interest. To a great extent, we historians must blame ourselves for this predicament, insofar as we have not offered current critical minds valid and vibrant ways to think historically about the past in relation to the present and the future. We have often slipped from grand narrative into antiquarianism. In our allergy to the sins of projection and presentism, we have often been responsible for leading our scholarship and our students into a playground of exoticism. Or we have forged an alliance of exoticism and theoreticism: the aesthetically conceived, mutual mirroring of an obscure archival cluster with a pre-formed theoretical framework. This is the problem with the so-called "new historicism." It is the problem with the widespread application of Foucault without the dimension of the historicization of Foucault himself/itself.[4] Even that aspect of the breaking of the grand narrative known as "Otherness" can often be exposed as a sub-critical exchange of ideology for entertainment: the Pocahontas syndrome. The taming of Otherness is always a scholarly crime, and the past is perhaps the first Radical Other.

Always historicize; historicize your life, your culture, your discipline and your critical practice. Although overhistoricization can be an occupational hazard of historians, in all likelihood they will date and define the "postmodern" as just one historical predicament among others. The question is: Does cultural studies define *itself* contextually and historically? And further, does the cultural studies carnivalesque derive from the assumption that it will itself be defined by the postmodern condition?

In its ascendancy and confidence—and notwithstanding its largely British origins—cultural studies shares the very American conceit wherein the sense of having arrived riding a wave of historical transformation justifies the sense of having been liberated from history altogether. It hasn't exposed the myth of The End of History as an ideological ploy. This is the danger of a certain neo-conservative consumerism to which cultural studies is not immune, in spite of itself. In its zeal to escape from historical determination, cultural studies has proved able to sacrifice the historical dimensions of present cultural reality. Indeed, in its agenda of self-dehistoricization, cultural studies looks to that branch of American social science called media studies in much the same way that American social science looked to

the fin-de-siècle German human sciences. It can easily suffer from the American problem of de-historicization, a syndrome that deliberately confuses itself with its alleged cure of the liberation from the past.

For all its variations and transformations, cultural history remains rooted as a nineteenth-century discipline. At the most banal level, but perhaps the most essential level, it depends on the communication of mind, body, and book. Inescapably, its archives are made of words. In this sense, its own modes of articulation come into contact with the world in pre-technological ways. Moreover, its themes remain the constitution and representation in time of selfhood, community, and society through symbolic practices and constructions of meaning.

History is accused of living in the past, and cultural history—indeed history in general—*is* fundamentally grounded in nineteenth-century attitudes. What then is its validity and necessity for contemporary critical thinking? Why should one listen? If it is the burden of historians to convince audiences in their critical autonomy why they should be interested in the past—their own or other people's—with what kind of historiographic practice should they do so?

Russell Berman has recently characterized cultural studies as "the examination of the symbolic orders in which intersubjective meanings and social practices are constituted and contested" (Berman, 1992: 10). Cultural historians would be unlikely to object to this description as a characterization of their own disciplinary practice. A similar translatability applies to the statement of the three editors of the first Routledge *Cultural Studies* anthology: "Cultural studies is thus committed to the entire range of a society's arts, beliefs, institutions, and communicative practices" (Grossberg, 1992, 4). To this immodest manifesto my German Jewish ancestors would have responded with the expression "Unberufen!": "Uncalled for!" The Yiddish-American analogue might be: "You should live so long."

The motto of globalization entails a risk of cultural and temporal reductionism. How can cultural analysis remain in touch with lived experience? Some principle of cultural specificity still holds, if globalization is not to be reduced to uniformity. This challenge is made harder, not easier, through the new regimes of the posts: post-colonial, post-national, post-textual, and post-subjective. How do these rubrics take lived and temporalized experience into account? How, finally, must one account for the extent to which the post-historical world is historically constituted?

The rubric "post-colonial" must take into account the intricate calibrations of autonomy with colonial legacy and memory. The post-national must take into account its liquid discursive and historical boundaries with the neo-national (Germany) and the never-national (Hong Kong). The "post-colonial" is thus a form of multiple consciousness, if W. E. B. Du Bois's category of double consciousness can validly be intensified. As such, it can be considered very close in meaning to the "multicultural." The multicultural must also be defined—through cultural history and cultural studies—as a form of inhabited, lived consciousness, rather than as a principle of neo-pluralism.

The post-textual is a category that must be used especially carefully, as textu-

ality itself needs to be understood as a level of representational and discursive intricacy rather than a category restricted to words or to what answers to the name of "print-based culture." Textuality marks a level of intricacy (as in "texture") rather than a formal or aesthetic attribute. In this sense, the post-textual doesn't exist at all.

The post-subjective is, to my mind, the most troubling category. "Subjectivity" is that dimension of modernity that allows for the continuing formation of individuality and solidarity, of autonomy and integration. It is not the same thing as "the subject." Indeed it is its corrective, both theoretically and historically. The category of "the subject" (or, perhaps, rather, "The Subject") represents in a "postmodern" perspective that creation of the European Enlightenment and modern Western society that uses the claim to universal reason in an instrumental mode to subjugate those who are politically, socially, and culturally excluded from sharing in its authority. "The subject" is thus exposed as an agent of power and particularism masquerading as one of knowledge and universality. "Subjectivity," however, is constituted as a desire for dialogical knowledge—for knowledge of the self and of the world. The knowledge of self cannot be separated from the knowledge of world, as the self is also "another," if we take modern hermeneutics and psychoanalysis seriously. Constituted (self-constituted) through the desire to balance autonomy and integration, subjectivity is loath to claim a position of power over the object-world, which means mostly over other subjectivities. Historically, subjectivity emerges from early nineteenth-century society and culture, especially civic culture, as a dialogical corrective to the claims of Enlightenment reason and Romantic ego-assertion.

Historically, modern subjectivity emerges as a function of bourgeois individuality (which, as John Stuart Mill argued in *On Liberty* in 1859, is distinct from individualism): the possibility of self-formation, the potential for personhood—they are the promise of modernity. Honest historians will admit that this promise was never fulfilled for most people. But in the shadow of many theorists of modernity, from Kant to Freud to Habermas, we must not confuse the weakness of the promise with its alleged illegitimacy. That promise is precisely the promise of subjectivity, and it is culturally and aesthetically constituted—say in patterns of civility and exchange and in Mozart's operas—as much as it is philosophically and textually constituted in the works of Rousseau, Kant, and Freud. The problem of modernity is not in the agonistic and exquisite evolution of its promise but in the successive and obnoxious claims to have fulfilled it.

Chronologically, the open possibility of self-formation exists in time after the breakdown of traditional status determinations and before the homogenization of human character through mass culture and modern ideologies. Subjectivity inspires and informs the generation of 1848, the generation that defines selfhood and history according to principles of temporality and movement rather than ones of stasis or reaction. Subjectivity is thus virtually synonymous with that form of inhabited life that Baudelaire defined in 1859 as "modernity." Modernity, he wrote in "The Painter of Modern Life," is the fleeting, the transitory, and the contingent,

one side of art, the other side of which is the absolute and the eternal. On the side of stasis and reaction—in space and time—are the European old regimes: the Bourbons till 1789 and again after 1815; the imperial dimensions of Napoleon's control of Europe in between; Metternich's de facto lock on Europe from 1815 till 1848. Against these behemoths, modernity and subjectivity claim ground through networks of civic and bourgeois culture in which modern personal integrity and interpersonal bonds have a chance. After 1848 and the failure of its revolutions, and more so after 1871 and the new lock on Europe exercised by the new German Empire, and by the subsequently intensified industrial capitalist economies, nationalism, and imperialism, the trajectory of modern subjectivity—which is synonymous with ego-inhabited modernity— becomes ever more desperate.

After 1870, the path and potential for the partnered formation of subjectivity and modernity become increasingly restricted due to pressures both political and psychological. The post-1870 political behemoth in Europe is nationalism. Collective and personal self-definition according to national identity becomes a cancer in the delicate corpus of ego-inhabited modernity. Nationalism, national identity, and the very category of identity itself are post-1870 ideological formations that reinvigorate norms of stasis and essentialism and hamper the fragile progress of subjectivity. At its most vicious, identitarian ideology becomes racist as it comes to insist on the nation as a site of purity and authenticity. At this level, the drive to purity conceives of itself as a sacred force of purification against impurity, disease, and perversion. In marking the cluster of nationalism and identitarian ideology as a cancer, I am consciously and aggressively using its own rhetorical weapons against itself. I do so in order to insist—as Karl Kraus wrongly insisted about psychoanalysis—that nationalism and identitarianism are the modern disease posing as the cure for the ills of modernity. In doing so I participate in that attempt to salvage ego-inhabited modernity, which has been called the hermeneutic of suspicion: Marx's critique of liberal ideology, Nietzsche's rage against modern identity options (against nationalism in particular), Freud's reconfiguration of cultural and psychical order, Weber's struggle with legitimate political options and organizations in a modern world characterized by systematization (rationalization) and disenchantment.

These self-historicizing *subjects* (in both senses of the word) of European intellectual and cultural history are also the controversial and indeed often contested theoretical companions of cultural studies. The viewer from the bridge sees through their eyes. The reconstitution of a lived, dialogical subjectivity strikes me as compatible with the ambitions of cultural studies. A notion of subjectivity that is dialogical and historically informed (but not determined) seems fully compatible with the principles of globalization.

Should cultural history and cultural studies be compatible? Or better: can cultural history and cultural studies proceed dialectically to form a syncretic critical practice—not an aesthetic synthesis with a neo-Hegelian aura but rather a multiple critical subjectivity? What would be the genealogy of such a practice?

Having spoken briefly about the centrality and marginality of Max Weber, I want to zero in on this problem of disciplinarity by addressing some of the work of five figures exemplary of different generations and perspectives. The two "founders" will be Max Weber (1864–1920) and Walter Benjamin (1892–1940), both professionally marginal and intellectually central to the passage of the practice of cultural history into the twentieth century, to the formation of a practice of critical history, and hence to the eventual definition of a syncretic discourse of cultural history/cultural studies. In different styles and with different achievements and inhibitions, both thinkers struggled to match a descriptive account of modernity with a normative sketch of adequate subjectivity. Modernity both promises subjective freedom and takes it away; the analytical and political agenda of the scholar becomes, for both thinkers, the adumbration of what we might call, in a term echoing one of D. W. Winnicott's: "good-enough subjectivity."[5] Good-enough subjectivity involves a devotion to the object-world in the manner sketched above; it involves listening to the world. This is the argument and metaphor of Weber's phrase "scholarship as a vocation": knowledge as an answer to the call of the world.

Following the brief treatment of Weber and Benjamin, three recent books will be questioned—studies whose scholarly practice exemplifies the potential syncretism of cultural history and cultural studies. They are Tejaswini Niranjana's *Siting Translation: History, Post-Structuralism, and the Colonial Context* (1992); Russell Berman's *Cultural Studies of Modern Germany: History, Representation, and Nationhood* (1993) and Paul Gilroy's *The Black Atlantic: Modernity and Double Consciousness* (1993).

2. Founders

A generation apart, Max Weber and Walter Benjamin rehistoricized modernity by rejecting the grand triumphalist narratives that their Wilhelmine origins had supplied them. Weber, born in 1864, grew up in the new metropolis of Berlin in the so-called take-off period of the German Empire's first decade and the reign of Wilhelm I; Benjamin's fin-de-siècle "Berlin childhood," as he called it, traversed the years of imperial crisis and hubris that followed the fall of Bismarck and coincided with the reign of Wilhelm II. Weber's mature style evolved through an increasingly critical perspective on Prussian and German nationalism in their heyday; Benjamin's evolved against a backdrop of political and cultural despair of the war and Weimar years. But whereas Weber jettisoned the *content* of the Wilhelminian grand narrative, he only rarely—and only unintentionally—abandoned its form; Benjamin abandoned the form altogether, which proved the more radical move.

Weber and Benjamin's intellectual styles show symptomatic marks both of continuing crisis and generational difference. They both pursued lifelong diagnoses of Western modernity defined by the principle of the disenchantment of the world. Disenchantment is the Weberian master-term for the loss of magical connection with the divine characteristic of modernization and secularization. Benjamin described the process according to the loss of "aura." Both judged this trajectory with agonistic ambivalence for its dialectic of liberation and loss. Predictably, both

located the cultural origins of modernity Germanocentrically in the Reformation and its attendant cracking of a totalizing Christian world view. For Weber, the Protestant Reformation severed, theologically, human life from the divine. It is the moment in the history of Western religion when magic disappears, as in the mystical union of the physical and the metaphysical in the ritual of Holy Communion. The Lutheran and, much more so, the Calvinist revisions in the doctrine of transubstantiation incrementally removed the physical presence of the divine body of Christ from the ritual, thus transforming a magical communion into a symbolic one. This disenchantment temporalizes age-old polarities into processes synonymous with modernization: enthusiasm into routine; charismatic leadership into bureaucratic administration.

As Weber's model recoiled more and more from the grand narrative of modernization as the normative process of state and nation formation, he told a profoundly ambivalent story of a process of rationalization that signified both freedom from traditional constraints and imprisonment in modernity's new "iron cage." If the optimism of the Hegelian grand narrative was gone, however, its form remained in place. History was still defined according to a linear grand narrative. Protestantism, in particular Calvinism, produced the emotional need for the proof of salvation, and the attendant emotional investment in material wealth as a sign of grace; the Protestant ethic created, unintentionally, the spirit of capitalism. The rationalization of capitalist enterprise separated economic motivation from popular religious desire. This new ungrounded, mechanized economy of desire formed, for Weber, its own iron cage. Just as Weber could find no way out of the grand narrative, he could find no way out of the iron cage. What he craved was the modern provision of subjectivity—what he called the sense of vocation, with its neo-religious aura. He recognized this potential in the restricted spheres of scholarship (*Wissenschaft*) and politics.

As a self-designated economic historian, Weber served the interests of Prussia and the German Empire in the 1890s, principally through his nationalistic engagement with the so-called East Elbian question, which was generated by his fear of the loss of Germanness to Polish inhabitants. As a self-designated historical sociologist he established the principles of that new discipline after 1908; as a political theorist he embarked on the constitutional formation of the Weimar Republic in 1919, an enterprise which suffered badly as a result of his sudden death in 1920. His art of historical sociology entails a Hegelian sweep through world civilization. His basic theme is the process of rationalization, i.e. the systematization of the world that arises with secularization. In his later years, his sense of history modulates from an evolutionary one to a comparativist one. Thus in the preface to *The Protestant Ethic and the Spirit of Capitalism*, written in 1920, almost two decades after the initiation of the project, he states his subject to be the "peculiarity" of Western rationalism in the context of other, alternatively systematized cultures.

For the intricate evolution and variability of its argument, *The Protestant Ethic* endures as Weber's most explosive and most penetrating work. The depth of its

116 analytical insight accompanies the degree of personal commitment. Weber conceived the argument in the shadow of mental illness in the late 1890s and reconfigured it repeatedly up until shortly before his death. Since his death the work has been depended on and criticized with virtual obsession by critical and historical scholars of Western modernity. The perplexity it engenders has to do with the uneasy fact that its most profound aspects are also its most symptomatic. It seems to show that both modernity *and its representation* require the reinvention of subjectivity.

What Weber did only symptomatically, Benjamin did more purposively. The Benjaminian analogue to *The Protestant Ethic* is *The Origin of German Tragic Drama*, completed in 1928. It is a history of the symptoms and performativity of cultural fragmentation disguised as a history of a literary form. In this work, Benjamin broke out of grand narratives. For him, the cultural schisms of the Reformation defined modernity in terms of rupture and fragmentation. Whereas Weber saw the cultural impact of the Reformation according to a gradualist, functionalist reordering of desire and behavior, Benjamin saw a general explosion and crisis. In this crisis, the northern German baroque is seen according to a literalized acting out of post-traumatic loss. Tragic drama (more accurately "mourning plays" [*Trauerspiel*]) is the frame for this practice.

There are two historical paradoxes here, which Benjamin recognizes immediately. First, northern German Protestantism is anti-theatrical, as the ideology of theatricality conjures the *teatrum mundi* of totalizing Catholicism. So these ritual mourning plays are immediately a kind of transgressive genre. Second, Benjamin's analysis parallels Freud's distinction between mourning as a recovery of the ego versus melancholy as a pattern of neurotic repetition of the loss of selfhood. The mourning play, in Benjamin's analysis, in fact produces melancholy. Melancholy, personified for the early modern era in the figure of Hamlet, becomes the modern inability to produce coherent action (to produce a politics). For this reason alone, modernity becomes a series of jolts, crises, and repetitions. Shock replaces progress.

Benjamin's sense of the historical record radically alters the available and legitimate structures of historical knowledge. Thus his historical imagination and practice are themselves informed by principles of rupture, montage, allegory, and what he calls the dialectical image. Rather than arguing for a linear narrative by which the origins of modernity in the sixteenth century produced or determined the structure of experience in the nineteenth and twentieth centuries, Benjamin argues for the dialectical correspondence between epochs as something to be recaptured by the historian. This restored, recreated correspondence creates a way out of the fragmented world and thus serves potentially as an agent of political as well as cognitive freedom. The politics of historical knowledge emerge as the will to work through the dynamics of historical, ideological repetition and repetition compulsion analytically.

Benjamin's conception of historical consciousness is thus radically new and decisive in its applicability to the post-modern resistance to totalization and grand

narrative. The ability to look incisively at cultural practice requires a degree of personal peace—what Weber's contemporary Aby Warburg called *Denkraum*: literally, the space for reflection. Weber, notwithstanding his enormous productivity, never achieved such a condition, to a degree because he was trapped in the iron cage of ideological reproduction. He stuck to evolutionary narratives, and projected modernity's ruptures only symptomatically. This occurred most obviously in his mental breakdown of 1896, but perhaps more importantly in his constant tampering with *The Protestant Ethic*, a work ultimately even more significant for its aporias than for its argument. Benjamin, on the other hand, developed a practice and a series of analytical, rhetorical instruments that enabled him to confront modernity without duplicating its ideological aspects and without being limited to the symptomatic as the only symbolic and expressive vocabulary correlative to the ruptures of modernity.

Walter Benjamin's modernity is Weberian; his methods of analysis are post-Weberian. Cultural history today, in its potential dialogue with cultural studies, is thus post-Weberian and post-Benjaminian. The cultural and intellectual moves these two thinkers represent are fundamental to the evolution of Western and global modernities. Weber and Benjamin embody the making of the kind of analytical subjectivity required for the practice of cultural history and cultural studies.

There are at least two arguments for the necessity of knowing Weber and Benjamin. A weak argument holds that their thinking represents key volitional and symptomatic intellection characteristic of modernity. You don't have to know them, but you have to know this kind of intellection, and knowledge of these cases will cut your reaction time in the identification and understanding of others. The strong argument is the one that places these thinkers and their texts as historical increments and actors in the discursive formation of modernity and post-modernity—not only in the "West" but wherever the categories are at all meaningful. Therefore you have to know them, period.

More accurately, you must be able to understand their voices. Benjamin's voice, in particular, is anticipatory of much of the logic of cultural studies. It rejects the ideological and professional logic of historical understanding while insisting on its political necessity. The post-historical world is historically constituted. You will perhaps recognize the following passage from Benjamin's last known work, the "Theses on the Philosophy of History" of 1940:

> To articulate the past historically does not mean to recognize it "the way it really was" (Ranke). It means to seize hold of a memory as it flashes up at a moment of danger. Historical materialism wishes to retain that image of the past which unexpectedly appears to man singled out by history at a moment of danger. The danger affects both the content of the tradition and its receivers. The same threat hangs over both: that of becoming a tool of the ruling classes. In every era the attempt must be made anew to wrest tradition away from a conformism that is about to overpower it. The Messiah comes not only as the redeemer, he comes as the subduer of the Antichrist. Only that his-

torian will have the gift of fanning the spark of hope in the past who is firmly convinced that *even the dead* will not be safe from the enemy if he wins. And this enemy has not ceased to be victorious.

3. Readers

In *Siting Translation: History, Post-Structuralism, and the Colonial Context,* Tejaswini Niranjana argues for a connection between a newly troped category of translation and a practice of radical historiography. Translation and historiography produce similar patterns of disruption and dislocation. The figure who explicitly provides her with this connection between translation and radical history is Walter Benjamin. She argues: "in Benjamin's later work the task of the translator becomes the task of the historical materialist or the critical historian" (114). Alternately: "Benjamin's practice as a translator seems to have led to his practice of radical historiography" (146). The latter practice is suggested by the citation I placed above. The former is most clearly articulated in the 1921 essay "The Task of the Translator," written both as an autonomous meditation and as an introductory essay to Benjamin's own translations into German of Baudelaire's *Tableaux Parisiens.*

Translation, for Benjamin, is the creation of something new. It is not a simple service intended for the reader. It creates a new way of living for a text. It is thus an extension of life into history. It is a dimension of the afterlife of a text. It makes something dead survive into history. Translation is a form of history as remembrance. It is precisely not a form of commemoration (which appropriates the past and imposes closure on it) but, much more aggressively, a dialectical relation that jolts something dead into present life and thereby also transforms the present moment. For this reason, translation is a form of radical historiography. Translation and historiography are disruptive of the past, the present, and the relation between them. It is the transcription of something Other—of which past-ness is a prime example—into a position of mutuality with the present.

All this rejects the conventional view of translation, history, and commemoration, and indeed of knowledge and language. "Conventionally," Niranjana suggests, "translation depends on the Western philosophical notions of reality, representation, and knowledge. Reality is seen as something unproblematic, 'out there'; knowledge involves a representation of this reality; and representation provides direct, unmediated access to a transparent reality" (2). This is exactly the ideology of objectivity I rehearsed at the beginning of this essay. Thus, the normal science of translation claims transparency in the secret interest of an agenda of appropriation: "Translation thus produces strategies of containment" (3). Moreover, "[i]n creating coherent and transparent texts and subjects, translation participates—across a range of discourses—in the *fixing* of colonized cultures, making them seem static and unchanging rather than historically constructed" (3). Such is precisely the fallacy of historical understanding that denies subjectivity and temporality to its subjects of analysis.

Niranjana pursues an ironic agenda of reading Benjamin through more contemporary critics while chastising them for not reading him properly. For literary

theorists who have made Benjamin a mascot of intricate reading in general and of deconstructive reading in particular (and this means, first, Paul de Man), Benjamin's sense of translation is a founding moment. Nevertheless, as Niranjana points out, neither de Man nor Jacques Derrida recognizes the function of Benjamin's concept of translation for his historiographical project. She asserts: "The refusal of these major proponents of deconstruction to address the question of history in Benjamin suggests a critical drawback in their theory and perhaps indicates why deconstruction has never addressed the problem of colonialism" (5). A stronger question is why some deconstruction has resisted the question and the demands of history and, in that process, has performed the cruelly ironic transformation of Walter Benjamin, one of the century's most decisive historical thinkers, into an a- or even anti-historical voice. There is no reason for a- or anti-historicality to be conceived as endemic to deconstructive projects, but why it is so apparently strong an occupational hazard is a fair question.

In her last chapter, called "Translation as Disruption," Niranjana turns explicitly to the discursive construction of post-coloniality. She cites Charles Trevelyan's *On the Education of the People of India* (1838) for its program to civilize and educate the "Hindoo" through the teaching of English. But she warns immediately against the temptation of nativism and nationalism as the reflexive responses to colonialism: "In the interests of constructing a unified national identity that will challenge colonial domination, the discourse of nationalism suppresses marginal and non-elite peoples and struggles" (166). It suppresses as well the possibility of intricate subjectivity. In the choices available for the making of post-coloniality, what holds here for post-British India holds as well for post-Napoleonic Germany, post-Austrian Italy, and post-Civil War American society.

The problem is that the production of nativism and/or nationalism, indeed the production of a politics of identity, reproduces the ideological apparatus of the (former) colonizer. Arguing for the avoidance of both old and new nationalisms and nativisms, Niranjana initiates a literal and metaphoric "practice of translation that is speculative, provisional, and interventionist" (173). She provides three translations of a twelfth-century South Indian sacred poem (*vacana*). The first translation Christianizes; the second one adopts the tone of "post-Romantic New Criticism" (180). The translation she advocates resists strategies of containing the original, by allowing the practice of translation precisely to be "claimed" by the "instability of the 'original,' which can be meticulously uncovered through the practice of translation" (186). The purpose of such post-colonial, non-appropriative practice, as Niranjana says in her book's last sentence is to bring history to legibility.

The need, in cultural history and cultural studies, is to have an ear for history: an ear that imposes and self-imposes stringent self-consciousness in the marking of the boundary between discovery and appropriation. This ear needs also to negotiate the resonances of language in the relation to cultural experience. The challenge increases for the comparativist or for the scholar working in learned languages. In this context, Niranjana's own ear occasionally slips when she alludes to Benjamin, because she may not adequately know—and indeed does not ever

120 claim to know, or have an ear for—the German linguistic and cultural context. Thus, in a sequence of citation to which I am of course adding, Niranjana approvingly cites an observation of Homi Bhabha's on a passage from Walter Benjamin. Niranjana writes: "It might be useful to remember here Walter Benjamin's remark that 'the state of emergency in which we live is not the exception but the rule. We must attain to a concept of history that is in keeping with this insight,' as also Bhabha's suggestion that 'the state of emergency is also always a state of *emergence*'" (168).[6] Niranjana thus sanctions Bhabha's elision into a single cluster that Niranjana goes on to refer to as "the state of emergency/emergence." But "the state of emergency" in Benjamin's writing is *itself* a citation, which is not being accounted for here. It is a vexed and fundamentally disapproving citation from the conservative Catholic political theorist Carl Schmitt, for whom the state of emergency was the condition to be declared rhetorically and seized politically and militarily by a dictator. The ideology of the state of emergency guided Schmitt to support National Socialism in 1933. This context makes it highly problematic to merge the trope of "the state of emergency" and its connotation of fascist power with "the state of emergence" and its normative reference to post-colonial subjectivity. In Benjamin's context, the "state of emergency," which is a fascist principle, is exactly what forecloses on any possible "state of emergence" of an oppressed group—the obvious example being that of the Jews. At the very least, the fascist context of Benjamin's allusion invalidates the claim that emergency *always* coincide with emergence. The play of "emergency" and "emergence" is thus a symptom of the reduction of history, which happens, among other places, in language, to a play of language alone that works to deny the materiality of historical experience.

I turn now to a brief discussion of a recent collection of essays in which Russell Berman—who knows Weber and Benjamin well—deliberately combines cultural studies and cultural history. His title is *Cultural Studies of Modern Germany: History, Representation, and Nationhood*; modern Germany covers the two centuries from the enlightenment to the present. His analysis is historical, even when he deals with the present. In his critical approach, his readings carry a presentist urgency. Berman thus makes a persuasive case for the uses and advantages of cultural studies combined with cultural history.

The eleven essays juxtapose the panoptics of current practices in cultural studies with the historically self-conscious cultural criticism of the Frankfurt School. Topically, Berman examines cases and general problems in literature, criticism, painting, film, and television. Temporally, he covers ground from Heine and Moritz Oppenheim to Nolde, Pabst, Böll, Handke, to the politics of deconstruction and to the Gulf War, the last viewed as the first foreign policy crisis of a reunited Germany. Unlike Niranjana, who wants to correct deconstruction's failure to address colonialism through an internal, sympathetic correction of its weak sense of history, Berman is more damning of the enterprise in general, for the same reason. The results are problematic in his case as well.

Berman characterizes cultural studies as "the examination of the symbolic orders in which intersubjective meanings and social practices are constituted and

contested" (10). Its "overriding concern" is "with the construction of collective identities precisely as such identities are modulated by difference and particularity." In modern Germany, cultural history and cultural studies can examine past and present through a common prism, refracting into particularities and multiplicities a complicated cultural field that has often been, and continues to be, ideologically constituted as a totality, as a coherent nation. Cultural studies thus keeps cultural history honest by beginning with the assumption of fragmentation and multiplicity as the first reality principles of modernity. But here, Berman and cultural studies alike stop short. The template of multiplicity begs the question: a multiplicity of what? Should we not avoid the slippage into the multiplicity of fixed, parochial identities, reduced to what Charles Taylor has called "the politics of recognition," duplicating the very essentialist fallacy of an official, overriding identity, national or other?

Berman's prose betrays a certain nervousness about his own voice, the voice of "the intellectual," whose politics causes him to draw himself out of his own picture. If "the intellectual" necessarily adopts a colonializing posture of analysis and totalization, then what must go, totalization or the "intellectual" himself? Here, cultural history can keep cultural studies honest. Cultural history is intrinsically able, and indeed intrinsically obliged, to historicize its own voice along with its objects of analysis. It thus speaks of and from categories of the modern and the postmodern with a degree of distance. Cultural studies, however, for the most part assumes that its voice and prerogatives are defined by and as postmodern. Its voice is more trapped, less open to the formation of subjectivity. In his introduction, called "Marking Time," Berman separates his voice from the reactionary declaration of the end of history, but he does not historicize the post-modern. He assumes that the only valid discourse is a post-discourse, as that is the only way out of the hegemonics of the intellectual. This leaves him, and us, in the uncomfortable position of having raced off the modernist cliff and being now suspended in mid-air, arms flapping like a Disney character. Such are the nerves of literary criticism, aggravated all the more so by its own politically questionable devotion to aesthetic objects. It takes refuge in the rediscovery of identities. The move from "identity" to "identities" is not ambitious enough, as it does not heed Niranjana's warning to avoid the reproduction of colonial ideology through the reproduction of new nationalist and nativist positions.

Berman's discussion of the painter Moritz Oppenheim offers a rich and fascinating analysis of cultural identity, authenticity, and representation. Berman reads the painting "Return of the Volunteer from the Wars of Liberation to His Family Still Living in Accordance with Old Customs," in versions of 1834 and 1880 with their attendant historically and ideologically encoded representational differences. This is also a kind of reading as translation: from image to image, from image to word. The successive images' subject is a soldier reintegrated into his family's house, table, and ritual culture—into a Jewish home that is also a nationalist home, proud of the soldier's achievements and their inscription of participation in the nation. The picture displays and argues, in Berman's words, the commitment to

"civil rights and an identity that can be simultaneously German and Jewish" (57). The returning soldier sits at the Sabbath table surrounded by an adoring family, who lean toward, gaze upon, and embrace both him and his new repertoire of symbols, including the Iron Cross on his chest—the ultimate symbol of German nation and Jewish assimilation. Crucial to Berman's analysis is the tension between Jewish tradition and nationalist desire. He assumes the latter, assimilationist imperative to be symbolically victorious in the painting, as he is sure that the represented moment takes place on the Sabbath and thus depicts an interruption of ritual life. The ritual table is indeed set with Sabbath props. Here Berman's assumptions may be hasty, as the scene might just as well be taking place on Friday afternoon, in time for the full ritual celebration that would begin at dusk. The soldier may have transgressed by returning home on the day of the Sabbath (when traditional observance forbids travel), or, indeed, he may have returned just in time, in a triumphant display of the two worlds' compatibility. In the 1880 grisaille of the painting, widely distributed in photographs, the soldier's bandaged hand has been augmented into a full arm in a sling, and his eyes are focused on his mother rather than fixed in contemplation of an externality (possibly the war he has left). Provocatively and convincingly, Berman works these representational changes into the picture's formal confrontation with the anti-Semitic tropes of the feminization and weakness of the Jews.

But the very act of visual representation can be deemed transgressive in a Jewish context, the context of the *Bilderverbot*. The painting, Berman argues, thus necessarily assumes an iconic status, where the formal terms of the celebration of cultural hybridity already betray the justice of its promise. The icon *is* the staticization of culture, the bearer of the drive to conversion. The gaze of the returning soldier's father is caught between his prayer book and his son's Iron Cross—between the word, narrative, and history, and the image, synchrony, and cultural resolution—the end of history. The word and the Jew both lose, as the painting itself claims priority for visual representation. The painting itself turns the Jew into an object. The Oppenheim essay ends heroically, with the desire for the analyst's own prose to rehistoricize and thus resubjectify the represented object-world: "For the diachronic narrative of progress, which is initially, as narrative, a literary undertaking, comes to encounter synchronic structures, visual representation and the world of sight, and it renders them historical. It is in that historical space that the community engages in its self-construction" (72).

In the Introduction, Berman suggests, provocatively and accurately, that "multiculturalism and Reaganomics are two simultaneous institutionalizations of difference" (5). A meaningful difference between the two requires the distinction to be made between cultural difference as a matter of multiple subjectivities or as collective objectification. Berman allows no such latitude to his other, much cruder alleged analogue to Reaganism, and that is deconstruction. "The doctrine of the free-floating signifier is the transubstantiation of the Teflon presidency: beyond good and evil, beyond logocentrism, and beyond congressional subpoena" (107). Here we have the world according to the *New York Times* and its precious Michiko

Kakutani; only the prose has been changed. I sympathize with Berman when he claims that the institutional politics of deconstruction in the 1980s involved a conservative guarding of turf, and when he claims, not originally, that the acolytes' defense of Paul de Man following the revelation of his anti-Semitic wartime journalism was often ill-conceived and occasionally perverse. But this does not justify the claim that "the only revolution [deconstruction] imagines is the revolution in the literary text" (106) and, in turn, the grounding of this claim in the assertion that "to privilege language means to marginalize other dimensions of existence" (108). What has happened in this condemnation to the "refusal to abandon" the word? The deconstructive equation of world with text involves the investment and enlargement of the text with worldly dimensions, and not, precisely, the reduction of the world to word. Deconstruction's investment of life in the word can be credited with origins in Jerusalem and Berlin as well as in Antwerp and New Haven. Berman somehow accepts this to a point, as his anti-deconstructive Jeremiad is followed by a classically deconstructive reading of Pabst's 1931 film *Kameradschaft*.

What Berman dubs the "*Gretchfrage* of deconstructive criticism" is also his own: "Wie steht es mit der Politik?"—"what's the politics?" (44). He thus concludes with an essay on "The Gulf War and Critical Theory." The Gulf War as home entertainment was created by the culture industry, and the new scholarship of popular culture was so invested in the idea of the subjective autonomy of the consumer that it failed, or refused, to recognize the pernicious CNN-ing of America—and Germany. Those who objected to the Gulf War but liked popular culture on principle had to disaggregate popular opinion from popular culture. Who is at fault, and whose pieties need to be exposed in order to assign fault? The pieties of some cultural studies decry the alleged scapegoating of organs of popular culture—television above all. A critical theory of culture must, first of all, avoid the fetishization of cultural products, which must include popular culture. Berman concludes by equating the ethical agenda of cultural studies with the need to reform social action on the basis of newly found and articulated collective values (200). Thus the intellectual and political legitimacy of cultural studies will derive from its attention to action rather than to identity: to accounts—and accountability—rather than to images.

In *The Black Atlantic: Modernity and Double Consciousness*, Paul Gilroy charts an intellectual history of *lived* multiculturalism. The black culture he analyzes is local, African, and European. Gilroy's own reading, following W. E. B. DuBois's trope of double consciousness, must then be both Afrocentric and Eurocentric.

On the way to locating in cultural hybridity a "counter-culture of modernity," Gilroy begins by arguing for the disruption of the Hegelian master-slave dialectic. He reconsiders the master narrative of modernity, with its story of enlightenment and progress, by advocating its alternative historicization according to the vantage point of the slave rather than that of the master. If the European Enlightenment is, as Lyotard and others have argued, the rhetoric of the master claiming to be the voice of universal reason, then such an act of counter-identification may allow an

124 important disruption in the history of ideology. Gilroy finds examples of such disruption in Frederick Douglass as well as in Nietzsche and Walter Benjamin.

> Although Benjamin was not attuned to the possibility that modern history could be seen as fractured along the axis that separates European masters and mistresses from their African slaves, there are elements of his thinking, particularly those which derive from his relationship to Jewish mysticism, which make it a valuable resource for my own critique. The time has come for the primal history of modernity to be reconstructed from the slaves' point of view. (55)

Gilroy's unfolding narrative makes it immediately clear just how high the stakes of identification with slave subjectivity can be. He recounts the case of the former slave Margaret Garner's 1856 act of infanticide—the historical basis for Toni Morrison's novel *Beloved*. Garner, a fugitive along with her family, killed her three-year-old daughter and attempted to kill her other three children at the moment of apprehension by slave catchers in Ohio. Gilroy refers to her act of murder as an "emancipatory assault" (66), thereby at least honoring, and possibly approving fully, of her act. Gilroy refers to the traditions and aesthetics through which such stories are told as a "hermeneutics of memory" (71). Having mentioned several times the diasporic parallels between African and Jewish memories, he might have mentioned the Masada story as the prime Jewish correlative to this lived and narrated collective trauma of salvation through murder. The Masada story is narrated as a mass suicide. But it involves, of course, a mass infanticide. One must wonder, I think, if infanticide can be subsumed by a story of suicide without enacting a regression to at least one inflection of the standard master-slave dialectic, i.e. the subjugation of children by adults.

Gilroy does not question the heroism of Garner's act. Neither, it might be added, does he explicitly advocate identification with it. To his and our relief, diasporic experience offers more welcoming models and stories. Abruptly, he turns in the following chapter to the relatively neglected cultural dimension of music. Music is a privileged signifier of authenticity. Specifically, "slave music is signalled in its special position of privileged signifier of black authenticity" (91).

> Music and its rituals can be used to create a model whereby identity can be understood neither as a fixed essence nor as a vague and utterly contingent construction to be invented by the will and whim of aesthetes, symbolists, and language gamers. Black identity is not simply a social and political category to be used or abandoned according to the extent to which the rhetoric that supports and legitimizes it is persuasive or institutionally powerful. Whatever the radical constructionists may say, it is lived as a coherent (if not always stable) experiential sense of self. Though it is often felt to be natural and spontaneous, it remains the outcome of practical activity: language, gesture, bodily significations, desires....
>
> These significations can be condensed in the process of musical performance.... (102)

The material as well as experiential history of contemporary black music and musical culture must engage the phenomena of technology and consumption.

Gilroy argues that racial (identity) politics have subverted the commodity-fetish and transformed object into event. We might call this process, as analyzed and, implicitly, valorized by Gilroy the supplementarity of authenticity.

What Gilroy sketches here is a model for a fluid but coherent identity expressed in music. He does not take the time to historicize his treatment of musical culture to the point of developing a model capable of incorporating the aesthetic—here, the musical—as a mode of identity-*creation*. He does signal in that direction, in the following chapter, with the statement that music's self-liberation from the status of commodity effects the "reconciliation of art and life," thereby becoming the "favored vehicle for communal self-development" (124). Neither does he locate black musical experience in a pre-technological context. (This latter approach would have its pitfalls, first among them the potential romanticization of a "primitive" mode of culture.) He is interested in authenticity, but in an authenticity that moves. Such movement gives the subversive ability to outwit commodification and colonialization in its various forms. This is a cheerful story, possibly even a redemptive one, and I suppose it's fair to say that you have to hear it to believe it.

Gilroy's discussion of music as a discourse of self- and community-building has rich analogues in other traditions, including the northern German musical culture initiated by J. S. Bach. This is the field addressed by much of my own writing about music as a form of aesthetic, cognitive, and cultural experience that is a central, if relatively neglected, dimension in the history of European modernity. It is thus remarkable that music is omitted from Gilroy's central chapter, which hinges on W. E. B. Du Bois and the founding metaphor of double consciousness. Double consciousness signals the dialectics of black and white; authentic and modern(ized); African (including diasporic Africanness) and European, particularly Germany. For Du Bois, double consciousness distills into black Americanness and black Africanness in the double confrontation with Germany.

Germany, for Du Bois, means nationalism; Germany and nationalism mean Bismarck. Behind Bismarck are Hegel and Heinrich von Treitschke, whose lectures Du Bois attended in Berlin. The young Max Weber attended these lectures as well; indeed it is not spurious to call Du Bois the Max Weber of African-American modernity. Both reconfigured the option of nationalism.

Nationalism can perhaps be described as an essentializing politics of location. It is significant that Du Bois's European models are Hegel, Treitschke, and Bismarck, whereas, a generation later, Richard Wright's principal European models are Kierkegaard and Husserl. In them, Gilroy suggests, Wright found "a standpoint of dislocation associated with black experiences of modernity" (160). The passage from Du Bois to Wright, from the cluster Hegel/Bismarck/Treitschke to Kierkegaard/Husserl, is thus the passage from a politics of location to a politics of dislocation. Gilroy doesn't ask, but his readers should, whether the word "folk" in Du Bois's landmark title "Souls of Black Folk" contains the desire for cultural imitation of the more fully formed and asserted collectivity of the German "Volk." In other words, how, if at all, does a term of expressive identity and expressive nationalism become a term of oppressive identity and oppressive nationalism?

Gilroy asks "What would it mean to read Wright intertextually with Genet, Beauvoir, Sartre, and the other Parisians with whom he was in dialogue?" (186). Such an approach, which Gilroy advocates but doesn't (here; yet) enact, would dismantle the "boundaries of nationality and ethnicity" within which "historians of ideas and movements have generally preferred to stay." Gilroy assumes that the traversal of boundaries leads "from the particular to the general." This is not necessarily the case. It can also be shown to lead from one particularity to other particularities. This is precisely the thrust, for example, of Walter Benjamin's allegorical conception of history. It is also the thrust of the kind of intertextuality that would bind Wright to his French interlocutors.

Richard Wright's own double consciousness inspires one of Gilroy's most stunning passages:

> Wright's relationship to the work of Heidegger, Husserl, Kierkegaard, and Nietzsche was more complex than many critics seem to appreciate. It is worth repeating that he was not straining to validate African-American experience in their European terms but rather demonstrating how the everyday experience of blacks in the United States enabled them to see with a special clarity of vision—a dreadful objectivity—the same constellation of problems which these existentialist authors had identified in more exalted settings (171).

These remarks about the everyday life and dreadful objectivity of American blacks are equally applicable and valuable for the context of European Jews. In both cases, confrontation with the dominant culture that is *both* of the self and of the Other cannot be understood in terms of "assimilation" or loss.

Gilroy concludes with a discussion of the shared tropes of black and Jewish histories, internal patterns of solidarity and schisms, and possibilities for mutual identification. The notion of diasporic culture draws the two cultures together. The convergence of diaspora and modernity points to an ultimate trauma in each culture: black slavery and the Holocaust. Mutual identification demands responsibility, and Gilroy is worried about tendencies current in "internal" Jewish and black discourses. He is concerned with Jewish tendencies to ignore black slavery and diaspora in discussions of "non-national nations" (213). And he is worried by the tendency of black thinkers and figures of popular culture to identify with the glamour of the Pharaohs rather than with the plight of the Hebrew slaves (205ff). His model for a production identification is the St. Thomas born black intellectual Edward Wilmot Blyden, who grew up among the indigenous Jewish community, learned Hebrew, and wrote of the shared historical experiences of blacks and Jews (210).

With this discussion, Gilroy moves implicitly from a discussion of identity to a normative discussion of patterns of identification. A vocabulary of "identification" places a phenomenological dimension, ala Ricoeur, at the center of the question of identity. It evokes a formative process whereby self, other, and self-as-other are in constant negotiation. Now, the term identification can be used without the assumption of such a phenomenological dimension. But I am not invoking it in such a sense. I am not invoking it in the sense of Karl Lueger's "Wer Jude ist, bestimme ich" ("I determine who is a Jew") but in John F. Kennedy's sense of "Ich bin

ein [sic] Berliner" ("I am a Berliner"). Identification, produced from and by the self, signals the augmentation of the self.

Gilroy's general model of the black Atlantic and of double consciousness proves capacious, generous, and also demanding in advocating certain general and specific trajectories for black identification. In general identification thus incorporates self-identification with patterns of cultural and historical affinity. Gilroy advocates multiple consciousness. He is suspicious of the discourse of Afrocentricity because it is parochial. It is parochial not in its Africanness but in its Americanness: "what is known as Afrocentricity might be more properly called Americocentricity" (191). Early European Zionism, one might add, reveals a similar dynamic. Theodor Herzl's idea of the Jewish state, as I have suggested elsewhere, was an imagined community in which Austrian Jews could live their lives as good Austrians.[7]

On a more specific level, Gilroy wants black identification to mark affinity with the Hebrew slaves rather than the Egyptian pharaohs. Similarly, he wants Jewish-identified discussions of modernity and the Holocaust to take modern African slavery into account. To do this, he carefully points out, in no way compromises the position of the uniqueness of the Nazi Holocaust, a position Gilroy explicitly accepts (213). Although he does not raise the category of identification to autonomous, normative status, it contains the core of the book's normative cultural argument. Double consciousness—or multiple consciousness, in the phrase I am using to increase the stakes—accrues through deliberate and deliberated processes of identification. The examples of positive and negative patterns of mutual identification among blacks and Jews all point in this direction.

The syncretism of cultural history and cultural studies for which I have been pleading would advance the understanding of modern subjectivities as instantiations of multiple consciousness. Multiplicity does not contradict coherence. Multiplicity accrues through connections and relations in time and in space. Multiple consciousness is the most valid form of multiculturalism. Coloniality and post-coloniality; Europeanness and Africanness; Germanness and Jewishness; Englishness and Indianness—all are instances of such lived multiplicity that the student of cultural experience has the duty to recognize. What Tejaswini Niranjana says about coloniality holds for the post-colonial as well: "[J]ust as translation is overdetermined, so is the 'subject' under colonialism, overdetermined in the sense that it is produced by multiple discourses on multiple sites, and gives rise to a multiplicity of practices" (32). The hope of and for post-coloniality, I would add, is the realization and practice of modes of sustained multiplicity and overdetermination without the burdens of hegemony and ideology. The normativity of continued post-colonial development will rest in the recognition and liberation of complicated, evolving subjectivities. This normativity has an analogue and an ally in the recognition of complicated subjectivities that existed in the past. Disruptive history is thus *accurate* history. The post-historical world is historically constituted; the desire of disruptive history is to politicize both the past and the present while serving them both truthfully.

128 **Notes**

1 Early versions of parts of this essay were given at the conference "Internationalizing Cultural Studies" at the East-West Center, University of Hawaii, in December 1994, and at the symposium "Identity: Who Needs It?" at the Internationales Forschungszentrum Kulturwissenschaften, Vienna, in May 1995. A penultimate version was discussed by the workshop in the history of the human sciences at the University of Chicago in November 1995. I am very grateful for the comments and criticisms I received on these occasions.
The lyric from the opening of Act II of *Oklahoma!* that I cite reads, precisely:
"The farmer and the cowman should be friends.
Oh, the farmer and the cowman should be friends.
One man likes to push a plow,
The other likes to chase a cow,
But that's no reason why they cain't be friends." (Hammerstein, 1942: 85)

2 Rendering this polemic more specific does not involve, I believe, identifying individual scholars as heroes or villains. Thus, when Catherine Hall says that "a lot of cultural studies is saying" something—in this case, incidentally, that cultural history and cultural studies are incompatible, a position she and I deplore—she is not identifying particular people but rather a certain *dimension* of the project as a whole, which she wants to see corrected (Hall, 1992: 272).

3 Steven L. Kaplan has recently analyzed the ideological battles and repetitions in French historiography in the context of the bicentennial commemorations of the French Revolution (Kaplan, 1995).

4 It would be too tangential to develop responsibly what I have in mind by the historicization of Foucault. In any case, I am just beginning to think about this problem. What it would involve is an investigation of the symptomaticity of Foucault's thinking with regard to the culture of secular French Catholicism: a dimension of twentieth-century French thought, especially with regard to Foucault and Lacan, which intellectual historians and theorists have not adequately explored. Foucault's subversiveness involves the disruption of the society of surveillance, that cluster of power and knowledge with which modernity internalizes the earlier totalizing mode of spectacle. This analysis is in itself a crucial contribution to cultural and political theory and history, even if it does not choose to historicize itself. But the lack of self-historicization, in Foucault and in much of the theoretical work that remains his legacy, does suffer from insufficient self-questioning. One result of this lack is the tendency to confuse performance and performativity, in other words to confuse a kind of repetition of (French, Catholic) theatricality with its critique.

5 Winnicott's term is the "good-enough mother," which he develops in his 1953 paper "Transitional Objects and Transitional Phenomena," in *Playing and Reality* (Winnicott, 1953). The good-enough mother "is one who makes active adaptation to the infant's needs, and active adaptation that gradually lessens, according to the infant's growing ability to account for failure of adaptation and to tolerate the results of frustration…. [S]uccess in infant care depends on the fact of devotion, not on cleverness or intellectual enlightenment." (10) The good-enough mother's devotion parallels that of the Weberian scholar: success is bonded to the necessary expectation of failure over time. Nevertheless, and most importantly, the quality of "good-enough" is more ambitious than "good" because it is more authentic, holding a more profound and responsible reality principle. It implies adequacy rather than performance; a giving of devotion rather than a demand for recognition.

6 The passage of Homi Bhabha's cited by Niranjana is in his forward to the 1986 English edition of Frantz Fanon's *Black Skin, White Masks*, xi.

7 See the chapter "The Catholic Culture of the Austrian Jews" in Michael P. Steinberg (1990).

References

Benjamin, Walter (1928) *The Origin of German Tragic Drama*. Trans. J.Osborne. London: New Left Books, 1977.

Benjamin, Walter (1940) "Theses on the Philosophy of History." In *Illuminations*, ed. H. Arendt; trans. H. Zohn. New York: Schocken Books,1969.

Berman, Russell (1993) *Cultural Studies of Modern Germany: History, Representation, and Nationhood*. Madison: University of Wisconsin Press,1993.

Fanon, Frantz (1986) *Black Skin, White Masks*. London: Pluto Press.

Gilroy, Paul (1993) *The Black Atlantic: Modernity and Double Consciousness*. Cambridge, Mass.: Harvard University Press, 1993.

Gombrich, E. H. (1970) *Aby Warburg: An Intellectual Biography*. Chicago: University of Chicago Press, 1970.

Grossberg, Lawrence (1992) *Cultural Studies*. Ed. Lawrence Grossberg, Cary Nelson, and Paula Treichler. New York: Routledge, 1992.

Hall, Catherine (1992) "Missionary Stories: Gender and Ethnicity in England in the 1830s and 1840s." In Lawrence Grossberg, Cary Nelson, and Paula Treichler, eds. *Cultural Studies*, New York: Routledge, 1992.

Hammerstein, Oscar (1942) "Oklahoma!" A Musical Play by Richard Rodgers and Oscar Hammerstein. New York: Random House, 1942.

Kaplan, Steven L. (1995) *Farewell Revolution* (2 vols.) Ithaca: Cornell University Press, 1995.

Niranjana, Tejaswini (1992) *Siting Translation: History, Post-Structuralism, and the Colonial Context*. Berkeley: University of California Press, 1992.

Novick, Peter (1988) *That Noble Dream: The "Objectivity Question" and the American Historical Profession*. Cambridge: Cambridge University Press, 1988.

Steinberg, Michael P. (1990) *The Meaning of the Salzburg Festival: Austria as Theater and Ideology, 1890–1938*. Ithaca: Cornell University Press.

Weber, Max (1917) "Scholarship as a Vocation." In Hans Gerth and C. Wright Mills, ed. *From Max Weber*. New York: Oxford University Press, 1946.

Weber, Max (1920) *The Protestant Ethic and the Spirit of Capitalism*. Trans. Talcott Parsons. New York: Scribners, 1958.

Winnicott, D. W. (1953) *Playing and Reality*. New York: Routledge, 1989 (1971).

Lawrence Grossberg

5

TOWARD A GENEALOGY OF THE STATE OF CULTURAL STUDIES

THE DISCIPLINE OF COMMUNICATION AND THE RECEPTION OF CULTURAL STUDIES IN THE UNITED STATES

This is a significant moment, not only for the Left in the U.S., but for cultural studies as well, though the problems facing cultural studies dwindle in comparison with the dystopian trajectories leading us into the next millennium. Still, insofar as cultural studies aims to engage such trajectories (and a neoconservative articulation of cultural studies may be part of the mechanism constructing them), the state of cultural studies demands attention. In fact, cultural studies has never been in a more precarious and ambivalent position than it is now in the U.S. academy. In one sense it is flourishing and proliferating across space, institutions, and disciplines. In another sense, that success has produced at least two conditions that threaten (which is not to say negate) its viability as a political and intellectual project.[1]

First, it has been so easily applied to a wide range of academic projects as to lose any sense of its own distinctive project. Perhaps this is unavoidable and even necessary: when it rains, one seeks a good wide umbrella, and progressive academics certainly need to come together not only to get in out of the rain but to ally their projects under a common banner. Cultural studies seems the umbrella of choice these days. But this also has serious dangers. When Jan Radway was asked recently about "the growing prominence, indeed the hegemony, of cultural studies," she

132 responded: "You'd think that some of us who have long been associated with cultural studies would be happy. But we're concerned by how easily it has been taken up and by the kind of research and writing that it increasingly seems to generate" (Winkler, 1994). Part of the problem here is a question of representation. In what sense and where is cultural studies hegemonic? How broadly must we cast the net to make this claim seem as reasonable as it apparently does to the readers of the *Chronicle of Higher Education*, or *Lingua Franca*, or even the *Village Voice*.

Second, as the image of cultural studies as hegemonic has become commonsensical for some part of the media, that image has become, paradoxically, extraordinarily narrow. Whether through the construction of celebrities or through attacks on particular scholars, what the media are producing is an especially truncated and static image of cultural studies. Nowhere is there the sense that part of what has made cultural studies so attractive for young progressive scholars is its sense of itself as an unstable and contested field of intellectual and political practices. That is, what cultural studies is or should be at any particular juncture (in any particular struggle) is part of what needs to be worked out. Instead, the media identify cultural studies with a charismatic (and somewhat diverse) group of Black intellectuals, or with a particular "populist" position in the field of cultural studies (a position which is constantly in danger of sliding from the important recognition that the practice of consumption may have contradictory and even productive possibilities to a rather uncritical celebration of consumption) or with a particular issue which can easily be constructed as scandalous (e.g., the science wars).[2]

This dual construction of cultural studies by contradictory vectors of representation (one expanding it beyond recognition, one contracting it beyond redemption) places cultural studies scholars in the untenable position Radway describes above. I have nothing against the "umbrella" function of the term—as long as we don't get so many people under the umbrella that it offers no protection. But perhaps the simplest way to understand and defend this overly broad use of cultural studies is as a return to the empirical, but one that refuses to give up the necessary advances of the theoretical. Indeed, the success of cultural studies in the U.S. academy in the 1980s might be understood as a reaction against the excesses of high theory without simply allowing the pendulum to swing back to an anti-theoretical empiricism (many of the critics of cultural studies speak from one or the other of these extremes). Yet I would want to differentiate cultural studies in some narrower (and hopefully more productive sense) from just the attempt to combine theory with a concern for questions of the "local" and even of power. I also want to distance it from the inflated claims made on its behalf: claims which would make cultural studies into the new organization (and hence salvation) for the humanities; claims which would build its counterdisciplinary impulses into a new totalizing discipline; and claims which demand that cultural studies become the latest incarnation of the academic dream of an intellectual revolutionary agency—the practice of cultural studies as the life of the organic intellectual. I believe that cultural studies must remain more modest in its goals and self-representations.

Stuart Hall described the Centre for Contemporary Cultural Studies as "the locus to which we [progressive intellectuals/educators/ activists of the English New Left interested in questions of cultural change] *retreated* when that conversation in the open world could no longer be continued: it was politics by other means" (1990: 12). This description plays into a common romanticization of the "marginality" (in Hall's terms) of cultural studies, and into a dangerous anti-academic critique of cultural studies. I want to argue, on the contrary, that the particular biographies of this generation of cultural studies scholars are less important than two other lessons of this history: first, that the questions of cultural studies are never generated within the academy (i.e., that cultural studies is always responding to "the dirty outside world") and second, that the move into the academy, the move to a "politics by other means," was itself constitutive of cultural studies at least in its British (and I would add U.S.) articulations. That is, cultural studies is a rigorous intellectual—even academic—practice which seeks to produce better knowledge of the political context of the world, knowledge which opens up new and hopefully progressive possibilities of struggle and transformation.

I am sure that using the example of British cultural studies here will raise the already hackneyed argument about its mythological status as an origin which erases the multiple histories and sites of cultural studies traditions. So let me be very clear. I do not want to argue that British cultural studies—even with all of its internal diversity and divisiveness—defines either the origin or the proper form of cultural studies. Yet it exemplifies certain aspects of my own sense of cultural studies and thus it can serve an important educative function. I also think that certain fractions of British cultural studies played an important genealogical role in the current success of cultural studies, if not globally then certainly within the U.S. At the very least it enabled some scholars and scholarly traditions to reconstitute and name themselves, and it helped them to place themselves in relation to other bodies of critical work. The move into the Centre for Contemporary Cultural Studies may have been a retreat from one possibility, but it was also a condition of possibility for a cultural studies which is both academic and, I might add, inevitably commodified. Thus the current (over) commodification of cultural studies is not an imposition of some external set of power relations on an otherwise pure political practice, but a specific articulation of the contradictory terrain on which cultural studies (in this genealogical trajectory) set out.

Hence, the troubled state of cultural studies in the U.S. cannot simply be attributed to its institutionalization in the academy, nor to its agreeing to its own commodification. We must look at the particular forms of both its institutionalization and its commodification. We must begin the impossible but necessary task of narrating the history—the formation, reception, articulation, distribution, and proliferation—of cultural studies in the U.S. This is a daunting task, but I want to make some observations that might contribute to that history. Obviously, there are lots of conditions—economic, generational, and cultural—that have contributed to the success of, and the excitement generated around, cultural studies. One could write any number of different "cultural studies" of cultural studies itself, con-

structing them from a number of different narratives: the empowerment of the margins; the emergence of a hegemonic conservatism; the media-tization of culture and the globalization of capital; the theoretical excesses of "critical theory" (as the term was used in the U.S.); the failures of traditional "left" political institutions and movements; the crisis of the humanities (and the social sciences)—a partly self-produced crisis, not only of value but also of representation; and the changing nature of intellectual culture itself (e.g., in terms of its increasing mobility, commodification, professionalization, and alienation). None of these narratives offers a singular vision of a homogeneous, progressively developing field. Any story of cultural studies will be as discontinuous, uneven, fragmented, and contradictory as contemporary culture itself.

Yet we still might inquire into the rapid proliferation of cultural studies throughout the academy as the specific form of its success in the U.S. Here again we could focus on any number of different trajectories. For example, we might point out that it is the baby-boomers (especially the latter half) and so-called Generation X (especially the first half) that has so passionately adopted cultural studies. These generations were not only the first in the world to be raised on the media but also the first to live in a context in which a commercial popular culture dominated the national culture, including that of an upwardly mobile, petite bourgeoisie. Moreover, both generations have been crucially shaped, albeit in different ways, by the apparent failures of the civil rights movement and the counterculture, and the lack of any credible alternative progressive presence on the political scene. They have also been shaped by the rise, since the election of Richard Nixon, of a new trajectory of conservatism, marked by the emergence of charismatic political and intellectual conservatives (and the absence of any such charismatic figures on the Left).

Paradoxically, the collapse of the Left and the fragmentation of its constituency into multiple forms of identity politics also invigorated the political possibilities of the academic left with all sorts of constituency defined units— African American Studies, Women's studies, Chicano Studies, Gay and Lesbian Studies, etc.—displacing the interdisciplinary claims of American studies with a more politicized if also fractious practice. This suggests a second trajectory: while the existence of these multiply overlapping intellectual and institutional formations provided a terrain within which cultural studies' commitment to "realpolitik" could find a sympathetic ear, at the same time, cultural studies' lack of a preconstituted constituency, its explicit commitment to theory and its rapid appropriation by university administrators in a time of shrinking budgets made it something to be distanced if not resisted. (Moreover, the fact that each of these areas provided a home for political intellectuals who identified with their particular constituencies allowed the perception to be created that cultural studies was largely the product of white male intellectuals.) Furthermore, because cultural studies appeared as an important force in the U.S. academy at a relatively late date (perhaps the mid-1980s) as compared with other countries (such as Australia and Canada), these constituency-oriented, politicized, and interdisciplinary endeav-

ors were also bound to have a much greater claim and impact on cultural studies in the U.S.

The claim that cultural studies did not appear in any significant way in the U.S. until the mid-1980s points to yet another determining trajectory. For the claim is only true in the context of the taken for granted organization of power within the academy, not only around the disciplines, but around particular disciplines as well. There are two conditions operating here: First, in the U.S., cultural studies became visible only as something that operated within the existing disciplines, even as it claimed to disrupt and challenge disciplinary structure. That is, unlike other interdisciplinary challenges, cultural studies has been only minimally successful in establishing a real interdisciplinary institutional presence. Rather it has operated within disciplines where it presents itself as a challenge to the discipline providing the parameters of its practice. Thus cultural studies in English has been used as a way to open the field to a broader range of texts without radically challenging most disciplinary assumptions. The same has been true across the curriculum. But the second part of this trajectory involves the hierarchical status and power of the different disciplines in the U.S. academy. Thus one common history of cultural studies in the U.S. begins with its appearance in the discipline of English literature (and to a lesser extent anthropology, and to an even lesser extent sociology and American studies). Apparently, cultural studies in the U.S. began only when it infiltrated such departments and was noticed by their professional organizations (the MLA and the AAA). I want to return to this point in a minute, because I think it is necessary to contest this disciplinizing history if we are to understand its current state.

But the most important determinant of the peculiar form of cultural studies' success in the U.S. involves the economics of the academy, for the sheer size of higher education defines it as a lucrative and attractive market—with competition for commodities like students and textbooks. In fact, unlike other nations, academic publishing—both texts and trade books—is a highly competitive and reasonably profitable market. In that context, cultural studies in the U.S. has been largely driven by the needs and actions of the publishing industry. I cannot do justice to this trajectory in a few sentences, but it is worth pointing out that cultural studies has been more visible and successful as a marketing category for books than for professors. Publishers quite naturally have tried to incorporate older bodies of work (leftist politics, critical theory, film theory, and media criticism) into the new category of cultural studies; and they have attempted to link cultural studies with their major markets in the largest disciplines of the humanities and social sciences. In publishing terms, cultural studies is everything from "high" theory to "low" or popular content, carefully and primarily articulated to the concerns of literature and anthropology. This link has been supplemented in the past five years by the over-visibility of issues of identity (especially around notions of race and ethnicity) in cultural studies, and of multiculturalism across the academy, which has enabled publishers simply to incorporate the concerns of the various constituency-oriented fields into their new chic category of cultural studies.

But these trajectories are still not adequate to construct a history of the reception and rearticulation of cultural studies in the U.S., nor would they fully explain its current state. One might have to begin with a very different sort of question, a more Foucauldean question: why is it that a cultural studies project did not arise earlier in the U.S.? There have been, after all, numerous intellectual openings in the twentieth century which could have given rise to indigenous articulations of cultural studies (and which are now being rearticulated retrospectively to cultural studies). Among others one might think of certain traditions of Afro-Caribbean and Afro-American criticism; Progressivism (and its intellectual affiliations with the Chicago School of Social Thought); early research on media (such as Lippman's *Public Opinion*, and the Payne Studies); significant efforts at interdisciplinary and multi-methodological studies of communication (Lazarsfeld's attempt to link quantitative and critical studies at Columbia University, or Schramm's later establishment of the Institute of Communications Research at the University of Illinois); the potential influence of Harold Innis (from Canada) or of Kenneth Burke (both created a model for a cultural studies, but neither was taken up in those terms in the U.S.); the mass culture debates of the 1940s and 50s; and of course, the limited experimentation and temporary successes of American studies after the 1950s.

Many of these moments share something with conditions during the emergence of British cultural studies. Both Richard Hoggart's and Raymond Williams's early works are generally interpreted as interventions into a particular crisis of "English" national identity following the second world war, a crisis embodied in the threat of "Americanization" and distributed in the materiality of American media and popular culture. Even Thompson's work, with its concerns for the origins and contributions of working class culture can be located in this crisis, for the crisis was, in part, a threat to the very existence of the working class (in its potential embourgeoisment) and its culture. However oversimplified this reading of the emergence of British cultural studies may be (ignoring for example the more varied interests of the New Left), it is still worth pointing out that U.S. intellectuals have confronted the problem of national identity and its relationship to culture and communication throughout the twentieth century (if not the entire history of the nation), and that many of the openings mentioned above are analogous to if not homologous with the beginnings of British cultural studies. That is to say, if cultural studies arose in Britain in part as a response to a perceived need to reflect upon and study the relationship of culture to, on the one hand, communication (at least in the form of media culture) and, on the other, to the problem of national identity,[3] then it is somewhat surprising that a comparable tradition did not arise at least as early in the U.S., where questions of culture, communication, and identity (involving issues of political representation, citizenship, technology, mobility, immigration, multiculturalism, etc.) have been central since at least the end of the 19th century. I cannot begin to offer a solution to this puzzle; I can only suggest that, insofar as the relation of power and culture was theorized at all in these various possible openings, power was considered an external intervention into or imposition on the processes of culture. On the other side of the Atlantic, one of the theo-

retical conditions of the possibility of cultural studies was precisely the recognition that power operates within culture (and communication) itself.

But I want to turn to a different trajectory and a different set of questions. Perry Anderson (1968) has argued that in England the question of culture as a matter of normative and historical concern could only have been raised in the field of English literature (through the influence of F.R. Leavis and what Williams would call the "Culture and Society" tradition). In postwar America, however, the issue of culture, especially in the so-called mass culture debates (and journals such as the *Partisan Review*),[4] was often located in other fields, such as sociology and education and, after the 1950s, was largely displaced into communication. Perhaps this helps to explain why, historically and genealogically, the discipline of communication was the site of the first major opening for an obvious and explicit cultural studies project in the U.S. This claim may be controversial, yet not only has communication provided key resources for the construction of various indigenous cultural studies, but, equally important, along with the field of education, communication studies was the first U.S. discipline to take up the developing work of British cultural studies. As early as the 1960s, James Carey was proposing something called "cultural studies" as part of an interdisciplinary project which would define "a cultural approach to communication."[5] And along with a small group of cultural historians and sociologists,[6] Carey was one of the first intellectuals to take seriously the work of Richard Hoggart, Raymond Williams and the newly formed Centre for Contemporary Cultural Studies.[7] The field of communications has continued to provide a place, albeit not without resistance and initially, often a minoritarian and marginal place, for emergent trends within the expanding field of cultural studies (e.g., popular culture, global culture, postmodernism). That this history has itself been marginalized if not erased says a lot about the hierarchical organization of disciplinary power in the academy and the relation of the media to particular professional associations.[8]

Now, why was the field of communication open to cultural studies as early as the 1970s? What was the relationship of communications to the project of British cultural studies? And finally, how has the centrality of communications in the history of U.S. cultural studies affected cultural studies in the U.S. (i.e., in what ways has it determined the current state of cultural studies)? The first question is perhaps the easiest to think about, partly because much of the work has already been done by others, including James Carey, Wick Rowland, Ellen Wartella, etc. The field of (mass) communication, while in its institutional infancy in the 1960s, already had a longer intellectual legacy. That legacy included an explicitly moral and political agenda defined by the Progressive movement, a sophisticated interpretive theoretical foundation defined by pragmatism and various idealist philosophers (including Cassirer, Burke, and Langer as well as various members of the Frankfurt School) and an unstated populism embodied in the constantly recurring notion of an active audience participating in a differentiated system of cultural texts (see Grossberg, 1993). In all these precursors to the discipline, questions of communication were intimately tied to issues of culture and community, to the social nature

of human reality, and to the political possibilities of utopian aspirations. However, under the pressures of the growing status of "science" and logical positivism, the emergence of psycho-linguistics and information theory, the demands of propaganda research and the recurring public fears over new forms and technologies of communication, that legacy was largely submerged. The field of mass communications, into the 1970s, was largely quantitative and scientistic, seeking to find the statistically or experimentally verifiable effects determined by particular media and message variables. Its theoretical foundations were almost entirely located in neobehaviorist psychology and structural-functional sociology. The normative, theoretical, and populist impulses implicit in the study of communication were rendered suspect and invisible. While there was a vital and important (albeit marginal) counterposition defined by political economy, its framework was largely reductionist and economist. Cultural studies was appropriated and deployed as a countermeasure into this field of struggle; it was aimed primarily against this particular hegemonic paradigm but also against the vulgar political economy which defined the only available alternative at the time. Consequently, the battle was largely fought on phenomenological grounds: meaning versus effects; interpretation versus quantification; consciousness versus behavior. Drawing upon its historical roots (as well as a specific appropriation of early British cultural studies) gave this emergent paradigm (best captured in Carey 1989) an authority that was largely unavailable to communications departments outside the U.S.

At the same time, the intellectual roots of this alternative (and certainly at the time oppositional) paradigm did not define either an explicit or implicit theory of communication; that enabled the field to be open to cultural studies in a way most other disciplines at the time could not be. The emergent "cultural approach to communication" was able to—in fact was forced to—operate with an ambiguous concept of culture. While this ambiguity sometimes resembled the polysemy Williams identified in the "Culture and Society" tradition, it was not identical to it. I have argued elsewhere (Grossberg, 1992) that this ambiguity is not only productive but absolutely essential in cultural studies. Whatever form it takes—culture as text and process; as communication and *Weltanschauung*; as communication and elite practices; communication as problem and solution; as a representation of and for reality; as community and representation—the fact that such ambiguities seemed almost unavoidable in the attempt to formulate an oppositional paradigm distinguished discussions of culture in communication from those taking place in the 1970s in both English and anthropology. Finally, the almost total lack of self-reflective theoretical work in the field left a real and serious vacuum which made the project of cultural studies with its strong commitment to "the detour through theory" particularly attractive.

When the early work of British cultural studies was appropriated into this disciplinary struggle, it was inevitably read as an alternative approach to the study of communication and media. There is in fact a certain historical rationale to this identification. Writing about the reception of Richard Hoggart's foundational book, *The Uses of Literacy*, Stuart Hall (1969–70, p. 2) acknowledged that it was read

"—such were the imperatives of the moment—essentially as a text about the mass media." Consequently, cultural studies was framed, both within and outside of the Centre, as a literary-based alternative to the existing work on mass communication. Hall continued: "The notion that the Centre, in directing its attention to the critical study of 'contemporary culture' was, essentially, to be a centre for the study of television, the mass media and popular arts…though never meeting our sense of the situation…nevertheless came by default, to define us and our work." What Hall seems to be hinting here is that this was an inappropriate or inaccurate reading of the Centre's work, that cultural studies is a radical alternative to the practice of constituting and interpreting the mass media and popular culture as objects of study.

Certainly media and mass communication were among the major concerns of the Centre, and they saw themselves at least partially involved in a debate with the field of communication. But it never defined the totality of the interests at those of the Centre (even as they were trying to construct a collective understanding of cultural studies), nor did they ever equate culture with communication (or with texts, as I shall suggest later). Yet this simple equation has had profound effects on the development of cultural studies not only in the field of communication but in the U.S. academy more generally. For even while many of the disciplines that have recently "discovered" cultural studies have ignored its history in the discipline of communications, they have at the same time uncritically accepted a number of key slippages and assumptions about cultural studies that were the result of the particular appropriation of cultural studies within communications. In fact, in order for cultural studies to accomplish what those in communications intended for it, it had to compromise and reinvent itself in the image of communication. Cultural studies was reduced to a theory of communication by too quickly equating "culture" and "communication." Those who championed cultural studies—and I include myself here—whether intentionally or not, ended up reconstructing cultural studies as "communicational cultural studies" (Grossberg 1993). This reduction can be partly explained by the fact that some people misread and then uncritically adopted Williams's and Carey's apparent identifications of communication and culture. Thus cultural studies has been submerged under a model of communication, making it an alternative paradigm to—rather than a serious challenge to—the existing forms of communication studies. And political struggles have been increasingly reduced to struggles over communication and culture, all magically solvable by the proliferation of communicative and cultural practices. I want to begin look at the consequences of this narrow vision of cultural studies, a vision which abandons its radical project and practice.[9]

By equating culture and communication, communicational cultural studies conflates the general problematic of cultural studies with its instantiation as a question about the constitution and politics of textuality (i.e., about the nature of cultural and/or communicational practices).[10] This itself has a number of important consequences. First, it installs the primacy of signification (with its logic of identity and difference) over power (with its logic of determination). It reduces the entire project of cultural studies to the admittedly important political and contextual

struggle to put questions of ideology (signification, representation, and identity) on the agenda. The politics of culture thus becomes a question of meaning and identity (with an occasional nod to pleasure). Power (domination and subordination) is always hierarchical, understood on the model of either the oppressor and the oppressed or oppression and transgression. And following the idealist tradition of modern philosophy and social thought, "the real"—the material conditions of possibility and of effectivity, the material organization and consequences of life—disappears into culture, and social life is reduced to experience. All cultural studies has to worry about is culture!

Second, conflating the problematic of cultural studies (articulation) with the question of textuality legitimates the reification of Stuart Hall's (1980) encoding/decoding model. What was offered as a theoretical-semiotic solution to a particular contextually-defined set of empirical problems has become instead *the* general model of cultural studies. The sophistication of Hall's model was (and is) ignored, so that it becomes little more than a recycling of the old, theoretically discredited, linear model of communication: sender-message-receiver with the terms changed (to hide the guilty): production—text—consumption. There are two issues here—whether the way this model is used distorts the power and originality of Hall's argument (as well as Marx's analysis of the relations among these three moments of the cycle of production—see Hall, 1974) and whether all of culture and cultural studies can be understood within this model.

The encoding/decoding model is generally used to frame a tripartite approach to the study of culture: the researcher is compelled to study the institutions and practices by which a particular text is produced, followed by a literary-critical analysis of the "encoded meaning" of the text, completed by an "ethnographic" study (usually in the form of interviews, questionnaires, or selected observational studies) of the uses to which different audiences put the text and/or the different ways in which they interpret it. Of course very few studies actually do all three and even fewer ever get around to examining the articulated relationships between these three moments, or the relationship between this "cycle of textuality" and the questions of social and political effectivity. Particular studies may argue against the need for a consideration of the context of production (since intentions do not guarantee meanings). Or the analysis of the text itself may be considered unnecessary (since the text's intrinsic properties do not guarantee meanings, thus granting specific audiences the full weight and power of determining the actual meanings). Or the ethnography may be jettisoned as either unnecessary (we already know that audiences are active) or complicitous (assuming the audience has so much power plays right into the hands of capitalism).

By taking the problem of culture to be solved by dividing it into three separable moments, communicational cultural studies leaves the disciplinary practices and methodologies of political economic, literary, and anthropological studies largely in place. Cultural studies is reduced to the task of bridging the unbridgeable gap between the three disciplines. Research amounts to a hermeneutic project of uncovering a relationship, a structure of meaning, that already and

necessarily exists. Whether embodied within the text or within the lives of some fraction of the audience, whether carried out through textual interpretation or ethnographic practice, communicational cultural studies attempts to open for critical scrutiny a dimension of human existence—meaning—which cannot be reduced to materiality but which bears some as yet undetermined relationship (representation, distortion, etc.) to this external reality. Communicational cultural studies is about the ways people make sense of the world and their lives, and the sense that is made for them. This dimension (of meaning) must be relatively autonomous from the real material and economic conditions of the world and people's lives. Consequently, communicational cultural studies can never actually confront the question of effects, because it cannot theorize the relationship of meaning to anything else. It cannot even decide when meaning (signification) becomes representation (ideology), for that involves its articulation to material practices and social relationships. Communicational cultural studies remains basically comfortable with the disciplinary boundaries of whatever field it is operating in, having largely abandoned the interdisciplinarity at the heart of cultural studies. Its questions, its methods, and not surprisingly its answers as well, remain firmly entrenched within the boundaries of culture, and within the only slightly expanded boundaries of the discipline.

It is not that matters of production, textuality, and consumption are irrelevant. They may well be crucial parts of the context within which cultural studies must locate specific cultural practices. But their identity and power cannot be identified apart from that context. The problem is that communicational cultural studies has prejudged the terms within which any context is to be analyzed, and within which the effects of any practice are to be sought out and measured. Such a view fails to understand cultural studies' more radical attempt to locate cultural practices within their complexly determined and determining contexts. It reduces cultural studies to a concern with texts (no matter how intertextual) and/or audiences which can be analyzed in isolation from their place within the material contexts of everyday life. In that sense, the study of producers, texts, and audiences merely provides some of the material cultural studies must grapple with in its attempt to understand specific contextual relations of culture and power. And since such material does not directly reveal how it is located within the context, we cannot know in advance what knowledge they provide us with. Indeed, it may be that such material does not provide the most important determinations.

Communicational cultural studies, in the end, reduces culture to the symbolic representation of power and grants it a certain apparent autonomy. As a result, communicational cultural studies finds itself constantly rediscovering what it already knew: regarding domination, that particular cultural practices reproduce the structures of domination and subordination, and that they reinscribe relations of identity, difference, and inequality; regarding subordination, communicational cultural studies seems satisfied with finding cracks in the processes of reproduction and reinscription. The assumption that people are active and capable of struggle and resistance becomes an apparent discovery. Domination and resistance are

142 assumed in advance to operate the same way everywhere. But real questions remain unasked and unanswered: Questions about the specific forms in which domination and subordination are organized, about the ways they operate, about how they are lived, mobilized, and empowered, that is, questions about the actual ways in which cultural practices are deployed in relations of power and how they themselves deploy power, questions about the actual effects of culture within specific contexts, questions about culture's relations to governance.

Not all work under the banner of cultural studies in the field of communication followed this particular trajectory into "communicational cultural studies," but this has become the dominant model of cultural studies in the field of (mass) communications. Moreover, it has become the dominant model of cultural studies in the U.S. This largely explains the paradoxical state of cultural studies I described at the outset. Though the field of communication is not wholly responsible for this trajectory, it has played a significant role. But other conditions and events have also had a part in this history: for example, many U.S. academics were "introduced" to British cultural studies and to cultural studies through Richard Johnson's "What is Cultural Studies Anyway." Published in *Social Text* in Winter 1986/7, it was the first major defining piece from within British cultural studies that was widely available to the U.S. academic audience. Johnson's essay presents a model of cultural studies that closely resembles the description of communicational cultural studies I have given above.[11] A fuller explanation of how this reading of cultural studies was put into place in the U.S. academy would have to re-turn to some of the conditions I discussed earlier.

Instead, let me turn to the question of "defining" cultural studies, at least as I would like to see it practiced (here and now as it were). I am not attempting to police its boundaries or to control its possible articulations across geographical or disciplinary boundaries—either task would be doomed to failure—but to define and defend a particular project and practice. Recognizing that cultural studies is always a contested field, and given its current position in the U.S., I would like to present cultural studies as one way—not the only way, not even the only interesting or useful way—of politicizing theory and theorizing politics. Cultural studies then "is" (I use this normatively, not descriptively) an academic practice of strategically deploying theory to gain knowledge which can help reconstitute political strategies. It seeks a politics based on a new kind of authority, posed in the face of relativism, cynicism, and conservatism.

In this project, it shares a number of "operational procedures" with other progressive and critical practices: It is concerned with relations between culture and power because it believes that culture is a crucial site and weapon of power in the modern world. It seeks to understand not only the organizations of power but the possibilities of struggle, resistance, and change. Cultural studies believes reality is continually being made through human action and that, therefore, there are no guarantees in history. As a result, contestation—both as a fact of reality and as a strategic critical practice—is a basic category. Cultural studies takes contestation for granted, not as a reality in every instance, but as an assumption necessary for

critical work and political opposition. Cultural studies is committed to the "detour through theory"; it is self-reflective, without allowing that self-reflection to become obsessive or disabling; and it is committed to a certain interdisciplinary (perhaps trans- or counter-disciplinary) practice. I will return to the question of interdisciplinarity and the relation of cultural studies to the disciplines.

But first, let me say something about what distinguishes cultural studies from other progressive and critical practices: namely, a radical contextuality which affects its every aspect and dimension. In cultural studies, the object of study, the questions, theory, politics, and practice are all contextually specific. To say that its object of study is contextual is to say that the context is the real object of study. Its questions are not defined by theoretical or disciplinary concerns but are posed, as it were, by the context. The particular theory it deploys will vary with the context and the problem, and it will be judged as a resource and measured by its ability to say something new about the context which can open up new strategic understandings. (Consequently, I would say that theory is "cheap.")[12] Its politics in any particular study (which is not the same as its moral commitment) is only available at the end of the study (and in that sense, I would say that politics is "costly"). And finally, its own specific practice—its attempt to embody what cultural studies can and should be—can only be arrived at by starting to do the work of analyzing the context.

For cultural studies, the context is everything, the beginning and the end point of intellectual and political struggle, although the two points are not the same. Cultural studies offers a theoretically grounded basis for intervening into contexts and power. It attempts, temporarily and locally, to place theory in-between in order to enable people to act more strategically in ways that may change their context for the better. Of course, how temporarily and how locally are themselves defined by the project. What the context is depends on the question that demands answering (and in that sense, it is the context that is asking the question). Obviously, by context I do not mean simply the local; context is not simply a geographical measure of size and boundaries. The fetishism of the local in the contemporary academic world has too often stopped us from asking important questions about, for example, how cultural studies should be globalized; how its already global dialogue should be institutionalized; and how to speak, from within the U.S., about the U.S., in and into a global context of power.

Certainly cultural studies is concerned with cultural practices, but only in a specific way. First, while culture may provide a crucial entrance into the context, the context itself cannot be separated from those cultural practices that articulate the unity and specificity of the context as a lived environment. Second, the cultural practices that cultural studies analyzes are always discursive alliances or contexts that the analyst begins by constructing, never isolatable texts that can be treated in and for themselves. Culture is an ambiguous concept that must be embraced and escaped. Or to put it another way, because cultural studies is really interested in what Meaghan Morris (1988) has called the relations between the politics of culture and the politics of politics, it is interested in the relations between the cultur-

144 al and the noncultural (which is not the same as an opposition between the cultural and the material).

Hence there is a peculiar logic to the practice of cultural studies as it attempts to map/reconstruct the relations between discourses, everyday life, and the machineries of power. Cultural studies begins with a context which has already posed a question; yet it always begins again by turning to discourses, as both its productive entrance into and a productive dimension of that context. But in the end, it is not interested in discourses per se but in the articulations between everyday life and the formations of power. This link between power/domination and everyday life defines cultural studies' interest in "the popular," not as a distinctive sociological or aesthetic category purporting to differentiate among cultural practices, but as the terrain on which people live and on which political struggle must be carried out. Thus it ends with a different understanding of the context than that with which it began, having gone through the mediations of both culture (discourse) and theory.

Cultural studies involves a context-specific, theorized analysis of how contexts are made, unmade, and remade, as structures of power and domination. It attempts to map out the particular relations within which both the identity and the effects of any particular practice are determined, for these are not given in advance; they are not determined by origins or intrinsic features of the practice itself. Cultural studies locates everything in relations (Nelson 1994) but assumes that such relations, while always real, are never necessary. Power is both produced as, and produces contexts as, the set of "relations of a nonrelation," to echo Foucault. This is the import of the concept of "articulation," which describes both the practice by which human reality is made and the practice of cultural studies. Analyzing the politics of culture involves placing particular practices into particular relations or contexts, and transforming one set of relations, one context, into another. Hence no theory defined independently of the context of its intervention can predefine the relations surrounding a practice, or its specific concrete effects. Thus cultural practices cannot be simply treated as texts, as microcosmic representations (through the mediating structures of meaning) of some social other (whether a totality or a specific set of relations). Cultural practices are places where multiple forces (determinations and effects) are articulated, where different things can and do happen, where different possibilities of deployment and effects intersect. A cultural practice is a complex and conflictual place which cannot be separated from the context of its articulation. And if this is the case, then cultural studies can be no less complex, conflictual, and contextual (Frow and Morris, 1993).[13]

Finally, let me return to the question of interdisciplinarity. While many writers have talked about cultural studies' aggressive anti-disciplinarity, and its disruptive effects on disciplinary boundaries, few have specified the form of its interdisciplinarity, the reasons for it or the nature of its disruptiveness. Raymond Williams once described the real power in the classroom as the power to ask the questions. Similarly, by allowing the context to pose the questions, cultural studies renounces the power of the institutional boundaries of disciplines in favor of doing the work

necessary, wherever it is, to begin to provide better answers. As Meaghan Morris (1995) put it, "a literary reading of a shopping mall that does not seriously engage with questions that arise in history, sociology and economics, remains—however productive a transformation of 'the' canon of English it may enable—a literary reading, not cultural studies." If cultural studies is interested in contexts as structures and milieus of power, if it is interested in the articulations between cultural practices and the noncultural, if understanding the cultural requires understanding everything that is not cultural, then any cultural studies project must transgress the institutionalized boundaries of the disciplinary organization of questions and answers.

This does not mean cultural studies must overthrow the disciplines or transcend them in a new unity. Rather it means any project will demand work, unpredictable in advance, that crosses those disciplinary lines. It means not that the cultural studies scholar knows the other disciplines (effectively becoming multi-disciplinary) but that, whenever necessary, he or she draws on the disciplines, critically and reflectively appropriating the most useful knowledge. At other times, it may be necessary to redo what other disciplines have tried to do but now in ways consistent with the project of cultural studies. None of this suggests re-mastering the disciplines into a new mega-formation; rather it suggests a rigorous and pragmatic approach to gaining whatever knowledge is necessary to map a particular context and answer a strategic question.

For example, I have argued that understanding the "becoming conservative" of everyday life and politics in the U.S. requires an understanding of the state of capitalism and hence, some foundational theory and empirical knowledge about contemporary capitalism. But if it is unreasonable to expect to master the highly contested field of economic discourse, it is also irresponsible simply to take a single position within the field as if it were uncontested, usually a position we think we know, and know we like before we begin. Like everything else in cultural studies, its interdisciplinarity is contextual. This is its disruptive power, for this approach to the disciplines, an approach which recognizes their legitimacy even as it refuses their power, challenges the particular disabling effects—rather than the fact—of disciplinarity.

Cultural studies seeks the middle ground between essentialism and anti-essentialism; it might be called, in Paul Gilroy's terms, an anti-anti-essentialism. It calls for both deconstruction and reconstruction; it puts the analyst-critic in the ongoing war of positions fought out through various practices of articulation. This is the only way I know to do cultural studies: redefine it constantly in response to changing geographical and historical conditions and to changing political demands, constantly remake a home for it within a specific discipline even as it challenges the legitimacy of the disciplinarization of intellectual work. I do not believe this "definition" installs a new mythology proposing cultural studies as the salvation for anything; it is a modest proposal for a flexible intellectual and political practice. But it allows me to say, optimistically, that the shape and impact of cultural studies in the U.S. are still to be determined.

Notes

1 I will not speak here about its existence in other parts of the world, for the two issues, while connected, are not the same.

2 Here the media repeat the injustice they did to poststructuralism in the U.S. by so quickly and totally identifying it with a few individuals associated with Yale deconstructionism and with a particular reading of Derrida.

3 This can be seen as a rearticulation of the founding question of social theory—namely, the relationship between modernity, modernism and modernization—although the transformation of the question is at least as significant as its continuity. Both versions are concerned with the problem of historical change and continuity, but they have radically different conceptions of the forces and forms of history.

4 See Ross (1989), chapter 2.

5 Significantly, like the development of British cultural studies, much of the initial motivation and rhetoric of this project came from wider public discourses outside of the academy. See Carey (1995).

6 For example, Jim Kaufmann, Hayden White and Loren Baritz at the University of Rochester.

7 After having studied at the CCCS (on the advice of those Rochester historians), and returned to the U.S., I asked Stuart Hall where to continue my graduate career in cultural studies in the U.S. The only answer he could give me was to go to the University of Illinois to work with Jim Carey. In fact, he either neglected to tell me or did not realize that Carey was a Professor of Communications. Moreover, insofar as the current boom can be traced back to any significant events, they would seem to be the presence of Stuart Hall at the Marxism and the Interpretation of Culture Teaching Institute and of Hall and other cultural studies scholars at the conference which followed, at the University of Illinois in 1983, Stuart Hall's keynote address at the International Communication Association meeting of 1985, and the Cultural Studies conference at the University of Illinois in 1990. It is important to note that in all of these events, including the two conferences (and teaching institute) at the University of Illinois, the discipline of communication was a key field.

8 It is, I would guess, more the result of the insularity of such disciplines than of any intentional misrepresentation.

9 Such a claim is not meant as a criticism of those working within the discourses of communications study, for in one way or another, in the contemporary academy, we all do. Rather it is meant as a call for a more reflective and critical contextualization of the power of our own discourses as communications scholars. My claim, or at least my hope, is that a more radical understanding of the possibilities of cultural studies, even as it is located within the discipline of communications, can contribute to such a project as well as to a better understanding of the imbrication of communicative and cultural practices in the material organization and deployment of power in the contemporary world.

10 However this might be defined—e.g., in its simplest form, the relationship between culture and society—what is really at stake here is the problem of determination or articulation between different domains of practices.

11 Although the *Journal of Communication Inquiry* special issue on Stuart Hall (which included a number of his most important articles) was published in the summer of 1986, the journal was not well known and was poorly distributed. Interestingly, I think it is true to say that while Johnson's article is frequently cited with some authority in the U.S., it is rarely cited as a definitive statement of cultural studies in the U.K.

12 Theories and problems may travel, but they travel as resources rather than answers and, in the end, the trajectory itself may be a more powerful force than either the departure or the arrival. For travel of any sort, of whatever bodies or practices, can never be entirely one

way, and what travels is always remade by the complexities of the journey.

13 Some people may find it ironic, especially given my description of why cultural studies was deployed in the field of communication in the first place (against the "effects" tradition) to find the language of effects so central to my own sense of cultural studies. But the notion of effects here is significantly different—both broader and less determined, and more contextual.

References

Anderson, Perry (1968) "Components of the national culture." *New Left Review*, no. 50: 3–57.

Carey, James W. (1989) *Communication as Culture: Essays on Media and Society*. Boston: Unwin Hyman.

_____ (1995) "American Cultural Studies and the History of Broadcasting." Paper presented at the conference "Across Disciplines and Beyond Boundaries" at the University of Illinois at Urbana-Champaign.

Frow, John and Morris, Meaghan (1993) "Introduction." In J. Frow and M. Morris, ed. *Australian Cultural Studies: A Reader*. Urbana: University of Illinois Press,.

Grossberg, Lawrence (1989). "The contexts of audiences and the politics of difference. *Australian Journal of Communication*, no. 16: 13–36.

_____ (1992). *We Gotta Get Out of This Place: Popular Conservatism and Postmodern Culture*. New York: Routledge.

_____ (1993). "Can cultural studies find true happiness in communication?" *Journal of Communication* 43: 89–97.

Hall, Stuart (1969-70). Introduction to *The Annual Report of the Centre for Contemporary Cultural Studies*. Birmingham, England.

_____ (1974). "Marx's notes on method." Working papers in cultural studies, no. 6: 132–70.

_____ (1980). "Encoding/decoding." In Stuart Hall, et al., ed. *Culture, Media, Language*. London: Hutchinson: 128–38.

_____ (1990). "The emergence of cultural studies and the crisis of the humanities." *October*, no. 53: 11–23.

Morris, Meaghan (1988). "Tooth and claw: Tales of survival, and Crocodile Dundee." In *The Pirate's Fiancee*. New York: Verso, 241–69.

_____ (1995) "A question of cultural studies," unpublished paper.

Nelson, Cary (1994) "Always Already Cultural Studies: Academic Conferences and a Manifesto." In Isaiah Smithson and Nancy Ruff, ed. *English Studies / Culture Studies: Institutionalizing Dissent*. Urbana: University of Illinois Press.

Ross, Andrew (1989). *No Respect: Intellectuals and Popular Culture*. New York: Routledge.

Winkler, Karen (1994). "Cultural-studies adherents wonder if field has lost sight of goals." *Chronicle of Higher Education* (November 4): A15.

Gail Guthrie Valaskakis

6

INDIAN COUNTRY

NEGOTIATING THE MEANING OF LAND IN NATIVE AMERICA

The feathered and blanketed figure of the American Indian has come to symbolize the American continent. He is the man who through centuries has been molded and sculpted by the same hand that shaped the mountains, forests, and plains, and marked the course of the rivers.

—Luther Standing Bear, 1933

Near Sitting Bull's grave, there is a bullet-ridden obelisk raised in memory of the Indian woman who accompanied Lewis and Clark on their expedition across the West. A plaque says that her name is "Sakaka-Wea, that she guided the expedition to the Pacific Ocean, and that she died and was buried at Fort Manuel in South Dakota on December 20, 1812" (Duncan 1987, 162). In the years since, Sacajawea has become a figure in popular culture, an Indian maiden with "more statues in her honor than any other woman in American history" (ibid.). And while historians agree that her name is Sacajawea, which means in her native Shoshoni, "boat launcher," image-makers have labeled her Sakakawea, a Hidatsa word for "bird woman" (ibid., 163). No one knows for certain whether she died at Fort Manuel at about age twenty-five or lived to be an old woman on the Wind River Reservation in Wyoming (Howard 1971, 192). But our image of the bird woman is ageless: a shapely Indian princess with perfect Caucasian features, dressed in a tight-fitting red tunic, spearing fish with a bow and arrow from a birch bark canoe suspended on a mountain-rimmed, moonlit lake.

Sacajawea is a reoccurring representation in the discourse of Native and other North Americans. We imagine her "blazing the trail" of western exploration between 1804 and 1806, an uncommon woman, intriguing in the contrast between

her actions and our historical images of Indians as passive extensions of the land or obstacles to its development. Her personal experience is lost to us; only pieces of the scaffolding of her life can be drawn from the journals, diaries, and notes of those who detailed the land they were dispatched to explore for economic and political purposes. We believe she was taken from her Shoshoni people by the Hidatsas when she was ten or twelve years old. At the time of the Lewis and Clark expedition, she was about 16 and pregnant, one of two "country wives" purchased by a member of the expedition named Charbonneau (ibid.,17). She traveled with her newborn son, supporting the mission that would expand the prospects for colonial settlement with the panoply of her person and the amity of her languages. At the end of the expedition, she was apparently left in St. Louis when Charbonneau resumed his life as a trapper in the Southwest (ibid.,156). This, like her experience of the land, the people in her life, and even her death, is conjecture drawn from the imagination of those who write popular history. But we know that as an Indian woman separated from the social structures of her tribe and living the hybrid cultural experience of her historical position, Sacajawea would not have been of interest to early anthropologists. But Sacajawea's hybridity, as cultural studies is now helping us to realize, says more about Native American history than could any more uniform acount.

Indians and Inuit have been at the heart of the anthropological project in North America. The academic work that began with Franz Boas's research for *The Central Eskimo* (1888) forged a corpus of writing on the patterned thoughts and behavior of tribal peoples, Indians and Inuit frozen in the isolation of history and territory, passive or predictable in response to the intrusion of white culture. Ethnography's methodological constraints are reflected in Edward Curtis's 40 volumes of photographs of Indians posed in tribal regalia against pristine landscapes in the early 1900s, about which Rayna Green (1992, 47) writes, "Just give me one (photograph) in overalls and a cowboy hat. Then we can get serious about what was happening to these people." Like Curtis's Indians, the field of Native studies is framed in isolated research on tribal world view and land use; social structure, kinship systems, and acculturation patterns; language, lifestyle, and the aftermath of empire.

The post-structuralist wedge that has opened the seams of anthropology has led to a persistent debate over ethnographic practice. This debate over research, writing, and representation has spread far beyond ethnography. Artists, writers, curators, academics—and Native Americans themselves—have rediscovered Indians in the politics of interpretation. The move to explain the range of cultural texts focuses on Indians as historical and cultural markers, revealing the meaning of their appropriated images in the discourses of cultural industry and commercial enterprise alike. Indians represent pivotal points of struggle, often over land that is romanticized for commodification; or reduced to background for confrontations over land rights; or location for cultural analysis of the trope of the Indian in writing about and by Native Americans that works the terrain of cultural identity and the politics of difference.

The full reach of writing on Native American culture is now loosely labeled

Native studies, an academic and popular umbrella for work in which the objects of inquiry are Indians or Inuit. The name is not one Indians have chosen, though many have appropriated it. Native studies reflects the shared desire of the academy and the polity—including Native Americans—to define the boundaries of difference in being Indian. If, to adapt Said's (1979, 29) quote from Disraeli to a North American context, Indians are a career, they are also an industry. Native studies is a topic, not a methodological approach; and although it draws heavily on its anthropological and historical roots, writing about Indians incorporates all the disciplinary boundaries of the fields which are absorbed within it. More recent work, however, reflects a blurring of the disciplinary lines between academic fields, the result in part of writing in cultural studies.

Reconceptualizing culture as everyday actions, discourses, and events, cultural studies has helped unsettle the static analysis of bordered tribes to reveal the lived experience of individual Indians in the unity and difference of collectively constructed cultures. Cultural studies's historical anti-essentialism, combined with its willingness to credit the complex, conflicted, and overdetermined nature of discourses, makes it particularly helpful in Native studies. The ambiguous play of power and identity which situates the field of current practice thus emerges with a kaleidoscopic past of intertwined experiences, representations, signifiers, and borders. In the range of interwoven discourses involving Indians, cultural studies has begun to unravel the way Native American cultural struggle is embedded in relations of power, including conflict over the land.

Today, in the cultural resurgence of "Indianness" that North America is experiencing—traces of which are found in the bricolage of popular culture in everything from the feathers and beads of fashion and New Age prophets to Robbie Robertson, *Dances with Wolves*, and the Walt Disney film *Pocahontas*—land and Indians remain yoked together in the academic images and popular narratives that circulate in the discourses of Native and other North Americans. Images of Indians and land remain a barometer of both the difference attributed to Indians and that expressed by Native Americans themselves.

At the same time, Native Americans have played a small but significant role in contemporary political struggles. The Indian movement that began in the 1960s and '70s with the occupation of Alcatraz and the stand-off at Wounded Knee propelled struggle across the continent. This decade began with Canada's so-called "Oka crisis," in which Mohawk "warriors," protesting the expansion of a golf course bordering their ancient cemetery, confronted the Quebec police and the Canadian army. In the United States, spear fishing Chippewa and angry protesters faced each other on the boat landings of northern Wisconsin over treaty rights enacted in the practice of Spring spearing. In 1992, Indians and newcomers disputed the meaning of the "Columbus Quincentennial" and the 150th anniversary of Canada's independence. The struggle between Indians and Others continues to erupt over casinos and cigarettes, trees and taxes, dams and water and mining, representation and appropriation, sovereignty and self-determination. This continuing contest involves underlying issues of land in America: continental terrain—explored, set-

tled, mapped, treatied, reserved, privatized, developed, idealized, contested, and imagined. As Roger Moody (1988, 355) writes, "underscoring virtually every contemporary struggle by indigenous peoples—be it against specific damage, or for cultural and political self-determination—is the demand for land rights."

The political combat over land is wrapped in a complex of oppositional discourses, contradictory representations, and diverse cultural constructions. As Barri Cohen (1994: 33) suggests in writing about the Cree and their fight against the expansion of hydroelectric projects in Northern Quebec, it is "a struggle that has unraveled a complex braid of conflict between radically different knowledge systems and representations about the land and territory, progress and survivability, rights and justice—the latter two couplets hitched to differing commitments of nationhood and its attendant cultural and political desires." The land is constructed in what Gerald Vizenor (1994, 53–4) calls narratives of dominance and survivance, historical and current simulations of the Indian by Native and other North Americans.

In earlier work, I have written about the land of the Lac du Flambeau, Wisconsin reservation where I was raised. There a traditional culture is enacted and transformed through protests over treaty rights focused on the practice of Spring spear fishing (Valaskakis: 1988). This continuing struggle is a dispute over the meaning of land—land articulated to history and identity, absorbed in the discourse of spirituality and territory, worked in the power of politics and privilege. The meaning of land emerges in the historical specificity and cultural practice of local Native American communities. But here, I want instead to consider the general discourses of the land that encircle Native American political struggle with whites and with each other, and that have engaged the interest of cultural studies.

Empty Land and Nomadic Indians

The relationship between the "empty land" metaphor and the colonization of "primitive" Indians is well-worked theoretical territory in cultural studies; but this relationship is important to recall because it frames Native American experience and structures the critique of colonial culture. As Barri Cohen (1994, 48) writes about Northern Quebec, "The territory is a place of Cree and Inuit habitation, history, myth, and technology, while for southern power it is 'barren land' and 'wilderness,' passively awaiting further conquest." But this framework for the struggle over land has even more ominous implications.

European and North American practice is predicated on the construction of land as a material object that de Certeau (1986, 73) tells us, like the place of Montaigne's Cannibals, "is emptied—it becomes vacant and distant." The texts of early explorers and anthropologists offer the other as a vehicle for the interests of the dominant culture. In the North American context, Cabot and Frobisher and Columbus encountered Native people with whom they interacted and traded, and about whom they and others wrote. As early as 1501, Gaspar Corte Real kidnapped 57 Beotuk Indians for the slave trade in Portugal (Morison 1971, 215), a practice that occurred throughout the exploration period. The texts that spiraled from encoun-

ters with Indians created the 16th century debate over whether Native people in their pagan and primitive state could be considered human beings. The discursive ambiguity of Indians as extensions of the natural continued to plague Native people long after the Spanish theologian Francisco de Victoria in 1532, and Pope Paul III in 1537, acknowledged that "the Indians are truly men" (Cumming and Mickenburg 1972, 14); the moral argument over their treatment continues today.

These early texts collectively construct the ambiguous social imaginary of the nomadic Indian, about which Robert Berkhofer (1979, 71) writes, "for most of the past five centuries, the Indian of imagination and ideology has been as real, perhaps more real, than the Native American of actual existence and contact." The barbarian of an imagined empty land emerges in Abbe Raynal's armchair-travel description of the Inuit cited in Chappell's (1970, 83) 1817 journal of his voyage to Hudson Bay:

> few in number, and scarce any of its individuals above four feet high. Their hands bear the same enormous proportion to their bodies as those of children: the smallness of their feet makes them awkward and tottering in their gait: small hands and a round mouth, which in Europe are reckoned beauty, seem almost a deformity in these people…their men have neither hair nor beard, have the appearance of being old, even in their youth: this is partly occasioned by the formation of their lower lip, which is thick, fleshy, and protruding beyond the upper.

In contrast to the people who inhabited the expanse, the land itself was represented in early texts by romanticized images of Indians engraved on the landscape. While the Spanish were debating the ambiguous humanity of Indians, the rough, earthy beauty of the new territory was symbolized by pairs of Indian men and women, Caribbean or Brazilian Natives framed in the exoticism of flora and fauna. By 1575, the bare-breasted Amazonian Indian queen became a figure for the New World. Draped in feathers and furs, carrying arrows and spears, this contradictory figure incorporating the warrior woman and the mother goddess drew from European roots to portray the primitive challenge of America: "exotic, powerful, dangerous, and beautiful" (Green 1976, 702). When the colonies began to move toward independence, the mother-queen figure of the 1600s is transformed into the more independent princess image of the 1700s. The statue-like figure of liberty in flowing robes is younger and overtly Caucasian; but armed with a spear and a peace pipe or a flag, she is equally ambiguous. And this ambiguity, incorporating the Native and the noble—which Rayna Green (1976) calls the "Pocahontas Perplex"—circulates with what Berkhofer (1978, 121) calls the "anti-Pocahontas." Images of the Princess and the squaw accommodate the colonial experience, the western expansion of settlement, and the development of the land over which we continue to struggle. We are still in a struggle over discourse that constructs the land as the mother-queen and the princess with spears and arrows, and the romanticized Indian representation of Mother Earth, "a misogynous metaphor traced to the long colonial gaze of Christopher Columbus" (Vizenor 1994, 120).

Like Said's (1978, 12) *Orientalism*, the configurations of power represented in

these contradictory discourses elaborate "a whole series of interests which, by such means as scholarly discovery, philological reconstruction, psychological analysis, landscape and sociological description," create and maintain "a certain *will* or *intention* to understand, in some cases to control, manipulate, even to incorporate, what is a manifestly different (or alternative and novel) world." The discourse that claimed, named, and deeded the land constructed Native Americans as nameless, nomadic vagrants who flow in and out of continental histories. As early as the fifteenth century, John Cabot gave an island in Beotuk Country to a friend and another to his barber (Raimondi 1497, cited in Stefansson 1947, 153). Cabot's actions were legitimized in two judicial opinions written by Chief Justice Marshall in 1823 and 1832, which established both the territorial authority of European nations and colonial land policy by legislating title acquired by respective discoverers; limited application of sovereignty for Native peoples; and ratified land surrender by any possible means (Cumming and Mickenburg 1972, 17–18).

Yet the texts that help empty the land and justify its occupation also produce both the bounty of ethnographic research on Native American cultures (from which Indians themselves draw in reconstructing their history and culture) and an ironic—and strategically important—invisibility related to the lived experience of Indians. As Paul Chaat Smith (1994: 38) writes,

> When we think of the old days, like it or not, we conjure up images that have little to do with real history. We never think of the great city of Tenochtitlan, the capital of the Aztec Empire, five centuries ago bigger than London. We never imagine sullen teenagers in that fabled Aztec metropolis, in some pre-Columbian Zona Rosa dive, badmouthing the wretched war economy and the ridiculous human sacrifices that drove their empire. We don't think of the settled Indian farming towns in North America (far more typical than nomads roaming the Plains).... Yet the amazing variety of human civilization that existed five centuries ago has been replaced in the popular imagination by one image above all: the Plains Indians of the mid-19th century.

The lived experience of Indians has been less important than their presence "as symbolic referents in a discourse about European civilization's virtues and vices, triumphs and failures" (Johnston 1987, 50). This "encoded Indian" endures in the discourse of dominance. But today, "the postindian warriors ensnare the contrivances with their own simulations of survival" (Vizenor 1994, 11).

Approaching Land

The Indian has been the object of both ethnography's methodological debates and the dominant culture's drive to colonize the land. For both, the land is part of what they are struggling over, whether by way of territorial expansion, competition for material resources, or the discourses of New Age ecology. But the physical environment is much more dynamic in the narratives and experiences of Native Americans. Indeed, Deloria (in Noftz 1987: 229) suggests that Indian history is situated in space rather than time; where events occurred is more important than when they occurred. But when Native Americans map community onto territory,

time qualifies space in interwoven configurations. As Ward Churchill (1992, 131) writes, "land, as Red Cloud, Hugo Blanco, and myriad others have noted, is the absolutely essential issue defining viable conceptions of Native America, whether in the past, present, or future. A deeply held sense of unity with particular geographical contexts—and the vicissitudes of historical and spiritual experience they embody—has provided, and continues to afford, the spiritual cement allowing cultural cohesion across the entire spectrum of indigenous American societies."

In the words of Paul Chaat Smith (1994, 38), "what makes us one people is the common legacy of colonialism and diaspora. Central to that history is our necessary, political, and in this century, often quite hazardous, attempt to reclaim and understand our past—the real one, not the invented one." Jonathan Boyarin (1994, 9) puts it another way: "The emancipatory claims of colonized people were also grounded in narratives of territorial priority…those whose collective consciousness was articulated in the context of a struggle against European imperialism adopted the notion that collective identity, and hence both loyalty and legitimate deployment of power, was determined by spacial relations." But the nature of these spacial relations remains elusive and confusing. As Gerald Vizenor (1994, 52) writes, "The literature of dominance, narratives of discoveries, translations, cultural studies, and prescribed names of time, place, and person are treacherous in any discourse on tribal consciousness."

The questions of meaning that emerge engage the conceptual borders of both Native studies and cultural studies. About the theoretical challenge of environmental issues, cultural studies scholars Jody Berland and Jennifer Daryl Slack (1994, 2) write "how can we understand something as discursive and non-discursive at the same time? Nature and not nature? Culture and not culture?" Native Americans add that the meaning of the land is spiritual and thus difficult to express. In their own way Native Americans describe the land and the environment as spiritualized and unrepresentable empty space. Thus images of land as first invisible, and now seemingly inaccessible or inexpressible, reflect surprising points of similarity in texts by entrepreunial, academic, and Native Americans. These different, but equally forceful, investments in the land as discursively empty, as silent, support the romanticized discourse which traverses sentimentalized photography, historicized ethnography, appropriations of New Age spirituality, and statements of prophetic Indian traditionalism. And silence rebounds as well from the discomfort that academics feel in analyzing the "spiritual cement" that joins Native Americans to the land and to each other; and the comfort with which Native American "warriors of survivance" (Vizenor, 1994) mystify the experience of the land. The empty space produces books like T. C. McLuhan's *Touch the Earth* (1972) and *The Way of the Earth* (1994), which add to the accumulation of romanticized Indian words interspersed with static landscapes. These images of what Paul Chaat Smith (1995) calls "the coffee-table tribe" conflate land and Indians in new narratives of dominance which are, ironically enough, sustained by Indians themselves. The Indian movement now appears absorbed either in the promise of pow wow and "healing" or the politics and profits of casinos. Yet as texts are newly created or appropriated,

156 new spaces are nonetheless opened for Native American ideological opposition and political resistance.

Indian Territory and Sacred Places

Across Native America today, writing about the land reflects the differing experiences and practices of individuals and communities, even nations. But these differences are absorbed in an appeal to communality related to two distinct but intertwined cultural conceptions of the earth. Positioning themselves in the fluidity of space and time, bounded only by stories of creation or migration, survival stories speak of land as a specific cultural construct articulated to the physical environment, an expanse of territory which locates the ideology, identity, and practice of a particular nation or community. But these stories also speak of "the land" as a general cultural construction, a site as broad as the earth and the sky.

The meanings of these territorial and spiritual places are woven together in living traditionalism: the practice of everyday life experienced collectively and individually as heritage, a multi-vocal past re-enacted daily in the play of power and identity. In the language of reconstructed traditionalism, land is both territory and sacred site. The meaning of these two views of the environment is merged in the discourse of Indian Country, a place that gathers all Native Americans together— whether on any reservation, at any pow wow or Indian conference, in any Indian bar or Native American Center, participating in any Native ceremony or feast or communal event. In Indian Country, the struggle over land is told and re-told in the stories of survival that reconstruct, imagine, and most of all, assert, Indian experience permeating the memorized past and the politicized future.

Indian Territory

Indian land is a site of meanings that fold in upon each other in the process of being articulated to cultural nationalism and political agency. The notion that land is merely property, on the other hand, emerges from the dominant society's belief in "the social fiction that lines on a map and signatures on a deed legitimately divide the earth"(Limerick 1987, 56). Patricia Nelson Limerick (ibid.) writes, "of all the persistent qualities in American history, the values attached to property retain the most power." Popular literature in Native studies often maintains that tribal peoples have no concept of private property. Joined with the image of the nomadic Indian, Native American land is owned by no one and available to everyone. This concept of shared, and therefore unowned, property, hotly contested in current Native American land claims, is also a central organizing principle in the research on Indian social and economic life and the environment.

Research on land and Indians emerged within two distinct trajectories: popular environmentalism and cultural ecology (White 1984, 179). Environmentalist writing is rooted in the early image of the noble savage, the Indian who, as an extension of nature, demonstrates a fundamental "oneness" with the land. In later writing, this essentialist discourse transforms the noble savage into the conservationist, the nostalgic Indian who is capable of living on the earth without disturb-

ing it. Chief Standing Bear (in Hamilton 1972, 1) speaks in such reifying images that ignore cultural conflicts: "The American Indian is of the soil, whether it be the region of forests, plains, pueblos, or mesas. He fits into the landscape.... He once grew wild as naturally as the wild sunflowers; he belongs just as the buffalo belonged."

This innate connection between Indians and the land was ignored by early cultural ecologists, who researched the social organization and economic activity of Indians in relation to various products—buffalo, caribou, corn. Their functional approach focused on techniques of productivity that Indians developed in hunting and agricultural societies. As early as 1915, Speck (1972) observed that northeastern Algonquin hunting territories represent a system of land ownership; but he focused on Cree economic enterprise, in which, he argued, land was a form of private property with hereditary family tenure. This controversial position is supported by Adrian Tanner (1987) who, along with Harvey Feit (1973), recognizes the extent to which culture— including spiritual beliefs—mediates social organization and the environment. But cultural ecology draws from a Marxist analysis that centers on material production as the driving force behind human activities. "The environment itself is viewed as an external entity—a storehouse of raw materials for the ongoing production of material goods" (Nofz 1987: 227). Tanner (1987: 71) writes of hunting territory as a "unit of management" in which emphasis is placed "on animals rather than on land, and thus suppresses the question of the clear definition of boundaries." This concern with materialism and boundaries, which is central to anthropological conceptions of culture, has been challenged in the recent work of anthropologists themselves; but in Native studies, the theoretical shifts articulated by Clifford (1986), Rosaldo (1989), and Geertz (1983), have not been widely adopted.

In this era of Native land claims, land use and occupancy studies map the typography of Native American territory in the historical and current placements of social units and their relationship to economic activity. Ethnographic research related to Native land claims appropriates the demographic methods of geography which privilege counting—people and fish and beaver and bear—in defining the meaning of cultural practice. Those who write on Native relationships to the land from a more interpretative ethnographic approach, like Hugh Brody (1981) and Robin Ridington (1992), tend to retreat to the traditional discourse of the tribal.

This disjuncture between academic writing based in empirical analysis versus that drawing on Indian experience is less evident among anthropologists who work from an ethnomethodological, symbolic, or cognitive approach. But until recently, their research has focused on how isolated cultures or individual members of a bordered culture create meaning from the range of experience that defines their reality. In this context, Indian conceptions of territory or spirituality are understood as a complex of culturally-specific beliefs, rituals, and activities, some of which are expressed in association with the land. This concentration on decoding the meanings that "real Indians" embody in the discrete environments of respective cultures is redirected in recent writing in feminist theory, cultural geography,

158 cultural studies, and ethnography itself. New work moves toward understanding Native American land as discursively constructed terrain that connects the hybrid experience of the reconstructed past to the fragmented politics of the present. It is not enough to recognize "that memory *has* a politics, and that effective rights depend on shared memories" (Tilly 1994: 244). Politicized memory emerges in hybrid cultures that incorporate an active sense of place beyond material production, a sense of tentative but material locatedness that works to reconstruct "the relation between identity and the spaces through which identity is both produced and expressed" (Keith and Pile 1993: 9), and the formation of contingent community and ideology.

Sacred Land

Research and writing about the meaning of Native American culture has, of course, engaged anthropologists more than Indians. Even with new sensitivities and methodologies, the ethnographers' pursuit of cultural knowledge reflects a tension between the Indian and the Other around issues of the sacred or the spiritual. Early anthropologists like Frances Densmore (1910, 1929) were interested in recording songs and stories, collecting the materiality of religious practice, and decoding the organization of action. Most of the early accounts of Indian spirituality were by Christian converts. Native Americans like my father always said that Indians did not speak of spiritual beliefs when they practiced them, and if they renounced Indian spirituality and were willing to speak to anthropologists, one should be wary of what they said. His perception emerged from watching my great-grandmother decipher Rohrshak tests for Hallowell (1967) and Barnouw (1950), who studied the psychology and world view of the Chippewa. They paid her by the hour to inform or interpret. She spoke at length; but there were clear silences. Even with me, she was evasive in speaking about the traditional Midewiwin religion of the Chippewa. She sometimes attended the ceremonies, but she wore her cross and sat outside the lodge. She spoke of the drums of the Midewiwin with undisguised sentiment; but she knew very little about the details of Midewiwin spiritual practices. What she knew was the reality of the multiple identities of her mixed-blood, traditional-Catholic, Indian experience, and this was masked in the silence of unstated questions.

Ethnography's rejection of ambiguous information and Indians' refusal to discuss the sacred or spiritual were undoubtedly more common than anthropologists have acknowledged. Hybrid experience was consigned to autobiographies that were omitted from cultural analysis; and it's likely that other ethnographers shared the experience of Boas (in Rothenberg 1972, 3) who, in 1920, was told by an informant: "Long ago her mother had to sing this song and so, she had to grind along with it, the corn people have to sing too, it is very good, I refuse to tell it."

But the search for authenticity that structured anthropological inquiry has never discouraged popular writing on Indians. As Paul Chaat Smith (1994, 33-34) suggests, if anthropologists needed Indians to speak about Indian culture, it didn't much matter to those who wrote—or read—popular books. He reminds us that, from

to *The Memoirs of Chief Red Fox* (1971), fictive best sellers on Indian culture often masquerade as narratives of the "real." The journeys of spiritual experience written by Jamake Highwater (1981), Carlos Castaneda (1968), and Lynn Andrews (1981) affirm that authenticity has little to do with popularity. Though Native Americans are now encouraged to speak for themselves, their refusal to reveal remains common; and it is joined by suggestions that spirituality and sacred land are encoded in mystical experience which is elusive, even inexpressible. Joy Harjo (1992: 89) writes: "I felt as if I had prepared for the green corn ceremony my whole life. It's nothing I can explain in print, and no explanation would fit in the English language. All I can say is that it is central to the mythic construct of the Muscogee people (otherwise known as Creek), a time of resonant renewal, of forgiveness." And N. Scott Momaday (1995: 29) tells us "those who seek to or understand the sacred in academic terms are mislead. The sacred is not a discipline. It is a dimension beyond the ordinary and beyond the mechanics of analysis. For those who come to the sacred, to sacred ground, it is a kind of mystical experience, a deep and singular encounter. Sacred ground is ground that is invested with belief. Belief, at its root, exists independent of meaning." Nonetheless, it is Kiowa writer Momaday who, through his books and poems of the last twenty years, reveals much about the meaning of Indian country.

Vine Deloria (in McLuhan 1994, 419) says, "Every society needs…sacred places. They help to instill a sense of social cohesion in the people and remind them of the passage of the generations that have brought them to the present." But sacred places represent more than remembered community. They are sites of the presence of the other world, which provide mandate and meaning to the disturbing reality of Indian history and everyday life. And they name and recall sites of sacrifice, which articulate to the discourse of Native political agency.

Sacred places are not fixed locations set by religious prescription. They are spiritual spots of interaction between individuals and the land itself that, if they are indigenous elsewhere, are uncommon in North American secular culture. The land may be signed with memorable places, noted for events like Civil War battles or extraordinary features like the Grand Canyon; but their appeal to common experience is historical, not spiritual. Native American narratives about land as both territory and sacred site are emergent voices interweaving survival stories of history and spirituality. Storied voices act as goads to the gathering together of past generations and current companions of the land: local, national, international, metaphysical. This call to the formation of community—imaginary, symbolic, and real—stakes a claim to a resolute future drawn from the fragments of an unresolved past. Leslie Marmon Silko (1977, 2) writes, "I will tell you something about stories…. They aren't just entertainment. Don't be fooled. They are all we have, you see, all we have to fight off illness and death. You don't have anything if you don't have the stories." The stories of journeys and names are referents for a mixture of real, imagined, and symbolic experiences. Elusive, storied referents and inter-subjective practices build the collective experience of dynamic, conditional commu-

nity. This is not a neat process of accessing common histories to form a basis for community; nor do common memories of experience create a monolithic collective identity within North American nations (Boyarin, 1994). Like the unities in difference of the communities they negotiate, memoried experiences rise in kaleidoscopic constructions: individual, incomplete, contingent images constructed around powerful referents.

Journeys

Like other peoples whose language expresses their "relational positioning" in the "entangled tension" (Clifford 1994: 307) of diaspora, the journey is a metaphor of Native American territorial claims in the present nation-state drawn from the fragmented heritage of the past. As Gerald Vizenor (1972, 35) wrote in 1965, "The *Anishinabe* (Chippewa) did not have a written history. The past was a visual memory and oratorical gesture of dreams plaiting an endless woodland identity between the conscious and unconscious worlds of *the people*." In Chippewa heritage, the journey through which the people become a nation begins at the eastern shores of North America, where "the (Algonquin) people were so many and so powerful that if one was to climb the highest mountain, and look in all directions, they would not be able to see the end of the nation" (Benton-Benai 1988: 94). This migration carried the sacred fire for 500 years, moving through the waterways of the St. Lawrence River and the Great Lakes, stopping at locations signed in the sacred megis shell of the ancient Midewiwin religion and claimed in Chippewa rock carvings. Eventually they settled throughout what is now Ontario, Minnesota, Upper Michigan, and Wisconsin. Vizenor (1972, 33) writes about this journey, deep in the vague discourse which maps the claim to Chippewa territory: "The *Anishinabe* (Chippewa)—the original people of the woodland—believe that they were given wisdom and life color from the sun reflecting on the sacred shell during the long migration." And Edward Benton-Banai (ibid., 102) tells us, "we descendants of these great people can gather strength from their strength."

The metaphor of journey is expressed in the conflicting, reconstructed reality of later travels, forced and voluntary, spiritual and ordinary. The Wisconsin Chippewa were ordered to move to Minnesota in 1852 to empty the land for loggers; but like other Native Americans, Chippewa experience the removal orders of the 1830s in the "Trail of Tears" through which Russell Thornton estimates four to eight thousand Cherokee were lost to the nation (in Limerick 1987, 194); and the "Longest Walk" of the Wounded Knee Lakota in 1890, remembered through footprints retraced in reenactments and the walks to Washington in this era which bear their names. Vizenor (1993, 43) rewrites the words of an ancient poem:

> moving forward and back
> from the woodland to the prairie
> Dakota women
> weeping
> as they gather

their wounded men
the sound of their weeping
comes back to us

And there are other journeys transformed in the memoried experience that recalls and rewrites non-linear fragments of collective culture: the political journeys to generations of treaty tables; the journeys of legendary and current leaders who go to Washington in the delegations which "have been basic to the administration of Indian affairs in the United States from 1789 to the present" (Viola 1981, 22); the journeys of social identity enacted in the pow wow circuit and spiritual identity performed in ceremony; and the imaginative journey which calls upon the collective experience of all these, the journey home. As Momaday (1969, 4) writes in *The Way to Rainy Mountain,*

> the journey herein recalled continues to be made anew each time the miracle comes to mind, for that is peculiarly the right and the responsibility of the imagination. It is a whole journey, intricate with motion and meaning; and it is made with the whole memory, that experience of the mind which is legendary as well as historical, personal as well as cultural. And the journey is an evocation of three things in particular: a landscape that is incomparable, a time that is gone forever, and the human spirit, which endures.

This journey represents ragged-edged movement—performed in mythical and real time—with the land, not on the land, a pilgrimage home, somewhere in Indian country, located in the recollection, practice, and placement of heritage. As Momaday (1976, 142) writes in his memoir *The Names,* "the events of one's life take place, *take place.*... I existed in that landscape, and then my existence was indivisible with it." Both the memory of the journey and the construction of home are reoccurring themes. William Bevis (1987, 581–82), writes about the "homing" plots in the Native American novels of McNickle (1978), Momaday (1966), Silko (1977), and Welch (1979): "American whites keep leaving home: *Moby Dick, Portrait of a Lady, Huckleberry Finn, Sister Carrie, The Great Gatsby*—a considerable number of American 'classics' tell of leaving home to find one's fate farther and farther away.... In Native American novels, coming home, staying put, contracting, even what we call 'regressing' to a place, a past where one has been before, is not only the primary story, it is a primary mode of knowledge, and a primary good."

Names

If Momaday (1995: 29) suggests that the sacred emerges in belief that can't be expressed, he also tells us, "language and the sacred are indivisible. The earth and all its appearances and expressions exist in names and stories and prayers and spells." This seeming contradiction is absorbed in stories and names that locate, recall, and re-tell the silence of inexpressible experience.

Roger Williams (in Berkhofer 1978, 15) wrote in 1645: "I cannot observe that they [Natives] ever had (before the comming [sic.] of the *English, French* or *Dutch* amongst them) any *Names* to difference *themselves* from strangers, for they knew

none." In contrast, Vizenor (1993, 10) writes, "The stories of nature were heard in names. Place names and personal nicknames were communal stories. The *anishinaabe* (Chippewa) were never alone in their names, visions, and stories. In the new narratives, the style and historical content of oral tradition move with the nomadic reconstruction of Native American experience. Rayna Green (1984, 5) speaks of the colloquialism and contingency—and the call to cultural continuity—in the discourse which reconstructs Indian country:

> Sometimes she thinks it's funny the way the stories change when she tells them. She doesn't know Indian Country the way Grandma knew it, and no matter how much she might wish she looked like the old ladies out in the plaza sometimes, she knows she never will. It's blue jeans and sun-glasses for her after all—save the fringed shawl for pow wow. One of her cousins called her a Disco Indian last week. But still, she's not as hip as she looks sometimes. It's not that she could ever get away from the old stories, even if she wanted to. She can't tell them the way Grandma did, but she's hardly ever in situations like the ones Grandma thrived on. Still some of the stories took root so deeply in her that she tells them without thinking, in new forms, especially the ones that have to do with being a woman or being someone with a name.

The detail of personal and cultural knowledge is remembered or imagined in recycling traditional stories told in English, interspersed with Indian words. Gerald Vizenor (1994, 33) tells us of this process of reconstruction and invention: "Sacred names, those secure ceremonial names, were scarcely heard by missionaries and government agents and seldom translated as surnames; nicknames were assured in tribal stories, but the stories were lost in translation as surnames. Later, most surnames were chosen and dictated at federal and mission schools. Some tribal names endure in stories, and nicknames are identities learned and ascertained in language. Moreover, descriptive names seem to be more esteemed in translation, and certain choices of names are mere simulations with no memories or stories."

Old names are uttered and new names are formed in the experience of everyday life and the ideological struggles of continually-constructed identity and community. These names speak the reality of the personal and the public in the discord of lived experience. Again, Rayna Green (1984, 5) speaks of the emergent discourse of Native American popular culture:

> Spending so much time with women from other tribes—in Indian school and now in the city—gives her even more stories and names—so many she doesn't remember what tribe they came from anymore. She thinks the names belong to her now, and she's right. Clan Mother, White Buffalo Calf Woman, Beloved Woman, Early Morning Woman, Night Wind Woman, Earthwoman, Corn Mother, Iyetiko, Persimmon Woman, Rainwater Woman, Grandmother Turtle, White Shell Woman, Ohlone Woman, Brave-Hearted Woman, Spider Woman, The Woman Hanging from the 13th Floor Window, Suicid/ing (ed) Indian Women, the Pueblo Woman Who Got Down in Brooklyn. She knows her names now, just the way she knows the places and languages she wasn't born to. But every time she starts to tell a story, she remembers more, as

though she'd always known. The way she'd always known the laughter and the trouble. Sometimes, she chants them over to herself, the way she'd sing a song. Just for the comfort of it, especially when things get bad or when she feels really out of touch with what Grandma calls "Indian-ness."

The names and social imaginaries which seem to historicize as they circulate in Indian Country are wrenched into the social fray of present cultural and ideological difference and the dislocations of poverty and place. The "contrivance of names" (Vizenor 1994, 11) appears to signify some pristine spiritual experience whose power lies in the practice of the private, even secret, or the words of ceremonies. But these names are public expressions of popular culture that, when they are voiced in the lived experience of the Indian struggle with the continually-colonizing other, emerge as a call to collective identity. In N. Scott Momaday's (1976, 61) words, "Memory begins to qualify the imagination, to give it another formation, one that is peculiar to the self." What might be called "storied memory" defines Indian Country in a mixture of metaphorical and actual experiences that join with contested attributes like color, language, bloodline, and tribal enrollment, to stake the claim to being Indian. This storied memory reconstructed in the context of absorbing and opposing white culture forges the trajectories of Native American identity and community.

The names that reoccur in this storied speech which works to build, reconstruct, and realign community are voiced by Native Americans in the mystifying, but familiar discourse of persons, places, phenomena, and objects. "The names at first are those of animals and of birds, of objects that have one definition in the eye, another in the hand, of forms and features on the rim of the world, or of sounds that carry on the bright wind and in the void. They are old and original in the mind, like the beat of rain on the river, and intrinsic in the native tongue, failing even as those who bear them turn once in the memory, go on, and are gone forever" (Momaday 1976, 3).

These names signify power and knowledge articulated to the land in interwoven constructions of the ordinary and the anthropomorphic: human and mythical persons; historical and spiritual places; ordinary and legendary objects; physical and environmental phenomena. For the Chippewa, this discourse with the land and the other-than-human beings with whom they communicate is expressed sometimes in fear or desire or hope, sometimes in practice; but always in the hybrid discourse of contemporary re-telling. Keeshkemum (in Warren 1885: 373), hereditary chief of the Lac du Flambeau Chippewa in the 1880s, responded to the questions of British military officers "with a personal dream song that has become one of the common stories of tribal liberation" (Vizenor 1993, 9): "Englishmen! You ask me who I am. If you wish to know, you must seek me in the clouds. I am a bird who rises from the earth, and flies far into the skies, out of sight; but though not visible to the eye, my voice is heard from afar and resounds over the earth!"

Today, Ron Geyshick (1989, 13), an Ojibway elder from Ontario, speaks of his experience of Indian spirituality: "I know living inside me are two moose and two

164 deer, a few butterflies, and the Lord in my heart." Sarain Stump (1974) writes, "Great
names I heard in the dark of the night, but a name can't steal the bear's child." And
Joy Harjo (in Green 1984, 132) writes,

> A woman can't survive
> by her own breath
> alone
> she must know
> the voices of the mountains
> she must recognize
> the foreverness of blue sky…

Keeshkemum and Geyshick, Stump and Harjo, speak of dynamic experience
that is not about the land, but with the land and other persons who inhabit it. This
expression of a relationship with the material environment is multi-faceted, includ-
ing not only words and sounds, but a range of signs that, like Chatwin's (1988)
Songlines, emerge from the shadowed recesses of oral tradition, often translated
and written, usually by others; or inscribed on the land itself in the mnemonic
etchings of mounds, effigies, petroglyphs, and particular natural formations; or
invested in natural phenomena like wind and thunder, or mythical persons like the
man-eating Windigo and Chippewa trickster Naanabozho, "a cultural folk-hero
who disguises himself in many living things to explain and justify through imagi-
nation the conflicts of experience in tribal life" (Vizenor 1993, 155). Hallowell writes
of the difference between Ojibway and English-language representations of the ani-
mate and inanimate, noting that, for the Ojibway, "trees, sun and moon, thunder,
stones, and objects of material culture like kettle and pipe—are classified as ani-
mate'" (1960: 22–23). It is the reconstruction of animals, mythical characters, and
features of the physical environment as *persons*—named and equally involved with
people of the past and the present—which, like sacred places, situates Native
American identity and locality.

Politicizing Stories

This sense of the spiritual as mystical experience framed in a "deep and singular
encounter" establishes "the intrinsic power of sacred ground (that) is often ineffa-
ble and abstract" (Momaday 1995: 29). This power beyond words seems to tran-
scend definition, comprehension, and analysis; but it signifies meaning and identity
in experience: memoried, imagined, or real. The vagueness of discourse allows con-
structions of the sacred as political and forms its articulation to territory. Momaday
(ibid.) tells us, "Sacred ground is in some way earned. It is consecrated, made holy
with offerings—song and ceremony, joy and sorrow, the dedication of the mind
and heart, offerings of life and death. The words 'sacred' and 'sacrifice' are related.
And acts of sacrifice make sacred the earth."

Indian heritage is empowered in sacrifice: the pain of the past endured in the
silence of ancestors about whom others speak; the distress of the present voiced in

stories. This sense of sacrifice fuses territory and sacred ground in narratives that accommodate "the perpetual need to create, conserve, and re-create political spaces" (Keith and Pile 1993: 37). Political spaces are formed in the affectivity and spirituality of names and journeys of land that are renamed and reclaimed.

What Deloria and Lytle (1984, 236) call the "consolidated Indian movement" of "ethnic Indians," as opposed to "tribal Indians," began in the cities of Indian country in the 1960's and '70's and persists today; and they contend that "the merging of many tribal identities and histories in the urban setting meant the adoption of a common, albeit artificial heritage": "The 1868 Sioux treaty became regarded as the common property of all Indians, and when the Indian college students of varying tribal backgrounds invaded Alcatraz Island in San Francisco Bay, and later Fort Lawton near Seattle, they laid claim to these pieces of federal surplus property under that treaty. The claim was mythological and depended primarily upon the memory and oral tradition carried forward by the traditional people among the Sioux" (ibid., 234).

Tribal and ethnic identities are expressed in differing approaches to cultural specificity and political process. And even as Indians move back and forth across the perforated borders of identities, differing discourses of political possibility are formed and enacted. Conflict emerges between tribal trust in the moral possibility of American institutions to redress Indian inequities, and the pragmatic realism that Indians assert in political strategies (ibid., 242). This friction in Native American communities is encased in differing narratives of dominance and survivance: the efficacy of casinos; the authority of tribal and traditional governments; the struggle over membership; the pronouncements of policy; the traditions of religion; the strategies of protest. But these narratives also reveal a common thread of knowledge and power from the past. Land articulated to spirituality does not suggest a simple synthesis; but it does express common referents in the word games of Indian performance. John Trudell (in McLuhan 1994, 423–24), a spokesman of the American Indian Movement during the Wounded Knee occupation of 1973, speaks of spirituality and the land at the Survival Gathering organized by the Black Hills Alliance in 1980:

> We are a natural part of the Earth. We are an extension of the Earth; we are not separate from it. We are part of it. The Earth is our Mother. The Earth is a Spirit, and we are an extension of that Spirit. We are Spirit. We are Power. They (the white power structure) want us to believe that we have to believe in them, and depend upon them, and we have to assume these consumer identities, these religious identities, and these racial identities. They want to separate us from our Power. They want to separate us from who we are…. They can't stop power. We have a spiritual connection to the Earth and collectively, we have the same power as the Earth-quake, the Tornado, the Hurricanes. We have that potential. We have that connection…. And All Our Ancestors, All Our Relations who went to the Spirit World, they are here with us. They have power. They will help us to see if we are willing to look. We are not separated from them because there is no place to go. This is our place, the Earth. This is our Mother.

166 Today, Ovide Mercredi (and Turpel 1994, 107), Grand Chief of the Assembly of First Nations of Canada, speaks of "Self-government as a way to heal"; and Matthew Coon Come (1995: 18), Grand Chief of the James Bay Cree, says simply, "Our land is our memory. Everything has a story."

Contingent formations of Indian identity and community are negotiated in the stories of sacrifice and survival—remembered, appropriated, and invented. In the ambiguous borderlands of urban and reservation experience, Indians express a primary attachment to the land, not the state (Tanner 1983: 27); and self-determination conflated with the land takes on many guises. It is the practice of Spring spearing and the protection of Indian casinos; the rejection of hydro projects and the refusal of Indian out-group adoption; the growth of "Indian Way" and "Survival" schools; the rights to resources, land, treaty benefits, and traditional government; and the protests involving logging, mining, and fishing; all discursively expressed in the vague spirituality of a singular relationship with the land. This relationship is the basis for an Indian ideology that is their most effective political resource in negotiations with each other and the state.

With their small population and meager financial means, it is this ideological stance, this "difference," that distinguishes Native Americans in the minds of both Indians and others. The ideology of aboriginality, which circulates in the representations of anthropologists and ecologists, New Agers and producers of popular culture, continually renews the moral argument articulated by Native Americans themselves. Indian resistance is cultural persistence; and it is voiced in strategies of direct and indirect opposition. In the discourse of spirituality articulated to the land, Indians have become, as Paul Chaat Smith (1995) puts it, "shape-shifters for the national consciousness." From this position, Indian "spiritness" asserts the promise of political autonomy, economic possibility, and cultural survival. Momaday (1972: 39) writes: "By means of words can a man deal with the world on equal terms. And the word is sacred. A man's name is his own; he can keep it or give it away as he likes."

The vague consciousness expressed in narratives of survival and dominance is not a paradigm for Native American cultural construction of the land. But these narratives do access the meaning of Native American environments in the very process of transforming traditionalism. Indian discourses of the land affirm that space is cognitively and politically marked in metaphorical and real expressions of politics and ideology. The meaning of land is negotiated in the context of "a politicized consciousness and a radical spacial praxis" (Soja in Keith and Pile 1993: 5).

In the narratives that circulate today, Sacajawea remains romanticized as the "guide" of the Lewis and Clark expedition. Her experience is impossible to retrieve. The meaning of her presence, which must have signified to Indians that this group of men, traveling with a woman and child, was not a war party, is unspoken. Like the bullet holes in the obelisk that bears her name, "the monument stands, the plaque calls her the expedition's guide, and the public [including Indians] considers anything that says otherwise vandalism" (Duncan 1987, 165). As Paul Chaat Smith (1992:99) says, "We are hopelessly fascinated with each other, locked in an

endless embrace of love and hate and narcissism. Together we are condemned, forever to disappoint, never to forget even as we can't remember."

References

Allen, Paula Gunn (1986) *The Sacred Hoop: Recovering the Feminine in American Indian Traditions*. Boston: Beacon.

Andrews, Lynn (1981) *Medicine Woman*. New York: Harper and Row.

Barnouw, Victor (1950) "Acculturation and Personality Among the Wisconsin Chippewa." *Memoir of the American Anthropological Association*, 72.

Benton-Banai, Edward (1988) *The Mishomis Book: The Voice of the Ojibwa*. St. Paul, Minnesota: Red School House.

Berkhofer, Robert F., Jr.(1978) *The White Man's Indian*. New York: Vintage.

Berland, Jody and Jennifer Daryl Slack (1994) "On environmental matters." *Cultural Studies* 8 (1): 1–4.

Bevis, William (1987) "Native American Novels: Homing In." In *Recovering the Word: Essays on Native American Literature*. Ed. Brian Swann and Arnold Krupat. Berkeley: University of California Press.

Boas, Franz (1974 c. 1888) *The Central Eskimo*. Toronto: Coles.

Boyarin, Jonathan (1994) "Space, Time, and the Politics of Memory." In *Remapping Memory*. Ed. Jonathan Boyarin. Minneapolis: University of Minnesota Press.

Bredin, Marion (1993) "Ethnography and Communication: Approaches to Aboriginal Media." In *Canadian Journal of Communication* 18 (3) (Summer): 297–313.

Brody, Hugh (1981) *Maps and Dreams*. Harmondsworth, Middlesex, England: Penguin.

Carter, Forrest (1976) *The Education of Little Tree*. New York: Delacourte Press.

Castaneda, Carlos (1968) *The Teachings of Don Juan: A Yaqui Way of Knowledge*. Berkeley: University of California Press.

Chappell, E. (1970 c. 1817) *Narrative of a Voyage to Hudson's Bay*. Toronto: Coles.

Chatwin, Bruce (1988) *The Songlines*. Harmondsworth, Middlesex, England: Penguin.

Churchill, Ward (1992) *Fantasies of the Master Race: Literature, Cinema and the Colonialization of American Indians*. Monroe, Maine: Common Courage Press.

Clifford, James (1986) *Writing Culture: The Politics and Poetics of Ethnography*. Berkeley: University of California Press.

———. (1994) "Diasporas" in *Cultural Anthropology* 9 (3): 302–38.

Cohen, Barri (1994) "Technological colonialism and the politics of water." *Cultural Studies* 8 (1): 32–55.

Coon-Come, Matthew (1995) *Maclean's* (February 27). Toronto.

Cumming, P.A. and N.H. Mickenburg (1972) *Native Rights in Canada*. Toronto: Indian-Eskimo Association of Canada.

de Certeau, Michel (1986) *Heterologies: Discourse on the Other*. Minneapolis: University of Minnesota Press.

Deloria, Vine Jr. and Clifford M. Lytle (1984) *The Nations Within: The Past and Future of American Indian Sovereignty*. New York: Pantheon.

Densmore, Frances (1910) "Chippewa Music, I" *Bulletin of the U. S. Bureau of Ethnology*, 41.

———. (1929) "Chippewa Customs." *Bulletin of the U.S. Bureau of Ethnology*, 86.

Duncan, Dayton (1987) *Out West: American Journey Along the Lewis and Clark Trail*. New York: Viking Penguin.

Feit, Harvey (1973) "The Ethno-ecology of the Waswanipi Cree: Or How Hunters Can Manage Their Resources." in *Cultural Ecology: Readings on Canadian Indians and*

168 *Eskimos*. Ed. Bruce Cox. Toronto: McCelland and Stewart.

Fox, Chief Red (1971) *Memoirs of Chief Red Fox*. New York: McGraw-Hill.

Geertz, Clifford (1983) *Local Knowledge: Further Essays in Interpretive Anthropology*. New York: Basic Books.

Green, Rayna, ed.(1984) *That's What She Said: Contemporary Poetry and Fiction by Native American Women*. Bloomington: Indiana University Press.

────. (1976) "The Pocahontas Perplex: The Image of Indian Women in American Vernacular Culture." *The Massachusetts Review* 16 (4).

────. (1992) "Rosebuds of the Plateau: Frank Matsura and the Fainting Couch Aesthetic." In *Partial Recall: Photographs of North American Indians*. Ed. Lucy R. Lippard. New York: The New Press.

Geyshick, Ron (1989) *Te Bwe Win: Truth*. With Judith Doyle. Toronto: Summerhill Press.

Gupta, Akhil and James Ferguson (1992) "Beyond Culture: Space, Identity, and the Politics of Difference." *Cultural Anthropology* 7 (1) (February): 6–23.

Hallowell, A. Irving (1960) "Ojibway Ontology, Behavior, and World View." In *Culture in History*. Ed. S. Diamond. New York: Columbia University Press.

────. (1967) *Culture and Experience*. New York: Schocken Books.

Hamilton, Charles, ed.(1972) *Cry of the Thunderbird*. Norman: University of Oklahoma Press.

Harjo, Joy (1992) "The Place of Origins." In *Partial Recall: Photographs of North American Indians*. Ed. Lucy R. Lippard. New York: The New Press.

Highwater, Jamake (1981) *The Primal Mind: Vision and Reality in Indian America*. New York: New American Library.

Howard, Harold P. (1971) *Sacajawea*. Norman: University of Oklahoma Press.

Johnston, Gordon (1987) "An Intolerable Burden of Meaning: Native Peoples in White Fiction." In *The Native in Literature*. Ed. Thomas King, Cheryl Calver and Helen Hoy. Oakville. Ontario: ECW.

Keith, Michael and Steve Pile (1993) "Introduction Part 1: The Politics of Place." In *Place and the Politics of Identity*. Ed. M. Keith and S. Pile. New York and London: Routledge.

Limerick, Patricia Nelson (1987) *The Legacy of Conquest*. New York: W.W. Norton.

McLuhan, T. C. (1994) *The Way of the Earth*. New York: Simon and Schuster.

McNickle, D'Arcy (1978) *Wind From an Enemy Sky*. San Francisco: Harper and Row.

Mercredi, Ovid and Mary Ellen Trupel (1993) *In the Rapids: Navigating the Future of First Nations*. Toronto: Penguin.

────. (1972) *Touch the Earth: A Self-Portrait of Indian Existence*. New York: Pocket Books.

Momaday, N. Scott (1995) "Sacred Places" in *Aboriginal Voices* 2 (1): 28–29.

────. (1976) *The Names*. New York: Harper and Row.

────. (1972) "A Word has Power." In *The Way: An Anthology of American Indian Literature*. Ed. Shirley Hill Witt and Stan Steiner. New York: Vintage.

────. (1969) *The Way to Rainy Mountain*. Albuquerque: University of Mexico Press.

────. (1966) *House Made of Dawn*. New York: Harper and Row.

Moody, Roger, ed.(1988) *The Indigenous Voice: Visions and Realities*. London and New Jersey: Zed Books.

Morison, S.(1971) *The European Discovery of America: The Northern Voyages*. New York: Oxford University Press.

Nofz, Michael P. (1987) "Treading Upon Separate Paths: Native American Ideology and Marxist Analysis." In *Sociological Inquiry* 57 (3) (Summer): 223–36.

Ridington, Robin (1990) *Little Bit Know Something: Stories in a Language of Anthropology*. Vancouver: Douglas and McIntyre.

Rosaldo, Renato(1989) *Culture and Truth*. Boston: Beacon.

Rothenberg, Jerome (1972) *Shaking the Pumpkin: Traditional Poetry of the Indian North Americans.* Garden City, N.Y.: Doubleday.

Said, Edward W. (1978) *Orientalism.* New York: Vintage.

Seattle, Chief (1991) *Brother Eagle, Sister Sky: A Message from Chief Seattle.* New York: Dial Books for Young Readers.

Silko, Leslie Marmon (1977) *Ceremony.* New York: Signet.

Smith, Paul Chaat (1994) "Home of the Brave." In *C Magazine* (Summer): 32–42.

———. (1995) "Fables of the Destruction: Mistaken Identities and New Inventions." Public readings. Oboro Gallery. Montreal, Quebec. March 9.

———. (1992) "Every Word Tells a Story." In *Partial Recall: Photographs of North American Indians.* Ed. Lucy R. Lippard. New York: The New Press.

Speck, Frank G.(1972 c. 1915) "The Family Hunting Band as the Basis for Algonquin Social Organization." In *Cultural Ecology.* Ed. Bruce Cox. Toronto: McClelland and Stewart.

Stefansson, V. (1947) *Great Adventures and Explorations: From the Earliest Times to the Present as Told by the Explorers Themselves.* New York: Dial Press.

Stump, Sarain (1974) *There is My People Sleeping.* Sidney, British Columbia: Gray's Publishing.

Swann, Brian and Arnold Krupat (1987) *Recovering the Word: Essays on Native American Literature.* Berkeley: University of California Press.

Tanner, Adrian (1987) "The Significance of Hunting Territories Today." In *Native People Native Lands.* Ed. Bruce Alden Cox.

———. (1983) "Canadian Indians and the politics of Dependency." In *The Politics of Indianness: Case Studies of Native Ethnopolitics in Canada.* Ed. A. Tanner. St. John's: Institute of Social and Economic Research, Memorial University of Newfoundland. 1–35.

Tilly, Charles (1994) "Afterward: Political Memories in Space and Time." In *Remapping Memory: The Politics of Time and Space.* Ed. Jonathan Boyarin. Minneapolis: University of Minnesota Press.

Valaskakis, Gail Guthrie (1988) "The Chippewa and the Other: Living the Heritage of Lac du Flambeau." In *Cultural Studies* 2 (3) (October): 267–93.

Viola, Herman J. (1981) *Diplomats in Buckskins: A History of Indian Delegations in Washington City.* Washington, D.C.: Smithsonian Institution Press.

Vizenor, Gerald (1994) *Manifest Manners: Postindian Warriors of Survivance.* Hanover, New Hampshire: Wesleyan University Press.

———.(1993) *Summer in the Spring: Anishinaabe Lyric Poems and Stories, New Edition.* Norman and London: University of Oklahoma Press.

———.(1972) "Songs of the People (Anisinabe Nagamon)" In *The Way: An Anthology of American Indian Literature.* Ed. Shirley Hill Witt and Stan Steiner. New York: Vintage.

Warren, William (1885) "History of the Ojibways." *Minnesota Historical Collections,* 5.

Welch, James (1979) *The Death of Jim Loney.* New York: Harper and Row.

White, Richard (1984) "Native Americans and the Environment." In *Scholars and the Indian Experience.* Ed. W. R. Swagerty. Bloomington, Indiana: University of Indiana Press.

7

CULTURAL STUDIES AND THE CHALLENGE OF SCIENCE

I

When future historians, as the cliché goes, survey the modern versions of the division of knowledge, what will seem most anachronistic? One of the likely contenders will be the strong pact by which the empirical pursuit of reason, at one end of the field, was guaranteed immunity from socio-political scrutiny at the same time as the ethical realm of values, at the other end, was relieved of any obligation to respond to advances in scientific knowledge. This entente proved to be the source of the dominant traditions of inquiry in the natural sciences and the humanities for most of the 20th century. Science would undertake to provide neutral, public knowledge in a value-free setting so that humanists could grapple with the corrosive, contradictory life of social, cultural, and political issues in a milieu barred to technical experts; and vice versa.

For different reasons, this entente worked to the advantage of both traditions, reaffirming core elements of their respective professional ethics. Arguably, the greatest value has accrued to managerial elites, whether in the academy, in business, or in politics, who have benefitted from the separation of the realm of facts from that of values: administrative control can be established with ease once employees or subjects have acknowledged the principle of "that's not my depart-

ment." But the mutual pact also meant different things at different times. Robert Proctor has described, for example, how the social sciences initially sought the value-free imprimatur of science—Weber's *Wertfreiheit*—in order to build a protective neutrality zone against political coercion, primarily from the right, since sociology was perceived first as a socialist, and then, by the Nazis, as a Jewish discipline. The value-free neutrality of this paradigm had an especial appeal to the American academy in the "end of ideology" period of the Cold War. For its critics, the ascendancy of the principle of *Wertfreiheit* over the course of the next two decades came to signify political quietism in the social sciences, and selling one's skills to the highest bidders in the natural sciences (Proctor, 1991). In the humanities, a cognate set of "self-evident" principles of taste—crystallized in the concept of the literary "canon"—encouraged a formalist dogma whose death throes engendered the bitter spectacle of the Culture Wars in political life at the end of the 1980s. The powerful Cold War consensus that had ruled out of court any attention to the institutional arrangement or social conditions of knowledge did not end with a whimper.

So when C.P. Snow issued his famous midcentury complaint about the increasing divergence of the "two cultures," he was describing a condition that was not so much tendential as contractual (Snow, 1959). And since science had long since become the dominant civil authority in society, there was no real symmetry in this arrangement. While humanists preferred to think of the field of knowledge as an even spectrum, running from hard sciences to the fine arts, logical positivists of the Vienna circle reflected the much greater cultural power of abstract reason in their topographical choice of a hierarchy, with physics at the very top. Accordingly, for Snow, and those who swallowed his story about the two cultures, the burden of education fell, not upon scientists, but upon humanists whose alleged technophobia had made them anachronistic legatees of a Romantic past, ill-equipped to face the challenge, technocratic or otherwise, of the future. For too long, Snow's fellow British intellectuals had followed William Blake's thunder, and paid too little heed to what Harold Wilson would shortly come to call the "white heat of the technological revolution." While Snow's polite thesis almost immediately became part of the folklore of intellectual life, there was little evidence that science was taken any more seriously as a cultural force. Speaking from the heart of the radical science movement in the early 1970s, Hilary Rose and Steven Rose lamented that there had been virtually no discussion of science's *cultural* role in central New Left history surveys like Raymond Williams's *The Long Revolution* or Perry Anderson's *The Components of the National Culture* (Rose and Rose, 1976, 13). In the more pragmatic U.S., things were little better. Scan the writings of the New York Intellectuals, or the more academic tracts of postmodernism and multiculturalism in the 1970s and 1980s, and sustained engagement with the institutions of science is thin on the ground, despite feminism's sweeping indictment, during the same period, of the long history of biological and medical disciplining of women.

In recent years, however, it is not the education of humanists but the education of scientists that has been questioned. Fears about "scientific illiteracy" are now

more often applied, as Sandra Harding puts it, to the "Eurocentrism and andro-centrism of many scientists, policymakers and highly educated citizens" with an outcome that "severely limits public understanding of science as a fully social process." Such influential people, she argues, need "a kind of scientific educa-tion"—rooted in social experience—"that has not been available to them" (Harding, 1995, 1). Indeed, the cloistered scientist, shielded from self-critical knowl-edge about the social origins and conditions of his or her instruments, empirical methods, and research applications, has emerged as a much greater danger to our social and environmental survival than the cloistered humanist. In view of the restructuring of our business civilization around the future of technoscience and biomedicine, the narrow, technical education of a small number of Western scien-tists has far reaching consequences for everyone else. The long history of science serving as the handmaiden of militarism and capital accumulation may only be a prelude to the role being cast by today's corporations for their own technoscientif-ic workforce and their subcontracted hands in the academy. Indeed, the social edu-cation of scientists is increasingly seen as one of the more important pedagogical tasks of the day.

Does cultural studies have some part to play in this education? The knowledge that science is not only socially determined but also culturally specific has a mod-ern scholarly lineage that dates back at least to the famous paper given by Soviet historian of science Boris Hessen at a London conference in 1931, in which he demonstrated how Newton's *Principia* responded to the emergent needs of British mercantile capitalism: particularly in the areas of transportation, communications, and military production. This knowledge was subsequently drawn out in the work of J. D. Bernal, J. B. S. Haldane, and Joseph Needham. The externalism of these British Marxists was displaced and depoliticized in the Mertonian school of the sociology of science and in Kuhn's influential volume on scientific revolutions, and then revived in a more empirical form in the 1970s movement known as SSK (soci-ology of scientific knowledge), with its many factional variants (Edinburgh, Bath, Paris, York, Tremont) and recent offshoots. The radical science movement that grew out of the anti-war movement in the late 1960s established "science for the people" as a rallying cry, while the U.S. academic field of STS came to maturity with its less radical, vocational agenda of democratizing technoscience. Today's bur-geoning field of science studies is driven by assumptions and principles that are consonant with cultural studies, and includes prominent practitioners, mostly fem-inists, who are quite comfortable working under, or adjacent to, the rubric of cul-tural studies. Indeed, the watchword of "science as culture" (also the name of the splendid journal that succeeded the *Radical Science Journal*) has come to be an eclectic rubric, including not only ethnographic attention to the minutiae of sci-entific culture, and the analyses of the role of science and scientific authority in the culture at large, but also interventions in matters of science policy and ideology. This is the point at which the broad tradition of cultural studies meets up with developments in science studies—when a continuum of power is established between the interests of the state and the expressive, daily realm of rituals.

174 The most consistent origin story for cultural studies describes it as the adul-
terated offspring of an insurgent sociology in revolt against Parsonian function-
alism, and a "left-Leavisite" cultural criticism (minus the high cultural elitism),
pledged against what F. R. Leavis had called "technologico-Benthamite civiliza-
tion" and its rule of utilitarian reason. In this account, cultural studies has always
been in flight from particular forms of instrumental reason, although not from
rationality as such. Nonetheless, the cause it has primarily pursued—that of cul-
tural politics—has often been trivialized, on the hard left, as a displacement of
"real" politics, and, ultimately, as a dangerous immersion in the destructive ele-
ment of unreason—the stuff of nationalism, fascism, imperialism, and capitalist
commodification. According to this view, which has deep roots in the doctrine
of "scientific socialism," the path of progressive politics is an insuperably ratio-
nal development, whose objective processes are contaminated by attention to the
"subjective" factors posed by cultural issues. In the wake of the Culture Wars,
which have propelled cultural issues and values to the forefront of the New
Right's political agenda, this position, often described as "unreconstructed,"
seems especially untenable. Consequently, cultural politics has emerged as legit-
imate, unavoidable, and indispensable. At least one outcome of the face-off
between mono- and multi-culturalists is the recognition that people feel their
right to cultural respect and civility as strongly as they feel their right to the ben-
efits of a social wage. Consequently, full citizenship has come to be seen as a cul-
tural, as well as a socio-economic, achievement.

What does this account of citizenship have to learn from cultural studies of sci-
ence? Adherence to scientific reason is a constituent element of cultural belief in
advanced industrial societies, even in countries like the U.S. where a vast portion of
the population also believes that the world was created in six days. The authority of
science is thus a central vehicle of consent in a technocratic democracy. This
authority is exercised largely through appeal to expertise, from the dismal science
of the economists at the commanding heights of the corporate state to the routines
followed by technological dead labor in the workplace. Where scientific reason is
the dominant cognitive authority, its cultural and economic role in maintaining a
social system of inequalities must be open to analysis and to reform in ways that
go far beyond internalist adjustments and purifications. While the value-free neu-
trality of the scientific method is the legitimating basis for empowered forms of
technical expertise, scientists themselves rarely feel personally or professionally
responsible for any of the social or political uses of the name of science. The divi-
sion of labor that accompanies value-free ideology—"that's not my department"—
means that scientists have been able to disavow knowledge about the social origins
or applications of their research. The model for this division of labor, of course,
was the archetypal example of the "abuse" of science—the Manhattan Project,
where the specialized allocation of research tasks preempted any knowledge on the
part of individual participants about the overmanagers' mission.

The state's utilitarian endorsement of the ideology of "value-free science" has
long been a source of criticism and activism, and most egregiously in a period

when so many of the world's scientists have been involved in military research or its spin-off industries. Yet many scientists charge that the criticism of scientific research and its results is often uninformed or non-specific. In the 1970s, this complaint met with an empirical response in the "descriptive turn" of the SSK school, represented in the work of Barry Barnes, David Bloor, Steve Shapin, Michael Mulkay, and Harry Collins, and followed by Nigel Gilbert, Joan Fujimura, Ian Hacking, Eric Livingston, Trevor Pinch, Sal Restivo, Nancy Cartwright, David Gooding, and others (Pickering, 1992). Rather than study the products of science, or scientists' own representations of science, the strong program of SSK endorsed the rigorously sociological study of science in practice, through first-hand observation. This empirical approach generated research in three main genres: studies of scientific controversies (e.g. Collins, 1985); historical studies (Barnes and Shapin, 1979); and ethnographic accounts of laboratory procedures, such as Bruno Latour and Steve Woolgar's *Laboratory Life* (1979), Karen Knorr Cetina's *The Manufacture of Knowledge* (1981), Michael Lynch's *Art and Artifact in Laboratory Science* (1985), and Sharon Traweek's *Beamtimes and Lifetimes* (1988). Such studies, identifying the role played by social interests in every aspect of research, demonstrated that scientific knowledge is not given by the natural world, but is produced or constructed through social interactions between/among scientists and their instruments, and that these interactions are mediated by the conceptual apparatuses created in order to frame and interpret the results. The knowledge produced is often so local and context-specific that it only makes sense in relation to the laboratory instruments, modes of analysis, and specialized textual practices engineered within a specific field.

The result of this kind of attention has been a more systematic description of "science in action," better equipped to demystify scientists' perception that their research laboratories and working communities are value-free zones. Each zone, in turn, came to be seen as an intersection of various belief systems, patched together to form a seemingly coherent whole. But the relativism inherent in the descriptive turn was much criticized as a theory that ultimately declared the sociological equivalence of all beliefs, whether true or false according to internal or external criteria. It did little, as Steve Fuller has argued, to dislodge the elitist perception that only scientists can do science, and it shied away from all normative or evaluative analysis that might produce change in scientific institutions (Fuller, 1992, 390-428). In opting for a program of social realism that eschewed value-laden or moralistic critique, SSK's passive "explanation" of science's social and cultural construction was open to charges of quietism. Contrary to the positivist view of science which stressed the universality of scientific knowledge, SSK demonstrated that there was little distinctive to differentiate science from other social activities. But this evidence could not in itself lead to alternative ways of doing science. Nor would it suggest alternative criteria (i.e. other than these framed by the needs of the military, capital, or the state) to judge the successes and failures of science. Only normative critiques could change the status quo.

It could be argued that a similar set of concerns accompanied the ethnograph-

ic turn in cultural studies, coming, as it did, at a point where excessively abstract theorizing about "spectators" and "readers" had devolved attention away from the contexts in which people actually utilized culture. Turning its back on the long history, within cultural theory, of moralizing assumptions about the behavior and beliefs of "the masses," cultural studies tried to relinquish patronizing value-judgements, sought to renounce recruitism, and vowed to find out instead what real people said, thought, and did in their lived environments. The powerless and disenfranchised turned out to be creative, diverse, and, yes, resistant in response to the media flow in which they had been immersed. Intellectuals found a way to salve their separation from the popular classes, and in doing so, found a refuge from the pressures of bourgeois taste. And a much greater understanding of the processes of cultural consumption emerged. As in the case of SSK, criticism of this ethnographic turn appeals to the need to recommend and exhort alternatives to the status quo. Eschewing value-judgements (suspending opinions about whether cultural texts were good or bad) meant that critics also gave up the authority to demand change, a dereliction, in some respects, of the tradition of the "responsibility of intellectuals."[1] Since normative judgements of taste were hardly absent from the realm of popular opinion itself, the cultural studies classroom, as Simon Frith recently points out, became virtually the only place where the act of passing value-judgements was more or less prohibited (Frith, 1996). By contrast, conservative intellectuals picked up the baton, and have been running away with the "values" contest. Accordingly, this critique of the ethnographic phase of cultural studies has been largely responsible for the emergence of the new cadre of "public intellectuals," pursuing the limited access available in the public, non-academic media to left-wing intellectuals.

In accord with similar developments in science studies, that part of cultural studies that has concerned itself with state policy, (primarily in Australia, and, to a much lesser extent, in the UK), finds itself inevitably compromised not only by bureaucratic calculation but also by accommodation to the "direction" of the corporate state. Attempts to redirect science policy or cultural policy towards the public interest or the service of social relevance have been obliged to abandon, or dumb down their critiques and oppositional strategies. On the other hand, the route of institutional empowerment provides opportunities for reform of policies and structures rarely open to the fiercely independent dissident.

Clearly, the mutually exclusive attractions of administrative influence and prophetic opposition pull both ways for both fields. In addition, cultural studies and science studies share the position of bridge disciplines, the former crossing humanities and the social sciences, the latter crossing social sciences and the natural sciences. So much is shared between the two fields that conservatives active in the recent Science Wars have been able to group together, in a spurious "anti-science movement," as their common antagonists, social constructionists and postmodernists in both cultural studies and science studies. (The eclectic mix of arraigned "irrationalists" also includes astrologists, ecofeminists, Afrocentrists, New Agers, and Christian fundamentalists.) Of course, there are many significant dis-

tinctions between these intellectual tendencies, but the immediate outcome of the Science Wars, as I shall discuss below, has been not only to encourage unity and alliances among these tendencies but to more clearly highlight the ideas, assumptions, and principles that lie at the core of scientific conservatism.

II

Every time I fly these days, I remind myself that I am sitting in a slightly modified bomber. After all, that is what civilian aircraft are. Sometimes, I even imagine that I am on a combat mission, in cynical sympathy perhaps, with my fellow flyers, many of whom (on weekdays, when I mostly travel to give lectures) are invariably business people, psyching themselves up for some hardball meeting with their regional peers. Most recently, I've had to think about the following, infamous statement made by Richard Dawkins in a September 1994 issue of the *Times Higher Education Supplement*: "If it gives you satisfaction to say that the theory of aerodynamics is a social construct that is your privilege, but why do you entrust your air travel plans to a Boeing rather than a magic carpet.... Show me a cultural relativist at 20,000 feet and I will show you a hypocrite" (Dawkins, 1994, 17). As Sarah Franklin has retorted, "Show me a person who denies that airplane design is a highly organized human social activity, and I'll show you an unreconstructed objectivist" (Franklin, 1995). Philosophers like Wittgenstein used the desk or table as the favored example of their ontological proofs and refutations. Currently, the airplane is a likely candidate as the object of choice in disputes within science studies. On the one hand, objectivists can invoke the irrefutability of the law of gravity, on the other, their antagonists can show how the history of entire sciences like the "pure" mathematics of aerodynamics have been determined by military needs in ballistics research and technologies. We needn't even get into the history of how Newton came to apply the metaphor of *gravitas*, originally a human attribute, to the principle of mutual attraction between bodies. The metaphor eventually died off into literalness (Young, 1993, 392).

But the choice of the airplane would also be emotionally magnified, I suspect, by the complex set of fears and anxieties associated with the experience of civilian air flight, including a response to the rituals and institutions pioneered by military usage and preserved to this day in the culture of air transport. The massive surveillance at airports, the inflight physical experience of involuntary confinement and submission to centralized commands, and the rituals of national identification that accompanies border crossing, are more evocative of military service than most routine civilian events. That terrorism is associated with air travel has as much to do with its continuity with the militarized cultural environment as with the fact that passengers are particularly vulnerable in mid-air.

The risks and fears associated with airplanes could be characterized as technophobia in the fullest sense of the term; no longer a knee-jerk reaction to the unknown world of machines, but a complex and informed response to objects and ideas within a daily environment pervaded by the sway of technoscience. This kind of technophobia has become part of our routine response to modernity, perhaps

even an intrinsic feature of modernity itself. No less complex, these days, is its manifestation in the field of knowledge. If I had to say what it is that terrorizes my students most today it would be the task of engaging with technoscientific rationality and all of its imposing institutional fortifications, a task that they nonetheless feel more responsive to than have previous generations of cultural critics. Why do they feel more responsive to meeting the critical challenges of science?

Some cynical commentators might say that it is all part of the colonizing will of cultural studies to penetrate every corner of the field of knowledge in an expansionist movement that masquerades as postdisciplinarity. Whatever truth there might be to this ambition, it would still pale beside the reductionist aspirations of science's Holy Grail of a unified theory of the natural world. When Francis Bacon announced, "I have taken all knowledge to be my province," Eurocentric science was acquiring a colonizing voice that sought universality for its particular views. Conservatives in science get nearer the mark when they see the knowledge claims of cultural studies—local, specific, and social—as contaminants, and likely to weaken and infect the core, universalist beliefs of the natural sciences in the same way as its contagion has swept through the humanities and social sciences. The viral metaphors are not mine; I cite them because they are typical of the epidemiological rhetoric utilized by science purists.

My own impression is that these students are probably not acquiescent agents of either intellectual contagion or disciplinary colonialism. To my mind, they are responding, in a much more informed way, to conditions largely created in the last two decades in which technoscience has played a conclusive role in reshaping the economic and cultural composition of most people's productive lives, especially those involving intellectual and knowledge workers. Most of these students are Internet-savvy, and are therefore proficient in the cyberculture that is emerging as the international language of the professional-managerial class, and arguably, the first *lingua franca* of business, government, and academic elites to be inaccessible to most of the population since preliterate, preindustrial times. They also know that the utopian trappings of that cybermedium may very soon be remembered only as a brief Golden Age before Disney, Murdoch, Microsoft, AT&T, and Time Warner monopolized the real estate, in accord with the privatizing rage of capital-intensive technoscience. Whatever opportunities remain for the academy and the Internet's spectrum of independents to develop a halfway-decent public sphere are more compromised by the day, and in the scarcity climate favored by national and global managers, resources will only dwindle. Our students, acutely aware of their tenuous future in the shrinking educational sector, are highly conscious of the factors driving the scarcity revolution.

As little as twenty-five years ago, it was naive, but still tenable, to ignore the pivotal contribution of universities to emergent forms of post-industrialism—in retrospect, a socio-economic revolution driven by the commercial potential of scientific R&D, managed by technocratic cadres churned out by higher education, maintained by Third World labor pools and resources, and facilitated by global economic restructuring. Indeed, the student movements of the 1960s were, in part,

prompted by a generational aversion to the prospect of being apprenticed en masse to occupy semi-professional niches in the technostructure of the corporate state and the burgeoning transnational metastate. The anti-war movements on campuses were directed at the widespread use of university facilities and resources for military research and applications—a public relations debacle for the vaunted ideology of science's disinterested ethos.

Today, your head has to be buried very deep in the sand to ignore the pervasive presence of technoscience in all of the institutional environments that house our intellectual work. I am referring not simply to the computerization of the workplace and of the professional culture of intellectual work in general. The demand for productivity at reduced wages, the erosion of benefits and job stability, the geographical dislocation of economic life, the maintenance of a swollen, reserve army of highly educated labor, widespread technological disemployment and downsizing, the privatization of public work environments and the routinization of concessions and other sacrifices at the budgetary altar of pro-scarcity politics—all of these conditions characteristic of the postindustrial economy as a whole have taken a sizeable toll upon the workplaces of higher education. While the ever-eccentric rituals and traditions of academic life serve to distribute the full impact of technological change unevenly across our campuses, most of our research universities resemble commercial laboratories more than they do ivory towers these days.

This state of affairs is a consequence of the contractual agreements forged during the 1980s that bound academic science to the industrial marketplace, and redefined universities as public institutions doing private business, patenting genetic material today, for example, like any pharmaceutical company, or else handing the patents over to the corporate sponsors of academic research as contractually required. In the Reagan-Bush years, at the height of the Pentagon's cashflow volume, basic science was forced onto the international marketplace in the name of competitiveness in war and in trade. Economic restructuring around science and technology has meant that industrial sponsorship of the academic scientific community is now a primary basis for corporate competitiveness where access to basic science is the driving force (Dickson, 1988). Under these circumstances, it is all the more necessary for boosters to prop up the old distinction between science and technology—the idea that science is the disinterested pursuit of public knowledge made internationally available at no cost and that technology alone applies to the sector of commercial product development. But in today's marketplace, it is the corporate bottom line, expressed, for example, in the golden rule of patent protection, that decides when public sharing of scientific information ends and when product development and monopoly control over profits takes over—very quickly, in most instances. The Human Genome Project has been the exemplary modern instance of this rule; even as it proceeds under the benign rubric of public enlightenment, only a dunce would bet that, in the current economic climate, it will not lead to the private ownership of life processes. Universities and corporations already hold private patents on all sorts of genetic material. The section on Trade-Related Intellectual Property Rights in the GATT agreement has, most

180 recently, guaranteed a future of biopiracy for the gene hunters of the North unmatched since the heyday of botanical imperialism.

To cut a long story short, we live and work now in conditions and environments that demand a critique of technoscience as a matter of course, as part of a commonplace response to daily life. Our students have absorbed this critical temper, not because of their proximity to campus research environments but because it has become a normalized feature of life in an advanced industrial society. Skepticism about the artifactual power harbored within the laboratories and hi-tech factories is a minimal exercise of citizenship. It forms the basis for massive public anxiety about the safety of everything from the processed food we consume to a biologically engineered future often described, in popular shorthand, as "tampering with nature." Knowledge about the risks surrounding us is unevenly shared, as a result of class and education, but it is a part of everyone's daily experience of modernity.

One of the touchstones of cultural studies is Raymond Williams's maxim that "culture is ordinary"—an everyday creative activity that everyone does. So, too, we might say that the critique of science is ordinary, exercised in a hundred little ways on a daily basis; from suspicion of the latest nutritionist advice to distrust of the first and second medical opinions; from doubts about the safety of the nearest chemical storage facility to apprehension about the latest biogenetic laboratory animal. These are routine responses, often made without prolonged reflection, but that does not make them mindless. They are invariably based upon a complex process of risk perception and risk assessment. In his influential book, *Risk Society*, Ulrich Beck has described a society increasingly characterized by the overproduction of risks, and socially organized around the power that comes from achieving and possessing a risk-free environment (Beck, 1992). In such a society, popular technoscepticism has come to replace the older semi-rational fears once associated with the term technophobia. Demonizing technology is by now a campy part of retro culture, reminiscent of a B-Grade science-fiction movie. By contrast, today's anxieties are thoroughly domestic, and so much under the skin they can no more easily be projected onto discrete objects than can boundaries be strictly maintained between the ecosphere and the technosphere. They have become part of the birthright of modernity, an offshoot of the Enlightenment rationality that fostered modern science itself.

If the critique of technoscience has come to be normalized, the same cannot be said of science itself. Science is not recognized as an ordinary activity because it is practiced by highly specialized and highly credentialed experts. So too, a consideration of who is qualified to critique science leads to no ordinary conclusion. At the very least, it requires some recognition of the priestly order that obtains within scientific institutions (wielding a power that is further concentrated and sanctified as scientific and technical knowledge attains more and more importance in society), and, on the other hand, the lay status automatically accorded to all nonprofessionals who are not involved directly in the networks of prestige that determine decision-making within science communities. This is a status as readily accepted by most of us, through science envy as much as anything, as it is exploited by those

seeking the name of science for their political purposes. Let me give you a succinct example of how both of these outcomes reinforce each other. In Stephen Jay Gould's review of *The Bell Curve* in the *New Yorker*, he noted that reviewer after reviewer in the public media confessed that he or she was not a scientist or an expert in any of the empirical fields represented in Murray and Herrnstein's book, and that they therefore did not feel qualified to judge fully the worth of the book's arguments. Gould concludes that *The Bell Curve*, though only "a rhetorical masterpiece of scientism," succeeds largely because "it benefits from the particular kind of fear that numbers impose on nonprofessional commentators" (Gould, 1994, 142). He then proceeds to tear apart the numbers in his own incisive way. Bestowing the status of a masterpiece, even of scientism, is a little overgenerous, but Gould's observation allows us to see how a smelly piece of racist welfare-bashing can succeed in cowing ordinarily feisty opinion-makers into silence simply by wheeling in some heavy statistical artillery and festooning its pages with references to science scholarship that has been fully discredited for decades. Of course, *The Bell Curve* was not written to generate debate among experts. It was designed to feed intravenously into public policy, and so few people were prepared to take a stand over its scientific validity. In the current climate, however, when the social institutions targeted by Murray are being undermined daily, it is only a matter of time before we see more concerted efforts at scientific racism, at which point critics of these ideas will be tarred with the science-bashing brush that has been so broadly applied by conservatives in the Science Wars.

III

While science boosters have seldom missed an opportunity to scare up anti-science folk devils in order to reinforce access to resources, funding, and other privileges, the origin of the current backlash can be traced to the publication of Paul Gross and Norman Levitt's book *Higher Superstition: The Academic Left and Its Quarrels with Science* in the Spring of 1994.[2] Drawing directly upon the lessons of the Culture Wars, Gross and Levitt cut a swathe through the usual PC suspects, caricaturing multiculturalists, postmodernists, and constructionists alike. The book escalated the low-level friction between conservative scientists and the science studies community. Soon after, the National Association of Scholars took up the cause, launching and coordinating a well-funded campaign to promote the backlash. In October 1994, the NAS convened its second annual conference, "Objectivity and Truth in the Natural Sciences, the Social Sciences, and the Humanities" in order to combat what it presented as the growing "denigration of science." In the words of the advertisement for the conference, this denigration, hitherto confined to "quarters outside the academy," increasingly now "comes from within" and has to be stopped because it "undermines public confidence...alters directions of research...affects funding...[and] subverts the standards of reason and truth." Another large conference, "The Flight from Reason and Truth" was convened at the New York Academy of Sciences in June 1995, and by July, the press campaign had worked its way up the media food chain from the glossy weeklies to the op-ed pages

182 of the quality dailies. By this time, proponents of critical science studies were being grouped alongside astrologists, New Age cultists, Creationists, Lysenkoists, and Nazi Aryan scientists. In the meantime, Gross and Levitt (nicknamed Love-it or Leave-it by the science studies community) and their colleagues had begun what amounted to a holy war at the risk of exhibiting all the symptoms associated with the popular stereotype of the bad scientist; arrogant, insular, self-interested, and aggressively resistant to external inquiry and public accountability.

Many factors have been cited for the sudden advent of this backlash, but most commentators agreed that the decline in funding of science, and the erosion of its popular authority combined to service the need for public scapegoats (Ross, 1996). On the other hand, it was clearly triggered by, and targeted at the influence of cultural studies within science studies. SSK, STS, History of Science, Sociology of Science, Anthropology of Science, and other disciplinary undertakings had ruffled feathers over the years. But it was the offending combination of attention to gender, race, ethnocentrism, and elite culturalism—the same potent mixture that had fuelled the Culture Wars—that raised the temperature to the boiling point. Critiques of defense funding and corporate sponsorship could always be answered by the "abuse of science" argument, i.e. humans kill, not guns. So, too, SSK critiques drew the kind of response that promised to reconstruct science from within by rendering it more objective yet in its pursuit of better knowledge through less impure procedures. At bottom, it could still be maintained in both instances that the "scientific method" was sound. This was less the case with the "science as culture" critiques, directed, as they were, at more fundamental flaws, and suggesting changes in the very epistemology of the scientific method. If everything from the socialization of scientists to the corporate structuring of research institutions has a recognizable effect upon the shaping of science, how can the purified method of experimental objectivity be declared off-limits to social inquiry and reformation? When there are so may different versions of doing science, even within the domains of Western science (the world's dominant paradigm of rational inquiry), who would dream of reserving an uncontested status for the truth claims of a unitary, abstract method? Consequently, there has been a wholesale challenge to the assumption that objectivity in science is best served by methods pursued at a distance from the social contexts in which science is applied and from the communities most affected by science. In a society so organized hierarchically by class, race, and sexuality, there is no prospect of real objectivity.

Thus Harding argues that objectivity in science would be better ensured if anti-sexist, anti-racist, and pro-democratic principles were adopted as the governing assumptions of research. Only if such moral and political programs were embraced could the prevailing anti-democratic prejudices in science be expunged (Harding, 1991). Against science's God's-eye view of nature, comprehensive and yet located nowhere in particular, Donna Haraway argues for "situated knowledge" on behalf of "embodied" perspectives of the natural world (Haraway, 1991).

Other than reiterating the bromide that science serves truth and not society, interpretations of objectivity that challenge the exclusivity of the empirical method

have mostly been answered in the Science Wars by caricature and red-baiting. The more academic response—based on the charge of technical ignorance—has been selected by Gross and Levitt as the ultimate Science Wars put-down: if you haven't solved a "first order linear differential equation," then you have no business recording your opinion on any of the pressing business that science does in society. Given the arcane authority of credentialism in a technocracy, such an argument will suffice to silence many. On the contrary, it should be seen as the kind of argument that exposes the way in which technical elites protect their privileges in a society where the most valued forms of knowledge are well nigh inaccessible to most of the population. Indeed, the use of technical expertise as a criterion to intimidate, exclude, and disenfranchise is a primary exercise of power in the knowledge society we now inhabit. If you are a nonprofessional, of course you will never know enough to satisfy your scientist interlocutors (To do so, you have to be head of a lab, with a fistful of funding, and with a good deal of clout in other places). But how much do you need to know about nuclear fission to know that nuclear reactors are an insane idea?

On the other hand, we live in times when corporations have their eyes fixed on the patent prize. Consequently, much more is at stake in these Science Wars than the self-interested status of scientists. Given the potential rewards, critique from the nonprofessional public or from non-credentialed professionals is a costly risk. And so the principle of the disinterested autonomy of scientific inquiry, voiced in the past as a protection against state interference, is more often a serviceable smoke screen today, at a time when scientific knowledge is systematically whisked out of the orbit of education and converted into private capital. The question raised earlier here—Who is qualified to critique science?—already carries set answers in a culture of expertise. One of our jobs is to turn this question around. How can science qualify *us* to sustain a critical view of society?

Notes

1 One example of this argument, from debates over the key field (for cultural studies) of TV audience studies, can be found in Brunsdon (1990), 138–55. If, in audience studies, all authority is equated with audience opinion, then the critic is rendered incapable of asking for "better" TV.

2 In the UK, Lewis Wolpert's (1992) book had played a similar, if less scurrilous, role in rebutting science studies.

References

Barnes, Barry, and Steven Shapin, eds. (1979) *Natural Order: Historical Studies of Scientific Culture.* Beverley Hills: Sage.

Beck, Ulrich (1992) *Risk Society: Towards a New Modernity.* Trans. Mark Ritter. London: Sage.

Brundson, Charlotte (1990) "Television: Aesthetics and Audiences." In Patricia Mellencamp, ed. *The Logics of Television: Essays in Cultural Criticism.* Bloomington: Indiana University Press.

184 Collins, Harry (1985) *Changing Order: Replication and Induction in Scientific Practice.* Beverley Hills: Sage.

Dawkins, Richard (1994) "The Moon is *Not* a Calabash," *Times Higher Education Supplement,* 30 (September).

Dickson, David (1988) *The New Politics of Science.* Chicago: University of Chicago Press.

Franklin, Sarah (1995) "Science as Culture, Cultures of Science," *Annual Review of Anthropology,* Vol. 24.

Frith, Simon (1996) *Performing Rites: The Aesthetics of Popular Music.* Cambridge: Harvard University Press.

Fuller, Steve (1992) "Social Epistemology and the Research Agenda of Science Studies." In Pickering, ed., *Science as Practice and Culture.* Chicago: University of Chicago Press.

Gould, Stephen Jay (1994) Review of *The Bell Curve, New Yorker,* November 28.

Haraway, Donna (1991) "Situated Knowledges: The Science Question in Feminism and the Privilege of Partial Perspective." In *Simians, Cyborgs, and Women: The Reinvention of Nature.* New York: Routledge.

Harding, Sandra (1991) *Whose Science? Whose Knowledge? Thinking From Women's Lives.* Ithaca: Cornell University Press.

Harding, Sandra (1995) "Introduction." In Harding ed. *The "Racial" Economy of Science: Toward A Democratic Future.* Bloomington: Indiana University Press.

Pickering, Andrew, ed. (1992) *Science as Practice and Culture.* Chicago: University of Chicago Press.

Proctor, Robert (1991) *Value-Free Science: Purity and Power in Modern Knowledge.* Cambridge: Harvard University Press.

Rose, Hilary and Steven Rose (1976) "The Radicalization of Science." In Rose and Rose, eds., *The Radicalization of Science: Ideology of/in the Natural Sciences.* London: MacMillan.

Ross, Andrew, ed. (1996) *Science Wars.* Durham: Duke University Press.

Snow, C. P. (1959) *The Two Cultures and the Scientific Revolution.* Cambridge: Cambridge University Press.

Wolpert, Lewis (1992) *The Unnatural Nature of Science: Why Science Does not Make (Common) Sense.* London: Faber and Faber.

Young, Robert (1993) "Darwin's Metaphor and the Philosophy of Science," *Science as Culture* Vol 3, 3.

Bruce Robbins

8

DOUBLE TIME

DURKHEIM, DISCIPLINES, AND PROGRESS

Near the beginning of his lectures on *Professional Ethics and Civic Morals* (first delivered in the 1890s but published only posthumously), Emile Durkheim voices a sentiment that academic readers will probably find unfamiliar, incomprehensible, or amusing. He laments the fact that conferences are not held more often, and he expresses the wish that they might last longer. "It is quite an exception," he says, "to find a whole group of work-ers…meeting in conference to deal with questions of general interest." "These conferences last only a short time; they do not endure beyond the special occa-sions for which they were convened, and so the collective life they evoked dies with them" (1957, 9).

Yet Durkheim's implicit interlocutors here are not academics but rather leaders of business and industry. He is attempting to sell them the scholarly conference, and academic institutional organization in general, as a form of self-discipline, a means of creating and sustaining a professional ethics that can help civilize the marketplace—or rather, can claim to do so without taking control of the market-place away from them. By means of the same argument, Durkheim is also trying to sell them and the larger public around them the virtues of the newly emergent science of sociology, which was still politically controversial and institutionally

186 fragile. In the latter aim, at least, he was quite successful. The rise of cultural stud-
ies thus far, noteworthy as it may be, hardly compares to the extraordinary takeoff
of Durkheimian social science at the end of the nineteenth and the beginning of
the twentieth century. As Terry Clark observes in his *Prophets and Patrons: The
French University and the Emergence of the Social Sciences*: "Over a period of twen-
ty years, Durkheim and his thought...rose from near obscurity to dominate the
university system to the extent that for critics he symbolized its very essence, with
all the advantages and problems that this implied (1973, 194)."

 A century later, no one accuses cultural studies of being dominated in this way
by a single charismatic individual.[1] But its upward mobility is again greeted with
that special ambivalence reserved for narratives of social ascent, whether personal
or disciplinary. One of the key issues, both for its still fluid self-conception and for
its still contested self-legitimation, is thus the unfashionable, seemingly obsoles-
cent question of progress.

 Like Durkheim's sociology a century ago, cultural studies today is perceived as
dangerously inclusive in its subject matter and admissions policy and dangerously
internationalist in its scholarly values. Yet like all protagonists of upward mobility
narratives, it too is vulnerable to the charge that it has compromised its principles
by seeking endorsement, sponsorship, or merely acceptance from the powers,
authorities, and institutions above it. And the charge is clearly not baseless. Like
Durkheim's sociology, cultural studies has much to talk about with the leaders of
business and industry. Indeed, it sometimes seems to be doing less talking than lis-
tening. It is not always as easy as one might think to distinguish a cultural studies-
style interest in patterns of consumption from that of profit-oriented market
research. To some observers, the marketplace seems to be selling its example to the
new discipline rather than the other way around. Today one is more likely to hear
the symmetrical contrary of Durkheim's complaint: that the delocalized "collec-
tive life" of the professional lecture/conference circuit, mimicking the mobility of
capital itself, takes up too much of everyone's time, and that organizers are much
too anxious to rush each and every conference into print rather than allowing most
of them to remain local, ephemeral, uncommodified.[2] If the right tends to resist
cultural studies as a hotbed of would-be subversion, the left has not hidden its sus-
picions that the institutionalization of cultural studies in conferences, anthologies,
and degree programs is already blunting its radical edge or marking an all-too-
eager submission to the logic of commodification. And for many in between, cul-
tural studies seems to have given up the relative coherence and tested procedures of
a traditional disciplinary object (literature for criticism, society for sociology, cul-
ture for anthropology) without knowing quite what to replace them with, or
indeed without *desiring* for itself anything as solid and delimited as a disciplinary
object. In a period when leaders of business and industry have been seeking mas-
sive reductions in the funding of higher education, and when even well-established
disciplines are therefore feeling sudden and shocking pressures, voluntary dispos-
session of a disciplinary object may seem a luxury no one can afford. It may even
seem like acquiescence in a sinister stratagem, deviously intended to allow univer-

sities to restructure, that is, to downsize, in the honorable name of trans-discipli-
nary innovation and fresh thought.

My premise here is that progress and the legitimation that allows it are always
sustained by complicity with power of one sort or another, but that there is no
alternative to such complicity. Thus the parallel between the legitimation and
progress of social science then and the legitimation and progress of cultural stud-
ies now seems to me worth pursuing further. In order to do so—a step that involves
rethinking some reflex suspicions toward progressiveness as such—I want to begin
by exploring the strange doubleness that Durkheim's praise of conferences reveals
in disciplinary temporality.

Cultural studies has often been criticized for its presentism, its putative lack of
curiosity about the past, even as background to present practices. It has been
accused of making itself excessively comfortable in the midst of postmodern pas-
tiche, and thus of critique-less complicity with capitalism's annihilation of memo-
ry or with capitalism *tout court*.[3] Late nineteenth- and early twentieth-century
ethnography, including Durkheim's own *Elementary Forms of the Religious Life*, has
also been criticized for its characteristic temporality. We have often been reminded,
and rightly so, of its complicity with the goals of European imperialism in the same
period. As Bernard McGrane puts it, "In the nineteenth century…it was *time*, geo-
logical time, evolutionary time, that came between the European and the non-
European Other" (1989).

It is perhaps less obvious that ethnography also produces or embodies a second,
institutional level of temporality: the temporality that includes the frequency and
duration of scholarly conferences. What is one to make of this institutional or pro-
fessional time, the time that characterizes the emergence, formation, and repro-
duction of the social sciences and that is built into such elementary forms of
disciplinary life as conferences, publications, lectures, controversies, apprentice-
ships and mentorships, part-time work and tenure tracks? What meaning, if any,
should be ascribed to the embarrassing, trivial-sounding temporalities of inter-
pretive fashion, novelty, and banality of argument, authority and challenges to
authority, the rise and fall of careers and the rise and fall of fields and subfields? I
offer the speculative hypothesis that no discipline can be accurately characterized
without some account of this "temporality of the subject" as well as, and in rela-
tion to, the more obvious temporality of its object. Johannes Fabian has devoted a
book to what he calls anthropology's "denial of coevalness," that is, "a persistent
and systematic tendency to place the referent(s) of anthropology in a Time other
than the present of the producer of anthropological discourse" (1983, 31). But what
is the value of the attention paid to the otherness of the Other's time if there is no
corresponding curiosity about "the present of the producer of anthropological dis-
course," which may not be as simple as a progressiveness from which that Other is
excluded? There has been surprisingly little to say, after all, about the actual articu-
lations between the two, articulations that may be more complicated than mere
difference or sameness. Professional or disciplinary time might of course parallel
the models of "geological" or "evolutionary" time on which these sciences are said

to have based themselves. But it might also diverge from such models in more or less significant, more or less unpredictable directions.

The possible connection between the temporality of the anthropologist subject and the temporality of the anthropological object originally suggested itself to me as a topic of investigation in regard to the Victorian novel. Attracted by a vague sense of similarity between nineteenth-century fiction and twentieth-century professionalism, I found myself wondering what connection there might be between the upwardly mobile energies of nineteenth-century fictional protagonists and the professional career-making capacity of the critics who wrote about those protagonists. This led to the speculation, apropos of Franco Moretti's book on the *Bildungsroman*, *The Way of the World*, that there might exist an inverse logic according to which the protagonist's failure and/or death, in what Moretti calls the novel of vocation, is transmuted into a sort of cultural capital for the critic, a purification and affirmation of ideals too good to be accepted by realism's actual social world and of which, therefore, the critic deviously inherits the public curatorship, thus acquiring just that sense of vocation that was withheld from the protagonist. In some sense, then, one might surmise that as belief in "progress" is blocked and/or goes out of fashion in the social world represented by the novel, it is somehow displaced or transferred into the professional world of criticism, where it can persist in disguise, although not without undergoing a sea change.[4]

Referring to H.G. Wells, Bernard McGrane writes, "Nineteenth-century anthropology is in many respects precisely a time machine" (103). But if Wells's Time Traveller is an exemplary ethnographer, as has often been pointed out, then who or what is exemplified by the all-male group of listeners clustered around him in London, at the beginning and end of the book, and who—as in the frame narrative around Conrad's *Heart of Darkness*—are largely identified by profession rather than by name? If they can be seen as figures of a not quite emergent community of professional colleagues, and thus of life on a very different time scale, they are obviously also figures for the reader or critic today. And it would seem interesting to ask whether they too belong to some temporality that compares or otherwise links up with Marlow's trip "back in time" up the Congo. Despite the similar framing by professional listeners, Wells's forward-looking text seems to have had a lesser effect on the institution of criticism; specifically, it has produced less irony, one of the most desirable currencies of disciplinary value in criticism's recent history. Is it only a Conradian trip "back in time," then, that could have permitted the accumulation of such especially valuable ironies *in and by* the professional frame story, which is to say an anti-evolutionist criticism's tapping into a rich source of capital and temporal advancement?

The model of critical progress achieved through reporting on a literary object whose progress is blocked or refused invites comparison with what James Clifford has called, in anthropology, the "salvage" paradigm (1988, 337ff). Unfortunately, the comparison cannot resolve the important question of whether there is indeed a logic linking the progress of the subject to the blockage of the object. Does the critic's, anthropologist's, or sociologist's progress indeed *require* arrest and stasis in the

characters or cultures under discussion? If there exists such a necessity, does it differ from time to time, from field to field? In *Class*, Stephen Edgell's useful volume in the "Key Ideas" series, these questions converge on a single sentence. "Sociological research on social mobility," Edgell writes towards the end of the book, "affords an excellent example of the cumulative nature of Anglo-American scientific knowledge" (100). The chapter in which this sentence occurs concludes by doubting "the generalization that during this century, upward mobility is more common than downward mobility in modern societies" (101–102). While negotiating between neo-Weberian and neo-Marxist theories of class, the book as a whole emphasizes "the tenacity of class-based patterns of inequality" (122). The one example of upward mobility that is not doubted, indeed seems only confirmed by all this complexity of argument and research, is the upward mobility, the "cumulative" advancement, of the discipline itself. But it remains to be seen whether the contrast between an upward mobility blocked in society and permitted in scholarship is really a necessary one. Could the latter have perhaps worked just as well if the research had shown the opposite, in other words that there *is* significant upward mobility in society? Or could this alternative logic only emerge in some different disciplinary constellation?

The critical tools needed to make headway with these questions remain regrettably underdeveloped. And yet the questions are urgent, for they reflect directly on the undecided identity of cultural studies. In his critique of the salvage paradigm, Clifford urges anthropologists to give up the project of rescuing whole, continuous, authentic cultures (no sooner perceived than perceived to be dying) and instead learn to recognize that such cultures make and remake themselves, "patch themselves together," search for "contending or alternating futures," discover "new ways to be different" (338). Clifford's effort is of course to liberate culture from the usual narrative of "linear development" (338). Thus, while he opens culture to time and chance, his language works hard to remove from its temporality every trace of organic continuity and progressiveness. And yet all identity presumes *some* continuity. Why should this inevitable residue of continuity not be arranged on some scale of values and priorities? The continuing adaptation and self-redefinition Clifford stresses might as easily be recoded, even or especially from the viewpoint of an interested, partisan participant, not merely as identity-in-difference but as better rather than worse, as a break from the less desirable and an embrace of the more desirable, as a development beyond and above what one already was: in short, as a striving for the possibility of progress.

And we might conclude, therefore, that the recognition of this possibility defines the emergent viewpoint of cultural studies, distinguishing it from the traditional (anti-progressive) versions of criticism and anthropology. If so, what would it imply about the still vexed issue of the legitimacy of cultural studies? Does it follow that some new, less contrary logic now links the rising authority and professional status of the practitioners of cultural studies not to the denial, but rather to the acceptance of possible progress? As yet these questions have not received any positive answers from the practitioners themselves.

The project of describing logics like this becomes all the more difficult, that is, but also all the more intriguing, from the moment—I take it to be our moment, the moment if you like of cultural studies—when disciplinary reflexivity like Clifford's ceases to be a rare exception to a disciplinary norm of supposedly unreflective routine and moves toward a central or majority position within the discipline: if not quite its universal common sense, at least part of the initial assumptions of a large portion of those graduate students now entering it. Let me take another example from within the rising genre of disciplinary self-consciousness. George Stocking's monumental history of Victorian anthropology is of course obsessed, and rightly so, with the fortunes of evolutionism. But evolutionism is not just a problem for *Victorian* ethnography. It is also a problem in the present, a problem for the self-respect and professional standing of a historian of the period like Stocking. For like the rest of us, Stocking must explicitly or implicitly offer some publicly compelling answers to the "why?" or "so what?" questions of his chosen enterprise—answers that, whether conscious or unconscious, are one of the major forces shaping our rhetoric and research. To say the obvious, anything too obvious won't work. However accurate it may be, a simple condemnation of Victorian evolutionism will have trouble answering the "why?" question compellingly. Why should anyone go to the trouble of working up to this conclusion if everyone already *assumes* that Victorian ethnography was evolutionist and that evolutionism should be condemned? Why waste your time?

The problem of legitimation that Stocking thus shares with Durkheim seems directly related, once again, to the split between two levels of temporality. As if in silent response to the pressure to justify his enterprise, Stocking tries to mitigate Victorian ethnography's too obvious guilt by supplementing the *intellectual* history of the discipline—which identifies it with evolutionism—with a bit of *institutional* history. Although "the pervasive intellectual atmosphere within the broader community constituted by the [Anthropological] Institute was in a general sense 'evolutionary,'" he writes, "[v]iewing anthropology in institutional terms, as an activity carried on within a community of investigators rather than in terms of the intellectual contributions of a few leading figures,...the paradigm metaphor...does not adequately characterize the day-to-day anthropological activity of the post revolutionary period" (268). That is, anthropology can be partially absolved of the charge of evolutionism because it was still too lacking in disciplinary coherence to *count* as a discipline: it was "an extremely various and multifocal inquiry, for which the term 'discipline' seems appropriate only in a rather loose sense" (268–69).

This is not an unusual sort of intellectual parry, but it gets more interesting when you connect it with another, less defensive statement that Stocking makes elsewhere. In the preface to the second edition of his *Race, Culture, and Evolution* (1982), when Stocking talks about changes since 1968, not in anthropology itself but in the history of anthropology, he says, with some understatement, "it is clear that the field has developed considerably" (xi). Here, notice, the "field" in question *does* cohere. There *is* a unified disciplinary subject. And, more to the point, this unified disciplinary subject can therefore enjoy a progressive history. In other words,

something like the "development" or "evolution" that is so problematic for
Victorian ethnography, as we look back at it, can now be rediscovered by Stocking
in the *history* of Victorian ethnography. As development drops out of the discipline
of anthropology itself, it is transferred (though not unchanged) to the sort of new
professional community I imagine we are, or are becoming: a scholarly communi-
ty of "reflective practitioners" whose disciplinary work includes the routine his-
toricizing of disciplines, including our own disciplines. As the nineteenth century's
overt, generalized version of progress becomes difficult to sustain, a localized, sur-
reptitious, second-order version of progress is installed in its place.

It is a fact of our intellectual times, of course, that there has been an enormous
expansion of the genre in which I am now writing, the genre of self-conscious dis-
ciplinary history and critique, skeptical from the outset of all disciplinary claims
to the advancement of knowledge. The seemingly very marketable genre of self-
reflexive books that, like Stocking's and Clifford's, offer historical, ideological, or
rhetorical analyses of particular fields, includes such titles as Thomas Haskell's *The
Emergence of Professional Social Science*; collections like *The Rhetoric of the Human
Sciences* and *The Rhetoric of Social Research* along with Donald McCloskey's *The
Rhetoric of Economics* and *If You're So Smart*; Peter Novick's *That Noble Dream* and
Sande Cohen's *Historical Culture*, both on history; Bruce Kuklick's *The Rise of
American Philosophy* and David Ricci's *The Tragedy of Political Science*. And so on.
It seems worth testing the hypothesis that, like the passages from Stocking and
Edgell above, this genre asserts disciplinary or cross-disciplinary claims to embody
an advancement of knowledge to which we are elsewhere at pains to deny all pre-
tension—in other words, that in regard to the concept of progress, scholars
involved in the linguistic and reflexive turns haven't agreed on as univocally nega-
tive a view as seems to be assumed. Once upon a time, the usual story goes, the cri-
terion of cumulative progress in scholarship was objectivity, which permitted the
illusion of an ever-closer proximity to the reality of the object. Has that illusion
been replaced with another? Has objectivity merely ceded its role to self-con-
sciousness, which now serves the new "reflexive" fields, including cultural studies,
as a less explicit marker of an otherwise similar progress? Is this the meaning of
cultural studies as paradigmatic conjunction of the (unprogressive) humanities
with the (progressive) social sciences: that a progressiveness of the subject/object
relation gives way to a progressiveness of a subject *without* an object, or rather of a
subject that takes itself for its object?

I for one would be unhappy with a simple "yes" answer to these questions, an
answer in other words that, while usefully acknowledging that progress in schol-
arship is not inconceivable, once again monopolizes progress on the side of the
subject (now characterized by self-consciousness rather than by scientific objec-
tivity) while excluding even the theoretical possibility of a progress of the object.
There is nothing populist or falsely democratic about the desire to abstract oneself
from such an economy. But I wonder whether such a case should be argued any
longer within the usual dichotomies. Which is the better description of contem-
porary culture, commodification, or democratization? Which is the better descrip-

tion of the contemporary cultural critic: populist fan, or elitist snob? To place these terms in the larger if somewhat abstract problematic of the disciplinary object is to submit them to a different, perhaps less binary set of questions. What do disciplines want or need out of their objects? How do disciplinary objects address the needs of both scholarly practice and the public or publics that confer legitimacy on or withhold legitimacy from such practice?

Within this problematic, both populism and elitism could for example be reclassified as necessary aspects of legitimation. On the one hand, the elitist impulse would lay claim on cultural studies' behalf to a (necessarily) higher authority for its interpretations vis-à-vis untrained or unconsidered opinion. On the other hand, the populist impulse would speak to the question of why any interpretation of these objects might *matter*; it answers the (equally necessary) "so what?" question by appealing to the fact that such objects at least have *some* meaning for significant numbers of people. Even in these crude and schematic terms, the critique of populism could thus be usefully reformulated. In her classic article on "banality" in cultural studies, Meaghan Morris is surely right to cry out against the "circuit of repetition" within which critics are forever finding an "inevitable saving grace" in the objects of popular culture under consideration, however ideologically tainted (1990: 23ff). "Once 'the people' are both a source of authority for a text and a figure of its own critical activity, the populist enterprise is not only circular but (like most empirical sociology) narcissistic in structure" (23). But one could also say that, locked into this double role, "the people" necessarily *fail* to provide the desired "source of authority," either for individual critics or for the discipline as a whole. In other words, the repetitiveness of the populist appeal corresponds to an inability to address the *novelty* of our continuing democratic predicaments, the variability and complications of the issues that can and do bedevil even democracy's truest believers. Getting no help on those very issues that decide whether or not there will be progress toward a truer democracy, such people are likely to become disbelievers in the discipline. Hence a failure of legitimation.

This is not to suggest that the fate of cultural studies hangs on its direct contribution to the political questions of the day. But it is to say that how the object of cultural studies is defined concerns circles wider than its immediate practitioners, and that its legitimacy in these wider circles depends in part on its perceived relation to progress—a relation that can be ironic and even cynical. These circles of course include competing disciplines. The legitimacy question thus involves asking not whether cultural studies has a distinctive object of its own (overlapping territories are normal enough), but whether the object chosen or shaped for itself can be publicly represented as in some sense a progress in relation to the contiguous disciplinary objects that immediately preceded and/or surround it, objects that it will either displace, be crowded out by, or make its peace with: culture, literature, society. This question sends us back to Durkheim and "society" as the disciplinary object he so momentously put in play.

One might expect that the emergence of a science of society out of writings on "primitive" religion, as exemplified by Durkheim's *The Elementary Forms of the*

Religious Life, would form one chapter in the general rise of science and secularism, a rise that—given Durkheim's unabashed if only intermittent evolutionism—assumed the superiority of the Western secular self over its "primitive" others. Students of Durkheim will already be aware that this is a misleading picture. As Stocking says, Durkheim's influence in Britain led away from evolutionism and "toward a more holistic analysis." "Rejecting the evolutionist assumption…of the 'survival' of primitive belief, [Durkheim's British followers] sought to understand the 'function' of customs and beliefs in sustaining the ongoing existence of the group" (288). Or, as Jeffrey Alexander puts it, "Durkheim came to believe…that theories of secular social processes have to be modelled upon the workings of the sacred world…. In religion he had discovered a model of how symbolic processes work in their own terms" (1988: 2).

Thus Durkheim could speak seriously, and not flippantly, of scholarship as one modern instance of the sacred—even when he acknowledged progress as its theology. "Even today," he writes, "howsoever great may be the liberty which we accord to others, a man who should totally deny progress…would produce the effect of a sacrilege" (244). Thus the concept of the sacred could also apply to cases of upward mobility like his discipline's or his own: "in the present day just as much as in the past, we see society constantly creating sacred things out of ordinary ones. If it happens to fall in love with a man and if it thinks it has found in him the principal aspirations that move it…this man will be raised above the others and, as it were, deified" (243).

Is modern secular scholarship no different, then, from the supposed primitives it analyzes? If primitive society is static and unchanging, does the same hold for the professional society formed by a supposedly progressive social science? Strangely enough, this is just what Durkheim suggests. Those who *resist* the new science of sociology, Durkheim says in a first move, are like primitives. We can understand the mentality of primitive man better because "it has not yet completely disappeared from our midst. If the principle of determinism is solidly established today in the physical and natural sciences, it is only a century ago that it was first introduced into the social sciences, and its authority there is still contested" (41). "It follows that veritable miracles are believed to be possible [in society]…. It is admitted, for example, that a legislator can create an institution out of nothing but a mere injunction of its will, or transform one social system into another, just as the believers in so many religions have held that the divine will created the world out of nothing, or can arbitrarily transmute one thing into another. As far as social facts are concerned, we still have the mentality of primitives" (41–42). Predictably, the authority of the professional is here asserted at the expense of the layman. But a more interesting move follows immediately: "However, if so many of our contemporaries still retain this antiquated conception for sociological affairs, it is not because the life of societies appears obscure and mysterious to them; on the contrary, if they are so easily contented with these explanations…it is because social events seem to them the clearest thing in the world; it is because they have not yet realized their real obscurity" (*Elementary Forms*, 42).

This belongs ultimately to an argument in favor of "the laborious methods of the natural sciences to gradually scatter the darkness," the slow progressiveness of the enlightenment's perpetually incomplete project. And yet the emphasis falls more strikingly not on the shedding of light but on the disciplinary need for darkness. Sociology can bring enlightenment only because it has first seized true obscurity for itself and defended that obscurity against an invisible horde of competing enlighteners.

This embarrassing truth becomes evident in any interdisciplinary exchange where one discipline does another the backhanded compliment of borrowing from it. Let's say a literary critic appeals to "history" to ground an interpretation. The discipline that does the borrowing (here, criticism) thereby seems to the lender (here, history) to be proclaiming history's grounded truth, its *lack* of obscurity. But this is less complimentary than it might appear, for no one wants a field that is lacking in obscurity. Access to obscurity means access to potential intellectual value. Thus the historian naturally feels compelled to insist that, in her own field, these matters are by no means settled but in fact remain a focus of heated controversy, a continuing source of mystery and—though this is usually not said—also therefore a continuing source of work.[5]

This logic carries beyond local disciplinary self-interest. If the concept of "society" seems designed on the one hand to dissipate "primitive" obscurity and on the other to resist enlightenment, to cling desperately to darkness, these contradictory impulses would seem to characterize the disciplinary object as such. For a successful object can win legitimacy for its investigators only by implying both the superiority of their point of view to others outside the discipline and, at the same time, the incapacity of that point of view to conclusively master it, thus bringing work to an end. Indeed, the fact that any discipline's implicit legitimizing dialogue necessarily addresses a variety of extra-disciplinary interlocutors or publics more or less guarantees that its object will resist its mastery, for this competition of publics is mirrored internally, within the object. Leaders of business do not want out of "society" precisely what a state office of social services or an Algerian secular revolutionary or an academic economist might want.

Durkheim's word for the temporality of the present—the present created by those members of "the business professions" (*Elementary Forms*, 9) to whom he is recommending more and longer scholarly-style conferences—is flux. Flux is the time of the market, a time of chaotic, competitive desire. "Because, in principle, all vocations are available to everybody, the drive to get ahead is more readily stimulated and inflamed beyond all measure to the point of knowing almost no limits." Christopher Herbert quotes this passage in *Culture and Anomie* in order to argue, persuasively, that by positing the boundlessness of vocational desire, Durkheim creates the necessity for the boundedness of culture. (1991: 71). Yet he is also creating the necessity for a bounded *professional* culture that, thanks to its heroic opposition to the market, can lay claim to the curatorship of the rest of culture—thereby satisfying some vocational desires at the expense of others.

The crucial point here is that the temporality of this professional culture, a tem-

porality formed by the collective wielding of concepts, after all need not and per-
haps cannot simply mimic the characteristic or official temporality of its own time.
On the contrary, it takes its public authority from a stand *against* the time of its
time. "Sensual representations are in a perpetual flux," Durkheim writes; "they
come after each other like waves of a river, and even during the time that they last,
they do not remain the same thing…. On the contrary, the concept is, as it were,
outside of time and change; it is in the depths below all this agitation…. It does not
move of itself, by an internal and spontaneous evolution, but, on the contrary, it
resists change. It is a manner of thinking that, at every moment of time, is fixed and
crystallized" (481). Here, modern, secular, professional time is decidedly non-evo-
lutionary.[6] Indeed, Durkheim's presentation renders it almost timeless, like the
supposed time of primitive religions. If it is evolutionary in the last instance, as the
final pages of *Elementary Forms* suggest, in the prolonged meantime it is also dis-
quietingly static.

As Durkheim demonstrates, ambivalence toward the authority of science is a
constitutive part of the discipline of sociology, and not the symptom of its decline
or impending supersession. The divinization of society is not only a strategy by
which the sociologist deifies his own discipline, and thus himself; it is also a way of
setting limits to that discipline's achievements, limits that the discipline must both
welcome and chafe at. As the object of sociology, that is, Durkheim's "society" was
already producing what we have lately come to value as reflexivity, or at least a
structural impulse toward reflexivity. And this seems to be a general truth.
Disciplines do not merely build on or feed off the objects they construct for them-
selves; innerly divided, they also exist in tense and sometimes conflictual relations
with those objects. Hence for Max Weber, "scholarship as a vocation" means, tem-
porally speaking, the existential heroism of intellectual labor that the individual
should acknowledge to be transient, foundationless, without the comfort of a *telos*.
Though Durkheim says that the disbeliever in progress would be committing a
"sacrilege," he himself throws progress into question. The demand for a critique of
scholarly Eurocentrism did not have to wait until movements of national libera-
tion had forced it onto European intellectual agendas. Even if the demand was only
answered in a manifestly unsatisfactory form, the form Dominick LaCapra
describes as Durkheim's "benign reverse ethnocentrism," it remains important to
note that some of its power was already there in sociology's disciplinary object
(1972: 25f).

At the same time, this ancestral disavowal of Eurocentric progressivism is not
something that contemporary critics should be unambivalent about. On the con-
trary, it raises some doubts how different cultural studies can claim to be, and in
particular about the sort of object it has fashioned out of its disciplinary inheri-
tance. For anyone raised on Matthew Arnold and T. S. Eliot, or at any rate for any-
one acculturated in the version of the humanities on which they set their stamp,
Durkheim's vision of society-as-stasis will sound disappointingly close to "culture"
in a sense we are more accustomed to seeing *opposed* to society: culture in its liter-
ary or aesthetic form, whose seemingly infinite capacity to produce further ironies

and thus both to tempt and to resist critical mastery has meant, on the one hand, the impossibility of a progressive self-conception of criticism and, on the other, that fewer and fewer people outside the profession are ready to believe criticism's interpretations. Though the problem of public legitimacy thus posed for literary criticism preceded the advent of cultural studies, it also seems to have passed on to cultural studies—through social science.[7] Like Arnold and Eliot and any number of supposedly dialectical left-wing thinkers, Durkheim posits that history can only work in the present to impoverish, endanger, break apart all social coherence. In setting this history in motion, he establishes sociology in a heroic, compensatory role: imitating the static social coherence of its objects, whether distanced in time or in space, in order to provide what the present is missing. And in thus degrading or emptying out the present that the discipline occupies, he makes it impossible for the discipline to acknowledge its own more upbeat temporality, the temporality built around successive, cooperative acts of rescue. To the extent that we buy into this set-up, we again condemn ourselves, like Durkheim, to a schizophrenic split between the temporality we perceive and the temporality we practice.

If "society" is so very like "culture," whether in its Arnoldian or in its anthropological version, then the transition from one version of culture to another that is often taken to describe the object of cultural studies no longer looks very dramatic, and it is easier to understand why there sometimes seems to have been so little movement beyond the willed stasis of a literary or textual paradigm, even when the authorities appealed to, like Pierre Bourdieu, are social scientists deeply hostile to an aesthetic or culturalist perspective. Let me take one quick and obvious example. Unlike Durkheim and unlike most of the culturalist tradition gathered together in Raymond Williams's *Culture and Society*, Bourdieu speaks centrally and forcefully about social class. Yet when he does so, he replaces a polarized, economically-based model of class, as in Marx, with a cultural, status-striving model. Wherever he or she might be found in the class hierarchy, whatever his or her tastes or values, the class subject in Bourdieu is a status-striver, fighting for relative, culturally-defined marks of distinction. And whereas class in the polarized, economic sense aims at its own abolition, class in the differential, culturally-determined, status sense does not (Jameson 1993: 37). It has no equivalent to the ultimate reducibility of economic difference (and the liberation of other differences) that defines progress for Marx. It is eternal. For as imagined by the sociologists, society is infinitely fertile in the marks of status, always capable of producing more means for the privileged, if threatened with creeping democratic indistinction, to distinguish themselves anew. The possibility of a *telos* and the possibility of progress toward it are precluded by the very nature of the sociologist's object. As Craig Calhoun (1995) comments, Bourdieu appears to believe that "the motive force of social life is the pursuit of distinction, profit, power, wealth, etc.," and he thus fails to imagine any reason "why a logic of reproduction would not work (p. 141)." "He *assumes* rather than empirically demonstrates…an absence of systemic contradictions, and therefore a tendency toward social integration and stable reproduction of the encompassing field of power" (153). And so, ironically, Bourdieu becomes a

new and fashionable guide for an anti-progressive strain of cultural studies. Ironically because, despite his loud anti-populism, his theory so flatteringly resembles the cynicism or fatalism of everyday non-elite opinion: the theory that nothing ever changes.

In pointing out the resemblance between these unprogressive disciplinary objects, I'm aware of two related problems. The first is that, as its persistence suggests, the legitimizing strategy that defines culture, society, and literature in terms of a principled refusal of progress has a history of working, however imperfectly. There is no guarantee that a hypothetical alternative would serve the disciplines as well. The second problem is that, perhaps for this reason, this strategy is still very firmly rooted in the academic consciousness, and in particular in the academy's unceasing skepticism toward its own disciplinarity. As one excellent recent collection (Messer-Davidow 1993) notes drily, "disciplines produce the idea of progress. They proliferate objects to study and improve explanations. They devise notions that command ever-growing assent: the conservation of mass, the class struggle, the irony of Jane Austen. They tell stories of progress, showing how knowledge advances within existing disciplines and by the establishment of new ones" (vii).

Think for example about *how* it is noticed, when it *is* noticed, that some of the fashionable new scholarship has perversely and inexplicably come to embody the progressive assumptions that no one would dare utter out loud. Anne McClintock's critique of so-called "post-colonial studies" is an eloquent example. She writes: "'Post-colonial studies' has set itself against [the] imperial idea of linear time—the 'grand idea of Progress and Perfectibility,' as Baudelaire called it. Yet the *term* 'post-colonial'…is haunted by the very figure of linear 'development' that it sets out to dismantle. Metaphorically, the term 'post-colonialism' marks history as a series of stages along an epochal road from the 'pre-colonial,' to 'the colonial,' to 'the post-colonial'—an unbidden, if disavowed, commitment to linear time and the idea of 'development'"(1992: 85). I can only agree about the assumptions behind the usual "modernization" narratives. But I'm not ready to assume in advance that the achievement of national independence after long struggle did *not* represent a progress over colonialism (though the debate might be interesting). And I can't help but wonder whether there isn't another, more narrowly academic source for what appears to be the contrary assumption, accompanied by an overwhelming impulse to root out and expunge from the temporality of scholarship any possible vestige of progressiveness. What does it say, for example, when a discipline's preferred sense of temporality is expressed by the formula "always already"? What does it mean if the interpretive community is willing to assume, with Stanley Fish, that nothing can happen until it has already happened? It is arguable that Michel Foucault is now doing as much to provide a rationale for work in cultural studies as Matthew Arnold once did for the humanities. If so, I think it is in large part because Foucault's critique of emancipatory and developmental narratives offers an updated, theoretically respectable version of just that refusal of progress, and that anti-progressive sense of cultural work, that was so essential to Arnold. It should be a bothersome continuity.

198 There are less disingenuous alternatives. Pragmatism, for example, rests the potential for intellectual progress neither on objectivity nor on self-consciousness, but rather on the *telos* of consensus among the community of scholars. Robert Scholes describes the "quintessentially pragmatist view" as follows: "a thorough skepticism about absolute proof is sustained by a faith in the results of continuing investigation building toward consensus" (1993: 175). Here progress in society itself need neither be affirmed nor denied, but it is seemingly guaranteed within the ideal micro-society formed by the ongoing professional community, the bounded community of the continuing investigators.[8] One will want to be wary of the guarantees, as well as the *telos* of consensus. But one may still want to value the option of leaving progress a possibility *without* guarantees or consensus—progress in a sense described by Peter Novick with regard to the discipline of history. "In the early decades of the twentieth century the most professionally accomplished work on Reconstruction—work hailed by the profession as the most objective, the most balanced, the most fair—was viciously racist; antiracist accounts were for the most part crude and amateurish. Nowadays generally the opposite is true; 'progress,' to be sure, from my point of view, but neither inevitable nor irreversible—nor, I think, attributable to history's becoming more professional" (1988: 14). In spite of the scare quotes around "progress," it is hard to imagine a scholarly account of recent attention to race in the academy that would not agree with Novick that there has been progress—though neither inevitable nor irreversible progress.

Progressiveness is not an obvious way of rethinking knowledge production today, even if certain voices have started to suggest, with Michael Bérubé, (1994: chap. 9) that the keyword of "politics" should make more room for matters of *policy-making*, a concept that allows for visible extra-disciplinary criteria of improvement. Undeterred by the prospect that knowledge will fail to improve or accumulate, many in the public as well as in the academy would probably prefer to see us preserve the reverence for the mysterious, the unfathomable, and the constitutively non-linear already inscribed in existing disciplinary objects. Still, there is some reason at least to leave the question open, even at the risk of threatening a legitimacy already acquired. Our fits of misplaced democratic self-purging may in fact play well to listeners from outside, as for example when participants in the first Illinois cultural studies conference complained that "the conference reinforced the very hierarchies it proposed to dismantle" (Bérubé 1994: 156). The same may hold for our equally exacerbated anti-disciplinarity. Stuart Hall notes that cultural studies "was not conceptualized as an academic discipline at all…. When I was offered a chair in sociology, I said, 'Now that sociology does not exist as a discipline, I am happy to profess it'" (1990: 11–12). These are not sentiments that will necessarily disturb an extra-academic public. But perhaps we can educate that public and ourselves at the same time. We need not assume, after all, that a discipline's true political project or object can only arise elsewhere. Nor do we need to accept the decline of narrative of ineluctable institutionalization that results from it—as if real critique could only come from outside and as if once that outside becomes a new disciplinary inside, it too would demand critique, more critique, and nothing but critique.

Out there in the real world, there is at present a crisis in the naming of injustice. How successfully can we manage to define our disciplines and name their objects in response to that crisis? This is not a bad test of whether those disciplines deserve to rise or fall.

Notes

1 According to Wolf Lepenies, charisma had less to do with it: "sociology was a discipline whose progress depended less on cultivated individuals than on the cultivation of capable research groups; in this endeavor division of labor and cooperative undertakings were vital" (1988: 50). In other words, there is a doubling of content and form in sociology's rise, a need to *be* what it is also about.

2 See the Preface to Ellen Messer-Davidow (1993) for a reference to "ephemeral conference papers" like those that volume preserves (vii).

3 Brett Neilson turns this around very deftly in his account of how the speed-up, a familiar aspect of postmodern work and cultural rhythms, affects critical self-conceptions. When the rate of scholarly production vainly tries to catch up to the (accelerated) rate of production of the popular cultural artifacts interpreted, the result is a lack of temporal distance that translates as lack of critical distance. Neilson's essay, "Close Retro: Time Lag in Cultural Criticism," is available from the author, Department of English, Yale University.

What we usually call "critical distance"—the crucial place where, or the time when, intellectual value is added—can also be described, and perhaps in some cases must be described, as a *temporal* distance, a time lag.

4 I treat this topic in more detail in *Secular Vocations: Intellectuals, Professionalism, Culture* (1993).

5 I discuss this principle at greater length in "Poaching off the Disciplines" (1987), 81–96.

6 This follows for Durkheim from the fact that scientific concepts are collective, professional, social: "The nature of the concept, thus defined, bespeaks its origin. If it is common to all, it is the work of the community…. If it has more stability than sensations or images, it is because collective representations are more stable than individual ones" (*Elementary*, 482).

7 For George Marcus, "The core tension in cultural studies has…been between text-based practices of analysis, theorizing, and framing questions and a desire to know the contemporary world, with its immense challenges and diversity, in a more unmediated way" (2). Marcus therefore offers "experimentation with reportage" as a supplement to "the slow, trickle-down influence" of text-based cultural studies concepts on existing empirical research (1993: 1). See also Virginia Dominguez, "Disciplining Anthropology," on the difficult relations between anthropology and cultural studies.

8 I comment further on this sentence in "Modernism and Literary Realism: A Response," 229.

References

Alexander, Jeffrey C., ed (1988) *Durkheimian Sociology: Cultural Studies*. Cambridge: Cambridge University Press.

Bérubé, Michael (1994) *Public Access: Literary Theory and American Cultural Politics*. London: Verso.

Calhoun, Craig (1995) *Critical Social Theory: Culture, History, and the Challenge of Difference*. Oxford: Blackwell.

200 Clark, Terry Nichols (1973) *Prophets and Patrons: the French University and the Emergence of the Social Sciences*. Cambridge: Harvard University Press.

Clifford, James (1988) *The Predicament of Culture*. Cambridge: Harvard University Press.

Dominguez, Virginia (1996) "Disciplining Anthropology." In Cary Nelson and Dilip Gaonkar, eds. *Disciplinarity and Dissent in Cultural Studies*. New York: Routledge.

Durkheim, Emile (1915/1965) *The Elementary Forms of the Religious Life*. Trans. Joseph Ward Swain. New York: Free Press.

—— (1957/1992) *Professional Ethics and Civil Morals*. Trans. Cornelia Brookfield. Preface by Bryan S. Turner. London: Routledge.

Edgell, Stephen (1993) *Class*. London and New York: Routledge.

Fabian, Johannes (1983) *Time and the Other: How Anthropology Makes its Object*. New York: Columbia University Press.

Hall, Stuart (1990) "The emergence of cultural studies and the crisis of the humanities." *October*, 53 (Summer).

Herbert, Christopher (1991) *Culture and Anomie: Ethnographic Imagination in the Nineteenth Century*. Chicago: University of Chicago Press.

Jameson, Fredric (1993) "On 'cultural studies.'" *Social Text*, 34: 17–52.

LaCapra, Dominick (1972) *Emile Durkheim: Sociologist and Philosopher*. Ithaca: Cornell University Press.

Lepenies, Wolf (1988) *Between Literature and Science: The Rise of Sociology*. Cambridge and New York: Cambridge University Press and the Maison des Sciences de l'Homme.

Marcus, George (1993) *Perilous States: Conversations on Culture, Politics, and the Nation*. Chicago and London: University of Chicago Press. Late Editions, 1.

McClintock, Anne (1992) "The angel of progress: Pitfalls of the term 'post-colonialism.'" *Social Text*, 31/32.

McGrane, Bernard (1989) *Beyond Anthropology: Society and the Other*. New York: Columbia University Press.

Messer-Davidow, Ellen, David R. Shumway, and David J. Sylvan, eds. (1993) *Knowledges: Historical and Critical Studies in Disciplinarity*. Charlottesville and London: University Press of Virginia.

Moretti, Franco (1987) *The Way of the World: the Bildungsroman in European Culture*. London: Verso.

Morris, Meaghan (1990) "Banality in cultural studies." In Patricia Mellencamp, ed. *Logics of Television: Essays in Cultural Criticism*. Bloomington and Indianapolis: Indiana University Press.

Novick, Peter (1988) *That Noble Dream: The "Objectivity Question" and the American Historical Profession*. Cambridge: Cambridge University Press.

Robbins, Bruce (1987) "Poaching off the disciplines." *Raritan*, 6, 4 (Spring): 81–96.

——(1993) "Modernism and literary realism: A response." George Levine, ed. *Realism and Representation: Essays on the Problem of Realism in Relation to Science, Literature, and Culture*. Madison: University of Wisconsin Press.

——(1993) *Secular Vocations: Intellectuals, Professionalism, Culture*. London: Verso.

Scholes Robert (1993) "Tlon and truth: Reflections on literary realism: A response." In George Levine, ed. *Realism and Representation: Essays on the Problem of Realism in Relation to Science, Literature, and Culture*. Madison: University of Wisconsin Press.

Stocking, George W. *(1982/1968) Race, Culture, and Evolution: Essays in the History of Anthropology*. Chicago: Chicago University Press.

Stocking, George W. *Victorian Anthropology*. Chicago: University of Chicago Press.

GOING PUBLIC, GOING GLOBAL, GOING HISTORICAL

CULTURAL STUDIES IN TRANSITION

Herman Gray

9

IS CULTURAL STUDIES INFLATED?

THE CULTURAL ECONOMY OF CULTURAL STUDIES IN THE UNITED STATES

The question posed by my title—"Is cultural studies inflated?"—is prompted by a set of conversations, discussions, and exchanges that I have had over the years in corridors, living rooms, and around conference tables with colleagues and friends about the particular set of intellectual practices and political desires called "cultural studies." More, specifically, my title is prompted by a series of discussions, planning sessions, and teaching activities in which I have participated at my own university and in my own academic department. While my formal academic appointment is in sociology, I maintain an ongoing professional affiliation and intellectual identification with the formation and practice of cultural studies in the United States.[1]

These professional and personal connections to cultural studies have prompted me to ask, just what is it that we (those of us who make some claims to be doing "cultural studies") do?[2] And, what is the nature of our travel to cultural studies—that is, what are the intellectual conditions, frustrations, retreats, desires, that lead us to cultural studies? More to the point, how is the nature of the work—the intellectual and political practice—impacted by the construction, circulation, evaluation, attack, and embrace of cultural studies in the American university? Do the multiple and varied claims on cultural studies from the social sciences, humani-

ties, area studies, and communication studies, essentially render the practice, in the language of my title, "inflated?"[3]

In trying to think about some of the specific social, cultural, economic, and political conditions of production of cultural studies in the United States, I have been surprised by just how much of the academic debate and public discussion of cultural studies fits snugly within contemporary political discourses about politics, economics, and culture that dominate debates in the national government. Many of the most salient features of cultural studies—its eclectic character, its amorphous formation, its uneven travels, its active rejection of rigid intellectual boundaries and professional territorial imperatives—are also some of its more vulnerable features. These very same qualities make cultural studies open to attack from conservative intellectuals, academic traditionalists, and skeptics of academic fashion deeply committed to disciplinary boundaries.[4] And since much of the work in cultural studies focuses on the intersections between race, class, gender, sexuality, and their relationship to cultural meanings and social practices of everyday life, its trans-disciplinary emphasis also places cultural studies in dialogue with (and suspicion from) a group of recent intellectual and political projects that I will, somewhat unconventionally, call area studies: African American Studies, Gay and Lesbian Studies, Asian American Studies, Chicano/a Studies, Ethnic Studies, Post Colonial Studies, Diasporic Studies, and Women's Studies. (Ironically enough, its very proximity to area studies makes cultural studies a potentially attractive area of expansion for administrators and departments, who in an increasing climate of fiscal austerity and organizational downsizing, are forced to grapple with duplication and redundancy; in the American university, the limited choices in such a difficult environment can sometimes pit area-studies programs and cultural studies against each other in games of intellectual justification and legitimization.)

Hence, in addition to its exciting intellectual and political possibilities, in the American university cultural studies is also being made to do other, more troubling kinds of work. I worry that, without critical intellectual reflection and active political engagement both within the university and beyond, cultural studies could be enlisted to help to displace and marginalize those very quarters of the university (e.g. area studies) and public life with whom important and productive alliances might be made.

If this characterization of the conditions of the practice and circulation of cultural studies in the United States is even modestly resonant, how might (indeed should) cultural studies be consolidated as an intellectual and social formation in the American university? How might (indeed should) cultural studies be made into a more critical intellectual practice and a more productive political practice? Leaving open the question of who might actually rescue cultural studies from its various inflationary influences, then, how might it be distinguished from the excesses of intellectual fashion and trendiness that have produced this inflated condition in the first place?

Of course the desire to consolidate the formation and practice of cultural studies in the United States is by no means widely shared. There are many, myself

included, who regard any move to create a coherent and monolithic cultural studies as misguided and as a capitulation to the very disciplinary boundaries and academic professionalization that its practice seeks to disturb. This is one of the paradoxical conditions of the formation and practice of cultural studies in the U.S. Yet any effort to organize cultural studies must take account of this strong and warranted resistance, aiming to insure cultural studies' critical edge without turning it into a monolithic enterprise.

I deliberately resort to the metaphor of inflation in evoking the risks of cultural studies becoming successful, not so much because I want to align cultural studies with the social and economic policies of post-civil-rights America but because, like dominant political debates that have characterized public discourse about the U.S. (and global) economy for the last 25 years, the intellectual discourse and the social conditions in which cultural studies operates in the contemporary American University, have a normalizing power and reach. This normalizing power has the potential to translate some of the most critical and productive aspects of cultural studies into a weak and superficial intellectual practice concerned only with its own professional status and intellectual legitimacy. Given its increasing visibility, exemplified in the proliferation of cultural studies lists by academic publishing houses, in the United States at least, cultural studies seems poised for a wholesale retreat into the privatized world of the academic star system and narrow professional self-interests dominated by the politics of status, glamour, and self-preoccupation (Boynton 1995; Mead 1994; McRobbie 1994). Hence, while my title is intended as a parody, I also offer it both as a critical comment on the limitations of dominant institutional practices and as a prompt to serious contemplation by students and scholars of cultural studies about the current political and intellectual labors of cultural studies in the United States.

I want to inquire, then, into the specific conditions, circumstances, forces, and tensions surrounding the recent expansion and practice of cultural studies in the American University. In particular I want to comment on cultural studies as an intellectual formation and cultural practice as it bears on questions about the configuration of, and access to, the university, on notions of public intellectuals, and on politics. My major concern here is to illuminate just how cultural studies is implicated (if at all) in these conditions and developments; more importantly I am interested in what cultural studies has to contribute to these debates.

Narratives of Travel/Narratives of Arrival

The story of the formation of cultural studies in England is, by now a familiar, though still contested one, having been narrated and re-narrated a number of times so as to resist the reification and canonization that popularization and institutionalization can inevitably produce (Fiske 1987; Grossberg 1989, 1992, 1993; Hall 1990, 1992; Johnson 1986/7; McRobbie 1994). All these authors offer excellent and thorough accounts of the formation of cultural studies in England, but I am mindful of the cultural and political implications of limiting the narration of the formation of cultural studies to England. I am grateful in this context to Angharad

206 Valdivia for her insistence that such narration results in the continued marginal-
ization and displacement of similar formations and approaches to questions of cul-
ture that developed around studies of film, music, and popular forms in Latin
America (and I would add still more local studies and practices that developed in
the United States). Indeed, Stuart Hall rejects the narration of an origin story for
cultural studies that begins exclusively in England and that posits the British ver-
sion as the "only way to do cultural studies" (Hall 1990: 11). While appreciating these
insights and qualifications, however, I still want to point to the formation and trav-
el of cultural studies from the Birmingham School in England because of conver-
sations and discourses that it stimulated and because its sheer visibility and
influence in the U.S. remains indisputable, instructive, and indeed makes my point.
Rather than rehearse that particular history here or make claims on one particu-
lar version as more authentic than another, I point to widely accepted points of
agreement about the dominant contours of the story to indicate the specific con-
ditions (and differences) of its formation and travel to the United States. Indeed,
the political point of telling and retelling the story of the formation of cultural
studies in England is to note the major tensions, ruptures, ambivalences, and inter-
ruptions that were profoundly influential on the organization, practices, and works
that eventually emerged from the Center for Culture Studies (Hall 1992).

What eventually emerged in quasi-institutional form under the initial impetus
and influence of Richard Hoggart, Raymond Williams, E. P. Thompson, and Stuart
Hall was first and foremost a political and intellectual project that developed, Hall
puts it, as "an adaptation to its terrain" (Hall 1990, 11). That is, cultural studies
emerged in conjunction with a particular set of political problems, theoretical
crises, and social and cultural transformations in postwar England (Hall 1990,
1992). The intellectual projects and political praxis that developed around this first
generation of cultural studies scholars, researchers, and students developed on the
margins of the English university and was guided most of all by politics (of sur-
vival and social change) and intellectual necessity. This, of course, meant mastery of
materials that fell beyond the strict boundaries of a particular disciplinary special-
ty. It is instructive to reflect on Hall's description of this moment and the intellec-
tual strategies they employed:

> "the strategy of the Center for developing both practical work that enable research to be
> done in the formations of contemporary culture and the theoretical models that would
> help to clarify what was going on was designed as a series of raids on other disciplinary
> terrains. Fending off what sociologists regarded sociology to be, we raided sociology.
> Fending off the defenders of the humanities tradition, we raided the humanities. We
> appropriated bits of anthropology while insisting that we were not in the humanistic
> anthropological project, and so on. We did the rounds of the disciplines" (Hall, 1990,
> 15–16).

These disciplinary incursions were part of the theoretical and methodological
map that was required to navigate intellectual and political claims and counter
claims about the concept of culture that members of the center faced in this for-

mative stage. In many instances the models and approaches to which members of the Center turned were to be found outside of the structure of the English university, forcing members to look elsewhere, to make them up from other sources and to look to traditions and work (e.g. Frankfurt School and Gramsci) that had no presence in the university.

Because the English university operated as a powerful and closed institution, particularly with respect to Williams, Thompson, Hoggart, and Hall's approach to culture and the humanities, the intellectual project of cultural studies was from the very beginning situated on the margins of the English university. This circumstance, together with changes in the political fortunes of the Left and the Labor Party (consolidated with the emergence of Thatcherism), the crisis of Marxism, and the general linguistic turn in the humanities and interpretive social sciences, helped to give the emerging practice a sense of urgency, immediacy, and direct engagement with politics. Standing intellectually and politically at the intersections of a number of related social conditions, impulses, and cultural forces, the cultural studies project disturbed and reconfigured arrangements—intellectual training, political interventions, disciplinary boundaries and understandings. As they bear on questions of the relationship between culture and social change, matters of agency and structure, theory and praxis, production and reproduction, culture and political economy were pressing issues with which members of the Center and their students struggled in new and different ways. (Different from, that is, the way these questions were explored in distinct disciplines like anthropology, communications studies, linguistics, sociology, and psychology, each with a distinct set of perspectives, methodologies, and professional territories to protect.) While culture and social class served as a unifying trope in the earliest period of the center, issues like sexuality, gender, and race/ethnicity later produced a series of profound but productive "interruptions," as Hall calls them, to the work at the center (Gilroy 1992; McRobbie 1994).

Thus the formation and practice of cultural studies in England developed out of a set of specific social and historical conditions. Its earliest practitioners were public intellectuals whose political and intellectual practices were structured by "adaptations"—cultural conditions and social circumstances—that made it a vital necessity to disturb disciplinary boundaries, to challenge and negotiate the structure of a university that marginalized them and their intellectual projects; these same circumstances also produced the desire, indeed necessity, for this early generation of cultural studies intellectuals to train succeeding generations of scholars, researchers, and intellectuals.

Cultural studies did not, as Stuart Hall has repeatedly insisted, spring full-blown as a fully realized intellectual discourse and institutional formation (Hall 1990). Moreover (noting differences in time period, direction, and emphasis), it is more accurate to describe several different periods and types of cultural studies that were practiced at the Center in Birmingham—the period of subcultural and ethnographic studies of popular culture and media; the period of engagement with structural Marxism; the culturalist period; and the period of the new ethnicities

and gender studies. It is fair, moreover, to characterize cultural studies in England as a dynamic and changing formation; one full of (productive) tensions and conflicts; one in constant search for the institutional and intellectual spaces in which to consolidate its own intellectual productions and from which to make critical political and intellectual interventions into national debates and discourses about life in Britain.

In its travels to the United States (and Canada, as well as Australia), cultural studies developed by way of a series of encounters, interventions, and alliances with discourses and disciplines structured by an historic set of social, professional, and disciplinary imperatives. The radical and critical wings of American sociology and communication studies are but two of the more explicit points of early entry in the American university. In the late 1970s, an entire generation of graduate students, (myself included), in sociology, communication studies, education, and comparative literature were introduced to works of Stuart Hall, Paul Willis, Dick Hebdige, E.P. Thompson, Raymond Williams, and Antonio Gramsci (among others).

Many of our professors were students of the New Left and Civil Rights Movement who recognized and responded to our dissatisfaction with the dominant theoretical models of media and cultural power, viewing them as expressing the un-contested imposition of the economic logic of commodity capitalism on the one hand, and emphasizing the cultural incompetence of the social agents on whom these forces acted on the other. My classmates and I were on the lookout for ways of complicating the relationship between the cultural and the material, between dominance and resistance, between agents and structures, that were more subtle and nuanced than the analysis offered by the Frankfurt School, by communications scholars rooted in uses and gratification theory, or by the Effects School. We turned to Gramsci, Raymond Williams, and Stuart Hall for theoretical direction; Paul Willis, E.P. Thompson, and Dick Hebdige provided ethnographic examples of the complex possibilities for seeing culture and media as sites within which ordinary people actively engage their social world to fight back and transform it. While my own journey to cultural studies is by no means representative, it does, I think, illustrate some of the distinct elements and circumstances of the reception of cultural studies by American social science. My encounter with cultural studies from the disciplinary "home" of sociology is characteristic, not so much because sociology looms so large in American academic discourse, but because, as a discipline, it has been shaped by, and is deeply invested in, the discursive power of disciplinary-based organizations of knowledge in the American university.

Whether sociology, communications studies, literature, film, education, or anthropology, the central point is that the American university is structured by professional and intellectual commitments to academic disciplines as the organizational and discursive basis for the production of knowledge. Since cultural studies necessarily disturbs the very presumption and neatness of such disciplinary distinctions and investments, its successful (albeit problematic) migration to the American academy has, in part, been made possible and realized by its effective

incorporation into the existing disciplinary boundaries and professional impera-
tives of the American university.

Disciplinary Boundaries and American Cultural Studies

In the essay "Cultural studies and/in new worlds" Lawrence Grossberg poses the
question: "How should cultural studies travel? How should it locate itself in rela-
tions between its local speaking position and the increasingly dense and intense
lines connecting these positions?" (Grossberg, 1993, 1). In the wake of the success
and visibility of cultural studies and its international dispersion and travel,
Grossberg worries that cultural studies is threatened with stagnation and canonical
fetishization, particularly in its need to move beyond identity, its need to rethink
the machinations of power, its need for a politics of the global and the local that
appreciates contemporary conditions of global transformation. Grossberg's con-
cerns bear directly on the specific question of the travel and reception of cultural
studies in the U.S., particularly its appeal and success in the American university.
Indeed, the American academy has become one of the focal points from which a
speaking position on and about cultural studies has been most visible and influ-
ential—owing to the proliferation of its institutionalization and its circulation in
classrooms, at conferences, on reading lists, and in areas of specialization among
faculty and graduate students (Boynton 1995). Given the conditions of its forma-
tion, its migration to the U.S., and the existing disciplinary configuration and pro-
fessional organization of the American university, one must wonder how the
American academy has received an intellectual practice that, by definition, aims to
transgress and disturb its very institutional structure.

The question of the intellectual and political labors of cultural studies in the
American university requires a small detour—a brief exploration of the nature of
cultural studies (particularly in the wake of its success and what Grossberg (1993: 1)
calls "the proliferation of its speaking positions"), as it is actually organized and
practiced in the humanities (Literature, English, History, American Studies) and
the social sciences (Anthropology, Sociology, Communications) in the American
university.

Recognizing the territorial dominance of traditional disciplines and the signif-
icant influence of professional academic culture in the U.S., the multiple sites in
which cultural studies has taken hold and even thrived, has produced some rather
interesting, even troubling tensions. These tensions revolve around a number of
distinct issues and tropes. In the social sciences, cultural studies has placed a certain
pressure on the very notion of culture. In Anthropology and Sociology alike, claims
on culture, social theory, theory, and social context have been disturbed and in
some instances reconfigured.

For example, while cultural studies has been received with interest and engage-
ment in some limited quarters of American sociology (symbolic interaction, social
construction, race and ethnicity, gender studies), considerable suspicion and wari-
ness characterizes the more general response. This wariness and suspicion comes

from the area in sociology historically concerned with culture, cultural sociology, or the sociology of culture. Professional mainstream theorists strongly identified with specialties like social theory and the sociology of culture hold fast to the claim that sociology long ago dealt with the issues and questions that now appear under the sign of cultural studies; it dealt with them not only adequately, but decisively, so the argument goes, through the work of canonical figures like Emile Durkheim, Max Weber, Talcott Parsons, Erving Goffman, George H. Mead, and Herbert Blummer. Concerns with the relationship between agency and social structure, collective representation, collective consciousness, the social basis of meaning, ritualized social interaction, and dramaturgy, they contend, have already been addressed in traditional sociological scholarship. A May 1993 *Contemporary Sociology* review of the Grossberg, Nelson, and Treichler volume made exactly that point.

While such battles within sociology continue to rage over the status of the concept of culture, the social sciences have nonetheless contributed, in some instances quite productively, to the discourse of cultural studies—particularly on the question of the salience of social structure, social context, and the value of empirically based explorations of the relationship between culture and social structure. Indeed, the presence of cultural studies as a formation and practice has forced a productive critical re-examination (by some sociologists) of sociology's role in the newly configured discourse on culture and theory.

Still, the movement of cultural studies into the territory of a social science discipline like sociology has produced suspicion and critique. From the vantage point of professional sociology and anthropology, cultural studies may well be viewed as poaching (or, as Hall puts it, making incursions) on the turf of culture in particular and social sciences in general. Of course this charge of poaching is often leveled at theoretical conceptions and observations whose conclusions are thought to be problematic, because their theory, method, and data (and the relationships between them) are neither systematic nor explicit. In short, it is a charge whose appeal is rooted in positivist and empiricist traditions. But cultural studies has been equally suspicious and wary of a strong-willed social science on matters relating to the study and analysis of culture. In many respects the mere presence of cultural studies has served to up the intellectual ante a bit. For cultural studies is critical of static, organization-focused studies of culture and critical as well of the continuing commitment to an epiphenomenal conception of culture that continues to exert a rather strong hold on the imagination of many in the social sciences (Carey 1995; Grossberg 1995).

On the other hand, humanities departments like Literature, English, American Studies, and Film have been quite a bit more receptive to the presence of cultural studies. Professional organizations such as the American Studies Association and the Modern Language Association regularly include sessions on cultural studies at their annual convention. Yet the incursions of cultural studies into the territories of the humanities has not been without problems and tensions (both for cultural studies and the humanities). For the presence of cultural studies in the humanities has exacerbated what Stuart Hall describes as a crisis of the humanities, including

debates about the role of politics, issues of identity, the preeminence of the text, and questions of social context. One impact of cultural studies in literature, for instance, has been to dislodge the text from literature's traditional disciplinary grip, a grip which does not grapple adequately with the centrality of context, history, and the activities of real active agents and cultural practices in the social world.

Cultural studies scholars who take seriously the necessity for multiple sites and levels of analysis regard the turn toward literature, the text, and the sign, with suspicion. By privileging cultural texts over practice as the site of the social and political, the social and historical contexts that shape, situate, and structure cultural texts/products are largely ignored. Moreover, the meanings that are constructed for such texts, and the everyday practice to which they are put are read out of context. This privileging of the text and the incorporation of cultural studies within the disciplinary boundaries of traditional disciplines in the social sciences and the humanities contributes to the very inflation to which my title refers.[5] Of course there are American scholars who, while located in such disciplinary homes, bring a distinctive American understanding and emphasis to their work while actually resisting the binary separations; George Lipsitz has, in fact, proposed that American Studies is perhaps the most receptive site for the practice of a distinctive American-based cultural studies (Lipsitz 1990).

Cultural Studies/Area Studies

One of the arenas of the American university to which cultural studies has effectively (but selectively) migrated is area studies—e.g. Women's Studies, Gender Studies, Gay and Lesbian Studies, African American Studies, Asian American Studies, Diasporic and Post-colonial Studies, Latin American Studies, and Chicano/a Studies. Recognizing these distinctive and peculiarly American inflections and concerns of cultural studies, it is productive to emphasize the plural but specific nature of the practice of cultural studies in the U.S. Indeed, it is fair to say that from the very beginning, some area studies programs were engaged in a cultural studies-like practice and project without naming it as such. That is, upon its arrival cultural studies in some instances joined existing programs concerned with issues of race, gender, sexuality, and identity. In other instances, cultural studies provided existing programs and projects with the discursive space for a practice and methodology which was already in existence by way of area studies. The point is that while there were parallel developments, practices, and concerns occurring in a variety of places cultural studies aligned itself with and was taken up by practices broadly defined around questions of identity and representation (Fregoso and Chabram 1990; Lipsitz 1990).

A multiple and multiply positioned cultural studies practiced within the quarters of area studies is not, however, without its own set of problems and tensions (Diawara 1993; Fregoso and Chabram 1990; Lipsitz 1990). These tensions have to do with the particular narration of the origin (and travels) of cultural studies as well as with the distinctive features of the American university, its disciplinary boundaries, professional imperatives, and those purported spaces of interdiscipli-

nary work that area studies programs and cultural studies occupy in the university. For despite their very different histories and genealogies cultural studies and area studies do often occupy the same discursive and institutional spaces. That is, owing to similar theoretical tropes, objects of analysis, and methodological approaches— race, gender, sexuality, and interdisciplinary study—cultural studies and area studies programs and departments are increasingly engaged in struggles for limited resources, faculty, students, recognition, and legitimacy from universities and broader publics. Such competition produces suspicions on the part of programs that have very real stakes in maintaining resources, autonomy, and legitimacy in the American academy. On the other hand, such programs are just as often viewed by cultural studies scholars as parochial, chauvinistic, and too preoccupied with territorial imperatives and identity politics which prevent productive political and intellectual alliances (Diawara 1993; Grossberg, et. al 1992).

To be sure, some area programs have actively sought out and welcomed cultural studies approaches and scholars into their quarters, thereby fortifying intellectual and political alliances that have strengthened both in hostile and suspicious circumstances. Other area programs, increasingly forced to justify their continued claim to institutional resources, have simply erected higher barriers, keeping cultural studies discourse and its practitioners at arm's length.

While it is perhaps inaccurate to characterize these responses as an expression of the "inflation" of cultural studies, these situations do speak to the distinctive conditions and circumstances in which cultural studies is practiced in America. More importantly, they illuminate both the limitations and possibilities for the institutional formation and practice of cultural studies in the U.S. This recognition, critical interrogation, and formation of strategic institutional alliances may provide a temporary barrier against the inflation with which I am concerned.

The Academic Star System and the Public Intellectual

A 1995 *New Yorker* article by Michael Bérubé details the reemergence, (on the liberal Left anyway), of a new generation of public intellectuals, including Cornel West, Eric Michael Dyson, bell hooks, Derrick Bell, and Manning Marable (Bérubé 1995). Bérubé is particularly keen on the public visibility and robust intellectual contributions of critical black intellectuals to contemporary public debate. In fact, he compares the current generation of black intellectuals to New York Jewish intellectuals in the 1950s, noting especially the social conditions for each generation's emergence and their engagement in the public sphere.

To be sure, these welcomed critical voices add much to the richness and vitality of public debate and dialogue, and it is fair to say that most, if not all of the people featured in the *New Yorker* profile might in one way or another be identified with, or make some claims to be engaged in, the project of cultural studies. Indeed, Manthia Diawara has offered a wide ranging conception of black cultural studies that includes both concerns with studies of oppression and domination as well as transgressive and performative enactments of blackness. Yet the very sharpness of the public focus on this small group of very visible and pro-

ductive black intellectuals has also produced often harsh, usually polemical, and occasionally probing criticisms of black public intellectuals, particularly their seeming uncritical celebrations by the liberal-left press (Reed 1995). I am less concerned, as some have claimed, that the intellectuals featured in the *New Yorker* piece are the "usual suspects" or for that matter that they constitute a mutual admiration society. Rather I am concerned with the social, cultural, and political conditions of public intellectual practice, particularly the articulation (collusion?) between the press, media, celebrity, and the increased attraction to, as well as suspicion, which media attention and the cult of celebrity generates for cultural studies as an intellectual practice.

I point to the media coverage and publicity surrounding highly visible public intellectuals affiliated with the practice of cultural studies because it illustrates many of my concerns about the connection between the visibility of cultural studies intellectuals, the creation of vital public spaces, the academic star system, the machinery of mass media and public relations, and notions of public intellectuals. There is a very crucial articulation between the visibility enjoyed by many of our best and brightest intellectuals, their location in major metropolitan centers, and the kind of exposure they generate (Mead 1994). In many respects these and other highly visible intellectuals force critical intellectuals, especially those in cultural studies, to reckon with the notion of the public sphere and the notion of political practice. This raises the question: Is public visibility and media attention the same as being a public intellectual? In a media-saturated environment such as the U.S., with its highly professionalized academic culture, how is the practice of cultural studies impacted? And conversely has the visibility and circulation of cultural studies in the American university contributed to the conflation of these sites of public intervention and hence the inflation in my title? Perhaps we should, as some would have it, be scornful and suspicious of those spaces of public discourse and exchange made available through the media, the book tour, and the lecture circuit, simply because they are all crassly careerist and therefore necessarily corrupt and commodified.

My argument here is not that many of our most visible and media-savvy intellectuals are not valuable allies and members of a critical intellectual community who have added much to public discourse; my concern is with the voices, practices, alliances, and critical intellectual work that gets pushed out and marginalized by media preoccupation with stars and the cult of personality. Where is the coverage, circuits of travel, and conversation for those scholars engaged in the practice of cultural studies at the level of everyday life—in the classroom, with grassroots organizations, with movements for social justice? While the "culture" in cultural studies necessarily remains a central concept of critical analysis and a vehicle for important forms of social organization and transformation, to what extent, I wonder, has the category of culture in this new climate been cut loose from the articulation between the global and the local, from those multiple locations of material and cultural practice which provide the context, the juice, the drive for cultural studies in the first place? Is a consequence of the turn toward culture (and the success of cul-

tural studies), that cultural questions and questions about culture are no longer articulated to and through social and material conditions that make it necessary also to inquire into questions of power, policy, inequality, and social justice? (I frame the issue as one of severance and not displacement, since I want to avoid rehearsing once again the tired and well-worn charge that the turn to culture stimulated by cultural studies has displaced the more urgent, salient, and material matters of politics.)

Hence, I would want to ask, has the visibility and wide circulation of cultural studies in the American academy (and subsequent media coverage) contributed to a redefinition of the (black) public sphere and the public intellectual? Of course, this may well be too much to lay at the hands of either cultural studies or some of our most visible and important critical intellectuals.

Nevertheless, it seems like a question worth raising in the context of cultural studies, because cultural studies through its very practice can be a space in which, and through which, to inject more vibrant, pluralistic, and critical notions of the public sphere and public intellectuals. It seems to me that the formation and practice of cultural studies in the United States has played (and will continue to play) a central role in constructing notions of the public sphere, cultural politics, public intellectuals, and the conditions, limitations, and possibilities that structure these as arenas of public life. Because of its central concepts, institutional locations, professional investments, intellectual practice, and intellectual visibility, cultural studies has contributed to both a limited notion of the public and a limiting notion of politics, at least as practiced in the U.S. Oh, of course, cultural studies has been very much a part of the game of public debate but ironically not in ways that matter.

Intellectually and politically we need critical cultural studies now more than ever. With concerted and sustained attacks on diversity, affirmative action, the poor, undocumented labor, and the welfare state on the one hand and programmatic cutbacks and reconfigurations of the public sphere and the university on the other, cultural studies offers much as a critical and self-reflexive practice. We do need to expand our horizons, to make connections between the global and the local, to resist the seductions of professional preoccupation and disciplinary stability, to continue to understand specifically just how culture matters in the everyday lives of people, and ultimately to make interventions that matter. A mature but dynamic cultural studies can offer the intellectual substance, the visibility, and the access to produce an effective and consequential discourse and intervention in the public sphere that transcends limited and limiting academic and professional preoccupations.

While I am concerned about the creeping inflation of cultural studies in the American university, I am also hopeful. This is yet another moment or point of articulation for cultural studies in the U.S. and throughout the world, one that requires clear sight, critical interrogation, self-reflection, and decisive intervention.

Notes

1 I locate my research and writing within the perspective of cultural studies; I publish in and served on the editorial board of the journal *CULTURAL STUDIES*; I am a member of the advisory board of the Center for Cultural Studies at the University of California at Santa Cruz; and, finally, in my own university and department I am involved in planning curriculum and training graduate students with interests in cultural studies.

2 My thanks to George Lipsitz for organizing a roundtable at UC Irvine in Spring 1994 to discuss just this question, especially as it concerned the practice of cultural studies in the California, specifically in the UC system. My thanks also to conference participants who included Rosa Linda Fregoso, David Sanchez, George Lipsitz, Saidya Hartman, Wendy Mink, Carl G. Jones, and Adele Clark. This was a very stimulating discussion and further prompted some of the ideas that have found their way into this paper. Similar conferences and discussions have also been held at the UC Santa Cruz, UC Berkeley, and UC Santa Barbara.

3 A similar set of themes and questions animate Nelson, Grossberg, and Treichler's introduction to their edited volume *CULTURAL STUDIES*. These themes are repeated by a number of contributors as well. See Grossberg, Nelson, and Treichler (1992), 3–4.

4 See the exchange in the "Colloquy" section of *CRITICAL STUDIES IN MASS COMMUNICATION* 12, 1 (March 1995):65–95; participants include Nicholas Garnham, Lawrence Grossberg, James W. Carey, and Graham Murdock.

5 Grossberg among others also charges that the preoccupation of cultural studies with identity politics, an uncritical celebration of resistance, and a focus on local concerns at the expense of global issues also contribute to what I am calling an inflated intellectual condition. See: Grossberg 1993.

References

Bérubé, Michael (1995) "The new black intellectuals." *The New Yorker*, (January 9): 73–80.

Boynton, Robert (1995) "The Routledge revolution." *Lingua Franca*, (March/April): 25–32.

Carey, James W. (1995) "Abolishing the old spirit world." *Critical Studies in Mass Communication*, 12, 1: 82–89.

Diawara, Manthia (1993) "Black studies, cultural studies: Performative acts." In C. McCarthy and W. Crichlow, eds. (1993) *Race, Identity, and Representation in Education*. New York: Routledge.

Fregoso, Rosa Linda and Angie Chabram (1994) "Introduction: reframing alternative critical discourse." *Cultural Studies*. 4, 3: 203–12.

Frow, John and Meaghan Morris, eds. (1993) *Australian Cultural Studies: A Reader*. Urbana: University of Illinois Press.

Garnham, Nicholas (1995) "Political economy and cultural studies: reconciliation or divorce?" *Critical Studies in Mass Communication*. 12, 1: 62–72.

Gilroy, Paul (1992) "Cultural studies and ethnic absolutism." In L. Grossberg et al., eds. (1992) *Cultural Studies*. New York: Routledge.

Gray, Herman (1993) "Cultural theory, social construction, and social problems." In J. Holstein and G. Miller, eds. (1992) *Constructionist Controversies: Issues in Social Theory*. Adline.

Grossberg, Lawrence (1995) "Cultural studies vs. political economy: Is anyone else bored with this debate?" *Critical Studies in Mass Communication*, 12, 1: 72–82.

——— (1993) "Cultural studies and/in new worlds." *Critical Studies in Mass Communication*, 10, 1: 1–23.

——— (1992) We Gotta Get Out of This Place: Popular Conservatism and Postmodernism. New York: Routledge.

216 ———, with Cary Nelson, and Paula A. Treichler, eds. (1992) "Cultural studies: an intro-
duction." In *Cultural Studies*. New York: Routledge.
Hall, Stuart (1992) "Cultural studies and its theoretical legacies." In Grossberg et al., eds.
(1992) *Cultural Studies*. New York: Routledge.
——— (1990) "The emergence of cultural studies and the crisis of the humanities." *October*,
53: 11–25.
Johnson, Richard (1986/7) "What is cultural studies anyway?" *Social Text*, 16: 38-80.
Lipsitz, George (1990) "Listening to learn and learning to listen: Popular culture, cultural
theory, and American studies." *American Quarterly*, 42, 4: 615–37.
Mead, Rebecca (1994) "Yo, professor." *New York* (November 14): 49–53.
McRobbie, Angela (1994) *Postmodernism and Popular Culture*. London: Routledge.
Reed, Adolph (1995) "What are the drums saying Booker?: The current crisis of the black
intellectual." *Village Voice* (April 11): 31–36.

Benjamin Lee

10

BETWEEN NATIONS
AND DISCIPLINES

We are living in a world in which the local, national, and transnational are increasingly intertwined, whether it be the production of commodities, social movements, or ideas and values in Hong Kong, New York, or Moscow. Consumer products are assembled in one country from parts and raw materials produced in many others, and then marketed internationally; global capital and investment move through transnational corporations capable of coordinating massive amounts of information about new sites of production with new markets. Networks of coordinated production are now competitive alternatives to more traditional, "vertically" organized, hierarchical corporations. These networks are producing global classes of "symbolic analysts" and "information professionals" that link Bangalore to Palo Alto and Taipei. The forces behind this internationalization are increasingly outside direct state control, and yet they form the dynamic edge for changes all over the world.

Similar processes of decentering and internationalization are at play in social and cultural transformations of all kinds. Human rights, democracy, ecology, and women's movements draw upon an overlapping repertoire of ideas and practices adapted for local purposes and used against state policies. Popular culture has gone global: Michael Jordan may be the best known athlete in China, and B-grade

218 Hollywood movies are produced with an international video market in mind. In education, international conferences have proliferated; the MLA has become a point of reference for both American and foreign colleagues, as have similar annual meetings in other disciplines. We are seeing the rise of a global professional culture of academics, cultural practitioners, and policy experts; they play a crucial role in the internationalization of the public domains in which value formation and change take place.

At the same time, the end of the Cold War is making more apparent processes that have been underway for several decades and that are responsible for the events reshaping the modern world. The demise of Cold War alliances has revealed the existence of global cultural and communicative practices in which the nation-state is only one organizing component. Developments such as the vast network of exchange relations between states and non-state corporations, the diaspora of national populations not limited to old national boundaries, the rising importance of non-government organizations in all kinds of cultural and economic activities, and international debt patterns that straddle state and non-state institutions—all make traditional comparisons of states, corporations, and institutions increasingly suspect. As Eric Hobsbawm has pointed out in his recent book, *The Age of Extremes,* this international order is being challenged by a transnational world economy in which "older units such as the 'national economies', defined by the politics of territorial states, are reduced to complications of transnational activities (15)."

Understanding these transnational phenomena requires going beyond the categories of the nation-state; access to such information also means going beyond traditional sources of disciplinary knowledge and expertise. The interplay between local, national, and transnational is producing a world in which dealing with local and domestic issues requires placing them in cross-national contexts, while understanding the "emerging global order" requires greater cultural sensitivity to such problems elsewhere. From this interplay, a paradox emerges: there can be no understanding of the global without understanding it as the ways in which different "local" sites are coordinated; yet there can be no understanding of any "local" without understanding the global of which it is a part. Our existing forms of knowledge production and expertise are not exempt from these global processes; it is increasingly impossible for us to understand contemporary changes both here and abroad without seeing how they are intertwined with other perspectives. The challenge is how, from a given location, do we create forms of understanding that can grapple with both the situatedness of local knowledge and its more global implications?

New Challenges: The United States

From the location of the American academy, the emerging world order presents severe challenges to institutions as they try to adapt to changing economic and social conditions. International studies is the fastest growing major in the United States, and many universities have made "internationalizing" their institutions a

priority in their planning. Yet these programmatic statements come at a time when the demise of the cold war's bilateral model of nation-state relations has made it increasingly apparent that traditional area-based and disciplinary models of global processes are out of touch with the hybrid and multilateral nature of global changes. International relations programs think globally but lack a rich, "thick" understanding of local culture, especially in the more dynamic areas of social and cultural changes. Area programs encourage work on local cultures, but have generally overlooked the global processes that are changing them. Cultural studies programs have focused on contemporary culture, but lack historical and comparative depth.

International relations programs, especially those at universities with affiliated professional "schools" (such as Woodrow Wilson at Princeton, SAIS at Johns Hopkins, Fletcher at Tufts University), have tended to focus on the economics and politics of nation-states, and have been struggling to readjust to a world in which non-state relations are increasingly important and the power of states in an "international system" may not have the hold on global processes it once had. Although their intellectual interests would seem to place them in closer relationship with the more social science oriented area programs, professional schools usually exist independently of the intellectual agenda of the rest of the university. As a consequence, such programs have had until recently almost no impact on general education debates in the humanities or undergraduate curriculum, despite the fact that they often possess substantial resources.

Area programs, such as those at Columbia, Chicago, and Harvard universities, are typically built around a large library collection, and try to create "vertical" depth in language instruction (usually through NDEA title VI funding), history, and literary studies. For some of the older, "great civilizations" with long textual histories (China, Japan), departments such as "Oriental Studies" pre-exist the development of area programs and were often incorporated into them. The existing system of area centers and libraries is mainly a product of post World War II support by the government and private foundations, especially Ford, and now administered nationally by the Social Science Research Council and the American Council of Learned Societies. These councils have area committees staffed by area experts specializing on specific parts of the world (Eastern Europe, Southeast Asia, China, South Asia, etc.) and administer programs that support much of the research on these regions; the emphasis was, historically, not on international relations issues, but usually more area specific work requiring in-depth language, culture, and historical training. Given this history, it is not surprising that the models that guided area based research in both the humanities and social sciences used theoretical and methodological frameworks derived from the various disciplines they were historically connected to, inflected by sources of funding often determined by American strategic interests, especially in the cases of the Soviet Union, Eastern Europe, and China. The intellectual marginality of such programs was produced by a structure in which theoretical advances were made in the disciplines and then applied to area research. The uniqueness and relative autonomy of area

220 studies lay in language teaching and the translation and preservation of specialized texts.

Present global conditions also call into question the assumptions that have developed around area learning and training. The older language, culture, and civilizational model has been criticized by recent intellectual developments, and with the downfall of state socialism and communism, the strategic models developed during the Cold War are out of date. The Social Science Research Council is phasing out its area committees in favor of new regional and transnational configurations. In some cases, strategic interests placed the study of contemporary social developments mainly in the control of political scientists, sociologists, and economists, and more culturally oriented work in the hands of historians and literary specialists. An upshot of this is that social scientific approaches (with the possible exception of anthropology) tend to predominate in contemporary studies, while cultural and literary approaches are more strongly represented in historical work.

This bifurcation also affects work in cultural studies that has the additional problem of being relatively Eurocentric and noncomparative. Heavily influenced by British cultural studies and American communications research, American cultural studies has been at the cutting edge in the debates within the humanities over the analysis of contemporary cultural forms, especially film, television, and popular culture. However, many of the most intense points of public engagement around issues such as multiculturalism and the canon are extremely nationalistic and lack any comparative or cross-cultural perspective; furthermore, the links to more traditional area studies and social science research are unclear.

The recent popularity of cultural studies builds upon at least two important historical events. The first is the new social movements of the Sixties, especially civil rights, feminism, and the anti-war protests, which made contemporary culture a legitimate object of study. The second is the so-called "linguistic turn" in which problems of meaning, interpretation, and discourse became central to much of the humanities and social sciences. The linguistic turn was triggered by the importation of structuralism into anthropology, resulting in the triumvirate of Chomsky, Piaget, and Levi-Strauss, which promised to uncover the deep structures of society and the human mind. This turn to language and meaning paved the way for post-structuralist reformulations of subjectivity and identity. At the same time, British cultural studies was entering the United States through communications programs, and the combination of post-structuralist theory and media studies provided an important part of American cultural studies; the emphases on popular culture and media filled the growing interest in identity issues and contemporary culture in disciplines such as English, comparative literature, and anthropology. The disciplinary history of the development of cultural studies also explains why issues of comparison, language training, and area or field research have not been important. Nowhere is this more evident than in the separation of area and ethnic studies programs. For example, there is almost no interaction between Chinese area studies and Chinese-American ethnic studies and often antagonistic relations between African-American and African studies. Area experts suspect that frame-

works used to analyze identity issues in the United States are not easily transportable elsewhere. Debates such as those over multiculturalism in the United States arise in a civil society structure with highly specialized professional cultures; can issues from such a specific social background be applicable elsewhere?

An underlying problem for international, area, cultural, and ethnic studies is that present-day disciplinary divisions work against understanding the nature of global processes affecting contemporary society. One effect of academic professionalization is that each discipline has tried to create its own unique objects of inquiry in order to establish its autonomy and independence from other disciplines. Yet contemporary cultural phenomena are not neatly subsumable under disciplinary categorizations, especially those in public domains mediated by mass communications and popular culture. When coupled with the view that the nation-state is the basic unit of social and cultural analysis, this has produced a situation in which the current methodological and theoretical frameworks are increasingly counterproductive for the analysis of non-state interactions, especially those which draw upon processes with different spatio-temporal flows and organizations.

Intellectual Challenges

What would the intellectual content of an international cultural studies look like? Are there any frameworks available that could (1) deal with contemporary global changes, (2) contribute to the decentering of disciplinary hegemonies, and (3) provide the basis for transnational collaborative work? Can area research be expanded to reflect the transnational issues that might be the basis for a refigured international studies? How can cultural studies' interests in mass media, popular culture, and new forms of subjectivity be reconciled with the in-depth study of the language, culture, and history of a given society or region?

One possibility might be to look at how changes in communication affect conceptions of publics, publicity, and publicness; these conceptions are crucial to the construction of the forms of peoplehood and subjectivity at the heart of the modern nation-state and contemporary social movements. Tropes such as the "collective interest" and "popular sovereignty," which are presupposed by modern notions of nationhood, democracy, and many of the new social movements, all depend upon forms of public subjectivity closely tied to ideologies of speech and communication manifested in terms like "the voice of the people" and "public opinion."

Although the invention of "the people" was a long historical process, its roots lie in the new forms of subjectivity developing in the public spheres of Europe and its colonies during the eighteenth century. In a series of recent books and articles, Charles Taylor (1989, 1990, 1994) has been tracing the development of Western notions of subjectivity from their inward turn in Augustine to their present embattlement in the politics of recognition and identity. In Greek and early Christian society, personal fulfillment meant being in touch with some source of inspiration and feeling outside of one's self, whether it be the Idea of the Good or God. Augustine begins the inward turn by insisting that the road to the discovery of God led through self-examination, through the probing of inner depths that would then

reveal God as the immanent source of truth. Descartes goes one major step further in his insistence that both epistemological and moral sources lie within our consciousness of ourselves. Self-reflexive reason provides us with the instruments both for the objectification and control of the outside world and our own self-mastery and self-control.

Locke takes rational self-mastery out of the internal discovery of self-evident innate ideas, and objectifies the self. By disengaging from Augustine's and Descartes's first person standpoint, Locke reifies subjectivity into a stream of associationist connections of simple ideas. At the same time, he sees society as the objective product of the mutual consent of these rational self-objectifiers, laying the groundwork for the notions of social subjectivity that would be necessary to develop modern notions of civil society. Locke's "law of opinion" would pave the way for Edmund Burke's conceptualization of a "general opinion" based upon public discussion as the source of political and legislative legitimacy.

Taylor emphasizes that in the eighteenth and nineteenth centuries the foundation for modern forms of subjectivity were laid through the interaction between philosophical notions of publics and peoples and a wide range of other forces such as new types of fiction, all of which helped to articulate a growing sense of the fundamental importance of values of ordinary life. The exploration of these values of everyday life, especially in novels such as Rousseau's *La Nouvelle Heloise* that explored the psychology of bourgeois family relations, led to the development of an expressive individualism in which authenticity, self-fulfillment, and self-realization become paramount. In the nineteenth century, a Kantian conception of rational public opinion interacts with a new, essentialized romantic expressionism to create forms of individual subjectivity that in the hands of a writer like Herder, become crucial for the articulation of national subjectivities that should be true to their own languages and cultures. At the same time, this identity, whether at the individual or cultural level, needs and demands recognition by significant others for its full development; it is this strand of the bourgeois public sphere that has been picked up in the recent battles over identity politics and the politics of recognition.

In order to articulate its own interests, the rising bourgeois class adopts the ideology of civil society as a self-governing sector of independent associations that can buffer individuals and families from the market and state domination. Public opinion, especially in the form of the "voice of the people", becomes the founding trope for this ideology as it seeks to create a new kind of public space for itself between the market and the state. With the fall of the absolutist monarchies, the "voice of the people" is the source of authority and legitimacy. Within the egalitarian assumptions of modern civil society and democracy, the "double-voicing" of the people as the source of both authority and power leads to the present day politics of recognition and identity both within a given public sphere and between them.

These new forms of philosophical subjectivity originate in what Jürgen Habermas has called the "bourgeois public sphere"; they provided a political ide-

ology for the emerging bourgeois class in its struggles with the absolutist state. By
linking these developments to specific institutions such as coffeehouses, salons,
newspapers, and journals, and to new forms of subjectivity embedded in particu-
lar discursive forms such as fictional narration, epistolary novels, and philosophi-
cal texts, Habermas shows that new forms of social subjectivity such as public
opinion or "the voice of the people" are the product of complex historical relations
between competing institutionalized discourses.

According to Habermas, the bourgeois public sphere first emerges in England
during the late seventeenth century and early eighteenth century. Its ideas of the
individual develop in the literary public sphere through a network of coffeehouses,
newspapers, literary journals, and reading clubs. "Rational critical debate" arises in
the world of letters out of a dynamic of reading, narration, commentary, and crit-
icism. The structuring ideals of this literary public "field" would be used in politi-
cal debates to criticize absolutist conceptions of public authority. The political task
would be the creation of norms to protect and regulate civil society, and the key
idea mediating the literary and political fields would be that of a rational public
opinion in which what is right converges with what is just; law should be the
expression of public opinion, which itself is the expression of reason.

The literary public field encouraged the development of this conception of pub-
lic opinion by linking some of its structuring presuppositions with new forms of
subjectivity and publicity. These presuppositions included the equal status of all
its members, the bracketing of forms of economic dependence, and a relative inde-
pendence from direct state interference. Realistic fiction provided the new forms
and models of internal subjectivity at the same time that the locus of subjectivity,
the family, was undergoing massive changes in the face of the widespread develop-
ment of wage labor and capitalism. These new forms of subjectivity were produced,
discussed, and criticized in a literary public field constituted by its own self-refer-
ence, as is suggested by the titles of its most popular magazines: the *Tatler,* the
Spectator, and the *Guardian.*

In this print-mediated institutional holding environment of coffeehouses, jour-
nals, and literary clubs, a new form of social subjectivity and publicity emerged. It
is the product of a self-referential discourse in which forms of discourse are them-
selves topics of discourse. As a form of subjectivity, it is an objectification both of
the egalitarian presuppositions of that discourse and the dynamic of its internal
self-criticism and publicness: a rational public opinion that in its universality and
abstractness can subsume all its participants as "common human beings," equal
not only in their potential to partake of such a community but also in the autono-
my of their individualized subjectivities. The criterion of access was the ability to
participate in rational public discussion, which in turn presupposed both educa-
tion and property; the bourgeois public sphere was held together as a reading and
debating public.

Yet as Habermas himself points out, this public sphere also nurtured the devel-
opment of new forms of "expressive" subjectivity that were most clearly realized
in the development of fictional narration. The juncture between philosophy and

224 literature will also provide the "transportable" forms necessary for Benedict Anderson's imagined communities of nationalism. The crucial moment is when a new structuring consciousness emerges through the development of a print capitalism mediated by an institutionally structured, self-reflexive appropriation of the potentials of narration. Narration is constituted by a semiotic reflexivity of the event of narration and the narrated event, whose coordination reveals the locus of a new type of subjectivity, that of the narrator; it is these narratorial perspectives that provide the "objective" and "subjective" forms of consciousness characteristic of modern nationalisms. The authority of omniscient narration interacts with a new form of narration that was especially popular around the time of the American Revolution—the epistolary novel. This novel form created a tone of narratorial intimacy and reader solidarity among an extended, print mediated audience and contrasted sharply with the "objectivity" of omniscient narration.

The bourgeois public sphere produces the connections between the modern nation state, peoplehoods, and publics, which then circulate across the world. The discursive origins of these ideas were novels and newspapers; the supporting cultural economy was that of an expanding print capitalism that linked educated and cosmopolitan elites around the world. These networks circulate the new political ideas that give rise to the birth of the modern nation-state. Although the intellectual sources are European, their first practical realizations are in the North and South American colonies; the first modern revolution (and the first modern nation-state) was the diaspora that led to the United States. The American revolution was a battle over how to represent the people; in the Declaration of Independence and the United States Constitution, the people are invoked as the source of legitimacy and authority. This idea was unprecedented at the time, but was immediately seen as absolutely reasonable and natural; it forms the foundation for the model for modern nationalisms that are built around an imagined community of the nation-state held together by a constitutionalized peoplehood whose legitimacy rests upon public recognition. The idea that nation-, constitution-, and people-building are coeval was a uniquely American idea, but "constitutional people-making" quickly spreads to other societies through the networks of a globalized print capitalism.

The first "wave" of people-making results from the transmission of European debates over peoplehood and sovereignty to the Americas and results in the formation of the first modern constitutional democracies built upon popular sovereignty. A second wave consists of the transmission of these models to Europe in the nineteenth century, which then gives rise to European nationalisms and their colonialisms. A third wave of people-making, catalyzed by the events of 1968 and the development of new social movements across the world, builds upon a globalized communications infrastructure; it is producing notions of publicness and peoplehoods that challenge traditional models of national sovereignty in which individuals, citizens, and the nation-state are "vertically" linked. Connected by faxes, e-mail, and supported by networks among diasporic populations, new transnational movements work around state organizations and bureaucracies and link 'peoples' with shared interests such as women's issues or the environment.

These "new social movements" have made it clear that contemporary issues develop in different public domains that are being brought into contact with one another through the development of a global media industry and cultural economy; these "contact points" have become the catalysts for change at all levels of society across the world. As the events that swept across Eastern Europe, China, and Russia repeatedly demonstrated, political changes grow out of public domains that are increasingly internationalized, and which go beyond the realms of official culture and discourse. Economic proposals, foreign policy statements, even popular music can become potent forms of social criticism when they are enacted in mass-mediated public contexts. The development of "new social movements" is linked to a variety of cultural sites, including the media, performing arts, academic and research institutions, and popular culture, all of which are being pulled into international networks of communication. Mass media—print, film, and television— draw together materials from political, intellectual, and popular culture "discourses" to form distinct "public cultures" that vary from society to society in their organization. These public cultures are, however, structured not only by local and national traditions, but contain new modes of communication which link them to rapidly expanding international networks of communication.

These public cultures mediate and represent both local and transnational perspectives. They are environments for the creation of new cultural and political values, and are also the sites for ideological contestation; their multi-leveled imbrications suggest that political change and cultural change cannot be separated. The political arena, for instance, can be the point of engagement for forces which have been developing in other cultural areas. In England, bourgeois conceptions of the individual first arose in fiction and then entered political debates through their circulation in journals, salons, and coffeehouses. In pre-Tiananmen China, new representations of social reality first occurred in media such as movies, literature, and music, and only later in the politics of the reform factions.

Understanding the development of public spheres and public cultures would thus require an historical understanding of indigenous forms of cultural criticism and the relations among various discourses such as economics, literature, popular culture, and philosophy. Developing such a framework would create a bridge between the strengths of a focused work on language, history, and literature, with contemporary cultural research on popular culture, new social movements, and transnational movements of people, goods, and ideas. The emphasis on the institutions that circulate peoples, commodities, and ideas provides links with work on the transformation of the global cultural economy and communications structure. In-depth work on language, history, and culture provides a comparative and contrastive perspective to cultural studies, the "multiculturalism debates," and identity politics, as well as a culturally sensitive dimension to international studies. Finally, focusing on communication provides ways of seeing how the mass media and information technologies are creating new forms of subjectivity, including diasporic and transnational identities and what Benedict Anderson has called "e-mail nationalisms."

Towards an Internationalized Cultural Studies: A Chinese Example

If concepts such as the public sphere are to be useful in analyzing how the internationalization of communication is transforming public cultures both here and abroad, they will need to be placed in historical and comparative perspectives. Although the term "public sphere" was originally used with reference to a specific institutional structure in Western Europe in the eighteenth and nineteenth centuries, it can be revised to describe the institutional and communicative organization of social and cultural criticism; the bourgeois public sphere would thus become a particularly important local variant. Such a comparative and historical contextualization would see the Western bourgeois public sphere as the product of a particular type of cultural economy (print capitalism) whose institutions (coffee houses, journals, publishing companies, etc.) and discourses (novelistic fiction, journalism, and philosophy) produced the values of bourgeois civil society. Since other societies have their own networks of cultural criticism that organize the relations between discourses and institutions differently, comparative and historical approaches sensitive to the local differences and traditions will be necessary to understand the development of contemporary public spheres and public cultures.

At the same time, the ideas of a constitutionalized peoplehood that is the source of political legitimacy has become a presupposition for modern conceptions of the nation-state and the "we-ness" of contemporary nationalisms. Although the origins of such conceptions are linked to the bourgeois public sphere, the particular national forms they have taken are the products of complex interactions between local public spheres and the processes of internationalization they were drawn into by the spread of print capitalism (and "print socialism" for the cases of the Soviet Union, Eastern Europe, and Mainland China). In most cases, the result has been a conceptual structure in which the individual is linked in his role as citizen to a shared "we-ness" constitutive of a national public and peoplehood, which in turn is appealed to as the source of political legitimacy.

The development of a global mass media and telecommunications infrastructure is now undermining the structure of audiences and publics created by print capitalism. The international circulation of movies and soap operas present alternative and competing images of everyday life, and provide the communications infrastructure for identities not bounded by spatial co-presence or national boundaries. Some of these new identities are formed by diasporic communities supporting or rejecting national and ethnic identities in the name of alternative national sovereignties; in some cases, they use international networks to provide financial support for movements and activities in their home countries. Others use international telecommunications to form transnational networks based upon common interests such as women's issues or the environment, which transcend national boundaries. One of the most remarkable developments is the rapid growth of non-government organizations and not-for-profit institutions. These have increasingly become the site of "movement politics," often replacing older coalitions built around class and labor, and are the forefront of creating new identities and commitments. As the Beijing women's conference demonstrated, these NGO's now

form an active political constituency that can challenge governments and their bureaucracies.

Perhaps the most dramatic example of how these forces are transforming national imaginaries was the Tiananmen student movement in the spring of 1989. Because of an impending visit by Gorbachev, the international media was assembled in Beijing and the world watched an historic transformation in the Chinese public sphere. For Americans, the issues seemed familiar, but the faces were different—students demonstrating, singing songs, talking of freedom and democracy, at the same time tweaking their elders who seemed to watch on in stern silence. In addition to the global media, an international network of faxes and telephones linked overseas Chinese with their friends and colleagues in Beijing; for over a month, the government was paralyzed by public confrontations for which its models of political control were not prepared.

Yet despite the surface similarity to student movements in the West, Tiananmen needs to be put in the context of the history of student and intellectual protest in China. The students had been preparing for a march on May 4th to commemorate the seventieth anniversary of the May Fourth movement. It was the student demonstration on this momentous date—May 4, 1919—that marked the formal beginning of "student power" in modern Chinese politics, as well as the precedent of patriotic students speaking on behalf of the people vis-à-vis the government. The student demonstrations drew upon this history, and in the run-up to the May 20 declaration of martial law, they had catalyzed public opinion and legitimately (in the eyes of most of Beijing's population) claimed the role of spokesman—to articulate the voice of the masses. This immediately clashed with the government which also claimed to represent the people's will.

The government model was, of course, based upon the Chinese communist appropriation and transformation of Marxism. Private property, rather than being a presupposition for freedom and equality as in the ideology of the bourgeois public sphere, was seen as the source of social inequality and loss of freedom, especially for the working class. Lenin completed Marx's political agenda by calling for the elimination of private property and also, in effect, for the elimination of civil society. The Communist Party, as the vanguard of the people and itself led by a revolutionary elite, would penetrate into and mobilize all sectors of society, including the arts and media. Mao contributed further to this consolidation of state and society not only by substituting peasantry for the urban proletariat to form the revolutionary core of the people but also by evolving an all-embracing ideology—Maoism—that speaks on their behalf, thus unifying all civil voices into one. In the Maoist domain, there can be no public sphere in either theory or practice.

The students and intellectuals saw themselves as maintaining the May 4th tradition of public protest; if we look at the history of this tradition, we can find some precursors to what could be called a Chinese public sphere from the late Qing (the end of the nineteenth century) up to 1949. Liang Qichao's journalistic undertakings in the early twentieth century marked the beginning attempts to establish a

forum of public opinion in contradistinction to the Qing court. The rich legacy of new journals and intellectual societies (*xueshe*) in the May Fourth period, the emergence of salons and tea and coffeehouses in urban centers like Shanghai, the huge influx of foreign literatures and translations, not to mention the development of the modern vernacular (*baihua*) as an acceptable form of literary discourse, especially in novels and short stories—all paved the way for an indigenous public sphere if we conceive of that as a set of institutions of social and cultural criticism relatively independent of both the market and the state. Unfortunately, the Chinese political power elite, whether the Kuomintang or the Communists, have always insisted upon the unity of state and society in the name of nationalism. They have never allowed a separate critical public voice to develop fully that might have promoted democratic ideals. Despite the auspicious beginning by Liang Qichao, newspapers in the Republican era increasingly became the instruments of political factions, thereby calling into question both their independence and objectivity. And unlike the case in Europe, the growing business class never formed a unified political group to promote their own public interest. Shanghai tea houses were merely places for social intercourse, as were the emergent literary salons of the 1930s, which never became an influential institution to promote political or literary change. This critical intellectual tradition and the surrounding institutions persisted under the Kuomintang regime despite the fact that the regime since the 1930s had become increasingly repressive. After the 1949 "liberation," however, even the small havens allowed by the Kuomintang government (e.g. the treaty concessions in Shanghai and a few other cities) were eradicated; the Communist government quickly established Party control of both state and society under the banner of the "people's democratic dictatorship."

Thus it is not surprising that from the very beginning in April 1989 the government model of political communication as monolithic consensus contrasts sharply with the students' models that evolved over the course of the democracy movement. Since the Leninist tradition of Party organization dictates emphatically a unified command, general Yang Shangkun put it quite explicitly in his May 26 address to the military commission (which was also a not-so-veiled attack on Party Secretary Zhao Ziyang, leader of the liberal reform faction): the Party cannot tolerate "two voices" either within or outside of it. Using the old metaphor of "two command posts," Yang blamed the upheaval on factionalism within the Party— "the present problem is that two voices within the Party have been exposed to society," thus inevitably leading to social chaos.

What Yang and other members of the Chinese gerontocracy failed to realize is that the preceding decade of "openness" and reform had also effected major changes in Chinese society—to such an extent that an infrastructure of new institutions had developed with exchanges of people and ideas both within China and abroad. Chinese graduate students studying in the United States would send articles back to influential liberal magazines like *Dushu* (Reading) on topics ranging from democracy to feminism and postmodernism. Chinese universities and think tanks would invite guests as various as Milton Friedman, Fredric Jameson, and

Jacques Derrida in an almost frenzied competition for new ideas from abroad. New research organizations sprouted up, ranging from the privately supported Academy of Chinese culture, established by Beijing professors, to the Social Science Research Institute of the Capital Iron and Steel Company. New journals mushroomed, offering a most varied intellectual fare from sensational exposés to avantgardist experimental literature. Privately run coffeehouses made their appearance in the major cities: one such coffeehouse and bar became the meeting place of dissident intellectuals and was used by the publisher of one dissident journal to hold a press conference. Intellectual salons were formed on university campuses and elsewhere with the express purpose of discussing pressing issues such as democracy. One member of the Philosophy Institute of the Chinese Academy of Social Sciences was the editor of a dozen different series of translations of Western social theory ranging from Heidegger to Max Weber and Isaiah Berlin. In sum, the government policy of encouraging individual entrepreneurs (*getihu*) in the economy also spawned social entrepreneurs in cultural production, and the groups and institutions with which they are associated linked together to form a burgeoning public sphere, Chinese style, within the existing political structure. This loosely articulated network of individuals and institutions formed the basis for the forms of social and cultural criticism that would provide the intellectual background and stimulus for the student democracy movement.

The democracy movement brought together forces that were changing the notions of peoplehood and publicness upon which state authority rested. The Chinese phrase for democracy, "*minzhu*," gives a clear and strong connotation of people's sovereignty; however, in the Maoist reformulation, that sovereignty rests with the Chinese Communist Party, which considers itself the vanguard of the people and speaks on its behalf. For some three decades since the mid-1950s the Party had molded the various segments of the population into *its* monolithic vision of the People, thus ironically depriving them of a real voice. Consequently, the immediate manifestation of the student movement was the simple demand to be heard—the articulation of a true voice, a genuine *vox populi* no longer manipulated by the Party. Orderly march and demonstration was considered a right granted by the Chinese constitution to convey the voice of the people to the government.

Although the forms of peoplehood and publicity advocated by the students challenged official models, they shared with their antagonists a face-to-face notion of political representation. The demonstrations did introduce a more pluralistic conception of public voicing, especially in the early marches when different work units joined the student demonstrations. The polyphony and relative decentering of voices contrasted sharply with the government's monological insistence on hierarchy and consensus.

Looking back at the student movement, we can see it as challenging some of the basic assumptions about peoplehood and public opinion that underlie modern Chinese politics. Tiananmen brought into public purview a variety of discourses that formed a counter public sphere to that of the state. Unlike the Western bourgeois public sphere, the Chinese public sphere did not grow out of or help to create

a buffer zone between the market and the state; it was not the institutional locus for the articulation of ideologies supportive of civil society. Indeed, the very institutions that supported its development were dependent upon government support and were quickly eliminated after Tiananmen.

In the post-Tiananmen period, the futility of directly oppositional reform efforts and the rapid pace of commercialization are producing a very different structure of social and cultural criticism than in 1989. The success of Deng's economic policies has resulted in the loosening up of the "work unit" (*danwei*) system that regulated employment, housing, education, and medical support. The work unit system was the means by which the state regulated everyday life, even to the point of overseeing marriages; it was the institutional locus of the individual's incorporation into the state. Since Tiananmen, many people have left their work units to pursue individual enterprises, or maintain a nominal presence (to keep housing benefits) while working at other jobs. In addition to the explosion of gossip magazines and sexy tabloids, there are several new magazines in Beijing that reflect the development of various cultural niches; one, *shenghuo* (*Life*) self-consciously imitates *Life* magazine, while *ai yue* (*Philharmonic*) is the first audiophile magazine in China. *Ai Yue* is an interesting example of how new publics are forming. It was started by an editor for *Beijing Literature* who was deactivated because of his Tiananmen politics. With much spare time on his hands, he decided to start a magazine that would review recordings and equipment, along the lines of stereo magazines he had seen in the United States and Taiwan. The music to be reviewed would be classical; it very much developed out of the editor's private tastes. The first issue sold out; it now has a circulation of over five thousand in Beijing alone. What at first seemed to be a private sensibility struck a resonant chord among a previously unidentified public, which quickly grew up around the magazine.

Along with television soap operas such as *ke wang* (*Yearnings*) and *bian ji bu de gu shi* (*Stories from an Editors' Bureau*—a Chinese *Murphy Brown*), a new mass-mediated and commercial public is being created. The production models for these soap operas and movies often come from abroad, and are heavily influenced by similar products in Taiwan and Hong Kong. What they all share in common is the discovery of values of everyday life; this stands in stark contrast to earlier works that would portray communist heroes overcoming incredible hardships.

The situation for intellectuals and academics is more complex. Teachers and professors still belong to work units, even while state salaries have not kept up with inflation. Among elite intellectuals, there has been an increased circulation abroad, especially by those who have a command of English. Indeed, many of the graduate students who went abroad right before or after Tiananmen have received their degrees, and some have returned to China or Hong Kong. Along with their counterparts from Taiwan, Hong Kong, and Singapore, they are forming a transnational Chinese intelligentsia that will shape the future direction of Chinese social and cultural criticism. The result in Mainland China is an internationalized professional culture in which the social sciences draw heavily upon Western models and

methodologies, while the humanities are experiencing what has been called "a crisis in the human spirit of the humanities" (*ren wen jing shen wei ji*).

Commercialization has thus introduced the possibility of sites of cultural criticism not dependent upon government support, which are also increasingly part of a pan-Chinese cultural sphere. This potential multiplicity of voices is developing independently of the state. At the same time, the emphasis on values of everyday life shared across these regions creates the image of a contemporary Chineseness that crosses national boundaries.

With the post-Tiananmen economy opening up, these forces have accelerated, leading to the creation of a pan-Chinese cultural nationalism that will have profound implications for all of Asia. This "culturalism" is built upon shared print (the written language is the same in Singapore, Taiwan, Hong Kong, and the Mainland) and mass media cultures (especially movies, videos, and television soap operas) and the increasing international circulation of Chinese intellectuals and cultural practitioners. For example, the Mainland government, in its search for "a socialism with Chinese characteristics" has embraced Singapore's neo-Confucianist rhetoric as a model for the creation of uniquely Chinese values that might support both political authoritarianism and entrepreneurship. Yet Singapore's neo-Confucianism owes a great deal to the work of Du Weiming, a professor of Chinese studies at Harvard who was educated in Taiwan and later became an advisor to Singapore's prime minister, Lee Kuan Yew. At the same time, this has also led to the Mainland government's promotion of "*guoxue*," or national cultural studies, which strives to determine the uniqueness of traditional Chinese culture; ironically, several of its advocates turned to *guoxue* as a way of avoiding politics during the post-Tiananmen period and asserting the primacy of Chinese studies in the face of the massive importation of Western literary and cultural theories (including cultural studies).

In addition to these new forms of cultural nationalism, the internationalization of communication (Mainland China has just joined Internet) is also beginning to link non-government groups within China to their counterparts elsewhere. As we saw with the Beijing Women's conference and the international controversy over the Three Gorges Project to dam the Yangtze River, there are now local, subnational constituencies in Mainland China for the new social movements which are sweeping the globe. The greatest irony of all may be that it is this third wave of people-making and not the state that is creating the institutional conditions necessary for developing those "uniquely Chinese values" necessary for China to adapt to the processes transforming it.

Conclusion

The working assumption behind these suggestions for how to create a more culturally sensitive international studies is that the internationalization of culture and communication is producing a situation in which local and transnational issues are being brought into closer and faster contact. Our views of ourselves and oth-

ers are increasingly intertwined, and no single site possesses either the intellectual or institutional resources to understand those processes affecting all of us. Understanding these changes will require new forms of international collaboration, and a reorientation of established disciplinary frameworks and a redirecting of resources.

Despite the current reductions of support for area and international studies, present conditions provide us several new opportunities for constructing more culturally sensitive international perspectives. The most important is a decentering of expertise from the United States and Western Europe, and its expansion to non-Western societies. There are increasing numbers of intellectuals, scholars, I and cultural practitioners who have been trained in at least two cultural traditions; the Chinese example is certainly not an isolated one. Familiar with Western forms of knowledge, they are often intellectually, artistically, and politically active in their home countries, whether or not they actually reside there. Their cultural and linguistic sensitivities, as well as their involvement in contemporary debates and problems, provide unique insights and resources for collaborative work. The international networks that have grown up around these people provide alternatives to those of international bureaucrats and politicians, and directly tap into the range of activities and institutions that are at the cutting edge of changes in their home countries.

In addition to human resources, area center libraries and museums have developed collections that often surpass those of the home countries both in size and ease of access. These collections are "world information resources"; they need to be supported and developed, but also opened to researchers from other countries. Existing area centers could also become unique sites where people from different cultures can have the opportunity to meet and discuss issues of common concern; in many cases, they might not have the opportunity to meet each other because of political or economic constraints in their home countries. In the United States, intellectual and artistic exchanges and collaborations often overlap with diasporic ethnic migrations. Local ethnic communities are no longer backwater outposts, but may play a crucial role in the internationalization of their mother countries and provide unique perspectives on globalization processes. For example, there are over 100,000 Chinese students from Mainland China, Hong Kong, and Taiwan in North America who represent the future of a pan-Chinese cultural identity; at present, they play little role in Chinese ethnic studies despite the fact that they make up the majority of the post-1968 Chinese diaspora.

Another resource is the growing number of institutions both here and abroad which possess different interests, research traditions, and cultural backgrounds, but share interests in contemporary culture. In addition to work in economics, politics, and development policies, there are new institutions and nongovernment organizations that look at popular and mass media, or are directly involved in supporting the arts or various social issues ranging from women's rights to ecology. The development of these institutions provides an unprecedented opportunity for coordinated collaborative work that can examine the links between local and glob-

al processes; indeed, these networks are part of the ways in which local interests become internationalized.

These developments point to the possibility of decentering traditional notions of expertise by collaborating with foreign colleagues in identifying those issues of contemporary relevance in other societies. What the United States needs to know may not be the relevant starting point. Instead, we need to identify what Brazilians, Indonesians, and Chinese already know, including their criticisms of existing frameworks of analysis, and what issues they think are important to study. These collaborations need to go beyond the selection of relevant topics for study, but also to the selection of methodologies and analytic frameworks.

In the United States, the creation of a culturally sensitive international cultural studies would entail the pluralization of many existing assumptions about research and teaching and a reorientation of international, area, and cultural studies, and present disciplinary interests. If we are living in an interdependent world in which our views of ourselves and others are intertwined, then overcoming the sharp separation between domestic and international perspectives is not only necessary for understanding other cultures, but also our own. Redefining the role of international studies thus entails seeing its crucial role in the life of the university as a whole. It will become increasingly inappropriate to segregate domestic from international, or professional schools from department structures. Indeed, departments, area programs, and professional schools all have different perspectives on internationalization, and one of the purposes of an international cultural studies would be to decenter these perspectives by introducing them to one another and those of our foreign colleagues. Since these global processes are affecting the areas studied by all disciplines, an international cultural studies becomes a unique area where different academic and professional interests can meet; it becomes a critical juncture where the role of the university can be redefined.

References

Anderson, Benedict (1991) *Imagined Communities*. London: Verso.
Habermas, Jürgen (1989) *The Structural Transformation of the Public Sphere.* Trans. T. Burger and F. Lawrence. Cambridge: M.I.T. Press.
Hobsbawm, Eric (1994) *The Age of Extremes*. New York: Pantheon.
Taylor, Charles (1989) *Sources of the Self*. Cambridge: Harvard University Press.
——— (1994) *Multiculturalism*. Princeton: Princeton University Press.

Constance Penley

11

FROM NASA TO *THE 700 CLUB* (WITH A DETOUR THROUGH HOLLYWOOD)

CULTURAL STUDIES IN THE PUBLIC SPHERE

In April of 1993 I heard that Pat Robertson, in a *700 Club* special on godlessness in public schools, had denounced the course I teach on pornographic film. A feminist teaching pornography, the good reverend said, is like Scopes teaching evolution.[1] That same day in April I got an invitation to present my research on women in space at NASA's Jet Propulsion Laboratory at Caltech.[2] That coincidence made my day, since I am working on a book on popular science and sex in America, and it convinced me that I had finally arrived, public sphere-wise.

As it turns out, I was on a roll. While my pornography course was written up in every mass circulation publication from *Readers Digest* to *Playboy* (I got a lot of interesting mail), my newly appointed chancellor at the University of California-Santa Barbara, the former Neil A. Armstrong Professor of Aerospace Engineering at Purdue, asked me if I would like to be nominated to the astronaut corps. A bit later I was asked to be an expert witness in a Federal obscenity trial of some adult videos. And then a Hollywood documentary production company approached me to appear in, and be a consultant on, *The Skin Game: Porn in the USA*, a theatrically-released film that will survey the current state of the industry, the ongoing legal battles around obscenity, and the most recent humanities and social science

236 research on sexually explicit images and their uses. As a sign of the desperate inge-
nuity of academic publishing today, my editor immediately called the producer of
The Skin Game to arrange a deal for a book on the making of the film. This is the
same editor who had already decided to use Pat Robertson's apoplectic description
of my pornography course—"a new low in humanist excess"—as a jacket blurb on
my forthcoming book.

A friend said that my essay for *Disciplinarity and Dissent in Cultural Studies*
could be entitled "Connie's Big Adventures in the Public Sphere" because it is fash-
ioned out of three stories about my attempts—successful, failed, and inconclu-
sive—to travel the kind of cultural studies work that many of us are now doing into
other public spheres. I say "other public spheres" because, of course, there are more
than one, and to oppose the kind of thinking (too often coming from the left) that
does not consider the university to be a significant public sphere. But in my expe-
rience, and for my purposes, the university is not so much an ivory tower as it is
the muddy trenches. After all, everyone from Stuart Hall to Pat Buchanan insists
that we are in a state of cultural war and the university, in both its public and pri-
vate versions, has been a site of some of the messiest skirmishes and prolonged bat-
tles. I do not imagine this traveling, then, to consist of trips "out from" or "beyond"
the university but as a to-ing and fro-ing between and among public spheres.

In recounting these stories, all of which are more or less at my expense, I hope to
communicate something of the possibilities and also the limits of traveling the kind
of interdisciplinary activist scholarship that goes under the name cultural studies.
(I know some would prefer "postdisciplinary" but to my sensibility that sounds, at
least for now, too smugly transcendent.) Along the way I want to raise, more
implicitly than explicitly, as many awkward questions as I can about "the public
sphere" and "the public intellectual." It will quickly become apparent that I operate
on the principle that public spheres do not so much exist as have to be made and
that public intellectuals *do* exist, we just have to know where to find them (Robbins,
1990, 1993). No more dallying, then, three stories about three trips, into the worlds
of science, law, and Hollywood.

Why did my chancellor want to send me into space? Some colleagues suggested
it was because of the porn class and lingering thoughts of what happens when
teachers get sent into space, but I saw a nobler impulse. It was, however, precisely
my research on teacher-astronaut Christa McAuliffe that convinced the chancellor
I was sufficiently knowledgeable about—and committed to—space science and
policy issues to make a good teacher-astronaut. We need a humanities professor in
space, he said, to be able to give the humanities perspective on space exploration,
and you're just the one to do it. He had first come across my work just six days after
arriving on campus, when I sent him a copy of an essay called "Spaced Out:
Remembering Christa McAuliffe," that I had written for a special issue of *Camera
Obscura* on gender, science, and technology. The essay was part of a larger project
of examining the way NASA figures in popular culture, looking at NASA *in* and *as*
popular culture. In "Spaced Out," I gave myriad examples of the way NASA has
deliberately tried to make itself popular, largely through modeling itself after its

fictional twin *Star Trek*, and showed the way references to NASA, and *Star Trek*, pervade everyday speech and institutional discourse. I then took the Teacher-in-Space Program as the major and most symptomatic instance of NASA's failure to be popular, an instance where the effort literally blew up in its face. NASA does not, however, get the entire share of the blame; I also tried to demonstrate that we all have difficulty imagining a place for women in space— using "space" as a stand-in for the world of science and technology—which can be seen in the way we write and talk and think about this issue in jokes, songs, stories, movies, television shows, recorded memories, media accounts, and histories of space exploration. I do not conclude that NASA should not *try* to be popular—especially if being popular consists of appealing to people's pleasure and curiosity around science and technology—but say that it needs to do a better job of it, needs a better script, as it were.

I was prompted to send my essay to the chancellor because a history of science colleague who knew of my work on women in space had just given me an Associated Press clipping about a NASA press conference that had been called to announce the formation of a committee to consider whether to revive the Teacher-in-Space Program. I immediately mailed my essay to the head of the NASA committee, with a cover letter offering to talk further with any members who found this kind of cultural analysis of NASA useful. But of course what I really wanted was to be on the committee. Not only did I believe I could make a contribution to the deliberations, I also wanted the chance to see how people from other disciplines and backgrounds understood NASA's cultural role and, specifically, everything that had been both right and wrong about sending a teacher, and especially Christa McAuliffe, into space. Realizing I had little clout to get myself onto this committee and casting about for more, I thought of the new chancellor, whose previous university had graduated more astronauts than any other school and whose record on bringing women and minorities into engineering was impressive. Since he had also served as a consultant to NASA head Daniel Goldin, I thought a recommendation from him might mean more than the transparent plea of someone writing so far out of her "field" as to risk being dismissed as yet another spacenut who had been to one too many *Star Trek* conventions. So I sent him my essay, with a cover letter offering him many outs if he decided he could not recommend me: that he was too new to the job and did not yet know the faculty, much less the humanities faculty; that he might disagree with my arguments, finding them too harsh or too explicitly feminist; or that he was simply too busy. I would understand any of these reasons.

A few days later he called to tell me that he was so impressed with my knowledge and interest in NASA that he would be delighted to recommend me. He ended that phone call by telling me that he had in front of him, on his desk, the nomination forms for the 1995 astronaut corps and asked me if I knew anyone on campus I could recommend. I told him that one of the problems with our campus, which people were hoping he could help rectify, was the split between the arts, humanities, and social sciences on the one hand and the natural and physical sciences on the other, and so I knew no one from the "other" side of campus to recommend.

238 As I put down the phone, though, I thought, "Was he asking me if *I* were interest-ed?!" When I went to his office to look over his letter before he sent it off, I asked him if he had indeed been inquiring after my own interest in being an astronaut. He said yes, and handed me the application form. Flattered, if a bit staggered, I told him I appreciated his belief in my astronautical potential. But, I said, I like to be bold yet realistic: I have a better chance of getting on a plane to Washington than on the space shuttle, so first, recommend me as a member of the Teacher-in-Space committee, and we'll think about the astronaut part later. I also pointed out to him that the official Astronaut Candidate Program brochure does not even bother to proscribe humanities scholars, so far are they off the map of those imagined to be suited for space (psychologists, anthropologists, and all other social scientists are explicitly told not to apply). So, too, I continued, applying to the Astronaut Candidate Program could be perceived as a conflict of interest: I could not be try-ing to get on the committee to decide *whether* there should be a Teacher-in-Space and also be trying to *be* the Teacher-in-Space. He agreed and so, for now, the appli-cation for federal employment remains pinned to my bulletin board.

 NASA responded in true NASA fashion, that is, through ineptness, evasion, and several other varieties of nonresponse. Eric J. Chaisson, in his hugely informative book *The Hubble Wars* (1994), cites the several other NASA commentators who have said that while some institutions have a public relations agency, NASA is a public relations agency with an institution (120), one long on hype and spin and short on information and savvy about how to explain its goals, mission, successes, and failures. The first thing that happened was that the NASA spokesperson who was the original head of the committee, to whom I had sent my essay and the chan-cellor had written, had to resign. It seems that during the press conference called to announce the formation of the committee he had, when asked by a reporter, said that he believed another teacher should be sent into space. Since it is not a good idea to have the head of an exploratory committee announce in advance what he thinks the conclusions to the deliberations should be, he was immediately replaced. I found this out when I finally reached him in one of many follow-up telephone calls that I and the chancellor made. Embarrassed, he said that in any case the com-mittee could not have included me because it was an internal NASA committee; the issue of whether to send another civilian-teacher into space is such a fraught and complicated one that NASA wanted to consider whether it was ready to take it on again before opening it up to public discussion. He assured me that the mem-bers of the committee had all been given my essay. But neither I nor anyone else who had something to say to NASA about the Teacher-in-Space Program will ever learn how far our ideas travelled. Although the formation of the committee was announced with much fanfare, NASA has refused to release the resulting report. We can know neither the conclusions of the committee nor the quality of their deliberations.

 I failed, too, to get my ideas about space policy across in the public sphere of the print media. I used the occasion of NASA's finally releasing photographs of the *Challenger* crew cabin debris (in February 1993) to send a very abbreviated version

of "Spaced Out: Remembering Christa McAuliffe" to the Op-Ed page of *The New York Times*, which had previously published a piece I had co-authored on television and the Gulf War. To my surprise, the editor accepted this piece much more readily than the first one but asked for a major revision: I had to take out all the sick jokes about the *Challenger* explosion that I had used in the piece because the other Op-Ed editors believed they were in poor taste ("All the news that's fit to print") and would offend the dead astronauts' families. I labored mightily over one weekend to make the piece fit the paper of record's taste requirements. When I faxed it back again, the response was that it lacked the punch and interest of the first version; it did not work without the sick jokes. I could not have agreed more because the piece was structured around the kind of popular knowledge and critique of NASA that gets articulated in this form of everyday humor so brilliantly studied by folklorist Alan Dundes. *Challenger* explosion sick jokes such as "What were Christa McAuliffe's last words?" "Hey guys, what's this button?" and "Where did Christa McAuliffe spend her vacation?" "All up and down the Florida coast" helped me to demonstrate that there is, in the public imaginary, a great deal of anxiety about and even antipathy toward women's entry into the world of science and technology. All of the *Challenger* explosion sick jokes, as well as the Internet lore about the event, such as the putative transcript of the astronauts' dying words as they plunged toward the ocean, center on Christa McAuliffe, on the teacher as the cause of the accident, or on her body in pieces. The Op-Ed editor went back to the original version and held onto it for three weeks before finally deciding that no argument was compelling enough to justify the poor taste of reproducing these jokes, even if the argument could be made no other way because the jokes were the object and the evidence.

As for my lecture on women and space at the Jet Propulsion Laboratory, I got out of there relatively unscathed, which is more than I can say for another venue that I will mention shortly. As I was speaking to the JPL audience, I realized that it is one thing to write *about* NASA and another thing to speak *to* NASA. I think my having prefaced that talk with two necessary explanations helped the audience to consider my criticisms of the space agency. The poster announcing my talk invited the JPL workers to "come hear a cultural critic talk about NASA." I was told that there had been much puzzlement about what a "cultural critic" was, so I should open with a helpful definition, which I think I did, by describing the wide range of textual, ethnographic, and empirical materials that I would be using to make my argument about the enduring difficulty we have imagining a place for women in space even as we are consciously striving to create that place. I also let the audience know that I was making my criticisms as a fan of NASA, as a supporter of the social, ideological, and scientific gains of having a space program, if it is a program that emphasizes both "manned" and automated space exploration, as well as "Mission to Planet Earth" environmental studies, and cooperates internationally with other agencies, especially that of the former Soviet Union. I have found that once that basic support is enunciated, any audience, even a prickly NASA audience, can accept the kind of criticism inherent in my kind of tough love approach. I am

grateful to a group of *Star Trek* fans, the women writers who have so ingeniously "slashed" that popular show, for teaching me that approach and the advantages of being a fan/critic; after all, no one knows the material better than a fan and no one is more critical, yet also willing to spend the time massaging (sometimes it hurts so good) the chosen object into a form more answerable to everyday needs and utopian desires (Penley, 1991, 1992).

The even pricklier audience for my research on women and space turned out to be one composed of left cultural studies comrades who admired the exposé part of my argument but were aghast when they realized that ultimately I was writing as a fan of an institution they believed to be entirely militarized, governmental, and corporate (a triple whammy) and therefore available only for critique not engagement. How had I ever imagined engaging such a compromised socio-political structure as NASA?

My first reason for having believed it to be possible was that NASA had put itself squarely on our turf in its efforts to be popular. Since we now generally accept the idea that popularity necessarily depends on an appeal that is both pleasurable and cognitive, then insofar as NASA has been successful at being popular, it has had to put its ideas out there for public use and likely criticism and no one can know in advance what those uses or criticisms may be. So, too, we now accept that it is not very useful to see institutions and their powers as monolithic and seamless. Many of the most important criticisms of NASA have come from current or former NASA scientists, engineers, technicians, and staffers, and the NASA librarians are terrifically generous and analytical (*they* should be running the public relations department).

Another reason why I believed NASA to be ripe for engagement was my reading of the histories of NASA's relation to the military, which has been much more fraught and antagonistic than generally known (Trento, 1987; McDougall 1985; Chaisson, 1994). NASA, a civilian organization, is now fully demilitarized. Even at the peak of militarization, under President Reagan's scheme to use the space shuttle to ferry *Star Wars* components into orbit, the military wanted to have nothing to do with the NASA vehicle, insisting instead on the priority of launching secret payloads on automated rockets from Vandenburg Air Force Base. The history of NASA is rife with stories about the mutual scorn between the civilian agency and the military. One of the most recent such instances was the military's refusal to help the Hubble scientists detect a problem with the solar panels on the space telescope, which could be seen by the military's spy satellites. The military did not want to give away too much about the resolution capacities of the orbiting spy lenses but also did not want the blatant display of the superiority of their imaging systems (at a cost to the taxpayers of $100 billion) than anything civilian scientists can ever hope to have (Chaisson, 270).

And yes, NASA is governmental in that it is funded by tax dollars and must be authorized every year by Congress. Such a system of course leads to wretchedly politicized and short-term, short-sighted decision-making and rampant porkbarrelling, with the proposed space station as a prime example, aptly called "orbiting

pork" by critics. But here, as well, the arguments—such as, "what you're calling pork is my idea of crucial R&D in the national interest" or "Cold War military technology must now be turned to studying the environment"—take place in at least a semi-public space, the legislative wing of the state that intersects with all kinds of other public sphere activities (Fraser, 1993, 23–25). And wondrous compromises can be worked in that particular public space, like the recently announced plan to use the existing military spy satellites to monitor 500 ecologically sensitive sites around the world, supervised by a university-industry coalition run out of the Pentagon's National Reconnaissance Office and coordinated by a CIA now operating under an expanded notion of national security. Even the Republican Congress, which has been hell bent on eviscerating support for scientific research, especially environmental research, has supported the project because it is too hard to argue against a project with such widespread support and whose costs are so low (Congress and the White House appropriated between $15 and $17 million) and the potential gains in knowledge so great.

And yes, NASA is corporate and yes, this is where the most shocking abuses of the public trust take place, in NASA's corrupt relation with corrupt private sector contracting. The list of such abuses is too long to enumerate here. I will just mention, by way of epitomizing the abuses, that Utah's Morton-Thiokol had never manufactured anything remotely like O-rings when it won the bid to produce them for the space shuttle. Fortunately for all of us, Morton went back to making salt after supplying NASA with the *Challenger*'s fatally faulty O-rings. But even here, in the private sector, which is so little scrutinized by either the corporate-owned media or the radically declawed regulatory state, some cultural studies scholars have found evidence of the possibility of constructing new forms of publicness in the supposedly private world of the market (Robbins, 1993). At the very least, activity in the commercial sphere is not being cast as inherently less democratic and empowering than what goes on in other spheres including the state. This claim cannot, of course, be evaluated in the abstract but must be made on a case by case basis.

There are many ways, then, to engage NASA insofar as the space agency is both popular and public, or can be understood or *made* to be so.

My second adventure concerns the attempt to make a space for public discourse and debate about sexual expression amid the arcane legal complexities and bizarre ethnography of the obscenity trial courtroom. As a professor who teaches an accredited university course on pornographic film, I was approached, in early 1995, to be an expert witness in a Federal obscenity trial in Louisville, Kentucky.[3] The videos being prosecuted had been charged as obscene on the grounds that they were nonnarrative and, without a story, could not therefore convey ideas or, by extension, be the bearers of any values such as political or artistic ones. The defense for Leisure Time Communications, the distributor of the videos, thought that I could speak authoritatively on the issue of whether nonnarrative works were capable of conveying ideas and therefore bearing values, which indeed I could because

two of the other film genre or movement courses that I teach are explicitly concerned with this issue, "Experimental Documentary" and "History of Avant-Garde Film," two forms often characterized as nonnarrative (even if we know that there are almost no purely nonnarrative forms) that are considered prime cultural sites of contestatory ideas that have historically produced many important, if controversial, political and artistic values.

At first I was astonished that the prosecution would make such an easily refutable claim. But as I came to find out, the prosecutors had felt compelled to use the argument that, without a story there are no ideas, to try to make an end run around the judge's injunction that he did not want to hear the words "First Amendment" in his courtroom; if the videos could not convey ideas, they could not be speech warranting protection.

This already fascinating case got even more intriguing for me, however, when I was finally able to examine the videos being charged and decided to show them to the film majors in my pornographic film class. Schooled in film theory, history, and historiography, with a good working knowledge of narrative theory, the students saw what I had seen: the videos were, in fact, full of narrative. *Gay and Kinky*, *Three Guy Ass Attack*, *Girls Who Eat Cum #7*, and *Kinky Anal #2* were admittedly more in the nature of vignettes than extended stories but they were structured by cause and effect, edited so that story time was longer than screen time, and contained many other markers of narrative and mise-en-scene such as fantasy or dream sequences, costumed characters, distinctly chosen locations, and meaningfully selected set decoration and props. My conceptual, rhetorical task then became how to demonstrate that "nonnarrative" work indeed conveys ideas, and therefore embodies values, but then also to confound the prosecutors by flipping around to show that the videos were in fact thoroughly narrative in character and thus, in the prosecutors' own terms, speech warranting protection. I, too, following the judge's injunction, would never utter the words, "First Amendment," but the concept would have been at least implicitly entered into the trial's discourse, by both the prosecution and the defense, for the jury's consideration.

Under *Miller v. California* (1973), the juror in an obscenity case must determine whether the average person, applying contemporary community standards, would find that the work, taken as a whole, appeals to prurient interest; whether the work depicts or describes, in a patently offensive way, sexual conduct; and whether the work, taken as a whole, lacks serious literary, artistic, political, or scientific value. A work cannot be deemed obscene unless all three criteria are held to apply. I understood that my expert witness comments would be speaking to the third prong of *Miller* and would at least establish that nonnarrative works (if the prosecution wanted to characterize the videos in that way) *could* have serious artistic or political value. I also understood that the fact that I teach an accredited university course on pornographic film could be used by the defense to argue that such videos had scientific value insofar as they could be the object of teaching and research. The jury, however, does not have to conclude that because such videos *could* have value, these particular ones do, especially since the videos strategically chosen for prose-

cution were low end and looked quite tacky, even amateurish, and were laden with bad jokes and visual puns. How could the values they possessed possibly be the "serious" ones that warrant protection?

Lawyers are still trying to defend *Three Guy Ass Attack* on the same grounds they used to protect *Ulysses* from the censors. Although such a defense has little to do with social reality, it remains the standard defense strategy because it worked in the past. So, too, defense lawyers prefer working with the third prong of *Miller*, which relies on the jury determining what a "reasonable person" would think about the work's value, than on the other two prongs, which rely on the jury determining what a hypothetical member of their community believes the (local) community standards are for acceptance or tolerance of prurience and patent offensiveness. Expert witnesses can be brought in to testify to the work's "value," which can be a national standard of value, not a local one, but so far courts have not allowed jurors to hear the results of social scientific surveys of the beliefs of actual members of their communities (Linz, Donnerstein et al., 1995). Because jurors are not supposed to respond subjectively to what they feel about the material but decide what a hypothetical member of their community would think, they are required to do social scientific work without any of the conventional tools such as questionnaires or interviews.

The big lie here, of course, is that deprived of any other means of ascertaining community standards, jurors won't fall back on their own feelings and beliefs. It is for this reason that prosecutors choose to prosecute hard core materials almost entirely in the South in the hope and (reasonable) expectation that religious, con-servative jurors will apply the community standards tests (in fact, their personal rsponses) more harshly than jurors elsewhere. And, as it has increasingly become difficult to find juries anywhere in the country that will deem heterosexual adult videos obscene, prosecutors are targeting mainly gay videos, hoping that the jury members' homophobia will make them find sexual acts obscene that they would not find obscene if engaged in by heterosexuals. Similarly with Southern juries, prosecutors like to target interracial videos. They feel they have hit the jackpot with videos that are gay *and* interracial, as some of the videos in this case were, including an extraordinary one that shows two white men at once anally penetrating a black man. (I guess it could only have been worse if it had been two black men buggering a white one.) In an obscenity trial all the prosecution has to do is show the films to the jury; it can then rest with no further presentation of evidence. With the right jury, the pictures are expected to speak for themselves and are guilty until proven innocent, which is the lengthy and costly job of the defense to do.

The more I came to know about the prosecution of this case, the obscenity defense, and its long and convoluted legal history, the more I began to wonder whether it would now be possible to defend hard core (which like almost all of the material that gets prosecuted is nonviolent—no rape or torture—and depicts only consenting sexual relations among adults) not as art but popular culture.[4] Perhaps the real contribution I could make as a cultural studies scholar would not be to help lay the groundwork for hard core as a kind of film art that conveys ideas that

deserve protection and therefore has value (*Gay and Kinky* is the same as *Ulysses*) but to try to demonstrate the value of popular culture in and of itself (*Three Guy Ass Attack* is "serious" on its own terms). As we shall see below, such a defense can even be newly and productively linked to the problematic community standards prongs of *Miller*.

In my classroom I had already come to understand the importance of examining pornography as popular culture. I could not have taught my course at all, I think, if Linda Williams had not done the kind of work she did in *Hard Core: Power, Pleasure, and the "Frenzy of the Visible"* (1989). The book's breakthrough was to think about pornographic film as film, not as art or deviance but simply film, a historical genre of film with its own conventional themes, motifs, iconography, stylistic features, and narrative forms that could be studied with the same kind of methodological tools film scholars use to the study other genres such as the gangster film, the science fiction film, the western, or, what Williams argues is pornography's closest kin, the musical. But Williams's *Hard Core* is far more than a formalist genre study. Her arguments—startling at first because so counterintuitive and opposed to received opinion, but ultimately persuasive because of the authority of her research and strong feminist stance—include the claim that pornographic films are most concerned, as is cinema in general, with trying to picture that which has been previously invisible. In the case of porn, it is the woman's orgasm that is invisible, so porn film strives to represent that which cannot be directly seen (and can even be faked). In so doing, Williams argues, porn film necessarily makes a significant detour through the woman's desire, in trying to discover the nature of female pleasure, even if only ultimately to return to the man's pleasure.

By looking at pornographic film as film, Williams is able to describe and explain so much more about the genre and how it figures in people's lives than we have ever known before. But the more access I had to a range of historical examples (through the luck of stumbling onto the archives of the Institute for the Advanced Study of Human Sexuality in San Francisco and the generosity of directors and producers I contacted), I began to wonder what we could understand about pornography by also thinking about it as popular culture. It had been my encounter with the slash fans and their ingenious efforts to fashion sexually explicit stories for women using characters from popular television shows like *Star Trek* that had first prompted me to think about pornography as popular culture. I had also been inspired by Andrew Ross's argument in "The Popularity of Pornography" (Ross, 1989) that feminists have not been able to do a good job of describing and explaining pornography and its uses because of their class-based disdain for it, fueled as it is by a Victorian idea that women, good middle-class women, should not be associated with anything the lower orders do. Important, too, was the way Laura Kipnis built on Ross's insight about feminism and the class politics of porn in her essay "(Male) Desire and (Female) Disgust: Reading *Hustler*" (Grossberg, et al., 1992). She tells us how she made herself overcome her revulsion for *Hustler*, to actually sit down one day and look at it. She discovered that this most reviled instance of mass circulation

porn is at the same time one of the most explicitly class-antagonistic mass periodicals of any genre. *Hustler*, she found, is militantly gross in its pictorials, its cartoons, its editorials and its political humor, with bodies and body parts straight out of Rabelais, all put to service in stinging attacks on petit-bourgeoisiehood, all forms of social and intellectual pretensions, the social power of the professional classes, the power of the government, and the hypocrisy of organized religion. Kipnis's description of *Hustler* matched my knowledge of the popular and populist imagery and impulse of a great deal of contemporary porn as well as its historical predecessors.

What kinds of working premises about popular culture do we take to pornography once we conceive of it as popular culture? The shorthand version would look like this (imagine a *Max Headroom*-like amalgam of Hall, Jameson, Bourdieu, and de Certeau delivering this as a one-minute lecture):

1. For popular culture to be popular it must engage both our pleasures and ideas, our dreams and anxieties.

2. We do not have anything like folk culture anymore because no culture is autonomous from mass-produced culture, so we have to make our popular culture out of mass-produced culture.

3. Consumers are not passive cultural dupes, but actively resist, negotiate, and transform the artefacts of mass-produced culture.

4. Although taste cultures are formed to express class distinctions, cultural values and uses are not purely coincident with class status and interests.

5. Popular culture is now a major site of social, political, and moral discourse and debate. Both Stuart Hall and Pat Buchanan agree: This is cultural war.

6. Any production or consumption of popular culture is politically impure: one cannot find pure instances of containment or resistance, ideology or utopia, reaction or progressiveness.

7. We cannot know beforehand what popular culture means to people, how it figures in their lives, how they use it; it must be studied, textually and institutionally, but also on the ground by observation and listening to what people have to say about their own practices.

Meanwhile, back in Louisville: for many complicated reasons, the Justice Department and Leisure Time Communications cut a deal (involving a large fine and probation) as the potential jury members were filing in to fill out their questionnaires. Until the next time (and there will be a next time because porn prosecution is such good politics and such effective extortion for there not to be a next time) I cannot know whether lawyers could be persuaded to try defending adult materials as popular culture or whether a jury could be convinced to take popular culture seriously, which would mean granting all seven above points. It is hard enough to convince the college students in my courses who often think of their current consumption practices as no more than the guilty pleasures of youth from which they haven't yet weaned themselves. How much more difficult, then, would it be to convince jury members who, the lawyers remind me, must be addressed as if they had an eighth grade education? After all, as Mark Rose recently said in a talk

about his own experience as an expert witness in copyright infringement trials (Rose, 1995), we do not get to lecture on the stand; we can only respond directly to the questions that are asked us, which depends on the defense lawyers understanding points 1–7 above well enough to frame the questions.

And what about those jury members, who I am instructed to treat as adolescents? They are the ones who must try to figure out whether a reasonable person would believe the charged materials have value and whether a hypothetical member of their community would think the materials violate local community standards. It may be helpful to remember here that all those jury members are consumers of popular culture, although they are more likely to think of themselves as hobbyists, romance readers, CNN or Weather Channel junkies, fans of the NFL, the soaps, WWF wrestling, or *America's Funniest Home Videos*. I do not yet know how, but I am wondering if their implicit understanding of the value of their own popular consuming practices (Radway, 1984; Bobo, 1988; Penley, 1991, 1993; Ellsworth, 1988) could be tapped into and then extended to that of porn consumption. I probably do not need to add that, even in Louisville, there are bound to be at least a few members of any given jury who are themselves consumers of adult materials. In fact, this case had already gone to trial and ended in a hung jury, with one man, an electrician, holding out on the grounds that the charged materials, or ones almost identical to them, were available in stores all over Louisville. It is probably now possible to see how the defense of porn as popular culture could link up to the community standards criteria of obscenity law, especially if porn consumption could be at least relatively normalized by the kind of expert witness testimony I have been describing, that is, seen by the jury as one of the myriad popular consumption practices found in their community. Most people reading this will be thinking, "In your dreams!", especially given the current moral and political climate. But in my experience it is better to err on the side of overestimating rather than underestimating the possibility of appealing to people's pleasures and utopian ideas over and above their desires for discipline and punishment even when those desires, as they are today, seem so hegemonic.

And now, to Hollywood, and the possibilities and limits of creating public space for discussion out of private, commercial space. The idea for *The Skin Game: Porn in the USA* had its origins in an event that Linda Williams and I organized for the 1994 Telluride Film Festival, a two-hour "History of Hard Core" lecture with clips and invited talent, adult star Nina Hartley and veteran director Radley Metzger. Of the hundreds of people who saw our presentation (we had to stage it three times so everyone who wanted to could attend), several film and television producers approached us to consider turning it into a film or cable special. The festival that year was paying tribute to Ken Burns whom we thought he would be ideal to do "The History of Hard Core—The Movie," since it seemed to follow so well from his passion for putting Americana on film in *The Civil War* and *Baseball*. But it was finally the head of a Hollywood company that produced documentary films for

theatrical release, network television, and cable who most faithfully and intelligently pursued the project.

Even documentary films have scripts. Although it is not possible to write out everything that is going to happen or get said, some kind of outline must be created to give potential backers a sense of the theme, contents, overall structure, characters, and locations. A writer whose previous credits included a script for a film on skinheads and another on women on death row in Texas prepared the first draft. We were warned that it would be a bit sketchy but that we would be very welcome to comment on it and make suggestions. I thought the writer did a pretty good job, especially with the strategy she took of weaving together a dangerously cheesy and clichéd story about the life of a young porn star hopeful, fresh off the bus from the Midwest, of course, with a great deal of talking head information about the industry, the legal battles, and the scholarly research. And I liked some of the locations, especially a scene that takes place in my pornographic film class, which Linda Williams, Nina Hartley, and Susie Bright just happen to be visiting; or, at the end of the film, where Nina Hartley takes my students on a field trip tour of (completely coincidentally!) Leisure Time Communications.

The script, even in its initial sketchiness, seemed to get so much right. I was stopped short, however, by the script's characterization of me and the feminist politics around porn. The writer had met me, talked to me, and seen me lecture, at a conference I organized at UC-Santa Barbara on "Censorship and Silencing: The Case of Pornography" two months after Telluride. Here is the way I am depicted in the script after being described as someone who "teaches the first course in the country dedicated to the study of hard core movies, treating them as a film genre just like the Western or Science Fiction or Comedy":

> Professor Penley isn't what you might expect. In her 30's, she's a liberal feminist…. Pornography has long been taboo in our society and Penley and her colleagues [Williams, Hartley, Bright] are at the forefront of a movement to begin an honest dialogue on the subject. It is a stance that has distanced them from the mainstream feminist movement. (5)

As flattered as I might have been at being depicted as a young sex radical and pioneer courageously taking on mainstream feminism's sexual and social conservatism, I knew I was going to have to give up this heroic portrayal if I wanted to be able to use *The Skin Game* as a mass (very mass, I hope) vehicle to convey a closer and richer view than is currently available of the nature of U.S. feminism and the feminist debate on sexual expression. Such an aim was particularly important to me because I had been impelled to teach my course by the realization that one of the biggest obstacles to feminism's popularity in this country is the way it has been conflated with the anti-porn movement. I encountered this obstacle first-hand when I saw that the slash fans—whose ideas and activities sure looked feminist to me—felt distanced from feminism by their media-induced belief that all feminists were moralistically against porn, which they also take to mean against sex and

248　against men, and, for that matter, against pleasure itself. Since my overarching project is to do what I can to help make feminism popular, I have every reason to want to undo that invidious conflation, which I see as uniquely harmful to the achievement of equality and justice for women.

I had told the writer of *The Skin Game*, as I had every journalist who interviewed me about the class, that I had received only interest and support from other feminists, both on campus, locally, and nationally. This was in response to the repeated question, "But how did feminists respond to your class?" No matter how often I told journalists about that interest and support, they would invariably go off and write that my course had been massively protested by feminists, so strong is the received idea that all feminists are anti-porn. The truth of it is, there are more academic feminists like myself than like Catherine MacKinnon and Andrea Dworkin. You would not know that from listening to feminist-bashers like Camille Paglia and Katie Roiphe or to the media itself, which has entirely ignored the wide spectrum of feminist opinion on sexual expression (and much else) to emphasize the spectacle of feminism degenerating once again into a public decency or moral hygiene campaign in league with religion and conservative politics.

In my notes for *The Skin Game*, all of which the filmmakers told me would be incorporated into the script, I also felt obliged to tell them that I am not, in fact, in my 30s. The writer was working from the impression, I think, that the feminist porn debates are generational, with younger, more sexually radical feminists pitted against older, more sexually conservative ones. As I explained in my notes, the split is not generational but political. I am, for example, about the same age as MacKinnon and Dworkin, as are many of the pro-sex, anti-censorship feminists.

And finally, I made a feeble attempt to say to the writer and producer why I cannot be described as a "liberal," but left the longer explanation of what a "democratic socialist" is to another day.

These three stories have all been about what my colleague the sociologist Harvey Molotch calls "going out." In a pointed and hilarious essay of the same name Molotch relates his despair—not sufficiently shared by his colleagues, he believes—that no one in this country listens to sociologists, not the press, not public policy makers, not the government, not the citizenry. "By listening to sociologists, the nation could learn why its antidrug repression will not work, why more cops will not stop crime, or why tax breaks for industries will not improve communities or build the commonwealth" (224). But his essay is much more than a lament about sociologists getting no respect. After first blaming the U.S. ("One of the things wrong with sociology, in our country, is that we need a better country" [222]), he turns his sights on what sociologists do to keep themselves from "going out," that is, going out of and beyond the university to become describer-participants in the public sphere. Most of the criticisms that Molotch makes of sociology are familiar to us all: its scientism, its arrogance as seen in its lack of openness to other disciplines, its retreat into writing about its own literature rather than writing about the world, its tendency not to try to solve the problem but to prove that only sociology can solve the problem, and, Molotch's most original criticism, its failure to culti-

vate personalities adept at going out. "Sociology," he says "does not select for field-work verve" (233).

When Molotch sketches out a sociology that does not stay inside— inside the classroom, the scholarly meeting—this sounds to me like the kind of cultural studies in the public sphere I have been trying to describe, although I would put more emphasis on what happens when you go back in and then, maybe, right back out, sometimes forgetting where you are. Molotch does not call it, however, "cultural studies in the public sphere," but "deep journalism," not "mere journalism," he says, but "deep journalism" (223), of the kind best practiced in the past by "free-lanceers" like Betty Friedan, Jane Jacobs, and Harry Braverman but which he thinks a whole range of people in the university might be capable of doing now, if they would only go out—what I earlier called trying to travel the work of cultural studies into other public spheres.

What we can know about going out from the stories I have told is that it is a messy, messy business. Those seeking political or disciplinary purity or already established public spheres for their activity need not apply. But if we just remember to put on our rubber boots before exiting, we can, in Captain Picard's words, "Make it so."

Notes

1 The *700 Club* special was broadcast during April 1993.

2 Thanks to Stephanie Nelson of the USC Rhetoric Department and the Jet Propulsion Laborator for arranging the visit and for all of her good advice.

3 Thanks to Paul Abramson for giving me this opportunity and for the crash course in the legal aspects of pornography. His idea that pornography is sexual speech that often communicates controversial ideas about morality and should therefore be protected, has been helpful to my understanding that pornography, as popular culture, is a major site of socially and politically dissident speech as well. See "Porn: Tempest on a Soapbox" in *With Pleasure: Thoughts on the Nature of Human Sexuality*, Paul R. Abramson and Steven D. Pinkerton (New York: Oxford University Press, 1995).

4 For an extended consideration of pornography as popular culture, and the class politics of porn, see my "Crackers and Whackers: The White Trashing of Porn."

References

Abramson, Paul R. and Steven D. Pinkerton (1995) *With Pleasure: Thoughts on the Nature of Human Sexuality*. New York: Oxford University Press.

Bobo, Jacqueline (1995) *Black Women as Cultural Readers*. New York: Columbia University Press.

Chaisson, Eric J. (1994) *The Hubble Wars: Astrophysics Meets Astropolitics in the Two-Billion-Dollar Struggle over the Hubble Space Telescope.* (New York: Harper Collins).

Ellsworth, Elizabeth (1988) "Illicit Pleasures: Feminist Spectators and *Personal Best.*" In Leslie G. Roman, Linda K. Christian-Smith, with Elizabeth Ellsworth *Becoming Feminine: The Politics of Popular Culture.* Philadephia: Falmer Press, 1988.

Fraser, Nancy (1993) "Rethinking the Public Sphere: A Contribution to the Critique of Actually Existing Democracy," In Bruce Robbins, ed. *The Phantom Public Sphere.*

250 Minneapolis: University of Minnesota Press.

Kipnis, Laura (1992) "(Male) Desire and (Female) Disgust: Reading *Hustler.*" In Lawrence Grossberg, Cary Nelson, and Paula Treichler, eds. *Cultural Studies.* New York: Routledge.

Linz, Daniel, Edward Donnerstein et al. (1995) "Discrepancies between the Legal Code and Community Standards for Sex and Violence: An Empirical Challenge to Traditional Assumptions in Obscenity Law." *Law and Society Review* 29: 1: 127–68.

McDougall, Walter A. (1985) *The Heavens and the Earth: A Political History of the Space Age.* New York: Basic Books.

Molotch, Harvey (1994) "Going Out." *Sociological Forum* 9: 2: 221–39.

Penley, Constance (1991) "Brownian Motion: Women, Tactics, and Technology" In Constance Penley and Andrew Ross, eds. *Technoculture.* University of Minnesota Press.

———— (1992) "Feminism, Psychoanalysis, and the Study of Popular Culture." In Lawrence Grossber, Cary Nelson, and Paula Treichler, eds. *Cultural Studies.* New York: Routledge.

———— (1993) "Spaced Out: Remembering Christa McAuliffe." *Camera Obscura* 29: 179–213.

———— (1996) "Crackers and Whackers: The White Trashing of Porn," in Annalee Newitz and Matt Wray, eds. *White Trash* (New York: Routledge, 1996).

Radway, Janice (1984) *Reading the Romance: Women, Patriarchy, and Popular Culture.* Chapel Hill: University of North Carolina Press.

Robbins, Bruce (1993) *The Phantom Public Sphere.* Minneapolis: University of Minnesota Press.

———— (1990) *Intellectuals: Aesthetics, Politics, Academics.* Minneapolis: University of Minnesota Press.

Rose, Mark (1995) "Copyright." Conference on The Humanities and its Publics at the UC Humanities Research Institute, Irvine, CA.

Ross, Andrew (1989) *No Respect: Intellectuals and Popular Culture.* New York: Routledge.

Trento, Joseph J. (1987) *Prescription for Disaster: From the Glory of Apollo to the Betrayal of the Shuttle.* New York: Crown Publishers.

Williams, Linda (1989) *Hard Core: Power, Pleasure, and the "Frenzy of the Visible."* Berkeley and Los Angeles: University of California Press.

Michael Hanchard

12

CULTURAL POLITICS AND BLACK PUBLIC INTELLECTUALS

During a recent interview about his role in the game of baseball, Henry Aaron remarked that "White folks think of us as entertainers, that we are born to entertain them…. It was all right for me to hit home runs because I entertained them. It wasn't all right for my kids to go to school with their children." The great Hank Aaron's dilemmas are not unlike the controversies surrounding the handful of forty-something black academics who have been defined as "public intellectuals." His recognition of the ironies in his role as a public figure underscores the paradoxes of black people whose commentary and insights exceed the boundaries of their celebrity. With neither political offices nor constituencies to hold them responsible, they utilize their highly visible positions within the academy, arts, and letters to engage in public debate. The fact that the most significant figures within U.S. African-American communities—from Fannie Lou Hamer to Malcolm X, Martin Luther King, Muhammed Ali, and even Booker T. Washington—have never held public office speaks volumes about the ability of marginalized groups to make the best of the interstices of civic life when formal channels for debate in civil and political society are barred to them.

This also highlights the limitations of fighting for civil equality from vantage points that were not designed for direct political engagement—the concert hall or

musical lyrics, the press conference following a major sporting event, and, indeed, the university lecture hall. Eartha Kitt's blacklisting in the 1960s for her negative comments about the Vietnam war, the withdrawal of Paul Robeson's passport in 1951, and Muhammed Ali's loss of his heavyweight championship in 1965 because of his refusal to be inducted into the U.S. army are just three examples of black public figures whose celebrity did not shield them from state sanctions against their livelihood when they voiced political opinions that were divergent from dominant norms.

Their impact and outreach was limited by their politics, not their vocations. The curtailing of their activities signalled their relative powerlessness, and the uncomfortable distance between white political elites in institutions of power and black spokespeople for the race who, by and large, remained on the outskirts of dominant political institutions. The sanctions imposed upon these figures pinpoint the coordinates at which public discourse and state power meet.

The relative powerlessness of black public intellectuals and the larger crisis of black politics are themes that lurk behind numerous recent articles and debates concerning the role, virtues, and alleged decline of the black public intellectual. They are themes, however, that have not been addressed. As a consequence, considerations of what the characterization "black public intellectual" means for present day black politics has been largely absent. Instead there has been an emphasis on the celebrity status of certain individuals, with little attempt to place them in cultural contexts larger than their idiosyncracies, flaws, and personalities.

There is also little actual discussion of what constitutes their public. Is it the black community broadly defined or a particular segment of it? Does it consist of white liberal and leftist academics, who often rely upon these public figures for doses of essentialized "black" insight without bothering to read and discuss the works of a broader array of black scholars and activists? Is it, ironically, the new right, who point to flaws—both perceived and real—in the writings of people like Cornel West in order to critique black social advances of the post-Civil Rights era more generally? What significance, if any, does the emergence of black public intellectuals have for black politics, and the prospects of broader coalition building *within* their communities? Such questions will remain long after clamor over book and lecture series contracts, individual sexual odysseys, and the argumentation of a particular text or essay by any of these intellectual celebrities subsides.

To my mind, the three most substantive articles about the state of black public intellectuals are Michael Bérubé's *New Yorker* piece (January 9, 1995), Robert Boynton's ruminations on the new generation of black intellectuals under age 45 in the *Atlantic Monthly* (March 1995), and Adolph Reed's sustained critique in the *Village Voice*. Missing from these discussions, however, are two additional considerations that I believe are fundamental to any serious cultural consideration of the strengths and weaknesses of black public intellectuals.

In keeping with the continued segregation of black public discourse from other national discussions, black intellectuals are rarely—if ever—situated within broader analyses of the history of public intellectuals more generally, in the United States

or anywhere else. Second, while many of the recent articles compare the recent proliferation of black public intellectuals to the generation of emergent Jewish intellectuals in the post-World War II period, none of them attempt to compare black public intellectuals to their counterparts in the rest of the hemisphere, in Latin America or the Caribbean. The U.S.-centric cast of this debate highlights the manner in which the political imaginations and realities of our many, diverse neighbors to the south are largely ignored, even though many of their political and cultural experiences are similar to our own. In order to gain further insight into the complexities and paradoxes that mark the work of contemporary black public intellectuals, cultural studies practitioners must further examine the role of racial difference and cultural plurality in the new world more generally, not just in the U.S.

Black Intellectuals and the Limitations of the New York Left Paradigm

Bérubé and Boynton's articles utilize the New York, largely Jewish left of post-war New York as the comparative referent for their discussion of people like Michael Dyson, bell hooks (Gloria Watkins), Cornel West, Henry Louis Gates Jr., as well as black conservatives like Thomas Sowell and Stanley Crouch. There are obvious, albeit superficial similarities. Both groups cut their political teeth upon a dominant ideological current within their respective communities (Marxism for Jewish intellectuals, cultural nationalism for blacks), only to discard or drastically qualify their ideological—often doctrinaire—positions.[1]

Boynton emphasizes the role of racial difference as a line of demarcation separating black and Jewish intellectuals of these two very different time periods. Both Bérubé and Boynton note the societal transformations brought about by the Civil Rights movement and grudgingly administered by the U.S. government. Though both cadres had their respective shetls, crucibles of learning that combined experiential knowledge of the outsider with rarified academic training that was ultimately used both in the academy and on the streets, they lived in different neighborhoods and in different times.

What most accounts of the New York left (not only Russell Jacoby's *The Last Intellectuals*) fail to mention is that there were black public intellectuals, academic and otherwise, who were alive and well in New York between the 1930s and 1950s. Only Reed's *Village Voice* article "The Current Crisis of the Black Intellectual" (4/11/1995) notes this fact. Important figures like Ben Davis, a radical lawyer and Communist Party member in the 1940s, Marvel Cooke, the first woman to write regularly for a daily newspaper in the United States and a communist as well, Paul Robeson, and others *were* in New York during this period. The alliances between the New York (read white) intellectuals and black activists during this time were strategic but often uneasy due to the reductionist manner in which the former cadre—like many leftists then and now—treated racial oppression as mere flotsam on capitalism's undulating surface.

To put white leftists' neglect of racial oppression in the U.S. in perspective, it is instructive to recall how Lenin chided the Communist Party of the United States

254 at the Second International in 1919 for not developing a specific strategy to attract black workers in the United States, as the Communist Party in the Soviet Union had done after the October Revolution in response to what was termed "the national question" (Robinson, 1983).

Lenin (and Stalin's) development of a plan for addressing the "national question" was based not only on the presence of various subordinate ethnic groups in the nation, but a recognition of their legitimate cultural and territorial claims to national identity and the distinct problems they encountered under the Tsarist regimes. Thus, the economic determinists were no economic determinists.

Black leftists have struggled with white leftists over the importance of racism in maintaining capitalist dominance in the United States, formally and informally, from the 1920's until the present day, both within the CPUSA as well as in organizations like SDS, and other organizations too numerous to mention.

The fact that outsiders at a distance from the United States were able to identify shortcomings in the CPUSA's approach to racial matters in the U.S. should provide readers unfamiliar with the divide between black and white intellectuals during this era with a glimpse of greater cultural and political distances between white and black public intellectuals of the pre and post-World War II periods. Within this epochal context, it is more than coincidental that both Richard Wright's *Native Son* and Harold Cruse's *The Crisis of the Negro Intellectual* (two of the most important texts for black intellectuals in the United States and elsewhere in the post World War II period) were written, in part, out of frustration with white leftist organizations' analysis of racial politics. Indeed, the work of these and other black intellectuals during this period should serve as a foregrounding for a discussion of race, cultural production, and black intellectuals within the context of cultural studies. The history of black public intellectual engagement in public life can serve as a model for cultural studies as it struggles over issues of academic, political, and institutional legitimacy in the U.S.

Is The New World New To U.S.?

For these and other reasons, public intellectuals in Latin America and the Caribbean from the late 19th century to the present may be a more appropriate model for black public intellectuals of any period in the United States. The New York, largely Jewish left, were immigrants of the Old World and operated within a political culture that was Euro-Modernist, that is, steeped in the intellectual traditions, political ideologies and cultural practices of late 19th century Western Europe. National intellectuals in places like Cuba, Guatemala, Argentina, and Brazil worried over the juxtaposition of Old World traditions and New World realities in ways that most New York or other white leftists never had to, beginning with the movements toward national independence in the early nineteenth century.

While Latin American and Caribbean nations certainly had (and have) racial and ethnic inequalities, the melange of cultural differences became ingredients for the constitution of national identity. Afro-inflected expressive cultures were considered facets of national identity in various New World nations (salsa, samba, the

tango, West African religions) by the 1940's (earlier in some places), in contrast to their largely regional and urban influences of jazz and blues in the United States by this time.

At a more explicitly political level, the independence wars in many Latin American nations were directly tied to the fate of Afro-Latin peoples, since the freedom of African and African-derived slaves was often directly tied to their participation in wars of national liberation. The often unmet promise of emancipation after national independence, combined with the undeniable presence of Africanisms in language, foodstuffs, music, and art, has made the disjuncture of cultural richness and economic and political poverty among Afro-Latin peoples a source of introspection for Latin American and Caribbean intellectuals as diverse as José Martí, Rene Depestré, Pablo Neruda, José Vasconcelos, and Beatriz Nascimento.

This appropriation of African religious and musical expression, when combined with indigenous and European influences, would serve to erase distinctions between high and low cultures in many Latin American and Caribbean nations by the middle of this century, well before cultural studies and post-modernism were vogues (or graduate programs). C. L. R. James's *Beyond a Boundary* exemplifies the kind of cultural analysis that has served as a prototype for the sort of post-structuralist theorizing Euro-Modernist thinkers would undertake only much later. Already adopted by some as a model for cultural studies writing, James should be more widely acknowledged as a key figure in the reconstructed history of cultural studies. His examination of the role of cricket as a conduit for disparate ethnic groups, an anchor for national identity, an expression of Afro-Trinidadian pride as well as a transport toward his own political awakening is more akin to the writings of a Ralph Ellison or a Larry Neal than to the writings of Theodor Adorno or Russell Jacoby.

Other black intellectuals in the New World have been engaged in similar forms of cultural analysis and excavation that share certain epistemological affinities with cultural studies. A common feature of New World Modernist intellectual production by black thinkers has been the location of folk culture, music, and corporeal arts at the center of an analysis that focuses on the incorporation of black subjectivity into a national/popular lexicon, as well as the alienation of black subjects from a national/popular cultural economy. This, I believe, is what helps us identify stateside intellectuals like Zora Neale Hurston, Alain Locke, and Julian Mayfield, and Caribbean and Latin American counterparts like the Afro-Cuban Fernando Ortiz, the Afro-Brazilian sociologist Guerreiro Ramos, or the Jamaican folk historian Louise Bennett as members of the same genus species.

What distinguishes African-inflected and many white New World intellectuals from their white counterparts in the United States, Britain, and other Western European nations is their intellectual and artistic efforts to decenter the racialized national subject, that is, obliterate the correlations between whiteness, citizenship, and national subjectivity that has pervaded political discourse in Western Europe, Latin America, and the United States since the turn of the century. Whether in the

256 form of racial desegregation or national independence, Afro-New World and other New World intellectual attempts to *pluralize* the citizen/subject in the New World can be viewed as historical and theoretical antecedents to the 1980's movements toward hybridity and plurality in Britain generated in part by the theorizing of important cultural studies figures like Stuart Hall and Paul Gilroy in response to the phenomena of cultural melange in post-World War II Britain. This is in part due to the fact that nations like Britain and France had to contend with the uncoupling of whiteness and national citizenship at a much later point in their respective national histories than New World nations. New World intellectuals, faced with the realities of creole cultures since the inception of the nation-state in the New World, have been alternatively fascinated and repulsed but nearly always impassioned about the foundational myths created out of their "mongrelized cultures" since the 18th century.

In contrast, Bérubé explains the distinctive cultural features of black public intellectuals in terms of the encounter between black nationalism and post-modernism. A more comparative view of intellectual formation in the New World would show that they are closer relatives of their New World counterparts, white or black, than of the white, Euro-Anglo conscious intellectuals of New York.

In terms of "real" politics, it could be argued that New World academics and writers have had far greater impact upon public discourse in their own countries over the course of the 20th century than their U.S. counterparts have. In the process of national cultural development, Latin American and Caribbean intellectuals have long ago pulled back the transparent curtain separating "academia" from "real life," which is why, from a hemispheric perspective, the straddlings of a few black public intellectuals in the United States are nothing new. When one thinks of public intellectuals like Walter Rodney in Guyana, Octavio Paz in Mexico, Norman Girvan or George Beckford in Jamaica, and a slew of other intellectuals in other parts of America, one is struck by how Latin American and Caribbean intellectuals have played a greater role in public discourse than their counterparts in the United States, regardless of their ideological positions.

The ambiguities of black public intellectuals in the United States resonate with the dilemmas of their New World counterparts in other ways as well. Rigoberta Menchu, the 1992 Nobel Laureate for Peace and a Quiche woman from Guatemala, has been criticized by fellow indigenous activists in her own country for becoming world famous and capitalizing upon the plight of her people in her testimonial *I Rigoberta Menchu*. According to her critics, she has assumed the role of "honorary indigena" at international conferences and head-of-state dinners in foreign countries. How different—or warranted—is this criticism from the accusations hurled at Cornel West, bell hooks, and Michael Dyson in Reed's *Village Voice* diatribe about their purported betrayal of a black public? Like Rigoberta Menchu, black public intellectuals of the present day must leave the confines of their communities in order to make their plight more identifiable to a larger, presumably liberal audience.

Menchu's testimonial exemplifies the contradictions between cultural revela-

tion and cultural preservation that has plagued ethnic and racial intellectuals in the New World. In order to give evidence of the slaughter and oppression her people have experienced at the hands of white landowners, she must write a book about her community's ways and values. She notes, however, at several times in the testimonial that her community's cultural practices must be kept secret and discussion of them is viewed as betrayal.

In this sense, Menchu's dilemma is nearly identical with that of her U.S. African-American contemporaries; in order to embody the travails of one's community, intellectuals belonging to marginalized ethnic or racial groups must travel some distance from them to make their concerns "public", which may place them at a distance from the people they claim to represent, or at least, identify themselves with. Though these intellectuals may be able to go home again, their old comrades might look suspiciously at the fancy new car, the new suit, or the pounds gained from consuming lobster and Montrachet in their time away from community struggles over housing, race related violence, or glass ceilings in professional employment.

The Crisis of Black Politics

Adolph Reed's *Village Voice* article contains a variation of this worry about the vices of black public intellectuals, a sort of *Bonfire of the Vanities* of the black intellectual elite. Reed's medium is not the novel, however, but the essay in its most polemical form. While highly critical of the forty-something generation, Reed is the only commentator to attempt an analysis of black politics proper. Tellingly, he does not rely upon the black/jewish comparison and instead outlines a critical genealogy of black political debate, analyzing the parameters of black participation in national politics and criticism on its own historical and epochal terms. Reed provides insight into what could be characterized as a black public sphere over the course of the 20th century, where informed individuals participated in reasoned debate about the condition of their communities.

While Reed does not utilize Habermas's conceptualization of the public sphere, he discusses the impact of desegregation upon black journals and the demise of a racially-specific audience for the black intelligentsia. Within the vise grip of McCarthyism, he explains, the black public sphere shrank even more. Subsequently, integration provided black thinkers with a larger theater but fewer roles to play in media vehicles dominated by whites.

At this point, however, Reed's analysis takes a turn that unfortunately blunts his critique of the forty-something ensemble of black academic celebrities. He pays greater attention to their personal foibles, the cottage industry-like interactions between them, than the national political culture of the period in which bell hooks, Cornel West, and Henry Louis Gates, Jr. were spawned. Ironically, Reed is deeply implicated within the parameters of his own critique, in the sense that *all* black intellectuals, whether anointed with the title of public intellectual or not, are placed in an ambiguous position when they write for white newspapers and journals on issues of racial politics.

As a regular contributor to *The Nation* and other left journals on matters of

258 race, Reed himself is embedded in the national, popular tendency to treat the singular perspective of one black individual as the community perspective writ large, a quandary that has existed for black writers ever since they began writing with a white audience in mind, since the late 18th century (Phyllis Wheatley) at least. For U.S. whites specifically, this is often taken one step further, to the presumption that matters of race have little if anything to do with them and is simply a "black thing" that they wouldn't—and needn't—understand. While Reed may dislike the manner in which certain black intellectuals relate to a white public, he (like the rest of us) is invariably placed in the role of racial translator.

Since personalities and public demeanor seem to matter a great deal in this debate, some epochal considerations of the forty-something generation are in order. The post-Civil Rights era immediately coincided with the advent of the "me" generation—New Age science, sexual revelation as a means of "connecting" with others and oneself. Its effects were manifested among U.S. African-Americans in what film critic Clyde Taylor refers to as "the post-OPEC intelligentsia" of the black community. Liberal-left blacks profited from the socio-economic advances of the Civil Rights movement but found it less and less credible to account for their individual success in the name of the people. Conservative blacks struggled with this new-found access to white institutions, and spent much effort wiping the smudge of affirmative action off of their luxury automobiles, off of their lives.

Black public intellectuals, like other black middle-class professionals, have had to provide defenses for their personal success amidst high black unemployment, urban violence, and whatever else has been deemed to be a "black problem," as if their successful dance with U.S. capitalism and racism required them to explain why they had become neither middle managers, athletes, nor crackheads. A 1992 article written by Rev. Eugene Rivers in Boston, MA entitled "Black Intellectuals in the Age of Crack," addresses the theme of intellectual relevance to the societal problems that poor black people face. A conference inspired by this article in 1994 brought together Glenn Loury, Cornel West, bell hooks, and other black public intellectuals. Both the conference and the article are emblematic of the various tightropes of relevance black public intellectuals have been required to tiptoe across. Could anyone imagine Daniel Patrick Moynihan and Jeanne Kirkpatrick participating in (much less attending) a conference entitled "Irish Intellectuals in the Age of Whiskey" in order to explain their relevance to some monolithic Irish community? Like many other matters of racial politics, the claustrophobic scenarios black people often find themselves forced into appear ridiculous only when one switches the actors from black to white.

Both guilt and criticism of individual successes in this regard are informed by archaic presumptions about correlations between political commitment, creature comforts, and community advancement within black nationalist and white leftist traditions in the United States. According to this view, only spartans are really committed to struggle; repent, BMW and Cadillac driving black public intellectuals! Trade those capitalist rides in for Yugos! This is why—on this point at least—black nationalist and radical critiques converge with conservative ones.

Conservatives point to the materialistic aggrandizement of these individuals as examples of their selling out, coupled with the claim that only black self-help and not government programs will aid the black poor. This is a disingenuous position for free marketers to take. Never in the history of capitalism have the middle and upper classes been expected to assist in the socio-economic advancement of working-class people, yet this is a common sense assumption among many U.S. citizens about the role that middle-class blacks (this includes black public intellectuals) are to play in helping communities that white elites, private businesses, public corporations, and the U.S. government long abandoned.

Cultural Politics Versus Real Problems

Reed, however, is no conservative, and attempts to address a more substantive problem that has plagued left debate for at least thirty years. Reed's anxieties concerning what he terms "The Current Crisis of the Black Intellectual" stems from a belief that the recent crop of cultural studies specialists and post-modernists are obsessed with the circulation of capitalist production—the marketing of goods, libidinal impulses, and music as the cultural artifacts of authentic blackness—while ignoring issues like electoral gerrymandering and disproportionate unemployment. Bérubé echoes a similar discomfort at the end of his article.

In his concluding ruminations on the current crisis (*Village Voice*, 4/11/95), Reed asserts that blacks "should be in the forefront of the fight against ratification of the balanced budget amendment, crafting responses to the so-called tort reform, and finding ways to counter the assault on the Bill of Rights." And so they should. Reed correctly assaults one of the lacunae in some (not all) forms of cultural analysis; the absence of sustained investigation of institutional forms of power, and the assumption that discourse is all. Both Reed and Bérubé's worries, however, reflect an ongoing debate at cross-purposes not only between black social scientists and humanities scholars, but between structuralist and post-structuralist understandings of power.

Debates on tort reform, on the other hand, do not typically address issues of white supremacy, racial inequality or black subordination, regardless of the race of debate participants. If race plays a significant role in the structuring of social life in the United States, then its impact can be witnessed and experienced *across* a range of political, cultural, and economic phenomena, from redistricting to rap music. Rather than prioritize one form of analysis and political activism over another, as Reed does, there should (could?) be more synthetic and integrative analysis of the role of racism in national life.

Reed's dismissal of cultural studies and popular culture leads him to dismiss their subjects of analysis as well, including youth culture in general and black youth culture in particular. Reed states near the end of his essay that black youth are "the least connected, the most alienated, and the least politically attentive cohort of the black population," which for Reed is proof of their political and scholarly irrelevance. It should be recalled that the Student Nonviolent Coordinating Committee of the 1960s was replete with alienated, disaffected youth who became the shock

260 troops, key strategists, and thinkers of the civil rights and Black Power movements. Had scholars and activists of the civil rights movement considered the disaffection and alienation of black youth as grounds for dismissal of these young, aggressive uncouths, we would have had a very different type of civil rights movement and consequently, a very different national history.

A comparative perspective on the dynamics of cultural and institutional politics, and the dangers of ignoring cultural dimensions of political life is in order here. As Stuart Hall has argued, since the 1980's and the demise of the welfare state in advanced industrialized nation-states like France, Britain, and Iceland, rightist social movements have been able to gain significant advantage over liberal-left coalitions by commandeering the terms of public debate over issues of social welfare and immigration. Objective facts of social policies aimed at helping the poor and minorities, as well the changing nature of the international political economy, are obscured and discounted by a mountain of rhetoric and misinformation. The rhetoric, up to now, has revolved around issues of family, racial purity, immigration, and biological and cultural justifications for the poor remaining poor. This is the outcome of political and cultural struggles in which center-right coalitions have gained the upper hand, beginning with the Thatcherite and Reagan administrations of the 1980's. Such is the case with welfare and affirmative action debates in the United States.

In left academic circles, sectarian squabbles between structurally and culturally based approaches have been a recurrent theme in social theory and activism ever since people quoted Marx. Again, a less U.S.-centered view on such matters is instructive. The inaugural debates within the British journal *The New Left Review*, founded in 1962, featured advocates of both sides of the economic vs. cultural debate. This debate resurfaced in exchanges involving Stuart Hall, Bob Jessop, and others over the relevance of qualitative analysis in general and cultural studies in particular, in 1979. It is important to point out that Stuart Hall, Paul Johnson, and other founders of the cultural studies program at the Birmingham school in England did so in a two-tiered attempt to make their theoretical work accessible to working-class students outside of the Oxbridge circuit, as well as to meet these students on their own terrain. One of the attractive features of cultural studies has been its contextualization of knowledge and politics, as the efforts of Stuart Hall and others make clear. Unlike their renowned counterparts in the United States, many British cultural studies practitioners were—and are—affiliated with working-class institutions. It is no small irony, then, to read or hear scholars from both sides of the Atlantic criticize cultural studies practitioners for their insufficient attention to "material" conditions.

There are obvious affinities between the themes and problematics of cultural studies formations in Britain and black intellectual traditions in the United States. The traversal of the space dividing the university from a specific public, whether a working class or racial group broadly defined, has been the common task for intellectuals in both national/public spheres. Both traditions operate and gain their strengths from the margins of national and elite institutions, whether from work-

ing-class educational and community outreach programs, dance halls, or black churches. It is more apparent now in the United States not because of any specific proliferation of black thinkers, but because of the effects of desegregation upon both black institutions and white mass audiences. Both cultural studies and U.S. African-American intellectuals, tend to ignore their New World prototypes and intellectual traditions (except for a figure like C. L. R. James) that have been exercised over cultural hybridity and national plurality ever since Columbus decided the New World was a good locale for plunder.

For those who have had difficulty in differentiating between left and right critiques of some black public intellectuals, not to worry. There is, unfortunately, little difference. There will only be a qualitative difference in the level of critique when politically engaged commentators develop a more complex understanding of the integration of institutional and non-institutional political action and the role of black intellectuals, celebrated and anonymous, well-published and barely published, academic and non-academic. At this juncture, a return to the dilemmas of Rigoberta Menchu and indigenous social movements in Guatemala will underscore the importance of multi-faceted approaches and analyses of social change.

Public Intellectuals of Various Hues

The tensions between Rigoberta Menchu and other indigenous activists can, on one level, be attributed to jealousy, backbiting, the narcotics of fame and power, and other human failings. These tensions can also be viewed as the limitations of strategies for collective action and change that have not kept apace with the multi-mediated world that requires oppositional movements to be information disseminators and garret inhabitants simultaneously. Aside from the physical impossibility of being both at the same time, strategies for collective action in a multi-mediated world require community activism that forces intellectuals to inhabit distinct, often contradictory positions for the purpose of larger political aims.

There is no real contradiction to multiple divisions of labor within a goal-oriented political project. A progressive black movement could conceivably include both Cornel West as troubadour and Adolph Reed as movement critic without there being any fundamental incongruities (though a family therapist or homicide detective might be needed somewhere along the way). Yet such a movement could only be imagined for now, because nothing close to a coalitional party or organization exists among black leadership and its corresponding black mass publics that combines the agendas of the Nation of Islam with Robert Woodson's neighborhood enterprise programs and, say, the National Black Women's Health Project.

What then, are we to make of the newly defined black public intellectuals and their relation to black politics? After all, we are only speaking about, at most, two dozen individuals. They embody the Hank Aaron paradox, the general plight of informal political actors. One can scoff at Michael Dyson's discussion of gangsta rap before a U.S. Senate subcommittee and say "so close, and yet so far" but is Dyson to blame for the paucity of black intellectuals who have the opportunity to speak on Capitol Hill about rap music, $400 wrenches at the Pentagon, UFO's, or

262 any other topic of public discourse? The point I'm making here is the need for analysis that situates the relatively isolated speech or performance by a black public intellectual within the larger problem—the denial of access progressive black intellectuals have to mainstream media and political institutions, and ultimately, their relative inability to affect political change.

In *Representations of the Intellectual*, Edward Said writes that "There is no such thing as a private intellectual, since the moment you set down words and then publish them you have entered the public world." This broadens the category of the public intellectual to include those who engage in debate and political action with fellow citizens, yet it also limits the category to those who write. Grassroots organizers, academics, journalists, nurses, lawyers, and grandmothers in communities across this country who engage in sustained collective action against the burning of books, anti-abortion guerrillas, teenage violence, and the Contract With America are also public intellectuals but operate within a distinctive public realm in which they are highly visible to some and invisible (for lack of celebrity) to others. They operate in what Nancy Fraser has called micro-public spheres, an idea that suggests multiple publics. Transnationally, groups as radically committed to societal transformation as the Irish Republican Army and The African National Congress housed mass media and intelligence experts within their organizations without contradiction.

With different types of public intellectuals there is the possibility that some public intellectuals operate in different public realms, and that some intellectuals are more public than others. Perhaps a more appropriate reflection upon intellectual engagement in public life is Michael Walzer's *The Company of Critics*, rather than Russell Jacoby's *The Last Intellectuals*. Though there is only one female intellectual and no non-whites in Walzer's book, he surveys intellectuals actively engaged in public debate in a variety of societies both inside and outside the West, not just in Northwestern Europe or New York City. Walzer uses the term social critic, rather than public intellectual, to describe his civic-minded, progressive intellectuals. Their publicness is assumed, not lauded.

By depriving the term "public intellectual" of its sexiness, we can recognize that public and organic intellectuals are not always one and the same. Antonio Gramsci's organic intellectual, one who agitates for change from a specific set of issues, communities, and concerns and builds alliances with other groups who share common cause, is not always public in the ways in which a media-saturated society such as the U.S. defines its "celebrities."

For this reason, the category of the public intellectual needs to be broadened in public debate to include a class of committed people and their groups whose books (if they have them) and speeches may never reach the bookstores or your local video shop. Grassroots activists and organizations who fit into this latter category run the continuous danger of being ignored and neglected by an amorphous public whose intellectuals are already defined for them. What is at stake here, are definitions of leadership (another category that overlaps with public intellectual but is not its coeval) and who comes to define them.

Part of the confusion, I believe, over black intellectuals as community leaders, social critics, or charlatans stems from the lack of contextualization of these individuals within movement politics of any sort. Unlike Rigoberta Menchu, there is no specific movement or constellation of organizations for them to answer to.

The strengths and weaknesses of individual black public intellectuals are largely irrelevant without any consideration of larger political struggles they engage in, whether in the academy or in black communities. Like Hank Aaron, they are relatively powerless as black individuals in a predominantly white, racist United States, their lucrative book contracts and speaking engagements notwithstanding.

What is needed are prescriptive cultural analyses that could enable black progressives to begin discussions on how to suture the bits and pieces of coalitions together around common issues plaguing both black middle-class and working-class communities. Perhaps the shadows created by the institutional and non-institutional victories of the right have limited our ability to recognize that we are all trapped in the same corner, but the travails of a few black public intellectuals are the least of our problems. It's time for discussions of black intellectuals to move beyond mere entertainment, for whites and non-whites alike.

Note

1 Even this comparison, however, needs some qualification. First, cultural nationalism was but one parcel of the black nationalist landscape of the 1960s, and even cultural nationalism had both liberal-individual and radical strains. Most nationalisms of the period were invariably shot through with some variation or derivation of Marxist-Leninist-Maoist thought, with Fanon, Cabral, and other Afro-Marxist theorists thrown in for good measure. A glance at the testimonials/autobiographies and critical assessments of black activism and its political influences reveal this and runs counter to the impression left by Boynton and others that black nationalism was somehow divorced from the other ideological currents of the epoch. See, for example, Assata Shakur (1987), Elaine Brown (1992), and Fred Hampton (1969) for just three of many examples of various ideological currents intertwined in black liberation/ black nationalist thought.

References

Bérubé, Michael (1995) "The new black intellectuals." *The New Yorker* (January 9): 73–80.

Brown, Elaine (1992) *A Taste of Power.* New York: Pantheon.

Hampton, Fred (1969) *You've Got to Make a Commitment.* Chicago: People's Information Center.

Menchu, Rigoberta (1984) *I, Rogoberta Menchu.* Ed. Elizabeth Burgos-Debray, trans. Ann Wright. London: Verso.

Reed, Adolph (1995) "What are the drums saying, Booker?: The current crisis of the black intellectual." *Village Voice* (April 11): 31–36.

Rhoden, William C. "It's Time We Took Hank Aaron Into Our Hearts." *New York Times.* April 9, 1995: 3.

Robinson, Cedric (1994) *Black Marxism.* London: Zed Books.

Said, Edward (1994). *Representations of the Intellectual.* New York: Pantheon.

Shakur, Assata (1987) *Assata.* Westport, Connecticut: Lawrence Hill and Company.

Michael Denning

13

CULTURE AND THE CRISIS

THE POLITICAL AND INTELLECTUAL ORIGINS OF CULTURAL STUDIES IN THE UNITED STATES

In the fall of 1932, a group of American intellectuals came togeth-
er to form the League of Professional Groups for Foster and Ford,
and published a pamphlet entitled, *Culture and the Crisis: an open letter to the writ-
ers, artists, teachers, physicians, engineers, scientists, and other professional workers
of America.* "The United States under capitalism," they wrote, "is like a house that is
rotting away; the roof leaks, the sills and rafters are crumbling. The Democrats
want to paint it pink. The Republicans don't want to paint it; instead they want to
raise the rent." They announced their support for William Foster and James Ford,
the Communist Party candidates for president and vice-president, and called on
the "brain workers" of the United States to join the "muscle workers." "We reject,"
they wrote, "the disorder, the lunacy spawned by grabbers, advertisers, traders,
speculators, salesmen, the much-adulated, immensely stupid and irresponsible
'business men.'" "We too, the intellectual workers, are of the oppressed and until
we shake off the servile habit of that oppression we shall build blindly and badly, to
the lunatic specifications of ignorance and greed. If we are capable of building a
civilization, surely it is time for us to begin…time for us to renew the pact of com-
radeship with the struggling masses" (League, pp. 6, 3, 29).

If cultural studies is, as I will suggest, the engaged and radical reflection on the

266 "origins of the present crisis," the "history of the present," then that 1932 pamphlet, *Culture and the Crisis*, the *Port Huron Statement* of its generation, may be taken as one of the origins of cultural studies in the United States. Written by what might now be thought of as an interdisciplinary group—a Marxist economist, a literary critic, a popular historian, a philosopher, and a poet who had worked in advertising agencies—it attempted to articulate the links between an economic crisis and a cultural crisis in its architectural tropes of houses and building. And it sought to define and organize an emerging class of "intellectual workers," to understand their function and responsibilities, to distinguish it from the business classes, and to imagine some yet unimaginable connection to the working peoples of the United States. Though the ambitions of the League of Professionals were not realized—they did hold a lecture series on "Capitalism and Culture" but the plans for a magazine and for a book to survey the state of American culture never materialized—the League stands as an emblem of the emergence of a generation of radical intellectuals who created a new kind of cultural studies, the cultural studies of the Popular Front. In this essay, I will sketch out the lineaments of that cultural studies, and suggest that their work and their history remain an important part of any account of the origins of our own present, our own crisis.

This essay draws on my book, *The Cultural Front*, a history and interpretation of the left-wing cultural formations that emerged in the early years of the Depression out of the transformations in the culture industries, in the cultural apparatuses of the state, and in the symbolic practices of working-class daily life. These radical cultural alliances—workers theater collectives, proletarian little magazines, composers collectives, and film industry unions—depended upon a broad social movement generally known as the Popular Front, a radical social-democratic historical bloc forged around anti-fascism, anti-lynching, and industrial unionism. Though this social movement was defeated by the forces of the "American Century," and the "thirties" seemed to be over by 1948, the aesthetic ideologies and cultural politics of the Popular Front continued to live in a variety of American cultures, informing the life-work of a generation of artists and intellectuals. The roots of U.S. cultural studies lie in the cultural front, and I wish to look particularly at the work of several intellectuals who shared a socialist or left social-democratic politics, an interest in mass culture and the popular arts, a concern for rethinking notions of race and ethnicity, nation and people, and an interdisciplinary style of work. These figures are Kenneth Burke, Carey McWilliams, Oliver Cromwell Cox, Elizabeth Hawes, Sidney Finkelstein, and C. L. R. James.

Since these figures do not constitute any kind of group or formation, and since they were not fully aware of each other's work, I want to begin by reflecting on the search for intellectual origins and genealogies. I am not suggesting that there was a "cultural studies" movement in the middle decades of the twentieth century, nor am I trying to rescue an "American" parentage for the cultural studies we have imported from Great Britain. Rather, I am suggesting that our contemporary construction of "cultural studies" allows us to return to the intellectual work of the Popular Front and see it in new configurations, new constellations. It is only in this

way that we can challenge the configurations we have inherited from the historians, critics, and memoirists of the last half century. For the Cold War anti-communist purge of the culture industries and state cultural apparatuses left a deep cultural amnesia, as radical intellectuals were jailed, lost jobs, were deported or went into exile, were unable to publish, re-edited their earlier work and downplayed their earlier affiliations, and, in some cases, killed themselves.

There are three constructions of the cultural intellectuals of the Popular Front that have served as screen memories, versions of the events told as part of the formation of postwar disciplines and movements. The emerging profession of literary criticism focused its attention on the left-wing *literary* debates of the 1930s, carving a myth of origins out of the history of *Partisan Review*. In that story the Popular Front intellectuals were anti-modernist philistines, celebrating middlebrow kitsch, against whom the New York Intellectuals built their practice of literary and art criticism as cultural critique. The emerging American studies movement was more indebted to the Popular Front, but the euphemism and political caution of the Cold War years ended up turning the totemic figure of F. O. Mathiessen into the founder of a new nationalist canon. And some of cultural critics of the New Left completed the task, finding in the Popular Front a discredited kind of corporate liberalism, a sentimental and nationalist populism epitomized by the films of John Ford and Frank Capra (ones sees this in the work of Warren Susman, but also in the work of *Cahiers du Cinema*). By now, even our best cultural critics use the politics and culture of the Popular Front as a negative example, the emblem of reductiveness and simplicity against which we set our innovations.

In reconfiguring the "cultural studies" of the Popular Front, my model is the way the "tradition" we now know as "Western Marxism" was invented in the process of reconstructing it. Lukács, Korsch, Gramsci, Benjamin, and Adorno were neither a tradition nor a formation, but were exiles and prisoners, hardly read or known in their own time; they were reclaimed by a New Left, and are now, for worse and better, a part of our genealogy. A post-Fordist left in the U.S. needs reclaim the cultural intellectuals of the Popular Front; to begin that, this essay has parts: the first built around the notion of culture as the means of communication; the second on culture as a way of understanding communities; and the third on culture as the popular or vernacular arts.

Means of Communication

"So far as I can see," Kenneth Burke wrote in his 1935 book *Permanence and Change,* "the only coherent and organized movement making for the subjection of the technological genius to humane ends is that of Communism, by whatever name it may finally prevail" (Burke 1935, 93). This curious figure remains a starting point in reconstructing the cultural theory of the Popular Front. For most of the postwar period Kenneth Burke was considered a kind of eccentric New Critic, the inventor of a vast symbolic system based on a metaphor of drama. He was referred to with reverence, had a few disciples who explicated his system, and was generally ignored. With the emergence of literary theory in the late 1970s, Burke underwent a slight

268 revival, but it is only in the last few years that we have begun to see his project as a major cultural theory, and to see its political contexts. Burke, who was born in 1897, was at first an experimental fiction writer and music critic of the 1920s; his first work of critical theory, *Counter-Statement* (1929), was a major study of modernist aesthetics. However, like a number of the American moderns, Burke was radicalized in the early years of the depression, and in what he later called his "Thirtyminded" essays, he emerged as the most important communist cultural theorist in the United States. His writing of the Popular Front years is a remarkable mixture of occasional pieces on the political culture of the time—reviews of proletarian novels, the radical theater, and political theory in the weekly and monthly magazines of the left—and dense essays outlining a theory of symbolic action and its consequences for thinking about political transformation.

However, for the most part, Kenneth Burke has been portrayed as the quintessential fellow traveller, and critics have generally discounted Burke's symbolic acts of the 1930s. Both his topical agitprop essays—the "Revolutionary Symbolism in America" lecture, the "My Approach to Communism" manifesto, the occasional pieces on politics in *Direction*—and his "fellow-travelling" loan of his name to various Popular Front organizations are seen as finally incidental to the major theoretical projects of his books—the analysis of symbolic action and the theory of dramatism.

Indeed, the prevailing view of Burke's work suggests that the early provisional essays and books culminate in the theory of dramatism, elaborated in the great unfinished trilogy of the 1940s and 1950s—*A Grammar of Motives, A Rhetoric of Motives*, and the incomplete *Symbolic of Motives*; there is then a break and the later Burke emerges primarily as the expounder of "logology," building an ontology of language around the resemblance between theology—words about God—and logology, words about words. The principal expounders of Burke's systems, of Burke as a theorist of "man the symbol-using animal," have ignored his political affiliations: this is true of literary critics like William Rueckert and Greig Henderson and social scientists like Hugh D. Duncan and Joseph Gusfield. The most interesting arguments about Burke's politics (those of Jameson, Lentricchia, and Jay) see him finally as a New Deal liberal: for example, Fredric Jameson writes that Burke, "in the thick of a New Deal and Deweyan rhetoric of liberal democracy and pluralism," made a "desperate and ambitious attempt, in the *Grammar* and *Rhetoric of Motives*, to endow the American capitalism of the thirties and early forties with its appropriate cultural and political ideology" (Jameson 1978, 512). Similarly, though Frank Lentricchia suggests that Burke is part of the genealogy of Western Marxism—"one of the chapters of a full-scale history of Marxist thought will have to be on Kenneth Burke"—he argues that Burke's "comedic vision," translated into "an anthropological generalization about 'all people,'" is an "affirmation of bourgeois class values as universal, the mark of horizontal or democratic political desire" (Lentricchia, 66). Both of these views miss the radical nature of Burke's project and his accomplishments, in part because of Burke's own self-censorship in the face of the anti-Communist inquisition.[1]

For the editions of *Permanence and Change* and *Attitudes toward History* that we have had since the 1950s eliminated their Communist conclusions: as Burke coyly put it in his 1953 essay of intellectual autobiography, "Curriculum Criticum," "Unfortunately for the standing of this book [*Permanence and Change*] in these uneasy times, the family of key words that includes 'communication,' 'communicant,' 'community,' and 'communion' also has a well-known relative now locally in great disgrace—and the experimental author, then contritely eager to think of himself as part of an over-all partnership, had plumped grandly for that word, too" (Burke 1953, 215). When *Permanence and Change* was reprinted in 1954, he eliminated the political passages that concluded each of the three parts "since, under present conditions, the pages could not possibly be read in the tentative spirit in which they were originally written" (Burke 1954, xv); the line I quoted at the beginning will not be found in later editions of *Permanence and Change*. Burke was not the only left critic to emend his books like this in the 1950s; the endings of Malcolm Cowley's *Exile's Return* and Edmund Wilson's *The American Jitters* (retitled *The American Earthquake*) were revised in the midst of the Cold War. In reconstructing the Burke of the cultural front, we must return not only to the unrevised versions of these books but also re-read several uncollected essays.

The heart of Burke's work lies in the theory of symbolic action elaborated in the central books of late 1930s: *Permanence and Change* (1935), *Attitudes toward History* (1937), and *The Philosophy of Literary Form* (1941). The Motives trilogy that followed is best seen as a narrowing of focus, a magnification of specific aspects of the theory of symbolic action, and, to some degree, a turning away from the Marxist and modernist stance of the earlier books. If "dramatism" begins as a synonym for the dialectic, a cover term for Marxism not unlike Gramsci's "philosophy of praxis," it becomes, in the face of the Cold War, a cautious marker of Burke's move from his idiosyncratic Communist politics to a politics of "Neo-Stoic resignation" (Burke 1945, 442).

Burke's theory of symbolic action is perhaps best outlined in the short essay "Literature as Equipment for Living," originally published in the Popular Front magazine, *Direction* (for which he was fiction editor): cultural texts, from proverbs to works of literature are *strategies* for dealing with *situations*, "strategies for selecting enemies and allies, for socializing losses, for warding off evil eye, for…consolation and vengeance, admonition and exhortation, implicit commands or instructions of one sort or another. Art forms like 'tragedy' or 'comedy' or 'satire' would be treated as *equipments for living*, that size up situations in various ways and in keeping with correspondingly various attitudes." (Burke 1938, 13) "Every document bequeathed to us by history," he writes in another place (Burke 1973, 109) must be treated as a *strategy for encompassing a situation*." On this basis of seeing culture as a kind of "word magic" or "secular prayer," he then moves to build a distinctive theory of ideology—for typical situations, we develop typical strategies, what he will call "attitudes," "frames of acceptance" or "orientations." In *Permanence and Change*, Burke combines Veblen's notion of "trained incapacity," the situation where one's abilities serve as a blindness, with Dewey's notion of an "occupational psychosis," a

270 term for the habits of mind developed from a way of making a living, to develop a remarkable reflection on the way ideologies work and change. This leads to the book's account of the crisis of the capitalist orientation, and his calls for a new, communist orientation.

Attitudes Toward History develops the argument of the earlier book into a powerful theory of cultural change, a theory based on an account of allegiance to symbols of authority. "Our own program," Burke writes, "is to integrate technical criticism with social criticism (propaganda, the didactic) by taking the allegiance to the symbol of authority as our subject. We take this as our starting point, and 'radiate' from it. Since the symbols of authority are radically linked with property relationships, this point of departure automatically involves us in socio-economic criticism. Since works of art, as 'equipments for living,' are formed with authoritative structures as their basis of reference, we also move automatically into the field of technical criticism (the 'tactics' of writers). And since the whole purpose of a 'revolutionary' critic is to contribute to a change in allegiance to the symbols of authority, we maintain our role as propagandists by keeping this subject forever uppermost in our concerns" (Burke 1937, 2: 234–35). And in a short but brilliant essay entitled "Twelve Propositions on the Relation Between Economics and Psychology," originally published in the new Marxist journal *Science and Society* (of which he was a contributing editor), Burke argued that "the basic concept for uniting economics and psychology ('Marx' and 'Freud') is that of the 'symbols of authority'" (Burke 1973, 305).

Burke's notion of the allegiance to symbols of authority plays a not dissimilar role to the concept of hegemony in his communist contemporary, Antonio Gramsci. If hegemony is understood as the process by which a social group, an historical bloc, exercises power and leadership in society by winning consent, establishing patterns of loyalty and allegiance, then Burke's notion serves a similar role. Burke maintains that allegiance to symbols of authority is natural and wholesome, that cultures are built around symbols of authority; indeed, Burke suggests that "one 'owns' his social structure insofar as one can subscribe to it by wholeheartedly feeling the reasonableness of its arrangements" (Burke 1937, 2: 233).

However, "insofar as such allegiance is frustrated," Burke continues, "both the materially and the spiritually dispossessed must suffer....Even the dispossessed tends to feel that he 'has a stake in' the authoritative structure that dispossesses him; for the influence exerted upon the policies of education by the authoritative structure encourages the dispossessed to feel that his only hope of repossession lies in his allegiance to this structure that has dispossessed him" (Burke 1937, 2: 233). Moments of crisis occur—this is Burke's account of the "origins of the present crisis"—when these allegiances to the symbols of authority break down; these are moments of what Burke calls "impiety," when there is a struggle over new symbols. A revolutionary period, he will argue in the famous American Writers Congress speech, "Revolutionary Symbolism in America," is one when people drop their allegiance to one symbol of authority or myth and shift to another.

As social theory, Burke's account is somewhat thin: he offers little towards an

account of the social bases of a crisis. But as cultural theory, Burke's work offers a
powerful way of looking at the means of cultural struggle: the stealing back and
forth of symbols, and the processes of symbolic merger, identification and repre-
sentation. The notion of the symbols of authority serves Burke as a mediator
between different levels, between property relations, psychology, political domina-
tion and works of art. His famous examination of the "word magic" of Hitler's
Mein Kampf is a striking example of his methods, and stands as one of the major
cultural interventions of the anti-fascist movement.

Burke's account of the social meanings of symbolic action placed particular
accent on the intellectuals—the "spiritual bankers," the specialists in secular prayer.
He argues that the shape of the future "is really disclosed by finding out what peo-
ple can sing about. What values can enlist the most vigorous and original crafts-
men? And what values, on the other hand, can merely enlist the public relations
counsel?" (Burke 1937, 2: 244–45). His own understanding of the relation between
intellectuals and social movements is captured in this metaphor of enlistment and
affiliation. On considering a work in its historical contexts, he suggests, "we might
well find that the given philosopher, by manipulating the possibilities of emphasis
in one way rather than another, was able symbolically to enroll himself in one social
alliance, with its peculiar set of expectancies, rather than another. Here we should
see what participation in a Cause caused his work, by what Movement it was moti-
vated, on what sub-stance it made its stand" (Burke 1973, xix). In reconsidering the
cultural theory of Kenneth Burke, it is necessary to take full measure of the way he
symbolically enrolled himself in a social alliance, to see the Cause that caused his
work, the Movement by which is was motivated, the sub-stance on which it made it
stand.

Burke's symbolic enrollments—the communist conclusions to *Permanence and
Change* (1935) and *Attitudes toward History* (1937); his contributions to the *New
Masses*; his involvement in the left-wing League of American Writers over a num-
ber of years; his stance as a contributing editor of *Science and Society*, a leading
journal of Marxist thought, and as an advisory editor of *Direction*, the cultural
front's glossy arts magazine, and his participation in the controversies over the left's
cultural politics, including the famous debate over the symbol of the "people" at
the 1935 American Writers Congress, symbolic enrollments that came back to haunt
him when he was denied a teaching position in the early 1950s at the University of
Washington,—these were his own "dancing of an attitude," his strategies for nam-
ing the crisis of capitalist culture and the rise of fascism.

Moreover, like Dos Passos's account of the writer as technician, as part of a class
of "word-slinging organisms," Burke's account of the role of the "complete propa-
gandist" in the struggle for a revolutionary symbolism bears striking resemblances
to both Antonio Gramsci's account of the role of intellectuals in the construction of
hegemony and Walter Benjamin's invocation of the "author as producer," albeit in
the American idiom of pragmatism. The similarities derive from a common pro-
ject: all of these are attempts to theorize a new cultural politics, a politics summed
up in the phrase "cultural front," a metaphor both of a terrain of struggle and an

272 alliance of forces, that breaks with the avant-garde politics of proletarian culture: Dos Passos's earliest formulation of the "word-slinging organisms" occurs in a 1926 response to his friend Mike Gold's call for a proletarian literature; Burke's 1935 American Writer's Congress speech was explicitly posed against the rhetoric of proletarianism; Gramsci's important note on the struggle for a new culture was written in response to the proletarianism of Paul Nizan; and Benjamin's lecture on the author as producer was a response to Becher's conception of the proletarian writer. However, unlike many critics of the proletarian culture movement, they did not turn to an ideal of the autonomous intellectual or writer, but attempted to theorize the general role of symbol producers in a society dominated by mass communications. This was the somewhat inchoate project of the *Culture and the Crisis* pamphlet with which I started, and it remains one of the central tasks of an emancipatory cultural studies.

Common Ground

If one side of cultural studies has taken its project from the notion of culture as communication, as language and media—Burke's original title for *Permanence and Change* was "Treatise on Communication"—the other is rooted in the notion of culture as "community" and has explored the ways of life and struggle of "peoples" and the ways those peoples have been formed as ethnics, races, and nations. The first type of cultural studies has taken the means of communication as its central object of understanding: the means of communication as those institutions that controlled modern communication, the mass media, broadcasting, and the popular arts; and the means of communication as the forms and codes through which communication took place. This produced the classic accounts of the political economy of mass communications, as well as the detailed analysis of the figures and tropes, the signs and signifiers, that organized culture, understood through linguistic models. Several of the more formalist versions suggested that artworks of various sorts were fundamentally "allegories of communication." The ancient sciences of rhetoric and hermeneutics were dusted off because the new cultural studies was founded on the idea that we could "read" films, musical works, even sub-cultures as if they were "texts." Indeed an influential journal to whose editorial collective I once belonged called itself "social text."

None of this has disappeared exactly, but it now exists in a very different force field. The notion of culture as communication has been largely displaced by a notion of culture as communities, as peoples, and the central questions of cultural studies lie in the ways those peoples are produced. The concepts that produce a people—"nation," "race," "ethnicity," "colony," "margin," "color" (as in the older "colored" or the newer "people of color"), "minority," "region," "diaspora," "migrant," "post-colonial"—and the national and imperial discourses that underlie these fantasies of racial and ethnic identity, are at the heart of contemporary cultural studies.

There are many symptoms and markers of the transformation: the great debate about the "canon," which proved not to be about high and low culture, but about

the lineaments of a national language and literature; the trajectory of the work of the young post-structuralists Gayatri Spivak and Edward Said from their meditations on *différance* and beginnings to their critiques of the discourses of colonial and post-colonial regimes; the remarkable success in the humanities of Benedict Anderson's little book of 1983, *Imagined Communities*; the relative waning of Raymond Williams as the emblem of British cultural studies—largely because of his apparent blindness to questions of nation, race, and empire—and the inverse waxing of Stuart Hall in large part due to his brilliant resurrection of Gramsci's notion of the "national-popular"; the emergence of the leading intellectuals of the national liberation movements, figures like Frantz Fanon and C. L. R. James, into the mainstream of North Atlantic cultural theory; the re-emergence of Etienne Balibar, an architect of the Althusserian re-reading of *Capital*, as a theorist of racism and nationalism.

It has also been responsible for a minor but nonetheless remarkable change in the U.S. intellectual field over the last decade—the revival of "American Studies." Its professional association, the American Studies Association, has tripled in size over the last decade, and its conventions have grown since the mid-1980s, when they switched from bi-annual to annual events. When I first entered American studies in 1980, it was considered an intellectual backwater; the élan of the American studies "movement" of the late 1950s and early 1960s, with its interdisciplinary exploration of myths and symbols, had evaporated, and neither the intellectual radicalism of the New Left nor that of the New Right had taken up residence in "American Studies." In the decade since then, American studies has once again become a space of "radical critique," and this is in large part due to the "national" turn in cultural studies. For American studies, with its obsessional concern for the character of Americans, was the original "identity politics.[2]

I have argued in the past that one of the sources for "American studies" was the cultural criticism and history of the Popular Front, particularly the remarkable figure of F. O. Matthiessen. However, it is my sense that the welcome revival of Matthiessen's work—there are now several full-length studies of his contribution to the creation of a "American" national-popular—has tended to overshadow other genealogies of cultural studies. For the debate over the nature of the national-popular culture in among the intellectuals of the Popular Front was not limited to Matthiessen's canon of great figures. His book was only one of several revisions of American literary history—for it was in literary history not literary criticism that the breakthroughs of the period came. Both Granville Hicks's *The Great Tradition* and Alfred Kazin's *On Native Ground* are important in this respect. (One should beware of Kazin's dismissal of Hicks; from our perspective in the 1990s the two works share much, and in many respects Hicks is the more powerful model of literary history.)

However, the overemphasis on literature as the key to American cultural history in the postwar academy led to the relative eclipse of the most significant cultural histories of the Popular Front, works that probably remain more important for contemporary American cultural studies than Matthiessen's own *American*

274 *Renaissance*. I briefly mention two bodies of work. The first is the remarkable work produced by Constance Rourke, Alice Felt Tyler, and Caroline Ware. All of them were part of what Ware called "the cultural approach to history." They produced a number of works whose political and intellectual legacy we have yet fully to measure: Ware's community study of work and culture, *Greenwich Village*; Rourke's readings of the American national-popular through what she would call a "proletarian regionalism"; and Tyler's *Freedom's Ferment*, the still unsurpassed synthesis of the other American Renaissance, the one Matthiessen noted might be called the Age of Fourier or the Age of Swedenborg, the moment of cultural revolution and social movement that preceded the Civil War.

The second body of work is the powerful rethinking of the peoples of the United States that emerged from the Popular Front in the wake of the racial revolution of the 1940s, particularly in the work of Carey McWilliams and Oliver Cromwell Cox. It has long been maintained that the culture of the Popular Front ignored or downplayed the racial and ethnic formations in the United States, that it was a culture of "populism" and a sentimental American nationalism. So Warren Susman, perhaps the best and most influential interpreter of the 1930s, has argued that "the most persistent symbol to emerge from the bulk of the literature of the period…was 'the people'" (Susamn 1984, 178). For many critics, this sentimental populism was the great weakness of the art and thought of the period: in the cruelest cut of all, the contemporary political commentator Sidney Blumenthal suggested that the culmination of Popular Front culture was Ronald Reagan. Reagan, Blumenthal writes, embodied

> the last recapitulation of the popular liberal aesthetic of the Depression and war years: *The people, yes*. He still inhabited the mood of Frank Capra's populist movies, Archibald MacLeish's poetic tributes to the brotherhood of the common people, the uplifting social realism of the WPA post-office murals. Reagan echoed the spirit of "Ballad for Americans," the Popular Front pseudo-folk song about "nobody who was anybody" and "anybody who was everybody"—"You know who I am: the people!" His mass cultural style of democratic schwarmerei, like that of the old liberal left he once championed, was pitched for ideological advantage. *Let America Be America Again*. Conservatism is twentieth-century Americanism (Blumenthal 1986, 106).

The last line of course echoes the Communist Party's Popular Front slogan that "Communism was twentieth-century Americanism." Though he gets the lyrics to "Ballad for Americans" wrong, Blumenthal captures the prevailing sense that Popular Front culture was narrowly nationalist, aesthetically middlebrow, and finally conservative.

For a number of contemporary liberal Democratic thinkers, this is a lost world to be recaptured. The increasingly dominant interpretation of the "rise and fall of the New Deal Order" suggests that the populist and Americanist Roosevelt coalition was destroyed by the "turn to race," by an alleged alliance of anti-American "limousine liberals" and the rhetorically aggressive black leaders of a welfare underclass. This analysis—pioneered by the conservative political analyst Kevin

Phillips—has been adopted in such influential works as the Edsalls's *Chain Reaction*, Jim Sleeper's *The Closest of Strangers*, and Fraser and Gerstle's *The Rise and Fall of the New Deal Order*. The implicit and sometimes explicit counsel in these works is that the Democrats should turn away from the politics of racial justice to lure back the "Reagan Democrats" through the politics of white populism, a counsel adopted in the campaign of Clinton and Gore. This is combined with an attack on the supposedly "politically correct" universities where a new "cultural studies" is reducing Culture to racial and ethnic representation and promoting a balkanized, "ethnicized" curriculum, and, through affirmative action, a racialized travesty of the supposed meritocracy of the university.

Against this tendentious history, I will suggest that the age of the CIO marked a crucial turning point in the racial formation of the United States, and that this was recognized and grappled with by the left-wing cultural intellectuals associated with the Popular Front. If their solutions were a series of inadequate tropes—"common ground," "a nation of nations," "brothers under the skin," "rendezvous with America"—that is less a judgement on them than on the deep contradictions at the heart of settler capitalism. To reduce the vision of Paul Robeson to that of Ronald Reagan simply because they both invoked the figure of "America" is not simply amnesia but a willful mystification.

There are a number of ways to think about the Popular Front's imagination of "peoples," from the campaigns for Black history in the New York City schools and for the integration of white professional baseball, to the "ethnic renaissance" within the Communist Party after the 1938 convention broke with a militant assimilationism. The centrality of the IWO (International Workers Order), the multiracial, multiethnic left-wing fraternal association, to Popular Front popular culture was due in part to its organization by ethnic sections, supporting foreign-language newspapers, ethnic halls, sports teams, schools, and children's camps. In Hollywood, the "people" might refer to the "forgotten man," the ethnically unmarked white victim of the Depression, but for the Popular Front the "everybody who's nobody" was not "the people" but, in the actual words of "Ballad for Americans," "an Irish, Negro, Jewish, Italian, French and English, Spanish, Russian, Chinese, Polish, Scotch, Hungarian, Litvak, Swedish, Finnish, Canadian, Greek and Turk, and Czech and double Czech American." However, the most interesting and powerful reflections on the "peoples" of the United States emerged in the work of a California leftist, Carey McWilliams, and in the work of a marxist sociologist teaching at a black college in Texas, Oliver Cromwell Cox.

Carey McWilliams was a California writer who began as a literary critic and voice of Western regionalism. McWilliams turned to political life, becoming famous for his book, *Factories in the Fields*, which together with Steinbeck's *Grapes of Wrath*, drew national attention to the struggles of migrant farmworkers. As a result, he became the head of California's Division of Immigration and Housing under the left New Deal governor Culbert Olson, and subsequently wrote four major books on racism and the peoples of the U.S. during the 1940s: *Brothers under the Skin*, *Prejudice: Japanese-Americans*, *A Mask for Privilege*, and *North from*

276 *Mexico.* McWilliams was also at the center of a group of young West Coast ethnic writers, who included Louis Adamic, Carlos Bulosan, John Fante, Toshio Mori, and William Saroyan, many of whom published in the journal *Common Ground.*

There are two key threads guiding McWilliams's work. First, he insisted that the central issue was not the drama of "old-stock American" and European "new-immigrant"; rather, it was the color lines between white Americans and various peoples of color. His pathbreaking book, *Brothers Under the Skin,* was organized by essays on American Indians, Chinese Americans, Chicanos, Japanese Americans, the colonies of Hawaii, Puerto Rico and the Philippines, and black Americans—an organization remarkably different from either Louis Adamic's *A Nation of Nations* (which predominantly focused on European immigrant groups) or the "caste" theories of American black/white relations that dominated the liberal social science of the 1940s. In this sense McWilliams was one of the earliest U.S. figures to see race through Californian eyes, arguing in 1943 that the U.S. was "in the process of being orientated toward Central and South America" and the Pacific (McWilliams 1943, 14–16).

Second, McWilliams suggested a new periodization in the history of U.S. racial formations, noting that "the year 1876 seems to have marked a turning point in our dealings with all colored minorities, for about that time we decided to exclude the Chinese, place the Indians on reservations, and surrender the Negro to the South" (McWilliams 1943, 317). McWilliams's arguments about the relation between the end of the slave trade and the emergence of Chinese migrant labor suggest that the birth of the modern racial systems with their legal codes of segregation, exclusion, reservations, and anti-miscegenation in the mid-nineteenth century were a consequence of the ending of the forced labor systems of slavery, serfdom, and transportation.

McWilliams's work and its wide dissemination in the world of the CIO unions and Popular Front political groups marked a major advance not just for the American left, but for U.S. culture generally. The meaning of this intellectual shift—marked by such works of liberal social thought as Gunnar Myrdal's *An American Dilemma* (1944), Ashley Montagu's *Man's Most Dangerous Myth: The Fallacy of Race* (1942), and Ruth Benedict's *The Races of Mankind* (1943)—has too often been understood as simply an intellectual affair, provoked by the needs of wartime nationalism. Thus Gary Gerstle has argued that this wartime "cultural pluralism" was largely an intellectual ideal aimed at mobilizing a unified nation for war; it eventually turned energies and attention away from the issues of class, the "labor" question: "the liberal fascination with the cultural pluralist ideal that the war had spawned diminished the stature that the labor question had long occupied in the minds of American reformers" (Gerstle, 318). But this account—one repeated in many variations in the jeremiads against the Democratic Party's alleged abandonment of the "New Deal class coalition" for an upper-middle class liberal moralistic concern for race—fails to understand the social transformations behind the emergence of this discourse on race, peoples and cultural pluralism.

As McWilliams later noted in his autobiography, the irony of his four books of

the 1940s on racial matters is that they were not planned; he did not intend to spend 277 the decade writing on race and the peoples of the U.S.. Rather, they were a response to what he calls the "racial revolution" of the 1940s: "The fact is," McWilliams writes, "—and it deserves emphasis—that the civil-rights movement of a later period is to be understood only in terms of what happened from 1941 to 1945.... Catastrophe initiates social change; it was the war that set the racial revolution in motion" (McWilliams 1979, 114–115). We must understand the emergence of the *Common Ground* thinkers as a product of the transformations in the U.S. racial formation at the time. The racial formation constructed in the 1870s and 1880s based on racialized legal codes was beginning to unravel in the face of the anti-fascist war, the migrations of black Americans out of the apartheid, sharecropping South, and the emergence of Civil Rights movements.

In retrospect 1942 seems as much a turning point in the U.S. racial formation as 1876 had been: the war with Japan began a 35-years war in Asia—the Philippines, Korea, Indonesia, Vietnam, Cambodia; the 1942 evacuation and internment of Japanese Americans was a watershed for Asian Americans; 1942 marked the beginning of the Bracero program, which organized the importation of Mexican contract labor for agribusiness; and 1942 marked the beginning of the largest migration of black Americans out of the South to the war industry cities of the North and West. The beginnings of the black Civil Rights movement can be seen in the 1941 March on Washington movement led by A. Phillip Randolph, the militant Harlem organizing represented by Adam Clayton Powell and Benjamin Davis, and the extraordinary success of Richard Wright's novel of 1940, *Native Son*. 1943 was a year of exceptional racial conflict; a group of young Chicanos were framed for murder in what was known as the Sleepy Lagoon case. A few months later, white servicemen attacked Chicano youths across Los Angeles in the week-long zoot-suit riots. A summer of race riots followed: in San Diego, Philadelphia, Chicago, Evansville, Beaumont, culminating in the major riots in Harlem and Detroit.

It is in this context that we need understand the most important theoretical contribution of this period to issues of race and ethnicity: Oliver Cromwell Cox's *Caste, Class and Race*. Oliver Cromwell Cox was a Trinidadian contemporary of McWilliams who migrated to Chicago for his education; after being partially disabled by polio, he gave up plans to practice law in Trinidad and became a scholar, earning his doctorate in the University of Chicago's sociology department in 1938, and then teaching through the early 1940s at Wiley College, a segregated black college in Texas. *Caste, Class and Race* (1948) brought together his essays of the 1940s, and it has been usually treated as a distinguished but idiosyncratic work, often cited but rarely engaged. Outside the political battles of Harlem and Chicago, and, in contrast to his contemporary C. L. R. James, uninvolved in the internal polemics of left-wing parties, Cox has rarely been seen for what he is: the most important Popular Front theorist of race and ethnicity.

His Popular Front political stance can be read throughout the book: in his hopes for the organization of black workers in the South in the CIO's postwar Operation Dixie; in the section on "Negro leadership," which concludes by pointing to the

election of black Communist to the New York City Council; and in his interpretation of the racist meaning of the Cold War anti-Communist campaign. However, just as his Wiley College colleague, the poet Melvin Tolson, stayed aloof from the metropolitan literary skirmishes over "proletarian literature" and the "writer's responsibility" in order to develop an independent Marxist poetics, so Cox devotes his main energies to theoretical clarification, developing an account of the ways a capitalist world system not only proletarianizes the masses but racializes them as well.

Cox's theoretical work begins from his critique of the attempts to use the concept of "caste" to analyze race relations: caste theories dominated the work of white and black sociologists of the period as they tried to explain the racial formation of the segregated, sharecropping South. Against these works, Cox maintained the historical originality of capitalist race relations, which were based on the "commoditizing" of human labor in the New World (Cox, 486). If McWilliams points to 1876 as a *turning* point in the forms of capitalist racism, Cox adds a *starting* point: "if we had to put our finger upon the year which marked the beginning of modern race relations," he writes, "we should select 1493–94. This was the time when total disregard for the human rights and physical power of the non-Christian peoples of the world, the colored peoples, was officially assumed by the first two great colonizing European nations" (Cox, 331–32). Without capitalism, Cox maintains, there would be no racism.

Cox's essays attempt to work out the theoretical consequences of this stance. On the one hand, he develops and defines a variety of abstract concepts that would characterize the relations between peoples, refusing the conflation of racism, ethnocentrism, and intolerance just as he refuses the conflation of race and caste. If "ethnic" becomes the generic term for the social relations between peoples who think of each other as distinct, ethnic relations become racialized or nationalized only in particular historical circumstances. Thus, the other side of Cox's project is the account of how racialized social relations are formed not as a "natural, immemorial feeling of mutual antipathy," but as an "instrument of…economic exploitation." "Our hypothesis," Cox argues, "is that racial exploitation and race prejudice developed among Europeans with the rise of capitalism and nationalism, and that because of the world-wide ramifications of capitalism, all racial antagonisms can be traced to the policies and attitudes of the leading capitalist people, the white people of Europe and North America" (Cox, 322). Unlike those thinkers for whom racism is an irrationality within capitalism, a survival of earlier modes of exploitation, Cox offers an account of capitalism as a world system in which racialization is a fundamental economic and political process.

Though Cox's formulations are not the final word on these issues, they remain the starting point: both for their rigorous interrogation of the concepts used in theorizing "peoples," and for their attention to the specific forms of capitalist racialization. And this is why this history, this genealogy of cultural studies, is important for those of us in U.S. cultural studies. The racial revolution of the 1940s that Adamic, McWilliams and Cox witnessed and tried to make sense of created the

racial formation that we in the U.S. have inherited and continue to reproduce: that is the meaning of the supposed "turn to race" that the political commentators lament; that is the subtext behind the controversies over the very meanings of race and ethnicity, the seesawing dialectic that sees race alternatively as an essence and a trope; that remains the ground of the "liberation politics" of the 1950s and 1960s and the "identity politics" of the 1980s and 1990s; and the complexity of that racial formation unites the zoot-suit riots of 1943 with the Los Angeles riots of 1992.

The Popular Arts

Since cultural studies represents the uneasy alliance between those who understand culture as the means of communication, and those who understand culture as the ways of life of communities and peoples, it is perhaps not surprising that the popular arts have become so central to contemporary cultural studies. For the popular or vernacular arts lead us both ways: to the means of communication, the industries and rhetorics that form popular entertainment, and to the communities for whom popular entertainments are equipment for living. And, for the most part, the post-modern re-discovery of popular culture took its bearings from the "mass culture" controversy of the post-World War II years. That debate was dominated by the New York Intellectuals and their little magazines, and they repeatedly assailed the writers and intellectuals of the Popular Front for their surrender to mass culture and kitsch. Remarkably, though recent work on popular culture has sharply dissented from the orthodoxies of the "mass culture" problematic, few have challenged their depiction of the Popular Front's engagement with the vernacular arts. Thus, I will conclude this survey of the cultural studies of the Popular Front by looking briefly at three figures who pioneered the analysis of popular or vernacular cultures, all of whom stand outside the postwar moral panic over "mass culture." In some ways they represent the continuation and transformation of the "proletarian" avant-garde of the early years of the Depression. If that avant-garde had its weaknesses, it nevertheless heralded the emergence of a new working-class culture in the United States, a culture built at the intersection of the cultural commodities produced by the capitalist industries of art and entertainment and the symbolic forms and practices of subaltern daily life. These three critics—Elizabeth Hawes, Sidney Finkelstein, and C. L. R. James—represent powerful reflections on the vernacular cultures of the CIO working classes.[3]

Elizabeth Hawes represents an important and almost entirely unrecognized type of intellectual, a type central to the Popular Front as a social movement: the labor union intellectual. The organization of the mass industrial unions of the CIO not only attracted the sympathies and allegiances of traditional intellectuals, like Kenneth Burke, it also created its own organic intellectuals including organizers, economists, lawyers, writers, journalists, historians, musicians, theater workers, and cartoonists. They worked in the education departments of the unions, and in the labor press, including the Federated Press, the important left-wing labor news agency. Hawes was one of these union intellectuals, working for the education department of the United Automobile Workers, writing a weekly column in the

280 *Detroit Free Press* (the first of which called for public nurseries and a thirty-hour work week); editing pamphlets and a special issue of the UAW's magazine, *Ammunition*; and traveling the country visiting UAW locals. She eventually left the UAW as the anti-Communist purge was beginning; though she was not a Communist Party member, the Education department had been a stronghold of the left-wing of the union. One of the major consequences of the anti-communist purge of the unions after the war was that these radical intellectuals were driven out of the unions, destroying the cultural initiatives of the labor movement and widening the gap between radical intellectuals and the labor movement.

Hawes's road to the UAW is equally striking: she had been one of the leading fashion designers in the United States. Like Kenneth Burke, Hawes was one of the moderns, born in 1903 to a bourgeois family: her father was an assistant manager of a steamship line, her mother a Vassar-educated daughter of a railroad vice-president. She graduated from Vassar in 1925 and went to Paris to learn dress design, working in an illegal copy house, and writing fashion reports for the newly launched *New Yorker*. On the fringes of the expatriate artist's community in Paris, she, like many other "exiles" returned to the U.S. in the late 1920s and opened a successful fashion business. By the mid-1930s, Lord and Taylor had taken her up as part of a campaign to promote American designers, and she was well known in the elite New York arts world. As parts of that world moved left, so too did Hawes, and she worked with the left-wing director Joseph Losey in the WPA theater, designing the costumes for the famous Living Newspaper production, *Triple A Plowed Under*.

In 1940, Hawes closed her business and became the editor of the "News for Living" section of the New York daily, *PM*, a Popular Front tabloid that refused advertising and pioneered a new journalism. She became active in the Committee for the Care of Children in Wartime, a group lobbying for government-funded child care, and, in March 1943, she went to work as a grinder making screws in the Wright Aeronautics Plant, and from there she moved to the UAW's Education Department. The series of books she wrote in these years were not only widely read in the Popular Front social movement, but also stand as pioneering reflections on work and culture, mediated through a fundamental form of vernacular culture, clothing. Her first book, the best-selling *Fashion is Spinach* of 1938, was, in the words of her biographer Bettina Berch, a "fashion declaration of independence," criticizing Paris fashion and calling for the democratization of style; and *Men Can Take It* (1939) was a radical and satirical account of clothing for men (she had staged what may have been the first all-male fashion show in 1937). She also wrote two pioneering accounts of the transformations in women's work brought on by their large-scale entry into Fordist mass production: *Why Women Cry* (1943), which was in part a war-plant diary of her time at Wright Aeronautics, and *Hurry Up Please Its Time* (1946), an account of her work for the UAW.[4]

Perhaps her finest book, however, is *Why is a Dress?* (1942). Despite its informal style, it is a theoretical work. Its form—advice to the aspiring dress designer—raises fundamental questions: why clothes are worn, how clothes are made, how the garment industry works, what makes clothes beautiful. And *Why is a Dress?* begins

as a critique of her own earlier work: "the day of made-to-order clothes is over," she writes, "…our most important problem is to perfect the mass production of clothes" (Hawes 1942, 2,7). "I posed a specific clothing problem at the beginning of this book," she concludes, "There are in the United States thousands of secretaries…who must dress every day for work. What are they to wear?" (Hawes 1942, 160). Her answer, embodied in the book and in her own designs, was a kind of feminist functionalism. Criticizing the abstract, geometrical designs of the modernist Schiaparelli, Hawes argues that the sense of line in clothing must derive from the body in motion: beautiful clothes must be comfortable and attractive while working. There is a wonderful anecdote in *Fashion is Spinach* where she tells of meeting the architect Frank Lloyd Wright who was speaking in a tuxedo: "Every time he said 'modern' his stiff shirt cracked. Every time he said 'functional,' the shirt rose a little more out of the vest." Afterward Hawes asked Wright if he was comfortable in his clothes? "Of course he answered. Really, I thought your collar was cutting into your neck, she said. It's an old collar and it's rough on the edge, he explained. Then he added belligerently, 'There is *nothing wrong* with these clothes'" (Hawes 1938, 295–96). Hawes's aim was to do for clothing what Wright and others were doing in architecture; indeed, in *Why is a Dress?*, she remarks that clothes, not architecture, were "the most accurate artistic index of life." "Clothes are an expression of the social life of the time," she wrote, and "clothes designing is the expression of the social life of the time in terms of finished garments" (Hawes 1942, 149, 29, 75).

Hawes wasn't able to solve the problem in her own work: caught between her training in custom-made dressmaking and her experiences in the wholesale design of the garment industry, she admits that she had "not found a satisfactory way of plying [her] original trade" (Hawes 1942, 8). But she was unwilling to abandon the hope that one could bring together mass production and good design, that there could be a genuine democratization of style; as a consequence, she deeply involved in the politics of women's work and women's consumption. In a discussion of her reasons for going to work for the UAW, she writes, in a passage that echoes the *Culture and the Crisis* pamphlet, "no one is more hampered in his or her work today than the artist, no matter what his field. When that artist is as closely bound to commerce as it the dress designer, the hampering of her work is obviously traceable to the same things which prevent a third of the nation from being adequately clothed, housed and fed" (Hawes 1946, 2).

In the years after the war, Hawes became increasingly critical of the subordination of style and design to fashion, to the logic of the consumer market. Her last major work, *Anything But Love* (1948), was a critique of the mass media's continual hard sell to women, surveying women's magazines, radio soap operas, screen magazines and advice books, with their post-war messages of the Happy Housewife and Consumption as the Answer to Everything. A contemporary of de Beauvoir's *Second Sex*, it is an early left feminist account of what would come to be called "the feminine mystique."

If Elizabeth Hawes's writings on dress design and women's work offered a rich reflection on a vernacular culture torn between the culture industries and the sym-

bolic forms and needs of daily life, the writings of left-wing critics on jazz stand as a second body of cultural studies that has drawn too little attention. In fact, the cultural left is usually depicted as being hostile to jazz, and, as I argue in *The Cultural Front*, the prevailing view is that the music of the Popular Front was "folk music," the music associated with Woody Guthrie, Lead Belly, Pete Seeger, and the subsequent folk revival. Though the story of the folk revival is an important one, the music front was, I suggest, much more varied than this picture would indicate. Moreover, historians of jazz have long recognized that many of the major figures in jazz criticism were on the left: James Lincoln Collier has even claimed that the early Popular Front critics so dominated jazz criticism that their "falsifications" invented the "myth" of American indifference to jazz and the "myth" that jazz was a music of the ghetto. I won't try to answer Collier here, but it is clear that many of the important jazz writers of the period were associated with the Popular Front, including Ralph Ellison, John Hammond, Otis Ferguson, Charles Edward Smith, Fredric Ramsey, and R. D. Darrell, not to mention such European leftists as Andre Hodeir, Joachim Berendt (who debated with Adorno), and Eric Hobsbawn. Here I want to mention briefly one major contribution, Sidney Finkelstein's *Jazz: A People's Music* (1948). Though its title makes it seems all too familiar—another version of left populism—it is not a work built on folk sentimentality or the quest for authenticity. Rather, it begins by placing jazz in world music and by refusing the high/low culture distinction, criticizing the nostalgia and primitivism of jazz critics who wished to limit musicians to "folk" practices. "Commercialism," he writes, "should not be applied…to the desire of the musician to be paid for his work," nor to "the desire of the jazz musician to use the prevailing musical language of his period and audience"; "commercialism should be restricted, as term, to what is really destructive in culture: the taking over of an art by business" (Finkelstein, 157–58).

He rejects the notion of "purity" in music, seeing a dialectic of folk and nonfolk practices in jazz: "the mixture, absorption and highly conscious interplay of many musical languages" characterizes New Orleans jazz as well as bebop. Finkelstein argues that "bebop and modern jazz…raise the contradictions inherent in jazz from its beginnings, to their highest level. These contradictions in the music are directly a product of the contradictions in our social life, predominantly rising out the place of the Negro people in American life" (Finkelstein, 98,231). The heart of his work is a sustained examination of the formal contradictions faced and resolved by jazz artists.

Finkelstein suggests that just as the social history of jazz lies in the interplay and contradictions of the cultures of the black metropolises of the United States and the cultures of the urban "New Americans," so the formal history of jazz lies in the interplay and contradictions between the blues and the popular ballad. This dialectic underlies his brilliant formal explorations of the ways Duke Ellington solved "the problem of form and content for the large band" and the different ways Lester Young, Billie Holiday, and Charlie Parker solved the "problem" of the popular ballad (Finkeslstein, 194, 223).

In some ways, Finkelstein's work remains tied to the traditions of the philhar-

monic music in which he was trained. If this allows him to see Ellington in the same terms as Ives and Bartok, moderns who explored the new harmonic implications of folk melody and created new instrumental timbres with folk instrumentation, it also leads him to see the future of jazz in the terms of what we might now call the Lincoln Center model: large forms—operas and symphonies—and large bands—he calls for each American city to sponsor a permanent large jazz band. One doesn't sense that Finkelstein in 1948 had fully registered the impact that recording technologies would have on the dialectic of composition and improvisation. Nevertheless, Finkelstein's *Jazz* is a remarkable work of cultural criticism, and I wince every time poor old Adorno is dragged out as *the* example of Marxist writing about jazz.

Hawes's writing on dress design and Finkelstein's book on jazz stand as two examples of the attempt to register the meaning of the new vernacular cultures of the mid-twentieth century. But the outstanding synthesis of the period is the legendary manuscript of C. L. R. James on American civilization, written in 1950, but only published after his death. *American Civilization* was written in a period of defeat; the anti-communist purge was on, and James himself—though a bitter critic of the Communists—was unsuccessfully fighting a deportation order issued in 1948. He embarked on his account of American civilization as a kind of modern Tocqueville; it was written at a time when a number of studies of the American "national character" appeared, including David Potter's paean to abundance, *People of Plenty*, and Max Lerner's encyclopedic *America as a Civilization*. None can match the power and insight of James's account.

The heart of James's account is the understanding of mass production: for James, as for many modern social thinkers, Americanism was Fordism. But for James, in Fordism lies the future in the present, and it is worth following his argument about Fordist mass production. First, Fordism signifies *both* the assembly line and the family car, the creation of a new labor process and a new form of mass-produced culture. The two central chapters of James's study are the ones on the labor process and on the popular arts. I stress this old story because it is in danger of being lost in much of contemporary cultural studies. Cultural studies was built in a variety of places around the creative tension between the analysis of the labor process—recall the extraordinary influence of Harry Braverman's *Labor and Monopoly Capital* with its analysis of the separation of conception and execution in mental and manual labor—and the analysis of the mass culture. This dialectic was at the center of Stanley Aronowitz's classic *False Promises* (1971)—"trivialized work, colonized leisure" was the title of a central essay; this same tension informed the work of the Birmingham Center in the 1970s, where the work of Stuart Hall and others on the media stood in a vital dialogue with the work of Paul Willis and others on the labor process; and this dialectic lay at the heart of the early works of socialist-feminist cultural critique, which tied the labor processes of housework, of feminized occupations, and of birth itself to the mass culture addressed to women. Indeed, I am pretty sure that the catch-phrase of contemporary cultural studies, "contested terrain," originated in studies of the labor process.

Too often, contemporary cultural studies reads the cultural commodities of post-modernism without interrogating the labor processes of post-fordism, and James's notes on American civilization remind us of the necessity to yoke the two, even though he is writing about the very heartlands of Fordism. For James sought the utopian promise in both sides of mass production: though he was aware that the logic of mass production was to trivialize work and colonize leisure, he also maintained that "*mass production* has created a vast populace, literate, technically trained, conscious of itself and of its inherent right to enjoy all the possibilities of the society" (James, 36).

His central question is that of popular desire. The manuscript returns again and again to the question: "what is it that the people want?" The answer, he suggests, is the fulfillment of the promises of mass production in both the popular arts and the labor process. His account of the popular arts remains sketchy, surveying the serial narratives of comic strips, Hollywood films, and radio soap operas. As was the case for many intellectuals of his generation, Chaplin stands above all, holding out the promise of a new democratic art; but James argues that the American popular arts since 1929 are haunted by the sense of crisis: "the blight (and the turn to murder and violence) which has descended upon the American people since 1929 expresses the fact that the bottom has fallen out of the civilization, men have no confidence in it any longer and are brought sharply up against the contradiction between the theories, principles, ideas etc, by which they live and the realities which they actually face" (James, 138). By the end, he returns to ancient Greek theater as an emblem of the possibilities of popular art.

James unites this account of the popular arts with a version of the radical industrial unionism that characterized the social movement of the time. American workers, he argues, "want to manage and arrange the work they are doing without any interference or supervision." This is the meaning of the CIO: against the illusion that the CIO was formed as an instrument of collective bargaining, or a means to negotiate about wages, James argues persuasively that "it was the first attempt of a section of the American workers to change the system as they saw it into something which would solve what they considered to be their rights, their interests and their human needs" (James, 166, 173).

And so we come full circle. James captured the true meaning of the CIO, the reason the period needs to be remembered as the age of the CIO. The failure of the social movement represented by the CIO, the social movement I have called the Popular Front, left us with a different settlement, a different crisis, a passive revolution we have come to call post-fordism, post-modernism. What we recognize as our "cultural studies" comes out of that transition, the emergence of the new left and the new right.

One of the central aspects of that settlement has been, as James pointed out, the extraordinary expansion of the bureaucratic state. One might take this story as in part the story of the development of modern mental labor, what C. Wright Mills, the last thinker of the old left or the first of the new, called the cultural apparatus. Here James parted company with the other theorists of the Popular Front. The

Culture and the Crisis pamphlet had called on artists, teachers, engineers, and professionals, the "brain" workers, to ally with the "muscle" workers in building a new society, while James, like a number of his Trotskyist comrades, remained deeply suspicious of that "new class" of cultural bureaucrats, state administrators, labor leaders. "The division between manual mechanistic labor and scientific intellectual labor was never so great as now," James writes in 1950 (James, 227).

The divide still seems the urgent task of an emancipatory cultural studies: the recent initiative to create Teachers for a Democratic Culture was a distant echo of the League of Professionals. At a moment when the leading ideologues of this postmodern world are once more justifying the social divide between mental and manual labor as a "natural" ranking of IQ, and class and race are turned into the outward signs of innate intelligence, we need to recall the utopian demand and promise to reunite mental and manual labor, conception and execution, and restore James's conception of workers control and a democratic popular art.

Notes

1 In an earlier essay (Denning, 1986), I took issue with Lentricchia's characterization of Burke as a Western Marxist, accepting the received view of Burke as a non-Marxist liberal theorist of symbolic action, a view that Lentricchia's interpretation does not fundamentally contest; a reading of the original editions of Burke's works has led me to change my mind. Paul Jay's illuminating essay on Burke argues persuasively that the parallels between Burke and contemporary critical theory are less interesting than the way Burke responds to the crisis of the 1930s. However, I am not persuaded that Burke's response to his time is best charted through his changing treatments of Marx and Freud, as Jay suggests. Indeed, both Lentricchia and Jay cite the 1950s revisions of Burke's books of the 1930s; neither seems aware of the substantial changes made in the later editions. For more on the re-editing of *Permanence and Change* and *Attitudes toward History*, see my *The Cultural Front*.

2 In 1984, one of the early North American manifestoes announcing "The Need for Cultural Studies" took American Studies and Canadian Studies as "cautionary" examples of nationalist interdisciplinary enterprises in the academy that had retreated from "radical critique" (Giroux and others); similarly, in 1985, a writer in the right-wing *New Criterion* noted that "so far, the Marxist humanistic program in the universities has concentrated on criticism, social history, and the history of Marxist thought itself. It has nevertheless failed to develop a distinctive, persuasive critique of American culture comparable to the work of Adorno and Benjamin in the 1930s in the European context" (Cantor 1985, 32). I attempted to tell the story of the earlier American Studies formation in *American Quarterly* (Denning 1986) and others, including Joel Pfister, Gunther Lenz, Sigmund Diamond and David Shumway (one of the authors of "The Need for Cultural Studies") have since contributed to the history of that intellectual formation.

3 For further discussion of the debate over mass culture and the rise of cultural studies, see Denning 1990 and Denning 1992.

4 I am greatly indebted to Bettina Berch's fine biography of Hawes, *Radical by Design*.

References

Berch, Bettina (1988) *Radical by Design: The Life and Style of Elizabeth Hawes.* New York: E.P. Dutton.

Blumenthal, Sidney (1986) *The Rise of the Counter-Establishment*. New York: Times Books.

Burke, Kenneth (1935) *Permanence and Change*. New York: New Republic.

—— (1937) *Attitudes toward History*. Two Volumes. New York: New Republic.

—— (1938) "Literature as an Equipment for Living." *Direction* 1.4: 10–13.

—— (1945) *A Grammar of Motives*. New York: Prentice-Hall.

—— (1953) "Curriculum Criticum." In his *Counter-Statement*. Los Altos: Hermes Publications.

—— (1954) *Permanence and Change*. Second Revised Edition. Los Altos: Hermes Publications.

—— (1973) *The Philosophy of Literary Form*. Berkeley: University of California Press.

Cantor, Norman (1985) "The real crisis in the humanities today." *New Criterion*, 3 (June).

Cox, Oliver Cromwell (1948) *Caste, Class and Race*. New York: Monthly Review Press, 1970.

Denning, Michael (1986) "'The Special American Conditions': Marxism and American Studies." *American Quarterly*, 38.3: 356–80.

—— (1990) "The End of Mass Culture." *International Labor and Working-Class History*, #37: 4–18 and #38: 63–67.

—— (1992) "The Academic Left and the Rise of Cultural Studies." *Radical History Review* #54: 21–47.

—— (1996) *The Cultural Front*. New York: Verso.

Gerstle, Gary (1989) *Working-Class Americanism*. Cambridge: Cambridge University Press.

Giroux, Henry, David Shumway, Paul Smith, and James Sosnoski (1984) "The Need for Cultural Studies." *Dalhousie Review*, 64: 472–86.

Hawes, Elizabeth (1938) *Fashion is Spinach*. New York: Random House.

—— (1942) *Why is a Dress?* New York: Viking.

—— (1946) *Hurry Up Please Its Time*. New York: Reynal & Hitchcock.

Finkelstein, Sidney (1948) *Jazz: A People's Music*. New York: Citadel Press.

James, C. L. R. (1993) *American Civilization*. Cambridge: Blackwell.

Jameson, Fredric (1978) "The Symbolic Inference; or, Kenneth Burke and Ideological Analysis." *Critical Inquiry* 4: 507–23.

Jay, Paul (1989) "Kenneth Burke and the Motives of Rhetoric." *American Literary History*, 1.3: 535–53.

League of Professional Groups for Foster and Ford (1932) *Culture and the Crisis: an open letter to the writers, artists, teachers, physicians, engineers, scientists, and other professional workers of America*. New York: Workers Library Publishers.

Lentricchia, Frank (1983) *Criticism and Social Change*. Chicago: University of Chicago Press.

McWilliams, Carey (1943) *Brothers Under the Skin*. Boston: Little, Brown.

—— (1979) *The Education of Carey McWilliams*. New York: Simon and Schuster.

Susman, Warren (1984) *Culture as History*. New York: Pantheon.

TOWARD WILD CULTURE

Ackbar Abbas

14

CULTURAL STUDIES IN
A POSTCULTURE

I

A famous tenet of sixties' radicalism was that to live outside the law, you had to be honest. Such a proposition not only draws on something perennially attractive about the outlaw; it also gives to dissent a moral dimension. It shows that dissent, unless it is merely resentment or dissension, cannot be a blithe abandonment of discipline; it has to find its own form of discipline. The difference, then, between disciplinarity and dissent cannot be seen in terms of the presence and absence of discipline; it is rather a difference in kinds of discipline. Forced to specify, one might say that disciplinarity is the kind of discipline that has largely lost its critical and self-critical edge, associating itself more with daily routine and fixed forms. It may understand—to use Nietzsche's terms—the importance of having the courage of one's convictions, but not the importance of having the courage for an assault on one's convictions. On the other hand, dissent recognizes very well that "convictions are prisons," and that living outside the law means being free of these mind-forged prisons. The problem with this simple opposition, however, is that it gives an overly optimistic view of dissent. It forgets for one thing how subtly dishonest living outside the law can be. In a short parable, Kafka introduces a (dissenting) crow who maintains that a single crow can destroy the (disciplinary)

heavens; but this proves nothing against the heavens, which signify simply: the impossibility of crows. I take this to mean the following: crows are "impossible" not so much because they have no way of challenging the heavens, but more because they can be made a part of the heavens. This does not signify, I would also like to think, that dissent is futile; but it does suggest that dissent itself is always in danger of being institutionalized. Universities are filled with "heavenly crows" who are part of the heavens *and* think about themselves as crows at the same time.

This ambiguous relationship between disciplinarity and dissent (so much more than a straightforward opposition) is particularly relevant to how we might understand cultural studies today, which has reached an important moment in its history, the moment when cultural studies programs are beginning to proliferate all around the world. This may be the moment to ponder why this is happening and to ask what cultural studies is after all and whether the trajectories it has laid down so far need changing.

One of the major trajectories in cultural studies has been to introduce into the academy a culture of dissent, allowing previously excluded and disenfranchised subjects to be included. To take some well-known examples: when Walter Benjamin wrote his essay on "art in the age of mechanical reproduction" in Germany in the thirties, it was at least partly to expose how the Nazis used the aura of past cultures to serve political propaganda. Better mendacities, Ezra Pound once wrote in a lucid moment, than the classics in paraphrase; and it was in this spirit that Benjamin introduced in the essay as subjects for urgent attention the "mendacities" of mechanical reproduction, photography, and cinema: subjects that have since become highly important in cultural studies. In class-divided Britain, contemporary cultural studies emerged in the 50s and 60s as a form of dissent against the ideological bias of ruling-class culture, which took the directions of a critique of ideology, the study of subcultures and working-class youth cultures, and the study of the mass media. The related critiques of race and gender were also part of the same agenda. In a multiracial United States, the major contribution from the 70s onwards has been the introduction of "multiculturalism" and the politics of identity, which allowed "ethnic minorities" to voice their dissenting views on a culture without a center. Meanwhile, in other places, like Canada, Australia, and especially Asia, a postcolonial discourse that emphasizes the importance of local culture and marginalized areas of study has been developing .

From this brief rehearsal of well-known trends, the obvious observation we can make is that the content of cultural studies indeed changes in response to historical urgencies and geographical sites, and that these changes have opened the academic curriculum to alternative fields of study. But a number of questions remain. Is cultural studies merely a change in content, which can then be analyzed by the available methods, so that "high theory" can be applied to the study of "low culture?" Is it true that the value of cultural studies lies in its enlarged, non-elitist, and inclusive notion of culture, where all marginalities can find a place? Is cultural studies a more populist, media-wise, and sexy replacement for literary studies? The implications of these questions require a response along the following lines: while

it is important for cultural studies to develop an enlarged and inclusive notion of culture where alternative positions can find a place, it is even more important for it to problematize the notion of culture itself. Cultural studies did not emerge only out of a sense that previous notions of culture have been privative and limiting— ethnocentric, imperialistic, chauvinistic, and so on; it emerged also out of a sense that the very space of culture is somehow not what it used to be, that something has shifted. Cultural studies can therefore be regarded as an attempt to rethink the problematic *address* of culture. We have cultural studies because we do not know what or where culture is.

An initial indication that some urgent rethinking is required is the fact that modes of attention and perception seem to be changing. For example, perceiving the world in a state of distraction rather than of concentration has become practically a cultural norm. What are the implications of such changes in perceptual modes? It is not accidental that two of the most acute cultural critics of our time, Benjamin and Kracauer, have both written on distraction. Usually, distraction is dismissed as an undisciplined form of attention, or a form of inattention, associated with the way mass cultural products of our time like cinema before, or MTV today, are received. There is, however, another way of thinking about distraction, which is to regard it as a mode of attention appropriate to a certain kind of situation. It is not the attentiveness of contemplation, which is the proper mode in situations where objects can be studied in leisurely fashion. When conditions are destabilized by speed and movement, thought-as-contemplation finds itself at a loss. Benjamin cites the telling example of the French writer Duhamel's feelings of unease with the cultural form of the movies: "I can no longer think what I want to think. My thoughts have been replaced by moving images" (Benjamin, 1968, 240). It is when perceptual conditions threaten to outpace or elude contemplative thought that distraction takes on a critical dimension.

Important though the concept of distraction is to both Kracauer and Benjamin, they nevertheless give slightly different accounts of it. For Kracauer, ambivalence is what characterizes distraction and those mass cultural products of distraction he calls *mass ornaments*. The products of distraction play with the external, the peripheral, and the superficial; but "these surface-level expressions—by virtue of their unconscious nature, provide unmediated access to the fundamental substance of the state of things" (Kracauer, 1995, 75). They also produce a "total artwork of effects" which "assaults all the senses using every possible means" (324), more successfully in its own way, it might be said, than Wagnerian opera. To understand a cultural epoch, study its frivolities. There is something then about the products of distraction that cultural elitists who know only how to scoff at their triviality fatally miss. That is why highbrow complaints about mass culture often sound so pathetically anachronistic, as they are based on a set of cultural values that "evade the pressing needs of our time" (326). By contrast, in the products of distraction, the mass audience encounters its own order of reality, the reality of *social disorder*, i.e., distraction reveals what the ideology of "order" hides. These products are essentially ambivalent: they both symptomize and expose a social disorder that

would otherwise remain hidden, and we ignore them at our peril. It is not the tri-fling nature of the mass ornament that is nugatory, but on the contrary the vestiges in it of a will to art, which produces ideas like "artistic unity" or "organic whole-ness." Distraction then for Kracauer shifts culture as a site of value from its assumed and assured place.

In Benjamin, distraction is more than an ambivalent symptom. It is a method of attention exemplified in both the way we experience one of the oldest cultural forms, architecture, and one of the newest, cinema. In the experience of architec-ture, the "attentive concentration of a tourist in front of a famous building" (242) is very much a special case. Architecture is experienced more generally through use and perception, i.e., through touch and sight. In touch, we appropriate experience through what Benjamin calls "habit," which means noticing something in inciden-tal fashion. We "see" the architecture we live with in this incidental, distracted, or habitual way. Benjamin understands "habit" too in a special sense. Habit is certainly not rapt attention; but then neither is it the great deadener that so horrified Samuel Beckett. Interestingly enough, Benjamin sees it as playing an important part in our response to cinema's fleeting images. Habit-as-distraction is a *mobile form of atten-tion* that keeps pace with the mobile images, as when he writes: "The public [for the movies] is an examiner, but an absent-minded one" (243), where "absent-mind-ed" can be glossed as "non-contemplative." Distraction has an improvisatory qual-ity to it as well. This is implied in Benjamin's remarks elsewhere that "all the decisive blows are struck lefthanded" (Benjamin, 1979, 49); and in his only half-whimsical prediction that the era of the improving book with its "pretentious, uni-versal gesture" is over, to be replaced by improvisatory "leaflets, brochures, articles and placards," because only this "prompt language shows itself actively equal to the moment" (45). Thirdly, distraction can also be regarded as a *systematic displace-ment of attention*. We see this view in his famous remarks on "profane illumina-tion" as a "dialectical optic that perceives the everyday as impenetrable, the impenetrable as everyday" (Benjamin, 1978, 190).

For both Kracauer and Benjamin, distraction is a key term in cultural critique. Distraction persuades us to change the objects of attention, to read the trivial and the superficial as key signifiers of culture; and it induces us to modify our under-standing of attention itself, to see that there are an increasing number of situations where "concentration" and "contemplation" are not the only or even the most appropriate modes. Neither for Kracauer nor for Benjamin is distraction an ideal-ization of absent-mindedness, but rather an important strategy of perception at the very moment when the unfamiliarity and immense variety of what we see threaten to outpace critical understanding. But most important of all, distraction is a strategy that discloses what I shall call the *dis-location of culture,* or the discon-certing way in which culture is not located securely either where it used to be or where we want to imagine it to be. It may be argued of course that because culture is always subject to change, it has always been dislocated. What is different about the present situation, however, is the speed of change and the breaking down of

resistance to change as a result of the new technology. Yet it is not primarily the *fact* of change that gives all this a paradoxical aspect, but its *effect*: the way this kind of change introduces a cognitive dilemma. By dis-location then, I am referring to a situation where some radical alteration of cultural grids and matrices has already taken place; but because it has taken place so rapidly it is hardly discernible. On the other hand, what is readily discernible derives from the survival of older paradigms which ensure a kind of continuity and regulate even our sense of discontinuity. Contemporaneity outpaces understanding, *but without our knowing it*. Hence, whether we think of culture as "dominant" or "marginal," a matter of disciplinarity or dissent, culture can no longer be taken to be a site of validation for either objects or subjects. Culture is the problem, all the more so at the moment when it appears as a convenient alibi.

The dis-location of culture affects both the way we think about cultural objects and our position as cultural subjects. On the first, consider the old conundrum: why watch *King Kong* when you can read *King Lear*? This is more than a rhetorical question in so far as it also raises the issue of the relation of cultural objects to culture itself. To derive an idea of culture from cultural objects whose value is already assured is to be caught in a tautology, a kind of self-fulfilling prophecy that neatly locates *King Kong* and *King Lear* in different places and gives them different values. The situation changes, however, if we do not begin by assuming that cultural objects have a fixed value, and keep in mind that culture is what puts value at stake. From such a perspective, both the place and value of cultural objects come unhinged. It is then that the "total artwork of effects" found in products of distraction can show us something that we might otherwise miss.

This point is particularly relevant to emergent cultural sites, which today are everywhere. In Hong Kong for example, we find the emergence of a "Hong Kong culture" since the eighties, which is very much a response to the threat of disappearance after 1997 of the city as we know it today. Like *King Kong*, the productions of this Hong Kong culture, like its cinema for example, can often seem meretricious and derivative when compared to the classics of the Western cinema or even to Hollywood. Yet, as I shall try to show, reading these "imperfect" and "inartistic" cultural texts enables us to understand something about the elusiveness of colonial space. This is better than relying on "theories of colonialism" developed from other contexts that lament the injustices of colonialism and blame everything on "imperialism." Such an institutionalized discourse of dissent is like a mirror image of contemplative thought; it fails to grasp the cultural shifts that have taken place and consistently misses the point, precisely because it is a too firmly located discourse. This is not to say that colonialism is not an issue, but the way in which it is an issue is not easily or automatically discernible. It should also be noted that attention to these cultural texts whose value is not guaranteed in advance is not a kind of advocacy, understood as a bid for "status" and "respect" for these texts; much less the mark of an inferiority complex masquerading as aggrieved Third-Worldism. Above all, it is not an attempt to find a place for the marginal within world cul-

294 ture—a futile enterprise that shores up what it purports to want undone. Rather, it is a way of responding to what I am calling the dis-locations of culture and the experiential problems it introduces.

Dis-location affects not only objects, but subjects as well. This must be understood in a specific sense: subjects are dis-located not because they are alienated from culture, but because they are positioned in a reversible, asymmetrical, mobile field of shifting identities; a field that is no less paradoxical than what Lacan has analyzed as the field of desire and "the gaze" (Lacan, 1978, 67–119). It may be helpful at this point to recall some features of Lacan's analysis, which begins with a discussion of how Holbein's *The Ambassadors* is perceived. Holbein's painting, we remember, portrays in meticulous detail two formal ambassadorial figures that are themselves surrounded by a series of cultural objects that symbolize the arts and sciences of the period. However, in the foreground of the picture, something which we do not see immediately, is a strange, suspended, oblique-shaped object. If we focus too hard or too directly on this object, Lacan says, we do not see what it is. It is only when we turn away a little, shift the focus of attention—become distracted—that something recognizable comes into view: the anamorphic representation of a skull. I read this well-known analysis of Lacan's as an allegory of the position of subjects in the cultural field. The great and difficult lesson of Lacan is that as subjects we do not see *because of the gaze*, i.e., because of the acculturated way in which we look. The gaze is desire in the field of vision, and it is both true and false. The gaze does not so much "distort" the visual field as homogenizes it in line with desire. With reference to the painting, it makes one mode of representation—the perspectival one—recognizable and exiles the anamorphic image into a hallucinatory nowhere. In this way, it falsifies. But then desire is everywhere. As soon as we open our eyes we are faced with desire in the field of vision. Without desire we cannot see anything in the first place. So the gaze is true. Like desire, culture too is both false and true, both problem and solution, one dis-located in the other. And like desire, culture does more than distort: it catches the subject and holds it in an anamorphosis, within which no distortion is experienced. And just as we cannot get away from desire, there is no getting outside the cultural field, because it accommodates itself to us, and changes as we change. Culture too is everywhere—which is one definition of globalism. The trick or strategy is not indeed to see outside culture but to see something other than what culture persuades or constrains us to see. The realization of such possibilities may prove to be an important avenue of cultural resistance and survival, a point I shall return to later.

To draw some preliminary conclusions from the discussion so far: I am suggesting that cultural studies is not just the study of "culture" or even "cultures," if by these terms we understand a field that is homogeneous, even if highly complex and variegated. Nor is it a matter of exclusions and inclusions: both these gestures at some point run up against their own aporias. The dis-location of culture implies firstly that culture presents us with a cognitive dilemma because it is not where we might expect it to be; secondly, that it is as fluid, elusive, and complex as the movements of desire; and thirdly, that it is only possible to find resistances to culture

within culture itself. To indicate some of these dis-locations, I propose the term *postculture*. The notion does not imply abolishing past cultures to start anew; that was modernism and the Chinese Cultural Revolution, and in an ironic way, post-Cultural Revolution culture, which tries to distance itself as much as possible from the Cultural Revolution and its values. It does not mean postmodernist culture, if by that we are referring to a recognizable set of thematics. A postculture is culture in a situation where the available models of culture no longer work and where culture is experienced as a field of instabilities. But it is also a situation that presents opportunities for turning the reversibilities, asymmetries, and paradoxes of the field to advantage.

In what follows two topics will be focused on that provoke strong opinion and challenge cultural analysis. One is the analysis of the culture of colonialism, which I will examine in relation to one kind of popular cinema in Hong Kong. The other is the paradoxical survival of essentialist notions of East and West in an increasingly globalizing world, and what we are to make of them. Exploring these two topics will hopefully show some of the problems and possibilities of doing cultural studies in a postculture.

II

Hong Kong raises a number of peculiar cultural and political issues. Formally speaking, it is still a colony, even though the British government has for some time now fought shy of using that word; but the nature of colonialism here seems to have little relation to what is said about the subject in most critiques of colonialism or neocolonialism. Furthermore, while the general view may be that of the two, neocolonialism is the more complex and indirect cultural-political form, Hong Kong contradicts such a view. Its complexity stems from its colonial status, though it is a status made paradoxical, we must hasten to add, on the one hand by its divided loyalties to China, and on the other by the unclean breaks and residual connections between imperialist and globalist paradigms. With the end of the old-style empires, colonialism could persist only if it could adjust itself to the new globalism, by abandoning the old imperial attitudes and even taking on benign characteristics, belying more orthodox understandings of colonial history as mere narratives of greed and exploitation. It is not that colonialism has changed into some form of neo-colonialism; it has merely become dis-located, in the sense that it is no longer where it used to be or where we expect it to be. It has become more abstract and imploded, hence more resistant to both representation and critique. What looks the same may already be different and what is already different may still look the same. This makes colonialism in Hong Kong, if anything, even more elusive than neo-colonialism: it has a kind of *elusive presence* to it, which makes it even more difficult to grasp directly. Such a case can be very misleading, and it certainly does not lend itself to orthodox analysis. The fake radicalism that automatically puts all the blame for problems on the evils of colonialism will only find itself out-flanked and out-manoeuvred. Colonialism is not something that explains, but something that needs to be explained.

296 This can occur through a consideration of one of the Hong Kong cinema's most popular and enduring genres, the kung fu/martial arts movie. The genre, from Bruce Lee's *The Big Boss* (1971) through the offerings of Jackie Chan and Tsui Hark, to Wong Kar Wai's recent *Ashes of Time* (1994), has gone through a number of distinct transformations, each one a rewriting of the genre. Such films are not expected to do much more than provide entertainment through visual spectacle, (which is one reason why the brilliant and long-awaited *Ashes of Time* was such a disappointment to local audiences); but perhaps exactly because of that, we see all the more clearly the unstable shape of coloniality suggestively inscribed in these films over a period of roughly 25 years, undoubtedly the most important years in Hong Kong's short history. It is not that the kung fu film is ever a direct critique of colonialism; rather that the ethos of (mainly) male heroism and personal prowess so central to the genre has to define itself in relation to *what is felt to be possible* in a changing colonial situation.

Bruce Lee was a child star in the local Cantonese cinema and he learned his kung fu in Hong Kong. In the United States, he became a martial arts instructor who taught kung fu to Hollywood stars, and got a minor and ethnically stereotyped part in the television series *The Green Hornet*. He was passed over for the role of Kane in the successful series *Kung Fu*, the role going to David Carradine. However, when he returned to Hong Kong in the early seventies, at the beginning of the local craze for better quality martial arts films, which came in the wake of the international success of Kurosawa's sword play epics *Sanjuro* and *Yojimbo*, things were very different. He returned with the cachet of foreignness: the repatriate was an expatriate. And he returned with impeccable martial arts credentials, having won a number of international martial arts competitions. His first film *The Big Boss* set the pattern. Here was an actor who could really kick and punch, and it introduced a new level of authenticity and a new type of hero to the Hong Kong cinema: what Geoffrey O'Brien calls the stuntman as hero. But there was another equally important element in Lee's series of films, whether directed by himself or others. The physical authenticity was keyed to something else, something much more elusive, namely the re-assertion of an authentic and heroic Chinese identity. The repatriate/expatriate was also a patriot, the patriotism expressing itself as a form of anti-colonialism. There was a strong xenophobic tone in the Lee films, which took the form of the Chinese hero beating up Japanese or Caucasians in beautifully choreographed action sequences. The anti-colonialism was slightly paradoxical, however, and cannot be taken too literally. It came at the moment when both Bruce Lee and Hong Kong began to embark on very successful international careers. Hence two features can be noted. The anti-colonial anger did not refer to very much in the present, but only to *memories* of slights and insults suffered in the past: memories belonging to another place, and to an older generation. It was as if Bruce Lee were fighting again in a new Boxer Rebellion through the medium of cinema, in much the same way that Hollywood re-fought the Vietnam war. The second feature was the vaguely directed animus and the stereotyped opponents, as if there was no idea who the "enemy" really was. Every time Lee fights, he seems to fall into

a trance, and acts like someone shadow-boxing. As a result the films kick and punch themselves into a corner. *Fist of Fury* (1972) ends emblematically with Lee caught in a freeze frame executing a high kick, leaving both its star and all the plot strands up in the air.

Jackie Chan marks a second moment in the development of the martial arts genre, and a different moment in colonial history. With Lee's death, a successor had to be found. Like Lee, Chan is a martial arts expert, and he makes it a point of honor to perform all the action stunts himself. One of Jackie Chan's first films is called in fact *New Fist of Fury* (1976), to underline the succession. But while villainous colonizers are still around, everything now has a touch of slapstick. The result is essentially a transformation of the genre into kung fu comedy. The Jackie Chan character created in *Drunken Master* (1978) is neither a patriot nor an expatriate; he is just a regular local boy with good but not invincible skills. The heroism is not to be taken too seriously. Jackie Chan has the good humor of the professional rather than the dark taciturnity of Bruce Lee's avenging angel. This good humor is significant, because it could be closely related to the relaxation of colonial tensions in Hong Kong noticeable in the late seventies, a mood that lasted until Thatcher's visit to China in 1982. This was a moment when signs for optimism, like the end of the Chinese Cultural Revolution, were everywhere and colonialism seemed almost an irrelevance, no more than a formal administrative presence that did not interfere with the real life of the colony. A new sense of how it was local ingenuity and professionalism more than imported talent that had brought about the city's great success came with the force of a revelation. In other words, it was a growing confidence in Hong Kong's international viability that led to a rediscovery of the local, just as it was Bruce Lee who prepared the way for Jackie Chan. Nor is it accidental that Jackie Chan's kung fu comedy coincided with the new brand of comedy introduced by the Hui brothers, Michael and Sam, who used current Cantonese slang to explore the peculiarities of the local situation to brilliant effect. It was also during this period that Sam Hui introduced what has since been known as Canto-pop, where song lyrics are in the local idiom rather than in English or Mandarin. The new "local" culture was non-provincial and exciting, and appealed to a wide audience; unlike the earlier localism that appealed mainly to the non-anglophone sectors of the community. All these developments changed the way Hong Kong people looked at local culture and, for a while at colonialism. Nevertheless, the heavens cannot be so easily ignored. The eighties experienced the double trauma of the Sino-British joint declaration returning Hong Kong to China in 1997, and the Tiananmen Massacre of 1989, compounding the uneasiness over this return. The kung fu genre too fell into decline, only to re-emerge in the nineties in two different forms in films by Tsui Hark and Wong Kar Wai. It is in the style of these new kung fu films that we sense that some radical changes in the nature of coloniality in Hong Kong have indeed taken place.

In these kung fu films of the nineties, two realizations have sunk it. First, it is no longer possible to appeal with any conviction to some vague notion of Chineseness, as China itself may turn out to be the future colonizer, in fact if not

in name, once the present one has departed. Second, it is no longer possible to see local developments as separable or proceeding in isolation from global developments. It is from this perspective that we can interestingly consider the kung fu films of Tsui Hark, which obliquely convey the message that colonialism is on the point of becoming obsolete. This is particularly clear in the series *Once Upon a Time in China*, the first of which appeared in 1991. The series deals with stories about the legendary Chinese master, Wong Fei Hung, and contains, in addition to many action sequences, numerous references to history and colonial history. At one point, Sun Yat-San even makes an appearance—reminiscent of the way historical figures keep appearing in *Forrest Gump*. This makes the point that what sets the series apart are not the authenticities of action or history but its mastery of *special effects*. In Tsui Hark's films, it is no longer stuntmen, but special effects, that are the real heroes. Tsui Hark's star Jet Li, (who interestingly enough is Mainland Chinese) knows his kung fu, but there are no more authentic stars/ heroes of the order of Bruce Lee, as the real is more and more being "co-produced" (Virilio, 1991, 30) through special effects. For example, in the marvelous fight between Wong Fei Hung and another kung fu master that climaxes the first *Once Upon a Time in China*, Tsui Hark makes the two characters do wonderful gravity-defying things with ladders, but our main interest is focused on how Tsui Hark films these sequences, rather than on the athleticism of the actors. It seems that Tsui Hark is intent on showing that anything Steven Spielberg, Ridley Scott, or James Cameron can do, he can do better! This interest in special effects suggests not only that the Hong Kong cinema has caught up with the new technologies; more importantly, it now places the filmic action in a new technological, and by implication, transnational space where, we might be tempted to believe in an optimistic moment, the problem of colonialism will have been a thing of the past. Tsui Hark's kung fu series may be set in the past, but it is a past reproduced on laser.

Another view of technology and colonialism is implied in Wong Kar-Wai's recent *Ashes of Time* (1994), one of the most remarkable films to have come out of the Hong Kong cinema. It is Wong's version of the martial arts epic, made almost contemporaneously with Tsui Hark's kung fu films, but the style and emphases are very different. The beautiful cinematography of Chris Doyle merely serves to emphasize the film's somber tone, its focus on a landscape of ruins. As we watch the characters in their Issey Miyake-like costumes parade across desert and swamp in a series of fascinating tableaux, it is like watching a pavane. There is not one but four heroes, and the film uses a number of spectacular special effects; but it soon becomes clear that both heroism and special effects, as well as visuality itself, are being re-examined and found wanting. Consider the fight sequence that opens the film, involving the story's main figure Ouyang Feng. It is no longer a choreography of human bodies in motion that we see. In fact, we do not know what it is we are seeing. Things have now been speeded up to such an extent that what we find is only a composition of light and color in which all action has dissolved: a kind of Abstract Expressionism or Action Painting. It is not possible therefore to discern

who is doing what to whom. The heroic space of Bruce Lee is now a *blind space* (one of the four heroes in fact is going blind); moreover it is a blind space that comes from an excess of light and movement, that is to say, an excess of Tsui Hark-style special effects. *Ashes of Time* gives us a kind of double dystopia, where heroism loses its *raison d'etre* and special effects lose their air of optimism and exhilaration. Wong's film marks the *degeneration* of the genre, the moment when the genre self-destructs. The idea of presence and authenticity implied in the ethos of heroism is subverted, and the hope of happy inscription in a technology-based global utopia implied in the optimistic use of special effects is imploded. It is in this indirect way that it speaks to some of the problems and anxieties of *techno-colonialism*, which shows itself only abstractly and negatively, as something that cannot be directly represented, particularly not by means of sophisticated technological equipment. As for the Hong Kong kung fu film as a whole, it suggests that colonialism itself is made up of a series of slippery dis-locations: a kind of *morphing*. It is these dis-locations—not the morphology but the morphings of coloniality—that cultural studies has to address.

III

The second topic in this discussion of cultural studies in a postculture concerns the remarkably durable cultural notions of East and West, which even after all the deconstructions of binarism and the exposes of orientalism refuse to go away. This is, on the face of it, more than a little surprising, as even those who find theory alien can hardly be unaware that cultural comparisons cannot but be affected by the increasing globalization of culture and the impact that different cultures have on one another. The norm nowadays is to see East and West not as polar opposites but as permeable notions. Yet a certain essentialism remains. One explanation for this is that while we are all "between East and West," there are nevertheless different ways of understanding this in-between-ness.

One way of dealing with in-between-ness is by aiming for a reconciliation of the two terms. This is how David Clarke in an interesting essay on Hong Kong painting and sculpture, entitled (what else?) "Between East and West," presents the aspirations of a group of older artists, the most established of whom is Lui Shou-Kwan, who in technique and subject-matter are traditionalist but who realize the importance of responding to the realities of the contemporary city. The task for them is to reconcile being a Chinese artist with being a modern artist at the same time, with "modern" understood as synonymous with Western. By analyzing a number of representative paintings, Clarke is able to show that such a perspective, which *identifies* Chineseness with "tradition" and the modern with the West, makes the task of reconciliation an almost impossible one, involving the artist in a constant and hopeless balancing game, or worse still, in byzantine acts of avoidance and denial. For example, when Lui Shou-Kwan, in trying to be "Chinese" and "modern," uses the urban landscape of Hong Kong for subject matter, he has to blur the impact of high-rise buildings by adopting distanced viewpoints, by sketching in cloud and rain, or by choosing night-time views. In the case of some other Hong Kong artists,

the demand for reconciliation can sometimes produce near disastrous results. When the talented sculptor Van Lau was commissioned to create in 1989 a public sculpture for the foyer of the Hong Kong Cultural Center, he came up with a large metal relief entitled "The Meeting of Yin and Yang," which depicts a male and female figure standing side by side, symbolizing the balance of opposites and the situation of Hong Kong itself. It is largely the anxious need for reconciliation between East and West that produces such kitschy compromises.

An apparently more radical-looking way of dealing with in-between-ness is through sublation, where East and West are overcome and discredited as separate notions, and another space or a space of otherness is introduced: a third space. Yet consider what would happen when identities have merged or dissolved: we would more likely than not find ourselves in a space resembling the one in the following Hong Kong story, rather than in some third space:

> Does Hong Kong copy designs? Giorgio Armani, the Italian fashion designer, believed so, and tried to do something about it. He hired detectives in Hong Kong to stamp out the illegal use of his name on locally made clothes. One offending T-shirt was sent to him to see. He liked it so much, he copied it himself! (Wilson, 1990, 151–52)

The story alerts us to a space of global culture that we have to understand in terms of the problematics of reproduction, equifinalities, reversible subjectivities ("I copy you copying me copying you…"), and so on, a space that manages to knit itself together so well with the binaries at its disposal that it leaves no room for a third space. What we do find instead, even in the light-hearted Armani story, is a set of anxieties and confusions about identity, imitation, and cultural survival. It is these anxieties and confusions that continue to feed notions of East and West, and to give them a new if surreptitious lease on life. Rather than trying to reconcile or sublate the notions of East and West, the task for cultural studies it seems to me will be to read the renewed durability of these notions as an index of the kind of dis-locations we find in postculture. This argument develops by discussing three very different examples.

The first example is the famous essay by the Japanese novelist Tanazaki Jun'ichiro, translated as "In Praise of Shadows" (Tanazaki, 1991). The essay was published in 1927, at a time when both Japan and Tanazaki had passed through a period of infatuation with the West and seemed to be returning to native traditions. While the essay is clearly not an attempt at reconciling East and West, tradition and modernity, it does give the impression of being an elegant exoticization of the Japanese past as a means of re-asserting cultural identity. This impression, though, is deceptive. Tanazaki undercuts it himself, if only half consciously, by introducing a playful note of humor that imparts a certain irony even to expressions of nostalgia. The result is that Tanazaki comes across as someone who sees even his own search for a pure Japanese style in slightly comic terms, as an enterprise that is "nervous, fussy, excessively contrived" (10). The fastidiousness over correct style turns everything into an exercise in frustration. Even doing something so ordinary as putting up a shoji is fraught with pitfalls:

...for aesthetic reasons I did not want to use glass, and yet paper alone would have posed problems of illumination and security. Much against my will, I decided to cover the inside with paper and the outside with glass. This required a double frame, thus raising the cost. Yet having gone to all this trouble, the effect was far from pleasing. The outside remained no more than a glass door; while within, the mellow softness of the paper was destroyed by the glass that lay behind it. At that point I was sorry I had not just settled for glass to begin with. Yet laugh though we may when the house is someone else's, we ourselves accept defeat only after having a try at such schemes. (11)

The self-ironies here suggest that it is not simply a question of returning to an aestheticized version of the past, which is not only impossible, but also not even entirely desirable. Take Tanazaki's famous example of the Japanese toilet. Sitting in a Japanese toilet placed in some dim and quiet spot out of doors may inspire haiku poets; but a Japanese toilet is also inconvenient, impractical, and hard to keep clean. So why, for all the impossibility and questionable desirability, is it praised so highly? One reason is that these old toilets that so stimulate poets show up by contrast the literal-mindedness of the modern imagination, which does not accept anything that is not clearly seen to be real. The modern imagination needs light. It is not enough that modern toilets be clean; they must also be bright. But, Tanazaki comments, "how very crude and tasteless to expose the toilet to such excessive illumination. The cleanliness of what can be seen only calls up the more clearly thoughts of what cannot be seen. In such places the distinction between the clean and the unclean is best left obscure, shrouded in a dusky haze" (15). An ironic nostalgia is used as a critique of a modernity whose claims to an absolute monopoly of the real are beginning to look a little suspect: the modern sees only the literal as real and has no understanding of shadows. What then is shadow? Is it not something quintessentially Japanese?

As we follow Tanazaki's essay, we begin to see, against the grain of the opposition between East and West that he sets up, that shadow does not imply a simple idealization of the Japanese past or a stubborn repudiation of the contemporary. It is a notion that demands a rethinking of even of his own perceptions of relations between East and West, tradition and modernity. In the first place, shadow is related to style and elegance. But what gradually emerges is that it is not style in the narrow sense of a Japanese aesthetics or of Japanese preferences and peculiarities, like the preference for a "music of reticence" (20) that Tanazaki speaks of at one point. Rather, it is style in the larger sense of a paradoxical frame of mind that plays with nuances and displaces orthodox positions. What Tanazaki says about elegance can be taken to be both an example and a definition of this idea of style. Elegance, he says, in the context of the discussion of Japanese toilets, is frigid and filthy: frigid, because its *passions* are not to be confused with the simple pursuit of warmth, ease and convenience; filthy, because it sees beauty in unexpected places, understands nuances, and does not ruthlessly separate the clean from the unclean. It is therefore not Japanese aesthetics that we find here, but something very different, an aesthetics that involves a nuanced re-imagining of Japan, rather than a stupid

302 assertion of identity and heritage. Take for example the way Tanazaki looks at lac-
quer with its "colors built up of countless layers of darkness." He begins by admit-
ting that even for him, a contemporary Japanese, some superb piece of lacquerware
flecked with silver and gold "will seem to me unsettlingly garish and altogether vul-
gar. But render pitch black the void in which they stand, and light them not with
the rays of the sun or electricity but rather a single lantern or candle: suddenly
those garish objects turn somber, refined, dignified. Artisans of old, when they fin-
ished their works in lacquer and decorated them in sparkling patterns, must sure-
ly have had in mind dark rooms and sought to turn to good effect what feeble light
there was" (25). To see the appeal of lacquer, it is necessary both to register its gar-
ishness and to re-imagine the conditions under which their present garishness is
beautiful again. When aesthetics forgets to be historical and imaginative, it loses its
sense of nuance, its shadow, and a specific cultural viewpoint ("Japanese aesthet-
ics") tends to be universalized. This happens sometimes in the essay. For example,
to speak of the erotic as the half-seen (in describing the reticence of Noh theater) is
to have a sense of nuance; but to extol the Japanese custom of placing women in
shadow ("our ancestors…created a world of darkness, and far in the depths of it
they placed woman" [49]), is to be too literal. But the occasional slip into the over-
ly literal provides a criterion for saying that "In Praise of Shadows" cannot simply
be translated as in praise of Japaneseness, though Japanese examples are used.
Rather, it has to be read as an act of historical imagination, an intuition of post-
culture that eschews identifying culture with the past. Shadow exemplifies the para-
dox of cultural identity: we must first be prepared to let it go before we can achieve
it.

The second example is a Hong Kong film called *Wicked City* released in 1992
from the Film Workshop of Tsui Hark. It is a Sci-Fi horror film with allegorical
overtones, a work that has no shadow in Tanazaki's sense, a pure mass ornament
of light, special effects, and visual seduction. *Wicked City* is a film that is only too
easy to find fault with, from its feeble allegories to its sexism, but it is also provoca-
tive to focus on one specific aspect—its blatant imitation of spectacular Hollywood
films—not so much to find fault with it as to ask: is this another example of East
copying West? And what can be the interest of something so obviously imitative
and derivative?

The story concerns the conflict between a group of raptors—so-called because
they are half-human, half-reptile—out to dominate the world by addicting human-
ity to a nasty drug called Happiness, and the humans who try to stop them. After
the first half-hour, which is exhilarating enough, one quickly gets a sense of *déja-vu*
because the film plagiarizes shamelessly from all the popular Sci-Fi blockbusters.
For example, its raptors are a more crude and gothic version of the cyborgs in
Bladerunner, Alien, and *Terminator.* Windy, the raptor heroine, is an obvious copy
of Rachel in *Bladerunner.* The ending comes straight out of *Casablanca*: the hero
sends the heroine away to safety with Daishu, the head raptor who loves her, while
he walks away in classic macho fashion with the inspector. The climactic scene near
the end with the 747 jet-liner pitted against the China Bank Building, the tallest

structure in Hong Kong's Central, reminds us more than a little of *King Kong*. These plagiarisms can either be enjoyed as campy jokes (like the one at the beginning of the film about the prostitute who calls herself Perrier, because there is a popular ad in Hong Kong which runs; "After You've tried Perrier, nothing else will do"), or they may be dismissed with more justification as lacking in originality. Moreover, as an allegory about Hong Kong politics it is simplistic and obvious in the extreme—1997 when Hong Kong returns to China is also the moment when the raptors are most likely to invade. Similarly, the attempt to use cities like Hong Kong and Tokyo as metaphors for contemporary malaise—for example, in the film's title, in the shots of crowded traffic and high-rise buildings, in the voice-over about the city: "Its body glistens, it consists of ice and steel, it's our metropolis"—all these have been done much better before, in Fritz Lang's *Metropolis* or in *Bladerunner* itself. What is it that makes such an ersatz and imitative film worth a second look?

In a classic essay entitled "Mimicry and Legendary Psychasthenia" (Caillois, 1984), Roger Caillois argues that in plants and animals, mimicry is not essentially used for purposes of self-defense or camouflage. More interestingly, what it raises are questions of identity and representation (or simulation). Mimicry is a way the subject has of relating to its environment, to its space; the subject is seduced by space. In this spatial seduction (Caillois describes it as "a real *temptation by space*," [28]), the subject loses itself in space, confused about identity and the boundaries of the self. But there is also something else, namely that the subject *lets itself* be seduced; and this suggests that mimicry is a passive/active form of representation, or better still, of simulation. In mimicry, the subject gets assimilated to space in a confusion of boundaries; but at the same time, something about space that would otherwise have remained indiscernible is reproduced and represented in such mimicries and confusions. It might be worth noting too that this is very similar to how Kracauer describes the interest of the mass ornament, as in the following observations: "When significant components of reality become invisible in our world, art must make do with what is left.… No matter how low one gauges the value of the mass ornament, its degree of reality is still higher than that of artistic productions which cultivate outdated noble sentiments in obsolete forms" (79). Turning back to *Wicked City*, we might now find in its imitativeness something that speaks to us of more than the relative cultural positions of East and West. The imitation of so many different film genres result inevitably in a number of cliches and confusions; but at the same time it also gives us in spite of itself a representation of spatial and cultural dis-locations, all the more so because it is not obsessed by the need for consistency. It is by means of these confusions—about identity, about the world—that we glimpse a space where boundaries are breaking down, behind the back of the cliches that serve to support them.

There is to begin with a real confusion over technology. Unlike in some of Tsui Hark's other films where technically sophisticated special effects are blithely celebrated, in *Wicked City* the exuberant use of special effects goes together with an implicit criticism of technology. For example, in the figure of the evil female raptor who can transform herself into many things—chandelier, video game machine,

elevator, and so on—machines and technology are associated with the inhuman. Nevertheless, this implicitly negative view of technology comes in a film where the technical possibilities of cinema are explored with elan. In other words, the film says one thing and does another. This kind of *uneven development* suggests a space where different speeds and times co-exist. Going together with the confusion over technology is a confusion about the body. Is it human, animal, or machine? It is true that the main character Taki is unambiguously human and good, while Shudo the raptor son of Daishu is unambiguously animal and vile. But there is also a whole spectrum of other characters, like the beautiful Windy who is nevertheless part raptor, and more importantly, Ken, Taki's friend and partner, who changes back into a raptor towards the end of the film. Then there is the good raptor Daishu, and Orchid the bad and beautiful human. The constant transformations that take place tend towards breaking down the boundaries between human, animal, and machine, which encourages a breaking down of the boundaries of sympathy and affectivity. The alien is not elsewhere, it is part of everyday life. These confusions prepare us for the climactic scene at the end of the film, where the jumbo jet liner confronts the China Bank Building, a scene which has all the hallmarks of a camp classic. It can be read of course as another tableau of the confrontation between good and evil, allegory given spectacular form. But there may also be allegory in a less obvious sense. It is not just King Kong from the primeval forests challenging the Empire State Building, symbol of metropolitan power and modernity. Jet-liner and bank are now both, even in different ways, postmodern forms of speed, elements of a global economy of flows. The "confrontation" then is only apparent or ironic. In a similar way, we could say that the film is not just Hong Kong cinema aping the products of Hollywood. The allegory is an allegory of *the breakdown* of those spatial concepts that produced among other things the notions of East and West, and that refuse to give imitation a second look. The question it raises but recontains is not: who will triumph, humans or raptors? But the more difficult question: how do we deal with this new space of speed and information?

The third example is a ten-panel installation entitled "Still Life" by the modern New York-based Chinese painter Chen Danqing. This large work is the culmination of a remarkable series of diptychs and triptychs that Chen has been working on since 1989. I have discussed this series of "painting after Tiananmen," with the exception of "Still Life," in some detail elsewhere (Abbas, 1995). Let me draw some points from that discussion to situate the work we are now considering, beginning with a narrative.

For the first ten years after leaving Beijing to settle in New York, Chen Danqing could not do any major work, whereas before in China he was famous for his remarkable paintings of Tibetan peasants. Then came the Tiananmen Massacre of 1989, which seemed to provide a catalyst, and he started work on the Tiananmen series. How do we read this narrative? When western art critics speak of Chen's work as lying "between East and West," they point, on the one hand, to his use of oil as medium, to his "photorealist" style (a label Chen detests) of painting from photographs, to his astonishingly vivid copies of Western museum pieces; and, on the

other hand, to his use of scenes from the events at Tiananmen. Tiananmen, then, is the "Chinese subject matter" that—once found—allowed Chen's knowledge of Western art practices, techniques and theories to be applied. Such a reading of the narrative is both plausible and entirely misleading. It is worth trying to say why with some precision, because it is the fate of almost every non-Western cultural practitioner—whether painter, composer, writer, or theorist—to be represented on some such terms. We can begin with Tiananmen as subject matter.

Though Tiananmen is bound to have an especially important significance for Chinese people, it is not "Chinese subject matter" in the sense that it is something that being Chinese puts one in a better position to comprehend. This is a point that those who now make a career out of protesting against the Massacre will not want to acknowledge. The shock of Tiananmen was in fact its radical incomprehensibility, its violation of what was familiar. Those who were closest to it, its familiars, were those who found it the most difficult to understand. In Chen Danqing's paintings, Tiananmen is not subject matter in the sense that it can be stated as a theme ("oppression," "violent totalitarianism") that could be discussed. It is rather a kind of *brute content* that suspends and obliterates meaning, in particular, the meaning of "home." If even home is incomprehensible, then home does not correspond to any idea of home. Content in this sense is neither documentation nor protest; it is the experience of dis-location. It shocks one out of the twin pathos of home and homelessness as well as out of the obsession with finding an "elsewhere"; but it also allows work to begin again.

Turning now to Chen's new work. He calls it "Still Life," though it would be hard to imagine a more apolitical or contemplative genre of painting than what goes under that name. Chen uses the genre's name and even its style of meticulous attention to details, but changes the implications of the genre. We can read it as an ongoing dialogue between history and art history. The installation consists of a central double panel painted after a photograph by Peter Turnley of a burned tank on which one finds crushed and twisted bicycles. Flanking this central double panel on right and left are copies of Western artworks or fragments of artworks, from Caravaggio and Manet to Joseph Beuys. The first thing one notices is the installation's huge scale and diversity. It is 50 feet long and varies between 80 and 52 inches high. There is no position from which a spectator can take it in all at once. The panels themselves seem to be organized according to some law of symmetry, a left panel echoing one on the right in a corresponding position; but the symmetry is also arbitrary, as other orders can easily be imagined.

Consider first the flanking panels, which seem to give us a kind of selective or personal view of bits and pieces of the history of Western art. This history, as Chen Danqing himself has repeatedly pointed out, is necessarily a history of misunderstandings and misreadings, a history of ruins. The Western modern art tradition since Duchamp and Bueys has put the emphasis on "reading" rather than on "looking." When those like Chen Danqing, who come from outside the tradition, try to "read" these artworks, they can only do so by "looking," so there is inevitable misunderstanding. Yet Chen's installation is by no means a naif's look at modern art,

Fig. 1. Chen Danqing, "Still Life"

Fig. 2. Chen Danqing, "Still Life"

Fig. 3. Chen Danqing, "Still Life"

Fig. 4. Chen Danqing, "Still Life"

Fig. 5. Chen Danqing, "Still Life"

Fig. 6. Chen Danqing, "Still Life"

Fig. 7. Chen Danqing, "Still Life"

Fig. 8. Chen Danqing, "Still Life"

Fig. 9. Chen Danqing, "Still Life"

Fig. 10. Chen Danqing, "Still Life"

but very much a performance in its own right. The paintings begin by taking incomprehension as their premise. Hence they are all copies, where the copy signifies (somewhat as in *Bouvard and Pécuchet*): seeing and reading without understanding, brute content, the suspension of meaning. Yet the installation successfully ends up as a work that provokes its own misreadings, in this and other ways exemplifying the reversabilities ("I read you reading me reading you…") of contemporary cultural relations.

The central double panel (figs. 5–6), whose imagery of tanks festooned with crushed bicycles does not seem to require very much reading at all, is apparently the document of a real event. Yet this double panel is not, like the others, a copy of an artwork, but the copy of a photograph, the reproduction of a reproduction, and so in a sense one step further removed from the immediate than the other panels. But to see this is to erase the imaginary line that divides document ("Chinese subject matter") and artwork ("Western techniques and theory") into different hierarchical levels. *Everything is now content*: this is the radical meaning of dis-location. This is just making again, in terms of the installation, the crucial point that was made about Tiananmen as an experience of dis-location. "Still Life" restates, though the mediation of a dialogue with art history, the historical experience of dis-location, and draws it into the space of the artwork itself.

In each of the three examples discussed, the often invidious notions of East and West are not just dismissed or deconstructed. Rather the confusions and anxieties that made each side of the binary dig its heels in are allowed to surface; and in the process, some of the issues of identity, imitation, and cultural survival manage to be clarified. In Tanazaki, the surprising consequence of shadow as nuance, which begins as a way of narrowly defining Japan against the West, is that nuance requires a larger historical re-imagining of the Japanese past and present. In Tsui Hark's *Wicked City*, the blatant imitations of Western blockbusters and the confusions that arise turn out to be an allegory of the breakdown of cultural and affective boundaries. In Chen Danqing's "Still Life," the incomprehensibility of Western artworks juxtaposed with the different kind of incomprehensibility of Chinese "subject matter" becomes an essay on the dis-locations of history and culture today. These are some examples of work in a postculture. If postculture means, as we have said, that culture is not where we thought it was or imagine it to be, what must be emphasized now is that it is also nevertheless a set of anticipations, a preparation for cultural survival. And it is on this subject of cultural survival that necessitates a few brief and tentative remarks.

Whether we are thinking of Hong Kong or China, there is no chance of cultural survival unless we radicalize our understanding of culture itself. Thus cultural survival is not the same as surviving culture, i.e. living within the assumptions of what culture is and stubbornly defending it. Nor is it the same as holding onto a cultural identity. Cultural texts are valuable for cultural survival on condition that the old cultural myths do not survive in them. Cultural survival will also depend on our understanding of space or spatial history. One of the most important implications of globalism is simply that there is no longer a space elsewhere. This means

312 that instead of thinking in terms of displacements, a movement somewhere else, it is important for cultural studies to think in terms of dis-location, which is the transformation of place. Such transformations are often indiscernible and hence challenge recognition. That is why cultural survival is also, thirdly, a matter of changing the forms of attention, and seeing the importance of even decadent or degenerate cultural objects. Finally, cultural survival will depend on our recognizing that there is today a politics of the indiscernible as much as a politics of the discernible. One has not completely replaced the other but each acts as the other's silent support. All these are also the thematics of postculture, which cultural studies will have to address, if only to save dissent from being placed in the ignominious position of being seen but not heard.

References

Abbas, Ackbar (1995) *Chen Danqing: Painting After Tiananmen.* Hong Kong: Department of Comparative Literature, Hong Kong University. A revised version with the same title is forthcoming in *Public Culture* (Spring 1996).

Benjamin, Walter (1968) *Illuminations.* Trans. Harry Zohn. New York: Harcourt Brace and World.

Benjamin, Walter (1978) *Reflections.* Trans. Edmond Jephcott. New York: Harcourt Brace Jovanovich.

———— (1979) *One-Way Street.* Trans. Edmond Jephcott and Kingsley Shorter. London: NLB.

Caillois, Roger (1984) "Mimicry and Legendary Psychasthenia." Trans. John Shepley. *October*, 31 (Winter, 1984): 17–32.

Clarke, David (1994) "Between East and West, Negotiations with Tradition and Modernity in Hong Kong art." *Third Text*, 28/29 (Autumn/Winter, 1994).

Kracauer, Siegfried (1995) *The Mass Ornament.* Trans. Thomas Y. Levin. Cambridge, Mass.: Harvard University Press.

Lacan, Jacques (1978) *The Four Fundamental Concepts of Psycho-Analysis.* Trans. Alan Sheridan. New York: W. W. Norton & Company.

O'Brien, Geoffrey (1992) "Blazing Passions." *The New York Review* 9/92: 38–43.

Tanazaki, Jun'ichiro (1991) *In Praise of Shadows.* Trans. Thomas Harper and Edward G. Seidensticker. London: Jonathan Cape.

Virilio, Paul (1991) *The Lost Dimension.* Trans. Daniel Moshenberg. New York: Semiotext(e).

Wilson, Dick (1990) *Hong Kong! Hong Kong!* London: Unwin Hyman Limited.

Lynn Spigel

15

HIGH CULTURE IN LOW PLACES

TELEVISION AND MODERN ART, 1950-1970

In 1954, on the occasion of its twenty-fifth anniversary, the Museum of Modern Art presented an episode of the New York television program, *Distinction*. Hosted by museum director Rene d'Harnoncourt, this public affairs program served as a promotional vehicle for MOMA's collection of modern art. In the opening sequence, Harnoncourt presented a Léger painting and was joined by a professor from NYU's art history department. Unfortunately, while the two men had a distinguished command of the modernist canon, they hadn't yet figured out how to use live television as an art form.[1] In the opening sequence, when the professor decides to show Stuart Davis's abstract painting *The Flying Carpet*, he suddenly realizes the painting is not in the room. Clearly embarrassed, he asks the cameraman to move to another gallery space where the painting hangs. Unfortunately for the professor, however, more embarrassment is in store because when the camera moves to the next gallery, it reveals a rather disheveled looking TV technician hanging out in front of the painting, smoking a cigarette, so close to the canvas in fact that it appears he is going to burn a hole in it. When the technician realizes he is on live TV, he runs out of the frame. The befuddled professor then tries to make the best out of a bad situation and calls the technician back, asking him whether he likes the painting. The technician replies, "Uh, Yeh, I

314 like it, it's big," to which the professor remarks, "You can tell us what you really think. Because if you don't like it, you won't be the first person who didn't respond favorably to modern art."[2]

Today, at a time when Speaker of the House Newt Gingrich and his followers in Congress threaten to turn off public television for good, it seems especially useful for cultural studies to consider the historical dialogues that have taken place regarding art and education on our national broadcast system. Here these issues are explored through a consideration of the first two decades of television broadcasting, the time when television reached its mature form as a commercial and national medium with one venue—PBS—serving as its forum for the arts.

Insofar as recent television scholarship has been largely defined as the study of popular culture, researchers have tended to stay away from topics that engage the problem of art. Even while there has been important work on issues of taste and "quality" television, there is very little work on television's artistic practices and discourses about art.[3] Given that television is integral to the foundations of the postmodern blurring of "high" and "low" culture, it is even more curious that recent art historical work and museum exhibits on the fate of modernism and the avant garde after WWII have been relatively silent on the role that television played in collapsing this great divide. While debates about the postwar status of a distinctly American modern art and its relation to popular culture have circulated within art historical circles, art historians have primarily investigated the art world as the privileged term, giving little perspective on how popular media—especially television—served as a vehicle for the wide scale dissemination of ideas about modern art and its relation to national identity after World War II. Similarly, the recent high and low exhibits at museums such as the MOMA and the Whitney consider only how artists such as Robert Rauschenberg or Andy Warhol used television as a "subject" in their painting; yet there is virtually no understanding of how television used art as a subject. Respect for the presumed division of these domains remains widespread, but a cultural studies perspective needs to bring them into conjunction with one another.

As Pierre Bourdieu (1980) has demonstrated, the value art has in a culture is not neutral, but is rather a product of the way people in a social formation make distinctions between and among themselves based on notions of "taste." These taste distinctions generally are determined by social class and economic privilege, but also by access to "cultural capital" gained through such arenas as education. Constructed through such social differences, art—or what counts as authentic art vs. what counts as kitsch—is never universal across time and space; rather it is deeply historical and subject to change as other kinds of social identities and formations of everyday life shift among populations. Television's various representations of art and its own artistic practices have accordingly changed with larger social and cultural reformations. This essay will consider how television positioned itself in relation to the meanings of the visual arts—primarily painting—in the first two decades after WWII, during the height of the Cold War.

Television's discourses on art were rooted in the history of European colonialism (especially the art world's ties to Paris), and the perception both here and abroad that the U.S.—while an economic and political superpower after the war—was still a *cultural* colony of Europe. It was the urge to distinguish a new (and typically called, "modern") American art from European modernism that haunted the screens of American living rooms during the 1950s and 1960s. In the process, television contributed to a redefinition of the American vernacular that was ultimately based on the idea that American modern art was commercial art, with no apologies and no excuses. It is here, in the redefinition of the American vernacular, where the connections to postmodernism are most clear, especially as they pervade the POP art scene in the 1960s. Also in the process, there was a curious inversion of the ideological relationships between mass culture and modernism, especially as those terms have historically been associated with feminine consumers and masculine producers respectively. In the blurring of high and low, there was a "queering" of that distinction, one which the television medium often sought to police and control. The history of art on television is bound up with ideas about nationalism, race, xenophobia, and threatening sexualities that the medium both constructed and proliferated.

Before the Great Divide

For cultural studies to understand television's role in the redefinition of art in postwar America, it is important to question, as Andreas Huyssen has, the "great divide" thesis that pits a postwar and increasingly postmodern consumer culture against a pre-war, supposedly more political, modernism (Huyssen, 1986). Moreover, it seems crucial to reject at the outset the facile labeling of television as "postmodern," a label that is all too often used as if it were an MTV promotional slogan (which it is), and which is thus utterly tautological because it is so characteristically postmodern in and of itself to have a critical term that doubles for an advertising jingle. While there is something different in the air (and on the airwaves) that might amount to a cultural sensibility called "postmodernism," it is important to explore the ways in which television is, a priori, rooted in the logics of modernism and, in particular, to the marriage between the visual arts and industrial technology so crucial to the modern world of twentieth-century Western culture. In the postwar period, television responded to and expanded the definition of modern art—both in the sense of the modern "art for art's sake" movements and in the more avant garde notion of modern art as a revolutionary tool (or the "art for life's sake" position). To disclose television's role in this process, it seems necessary to understand something of the cultural moment that preceded it, particularly that moment—the 1920s–1930s—when modern art (in Europe) and commercial art (in the States) shared their first encounters.

Cultural historians have detailed some of the links between American consumer culture and the influx of European modern art and design (Marchand, 1985; Lears, 1994; Guilbaut, 1983; Marver, forthcoming).[4] As such research makes clear, the

advertising and fashion industries were among the first cultural sites where the public—especially bourgeois women targeted by corporations—encountered modern art.

A fascinating memoir of 1939, written by advertising executive Estelle Hamburger and entitled *It's a Woman's Business,* suggests women were not only the target consumers of this early merger between high and low, but also the producers of it (Hamburger, 1939). I want to dwell for a while on this memoir, not only because it suggests the central importance of women in the imagination of the American "modern"—a point to which I shall often return in this essay—but also because it exemplifies in a most explicit way the nationalist impulse that runs through the discourses found on television three decades later.

In this memoir, Hamburger recalls how, during the 1920s, she made her way from a copy girl at Macy's to the head of the advertising department in the more upscale and uptown Bonwit Teller. Once there, Hamburger tried to change Bonwit's image from its eighteenth-century French decorative style and its promise of "classic" fashions to one that spoke the language of the here and now. In the process of this transition, Hamburger found herself at the intersection of consumer culture and modern art.

In her chapter, "What is Modern?" she discusses her 1925 trip to the Paris Exposition of Decorative Arts that she said "became the cradle of modern design." She writes: "If America did not take 'Modern' to France in 1925, Americans brought it home. Only a few understood the objectives in the minds of artists who gave it birth. To American designers of furniture, rugs, fabrics, lamps, china, to creators of American advertising, Modern became a new commercial god" (178).

While Hamburger emphasized America's debt to European modern art, it was clear that the American design industry's interpretation of "modern" was also based on its global scavenging of what the business and art world alike deemed "savage" or "ancient" cultures. Hamburger spoke at length of her use of savage and ancient art for modern textile design.[5] She also detailed her debt to the Brooklyn Museum of Art, which she ransacked for nativist and primitivist inspirations. Explaining one such campaign she wrote, "In the window with the Bonwit Teller dresses, hats, and jewelry inspired by the African Congo were the treasures from the Brooklyn Museum authoritatively documented with explanatory cards." She goes on to note that when the director of the Brooklyn Museum "saw this marriage of Congo art with current fashion his pleasure was unbounded. It had been his life's labor to build a museum that would not be a mausoleum of dead art, but an inspiration to vital modern industrial design…[he] had the entire exhibit transferred to the Brooklyn Museum, to illustrate, in connection with his permanent display of the Belgian Congo, how the resources of a museum might be employed to inspire the creative impulses of the commercial world" (141–42).

Clearly, the art world of the 1920s had just as much to gain from its relationship with consumerism as did the consumer culture from its links to the art scene (and both, obviously, benefited from their use of what they deemed "savage" cultures as sources for modern design). At a time when museums were already being criticized

as "mausoleums of the dead"—that is, spaces that ripped art from its everyday con-
text—and when movements like DADA were promoting "living art," museum
directors could, in one simple stroke, answer to the demands of the art world and
also shamelessly pander to the (mostly female) bourgeois public through cross-
promotional ties with the world of fashion.

Hamburger's memoir demonstrates that the union of art and industry—high
and low—was crucial to the culture of the early twentieth century. Her text maps
out a series of relationships between and among art and industry, nationalism and
internationalism, modern and primitive, consumer and museum culture, and
intellectualism and populism. In addition, given Hamburger's status as a female
adman, her memoir also suggests a struggle between women and men for control
over art, culture, and commerce. These relationships would re-emerge on televi-
sion—the new shop window on the world—at a time when the meanings of mod-
ern art and consumer culture were being renegotiated in important ways.

In the postwar period, the relationship between art and industry was
embroiled in a new set of circumstances that revolved around America's pursuit
to define itself as a cultural center for the world as it emerged as a global super-
power. During the war "companies made use of art and advertising as a way of
keeping their trademarks alive before the public," a merger that contributed to a
popular embrace of art after the war (Guilbaut, 1983, 89). This growing public
interest in art was spurred in the early 1940s by increased discussion of the arts
in popular media, by such government sponsored campaigns as "Buy American
Art Week," and by the sale (through credit financing) of famous paintings at
Macy's and Gimbles, two of New York's largest middle-class department stores.
During the war, art appreciation was positioned as a form of patriotism linked
to the defense of American civilization against Nazi barbarism. MOMA and the
Metropolitan Museum of Art both gained respect by linking their institutions to
the war effort. In this context, museum patronage increased significantly; the
number of art galleries in New York grew from 40 at the beginning of the war to
150 by 1946, and both public and private gallery sales skyrocketed during the war
(Guilbaut, 1983, 91). These trends apparently continued after the war. In 1962, the
Stanford Research Institute estimated that "120 million people attend art-orient-
ed events"; that tourism at MOMA was "only outnumbered by the Empire State
Building"; and that "attendance at art galleries and museums almost doubled
during the 1950s" (Long Range Planning Service, 2). According to the Stanford
report the new "cultured American," was in part the result of technology that
made possible "first class reproductions" at a "cost many can afford" (Long Range
Planning Service, 4). To be sure, people in the art world (like the directors of
MOMA) manipulated the new medium of television to this end, appealing to
middle-class publics out in the mass-produced suburbs with "free" shows of
modern painting.[6] As the older, urban (and small town) conception of public
space and public culture now stretched across the freeway-linked boundaries of
city and suburb, as shopping practices moved consumers (and would be muse-
um patrons) from urban "districts" to corporately engineered malls, the muse-

318 um and the art world in general became increasingly dependent on the new electrical space of broadcasting for public relations and the maintenance of its middle-class patrons—not only in the New York area, but nationally as well. It is with regard to all of these issues that television engaged a particular set of discourses on modern art, one grounded in prewar mergers of culture and commerce, but now articulated in terms of the historical moment at hand.

Communists, Ugly Americans, and the Modern Vernacular

The nationalist urge to create a uniquely American form of modern art—both different from European modernism and from the art of the American past, resulted in a series of disputes regarding questions of style and taste that ultimately had to do with cultural imperialism. As Serge Guilbaut (1983) has discussed in great detail, debates about the relationship between European modernism (especially its roots in Paris) and a uniquely American form of modern art engaged intellectuals during the Depression, and increasingly during and after WWII "every section of the political world in the United States agreed that art would have an important role to play in the new America" (55).

For the U.S. government, the construction of this art scene had an important role to play both economically and culturally. Since the establishment of the Department of Cultural Affairs in 1938, the U.S. government had officially recognized the importance of culture in securing international good will. Despite many humanist intentions, the major strategic focus of these cultural exchanges was the government's desire to counteract the prevailing image of Americans as militaristic, vulgar brutes (or what one book later called the "ugly American"), an image that dominated the European and Latin American imaginations.[7] A major mission of the Department of Cultural Affairs—and later, during World War II, the Office of War Information—was to counteract this notion of the ugly American and spread a more genteel, peace-loving image of Americans abroad.

After the war, these forays into cultural imperialism were enacted under the Marshall Plan as American media industries and government offices applied policies of "containment" and searched for new markets for the "Free World" around the globe. Guilbaut shows that the attempts to construct an American art scene, distinct from Paris and situated instead in New York, coincided ideologically with the new "liberalism" that saw Communism as a threat and sought to contain it globally. Modern art and the American avant garde, Guillbaut demonstrates, were nourished by a climate of thought that divorced art from the politics of the thirties and favored the freedom of individual expression that Abstract Expressionism, with its sense of eccentric psychology, especially provided. At the same time, however, the popular press and government officials often scorned modern artists such as Jackson Pollack for their failure to represent subjects that might be consensually understood, and numerous people suspected that such art was itself unAmerican.

In both the domestic and global context, these contradictions resulted in a series of struggles over what exactly was meant by the terms American "culture" and

American "art." While various attempts were made to export America's fine arts—
painting, opera, dance, etc.—they were often fraught with problems. In 1946, when
the State Department put together an international exhibit called "Advancing
American Art," the contemporary paintings chosen for exhibition became the site
of public and Congressional controversy as Senator Dondero attacked the work of
painters who had once been connected to the Communist Party. More generally,
some critics objected to the "hams and eggs" art chosen for the exhibit on the
grounds the paintings were subversive of American values. At its paranoid extreme,
rumors circulated that American abstract painters were working as foreign agents
by inserting military maps into their canvasses. Then too, American art was not
received well on foreign soil, especially in the capital of modernism, Paris. The
European art public typically saw American "high" art as a cheap imitation of the
real thing, and at any rate these high art imports had little value for winning the
hearts of the more general world population. Ironically, then, despite their status
as vulgar and despite the fact that Europeans sometimes deemed them as such,
American popular arts typically did better with European audiences (as well as crit-
ics) and were thus seen as more viable vehicles for the solicitation of international
good will. The distinctions between high and low were thus imbricated in Cold
War sentiments during the period of postwar decolonializaton as Americans
searched for a way to rid themselves of their status as a cultural colony of Europe.

In this matrix, television played a key role in distinguishing American from
European modern art.[8] As one TV critic writing for the *Saturday Review* asked,
"'How many of us would like to know how American is American Art'? Simple
questions like these are effective grist for television" (Kuh, 1961, 61). This issue of
national identity was crucial as television sought ways to negotiate the "high" (and
typically assumed, communist) world of European modernism with the more all
American popular arts in the States. In the 1950s, when the television medium grew
to become the country's central communications medium, these concerns were
continually posed on 1950s "prestige" programs including TV specials and such
series as *Camera 3, Omnibus, Wisdom, See it Now,* and *Person to Person.*

In a 1959 episode of *Person to Person,* for example, Edward R. Murrow interviews
the premier poster boy of WWII, Norman Rockwell, showing his perfect American
family and little dog Lolita at home. Addressing Mrs. Rockwell, Murrow says, "You
must have quite a decorating problem. Do you keep many of Norman's original
paintings on your wall?" Painting thus becomes a domesticated and familial form,
much in line with the Office of War Information's use of Rockwell during WWII to
symbolize Roosevelt's "Four Freedoms," which all revolved around the right to pri-
vate life apart from government intervention. Not surprisingly, then, when Murrow
tours Rockwell's studio (also in his home), he points to two of the canvasses most
notable for this logic—"Freedom of Speech" and "Freedom of Worship." Making
the patriotic message even more clear is the fact that Murrow, in a previous seg-
ment, interviews Fidel Castro. Although Castro presents himself as a family man
(he is with his son and dog, and he even shows Murrow his baby pictures), the
unkempt beard, the fact that he appears to be wearing pajamas, his missing wife,

320 and the fact that he is in a hotel room rather than his home, marks him as decidedly outside the American iconography of family life that Rockwell made famous during the war. Thus the juxtaposition of Rockwell with the Cuban communist rebel speaks, not too implicitly, to the debates about American art and communism that circulated at the time.

Still, Rockwell's association with the patriotic art of the wartime past—as well as his own anti-modern stance—made him less than a viable leader in the quest for the American modern. Television thus explored a host of other possibilities, and in the process modern art was often ambivalently presented. On the one hand, as with the Rockwell-Castro program, television attempted to free modernism of its communist and elitist connotations. But it also tried to distance itself from the Depression Era's social realism, regionalism, and WPA funded art, as well as the Rockwell-esque imagery of the wartime past. Modern art, then, meant progress, but of a distinctly American and popular sort.

A 1955 episode of *See It Now* even more explicitly illustrates this point. Significantly entitled "Two American Originals," the program was divided into two segments, one which featured artist Grandma Moses; the other jazz great Louis Armstrong. Grandma Moses, who had come to national prominence in the early 1940s, was famous for her so called "primitive" art that rendered, in a craft tradition, realistic subjects such as houses, pets, and other domestic scenes. For some, she represented the quintessential American vernacular, the term "primitive" assuming a positive connotation here as the art world placed "high" value not only on Moses but other kinds of American "outsider art" (for example, children's art, art therapy, and the art of psychotics).

Murrow's interview took place in her humble home studio where her practical arts and crafts aesthetic was most notable through the folksy decor. Murrow asks Grandma, "Have you decided what picture you're going to paint next Grandma Moses?" and Grandma replies, "I'm going to try to get into something different…well more, more modern. I've been inclined to paint old scenes, I suppose since I'm old." To which Murrow retorts, "Or old enough to go modern."

This curious exchange between the grandmother of American art and television's premier newsman suggests the ambivalent attitudes toward the old and the new, tradition and modernization, that surrounded the definition of an American vernacular for the postwar world. The figure of Grandma Moses offers a resolution for this ambivalence as she is literally rendered a "modern primitive." As such she negotiates the contradictory values of the more traditional American representational art (by which I mean the rendering of recognizable subject matter) and the newer forms of abstraction that often worked to negate subject matter (as, for example, with Jackson Pollack's "drippings" or with Larry Rivers's *Washington Crossing the Delaware* that abstracted portions of this historical scene).

Moreover, as opposed to what President Truman called the "lazy, nutty moderns," Grandma Moses was distinctly American, a point that was "officially" recognized during the period. Truman said that comparing Moses to the moderns was

like "comparing Christ with Lenin," and President Eisenhower's Cabinet presented
him with a specially commissioned Grandma Moses depicting the Eisenhower
family (Marling, 1994, 76–77). In the *See It Now* episode, her nationalism is under-
scored when Murrow asks her, "Do you ever look at the paintings of a foreign
artist?" and she replies, "Some. I never have seen so much. You know I've never
been away from home much. Most that I've seen is in pictures." The exchange thus
clarifies that Grandma Moses is truly an American original, untouched by foreign
influence. The meaning of modern is thus construed simply as something con-
temporary, but it remains quintessentially American.

However, as *See It Now* makes clear, being "American" meant nothing if
American did not translate as such abroad. In other words, American art for the
modern world was art recognized as such in Europe. One of the reasons Grandma
Moses was famous enough to be on *See It Now* in the first place was because she
was one of the few American painters that Europeans embraced after World War
II. The segment with Louis Armstrong further suggests the relations between
American and European art as Murrow follows the musician on his European tour
where he plays in Parisian clubs for adoring audiences. Like Grandma Moses,
Armstrong negotiated the popular arts with modernism in such a way as to give
America both wide appeal and cultural clout overseas. Even in the States, jazz and
swing were adored by the masses and intellectuals alike. Modern American painters
with avant-garde status such as Stuart Davis and Harlem Renaissance artist Aaron
Douglas, were jazz enthusiasts and presented jazz lyrics and musicians respective-
ly in their canvasses *American Painting* and *Aspects of Negro Life.* Given its cross-
over potential (racially, internationally, across class and education levels, between
the visual and audio arts, and across the so called "primitive" arts of African
Americans and the "modern" arts of white Europeans), jazz presented a particu-
larly open text, and as such was easily assimilated by white Europeans and the white
Eurocentric avant garde (Wollen, 1993, 109–113). As testimony to this, in the *See It
Now* episode Murrow announces, "Satchmo is one of our most valuable items for
export."

I think it is no coincidence that American modern art and its exportability over-
seas is communicated on television by way of the figures of a grandma and a black
man—the figures that in traditional discourses on modernity would most likely
stand in for the "masses." In Andreas Huyssen's classic formulation, modernism is
typically associated with male prerogative while mass culture is represented by
means of feminine tropes associated with the figure of the unruly woman, who in
turn stands in for the unruly mob of immigrants, the working class, and racial oth-
ers (Huyssen, 1986, 47). In television's representations of American art, however,
these gendered terms are inverted. Femininity—at least white femininity—and
blackness—at least the black male musician—is often associated not with mass cul-
ture but rather with modern art.[9]

In the *See It Now* episode, this feminization and racialization of modernism
serves to render American art exportable, perhaps because white women and black

322 musicians (via the "minstrel" stereotype) were historically depicted as passive, childlike, and "primitive" figures, as opposed to the "ugly American" brute associated with militaristic masculinity.

Although much more consideration of these issues is needed than can be given here, it seems worth pointing out that the perception of American art in foreign countries increasingly posed a dilemma for television during the late 1950s and through the 1960s when foreign syndication became a lucrative market. By 1962, the sale of syndicated off-network programs abroad was higher than domestic sales, and in that same year the first private communications satellite, Telstar, was launched. Despite the *economic* gains in the early 1960s, however, the export of television became a subject of concern during Senator Thomas Dodd's hearings on television violence as various parties worried about television's cultural/ideological effects overseas, particularly with regard to the image of the "ugly American" that violent programs might perpetuate (and note the same concerns were earlier expressed in the 1950s during the Senator Estes Kefauver hearings on violence in comic books).[10] In this context, the more "art and education" that U.S. television could export, the better it would reflect on the nation as a whole and more conducive it would be to convincing people of other nations to join what President Kennedy called the "Free World."

Kennedy, of course, imbued his presidency with a sense of the higher arts from the start, using television as a key instrument for communicating his sense of taste.[11] On the occasion of his inaugural address in November of 1960, he invited Robert Frost to recite a poem. Another famous poem that came to provide the terms for the reigning discourse on television during the period was T.S. Eliot's *The Waste Land*—a poem that perhaps not coincidentally was modernist in nature and written by an American poet who lived in Paris in the twenties. Taking this avant-garde legacy into the New Frontier, Minow used the "Vast Wasteland" as a metaphor in his 1961 speech of that title before the May 9th meeting of the National Association of Broadcasters. Minow argued that television had broken the public trust by offering "a procession of game shows, violence [and] formula comedies," and he recommended more arts and educational television as a remedy (Minow, 1964).

For Minow and many others the Vast Wasteland came to symbolize the cultural demise of America through TV, and his speech reoriented the discourse on television from its obsessive interest in "family" life during the 1950s to a focus on public interest and national purpose. In the context of the new satellite technologies and Kennedy's Cold-War zeal for cultural and economic colonialism, television's national purpose was international in scope.

But despite its attempt to make the world safe for democracy, when it came to art, network television still represented America as a cultural colony of Europe. The Camelot presidency drew shamelessly on British and European art history to prove its appreciation of the legitimate arts. Again, the figure of the woman was integral to this endeavor. One of Kennedy's greatest triumphs was to secure the first American traveling exhibit of yet another famous woman—the Mona Lisa—which he got on loan from the Louvre. In a television press conference on the subject, the

connections between art and international diplomacy are made explicit as Kennedy positions the acquisition of the Mona Lisa as "a reminder of the friendship that exists between France and the United States."

And, of course, the first lady herself became the camera's favorite modern woman. CBS's 1962 documentary *A Tour of the White House with Mrs. John F. Kennedy* was an attempt to redecorate the nation with a sense of American history as Jackie discussed the need to fill the home with antiques that would speak to American heritage. Ironically, however, while Jackie kept pointing out that everything about the house was American, she nevertheless spoke mostly of British and European design, comparing the east room to the palace at Versailles, talking of Shakespeare, Ancient Greece, and even boasting that the wallpaper, with its scenes of America, was made in France. Moreover, while Jackie went to great lengths to prove that the redecoration was done on behalf of her fellow Americans, her Europhilia emerged in irrepressible ways. When asked whether she thinks "that there is a relationship between the government and art," or if it is "because you and your husband just feel this way?" she replies: "That's so complicated. I don't know. I just think that everything in the Whitehouse should be the best. The entertainment that's given here. And if it's an American company that you can help, I like to do that. If it's not, just as long as it's the best." Although President Kennedy soon told the audience that the purpose of redecorating was to teach young people to "become better Americans," Jackie's penchant for European art made her modernization scheme seem altogether foreign. In this regard, Jackie served as an ambivalent figure who skirted the boundaries of a popular celebration of American modern style and the popular mistrust of European art.

From Momism to POPism

As with its presentation of the First Lady, television often represented the idea of modernization through the figure of women art connoisseurs and artists. Sometimes this served a familiarizing function, schooling the public on ways to appreciate the much mistrusted European modernists through representing art as feminine, domesticated, and polite. But, as with *A Tour of the White House*, the attempts to contain modernism within the tropes of an aristocratic "refined" femininity never quite worked because this also posed the threatening presence of Europhile, snooty, eccentric, excessive, and overeducated elites, even when spoken in the whisperingly demure tones of the charm-schooled Mrs. Kennedy.

More generally, in popular culture "modern" women (aristocrats and otherwise) were decidedly suspect. In fact, the "threat" of the modern woman even achieved the status of a popular theory encapsulated by the term "momism." Coined by Philip Wylie in his 1941 book *Generation of Vipers*, the term was widely popular, so popular in fact that the book had gone through 16 printings by 1955. Wylie argued that women were in a conspiracy with industry to rob men of their power and create a culture of sissies. In his most bitter chapter entitled "Common Women," Wylie argued that women had somehow gained control of the airwaves in a plot to destroy not only men but the nation. "The radio," Wylie wrote, "is mom's final tool,

324 for it stamps everyone who listens to it with the matriarchal brand.... Just as
Goebbels has revealed what can be done with such a mass-stamping of the public
psyche in his nation, so our land is a living representation of the same fact worked
out in matriarchal sentimentality, goo, slop, hidden cruelty, and the foreshadow of
national death" (214–15). In the 1955 annotated edition, he connected these fears to
television, claiming that women "will not rest until every electronic moment has
been bought to sell suds and every bought program censored to the last decibel and
syllable according to her self-adulation—along with that (to the degree the mom-
indoctrinated pops are permitted access to the dial) of her desexed, de-souled, de-
cerebrated mate" (213–14). Wylie's hyperbolic ravings testify to Huyssen's (1986)
claim that femininity had historically been a figure for the threat of mass culture.
But importantly, when they were represented on mass cultural forms such as tele-
vision programs, the threat of femininity could just as easily be condensed with the
foreign (which typically meant communist) threat of both European and American
modern art.

Television fiction especially took up these interests, crafting plots around dubi-
ous paintings and women out of control. A 1957 episode of CBS's *Telephone Time*
entitled "One Coat of White" illustrates the point. In this drama the French actress
Claudine Colbert plays an American tourist in France who falls in love with
Lautisse, the greatest living French artist (a name which a critic for the *Saturday
Review* called "a provocative amalgam of the names Lautrec and Matisse").
Lautisse, who hasn't painted in years, refuses to let anyone know his true identity,
falls in love with Colbert, and follows her back to her home in Seattle where her
grown-up children are "horrified by what they consider to be their widowed moth-
er's middle-aged escapade." Colbert is torn between her love for her children and
her unsuitable European modernist suitor. The conflict is resolved when the chil-
dren in Seattle undergo a financial crisis and decide to put the home up for sale.
As the *Saturday Review* critic explains: "The children propose to help its salability
by giving its fence a coat of white paint. But Lautisse gets there first and begins to
cover the fence's surface with abstract forms which he quite rightly describes as
'rather like Miro.' His skill gives the game away naturally, his identity becomes
known to the children and the public, and within hours curators of some of the
leading American art museums have arrived on the scene and are bidding against
each other for sections of the fence at fabulous prices per running foot" (Soby, 29).

While "A Coat of White" has a happy ending, the odd couple of the older
American housewife and the French modern artist provides the terms of dramat-
ic conflict, asking viewers to decide whether an American woman ought to be
engaged with modern art. Moreover, like Grandma Moses, Colbert plays an older
woman, and according to the terms of the narrative, her age, even more than her
nationality or sexuality, precipitate the crisis.[12] In this sense, we might say, like
Grandma Moses this older woman represents not just femininity but the American
past, especially the recent wartime "patriotic" past that was rendered through
images of family life, most notably by Norman Rockwell. This program thus pre-
sents its female heroine and her out-of-control desires for French men as a threat to

the isolationist and family values of the previous two decades. However, it resolves the dilemma of the American family's place in an increasingly international post-war world by having the French modernist literally save the American family home.

Other television genres similarly presented housewives as arbiters of modern art, suggesting links between the suspect nature of European modernism and a potentially out-of-control American femininity. A perfect example here is a 1955 episode of the situation comedy *The George Burns and Gracie Allen Show*. Known for her illogical relation to language by way of her famous shaggy dog jokes, Gracie becomes the representative par excellence of the populist scorn for modern art. After going on a gallery tour for a lesson in art appreciation, Gracie decides to try her hand at painting. Misunderstanding the difference between industrial arts and fine arts, Gracie buys supplies from a house painter and decides to make a portrait of George. The painting turns out to be "abstract" despite Gracie's efforts to render her husband in the representational tradition of portraiture.

Predictably, at the end of the episode when Gracie shows the portrait, no one can figure out what the painting is about. One character thinks "it's a yellow cab with the doors open"; another says "no, it can't be…who ever saw a yellow cab with bloodshot headlights and a radish hanging inside"; and a third suggests, "someone threw a lighted cigar on a dying water lily in a stagnant pond." Although rendered humorously, the point here is that abstraction poses a threat to consensual meaning as no two people in the scene arrive at the same interpretation. In a television genre notable for its attempts to elicit consensual (mass audience) interpretations by staging and then resolving all eccentricities (even Gracie's) within the "norms" of suburban domesticity, modernism clearly has no place apart from its position of comedic excess—the exact position that Gracie Allen herself always occupies in the program. And in that regard, modernism is literally a woman.

In fact, the episode explicitly makes modern art an issue of sexual difference as Gracie's "screwball" persona and her proclivity for abstraction are countered by George who takes the opposite position of the "hams and eggs" anti-intellectual, anti-modernist, American populist. In one of his weekly monologue segments, George literally walks out of the plot, comes onto the stage to address the home audience, and recalls the time he visited his "highbrow" friend:

> Last time I was at Getz's house he showed me a modern painting he just bought and he asked me if I liked it. Well all I could see was some blue triangles on top of a yellow square so I had to be honest. I said, Bill, maybe I'm old fashioned. I like simple pictures like a little boy and his dog. He looked at me sort of pityingly. He says, "but George, that's what it is." Then he told me it was surrealism and that artists that do that kind of work have to paint the way they feel. Well, if you really feel that bad you should stop painting and go to bed.

In all cases the implication is that no one can understand modern art, and this is not because the art is non-objective, but rather because it is non-professional. Typically associated with psychosis (and note that George compares it to feeling bad) and also often compared to children's paintings, modernism becomes "out-

sider" art, which for populists has no value. In *Burns and Allen*, the wry dismissal is linked to an implicit relegation of modern art to women and madness—or at least mad-cap comedy.

If *Burns and Allen* treated the eccentric nature of femininity and modern art in comic terms, with the woman artist as the butt of the joke, other programs presented more troubling visions, linking issues of nationalism and modernism to unruly women artists. A perfect example here is an episode of *I Led Three Lives*, a syndicated program that revolved around the life of Herbert A. Philbrick, a counterspy for the FBI who posed as a pipe-smoking advertising executive. This episode told the tale of Margaret, a young female art student engaged to Paul, her art school teacher, who supplements his meager earnings as a painter through his day job as an ad man. At the beginning of the story, Paul visits Herbert to talk over an advertising campaign and tells him he suspects Margaret is a communist. Margaret, it turns out, is not only a communist spy, she is a modernist artist who plants microfilm in her collages. In one scene, when Herbert visits the art school, Margaret asks, "Did you ever see a collage painting before, Herb? Collage is old fashioned but we moderns go in for it when we want to puzzle people." Then, in more sinister tones she says, "We take little pieces like these…well they should be pieces of your heart…. Who are you Herb?… Oh, the man who corrupts commercial artists with money. Do you know what you've done to Paul? You've made him unable to understand my genius." As opposed to Margaret's interest in modernist collage, Paul and Herbert both express their preference for representational art that has recognizable subject matter—art with what Margaret calls "meaning," art that isn't what Herb calls "strange." In the end, in the true terms of Momism, it turns out that Margaret has turned communist because she hates her mother.[13] When mother and daughter finally reconcile, Margaret is purged of her communist sins, turns in her modernist collage for a wedding ring, and she and Paul live happily ever after.

This program is interesting not only because of the hyperbolic way it conflates the threat of modernism with the threat of women, but also because it makes the commercial artist into an American hero, a counterspy for the FBI who staves off the communist threat. We might note here that the presentation of the commercial artist as patriot was continuous in many ways with the figure of Norman Rockwell, himself a commercial artist, working for the good of the country. Only for Philbrick—and for the more general notion of American modern art after the war—the work itself did not deal with themes of patriotism, but rather was simply about products. In fact, the idea that advertising art was not only art, but the true American modern vernacular, became increasingly central over the course of the decade.[14] This could be seen not only in fantastic tales of communist infiltration, but also in documentaries on art education.

It is, for example, well demonstrated in two advertising segments of the *See It Now* episode featuring Grandma Moses and Satchmo. In the first segment, the narrator tells us, "Out of the modern Shulton plant come these two brand new men's products. Old spice electric shave lotion and old spice body talcum." Like Grandma Moses, old spice mediates the old with the modern. Meanwhile, the commercial,

which is rendered in abstract animation, is itself testimony to the fact that advertising art in the 1950s was one of the central places where American modern design was developed. (In fact, the design journal, *ID*, is full of this kind of abstract TV animation as it was constantly used for network promotional ads and logos like the CBS surrealist inspired eye).[15] The second commercial underscores the "art" value attached to industry as the narrator tells us that old spice is a real American original and shows us the "magnificent murals that decorate the lobby" of the Old Spice factory. The camera pans across the mural and displays Old Spice bottles in a kind of gallery setting—as if these products are art objects.

An even more striking example is a 1953 episode of *Omnibus* that revolves around a visit to the home of the premier Depression-era social realist and regionalist painter, Thomas Hart Benton. Benton is an interesting figure here insofar as his career was itself born in a curious mix of modernism (which he experimented with in art school in Paris) and mass culture (he painted movie sets for Fox and Pathe in the 1910s). His art was marked by an admixture of aspects of modern style into realistic subject matter that emerged in regionalist murals depicting slice-of-life scenes, scenes that he saw as critical of social inequities such as labor exploitation. Despite its ethos of social criticism, Regionalism was itself co-opted by big business such as Standard Oil, which saw this art as useful for advertisements. At first Benton eagerly accepted commissions, hopeful about the "possibilities of a fruitful relation between big business and art." He accepted commissions from *Life* for his 1937 painting of union workers at Twentieth Century Fox entitled *Hollywood* (which *Life* ultimately rejected because of its controversial subject matter), and in 1941 his *Outside the Curing Barn* was painted as an ad for Lucky Strike cigarettes. But by the postwar period, Benton realized that big business was not interested in art that contained social criticism, and felt that his liaisons with big business had been a failure (Doss, 1991, 147–228). By the time of the *Omnibus* episode, Benton had likewise rejected his connections to the New Deal inspired WPA funded art and the modernist arts that emerged from the Depression. Holding onto his regionalist aesthetic, he had moved to the Midwest as subject matter, which he thought spoke to the folksy values of the real America in a way that the New York City Art world (and especially Abstract Expressionism and his one time pupil, Jackson Pollack) never could.

Given his rejection of both the "art for business" ethos and big city modernism, and given his status as a regionalist painter of slice-of-life scenes, Benton would seem to serve as the perfect icon of the American vernacular. However, the *Omnibus* episode suggests that the vernacular was itself less easily defined because it presents Benton as a confusing hybrid of folk/high/and mass culture, all sutured together in a family scene. Moreover, if this is supposed to be American, it still depends on two British stage actors, Alistair Cooke (the host of *Omnibus*) and Claude Rains (a family friend) who, by way of their "Britishness," give the program a highbrow feel. At the beginning, Cooke invites viewers into the Bentons' home for a "typical" night of family life among the art set. Rains exhibits some of Benton's work and reads the poetry of Carl Sandburg. Then, after Rains shows Benton's

328 famous Huck Finn lithograph, Benton reads from a Twain novel. Folksinger Susan Reed plays the harp and croons a ballad, and Benton's thirteen-year-old daughter reads from the French novella, *The Little Prince*. Finally, as the whole family gathers in a sing-along, the camera moves to a painting on the wall, and then an off-screen narrator asks, "Have you ever wondered how the pretzel gets so twisted?"

If you are wondering what this question possibly has to do with the likes of Mark Twain, Carl Sandburg, and Thomas Hart Benton, you should be because the answer is not to be found within the logic of enlightenment that the Benton family scene strives to portray. Instead, we are now in the twisted pretzel logic of the advertising community where language can be used for convenience—in this case as a transition from program to ad—rather than as something that—like Twain, Sandburg, or Benton—strives towards reason. Specifically. the pretzel problem serves as a transition to a commercial for AMF industrial machines that are used in pretzel factories. This juxtaposition of Benton's populist interpretation of the American vernacular with the advertisement's image of pretzels and assembly line technology suggests that even while television presented the great "artists" of the Depression Era and World War II, its commercial nature was fundamentally incompatible with the interpretation of American art proliferated by the Bentons and the Rockwells of the past. Who in the audience would really be able to seriously contemplate the possibility of the folk and high cultural values that Benton here represented when they were simultaneously asked to ponder the hermeneutics of twisted pretzels?

From Pretzel Logic to Henny Picasso

By the 1960s, the issue of art and its links to commercial television had taken on national importance, with television squarely in the center of the debates. Now, the search for the modern American vernacular was no longer posed as a painter's dilemma that television might help to solve; instead it was posed increasingly as a televisual dilemma worthy of grave national attention.

Although critics in the 1950s had considered how television might become the "eighth lively art," and while many people at the networks thought about the adaptation of "high" cultural forms such as opera and ballet, and while some even pondered the use of the medium for experimental purposes, by the end of the 1950s the terms of the debate had shifted.[16] Now people began to wonder what the difference was between commercial television and the visual arts, and that sense of relativism began to make itself felt both in paintings and in television programs.

Widely seen as the onslaught of postmodern sensibilities, such relativism is typically discussed from the point of the view of the art world's scavenging of "low" forms and the art critic's various debates on Pop, Op, Camp, Minimalism, and the like. What needs to be addressed, however, is the blurring of high and low through the lens of the television camera; that is, how television's representations of the modern visual arts gradually caused a shift in focus to the increasing indistinguishablity between commerce, the "high" arts, and also—in terms of the technological sublime of President Kennedy's "New Frontier"—the "high" sciences.

It is curious in many ways that television's embrace of the postmodern blurring of high and low should take place in the 1960s because this decade was ushered in by a spate of modernist-inspired "Vast Wasteland" rhetoric that in fact tried very earnestly to make distinctions between what was authentic and what wasn't. In the land of Kennedy's New Frontier, this meant not only the arts but also the sciences, which were equally important in Minow's reform agenda.

This goal of making distinctions between real art and science as opposed to commercial pop was, however, quite difficult to achieve in relation to a medium that was all three things at once—a potential forum for the fine arts, a technology produced through and used as a tool for science, and a form of commerce and commercial culture. Moreover, since art, science, and commerce have all, at different points in American history, been viewed skeptically as "artifice" and even sorcery, it was always hard to decide which of these were "authentic" forms of experience and which were "frauds."[17]

The advent of the Quiz Show Scandals in the late 1950s exacerbated these confusions insofar as what the public had believed to be the hard facts about the arts and sciences that these shows featured were revealed to be the products of fraudulent sponsors who gave contestants answers before the programs. The Quiz Show Scandals and the hearings that ensued made these issues a national dilemma. While the prosecution claimed commercial fraud, the producers (in their own defense) argued they should not have been expected to tell the truth because television quiz shows never purported to be true to life—they were a dramatic art form that needed to present heightened conflict. The scandals, thus, had the effect of relativizing the difference between television's status as art, science, and commerce as the legal proceedings generated testimony that proved all three possibilities equally viable.

As should be clear from this highly publicized example, television's shifting status between the categories of art, science, and commerce caused considerable confusion and resulted in an array of disparate responses among different groups. For some, like Marshall McLuhan, these contradictions were resolved by privileging the scientific/technical explanation in his essentialist prophesies like "the medium is the message." According to this logic of technological determinism, television, like all media, is what McLuhan (1964) called an "extension of man"—or a kind of technical prosthesis that evolved out the evolutionary thought structures of the human mind. In the scheme of "the medium is the message," technology determined aesthetics, and commerce simply didn't matter much. For others, like Newton Minow, these contradictions were resolved by making distinctions between good and bad taste, between what was authentic art and what was hard (or real) science, as opposed to what was low art, pseudo science, and thus blatantly commercial trash. For others, however, creating distinctions between the high and the low was not the point. This third group resolved the contradiction between art, science, and commerce by turning to a more postmodern attitude that played with indistinctions among the three. This attitude was taken up by two apparently disparate camps whose opposing views were represented by a coastal divide: Hollywood producers vs. the New York art scene.

330 Although this divide between Hollywood and New York was not always geo-
graphically coherent (the networks had business offices in New York, and there
were, of course, artists and critics on the west coast), the two coasts did come to
represent two different attitudes toward the blurring of high and low.

After 1955, when television had moved its base from New York to Hollywood,
the production system fostered a kind of "regulated innovation." Networks and
Hollywood studios like Screen Gems often contracted with independents and
sought to produce a lot of different kinds of programming hoping for a hit.
Although this did not translate into avant-garde experimentation, it did mean that
production companies and networks were searching for new looks, especially looks
that took prime-time television away from its roots in New York legitimate and
vaudeville theater that had been the mainstay of the 1950s live anthology dramas
and variety shows (both typically shot in New York). These new looks were pro-
duced by turning to the non-theatrical arts including the literary movements of
Beat poetry and intellectual science fiction fantasy (which surfaced respectively in
programs like *Route 66* and *The Twilight Zone*) as well as developments in popular
music (including jazz, but particularly the youth music of folk, rock and pop), and
movements in the visual arts, especially painting.

The world of the painterly arts embraced television at the beginning of the
decade in a ceremonious gesture. One year after Minow's famous speech, in 1962,
New York's Museum of Modern Art (MOMA) held the first TV-Art exhibit, fea-
turing critics who selected the "Golden Age" programs of the bygone era of '50s TV.
The program book noted that television was divided in "two camps"—the industry
that is concerned with money and "artists and journalists whose standard of 'suc-
cess' is the degree to which television realized its potentialities as an art form" (Jac
Venza, 1962, 15). Predictably, given Minow's attack on Hollywood genres and its
own geographical setting, MOMA, especially selected the news documentaries and
anthology dramas that had been produced mostly in New York studios during the
1950s. *Gunsmoke* was the only Hollywood dramatic series that made the list. Clearly,
for all of these folks, the "vast wasteland" referred to anything west of the Empire
State, and especially anything that emanated from Southern California.
(Interestingly, however, the arty aspirations of Camelot were also exhibited back
in Hollywood where industry people got the city of Los Angeles to front seed
money for the Hollywood Museum, which was, according to its founders, intend-
ed to raise film, television, radio, and recorded music to the status of art.)[18]

Over the course of the decade, MOMA's canon of Golden Age TV was increas-
ingly out of touch with developments in the visual arts, particularly with the advent
of POPism. Increasingly in the 1960s, Hollywood commercial television seemed
more and more arty in New York as premier POP artists like Robert Rauschenberg,
Andy Warhol, and Roy Lichtenstein turned popular artifacts, stars, and politicians
into a painter's (or sometimes silk screener's) medium, thereby flattening out the
differences between and among them. Meanwhile, commercial television took an
interest in POP and the new Camp sensibility.[19] In 1966, ABC adapted *Batman* for
television, playing on POPism's visual iconography and pulp fiction themes with a

camp awareness of its own "badness." Moreover, insofar as POP canvasses were notable for their use of bright primary colors, this style (as well as Psychedelic art) was particularly conducive to the industry's big push in these years for the conversion to color TV—and not surprising, *Batman* was shot in color. Indeed, programs that worked in the POP tradition (including, for example, NBC's "in living color" *Laugh-In*) also had the advantage of making people want to buy color television sets.

The fact that television was both "POP" and popular was not lost to the network promotional department at ABC, which "dual" marketed *Batman* both as a camp parody for adult audiences and as an action series for kids, thereby maximizing ratings. For the adult crowd, ABC even held a posh "cocktail and frug" party for the premier episode which took place at the fashionable New York discotheque, Harlow's, with Andy Warhol, Harold Prince (director of the League of New York Theaters), and other celebrities attending the event. (POP icon Jackie Kennedy declined ABC's invitation.) After cocktails, the network staged a special screening of *Batman* at the York Theater, the lobby of which was adorned with Batman drawings and stickers that sported slogans proclaiming their status as "authentic POP art." Guests at the York were reportedly unexcited about the show, but in true POP style, they cheered when a commercial for corn flakes came on the screen ("Discotheque Frug Party," 1966, 79).

As these promotional gimmicks suggest, while POP artists like Warhol and Lichtenstein borrowed popular iconography to make "art," the "low" medium of television borrowed POP's aesthetics of borrowing—in this case essentially using the artist's tradition of the *"in-crowd"* opening reception as a publicity stunt staged for a *mass audience.*[20] While this scavenging act between the "high" and the "low" is now often seen in postmodern criticism to mark the demise of the myth of "authentic" expression, in the 1960s it was typically championed as proof of what many commercial artists had long argued—that advertising and commercial culture were themselves a legitimate "art" form—that ads could be just as authentically expressive as painting could.[21] Even *Television Quarterly*, the journal of the Television Academy of Arts and Sciences, agreed. In 1967, it included an article entitled "Be Quiet, The Commercial's On," which endorsed advertisers' "willingness to experiment" and reminded readers that in critical circles commercials were in the same league as cutting edge films and filmmakers:

> Almost every article about Richard Lester dwells on his experience as a director of commercials, and suggests that *A Hard Day's Night* and *Help!* are, technically at least, extended commercials. David Karp in the *New York Times Magazine*, insisted that television shows are supposed to be bad, and praised commercials and their use of *cinema verite.* Stanley Kubrick is quoted in the *New York Times* as finding "the most imaginative filmmaking, stylistically," in TV commercials. Even Herbert Blau, in *The Impossible Theater,* stops to ponder the skill that goes into TV ads. (Weales, 1967, 24)

More generally, *Television Quarterly* promoted this equivocation between art and industry by publishing articles on "taste" and the meaning of "culture." Appearing

on a regular basis during the decade, these speculative essays were written by such unlikely bedfellows as France's Minister of State in Charge of Culture, Andre Malraux (1963, 44–55) and the President of the CBS Broadcast group, Richard W. Jencks (1969, 5–21). Once again, in the true POP aesthetic of the time, television seemed to be the great equalizer between artists and bureaucrats.

Still, for some veteran Golden Age critics who had lived through the sponsor boycotts of McCarthyism and the histrionics of the Quiz Show Scandals, the celebration of commercialism as art was a hard pill to swallow, and many continued to express their preference for the older "Golden Age" formats. However, since these critics also traveled in New York art circles (and had originally been theater critics), they had trouble ignoring the fact that POPism was the latest thing in museums, fashion magazines, and even in the New York theater where *Superman* and *Mad* were both adapted for theatrical presentation. In this context, many of the east coast TV critics expressed ambivalence towards TV's POP attitudes. For example, while veteran *New York Times* critic Jack Gould admitted that *Batman* was a "belated extension of the phenomenon of Pop art to the television medium," and as such might "be an unforeseen blessing in major proportions," he also cautioned with an ironic wink that POP art had its own inverted standards, and that *Batman* "might not be adequately bad" when compared to *Green Acres* and *Camp Runamuck* (Gould, 1966, 1: 7). Similarly confused about the role of the critic in a television universe where aesthetic hierarchies were turned upside down, a reviewer for the *Saturday Evening Post* claimed: "*Batman* is a success because it is television doing what television does best: doing things badly. Batman, in other words, is so bad, it's good.... Batman translated from one junk medium into another is junk squared. But it is thoroughly successful and—this troubles critics for whom good and bad are art's only poles—it can be surprisingly likable" (Skow, 1966, 95). As such ambivalent commentary suggests, the transition from the theatrical conception of television (both legitimate theater and vaudeville) to a painterly one (which increasingly meant POP and Psychedelic art) was never smooth or fully achieved. Instead, television seemed caught in a style war that manifest itself in the most curious of ways.

The television variety show is a good demonstration of the problem, if only because it included such a schizophrenic mix of the 1950s "Vaudeo" aesthetic of variety theater with the newer stylistics. A dramatic case in point is *Rowan and Martin's Laugh-In*. Broadcast from 1968–1973 on NBC (and at the top of the Nielsen ratings for its first two seasons), it featured a POP-influenced psychedelic, Peter Max-like set design complete with a brightly colored "Graffiti Wall." But, the program eclectically mixed the new visual arts with the sensibilities of vaudeville clowns. *Laugh-In* showcased a classic vaudeville couple, straight man (Dan) and buffoonish clown (Dick), and many of its jokes were taken straight from vaudeville. For example, a script for a 1969 episode begins with stage instructions for a "vaudeville crossover" in which Dan remarks, "If Raquel Welch married Cassias Clay, that would be like bringing the Mountains to Mohammed," and then the stage

instructions, in true vaudeville fashion, call for "Music: 4 Bars and Into Vamp" (Script # 0283–21, 1969, 4A).

In fact, *Laugh-In* was itself often very self-reflexive about the ways in which POP and Psychedelic Art were being incongruously mixed with vaudeville. The "graffiti wall" for example, served as backdrop for cast members who literally "POP-ed" out of it to tell vaudevillian one-liner jokes. News segments (which were introduced with a vaudeville-type ditty that went "Ladies and Gents Laugh-In Looks at the News") sometimes included news of POP art. For example:

> DICK: Greenwich Village, New York: Work on Andy Warhol's new underground movie was halted today when the romantic lead, a 300 pound wart hog, died of a heart attack.
> (GOLF SWING)
> MUSIC: DRUM ROLL. (Script #0283–14, 1969, 27)

While the content of the joke was about POP, the form was clearly vaudeville. One year later, the same basic culture clash was evidenced in a "cocktail party" sequence that includes a bizarre crossover joke that features Dick imitating vaudevillian Henny Youngman's "one like this" shtick, as he tells Dan, "I got two pictures in the museum, one like this, one like this." To which Dan replies, "Oh that Henny Picasso." The skit closes with an off screen voice yelling "Andy Warhol…Soup's On!" (Script # 0283–20, 1969, 93).

As such instances make clear, television was in fact quite self-conscious of its own schizophrenic styles, moving as it was from the 1950s conventions that were developed in New York (and drew on Yiddish vaudeville humor) and toward the 1960s New York based visual art scene.

Laugh-In also suggests the move from the association of modern art with femininity per se to an increasing representation of modern art as "queer," both in terms of the "queering" of generic styles such as the unlikely merger of vaudeville and POP art and in terms of queer masculinity. To be sure, as Alex Doty (1994) suggests, variety show hosts, famous for their use of drag and their "straight" man/oddball couplets, always encouraged the possibility of being read queerly. But in the sixties, the "sexual liberation" found its way to television, and not only through overt "swinging singles" content (seen, for example, on programs like *Love American Style*), but also through the ambiguous sexuality of the POP style with its campy heterosexuality (rendered through subjects such as love comics, superheroes, and Elvis) as well as the unreadable sexuality of its most talked about artist, Andy Warhol. *Laugh-In*, famous for its "love in" sexual liberation ethos, included regular jokes about gay couples. One skit, for example, features Tony Curtis (who was well known for his drag performance in *Some Like It Hot*) playing the role of the quintessential Warholian artist, a "flamboyantly dressed" fashion designer/interior decorator who was hired by the military to redo the bunks and military uniforms, which of course he does in pink (he says things like, "a pink Marine is a happy Marine"/ and "I see the administration building in a psychedelic chartreuse"). By the end of the skit he and the Marine officer fall in love (Script

334 #0283–25, 1969, 194A-E). In another episode a cocktail party skit has the decidedly queer Tiny Tim talking about FOP art on the famous gay beach resort, Fire Island; following this, cast member Judy Carne comments, "TV's really getting arty—last year we saw the Louvre on Channel 4, and next year you're going to be able to see the Artists and Models Ball on Channel 28" (Script #0283–20, 1969, 92).

To be sure, the figure of the "queer" (by which I am referring to a kind of eccentric but not necessarily gay masculinity) and his relation to the politics of consumption and art also made themselves felt in other genres. In the anthology format, such figures as film auteur Alfred Hitchcock in *Alfred Hitchcock Presents* continually subverted his own genre and his own means of production. Whereas the 1950s live anthology drama presented itself as family programming brought to you by the "good will" of sponsors like Goodyear and were introduced by erudite hosts like Robert Montgomery, Alfred Hitchcock was known for his penchant for the macabre. What's more, Hitchcock always made fun of the sponsor and the system of commercial TV in general. In this sense, Hitchcock "queered" his own genre, presenting an eccentric masculine "artiste" in place of the paternalistic good will and "polite" theatrical enunciative system of the live anthology drama. This same eccentric masculinity was crucial to other, equally "queer" anthology formats including *The Twilight Zone*, which introduced its story every week with auteur Rod Serling smoking a cigarette, telling us we were "traveling into another dimension," as well as *The Outer Limits*, whose even more unusual off-screen (but markedly male) "control voice" announced, "There is nothing wrong with your television set. Do not attempt to adjust the picture...." while an artsy display of sine waves, vertical rolls, and other electronic abstractions took over the screen.

Although critics did not refer to these instances as "queer," the new modes of masculinity did not go unnoticed at the time. Critic Joseph Golden (1963), writing for *Television Quarterly*, noted that a host of genres, from the medical drama to the western to the single-dad sitcom, featured widowers as their main protagonists. Analyzing why women had been relegated to the "video graveyard," Golden compared television's new "provocative" and "sterile hero" to the "behavioral sterility, so aggressively explored by the European avant-garde in the last decade or so" (14). Interestingly, Golden accounted for the new arty hero via Philip Wylie's treatise on momism; he claimed that "the womanless society of television" was in fact women's fault because they had ruled the airwaves for too long with soap operas that portrayed women as "sexually aloof, emotionally eclectic, and morally rock-like" and turned men into "helpless ciphers" or "in the primeval days of television, lovable boobs" (17). Now, the avant-garde, alienated male hero took revenge against women for their previous broadcast crimes. Thus, at a time when the critical distance between TV and the avant garde was being blurred, male pop culture heroes in male identified genres (doctor shows, police shows, single-dad sitcoms) were being reclaimed as high art, largely because they had a "queer" relation to the "normal" heterosexual coupling of 1950s television.

Perhaps the most literal incarnation of the "queer" on television was a 1967 episode of *Batman* entitled "POP Goes the Joker" in which the Joker decides to steel

Gotham City's famous paintings and replace them with his own POP art. The Joker enters an art contest staged at the Gotham City Museum that has him squared off against equally bizarre artists whose paintings are all spoofs of European or American modern art. After winning, he sets up an art school for rich women who become partners in his art crimes. The Joker's perverse control of the women of Gotham City and their mutual irreverence toward the art of the city fathers is predictably countered by the equally queer Batman and Robin who retrieve the paintings and return them to their proper place.

From hindsight "Pop Goes the Joker" reads as a bizarre inversion of the more "serious" programs that represented museums on American television during the late 1960s. Intended in part as promotional vehicles for its parent company's new RCA color TV sets, NBC news presented a series of "in living color" documentaries that perpetuated the notion of the museum as a space of nationalism. These included documentaries on the Kremlin, the Whitney, and the Louvre. In the 1967 Whitney special, significantly entitled "The American Image," the nationalist pedagogy inherent in these shows was explicitly stated by host E. G. Marshall who introduced the program saying, "Our story is the story of the artists' search, the search for the American dream." The search turned out to be a colonialist narrative in which a title card stating "The Land" was followed by close-ups of wilderness paintings after which the camera focused on frontier paintings showing settlers conquering Indians. The program went on to show twentieth-century cityscapes and ended with postwar abstraction and POP. Despite this colonialist search for an American vernacular, the NBC news division still conceived of America as cultural colony of Europe, a point which is similarly apparent in the 1964 documentary about The Louvre. Entitled "The Golden Prison" and narrated by French actor Charles Boyer, this program also presents the national archive through a geographical metaphor of landscape. At the outset, Boyer gives the audience a history lesson in Parisian geography, demonstrating through maps that the Louvre has been the center of Paris for centuries. He then advises his American audience, "The way to see the Louvre is with a French man."

Although this kind of nationalist pedagogy was still the dominant discursive mode for representing the museum, it was being challenged at the time by an emergent set of revisionist and/or revolutionary positions toward art and its collection that was encapsulated by critical terms like "anti-art," terms which suggested that the avant garde was dead, that all art was fundamentally elitist, and that the only revolutionary position left was to reject art altogether. To be sure, such critics were in historical dialogue with a well entrenched intellectual critique of museums that people such as T. W. Adorno and Walter Benjamin had participated in during the 1930s and 1940s, and which the DADA movement had challenged in the 1920s with its idea of living art and the Cabaret Voltaire.[22] In the 1960s, art critics went one step further by suggesting that art itself could no longer function as a response to social and political crisis.

The art world's rejection of art dovetailed in complicated ways with the more populist "George Burns" dismissal of modern art on the basis of its inferiority and

336 illegibility. Although both camps argued against "elitism," the first group imagined art should *ideally* have a revolutionary function (but no longer could), while the second was conservative in nature, hoping to hold onto the kind of representational art that encouraged consensual viewpoints. But precisely because the two opposing camps shared some common ground (their anti-elitism), it was easy for television to conflate these radically opposing views and popularize POP and other art movements which implicitly challenged representational art. From the point of view of anti-art critics, The Joker, for example, could certainly be championed as a revolutionary Dandy who integrated art into his everyday criminal life and sabotaged the city fathers and their elitist canon. Or, from the populist point of view, the Joker could be read as a big joke on the illegible, untalented, and eccentric POP artists of the times. But, even as these alternative positions on POP art and popular culture prevailed, the emerging universe of global television was dreaming up its own possibilities in which the aesthetic hierarchies of "high" and "low" art would merge with the new scientific hierarchies of "high" and "low" tech.

Art into Science

When E. G. Marshall presented the modern art collection at the Whitney Museum he announced that "modernism is born of Einstein" and the theory of relativity. While he was certainly not the first person to put forth this view, the fact that modern art was conceptualized through a scientific revolution was symptomatic of a larger trend in television's relationship to modern art, a trend that was best encapsulated in 1967 when NBC News offered another, very different kind of museum documentary entitled *Bravo Picasso*.

The first global satellite television program to be produced by the networks, *Bravo Picasso* linked together European modernism, telecommunications science, and American commercialism in what the narrator called "an imaginary museum, a museum without walls. Using man's electronic genius to bring you his creative genius." Quite different from the previous "pedagogical" representations of museums, *Bravo Picasso* is instead a simple performance of the point of sale. It is an international auction of Picasso paintings that took place in 5 separate places: Paris, London, Dallas-Fort Worth, Burbank, and Los Angeles. Bidders from the different cities competed via satellite for bits of the master's oeuvre.

While the program continued with many of the conventions of art education on TV, its focus on the performance of the global sales pitch rendered the national pedagogy seen in programs like *The Golden Prison* an afterthought. For example, while *Bravo Picasso* told viewers that "the way to see them [Picasso paintings] is with a French man," in the same passage it also pointed out that the paintings were from eleven different countries, and in any case the spectacle of metropolises interconnected via satellite made the "French-ness" issue dull in comparison. In addition, while the figure of femininity still served to organize the representation of modern painting (Yves Montand, stationed in Paris, quotes Picasso saying, "When I love a woman, I don't start measuring my limbs, I love with my heart and my desire"), modernism's objectification of femininity is now

undercut by another object relationship—the commodity form—as the program makes a kind of "pretzel logic" transition to an ad for the Avnet company. Standing before one of the many women Picasso "loved," (that is, his famous *Girl in the Mirror*) the narrator says, "Art has many faces. The dictionary says art is the production of more than ordinary significance. At Avnet business is an art." Avnet (and its co-sponsor RCA) went on to show the new uses for satellite communications, computers, and space science for which these two companies were famous. This transition from a romantic conception of modern art to the art of big business continues with the trajectory of the 1950s, but now takes this merging of high and low away from the quest for the national vernacular and into the global space of high-tech satellite communication.

Meanwhile, making the situation even more uncanny, the celebrity bidder at this global auction was the premier modern woman (and one time representative of the nation), Jackie Kennedy (now Jackie O) who, famous for her utter rejection of fame, bought the painting in absentia on behalf of the Italian Rescue Fund. Lost to the national iconography, now the First Lady was transformed into the first home shopper floating somewhere in the cash flow of a global satellite mall.

Indeed, if any one instance can ever be said to precipitate a movement, *Bravo Picasso* signals, I think, the first truly postmodern media event on television. Its technologically constructed global marketplace, its "no excuses" attitude towards the mercenary nature of art, its utterly irreverent conception of modernism, its First Lady turned superstar consumer, it complete disregard for the "meaning" of the art work, and its dramatization of the work's arbitrary market value—all of this encapsulates the central elements of a television culture that moved away from the Wasteland's modernist rhetoric of nationalism and public culture toward a postmodern sensibility where the nation became a thrift shop for modern art. In *Bravo Picasso*, the modern ideal of the national museum that houses artists who express their "nation-ness" gave way to the postmodern concept of an art mart in global space where the real spectacle is not the work of art but the staging of the sale of art in the age of satellite transmission.

This new form of postmodern media event, constructed through the merger of space science, art, and commerce, was nowhere better seen than in the 1960s penchant for rocket take-offs and their culmination in the 1969 Moon Landing. For President Kennedy, who still imagined space travel in the modernist terms of national progress, the most important aspect of the space race was that it was being covered live and uncensored on American television. Indeed, to all the skeptics in Congress who opposed the use of tax dollars on NASA, Kennedy suggested that the ideological value of the space race lay in its ability to show that America, as opposed to Communist regimes, was a democracy with a free press.[23] Meanwhile, the television industry certainly had much to gain from his faith in the press because the rocket launches proved to be a great commercial success. The A. C. Nielsen rating service estimated that the average home was tuned-in for five hours and fifteen minutes of the ten hour coverage of John Glenn's orbital flight on February 20, 1962. This was, according to A. C. Nielsen, "by far the largest audience ever tuned to

338 daytime TV"; even at its "low" moments the program reached "5 million more homes than typically tuned to the highest-rated network [prime-time] program, WAGON TRAIN" (Ephron, 1962, 1). Presumably, the public's fascination with the new frontier had far surpassed its passion for the old.

Not only did the space race link science and commercialism, it also merged the two with art. At the level of everyday life, this interest was expressed in the visual culture of suburban design in everything from new space age facades tacked onto old diners to space age kitchenettes and fashions. This new anesthetization (or perhaps NASAfication) of everyday life was easily meshed with the ethos of avant-gardism that had historically celebrated art that was integrated into life. In the 1960s, the space race was embraced in this sense of "living art" by the New York art world—at least in the pages of one of its premier journals, *Art News*. Writing for the journal in 1971, critic Alan Kaprow argued:

> That the LM Mooncraft is patently superior to all contemporary sculptural efforts; that the broadcast verbal exchange between Houston's Manned Spacecraft Center and the Apollo astronauts was better than contemporary poetry; that, with its sound distortions, beeps, static and communication breaks, such exchanges also surpassed the electronic music of the concert halls; that certain remote control video tapes of the lives of ghetto families recorded (with their permission) by anthropologists, are more fascinating than the celebrated slice-of-life underground films; ...that the vapor trails left by rocket tests—motionless, rainbow colored, sky-filling scribbles—are unequaled by artists exploring gaseous mediums; that the Southwest Asian theater of war in Viet Nam, or the Trial of the "Chicago Eight," while indefensible, is better theater than any play, that...etc. etc., non art is more art than Art-art. (28)

Kaprow was part of the decade's general interest in breaking down high and low aesthetic hierarchies, and taking this to its terminal extreme, he was critical even of the "anti-art" crowd (those people who were against art), and instead championed what he called "non-art"—or media like television that were integrated into everyday life and unintentionally presented moments of what he considered to be sublime. Later in the essay he predicts that the new "inter-media" environments of computers, video, etc. (what we would call the information superhighway) will be the spaces where this type of non-art takes place.

What, however, stands out in this supposedly radical anti-elitist treatise is its amazing equivocation between what Kaprow sees as the unintentional art offered by television coverage of the space race and the more obviously lurid "fascination" with the theater of war and the "remote control video tapes of ghetto families recorded (with their permission)." Indeed, while many Americans positioned the space race as the stuff that poetry was made of (in fact, Kennedy's files are filled with poems about space that Americans sent to him), those people typically relegated to urban ghettos definitely did not give their permission to this set of images. They did not view the space race—on television or otherwise—as a poetic epiphany or a moral victory. Instead, critics in the black press often pointed out that while the space project was busy sending white men to outer space, housing

projects were undermining the nature of African American life in inner cities.
Ebony magazine, for example, reminded its readers that "from Harlem to Watts,
the first moon landing in July of last year was viewed cynically as one small step for
"The Man," and probably a giant step in the wrong direction for mankind"
(Morris, 1970, 33). Such criticism in fact was turned into an alternative form of
black poetry by singer-songwriter writer Gil Scott Heron. Most famous for his pop-
ular hit "The Revolution Will Not Be Televised," Heron composed a song he called
"Whitey On the Moon," which detailed the decidedly racist aspects of what art crit-
ic Alan Kaprow had imaged as a new technological/poetic sublime. For African
American artists and critics, whose ideas on these subjects did not typically enter
into the forum of debate with television executives, FCC commissioners, and art
world elites, the postmodern blurring of aesthetic hierarchies through television
and new media that a critic like Kaprow imagined did nothing to change racial
hierarchies. Indeed, as the TV trip to the moon proved, white men were still on top.

Whatever the intentions, it remains evident that the discourse of the "NASA
sublime" was blatantly racist and often worked through the binary logic of pitting
outer space against inner cities. What is particularly interesting in this case is that
Kaprow's poeticization of poverty found its televisual equivalent in a special CBS
documentary entitled "A Day in the Life of the United States" which was filmed on
the day of the Moon Landing. The special featured reporter Charles Kuralt (famous
for his "on the road" news segments), who took to the road in a quest to under-
stand what Americans were doing and thinking on this awesome day. At the outset
Kuralt told the audience, "Family life is the most common thing Americans did on
July 20th, 1969," after which the documentary showed a host of families around the
country. When, however, the reporter came to the Chicago ghetto, the narration
took a different spin as the cameras penetrated a barroom on Langly and 43rd
street, gaping at African Americans dancing and drinking "cheap wine" in a world
unimpressed by the white man's greatest colonialist venture to date. The segment
was also the only one in which the white Charles Kuralt was substituted with
George Foster, an "insider" black reporter who offers up poverty as a form of non-
intentional art, comparable to the Moon Landing. As the visuals show African
Americans dancing and drinking, he says: "You're in the ghetto's ghetto, the slum's
slum, you're at the bottom of the heart of America.... You tell me how you'd reach
these people. These half educated hustlers. Hiding behind hallelujahs and cheap
wine. Tell me if you don't feel some beauty here. Something noble in this nigger
bar." While reporter George Foster is strangely similar to Kaprow's notion of "non-
art" in his embrace of the unintended beauty of ghetto poverty, this documentary
does provide an alternative notion of art within the ghetto itself, one that main-
tains a sense of progressive politics. This is evidenced when the scene cuts to two
huge murals depicting black poets, artists, and civil rights leaders painted on the
building walls outside the bar. The murals are the work of artist Bill Walker.
Introducing him, Foster says, "He used to be a modern artist. He played the money
game with the galleries and the abstract art. But he gave it all up to paint this wall
with his friends."

340 Thus, by the end of the 1960s, television could no longer completely contain the racism at the heart of its search for the American vernacular. Instead, television seemed unsure of how to present the issue of race in relation to modern art and modern science on this day of the Moon Landing. Not invited along for the ride, African Americans could, so to speak, only "get high" through cheap wine and popular culture. Still, as the documentary also suggested, there was a long tradition of black artists who had struggled to paint counter-memories in the urban "wastelands," outside the white spaces of art museums and television culture, and now the white occupied territory of space itself. While CBS packaged this documentary in the "poetics of poverty" genre that ultimately appealed to the "humanism" of white viewers, the fact that CBS turned its eye to this alternate vision of modern art suggests that by the end of the decade the quest for the American vernacular, like the space race itself, was so disputed that it could no longer be represented as television's national purpose.

Newton or Newt?

Given the amount of fervor around the collapse of high and low, it is especially ironic that the technological "hardware" that was finally put in place after all these debates was the formation in 1967 of the Corporation for Public Broadcasting (CPB), which in turn launched its network, the Public Broadcasting System (PBS), in 1969. Funding came from the government as well as the now "old" modern captains of industry like the Ford Foundation. From the start, CPB was committed to the Progressive Era ethos of pedagogy and "uplift" for the masses that had been so central to modernity's museum culture, that had merged by the 1920s with advertising and store design, and which still dominates our commerce-oriented museum culture now.

Within this trajectory, the old ambivalences regarding the nationalist roots of American art resurfaced in programs that still express America's debt to Britishness (*Masterpiece Theater*), and which are sandwiched between more indigenous productions of American documentaries, video art, and the theatrical arts. Rooted in Minow's attempts to restore hierarchies of taste to the Wasteland, yet appearing at a moment when commercial television and the art world were collapsing these hierarchies (and even declaring them commercially unpopular and artistically retrograde), PBS has been forever lost in its struggle to preserve the distinction between high and low, winding up finally in the imaginary and ever narrowing "middlebrow" in its appeals to its private donor-public.

Clearly, this has been exacerbated by the fact that in making such distinctions, PBS, which is after all increasingly sustained by private funding organizations and private donors, and is even governed by a federally appointed private corporation (The Corporation for Public Broadcasting), has had to pretend to speak disinterestedly for what technocrats at the FCC always call the "public" interest. The Corporation for Public Broadcasting has historically been troubled by its failures to define what the public is, what they might be interested in, and what the meaning

of public art might be. Was PBS a place for experimental artists or simply a second rate transmission of the European and British classics? Would it address a nation of philistines with a deeply condescending form of art education, or would it be a venue for the last wave of a critical avant garde? Would it give in to corporate censorship, or would its leaders fight for some degree of autonomy from sponsors? Undecided about its own public image and structurally dependent on large funding corporations, private donors, and Congressional dollars, PBS—and the recent funding cuts it suffered—needs to be understood within a genealogy of discourses about the meaning of modern art on television. As my early research on the topic begins to suggest, those discourses have everything to do with implicit and related battles over nationalism, sexuality, race, and class.

By looking at television's historical representation of the arts, this generation of popular culture critics might usefully reinvestigate our own implicit and explicit embrace of popular culture over "high" culture. The scholarly investment in popular television and popular audiences, which itself grew out of the well intentioned "anti-elitist" critical environment of the 1960s, can nevertheless lead to a troubling complicity with Speaker of the House Newt Gingrich who sees Rush Limbaugh as the preferred substitute for public television and the public sphere more generally. While I am certainly not advocating a return to Newton Minow's paternalistic attempts to restore a certain form of privileged middle-class "taste" to the Wasteland, and while I am often unhappy with the way public television has turned out, I think it is time to be a little artsy and to imagine a form of critical engagement that takes us somewhere else for a while.

It seems particularly important for popular television (and television studies) to engage more with the work being done in video and to think more about why video and television (both the producers and the critics) have remained so completely detached from one another. Oddly enough, despite all the talk of the mergers between high art and low TV that has been going on since the 1960s, the truth is art and commercialism did not actually merge quite as fully as people seem to believe. Instead, in the late 1960s art was simply reassigned a new word—video— that made it distinct from television. Video and its portapak technology grew in the art world context of New York and posed a challenge to Hollywood through a resurrection of personal authorship, non-studio work, and a penchant for spontaneity over formula. In critical circles, the logic of the high and low distinction became wedded to medium specificity arguments as numerous critics began a frenzied debate over the essential properties of video vs. television.

Still, in some ways, by posing themselves as counter-television or medium specific, video artists and critics got weighed down by the discursive baggage surrounding modern art on television in the previous two decades. Now it was video art that represented the foreign threat of modernism. And while it had connections to the European Avant Garde (especially through the French New Wave and the work of Jean-Luc Godard), during the "hot war" years of Vietnam, the more immediate foreign threat was Asia: Sony was the company behind the portapak and its

342 premier artist was the New York-based Nam June Paik. (And, in this case, the video artists were even assigned the military language of the war in Vietnam insofar as they were known as "guerrilla" artists).

It should be obvious at this point that the contemporary issues surrounding art on television are deeply historical and political in nature, and these historical struggles are neither resolved through nor derailed by a new postmodern sensibility. Rather, the legacy of relationships between modern art and television continues to inform the way we make distinctions among "public" television, commercial television (which now includes cable), video art, and even such new technologies as the internet (with its collectors and fan lines) and CD ROMs (which now include interactive museums). Despite my desire to conclude with an appropriately modernist utopian statement about the way these technologies might integrate art into the practices of everybody's everyday lives, it seems disingenuous at best to make such a statement, especially given the complicated politics involved in the prior criticism that has done so. But it does seem important, at the very least, that popular culture critics start thinking seriously about their own relative silence on the state of the arts in television because if we don't speak, you can be sure the Speaker of the House will.

Notes

1 MOMA, however, did exhibit a slicker use of the film medium in a 1948 documentary entitled "What is Modern Art?" produced by the Princeton Film Center and filmed at MOMA. Promoting the museum's collection, the documentary uses a similar rhetorical style as the 1954 TV special, pairing a modern art expert (this time Russian painter Vladimir Sokoloff) with a skeptic (this time, Neva Patterson, a woman who poses as "just a photographer" taking pictures of the collection). The exchange between the couple is blatantly laced with sexual innuendo, which, as I will make clear, is a running theme in television's discourse on modernism. This film is held at the UCLA Film and Television Archive, Los Angeles, CA. The MOMA TV show is held at the Museum of Television and Radio, New York, N.Y. Unless otherwise indicated all the other programs herein are held at the Museum of Television and Radio.

2 MOMA continued to advertise its collection through television. For example, in a joint venture with the television program *Camera 3*, it publicized its show for the 75th anniversary of Picasso, and in another *Camera 3* museum director Alfred Baar presented a detailed study of the Guernica.

3 The two exceptions that seem particularly important are Rose (1985) and Caldwell (1995).

4 Amy Marver's unpublished dissertation research offers rich insight into the early links between MOMA, haute couture, and upscale New York City department stores.

5 See chapter 8, "Making It A Thing of Art." She included an ad for Bonwit Teller that pronounced "Art, History and Fashion collaborated to revive the vogue of figured fabrics, lifting the veil of ancient civilizations from Peru to Persia, souring the wide world from Java to Japan in quest of beauty in design" (137). This early connection between modern and primitive art, now being explored by art historians in relation to art movements such as cubism and fauvism, was already articulated by the fashion industry of the 1920s which made those connections in terms of the literal "material" culture of its day.

6 Although the Stanford report did not make this correlation, it is interesting to note that as art became cheaper to see through technological reproductions in mass media, according to the same report, "the price of original paintings rose over 600% in the U.S." (Long Range Planning Service, 4).

7 The term "the ugly American" was coined by William J. Lederer (1958) in his book of that title. I am using it to cover the concept that prevailed at the time, but it should be noted the term itself was not in popular circulation during much of the period.

8 As Guilbaut (1983, Chapter 2) suggests, mass media such as radio and magazines had in the 1940s popularized ideas about modern art in America.

9 This is not to say that white women and black men were exclusively representative of modern art. Indeed, they were just as often used as signifiers of mass culture on TV. I am simply pointing out that the demonization of women and blacks was rather "democratic" in its associative logic so that if modernism happened to be represented as the enemy in a given text, it could just as easily be represented by the unruly forces of femininity and race as could mass culture.

Meanwhile, in the case of network television's representation of heroines of color—which in the 1950s was rare—the issues seem somewhat different. I am thinking especially here of the one network program to feature a black woman, *Beulah*. Beulah's character (played in the 1950–1952 seasons by singer-actress Ethel Waters) had "jazz" age connotations, especially seen in an episode entitled "The Dance Teacher" in which Beulah teaches the young white son of the house how to dance in what she calls the "groovy" style as opposed to the refined ballroom dance styles the boy learns at his all white dance school. Perhaps not surprisingly, I have never come across a program that features a black woman (or man for that matter) portrayed as a visual artist. As with Armstrong, music is the central art through which blacks are depicted, and as with Armstrong this is coded as popular American music, even while it still has some connotations of "otherness."

10 William Boddy (forthcoming) discusses these issues around foreign syndication in his work on the Thomas Dodd television violence hearings.

11 One of the Kennedy Administration's greatest exploits was a closed circuit TV program entitled "An American Pageant of the Arts" that was aired to promote Kennedy's plans for the construction of the National Cultural Center. Produced by *Omnibus* producer Robert Saudek, the program was broadcast on 29 November 1962 to paying audiences in 100 cities across the country (ticket prices ranged from $100.00 to $2.00 according to venue). It included an eclectic mix of musical and comedy acts from the "serious" conductor (and host) Leonard Bernstein, the poet Robert Frost, and "legitimate" actors like Colleen Dewherst to the likes of popular entertainers like Danny Kaye, Gene Kelly, Tammy Grimes, Benny Goodman and Harry Belefonte ("An American Pageant of the Arts," [1962]: 3).

12 This theme of the older woman and her liaison with a modern painter was repeated in a 1953 episode of *Armstrong Circle Theater* entitled "The Secret of Emily Duvane," which is held at the UCLA Film and Television Archive. This episode, which is set in Singapore and deals with a woman and her extremely colonialist-minded husband, is an incredibly rich example of the way older American women are presented as modern primitives.

13 Michael Rogin (1987, 236–71) discusses the links between communism and momism in American film of this period.

14 As early as 1945, premier art critic Clement Greenburg, most famous for his opposition between the "avant garde" and "kitsch," noted the trend for industry's co-optation of modernism, warning, "We are in danger of having a new kind of official art foisted on us—official 'modern' art. It is being done by well-intentioned people like the Pepsi-Cola Company…. official 'modern' art of this type will confuse, discourage and dissuade the true creator" (604).

344 15 It also seems worth noting that cartoon art used for television reviews in major periodicals often employed abstract styles to depict television and television programming. In this regard, through the institution of TV criticism and its links to commercial art, the reading public would have occasion to acquaint themselves with elements of modern design. An article in *Television Quarterly* even compared the editorial cartoon (in both print media and on television) to the French new wave film *Last Year at Marienbad*. See Chase (1967, 4).

16 For a detailed study of the arts on television see Rose (1986).

17 Along these lines it is interesting to note that numerous fiction programs thematized the fraudulent nature of art in stories about forgery. One critic pointed out: "The most drastic proof of art's descendent popularity is that it so often supplied the dramatic plot for ambitious TV programs. I don't how many times during the past two years I've watched mystery stories in which the theft or forgery of a painting has been the subject of complicated exercises in skullduggery and sleuthing (Soby, 1957, 29).

18 The Museum Commission was formed by the Los Angeles Board of Supervisors in 1959. The Advisory Council included Desi Arnaz, Jack Benny, Frank Capra, Walt Disney, William Dozier, Jack Warner, Arthur Miller, Ronald Reagan, and Harold Lloyd. The exact wording of the founding document was "The goal is to portray these four communicative arts as having a justification not only as entertainment media but also as important contributions to humanity…the Museum will be of aid in a positive way in overcoming the damaging effect of the constant and growing criticisms of the industries by numerous private and public groups" (Lesser, 1962, n.p.). In line with Kennedy's use of art as a strategic force in "free world" rhetoric, the museum promoters sent a telegram to Robert S. MacNamara, Secretary of Defense, saying that the mass media represented in the museum would help create better understanding among nations (Schumach, 1963, n.p.). There were groundbreaking ceremonies in 1963, but the museum did not materialize.

19 One year before *Batman*, ABC aired the short-lived and still black and white series *Honey West*, a female spy show that was inspired by the popularity of James Bond, but also used POP pulp fiction themes and sometimes POP iconography. The program played with the "threat" of the modern woman and her eccentric visual style, presenting Honey as a high tech femme fatale dressed in leopard who kicked, whipped, and even wrestled male enemies. For a interesting analysis of the program see D'Acci (forthcoming).

20 It could, of course, be argued that POP borrowed mass culture's borrowing strategies before this insofar as both film and broadcasting had relied heavily on the fine arts for subject matter, and they both borrowed forms of exhibition from the world of theater and the arts. However, in this case, it seems to me that television now borrowed a particular kind of borrowing strategy from POP, one that was playfully ironic and self-reflexive. The *Batman* "in-crowd" reception was filled with this kind of playful irony and self-reflexivity, as was the program itself.

21 Lears (1994, 282–98) shows that this debate regarding the status of advertising as art took place as early as the 1890s.

22 For a discussion about the history of debates about museums see Sherman (1994).

23 For example, in his written script for his May 8, 1961 address to the 39th annual convention of the National Association of Broadcasters (NAB), Kennedy, speaking of the flight of Alan Shepard, admits that "This flight was not as spectacular as that which the Soviet Union conducted a few weeks ago," but adds "nevertheless this flight was a great achievement and, in a very real sense, the manner of the flight was a tribute to the strength of a free society. For no secrecy surrounded the launching of our first astronaut. We did not conceal the anxious hours of waiting, the dangers of uncertain adventure, the possibilities of failure. On the contrary, the members of your association and the members of the press car-

ried the news of each moment of tension and triumph to an anxious world." (Office of the
White House Press Secretary, 1961, 1).

References

Boddy, William (forthcoming) "Investigating Video Violence in the Early 1960s." *The Revolution Wasn't Televised: Sixties TV and Social Conflict*. New York: Routledge.

Bourdieu, Pierre (1980) "The Aristocracy of Culture." *Media, Culture, and Society* 2: 225–54.

Caldwell, John Thornton (1995) *Televisuality: Style, Crisis, and Authority in American Television*. New Brunswick, NJ: Rutgers University Press.

Chase, John (1967) "The TV Editorial Cartoon." *Television Quarterly*, 6:2: 4–19.

D'Acci, Julie (forthcoming) "Nobody's Woman: *Honey West* and the New Sexuality." In L. Spigel and M. Curtin, eds. (forthcoming).

"Discotheque Frug Party Heralds Batman's Film and TV Premiere" (1966) *New York Times* (13 January): 79.

Doss, Erika (1991) *Benton, Pollack, and the Politics of Modernism: From Regionalism to Abstract Expressionism*. Chicago: University of Chicago Press.

Doty, Alex (1994) *Making Things Perfectly Queer*. Minneapolis: University of Minnesota Press.

Ephron, Erwin H. (1962) A. C. Nielson Company Press Release, "News Nielson: 40 Million Homes Follow Telecast of First U.S. Orbital Flight." In White House Central Staff Files, Box 655: File 054, ca. 21 March, John Fitzgerald Kennedy Library.

Golden, Joseph (1963) "TV's Womanless Hero." *Television Quarterly* 2:1: 13–25.

Gould, Jack (1966) "Too Good to be Camp." *New York Times* (23 January): Sect, I: 17.

Greenburg, Clement (1945) *Nation* (1 December): 604.

Guilbaut, Serge (1983) *How New York Stole the Idea of Modern Art: Abstract Expressionism, Freedom, and the Cold War*. Trans. A. Goldhamme. Chicago: University of Chicago Press.

Hamburger, Estelle (1939) *It's a Woman's Business*. New York: Vanguard Press.

Huyssen, Andreas (1986) *After the Great Divide: Modernism, Mass Culture and Postmodernism*. London: Macmillan.

Jencks, Richard W. (1969) "Is Taste Obsolete?" *Television Quarterly* 8:(3): 5–21.

Kaprow, Alan (1971) "The Education of the Un-Artist, Part 1," *Art News* 69(10): 28.

Kuh, Katharine (1961) "The Unhappy Marriage of Art and TV." *Saturday Review* (21 January): 61.

Lears, T. J. Jackson (1994) *Fables of Abundance: A Cultural History of Advertising in America*. New York: Basic Books.

Lederer, William J. (1958) *The Ugly American*. New York: W. W. Norton & Company.

Malraux, Andre (1963) "The Meaning of Culture," 9 November Address before the French National Assembly. Excerpted and Reprinted in *Television Quarterly*, 3(1): 44–45.

Marchand, Roland (1985) *Advertising the American Dream: Making Way for Modernity, 1920–1940*. Berkeley: University of California Press.

Marling, Karal Ann (1994) *As Seen on TV: The Visual Culture of Everyday Life in the 1950s*. Cambridge: Harvard University Press.

McLuhan, Marshall (1964) *Understanding Media: The Extensions of Man*. New York: McGraw Hill.

Minow, Newton N. (1964) "The Vast Wasteland," *Equal Time: The Private Broadcaster and The Public Interest*. New York: Atheneum.

Office of the White House Press Secretary (1961) "The White House Address of the President to the Opening Session of the 39th Annual Convention of the National Association of

346 Broadcasters, Draft of Speech," 9 January–25 May, President's Office Files/Speech Files, Box 34, John Fitzgerald Kennedy Library, Boston, MA.

Rogin, Michael (1987) *Ronald Reagan: The Movie: And Other Episodes in Political Demonology*. Berkeley: University of California Press.

Rose, Brian G. (1986) *Television and the Performing Arts: A Handbook and Reference Guide to American Cultural Programming*. New York: Greenwood Press.

Rowan and Martin's Laugh-In (1969) Script #0283–14. Air Date: 6 January. Doheny Cinema Library, University of Southern California, Los Angeles, CA.

Rowan and Martin's Laugh-In (1969) Script #0283–20. Air Date: 17 February. Doheny Cinema Library, University of Southern California, Los Angeles, CA.

Rowan and Martin's Laugh-In (1969) Script #0283–21. Air Date: 24 February. Doheny Cinema Library, University of Southern California, Los Angeles, CA.

Rowan and Martin's Laugh-In (1969) Script #0283–25. Air Date: 24 March. Doheny Cinema Library, University of Southern California, Los Angeles, CA.

Sherman, Daniel J. (1994) "Quatremere/Benjamin/Marx: Art Museums, Aura, and Commodity Fetishism." In D. J. Sherman and I. Rogoff, eds. (1994) *Museum Culture: Histories, Discourses, Spectacles*. Minneapolis: University of Minnesota Press.

Skow, John (1966) "Has TV Gasp Gone Batty?" *Saturday Evening Post* (7 May): 95.

Soby, James Thrall (1957) "Art on TV," *Saturday Review* (13 April): 29–30.

Spigel, Lynn (1991) "From Domestic Space to Outer Space: The 1960s Fantastic Family Sit-Com." In *Close Encounters: Film, Feminism, and Science Fiction*. Ed. C. Penley, Elizabeth Lyon, Lynn Spigel, and Janet Bergstrom. Minneapolis: University of Minnesota Press.

Venza, Jac (1962) *Television U.S.A.: 13 Seasons*. New York: The Museum of Modern Art Film Library and Doubleday.

Weales, Gerald (1967) "Be Quiet, The Commercial's On." *Television Quarterly* 6(3): 24.

Wollen, Peter (1993) *Raiding the Icebox: Reflections on Twentieth Century Culture*. Bloomington and Indianapolis: Indiana University Press.

Wylie, Philip (1955) *Generation of Vipers*. New York: Holt, Rinehart and Winston.

Paula A. Treichler

16

HOW TO USE A CONDOM

BEDTIME STORIES FOR THE TRANSCENDENTAL SIGNIFIER

1. Boys' Life

A girl is told by her mother that she should allow her preferred boyfriend to have intercourse with her, and that when he leans back afterwards she should say "Well, what'll we name the baby?" and then he will have to propose. The daughter tries this method. "Well," says the man, throwing the condom out the window, "if he can get out of that we'll call him Houdini."[1] (joke, 1947; cited by Legman 1968, 434)

For many decades in the United States, the condom occupied a special place in the sexual imaginary of teenage boys, a place captured nicely in the 1971 film *Summer of '42,* itself an adult remembrance of adolescence during World War II.[2] In one scene, Hermie, the 15-year-old protagonist, is being tutored for a date by his more sophisticated pal Oskie, their text an abstruse sex manual swiped from Oskie's parents. Having worked his way through the manual's step-by-step instructions, Hermie (with misplaced optimism) spots a problem:

HERMIE: Look Oskie, if I follow these 12 points, she just might have a kid—and I tell you I can't afford a kid at this stage of my life. So the whole thing's off.
OSKIE: I really can't believe it, Hermie. You are really dumb!

HERMIE: I may be dumb but I'm not gonna be a father. Two wrongs don't make a right.
OSKIE: You use protection. You use a rubber. Haven't you ever heard of a rubber?

Oskie shows Hermie the treasured condom bequeathed him when his older brother went off to war. Armed with this talismanic authority, Oskie tells Hermie he will have to brave the drugstore to acquire his own.

HERMIE: Oh, no, I'm not gonna risk it. I happen to be underage. And, for your information, Oskie, women shop in drugstores.
OSKIE: OK, so where do you wanna get it? A sporting goods store?
HERMIE: Well, if you were a really good friend, you'd lend me *yours*.
OSKIE: WHAT?
HERMIE: I'll return it to you.
OSKIE: Hermie, I'm beginning to think you must be a homo!... You don't know *anything*. A rubber is to be used once and only once. And only by one party. Not even the best of friends can go halvsies on a rubber.

The drugstore scene depicts a rite of passage often recounted in twentieth century literature. With Oskie supervising through the pharmacy window, Hermie loiters miserably as long as he can but finally gets up the courage to approach the druggist and order: an ice cream cone. Stalling his way through three scoops, sprinkles, and a napkin, he's finally out of excuses:

DRUGGIST: All right—anything else?
HERMIE: How about some rubbers?
DRUGGIST: Pardon?
HERMIE: I understand that you carry them.
DRUGGIST: Carry what?
HERMIE: Aw, come on—you know what!
DRUGGIST: Contraceptives?
HERMIE: Yeah, right.

The druggist tortures Hermie:

DRUGGIST: What brand?
HERMIE: Brand?
DRUGGIST: Brand and style?
HERMIE: The usual
DRUGGIST: Well [setting samples on counter] there's a number to choose from. Which is your usual?
HERMIE: The blue ones
DRUGGIST: All right—how many would you like?
HERMIE: Ohhh...3 dozen.
DRUGGIST: Planning a big night?[3]

When the druggist queries Hermie about his age and what he plans to do with the

condoms, Hermie stammers out that they're for his brother. The druggist asks again whether he knows what they're used for.

HERMIE: Yeah, you fill em up with water and then you throw em off the roof
DRUGGIST: OK. I just wanted to be sure you know what they were used for.
HERMIE: My brother wouldn't send me to buy anything without telling me what they're used for!

The condom has been called the "perfect anticonceptual remedy" (Gordon 1976), a characterization both literally and metaphorically germane: for the condom is not only an effective birth control device, it is also an "anticonceptual" technology, so mundane and simple that anyone can make it work, anywhere in the world. The *Summer of '42* encapsulates the features of "condom discourse" that existed in pre-1980s cultural memory: a masculine oral tradition passed along from older to younger brother, veteran to rookie; a symbol of sexual knowledge and index of sexual prowess—make that heterosexual prowess, for as Oskie disdainfully charges, "homos" know nothing about rubbers. Indeed, the condom's historical non-relevance within homosexual subcultures was a major challenge gay men faced in pioneering safer sex campaigns for their community; there was no cultural tradition to build on. What's absent from the film is any implication that the condom will lessen the pleasure of the sexual experience. Rather, the condom's dual purposes invoke a world of adult male knowledge and practices, a world that both acknowledges and provisionally evades the entailments of the heterosexual matrix; to purchase a condom pits the would-be transgressor against adult professional authority. To pass successfully through this public Checkpoint Charlie into the patriarchal realm of the symbolic, he must speak the right language, naming out loud the commodity that the conspiracy of silence has long forbidden and withheld—a conspiracy that has been, for most of its history, decidedly gendered. When Hermie finally acknowledges that he knows what a condom is used for—you fill them up with water and throw them off the roof—he opts for a child's pre-symbolic universe.[4]

Today, however, in 1995, "condom discourse" is significantly different. It is varied and voluminous. The condom has become the mirror—or receptacle, if you will—for broad debates about disease and sin, technology and nature, transgression and desire; and it appears to have opened debates on these matters irrevocably. One of our central Illinois congressional representatives said a few years ago that he never dreamed that in his lifetime condoms would become a topic not only mentionable in public but discussed at his own family dinner table. Many readers have no doubt seen the heady safe sex poster in which a dramatically erect penis, rendered in glorious photographic detail, stands beside the textual imperative "MEN: USE CONDOMS OR BEAT IT." A 1991 news story from Dar es Salaam in the *Kenya Daily Nation* reported that a 24-year-old Tanzanian woman murdered her husband (hacked him to death with a hoe) when she found condoms in his trouser pocket and he bragged about using them with his mistress ("Woman kills husband," 1991).

350 In 1994, the *New England Journal of Medicine* cautioned that counselling women to insist their male partners wear condoms may, by raising the possibility of infidelity in the relationship, put them at greater risk of violence or death than HIV does. In 1996, oceanographic scientists discover a vast floating "reef" in the South Pacific formed from some portion of the world's used condoms (millions per year); the mass is almost two miles long, an eighth of a mile wide, and in places up to 60 feet deep.[5]

From these examples alone we can identify some of the social meanings that condoms have acquired as a result of the AIDS epidemic. As at earlier points in its history, the condom today provokes debate on all sides, dramatically revisiting the dilemmas generated throughout U.S. history whenever disease is linked with desire—dilemmas involving biomedical science and clinical medicine, official and popular metaphors and meanings, moral and ethical systems, technology and public policy, the free market, and human needs, pleasures, and desires. Moreover, the AIDS crisis has made this debate broadly accessible, amplifying voices and positions that under ordinary circumstances might have remained private or submerged. In short, condoms have acquired potent meanings and functions in current social discourse. Recommendations about how to use a condom go far beyond the immediate practical goal of properly installing a slippery piece of latex. For in truth nothing is non-conceptual. How to use a condom is never simply practical advice for global circulation in World Health Organization pamphlets. The imperatives of language and culture in everyday life do not work that way: rather, to inform is also to perform; to communicate is to create and interpret. Information does not simply exist, it issues from and in turn sustains a way of looking at and behaving toward the world; it shapes programmatic agendas and even guides capital investments.

The condom thus makes visible a global arena often left unexamined. Above I cited a 1991 newspaper report of a Tanzanian woman who killed her husband when she found condoms in his pants pocket. But this is only a tiny fragment of an extensive heteroglossic global post-AIDS condom discourse. In early 1988, for example, Zambia's campaign to slow the spread of AIDS and HIV infection featured a full-page advertisement in local newspapers. Sponsored by the Family Life Movement of Zambia [FLMZ], the ad urged readers to "stay on the ground" rather than chance flying on "Pleasure Airways" and "crash-landing" with "parachutes" that weren't safe. The *News and Features Bulletin* of the All Africa Press Service [*APSNFB*] cited the ad as an example of the "humor and innovation" of the anti-AIDS campaign in Zambia, and praised especially the way that a serious message about sexual behavior was cleverly communicated through metaphor (*APSNFB* Feb. 22, 1988, 7). The bulletin noted that Zambia's extensive screening and education campaign includes establishing 32 screening centers throughout the country, widely distributing a booklet called "AIDS Information for Schools," and enlisting Zambian journalists in an effort to combat western propaganda about AIDS in Africa, in particular the claim that African governments were "doing nothing" about the epidemic. By the following month, however, the Zambian govern-

ment was under fire from the Christian church, which argued that the information booklet would encourage promiscuity among the young and called on the FLMZ "to deal with AIDS advertisements in a more appropriate manner" (*APSNFB* April 19, 1988, 4). The *Times of Zambia*, owned by the government, countered by asserting that "the campaign against AIDS should…not fail because of crazy clerics" (*APSNFB* May 9, 1988, 2). In other central African countries the clash between church and state took a variety of forms. In Uganda, a planning survey had determined that 96% of Uganda's population were regular churchgoers, so from the beginning the government health ministry sought cooperation from the church in designing AIDS education programs: hence when 20,000 bibles were distributed to school children with AIDS information inserted, the first page answered medical questions about AIDS and prevention; the second page cited scriptural passages to answer spiritual questions about sex and marriage (*APSNFB* July 11, 1988, p. 3). But the church opposed the import of 3 million condoms donated by the United States on the grounds that the condoms represent a distraction from ongoing health priorities, especially minor and curable diseases (*APSNFB* July 25, 1988, p. 4).

The differing views over condoms and sex education in Zambia and Uganda challenge the portrait of unrelieved devastation in a monolithic "third world" and provide a useful corrective to the notion, still widespread in western media, that no fruitful discussion is occurring within Africa by Africans. These internal debates suggest rather that controversies in African countries over AIDS parallel those that have marked the unfolding of AIDS as a complex narrative in the developed world. They also suggest, perhaps, that debates over condoms will always be shaped by the politics, unique internal structuring, and pre-existing priorities of groups and interests within any given country or region. Likewise, resistance to condoms is not unique to the church or Zambia or Uganda and does not necessarily signal unfounded opposition to scientific public health measures. A pervasive theme of discourse in many developing countries, however—particularly in postcolonial Africa—is that the "AIDS crisis" with its corollary condom campaigns is merely the latest in a series of previously unsuccessful first world strategies to curtail population growth in formerly colonized territories (i.e., among people of color).

Yet the very mechanisms of public discourse in a liberal democracy pull in the radical endpoints of the debate itself, shrinking its universe of possibilities to those which the culture at large (whatever that means) can manage. Though no longer the disreputable item of previous decades, the condom remains a low concept product that is condescendingly lumped by high science and high commerce into the contemptible category of "gadgets and contraptions" (quoted in Brandt 1987, 146). Indeed a whole series of condom jokes turn—like Polish jokes, but unlike jokes about programming your VCR—on the general perception that you don't have to be a rocket scientist to use a condom. (A guy walks into a drugstore and asks for a dozen condoms. The druggist says, "That'll be 5 dollars plus tax." The guy says, "The hell with the tacks, I'll use glue." Like the little moron jokes of my youth, the humor lies in the dopey substitution that the pun signals.)

But maybe you *do* have to be a rocket scientist—or a biophysiologist or a mole-

352 cular biologist or a biomedical engineer—to design a perfect anti-disease and contraceptive technology or even a better condom. It certainly must take some rare combination of knowledge, technological expertise, and serious commitment to develop new and improved barrier products—because otherwise these alternatives would exist, right? And instead, serious gaps exist in basic science and clinical knowledge. "We know more about the atomic structure of the virus than about condoms," charged Malcolm Potts in 1987 (quoted in Gruson 1987, 21). Are the technical wizards all in computers instead of condoms while the corporate field of contraception just dries up?[6] Prior to 1980, nine pharmaceutical companies were doing contraceptive research and development. By 1990, the number was down to one. As science writer Philip Hilts recently reported, women in the United States have less access and fewer options than women in many less developed countries (Hilts 1990). For HIV and other disease prevention and for women's control over conception, our current state of affairs is a disaster. But it is not a surprise.

For all its simplicity, the condom has led a complicated and inconsistent double life throughout its history as a preventative of pregnancy and of disease: a device for birth control, that is, and a device for disease control (only occasionally has it been called "death control"). In this dual capacity, as the historian Allan M. Brandt observes, the condom loosens two of the foremost constraints on unchecked sexual freedom: the fear of pregnancy and the fear of disease (and associated stigmas). Put another way, by simultaneously preventing pregnancy and disease, the condom threatens—or challenges—civilized life as we know it and thus becomes an object of fear, anxiety, and promise. Like other technologies, the condom has evolved in the context of specific social, cultural, economic, and political realities, and it continues to play its own part on that larger stage: "Metaphor into hardware," as Donna Haraway (1985) has described the interaction of cultural ideas and technological invention, but "hardware into metaphor too."

In short, AIDS education is more than a matter of transferring information or technology, translating brochures into many languages, communicating with "cultural sensitivity," or even teaching people to read. We need to recognize too that at home and abroad, the condom's circulation in-the-name-of-the-father simultaneously authorizes frank speech and limits its possibilities. Condom campaigns require great effort in many locations to overcome objections to the articulation and dissemination of sexually-explicit language and images and to challenge the view that information inevitably produces increased sexual activity. Because they divert attention and support from alternative efforts, these campaigns have opportunity costs as well. In many of the African countries I have mentioned, for example, condoms represent yet one more effort whose effect, in the words of a 1985 report from WHO on women, health, and development, is to replace "potentially adaptable traditional female social practices with technological solutions controlled outside the community and often by men" (WHO 1985). What is gained by condom distribution American style is potential for controlling the transmission of HIV. What is lost is the opportunity to identify and make use of established women's networks—networks that are, in one form or another, a virtually univer-

sal feature of women's social life, which typically encompass learning, caretaking, decision-making, and discussion of "female matters." This failure to value and capitalize on the existing female infrastructure is widespread in AIDS education and Condom 101 prevention programs (as in the development projects on which AIDS education is often overlaid), and a profound problem repeatedly identified by women involved. Moreover, the failure to interact dynamically with the specificities of a given culture perhaps explains why even the technical dimensions of condom and condom use translate so poorly between cultures: in the brochures, information booklets, lectures, and illustrative posters I have surveyed, I have seen nothing that deals explicitly with the destructive effects of tropical climates on latex; and I have seen only one safer sex discussion that explicitly talks to or about uncircumcised as well as circumcised men.

In her analysis of the Anatomy Act of 1832, which enabled the bodies of the poor to be used for medical dissection, Ruth Richardson calls it "a gift for anyone interested in attitudes towards the body, the dead, death, grief, and beliefs in the afterlife." Richardson argues, in part, that the Anatomy Act was in some sense revenge, extracted by the rich from the poor, for the Poor Laws which had earlier levied taxes on the upper classes (Richardson, 1988, xvii). I will argue in this essay that the condom is a gift for anyone interested in the history, culture, and discourse surrounding sex, gender, and sexually transmitted disease. Moreover, I will argue, while the condom functions as an extraordinarily efficient barrier to both disease and conception, it is also the moralists' revenge on all forms of pleasurable or transgressive sexuality, made to function with equal efficiency as a barrier to more imaginative, technically sophisticated, and erotically charged alternatives. Put another way, the condom has become for the AIDS epidemic the transcendental signifier of all that can be said and done; its leading role is the price it pays for entry into the symbolic universe of public discourse. The condom forces notoriously difficult questions and potentially exciting solutions into a single and, as it happens, phallic shape. Why this occurs is itself a significant object of inquiry.

Like language, the condom is at once a word, an idea, and a thing; a name, a site of desire, and a device; a linguistic, material, and conceptual object. As it enters various domains of discourse, its metaphoric and metonymic potential is great. In the next section, I provide a condensed history of the condom and sketch its current role in the AIDS crisis. In section 3, I use the diversity of contemporary "condom discourses" to document the condom's extraordinary cultural and political makeover within gay, lesbian, and activist communities as well as its deployment across multiple cultural domains; analyzing these discourses—and what is absent from them—I suggest an agenda for ongoing debates about sexually transmitted disease, technological innovation, and intervention strategies. In Section 4, I examine in detail a 1987 Congressional hearing on AIDS and condom advertising, a hearing which exposes the blueprint for conservative attacks on progressive programs. One of its lessons is that conservatives like Jesse Helms know exactly how to use a condom: like meat thrown off a speeding sleigh, they throw out the condom for moderate and progressive folks to fight over; by the time we look up, they are miles

354 ahead of us. By fixating on, obsessing over every detail and statistic of condom use, which should be the taken-for-granted starting point of any rational public health effort, the right holds an entire Congressional hearing—and the country for which it stands—hostage. While thousands of acts of unprotected sex and many more thousands of acts of violence reach television audiences unimpeded, and while people continue to get infected with HIV and die, this tiny criminal band debates whether these same audiences can withstand the shock of seeing, or hearing about, or in any way encountering the terrible satanic device that dare not speak its name: the lowly condom.

My aim is thus to examine the strategies through which the condom is simultaneously trivialized and demonized, through which it is made to signify and hence to silence everything else that might be said. I want to illuminate the ways in which the condom's role as sexual signifier is produced and sustained, how it comes to be framed as good or bad and received as true or false, and above all how this fetishized and reified account of condom use bars us from exploring or even conceiving alternative possibilities. In seeking to characterize the dynamic of possibility and constraint the condom discourse repeatedly embodies, I am also examining how, at a historical point where sophisticated and desirable protective technology was never more urgent nor more technically achievable, this "perfect anticonceptual remedy" so effectively bars the signifier from the signified. It is as though this simple phallic sheath itself takes on the abstract transcendence of its master with similar power to deny, negate, prohibit, and paralyze. But though it may speak in the name of the father, the condom is not the villain of this piece: the wide world over it has fulfilled myriad tasks and demonstrated multiple talents in sex education, fertility control, and anti-AIDS campaigns. By examining the different kinds of cultural work this seemingly simple, "anticonceptual" device is sent out to do, I want also to suggest a special role for practitioners of cultural studies—for it is we who specialize in accessing diverse discourses, in employing for specific purposes whatever disciplinary knowledges and practices may be fruitful, and in advocating some positions over others to achieve a fairer, more just, more humane society. In that spirit, I conclude by suggesting where the condom, this transcendental phallic signifier, might take us if we let its historical, metaphorical, and cultural associations work to reveal rather than suppress alternative signifieds.

2. Condoms 101: Dossier of a Low Concept Product

> To guard yourself from shame or fear,
> Votaries to Venus, hasten here;
> None in our wares e'er found a flaw
> Self-preservation's nature's law.
>
> —1796 condom advertisement (cited in Himes 1963, 200)

> I do not care to shut myself up in a piece of dead skin in order to prove that I am perfectly alive.
>
> —Casanova (quoted by Himes 1963, 195)[7]

Three nuns go to the Mother Superior. The first one says, "Last night
I found a package of condoms in the confessional." The second nun
says, "We know they must belong to Father Brown." The third nun
says, "But don't worry, we stuck pins in all of them." The Mother
Superior faints.

According to the generally accepted classifications of population and birth control
studies, on which this section is based,[8] the condom is a barrier method of contra-
ception—functioning to prevent sperm from entering the vagina or uterus through
physical obstruction or killing sperm chemically once they are at the site. Barrier
contraceptives are one method within the broader category of contraception,
which conventionally refers to all devices and drugs used to control fertility. Birth
control, the broadest category, encompasses all methods used to control fertility.
The condom is the cheapest and most effective contraceptive available without a
prescription. As a device for disease prevention, the condom's barrier function is
also central. Even where prohibited, condoms are perceived by many as more "nat-
ural" than contraceptive methods like the pill, which fundamentally alters the
reproductive cycle, or the IUD, which can bring about profound changes within
the uterus. Note that there is no readily available term to designate the condom's
simultaneous performance of birth control and disease prevention, nor is there ter-
minology to distinguish methods of protection that perform one function but not
the other. "Protection" and "safer sex" are about the closest we come. Yet that such
linguistic discriminations are available enough is suggested by the ease with which
we can differentiate types of, say, soda pop as cola or non-cola, caffeinated or caf-
feine-free, Diet or regular. That terminology is significantly needed is argued by
the condom's evolution as a device with a dual yet schizophrenic role in birth con-
trol and disease control, by efforts to collapse and to rigidly separate the two, and by
the degree to which medicine, morality, sexuality, social reform, and market enter-
prise are intermingled.

The generic device is typically called a condom, sheath, preservative, or pro-
phylactic. The term prophylactic, conventionally defined as "preventive of disease"
but more loosely "safeguard" or "amulet," is from the 16th century French *prophy-
lactique*, in turn derived from Greek *prophulaktikós* "to keep guard before"
("before" referring both to space and time); the Greek root is shared with *phylac-
tery*, the packet of scriptures worn by Jews around their neck to remind them of
their obligation to the law. The term *condom* first appears in a 17th century tract
on syphilis. A widespread but discredited folk etymology derives *condom* epony-
mously from a Dr. Condom, supposedly an 18th century British physician who
invented or popularized some version of condoms. But *condom* has proved to be
one of those tough puzzles, like *okay*, that lexicographers and historians develop
theories about.

The earliest condoms are credited to ancient Egypt, though no doubt rival and
equally dubious claims will continue to be filed. Norman Himes, whose 1963
Medical History of Contraception remains the most reliable source, sternly rebukes
scholars who uncritically reproduce conventional wisdom about the word *con-*

356 *dom*'s origins, or the purpose to which given ancient devices were put, or their success in preventing pregnancy or disease. In existing accounts of contraceptive history, what is striking is the degree to which narrative genres exchange their data: what appears as "history" in one source is denounced elsewhere as folklore, anthropology, urban legend, myth, "speculation," or—inevitably—a dirty joke. This story from the development literature is a typical example: a government social worker explaining birth control to villagers in rural India uses a bamboo shoot to demonstrate how to put on a condom; he returns a year later to find a new crop of babies and the bamboo shoots meticulously covered with condoms.[9] One joke version goes: The doctor tells the little moron to put a condom on his organ before intercourse; he doesn't have an organ so he puts it on his piano.

As we move into recorded history, artifacts show that condoms were made of linen, silk, skin, and intestines. Also documented are devices designed to be used by women, including suppositories, sponges, screens, and metal inserts that acted both to regulate fertility or conception and to prevent or treat disease. Feldblum and Rosenberg argue against the evidence for condom use in ancient times, though they recount an intriguing variant of the legend of Minos and Pasiphae: Because Minos' semen contained serpents and scorpions, his marriage to Pasiphae, daughter of the Sun, remained childless. Proteris (who had taken refuge with Minos) had an idea to help him: "She slipped the bladder of a goat into the vagina of a woman. Into this bladder Minos cast off his serpent-bearing semen. Then he went to find Pasiphae and cohabited with her" (Feldblum and Rosenberg). Pasiphae went on to have eight children. Feldblum and Rosenberg argue that the legend has been misclassified "in that it was actually Minos and not his female partner who wore the bladder sheath." Presumably, however, one could argue that the bladder sheath could be seen as a prototype for a female condom, or at any rate that whatever it was a brainy woman invented it.

With the growth of scientific experimentation came barrier devices with spermicidal and antiseptic properties that anticipated modern physical and chemical barriers. The anatomist Gabriello Fallopius (who identified and named the fallopian tubes) invented a medicated linen sheath aimed at the known vulnerability of spermatozoa, just as von Leeuwenhoek carried out studies further detailing its susceptibilities (for example, he found that rainwater immobilized canine spermatozoa).

A detailed chronology would be needed to track the condom's evolution as medical device, technology, and commodity, hence I will skip to the United States in the early 20th century and the birth of the modern condom industry. Though rubber condoms had been manufactured in the U.S. since 1888, it was in 1916 that a merchant named Merle Youngs set up his own rubber company with the aim of establishing a reliable, stable source of condoms for sales and distribution; within ten years, Youngs had brought out the first "Trojan" brand condoms, a trademarked name that he later successfully defended against a lower quality knock-off.

That this took place in the wake of the 1878 Comstock Laws, which lumped contraceptives with obscene materials and prohibited them from import and the mails,

was a perfect example of the tug-of-war between medicine, morality, and market forces that has characterized the history of health-related industries in the U.S.[10] Thus at a point of rapid technological development in Europe (where the spring-loaded diaphragm was invented in the 1880s), the birth control business in the U.S. was driven underground.[11] But by the 1920s, contraceptive devices were beginning to come out of the closet: as Youngs developed his company, Margaret Sanger, fighting for women's right to birth control, challenged the Comstock Acts by smuggling European-made diaphragms into the U.S., then by arranging with a New York factory owner to manufacturer diaphragms within the state. By the end of the decade books on contraception were being published (e.g., Cooper's 1928 *Technique of Contraception* and Dickinson's 1931 *Control of Conception*).

In the 1930s, the condom market was aided by the substitution of latex for rubber, dramatically expanding condom development and manufacture. The industry was also aided by the Depression, when poverty and unemployment by necessity created broader public sympathy toward birth control; as understanding grew of venereal disease and its social and economic costs, sympathy likewise developed for government intervention. In 1936 a federal judge relaxed the Comstock Act so as to permit importation and mailing of contraceptive devices and information "which might be employed by conscientious and competent physicians for the purpose of saving life or promoting the well-being of their patients." Though that same year an American Medical Association report condemned physician involvement in contraception, the association reversed its position in 1937.[12] By the end of the decade, condoms began to be tested by the FDA and by Consumers Union, and efforts made to improve quality. Meanwhile, a study commissioned by Youngs of condom brands, sales, and distribution demonstrated the "sheer chaos of condom marketing," finding that condoms, often of poor quality, were "hawked like peanuts." Youngs successfully campaigned to restrict condom distribution points to drugstores, and in 1936 Long Beach, California became the first U.S. city to ban condom sales anywhere except pharmacies—a trend that continued until the 1960s, when more than 200 communities and 20 states had "druggist-only" laws. The military's anti-VD campaigns of the Second World War promoted condoms aggressively, with 50 million typically distributed to servicemen per month.

By the end of the war, the condom was well established in U.S. culture. Slang terms reflected its European history, from the traditional *capote anglaise* 'English ridingcoat' and *French letter* to rubber, skin, jacket, wrapper, galoshes, raincoat, and (British) *johnny*. Casanova's memoirs indicate that he regularly used condoms, referring to them as "the English riding coat," "the English vestment which puts one's mind at rest," "the preservative sheaths," "assurance caps," and "preservatives that the English have invented to put the fair sex under shelter from all fear" (cited by Himes 1963, 195). Like the diseases it is designed to prevent, the condom's origin is claimed with pride by no country, but is attributed elsewhere: *la capote anglaise* is a French term; the "French letter" is English. Brand names are also historically and culturally marked. Youngs' 1936 study of condom sales and distribution in the U.S. found a wide variety of brands and names, including Bobbies

358 (connoting Britain, thus high class), Sûreté (for the French equivalent of the FBI), and such military and aristocratic labels as Dred-Not, Tuxedos, Aristocrats, Man-o-war, Vikings, Hercules, and Cadets. A number of brands went for straightforward sex appeal, with names like Carmen, Cleo-Tex, and Mermaids, and showed scantily clad women on the package. Still others had no name at all, just pictured naked women on the wrapper (Henjo 1962, 14).[13] Along with the Trojan brand name, first manufactured in 1926, came other heroic mythological names like Ramses and Sheik. And finally there were dull workaday names: Durex, Fourex.

Natural skin condoms, made from a portion of the intestine of (mainly) New Zealand sheep, are descendants of the long line of condoms made of intestines, skins, and other animal parts (Himes believes that condoms were probably invented in slaughterhouses). Lambskin condoms are preferred by some users because they feel more "natural," but cost about three times more than the average latex condom. (Stand-up comic Danny Williams says, "Some condoms are made of sheep intestines, but I was so scared the first time I wore the whole sheep." Elayne Boosler's routine includes this rude line: "When the clerk tried to sell me condoms that were made of sheep intestines because they feel more natural, I said 'Only to Southern women.'") At present, the main problem with natural skin condoms is that no definitive research has shown them to offer protection against HIV transmission.[14] Latex condom makers, longstanding competitors of the natural skin manufacturers, claim that the low tech process of slicing up the lamb intestine (actually a portion of the intestine called the cecum) leaves an inevitable odor: Says one latex executive, "It all depends on what the animal had to eat on its last day." The lambskin manufacturers deny the charge, contending that all New Zealand lambs are "raised in a benign climate and on a healthy diet" (Leinster 1986, 107).

This is the history that might have set the stage for the arrival of the AIDS epidemic. Instead, though the condom market held reasonably steady from the mid-1950s to the mid-1970s, and quality continued to improve, three major developments over the same period helped transform cultural attitudes and practices toward sexual activity and its consequences. The development of penicillin gradually reversed the perception of venereal disease as devastating and long-lasting; recognition of a worldwide population explosion created the first major impetus to research on reproductive phenomena, with philanthropists and pharmaceutical companies putting significant money into the development of contraceptive technologies; and women began to be encouraged to enjoy sex—enjoyment enhanced by the culture of the 1960s and the development of a variety of birth control techniques.[15] When gas shortages in the 1970s cut into gas station distribution, the Supreme Court lifted restrictions on condom sales and marketing of condoms; no longer under-the-counter, condoms could be distributed in supermarkets and other outlets besides drugstores and gas stations. This coincided with adoption of the 1976 Medical Device Amendments to the Federal Food, Drug, and Cosmetic Act, giving the FDA significant authority to regulate condoms whose manufacturers make medical claims about the prevention of pregnancy or disease

(see Muirhead 1992 and Harper 1983). By the late 1970s, the condom industry was 359 still small, and had developed a reputation for being insular, close-mouthed, and paranoid. And the condom, thanks to the three p's—penicillin, population, and the pill—was still disreputable and now, in addition, perceived as increasingly obsolete: "a distasteful relic," as one commentator wrote, "of more primitive times" (Leinster 1986, 105). As sales fell, and the condom became a product not even its stockholders could love, its significant remaining use was in international family planning programs; and this outlet, too, was about to be severely undercut by the Reagan administration's policy of withdrawing foreign aid to projects that advocated any form of birth control.

Before turning to the entry of AIDS into 20th century American life, however, I want to conclude this historical sketch with the work of James S. Murphy, whose 1992 study, *The Condom Industry in the United States*, uses the condom to explore several questions in economic theory. Murphy identifies four defining characteristics of the condom as a U.S. market commodity that may be helpful in accounting for its history since AIDS:

(1) Legal restraints imposed by the Comstock Laws, which prohibited any form of interstate commerce in condoms, kept the condom industry localized until the 1920s; condom manufacturing was likewise small and fragmented. Insufficient demand in any given geographic market discouraged innovation in manufacturing techniques, rendering economies of scale impractical and incentive to improve the product uneven and local. Restrictions on advertising and dissemination of product information led to the purchase of unsatisfactory products. The clandestine nature of condom sales through barbershops and saloons created further confusion. The product and the industry had a shady reputation. By keeping the industry fragmented, the government thwarted two functions of a market system: efficient allocation of resources and incentive to improve the product.

(2) Youngs Rubber and Schmidt Laboratories grew because they recognized consumers' desire for standardized, reliable condoms and the pharmacy's role as a stable sales outlet. Not only would this stability curtail the distribution of shoddy products, it would also halt the sleazy sales to kids in schoolyards and other inappropriate places. The prospect of retail control over a high-priced product was attractive to pharmacists; in turn, giving druggists a monopoly in retailing positioned the condom industry as an oligopoly (a market situation where a small number of producers more or less constitute a ruling clique). Laws forbidding advertising or open display of contraceptive products made it difficult for new firms to enter the business.

(3) In the so-called Trojan War, Youngs' competitors tried to steal the Trojan name on the assumption that since condoms were illegal, the law would not protect the name. Young's successful defense of the Trojan trademark proved otherwise, with several direct and indirect effects: the court's 1930 holding that "there is no federal statute forbidding the manufacture or sale of contraceptives" (Hejno 1962, 14) established that a company's trademark and identity meant something. For

360 Youngs and Trojans, this means of product differentiation made it possible to create incentives that would improve the product, build brand loyalty, strive for greater efficiency, and standardize products. The market expanded rapidly.

(4) Knowledge of condom use was and continues to be widespread. In Murphy's view, however, neither knowledge nor broad social appeal appear to influence use. Only appeals to the selfish self-interest of the individual seem to work: fear of disease, desire not to conceive, and so on. Appeals to population control, morality, the health of society, or the social and economic cost of disease will not make people use condoms.

3. Contemporary Condom Discourses: A Fragment of an Analysis

The condom has been hailed as the single best hope in the battle against a deadly and exceedingly public AIDS epidemic. "It was an odd turn in the story of this dying product," wrote Colin Leinster in *Fortune* in 1986, "when a horrific disease revived it." But though it is ironic that the condom was disappearing from everyday as well as fantasy life just at the moment it was most urgently needed, it is not coincidental: the decline of condom use as well as its absence from gay male sexual culture contributed to the conditions that made the epidemic possible. Between 1975 and 1985 U.S. condom sales fell by half to about 150 million retail until 1985, when sales began to rise again. After a period of tremendous growth (20% a year), the industry is still above average with five to seven percent growth per year. In the U.S. last year, 450 million condoms were sold. Worldwide, it's a market characterized by uneven growth because the U.K. and the U.S. geared up quickly for condom sales; Europe is slower; many developing countries are just getting started. In some of these countries, where public debate about human sexuality is relatively new, careful marketing approaches are required. Leinster notes another irony of the condom's current resurrection: "in the battle for market share, competitors will find little advantage in talking about their good fortune" (Leinster 1986, 118; see also Hochman 1992). Experience with condoms since the advent of AIDS elaborates and annotates Murphy's observations, in particular providing a body of research and cultural documentation on the determinants of everyday use. Not only does this experience provide evidence that the successful promotion of condom use need not inevitably define self-interest narrowly. It also suggests that, in turn, the condom's history together with our current experience enable us to construct a fairly concrete list of desiderata for sexual protection technologies. Projects and research efforts around the world amplify this list, suggesting also current alternatives and future possibilities.

The condom's effectiveness in contraception and counter-infection (contrasepsis?) depends on product performance, social acceptability, and long term safety— what might in a sense be called market issues, moral issues, and medical issues. Its success as a market commodity depends on its ability to perform in all three areas as well as on advertising, pricing, and distribution.[16] In surveys by *Consumer Reports* in 1989 and 1995, product features important to consumers included reliability, price, lubrication, spermicide, texture, contour, and variability. The earlier

report noted that though the quality of U.S. condoms has improved as a result of FDA oversight (begun in 1987), European and Japanese condoms are subjected to a rigorous inspection, notably an air-inflation test in which the condom is inflated until it bursts. The "burst index" is the percentage of condoms tested that handled 25 liters of air without breaking. Air-inflation testing was finally added to U.S. inspections in 1994, though several of the condom types *Consumer Reports* tested for the 1995 report, purchased before the standard was raised, flunked the air-inflation test. Again, despite the generally high quality of branded condoms (brand name), rapid acquisitions and takeovers require continuous updating of tests and ratings.

The gay community took the lead in resurrecting the condom. The pamphlet *How to Have Sex in an Epidemic* (Berkowitz et al 1983), placing AIDS within the broader context of gay STDs, provided recommendations for reducing disease transmission without giving up sex. The pamphlet's respect for both sexual pleasure and cultural identity became a hallmark of "safer sex" campaigns within the gay community. Not an end in itself, the condom was inscribed as one mechanism for preserving significant features of gay practices and politics. As Douglas Crimp and Simon Watney, among others, argue, the condom also signalled the adoption of a communal ethic of universal protection (Crimp, 1988; Watney, 1988). Preserving sexual life for people with AIDS was not yet—and indeed is not still—part of public AIDS discourse except as a figure of demonization and blame (the sexually addicted homosexual and bisexual who continues to prey on and infect others). The condom was therefore an unauthorized device, a transgression against patriarchal expectations. This did not mean it was accepted automatically by gay men. As Les Pappas writes, describing the development of gay safer sex programs, "Until recently, gay men had as much interest in condoms as Eskimos do in air conditioning. The fact is that gay men for the most part have no history or tradition of condom use. Condoms, like other forms of birth control, were not a gay issue" (Pappas, 43).

The condom's growing social acceptability, which I described in Section 2, is one consistent focus of culture since AIDS, for example in the cartoon depicting the TV networks' shock at being asked to advertise condoms [fig. 1]. A 1986 ad for Trojans plays on the change between the condom's bad old drugstore days and its new incarnation as a high tech product [fig. 2]. Where AIDS activists messages about condoms have stressed sexuality, politics, and sexual politics [fig. 3], the appeal of more domesticated (official) ads and posters is largely earnest and humanist [fig. 4]. At the far reaches of irony and take-no-prisoners humor is *Diseased Pariah News*, which once featured the photograph of a burning teddy bear on its cover to commemorate the death of one of its founding editors (along with instructions on how to burn a teddy bear) and which comments on condoms in part through its regular comic strip Captain Condom [fig. 5].

The trend among manufacturers is toward higher concept techy images, along the lines of automobile makers: Lifestyles' Nuda brand has been praised as "the Porsche of condoms," and Adam Glickman, a 1980s Tufts graduate who founded

Fig. 1. "Heavens to Betsy." Ohman, cartoon, *The Oregonian*, 1987.

Fig. 2. "Hey, there's a guy here wants some information on Trojans." Advertisemtent, Carter-Wallace, Inc., 1986.

Fig. 3. Panels from a safer sex pamphlet, Safer Sex Committee of New York, 1984.

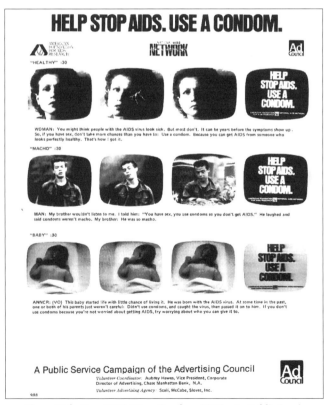

Fig. 4. Help Stop AIDS. Use a Condom. TV Spots, Public Service Campaign of the Advertising Council. AdCouncil press kit.

Fig. 5. Further Adventures of Captain
Condom #6. Beowulf Thorne, *Diseased Pariah
News* 6, 1992, 26.

the Condomania chain of specialty stores, says that names aside, the Japanese and
the Germans make the best condoms—just like cars (Seligman et al 1991); or
planes, if the Stealth condom is an example [fig. 6]. Even the old standbys—Trojan,
Sheik, and Ramses—come in various formats now (Ramses Nuform, Sheik Elite,
Trojan Naturalube Ribbed, etc.). In the U.K., Red Stripe has a distinct appeal, and
who could resist wanting at least to try Aegis Big Boy, Duet Supersafe, Durex Black
Shadow, Durex Gossamer, Erotim Banana Hit, Prime, and Forget-Me-Not. Though
the condom has some of its power to signify transgression as safer sex programs
have become institutionalized, some of these names attempt to retain a touch of
naughtiness.

Both names and styles have proliferated in the 1980s and 1990s, with careful
attention to markets and marketing, and today U.S. condom makers offer many
new lines. Among them are Excita (including the textured Excita Extra and Excita
Fiesta, in colors), Lifestyles (Lifestyles Conture, Stimula, Nuda, Nuda Plus, Extra
Strength), Personal, Prime, Protex (Protext Man-Form Plus, Protex Contracept
Plus, ultrathin Protex Secure and Protex Touch, Protex Sunrise in colors, textured
Protex Arouse, and for women Protex Scentuals and Lady Protex). There is now,
sadly perhaps, a move away from Greek brand names, presumably because the
younger generation is ignorant of Greek mythology.

I have discussed elsewhere the marketing of condoms to women (1988b).
Pondering the decision to name a condom marketed for women "Mentor," I have to
deduce that the older generation is equally ignorant or perceives mythological sub-
tleties that escape me. As the first person narrative of the Mentor ad suggests,
responsibility, not pleasure, is the selling point [fig. 7]. That may be important,

given the complicated instructions for using the Mentor which come complete with an 800 number; it should also come with a magnifying glass, like the *Oxford English Dictionary* does [fig. 8]. In any case, why not instead use the myth of Minos and Pasiphae, recounted above, and name a condom targeted to women after Proteris, who invented one? Protex? It's already in use, but I'm sure clever marketers could come up with something. "And how about some new nicknames for the old standbys?," writes Mimi Coucher; "Love skins. Slicks. Wet suits. Silk stockings. Eight-by-two glossies." Her "Girl's Guide to Condoms" (1989), like the best of the safer sex guidelines for women but unlike the Mentor ad, preserves the notion that there's some fun in all of this (e.g., Patton and Kelly 1987 for an early example). The same can't be said of the ubiquitous Channing Bete *About Women and AIDS* [fig. 9]: the generic cartoon figures of these Scriptographic booklets pondering the use of condoms might as well be at a Tupperware party. Now it would be really interesting if Channing Bete were to do a booklet about the safe sex parties, mainly by and for women, organized in fact to be literally like Tupperware parties (Diesenhouse 1989). Participants share concerns and suggestions, on everything from condoms to communication to sex toys. A condom for women is now on the market: the Reality condom press kit includes a video demo; the Women's Choice condom is called by a feminized noun form—*condomme*. The artist Masami Teroaka presents his very sensuous version in a 1992 watercolor [fig. 10].

Condom size is an important policy and marketing issue, and a favorite theme in condom jokes:

> In the early days of the Cold War, the Russians are placing an order for U.S. goods, including U.S. condoms. U.S. pharmaceutical companies get the condoms ready to export but the War Department intervenes on the grounds that latex is rubber and rubber is in the category of strategic goods. The Psychological Warfare office overrules this decision and gives permission to ship the condoms to the Russians provided each one is stamped "Made in the U.S.A.—junior size."

The joke came to life in the byzantine evolution of the European common market, where achieving consensus among all concerned countries on condom size and thickness specifications turned out to be almost as delicate and difficult as getting the French to accept British standards for butter and cream.[17]

A woman's version of a condom size joke involves a woman asking a man: "Did you know condoms have serial numbers?" "No." "Oh, I guess you never had to unroll it that far." A gentler approach was taken by women's health expert Barbara Seaman when she testified on birth control methods at a 1978 Congressional committee:

> We also think—and I'm sorry, gentlemen, if this disturbs any of your egos—that condoms should be marketed in three sizes, because the failures tend to occur at the extreme ends of the scale. In men who are petite, they fall off, and in men who are extra well endowed, they burst. Women buy brassieres in A, B, and C cups and pantyhose in different sizes, and I think if it would help condom efficacy, that we should package them in

Fig. 6. They'll never see you coming! Stealth condom package, Stealth Condoms, Inc., © 1993. Thanks to Constance Penley.

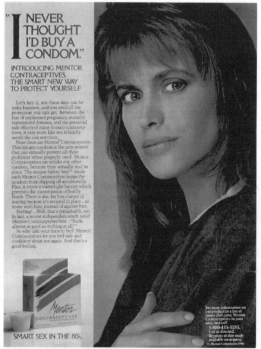

Fig. 7. "I Never Thought I'd Buy a Condom." Mentor Contraceptives advertisement © 1986 [appeared in several women's magazines, April 1987].

SAFETY-SEAL™ CONDOMS

IMPORTANT DIRECTIONS
FOR USE OF THE MENTOR® CONDOM

- The Mentor condom has two parts: The Safety-Seal condom and an easy to use applicator.
- The condom can only be used once.
- The applicator must be taken off before sexual contact.

BEFORE SEX

Be sure penis is completely dry before putting on the condom. Use a new condom every time you have sex — before foreplay, before penis gets anywhere near any body opening (to avoid exposure to any body fluid that can carry infection). Handle condom gently.

Put condom on as soon as penis is hard. The Mentor condom has a pointed tip on the applicator so it's easy to know which way to put it on. Be sure this tip is on the outside. Hold the condom directly against end of hard penis.

Squeeze the pointed tip so no air is trapped inside. Unroll the Mentor condom all the way down to the hair. Both parts, the condom and the applicator, will unroll at the same time.

Gently squeeze the Mentor condom onto the hard penis all the way around. This will secure the Safety-Seal in place. Twist the applicator around penis. This will lubricate the condom.

Remove the applicator before sex by sliding it off. Discard the applicator.

AFTER SEX

The Safety-Seal will help insure that the condom stays on when you pull out. For added safety, hold the condom in place on penis to avoid spilling semen.

Turn and move completely away before taking the condom off. Hold the open end of the condom near the hair and gently peel it down off the penis past the Safety-Seal.

Then slip the condom off. Throw the used condom away. And no more sex without a new condom. If a condom breaks and semen spills, don't panic. But quickly wash semen away with soap and water.

NOTE: This product contains a spermicide – Nonoxynol-9. If an allergic reaction and/or irritation occurs from using this product, discontinue use and consult a physician.

TIPS FOR SUCCESS

- Wash hands — as well as penis, vagina, and surrounding areas — before and after sex. This cuts the chance of infection.
- Never let a condom touch oil in any form — no petroleum jelly, no baby oil, no mineral oil, no vegetable oil, not even talcum powder. Oil rots rubber.
- If you want lubrication, use something water-based like H-R® Jelly or TROJAN® for Women Personal Lubricant.
- Keep unused condoms in their packs in a cool dry place (not a wallet).
- If a new condom feels sticky or stiff or looks damaged in any way, throw it out — use a fresh one.

Distributed by Carter Products
Division of Carter-Wallace, Inc.
New York, NY 10105
©1990 Carter-Wallace, Inc.
Issued: October 1990

IN-64103-02

Fig. 8. Important directions for use of the Mentor Condom. © Carter-Wallace, Inc., October, 1990.

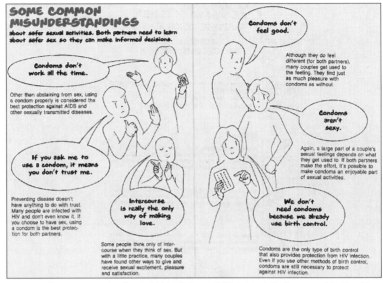

Fig. 9. *About Women and AIDS* (South Deerfield, MA: A Scriptographic Booklet by Channing L. Bete Co., Inc., 1989), 12–13.

Fig. 10. Masami Teraoka, 1992, *New Wave Series / Female Condom Tale*, watercolor on paper.

different sizes and maybe label them like olives: jumbo, colossal, and supercolossal so that men don't have to go in and ask for the small. (quoted by Djerassi 1979, 16–17; Mimi Coucher 1990 proposes jumbo, colossal, and humongous)

Condoms are now both gendered and global. This is true of "How to Use a Condom" messages, cautionary posters, commercial competition, and of social marketing campaigns. In some cases, a generic message is made culturally specific—its new format eerily echoing other times and places: A public service announcement in Brazil, for example, plays on longstanding cultural stereotypes about women as secret reservoirs of infection, its words almost identical to those of U.S. VD posters in representing the face of disease as female [fig. 11]; in turn this images reinforces even older associations of women with disease (see Brandt 1987). India experienced a nasty class battle between the upscale, sexy, and new Kama Sutra condom and the workaday government-sponsored and subsidized Nirodh, called "the khadhi condom" after the no-frills cotton cloth called *khadhi* (Suraiya, 1992). Barcelona's *goma* shops are said to carry as many as 50 condom varieties with names that play on male self-images and fantasies—Conquistador, El Cid, Brave Bull.[18]

Like U.S. debates about such terms as "safe sex" or "monogamous sexual relationship," several African prevention campaigns have provoked controversy over the wording of messages designed to promote monogamy, marital faithfulness, and/or condom use. As I noted earlier, the "Pleasure Airlines" metaphor drew both praise and criticism. Similarly, "Love faithfully," a warning against promiscuity, advocates monogamy and is preferred by church groups; but secular sponsors have rejected it in favor of less moralistic slogans like "Love carefully," an instruction to use condoms, "zero grazing" and "graze at home," to urge faithfulness within marriage including multiple marriages. Some programs have creatively introduced condoms into monogamous marriages as well: Brooke Grundfest Schoepf describes discussions between the CONAISSIDA Project and village elders in Zaire; other programs have sought to draw on women elders to incorporate condom instruction into marital preparation sessions. A calendar from Tanzania, designed as a source of revenue for AIDS education, shows a village training session in which condoms are one of several of the lessons [fig. 12]. Some publications create special materials to promote condom use. A fairly detailed illustrated booklet from Tanzania is made to fold up to pocket size [fig. 13], while a booklet from the Central African Republic works to make its instructions and pictures meaningful, showing the condom being discarded in a culturally specific latrine [fig. 14]. Many of these campaigns have made efforts to adapt Western science to local cultural priorities. In Zimbabwe, the Women's Action Group's AIDS illustrated book *Let's Fight It Together*, attempts to put AIDS in the context of broad social change, uses ordinary characters and ordinary language both to identify the hardships produced by AIDS and to model desirable responses. As a group of people discuss AIDS outside a clinic, a woman holding a baby speaks to the others: "AIDS is very hard for women who work at jobs. We also look after the children, fetch water and wood.

How can we rest?" One of the men responds, "We must support each other—maybe husbands will have to help more. We'll need to keep healthy, get exercise, stop smoking, worrying. Talk to people you trust—clinic, church groups, social workers." The book asks whether AIDS is really a serious issue or just the government's way of stopping people from having a free sex life. It raises other questions as well: How can I tell if someone has AIDS? How can I tell someone to wear a condom? Is it true children can get AIDS? The book, which seeks to transform how AIDS is understood, is available in both the Ndebele and Shona languages, both with English translations. Tension between church and state is reflected in an ad from Zimbabwe [fig. 15].

Research on sexuality and condom use may also serve to transform how AIDS is understood as well as challenge entrenched stereotypes about sexual practices in other cultures. Discussions in the U.S. of HIV and AIDS in Africa, widely influenced by Daniel Hrdy's 1987 review of cultural practices in Africa contributing to HIV transmission, typically assume that sexual promiscuity is the most important factor. Bertrand et al (1991), however, studying condom use in coital frequency among 1000 men and 1000 women in urban and rural Zaire found little evidence of "promiscuity" or of the anecdotal notion that African men need "sex every day."[19] The survey, administered in four national languages, was supplemented by interviews with focus groups.

By using the openness of the signification process to counter its cultural constraints, successful campaigns can alter meanings. A women's rap group called TLC is very explicit about this aim. Convinced that AIDS is "killing too many people and it's killing us (Black women) at an alarmingly fast rate," they set out to make condoms popular, integrating condoms and safer sex messages into every aspect of their performance. Says Left Eye (the L in TLC): "It's just a simple trip to the drug store. But everybody seems to think, 'It won't happen to me.'" T-Boz (the T) says the group still gets "a *lot* of negative feedback for talking about condoms. Our thing is: if you're having sex, you should have safe sex. We show condoms because we're trying to make it hip" (Mayo 1992, 49). Gran Fury's poster of an erect cock provided an in-your-face safer sex message from women: "MEN: USE CONDOMS OR BEAT IT." [fig. 16]

The concept of social marketing—marketing social attitudes as one would market a product—has accompanied condom education campaigns throughout the world. Manufacturers, media specialists, and advertising agencies are becoming increasingly involved in worldwide anti-AIDS campaigns (Wentz 1987). In marketing worldwide, Carter-Wallace cites two international strategies: go with what is generically acceptable in the target country; or gently challenge prevailing standards, usually with humor. Tony Whitehead, in his analysis of how masculinity is constructed in a Jamaican community, provides a pre-AIDS example of how such advertising can be done. Having discussed the widespread cultural view that the loss of semen, like the loss of money, is equated with the loss of masculine strength, he urges that family planning programs take this cultural construct into account:

Fig. 11. *Quem vê cara, não vê AIDS* (*Who sees the face of love does not see AIDS*). Public health announcement, Brazil Ministry of Health, © 1988. Thanks to Elizabeth Santos.

Fig. 12. Calendar, Tanzania. Thanks to Denise Roth.

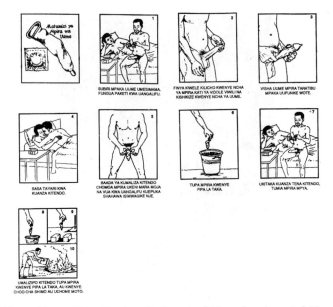

Fig. 13. How to Use a Condom. Pocket-size fold-out brochure; it folds out to 23" by 3". Tanzania. Thanks to Stacie Colwell.

Utiliser les préservatifs

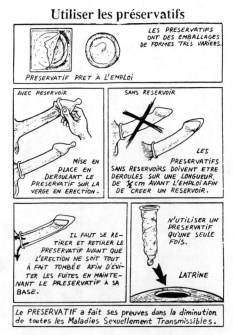

Fig. 14. *Promotion de L'Usage des Préservatifs en R.C.A.*, brochure, designed by Nambana Bernadin, Central African Republic, 1988. Produced by Lutte contra le SIDA. Thanks to Colin Garrett.

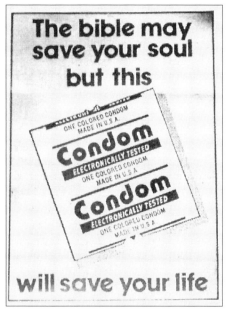

Fig. 15. The Bible may save your soul. Graphic
from Zimbabwe, reproduced in *Southern African
Economist* s.2, April/May 1992, 17.

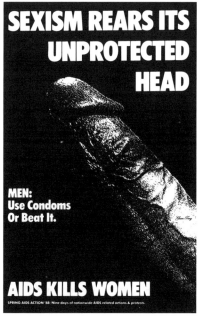

Fig. 16. Men: Use Condoms or Beat It.
Gran Fury crack-and-peel sticker, 1988.

Some readers may be uncomfortable with using the concept of semen loss as part of an education program because of the sexual explicitness of such material and the absence of scientific documentation of ill effects from semen emission. Yet the gap between scientific knowledge and folk knowledge is not as wide as once thought....

Moreover, the exploitation of the masculine symbols of strength, semen, and sexual prowess need not be explicitly stated in mass media education approaches, as a very popular television commercial for beer demonstrated in 1974. The commercial showed a small bespectacled man walking into a bar, edging between two big men wearing hard hats, ordering Guiness beer, and then leaving with the barmaid, while the narrator booms—'Guiness! The beer that puts it all back.' Family planning programs need the creativity found in the business sector's product-marketing divisions. (Whitehead 1992, 125)[20]

The voluminous discourse on condoms represents a constellation of interests, cultures, subcultures, and social positions. Even a casual inventory, limited to the United States, turns up a long list of parties who have had a hand in debates over condoms: Congress, print advertisers, AIDS activists, Gay Men's Health Crisis, ACT UP, AIDS artists, pharmaceutical companies, the stock market, the TV networks, other media (radio, specialized outlets, the Internet), the Television Information Office, Planned Parenthood, American Academy of Pediatricians, American College of Obstetricians and Gynecologists, primary care physicians, medical journals, ad agencies, account executives, investors, market analysts, condom manufacturers, Food and Drug administration, Public Media Center, laboratory testers, Surgeon General, Public Health Service, Centers for Disease Control and Prevention, statistical forecasters and computer modelers, National Academy of Sciences, Institute of Medicine, the Justice Department, Dr. Ruth, Phil Donahue, Oprah, Tony Brown, the Catholic Church, cities (billboard advertising), drugstores, gas stations, supermarkets, and other distributors, The World Health Organization, USAID, birth technology and population experts historians, AIDS activists and caretakers, adult bookstore managers and owners, people with AIDS, public interest groups including gay and lesbian lobbying groups, the FCC, the FTC, the National Association of Broadcasters, the so-called moral majority, rock groups, and much of the rest of the public. While the richness and multiplicity of current condom discourses makes it tempting to invoke William Burroughs' vision of language as a virus that can be immobilized only by its own density ("Language must be total—only way to stop it"), I will conclude instead by suggesting a number of desirable approaches to the prevention of disease and conception—ideas for products, approaches, features, and coalitions. These do not yet figure prominently in this discourse, but constitute an ambitious agenda of alternatives and possibilities.

Desiderata in sexual protection would

~ include technologies, devices, concepts, and projects

~ capitalize on fantasy, transgression, and anti-authority sentiments

~ include a range of high tech simulations, for example condoms designed to look, feel, smell, and taste like a penis[21]

~ include a range of products for women
~ be easy and convenient to use
~ enable women to control their own protection
~ be discreet and virtually invisible
~ function simultaneously to prevent disease and conception *or* to be used for one or the other
~ include a special line of condoms that would enable Catholics, with the Vatican's blessing, to use those color coded for disease prevention *only*
~ be free of side effects
~ be available in the form of a temporary suppository or spray-on sealant (like Pam for frying pans), with different flavors and consistencies for different orifices and with reliable sealant properties for at least 45 minutes, after which it could be peeled off like rubber cement, allowed to harden into a secure impenetrable sphere, and thrown away
~ merge latex with computer technology, embedding in a condom or other protective device a programmable vibrating chip to enhance sensation (it would have dual control programming, like a king-size electric blanket).[22]

Carl Djerassi wrote in the late 1970s that the "key way to increase the use of condoms is to emphasize their possible relation to sexual pleasure rather than to venereal disease or contraception—a fact the Japanese began to recognize some time ago…. Marketing approaches should take advantage of sexual fantasies" (1979, 17–18).

That was then: this is now. In a world made wiser by AIDS, a world in which condoms have become part of dinner conversation, a Congressional hearing in 1987 addresses a very different set of questions, few of which include pleasure, fantasy, marketing appeal, efficiency, education, incentives, or innovation. As a transition to this discussion, let me conclude with a fitting drugstore joke:

> A guy planning a honeymoon cruise goes into a drugstore and asks the druggist for a package of dramamine. "And while you're at it, throw in a dozen condoms." The druggist says "Why do it if it makes you sick?"

4. Condoms and Television Advertising: Fragment of an Analysis

> Our ambiguity about sex, our uneasiness in talking about it, our cultural fears about sex? Is that what is holding us up?
>
> —Congressman Henry Waxman, 1987
> (*Condom Advertising and AIDS*)[23]

> How can the Centers for Disease Control promote public health when the promotion of condoms—a very effective preventive tool for HIV infection—is essentially stifled because we can't use the C-word? …Now, Dr. William Roper will be forced to defend an indefensible position, which I think is a shame."
>
> —Don Francis 1992 (*Preventing the Transmission of HIV*)

Let me say it: "condom, condom, condom," lest someone say I can-
not or will not say the word.

—William L. Roper (*Preventing the Transmission of HIV,*
Committee on Government Operations Hearing, 1992)

Because of its equal time format and position-oriented testimony for the record, a
Congressional hearing is a uniquely useful forum for identifying the discursive uni-
verse of policy debate and, more to the point, the strategies and tactics that keep
debate strictly confined.[24] A hearing on AIDS and condom advertising, called in
February 1987 by the tireless Henry Waxman, Los Angeles Congressman and Chair
of the House Subcommittee on Health and the Environment, provided such a
forum. Immediate background for the hearing included the publication in late
1986—well into the Reagan presidency—of several authoritative scientific reports
on AIDS which unanimously charged the federal government with neglecting the
epidemic and argued for the effectiveness of condoms in preventing HIV trans-
mission; at the same time, successful conservative efforts had blocked anti-AIDS
funding and policy initiatives and forged regressive legislation, notably the so-
called Helms amendment, which barred "the use of federal funds for educational
projects or materials that promote or encourage, directly or indirectly, homosexu-
al sexual activity."[25] A final background fact was that television was emerging as
the single most important source of information about AIDS and HIV, giving it a
unique public health role for diverse populations in the U.S.—and elsewhere in the
world as well (see Treichler 1993).

The familiar *dramatis personae* in this hearing—Congressman Waxman,
Congressman William Dannemeyer and other members of the subcommittee, U. S.
Surgeon General C. Everett Koop, representatives of the three leading television
networks, and representatives of public health—played their scripted roles effi-
ciently, and at times with unexpected subtlety. In his opening statement,
Congressman Waxman is characteristically blunt about the AIDS epidemic and
HIV transmission:

> [HIV] disease is transmitted principally by sex, by what has been coyly referred to as "the
> exchange of bodily fluids," that is, by anal, oral and vaginal intercourse. There are two
> ways to be certain of stopping this transmission: safe sex or no sex. "Safe sex" is sexual
> contact without intercourse. No fluid is exchanged between partners, but such sexual
> practices are not common in America. "No sex" will stop the AIDS transmission—but if
> VD and unwanted rates of pregnancy are any example—abstinence, while preached for
> centuries, may be at an all time low in America. In the face of the limitations of these two
> alternatives, the professionals of medicine and public health have turned to the next best
> choice: condoms. (Hearing, 1)

This opening statement signals familiarity as well as solidarity with the safer sex
campaigns well established by 1987 in U.S. cities. It also suggests the problematic
locution of "safe sex." Used here to mean "non-penetrative" sexual activities, "safe
sex" is used elsewhere in the hearing to mean "abstinence" (that is, the only truly

safe sex is no sex) and sex without "fluid exchanges," including protected sexual intercourse and "sexual practices uncommon in America." Though safer sex projects in the U.S. have in fact advocated and even invented a variety of sexual activities that involve neither penetration nor fluid exchange, the hearing does not provide an opportunity for exploring them.[26] Noting that condoms may be the world's oldest medical device, have cut down disease transmission for centuries, and are now advocated by virtually every AIDS expert and public health group in the country, the Congressman continues:

> But information regarding condoms and AIDS has been restricted by the largest and most effective communications medium in America—television. The routine promotion of condoms through advertising has been stopped by networks who are so hypocritically priggish that they refuse to describe disease control as they promote disease transmission. While portraying thousands of sexual encounters each year in programming and while marketing thousands of products using sex appeal, television is unwilling to give the life saving information about safe sex and condoms. We cannot afford such selective prudishness. Television networks cannot continue to pretend that this public health crisis is limited and that their viewers do not need to know about preventive measures. If doctors had withheld penicillin from syphilis patients because they might have encouraged extramarital sex, we would have recognized that as medical malpractice. In the same fashion, the networks' continued refusal to allow condom advertising is media malpractice. At this point, information is our only defense in the war on AIDS. Television has a responsibility to help fight this war. Without all assistance, the nation faces a larger epidemic with more cases and more deaths. (Hearing, 1–2)

An important characteristic of this hearing is that both proponents and opponents of condoms advance moral as well as medical arguments, illuminating the power at present of both domains of social thought as well as the unique irony of the AIDS epidemic coinciding with the rise of the New Right.[27] Through his parallel between medicine and television and equation of "medical malpractice" with "media malpractice," Mr. Waxman suggests that television has the same kind of responsibility to fight this war that doctors had when they gave penicillin to patients with syphilis. The history of U.S. VD and birth control policies and practices is not so unambiguous as this: the provision of antibiotics, in fact, *was* criticized for its role in fostering imprudent or promiscuous behavior, and doctors were urged to withhold it.[28]

Even as Congressman Waxman charges the television industry with "media malpractice," California congressman William Dannemeyer, a stalwart author of conservative AIDS legislation, counters by citing evidence, in the form of anecdotes, published articles, and news reports, claiming that "casual contact" and "horizontal transmission" (by mosquitoes, shared living quarters, and so on) are both significant factors in the spread of AIDS—thereby undermining claims for condoms' effectiveness in controlling the epidemic.[29] Like many conservative champions of American individualism, individual moral responsibility, and sexual self-control, he advocates mandatory testing and contact tracing—that is, the use of

strong centralized authority and punitive powers to impose that control from above. Note, though, that in addition to moral arguments he also claims to be providing medical evidence to support his claims. Finally, Dannemeyer takes issue with a statement of January 30, 1987, by then Surgeon General Koop and then Secretary of Education William Bennett; while underlining the seriousness of AIDS, they included the following advice: "With regard to AIDS, science and morality teach the same lesson. The best way to avoid AIDS is a mutually faithful monogamous sexual relationship. Until it is possible to establish such a relationship, abstinence is the safest." While commending most of the statement, Dannemeyer expresses distress at the phrase "mutually faithful monogamous sexual relationship," suggesting that they should have specified a *heterosexual* sexual relationship, for this "is the foundation of our civilization." This is but one example of the vigilance with which the Surgeon General's AIDS discourse was being policed by the Right.

Dr. Koop is the first expert witness to testify. A strong conservative himself, Koop's strong advocacy of condoms had shocked the Reagan administration as much as it delighted the nation's political cartoonists [FIGURE 1]. He succinctly summarizes the advantages of latex condoms, noting that laboratory studies demonstrate that when used properly they "prevent both semen deposition and contact with urethral discharge and/or mucous membranes" ("Condom Advertising," 4); clinical studies to date support this conclusion, and more are underway. Agreeing that condom advertising "would have a positive public health benefit," Koop identifies two crucial tasks it could accomplish: broadcast verbal and visual messages specifically aimed at black and Hispanic groups; and emphasize that condoms function to prevent disease, including HIV transmission, as well as to prevent conception. "It appears that many people do not understand how to use condoms to prevent AIDS" (6). He concludes his testimony with a final opinion: "You cannot educate about AIDS unless you educate about sex." (Hearing, 7)

At several points in his testimony, Dr. Koop has referred to his October 1986 *Surgeon General's Report on AIDS*, an admirably straightforward document that shows little of the contradictory rhetoric that marks *Understanding AIDS*, the pamphlet sent to American households in early 1988 as part of the continuing America Responds to AIDS campaign; reports that Dr. Koop made the 1986 document public without administrative approval ensured that the 1988 pamphlet would be carefully vetted. Asked whether in advocating condoms he is not treating abstinence as an afterthought, Koop, the longstanding conservative, is ready with his defense:

> If you will read my report to the American people, you will find that before we talk about condoms, there are 13 moral statements that have to do with abstinence, with mutually faithful monogamous relationships, and with advice to teenagers. The way I stated it was only for the purpose of being told to present testimony in a short period of time.

He adds, echoing the sentiment Dannemeyer had earlier approved but shifting its meaning to support condoms and sex education, that "With AIDS, if you walk down the scientific path toward containment of this epidemic, the moral path par-

allels that, and not many public health problems can say that" (Hearing, 12).

Congressman Coats questions Koop about potential conflicts of interest between public health and private industry:

> Do you have reservations about the fact that…the pharmaceutical companies and the advertisers will subtly move from selling condoms as a preventive health measure to selling sex or selling condoms in a war of competition to see who's going to increase their marketshare and subtly encourage sexual activity as a way of increasing that bottom line?

Industry, so often championed in conservative rhetoric as the "victim" of "regulation" (e.g., the tobacco, oil, and pharmaceutical industries) is conveniently transformed into a scoundrel seeking to sell a product in a "war of competition." Here Koop merely responds that he is willing to discuss this with the condom manufacturers. But later Congressman Tauke observes that

> this industry has tried to ride various horses into the racetrack, I guess, of TV advertising, and they haven't been successful riding other horses, so they've found one that apparently is more appealing. (Hearing, 61)

It is Congressman Waxman, the liberal Democrat, who must affirm the reality of a market economy:

> I think that we want ads to be responsible. But after all, the condom manufacturers are going to make some money out of this epidemic, because the fact is, as people turn to condoms as the one way of protecting themselves from the transmission of AIDS, if they're going to have sexual activities. They don't have to hype it in order to attract more of a marketshare. They are simply the beneficiaries of this terrible tragedy, just as the pharmaceutical manufacturers are going to be the beneficiaries when they develop drugs to stop or treat the disease. (Hearing, 33)

At issue is not only the condom industry's purity of heart but also the nature of constitutional protections of commercial expression; existing precedents would distinguish among at least three types of advertising: ads developed and sponsored by the Public Health Service; ads developed and sponsored by PHS grantees (that is, with PHS money and under its auspices but developed and broadcast in the name of the grantee—e.g., the Hispanic AIDS Action Council); and ads developed and sponsored by commercial condom manufacturers. The public sector can't afford the high advertising rates of prime time television; its funding, moreover, would be subject to bureaucratic review and congressional oversight. Commercial advertising on network television, however, is subject to regulation by both the FDA and the FTC as well as by the industry's own forms of self-censorship. Public service announcements, which may mention a product generically but may not make a direct sales appeal about a brand-name product, tend in several respects to be less effective than commercial advertising.[30]

The second expert witness is Dr. June Osborn, director of the School of Public Health at the University of Michigan; Dr. Osborn was a member of the National Academy of Sciences/Institute of Medicine Committee on a National Strategy for

380 AIDS, whose 1986 report strongly advocated condoms as a preventive measure (Baltimore and Wolff 1986). At this hearing Osborn argues that condoms should be advertised on television because in the fight against AIDS all means available "should be deployed." Praising the "dazzling speed" of the country's response to the blood supply threat, Osborn advocates responding as rapidly to threats from sex and drugs (Hearing, 16–17). Sex, she observes, though evidently difficult for primetime news programs to address, is a common theme in other TV formats—soap opera, for instance (see O'Connell 1989, 488, for examples).

Like Waxman, Osborn has learned ways of playing the conservatives' own game. Where Congressman Dannemeyer and other conservatives argue that the advocacy of condoms licenses, even promotes, promiscuity, Osborn argues that an emphasis on condoms "represents sexual activities as hazardous" and therefore lends "momentum to the desire for a monogamous society." Of course a seasoned rightwing champion like Dannemeyer is not about to be placated by such a tactic, and he simply shifts his line of questioning:

> Mr. Dannemeyer: Do you believe we can separate in the field of education, sex education from morality and ethics and conscience?
>
> Ms. Osborn: I don't think we can separate education at all from morality and ethics and conduct. I think the preservation of human life and health is my strongest ethic and this is very important now, to be able to bring that forth as a very important component in this discussion.

In the ongoing battle over STDs, Osborn's statement reflects the values shared by modern medicine and modern liberal humanism, in which "the preservation of human life and health" unifies an array of health professionals, religious humanists, political liberals, AIDS advocates and activists, and a broad segment of the American public. Dannemeyer asks whether the Government should be involved in the private advertising of condoms. Osborn expresses ignorance of the law in terms of what "involvement" would entail but says it is certainly appropriate for the Government to "advocate" condom usage to limit the spread of AIDS.

> Mr. Dannemeyer: Don't we have somewhat of a dilemma then in our society? You believe the Government should be involved in advocating the use of condoms for preventing the spread of AIDS, [but don't you think] any effort on the part of the Government to combine morality and ethics and conscience with respect to education in sex would be a violation of the First Amendment of the Federal Constitution?

Precisely how this violation would occur is not spelled out and Osborn doesn't ask but claims instead that the government's foremost role must be thought of as the "duty to warn," a duty that must be communicated in very clear language—that is, in the vernacular of the given community,

> not in some very arcane language that is particular to those of us who have been fortunate enough to be highly educated. We have a society with a rather substantial, in fact, an embarrassing illiteracy rate. The television media in particular becomes very impor-

tant in that context. Its duty to warn its citizens of danger and inform them of preventive alternatives. (Hearing, 18–19)

In the context of AIDS education, the phrase "the vernacular" means dirty words—that is, slang, street language, and culturally specific colloquialisms in place of "arcane" medical and scientific terms.[31] In the VD campaigns early in the century, scientific and technical language was seen by health educators as the way to escape the vocabulary and moral baggage of the Victorian era. Lecturers being trained to talk to servicemen during World War I, for example, were given the following advice:

> Don't use words that (while good in themselves) have unfortunately acquired prejudices in the minds of many men whom it is particularly desired to influence. This includes words of semitheological connotation, as well as words with a sentimental or 'sob' tinge.[32]

Yet it was also recognized that technical language sustained a class-based exclusion of working class, poor, and uneducated people from access to information about disease prevention and birth control (Reid 1984, 133).[33] The argument for using everyday and street language in AIDS education programs is, similarly, that technical language will not be understood by many in the target audiences; the task, these days, is to translate biomedical knowledge into the vernacular. Everyday language is also preferred by some AIDS patients and activists on the grounds that scientific and technical words are politically tainted: while good in themselves, they "have unfortunately acquired prejudices in the minds of many men whom it is particularly desired to influence." Some educators appear to have decided that the scientific realities of HIV and AIDS are too difficult to communicate in any vocabulary, and that the simpler strategy is moral rather than medical (e.g., "Just say no").[34] "The vernacular," finally, stands for plain rather than euphemistic speaking, for naming names in concrete and specific ways rather than using phrases like "the exchange of bodily fluids." In the wake of the Helms amendment and other assaults on the public use of explicit sexual language and images, this has proved a crucial policy issue; the use of explicit, concrete language in AIDS educational materials and art has enabled conservative officials and legislators to deny or revoke funding to AIDS service organizations (see Crimp 1988).

Several lessons can be derived from even this abbreviated account of the hearing. The hearing raised, even replicated, many features of earlier debates identified by Brandt, Gordon, and other historians, including the dual role of condoms, the purpose of sexual intercourse, the link of sexuality and disease to urbanization, industrialization, and commerce; the threat to family values of sex outside marriage; concerns about safety, responsibility, and pleasure; the role of fear as a motivator versus the view that, in the words of an officer in the World War I quoted by Brandt, "the sex act cannot be made unpopular"; and the question of whether sex separated from reproduction and disease through contraception will increase promiscuity. The hearing, along with other examples of condom dis-

382 course, including its marketing tactics, makes clear that the incorporation of homosexuality into this weighty historical legacy has been challenging—-rhetorically, ideologically, and scientifically. In the hearing, for example, "the fallen woman" of 19th and earlier 20th century condom debates becomes the homosexual: yet arguments about pregnancy and birth control take on an odd cast in this new context, even while "the heterosexual population" remains the overt concern. What holds true over time is the vision that the nuclear Dick-and-Jane family is at once the most vulnerable target of sexually transmitted disease and the strongest armor against it.[35]

In many debates of policy and politics, scientific evidence does not always function to show the truth of one set of practices over another; rather, whatever practices are already favored dictates what evidence is assembled in support. Debates over decades about the safety and effectiveness of in-hospital versus out-of-hospital childbirth have acquired something of a scholastic, even ceremonial, character, with each side establishing criteria for defining acceptable "evidence," criteria usually constituted in such a way that the opposing side cannot possibly meet them. (As the U.S. health care system moves toward managed care, we can expect to see the long-rejected evidence for out-of-hospital birth now declared unassailable.) But debates about the statistical effectiveness of contraceptive and disease control strategies are not nearly so open to interpretation. High quality latex condoms, used correctly and consistently, are highly effective in preventing HIV transmission. Though opponents of condoms frequently cite failure rates of 30% or higher, this is largely because the figures are drawn from the birth control literature. In the hearing, the statistical effectiveness of condoms was addressed in detail by Michael Rosenberg, an MD and MPH who is the executive director of the American Social Health Association (the successor of the American Social Hygiene Association, one of the leading early 20th century anti-VD organizations). Because most of our statistics are based on studies of contraception among married couples, Rosenberg testified, we do not yet know precisely how they should be extrapolated to the prevention of serious or life-threatening disease, or to unmarried and/or same-sex partners. Rosenberg noted, however, that Sweden's pro-condom campaign against gonorrhea in the early 1970s demonstrated over two years a 50 percent increased usage and a 20 percent reduced disease rate. Problems in assessing condom success or failure, he notes, include not only the unreliability of self-report but also the close relationship of failure rate to motivation. When married couples use condoms for birth control, the failure rate is estimated to be 10–20 percent; but when the couple is highly motivated to avoid pregnancy, the failure rate drops to 1–2 percent.

This is not an ambiguous statistic. Its applicability to HIV prevention is confirmed at another AIDS hearing five years later, when Don Francis asserts that we should now be able to prevent almost 99 percent of new HIV infections. Could this Congress, this subcommittee—Henry Waxman and his enlightened minority excepted—be charged with responsibility for five years' worth of new infections, for its failure to act, to warn, to mandate any preventive measures in their power?

Of course it is responsible. Provided with Rosenberg's expert judgement that condoms can be extremely effective in preventing HIV transmission, did they ask "Great, how do we get more people to use condoms correctly and consistently?" Did they ask, "How can we ensure high quality products?" Did they even ask, "Where do we start?" No, they asked Rosenberg whether, if condoms are not *100 percent effective*, it isn't dangerous to advertise them. As he tells them, little in life is absolutely without risk. An extensive body of research confirms that condoms will significantly reduce users' risk of contracting a whole range of STDs, including HIV disease; reducing users' risk will reduce the risk of HIV's spread in a community: this is what we must strive for.

This Congressional hearing definitively established that the condom promises to be a partial but concrete solution to an intractable problem; it is a place to start. The hearing identified urgent work to be done: as Dr. Koop put it, "many people do not understand how to use condoms to prevent AIDS." Research also shows that many people believe that contraceptive measures—the pill, the diaphragm, sterilization—protect against HIV. These confusions underline Koop's point that "You cannot educate about AIDS unless you educate about sex." Indeed, you cannot educate about AIDS protection unless you educate, in some detail and cultural specificity, about the actual mechanics of sex, the sexual transmission of disease, and sexual reproduction. Moreover, television needs to be told much more loudly that there's a war on. In addition to the testimony of public health experts, the hearing enabled the television networks to speak their piece. The testimony provided by executives from ABC, CBS, and NBC suggested a beleaguered industry with little leadership. Each executive documented the extensive AIDS programming his network had broadcast, expressed total commitment to the struggle against AIDS, and concluded that present constraints made commercial condom advertising impossible at the present time.[36]

A harm reduction model, a model of probabilities and possibilities, of partial successes and incremental behavioral change, is a reasonable model. It holds promise for a range of interventions at the level of individuals, communities, and larger social and cultural units. The present agenda should begin with the condom but simultaneously move beyond it to encompass all the possibilities that I outlined in the previous section—imaginative safer sex projects, comprehensive research programs, incentives for technological innovations, initiatives across cultures, and discussion of alternatives we have not yet thought of. Yet where are we? Still trapped in the shadow of the transcendental signifier, frozen in symbolic space erected by the condom killers of the Reagan revolution. Forget birth control; forget disease control: what they want is sex control. And like the Terminator, they will not stop until we are dead. "The condom is a mechanical barrier, of course," said June Osborn during the hearing, "and therefore, its integrity can be breached" (Hearing, 17). Rep. Dannemeyer and his cohorts claimed in turn that only abstinence and faithful marriage offer true "integrity" against the virus. The police of the right cannot have it all their way: Metaphor into hardware, gentlemen; but hardware into metaphor too. The condom is both signifier and signified. Though

384 sometimes a condom is simply a condom, sometimes it is a barrier, and sometimes it is a barrier that can be breached.

5. Beyond the Barrier

> A guy goes into a drugstore and says to the druggist "I'll have a dozen condoms, please." Then he leans forward and says under his breath, ("And a package of Marlboros").

> A duck goes into a drugstore and asks to buy a condom. The druggist asks him "Shall I put it on your bill?" The duck says "No thanks, I'm not that kind of a duck."

I have argued here that the condom is a gift for anyone interested in the history, culture, and discourse surrounding sex, gender, and sexually transmitted disease. Wherever it goes, the condom—like the transgressive behaviors which it has come to signify—highlights existing and ongoing tensions, political and economic interests, interpersonal and cultural conventions, power relations, and moral and ethical struggles. Though much more could be written on the condom's history and present existence, I have tried to illustrate this with a variety of examples. Nevertheless it is a more urgent point I have also tried to argue here. There are many pragmatic and wholly admirable reasons for seeking to increase the world's use of condoms as a cheap, simple method of protection. But while the condom functions as an extraordinarily efficient barrier to both disease and conception, it has also become the moralists' revenge on all forms of pleasurable or transgressive sexuality. Given the leading role in the AIDS epidemic, the condom inevitably shapes the universe of possibilities to its own phallic shape. That is, by demonizing the condom, a small core of the immoderate and ideological right has proved adept at aggressively phallocentric discourse, preventing discussion of and research on a range of alternatives. In turn, by fighting—as we must—to maintain the right to use the word "condom" in the universe of public discourse, we abet the condom's emergence by default as the AIDS epidemic's transcendent signifier of sexuality: this is too high a price to pay for the condom's entry into the symbolic.

A condom is not simply a technological device. It has come to embody, the world over, a range of additional meanings, material interests, and comprehensive "safer sex" campaigns. It has come to stand in for, indeed literally to substitute for, its own alternatives in the form of perfected technologies, pharmaceutical preventions and cures, equitable economic arrangements, social and political justice, improved health care resources and treatment facilities, and mandated communication about sex and sexuality. One might even conclude that the condom has come to be the one sayable thing in a sea of silence, the one do-able intervention in a world of apparent impotence. Because they can be counted, condoms operate synecdochally to measure the effectiveness of AIDS prevention programs. "We sent 3 million condoms to Uganda," claimed USAID in 1988. "We gave away more than 250 condoms at the gay bar last night," claim community AIDS projects. Counting

is so important an activity that researchers' attempts to gain more accurate measures have entailed some unenviable fieldwork: morning-after scavenging yields estimates of the incidence of condom use within the population that frequents Lovers Lanes, while strained sewage permits them to recover and estimate the extent of condom use in a given geographical area over a given period of time.

But the condom cannot continue to stand alone. We face a conservative logic that Barry D. Adam, drawing on the historical work of Allan Brandt and Linda Gordon on sexually transmitted diseases and birth control, characterizes as a closed rhetorical system in which

—AIDS is an invariably fatal disease caused by the AIDS virus.
—AIDS can be contracted by having sex with an AIDS carrier.
—AIDS control, then, means finding out who the AIDS carriers are and stopping their irresponsible behavior, through mandatory testing and contact tracing.
—Limiting sex to the traditional family is the most effective means of limiting the spread of AIDS. (Adam 1989, 309–10)

Testifying at the hearing on condom advertising, Michael Rosenberg laid out what can be called, in parallel fashion, "liberal (progressive) logic about AIDS":

—An extensive body of research proves that condoms effectively prevent STD transmission.
—Because sex is a human priority along with personal safety and food, one cannot simply tell people not to engage in it ("the sex act cannot be made unpopular"). Therefore any campaign that offers abstinence as its only recommendation will fail.
—Condoms promote good health not only by preventing HIV transmission but by preventing virtually all STDs—whose numbers have escalated dramatically in the last decade as resources are reallocated to AIDS.[37]
—Even if condoms are not 100 percent effective, an effectiveness rate of 90 to 99% is not bad.
—Our duty is to preserve life and health.

The "moral" view and the "medical" view constitute an entrenched polarity of twentieth-century discourses on health that clearly dominated the hearing I have just discussed.

Some things are certain if we are to put the condom to bed and move on. First, pitting rightwing logic against leftwing logic against market logic is unlikely to achieve any kind of workable solution. To open up alternatives means undertaking a multi-dimensional struggle on many fronts, using as many strategies and constituencies and arguments as we can think of, drawing on knowledge and resources from many disciplines, addressing both short-term and long-term goals as well as individual, community, and social concerns—in short, contribute whatever strategies, technological politics, and theoretical insights of cultural studies to get the condom to bed and move on. This is what lies beyond the barrier. This is how you, too, can use a condom.

Notes

1 Jokes cited throughout this paper have been culled from many sources including scholarly reference works, notably Legman (1968) and Legman (1975), newspaper and magazine articles, stand-up comics, bartenders, TV, films, other pop culture sources, the Internet, and my colleagues. I want especially to thank my colleagues, too many to acknowledge individually, who have generously contributed to the collection of materials on which this project is based—not only jokes but memos, posters, flyers, press kits, research findings, graffiti, videos, greeting cards, stamps, stickers, scholarly references, song lyrics (special thanks to Najda Michel-Herf), anecdotes, memories, condoms of many varieties, and other treats too diverse to categorize. I am also indebted to Anne Eckmann and Kirsten M. Lentz for zealous assistance in this research.

2 *Summer of '42*. 1971. 102 min. Director: Robert Mulligan.

3 A pharmacist writing in the trade journal *Drug Topics* offered another perspective on this scenario and the changes that AIDS and other STDs have brought about:

"Condoms! They used to be kept in a drawer behind the counter, and men would sheepishly insist that the male R.Ph. wait on them. I remember being embarrassed myself the first time a woman asked me to sell her some (probably in the early '60s). The condoms came in plain boxes and had 'manly' robust names in those days. Now they come in boxes with pictures of loving couples, have soft, sensuous names, and are displayed on massive pegboards. Ads for them appear in magazines and on cable TV, and teenage girls buy them at the checkout counter." Since the AIDS epidemic, he notes, "I have given up teasing teenage boys. My favorite had been to give them a deadpan look and ask, 'Small, medium, or large?' The looks I got were priceless. Mouths gaped, eyes bulged, and there was usually some stuttering. But when one kid just turned and walked away before I could let him off the hook, I realized how disastrous my 'joke' could have been, and I decided to play it straight from then on." (Plagakis 1991)

4 David Owen, whose book *The Walls Around Us* seeks to demystify home repair, compares the agony of a boy's first condom purchase to an adult man's "fear of lumber" in later life: "Many substantially normal men feel a paralyzing fear when they have to buy something at a lumberyard or hardware store. Women are afraid of these places too, but for complex cultural reasons their fear doesn't matter. For men, these public exhibitions of ignorance are agonizing and, in fact, seemingly life-threatening." Owen's description of his anxieties the night before he goes to buy his first 2' x 4' is like a handyman's guide to castration anxiety. Owen (1992) 48–49.

5 This information comes from a press clipping released over the Internet, dated February 22, 1996, from Sydney, Australia. According to the article, the "reef" is caused by a fairly common phenomenon called "like aggregation" in which similar objects aggregate in the ocean over a period of time, driven into a mass by wind, currents, magnetic fields, buoyancy, and other factors. Marine biologists at the Oceanographic Laboratory Outpost on Macquarie Island, South Pacific, plan to map and monitor this latex landmass to see if it expands, breaks up, or drifts from its current location (63 degrees latitude and 154 degrees longitude for you sailors).

6 Zena Stein, testimony to Congressional subcommittee hearing on Women's Health, 1991. In practical terms, this means that many questions relevant to disease prevention are still unanswered: Where does semen go when it is ejaculated? How soon? How are semen and sperm different? What is a vagina shaped like? What is the function of vaginal mucus and the mucosal lining of other bodily orifices? Behind these and other questions are important political and intellectual impediments to envisioning, developing, and using safe devices for preventing disease.

7 While Casanova's indictment of condoms here vividly captures the sentiments of men

over the centuries, it apparently does not represent his own practice. According to Himes, Casanova used condoms fairly systematically, even going so far as to test them himself for reliability.

8 The overview that follows distills information from a large number of sources, including histories of contraception and infectious disease, birth control and population journals, technical reports, and industry fact sheets (see list of references). But I do not claim to have fully digested this material; indeed, I suspect that, taken as a whole, it may be indigestible. It is a literature concocted almost exclusively in the west, and even the anthropological literature on fertility control is often of the "quaint native customs" variety. Much critical thinking is needed here, and serious attention to historical and contemporary fertility and anti-fertility practices across cultures. I should note, too, that virtually no critical accounts exist of the condom industry, where the secrecy and paranoia that characterize many commercial enterprises are notorious. For more information, see American Social Health Association (1989), Brandt (1987), Darrow (1989), Djerassi (1979), Dumm, Piotrow, and Daismer (1974), Englade (1992), Gordon (1976, 1984), Harper (1983), Henjo (1962), Himes (1963), Jones and Forrest (1992), Kilpatrick (1962), Leinster (1986), Mack (1988), Mosher and Bachrach (1982), O'Connell (1989), Office of Technology Assessment (1982), Partridge (1962), Paul and Sanderson (1976), Petchesky (1984), Pincus (1965), Quinn (1979), Rapoport (1991), Reagan (1996), Redford, Duncan, and Prager (1974), Reid (1920), Reed (1978, 1984), Rosenberg et al (1992), SIECUS (1993), Solomon and DeJong (1989), Stanworth (1987), Stopes (1935), Sungaard (1938), Tatum and Connell-Tatum (1981), Treichler (1988a, 1988b, 1989, 1992a, 1992b), and Weller (1993).

9 In the Illinois heartland, actually, condoms *do* go on the plants: cornfields are planted so that male and female plants alternate to maximize pollination; when the weather gets hot, a paper "condom" must be tied onto each ear of corn to keep it from pollinating prematurely. A local version of a standard condom joke goes like this. A farmer orders several gross of condoms to cover the tassels of his corn. On Monday morning he comes into the pharmacy and says "You didn't give me enough condoms." The pharmacist says, "Sorry I spoiled your weekend."

10 As special government agent, Comstock carried out raids (in one of which he confiscated 60,000 "rubber articles") and mounted a campaign to entrap physicians dispensing contraceptives. In subsequent years, many state legislatures passed so-called Little Comstock Acts.

11 Of course, as Himes observes, aggressive attempts to discourage or criminalize a given activity may have the opposite effect, and argues that the publicity surrounding the 1877–79 Bradlaugh-Besant trial for distributing birth control information brought about the "democratization" of birth control methods. See 239–59 for discussion.

12 It is well documented that some physicians consistently provided birth control for their patients. As Leslie Reagan (1996) convincingly demonstrates, using the example of abortion, the practices of individual physicians did not necessarily conform to the policy dictates of the AMA and other medical organizations. Apart from the policy, however, some physicians were never comfortable with the condom as a technology. A 1943 editorial on contraceptive devices in a medical journal claimed that honest physicians "are ashamed of these messy makeshifts…and disreputable paraphernalia" and argued that the "messy little gadgets, the pastes, creams and jellies" are "an embarrassment to the scientific mind." [quoted by Gordon]

13 Robert Parker, my colleague at the University of Illinois at Urbana-Champaign, informed me that the character Benjy Compson in William Faulkner's novel *The Sound and the Fury* is given a shiny metal tin which bears the legend "Agnes Mabel Becky"—a container for Three Merry Widows brand of condoms. See Brown (1976), 19.

14 HIV is about 50 times smaller than sperm and about 10 times smaller than the pores in a lambskin condom. Transmission is considered unlikely, because, in typical Consumers Union prose,

> The pores aren't tunnels through the skin's wall. They occur in individual layers of the skin's multilayered membrane, so some experts believe that skin condoms can still offer protection against small viruses. To get to the outside, such a virus would have to zigzag through each layer's tortuous fiber structure, somewhat like negotiating a maze. But, given enough time, the virus might be able to do so. (Consumers Union [1989], 137)

Until research establishes this possibility, latex condoms are recommended for disease prevention.

15 G. D. Searle's 1957 announcement of a birth control pill took place after extended field testing in Haiti and Puerto Rico, testing which has since been widely criticized. Schmid pharmaceuticals targeted their contraceptive marketing to women as well as men, distributing a booklet to physicians called "Wanted: A Warm and Vital Wife"; it hailed the departure of the Victorian lady and her replacement with "the modern wife, who brings less 'no' and more 'know-how'" to the marriage bed. Birth control flourished with Zero Population Growth campaigns, approval by some authorities of the pill for Catholics, and, in the early 1970s, the development and marketing of the IUD, the invention of contraceptive-film, and the legalization of abortion.

16 In a 1989 study of condoms widely available in the U.S., *Consumer Reports* subjected a total of 16,000 latex condoms (representing 37 U.S. models and three Japanese imports) to a characteristically thorough series of tests, including a standard water test, a stretch test, visual inspection, and airburst testing. While most condoms fell well within FDA standards, a higher percentage failed to meet strict airburst standards (not yet required in the U.S. but likely to be). Two models were found unacceptable and several million condoms were recalled. Consumers Union believes that since April 1987, when the FDA stepped up its condom inspection program, product quality has been improving; they conclude that the Government presence is a strong incentive to improve quality control, encouraging most companies to step up their own internal testing. U.S. Inspection added airburst testing in 1994, just too late for *CR*'s 1995 update. See also Centers for Disease Control and Prevention [1993a, 1993b]). See also Goedert (1987), Jones and Forrest (1992), Samuel et al (1993), and Johnson (1994).

17 See Rapoport (1991). In his pre-AIDS book, *The Politics of Contraception*, Carl Djerassi, developer of the oral contraceptive, weighed the trade-offs between thickness and strength, taking U.S. condoms to task and urging the importance of making them more widely appealing:

> The FDA's condom requirements essentially guarantee condoms free from minor defects, but as a result lead to the manufacture of the thickest condoms produced *anywhere in the world*. That this is counterproductive should be obvious to any man who has ever refused to use a condom because of reduced sensation. In 1966 an interesting calculation was made which showed that if the FDA's standards were relaxed to permit an increase of *one* percentage point in pinhole incidence—thus permitting manufacturers to make condoms only half as thick—the increased risk in pregnancy would be equivalent to *one per 2.5 million to 5 million instances of coitus* (17).

18 Symanski (1981), 40. At my request, Manuel Martinez Nicolas, a colleague at the University of Barcelona, sought to update this report and could find no such shops nor such a variety of condoms. I would be glad to receive further information.

19 Bertrand et al. 1991. Mean coital frequency for the total study population was 1.7 relations per week compared to approximately 4 relations per week among the "sexually active" (347). "Relations" is defined as ejaculation by the male partner.

20 Whitehead has already elaborately addressed issues of sexism, gender equality, and relationships between the sexes in Jamaica, and in context the point he is making in praising this ad is not sexist, though the ad out of context might be taken that way.

21 Such a product was under development in the late 1980s; I do not know its current status.

22 A 1987 *Ms.* column on women's health reported the development of an experimental birth control technology in which a tiny battery inserted into a special cervical cap or diaphragm emits low voltage low intensity current designed to immobilize and kill sperm cells. The article also quoted the concern of women's health advocates that such a device constituted a foreign body and might provoke an immune response in the woman's body. (Fortina 1987)

23 Hereafter cited internally as "Hearing," by page number.

24 Because they are potentially subject to subsequent editorial revision and substitution, the published proceedings of Congressional hearings cannot, of course, be read as verbatim linguistic transcripts. Nonetheless, they enable us to get a flavor of the discourse of these debates together with the range of positions and interests that a given issue encompasses.

25 An early attempt in Australia to ban explicit AIDS education for gay men created such an outcry that a national campaign was organized before that of other countries. Despite the limitations of the Grim Reaper campaign, it captured the attention of the general population and represented, as well, considerable cooperation among diverse groups at risk. Though an attempt to create a Helms-like ban on projects failed in Canada, existing regulations have been used to seize materials at the border (see Kinsman [1987]). Clause 28, passed in the U.K. parliament, succeeded in creating Helms-like prohibitions on projects and materials. The Helms amendment was subsequently found unconstitutional in a federal court of appeals.

26 The conflation of protected sex and abstinence is satirized in a comedy routine of the group Kids in the Hall; when a bourgeois matron learns her son is gay, she says "I just hope he practices no-sex, like his father." Though Waxman's reference to "sexual practices uncommon in America" is not seriously addressed in this hearing, the historian Linda Gordon, among others, has identified a number of non-procreative traditions in the U.S. involving sex without intercourse, including programs for male chastity and sexual control, quoting a feminist birth control advocate: "Man should look at his own penis, until he is lord and master of it." The safer sex programs developed since the early 1980s by gay and lesbian groups and by sex worker organizations describe many forms of sex that avoids penetration and fluid exchange. See for example Berkowitz et al (1983), Patton and Kelly (1987), and Aggleton et al (1989).

27 The two decades preceding the AIDS epidemic were characterized by significant political upheaval and change, including the civil rights movement, the feminist movement, and the gay liberation movement. The rise of Reagan and the New Right were in part a reaction to progressive gains. At the same time, as Simon Watney, John D'Emilio, and others have argued, one can frame the irony differently and say that by the time a substantial conservative movement finally gained political power in the United States, a number of seasoned radical communities awaited them.

28 In Arnold Sungaard's 1938 the Federal Theatre play *Spirochete*, a moral reformer, representing the "Citizen's Moral Welfare League," confronts the microbiologist Elie Metchnikoff, who has just shown demonstrated that calomel ointment effectively treats syphilis at the time of inception:

THE REFORMER: I forbid you to make your discovery known to the world!
METCHNIKOFF: Do you really?
THE REFORMER: Syphilis is the penalty for sin! You are about to remove that penal-

ty and plunge the world into an orgy of sinful living. Man will be free to pursue his lustful impulses with no thought of any physical wrath being inflicted on him....

METCHNIKOFF: ...You say syphilis is the penalty for sin?

REFORMER: Indeed it is.

METCHNIKOFF: And it's a horrible ghastly penalty, you'll admit. A more horrible one could never be devised, could it?

REFORMER: I could think of none worse.

METCHNIKOFF: Then why in God's name hasn't it put an end to sin?... When all your moral prophylactics have failed to prevent the spread of this disease you wish to suppress a chemical one. (Sundgaard, 61–62)

29 Convictions that the condom cannot ultimately protect against immoral behavior are as entrenched as the quest for protection. Wrote Johannes Astrac as the sheath gained favor during the Renaissance: "I suppose, that thus mailed and with spears sheathed in this way, they can undergo with impunity the chances of promiscuous intercourse. But they are greatly mistaken" (quoted by Himes [1963]).

30 Although some PSAs, for instance those produced for MTV about drugs, condoms, and the environment, are dramatic and entertaining, studies generally find that AIDS-related PSAs tend to be dull, hence unable to compete with the high production values of prime-time commercial TV. Because they seek to communicate a global do-good message rather than call for specific action, their effectiveness is difficult to evaluate. They lack precise audience targeting and tend to ignore such factors as cultural identity and psychological associations. For discussion, see Magnier, Branham, and Moore.

31 In *The Summer of '42*, the boys begin to read the 12-point description of sexual intercourse contained in the illicitly acquired medical manual:

HERMIE: Oh, this is crazy.

OSKIE: What?

HERMIE: Point 3.

OSKIE: What's crazy about it?

HERMIE: Well, I've never even heard of this word.

OSKIE: It's Latin—the original guys were Latins.

HERMIE: I wouldn't even know how to pronounce it.

OSKIE: You don't *pronounce* it—you just *do* it.

HERMIE: I don't even know where it *is*.... And what the hell is this in Number 4?

OSKIE: That's Latin, too. It's all in Latin, Hermie. Jesus!

HERMIE: Oh, yeah? Well, I'm just gonna have to ask where some of these things are.

OSKIE: They're all approximately in the same place, Hermie. Seek and ye shall find.

32 Brandt (1987, 62) quoting from a syllabus prepared to guide lecturers in their discussions of the pamphlet *Keeping Fit to Fight*.

33 The physician's preference for technical language paralleled a broader tendency—that continues today—to provide more information to middle-class patients. Some physicians argued that the provision of contraceptive information to the lower classes was an unnatural form of manipulation; but others argued that withholding as well as providing contraceptive information equally made the physician a "*deux ex machina*, controlling the masses through enforced ignorance" (133).

34 Again, the moral and medical are often deliberately melded, and this too has its historical antecedents as an educational strategy. Brandt (1987, 65) notes the relish with which many educators used fear as the "backbone of every medical education campaign," showing graphic photographs of the untreated effects of syphilis (twisted limbs, open lesions, other deformities). "I stripped the moral issue to the naked bone," claimed one military educator, with "a world of medical facts."

35 In his analysis of gay and lesbian policy issues, Barry Adam (1989, 306) argues that sexual debates today inherit older struggles over religious and political freedom; positioned on "the latest frontier of a profound historical change," AIDS therefore "quickly came to bear a cosmological significance which other diseases escape." Discussing idealized notions of the family, Adam (315) recalls Simon Watney's description of this as the "just so" story in which family life is the antidote to disease.

36 The statement of Ralph Daniels of NBC is typical:

The question of whether to accept condom advertising raises complex issues. As a birth control device, such ads are offensive to segments of our audience on moral or religious grounds. Other viewers believe condom advertising in any context inherently delivers a message about sexual permissiveness, which they find objectionable. Still other viewers regard condom advertising as a potentially effective way to combat the spread of the AIDS virus.... We have to weigh all these factors in examining the question of condom ads.... The whole process of broadcast standards is an evolving one.... While we are continuing our policy that condoms are not acceptable as product advertisements, we are monitoring these arguments and attitudes. ("AIDS and Condom Advertising": 36–37)

37 *Newsweek*'s December 9, 1991 cover showed the words "Safe Sex" superimposed on a silver foil condom package; the inside article (Adler 1991), titled "Safer Sex," gives the following comparative figures for new cases of STDs acquired by a total of 12 million Americans each year, including 3 million teens:

syphilis 130,000 new cases each year
gonorrhea 1.4 mil
chlamydia 4 mil
PID 420,000
genital herpes 500,000
genital warts 1 mil
hepatitis B 300,000
AIDS 199,406 total through Oct 91

References

Adam, Barry D. (1992) "The State, Public Policy, and AIDS Discourse." *Contemporary Crises* 13 (1989). Rpt *Fluid Exchanges: Artists and Critics in the AIDS Crisis*, ed. James Miller. Toronto: University of Toronto Press, pp. 305–320.
Adler, Jerry et al. (1991) "Safer Sex." *Newsweek* vol. 118 no. 24 (December 9): 52–56.
Aggleton, Peter et al (1989) *Educating about AIDS: Exercises and Materials for Adult Education about HIV Infection and AIDS*. Edinburgh: Churchill Livingstone.
Agnew, Joe (1986) "AIDS fear revives condom market; women new target." *Marketing News* vol 20, no. 25 Dec 5, p. 1, 4.
"AIDS Research: Focus on Vaccine or a Better Condom?" *AIDS Weekly* October 18, 1993, p. 6.
American Medical Association (1936) Editorial, *Journal of the American Medical Association* 106: 1910–11.
American Medical Association (1937) Editorial, *Journal of the American Medical Association* 108: 2217–18.
American Social Health Association (1989). *Condoms in the Prevention of Sexually Transmitted Diseases: The Proceedings of a Conference*. Research Triangle Park NC: American Social Health Association [conference held in Atlanta February 1987].
Baltimore, David and Sheldon M. Wolff, eds. (1986) *Confronting AIDS: Directions for Public Health, Health Care, and Research*. Washington: National Academy Press.

392 Berger, Joseph (1992) "New AIDS Plan for Schools Entails an Abstinence Count," *New York Times*, June 4: B8.

Berkowitz, Richard, Michael Callen, and Richard Dworkin (1983) *How to Have Sex in an Epidemic*. New York: News from the Front Publications.

Bertrand, Jane T., Bakutuvwidi Makani, Balowa Djunghu, and Kinavwidi L. Niwenbo (1991) "Sexual Behavior and Condom Use in 10 Sites of Zaire," *Journal of Sex Research* 28:3 (August: 347–364).

Brandt, Allan M. (1987) *No Magic Bullet: A Social History of Venereal Disease in the United States Since 1880*. New York: Oxford University Press.

Branham, Joe n.d. "Ready…Aim…Identity and Outreach Campaigns." *Positively Aware*.

Brown, Calvin S. (1976) *A Glossary of Faulkner's South*. New Haven: Yale University Press.

Centers for Disease Control and Prevention (1993a) *HIV/AIDS Prevention*, July 30, pp. 1–3.

Centers for Disease Control and Prevention (1993b) "Update: Barrier protection against HIV infection and other sexually transmitted diseases." *Morbidity and Mortality Weekly Report* 42:30 (August 6): 589–591.

Christopher, Maureen (1986) "Nets Stand Fast on Birth Control ADS." *Advertising Age* November 10, p. 36.

Condom Advertising and AIDS (1987) Hearing before the Subcommittee on Health and the Environment of the Committee of Energy and Commerce. U.S. House of Representatives. February 10. Serial no. 100–1. Washington: U. S. Government Printing Office, 1987.

Consumers Union (1989) "Can You Rely on Condoms?" *Consumer Reports* 54:3 (March): 135–141.

Consumers Union (1995) "How Reliable Are Condoms?" *Consumer Reports* 61:5 (May): 320–25.

Coucher, Mimi (1989) "A Girl's Guide to Condoms." *Whole Earth Review* 62, Spring 1989, 137.

Crimp, Douglas (1988) "How to Have Promiscuity in an Epidemic." *AIDS: Cultural Analysis, Cultural Activism*, ed. Douglas Crimp. Cambridge: MIT Press.

Darrow, William W. (1989) "Condom Use and Use-Effectiveness in High Risk Populations." American Social Health Association. *Condoms in the Prevention of Sexually Transmitted Diseases: The Proceedings of a Conference*. Research Triangle Park NC: American Social Health Association, 15–18.

David, Paul A. and Warren C. Sanderson (1976) *Contraceptive Technology and Fertility Control in Victorian America: From Facts to Theories*. Memo no. 202, Center for Research in Economic Growth, Stanford Unit, June.

DeVincenzi, Isabelle, for the European Study Group on Heterosexual Transmission of HIV (1994). "A Longitudinal Study of Human Immunodeficiency Virus Transmission by Heterosexual Partners." *New England Journal of Medicine* 331:6 (August 11): 341–46.

Diesenhouse, Susan (1989) "AIDS Lessons Replace Tupperware at Parties," *New York Times* (February 12).

Djerassi, Carl (1979) *The Politics of Contraception*. New York: Norton.

Dumm, J. J., P. T. Piotrow and I. A. Dalsimer (1974) "The Modern Condom—A Quality Product for Effective Contraception." *Population Reports* Series H, Barrier Methods, H–21–H–36.

Englade, Ken (1992) "The Age of Condoms." *New York Times Magazine*, vol. 141 (Feb 16 1992): 12, 57.

Feinberg, David (1989) *Eighty-Sixed*. New York: Penguin.

Fortina, Denise (1987) "Health News." *Ms.* September, 104.

Franklin, Patricia et al. (1987) "The AIDS Business." *Business*, vol. 2 no. 2 (April): 42–47.

Frick, Timothy (1993) "Falling off the Safe Sex Wagon: Personal Issues around Maintaining 393
Safer Sex." *Positively Aware* (November): 18.

Giese, Jo (1987) "Of Rubbers and Lovers." *Ms.* (September): 100–102.

Giese, Jo (1987b) "On the Difficulty of Asking a Man to Wear a Condom." *Vogue* June: 227,
272.

Goldfarb, Brian (1994) "Intimate Interactivity: Creating Safer-Sex Software," *The
Independent* (January/February): 26–28.

Goldsmith, Marsha F. (1989) "Pregnancy Dx? Rx May Now Include Condoms." *Journal of the
American Medical Association*, vol. 261 no. 5 (February 3): 678–679.

Gordon, Linda (1976) *Woman's Body, Woman's Right: A Social History of Birth Control in
America*. New York: Grossman Publishers.

Gordon, Linda (1984) "Voluntary Motherhood: The Beginnings of Feminist Birth Control
Ideas in the United States." *Women and Health in America*. Ed. Judith Walzer Leavitt.
Madison: University of Wisconsin Press.

Gruson, Lindsey (1987) "Condoms: Experts Fear False Sense of Security." *New York Times*
(August 18): 1, 17.

Haraway, Donna. 1985. "A Manifesto for Cyborgs: Science, Technology, and Socialist
Feminism in the 1980s." *Socialist Review* 80: 65–108.

Harper, Michael J. K. (1983) *Birth Control Technologies: Prospects by the Year 2000*. Austin:
University of Texas Press.

Hendricks, Paula (1987) "Condoms: A Straight Girl's Best Friend." *Ms.* September, 98–102.

Henjo, John (1962) "The Contraceptive Industry." *Eros*, vol. 1 no. 2 (Summer): 12–15.

Hilts, Philip J. (1990) "Birth Control Backlash." *New York Times Magazine* (December 16):
41.

Himes, Norman E. (1963) *Medical History of Contraception*. New York: Gamut Press, Inc.

Hochman, David (1992) "A Safe Sex Product in Need of a Marketing Plan." *New York Times*,
September 29.

Hrdy, Daniel B. (1987) "Cultural Practices Contributing to the Transmission of Human
Immunodeficiency Virus in Africa," *Review of Infectious Diseases* 9: 1109–19.

Johnson, Anne M. (1994) "Condoms and HIV Transmission." *New England Journal of
Medicine* 331:6 (August 11): 391–92.

Jones, E. F. and J. D. Forrest (1992) "Contraceptive Failure Rates Based on the 1988 NSFG."
Family Planning Perspective 24: 12–19.

Judson, Franklyn N. (1989) "Condoms with and without Spermicide as Protection against
STD." American Social Health Association. *Condoms in the Prevention of Sexually
Transmitted Diseases: The Proceedings of a Conference*. Research Triangle Park NC:
American Social Health Association.

Kaplan, Herb and Rick Houlberg (1990) "Broadcast Condom Advertising: A Case Study."
Journalism Quarterly, vol. 67 no. 1 (spring): 171–76.

Kilpatrick, John W. (1962) "The Condom Conundrum: An Etymological Exploration with a
Hitchcock Ending." *Eros*, vol. 1 no. 2 (summer): 16.

King, Edward (1993) *Safety in Numbers: Safer Sex and Gay Men*. New York: Routledge.

Kinsman, Gary (1987) *The Regulation of Desire: Sexuality in Canada*. Montreal: Black Rose
Books.

König, Rolf (1992) *The Killer Condom*. Trans. from the German by J. D. Steakley (New York:
Catalan Communications). Written and illustrated by Rolf König. Originally published
1988.

Kraft, Scott (1992) "Africa's Death Sentence." *Los Angeles Times Magazine* (March 1): 12–16, 36.

Legman, G. (1968) *Rationale of the Dirty Joke: An Analysis of Sexual Humor*. First Series. New
York: Grove Press.

394 ———— (1975) *Rationale of the Dirty Joke: An Analysis of Sexual Humor*. Second Series. Wharton NY: Breaking Point.

Leinster, Colin (1986) "The Rubber Barons." *Fortune*, vol. 114 no. 12 (November 24): 105–18.

Link, Howard A. (1988) *Waves and Plagues: The Art of Masami Teraoka*. Honolulu: Chronicle Books.

Lippert, Barbara (1989) "Swimming Against the Tide, Will the 'C' Word Get Heard?" *Adweek's Marketing Week* (May 15): 63.

Mack, Arien, ed. (1988) *In Time of Plagues: The History and Social consequences of Lethal Epidemic Diseases. Social Research*, vol. 55 no. 3 (Autumn).

Magnier, Mark (1990) "World Sales in Condom Ease After Fast Growth." *The Journal of Commerce*, vol. 385 no. 27278 (July 26): 1A, 10A.

Mariposa Education and Research Foundation (1994) Mailing on condom rankings.

Mayo, Kierna (1992) "TLC: Demanding Respect." *The Source* (June): 46–49, 61.

Moore, Jeff (1993) "Reducing Risk for HIV." *Positively Aware* (November 1993): 22.

Mosher, W. and C. Bachrach (1982) *Contraceptive Use: United States, 1982*. Hyattsville, MD: National Center for Health Statistics [data from the National Survey of Family Growth].

Muirhead, Greg (1992) "AIDS Transforms Condom Marketing." *Supermarket News*, vol. 42 no. 3 (January 20): 44.

Murphy, James S. (1992) *The Condom Industry in the United States*. Jefferson NC: McFarland & Co.

Nulty, Peter (1987) "An Aging Boy Wonder Shakes Up the Ad Business." *Fortune* vol. 115 no. 8 (April 13): 86–88.

Office of Technology Assessment (1982) *World Population and Fertility Planning Technologies: The Next Twenty Years*. Washington, D. C.: Congress of the United States.

Owen, David (1992). *The Walls Around Us*. New York: Vintage.

Patton, Cindy & Janis Kelly (1987) *Making It: A Woman's Guide to Sex in the Age of AIDS*. Boston: Firebrand.

Petchesky, Rosalind (1984) *Abortion and Woman's Choice: The State, Sexuality, and Reproductive Freedom*. New York: Longman.

Pincus, Gregory (1965) *The Control of Fertility*. New York: Academic Press.

Plagakis, Jim (1991) "Changing Times." *Drug Topics* 135, no. 18 (September 23): 20.

Planned Parenthood of America (1986) "They did it 9,000 times on television last year: How come nobody got pregnant?" Full page advertisement, *Champaign-Urbana News-Gazette* (December 7): A15.

Preventing the Transmission of HIV (1992) Committee on Government Operations Chaired by Congressman Ted Weiss (July 2).

Rapoport, Carla (1991) "Eurocondom Treaty." *Fortune*, vol. 124 no. 15 (December 30): 12.

Reagan, Leslie (1996) *When Abortion Was a Crime: The Legal and Medical Regulation of Abortion, Chicago, 1880-1973*. Berkeley: University of California Press.

Redford, Myron H., Gordon W. Duncan, and Denis J. Prager (1974) *The Condom: Increasing Utilization in the United States*. San Francisco: San Francisco Press.

Reed, Lori (1992) "Turned on (-line): A feminist critical analysis of sexually explicit computer games," Unpublished M.A. Thesis, Ohio State University.

Reed, James (1983) *From Private Vice to Public Virtue: The Birth Control Movement and American Society since 1830*. Princeton: Princeton University Press.

———— (1984) "Doctors, Birth Control, and Social Values, 1830–1970," *Women and Health in America*. Ed. Judith Walzer Leavitt. Madison: University of Wisconsin Press.

Richardson, Ruth (1988) *Death, Dissection and the Destitute*. London: Penguin, 1988.

Rosenberg, M. J. et al. (1992) "Barrier Contraceptives and Sexually Transmitted Diseases in Women: A Comparison of Female-dependent Methods and Condoms," *American*

Journal of Public Health 82:5: 669–74.

Samuel, Michael C., Nancy Hessol, Steve Shiboski, Robert R. Engel, Terence P. Speed, and Warren Winkelstein, Jr. (1993) "Factors Associated with Human Immunodeficiency Virus Seroconversion in Homosexual Men in Three San Francisco Cohort Studies, 1984–1989." *Journal of Acquired Immune Deficiency Syndromes* 6: 303–12.

Schoepf, Brooke Grundfest (1992) "Women at Risk: Studies from Zaire." *The Time of AIDS: Social Analysis, Theory, and Method.* Ed. Gilbert H. Herdt and Shirley Lindenbaum. Newbury Park, CA: Sage Publications.

SIECUS Fact Sheet (1993) "The Truth about Latex Condoms," *SIECUS Report* (October/November): 17–19.

Solomon, Mildred Z. and William DeJong (1989) "Promoting Condoms: Recommendations for Efforts in Clinic and Community." American Social Health Association. *Condoms in the Prevention of Sexually Transmitted Diseases: The Proceedings of a Conference.* Research Triangle Park NC: American Social Health Association.

Stanworth, Michelle, ed. (1987) *Reproductive Technologies: Gender, Motherhood and Medicine.* Minneapolis: University of Minnesota Press.

Sungaard, Arnold (1938) *Spirochete: A History.* New York: Random House, 1938.

Suraiya, Jug (1992) "The Pleasure Principle." *Far Eastern Economic Review,* vol. 155 no. 1 (January 9): 25.

Symanski, Richard (1981) *The Immoral Landscape: Female Prostitution in Western Societies.* Toronto: Butterworths.

Tatum, Howard J. and Elizabeth B. Connell-Tatum (1981) "Barrier Contraception: A Comprehensive Overview," *Fertility and Sterility* 36: 1: 1–12.

Treichler, Paula A. (1988a) "AIDS, Homophobia, and Biomedical Discourse: An Epidemic of Signification." *AIDS: Cultural Analysis/Cultural Activism.* Ed. Douglas Crimp. Cambridge: MIT Press.

——— (1988b) "AIDS, Gender, and Biomedical Discourse: Current Contests for Meaning." *AIDS: The Burdens of History.* Ed. Elizabeth Fee and Daniel M. Fox. Berkeley: University of California Press. Rpt. in *American Feminist Criticism.* Ed. Linda Kauffman. New York: Basil Blackwell, 1993.

——— (1990) "Feminism, Medicine, and the Meaning of Childbirth." *Body/Politics: Women and the Discourses of Science.* Ed. Mary Jacobus et al. New York: Routledge.

——— (1991) "How to Have Theory in an Epidemic: The Evolution of AIDS Treatment Activism." *Technoculture,* ed. Constance Penley and Andrew Ross. Minneapolis: University of Minnesota Press.

——— (1992a) "AIDS and HIV Infection in the Third World: A First World Chronicle." Revised for *AIDS: The Making of a Chronic Disease* Ed. Elizabeth Fee and David M. Fox. Berkeley: University of California Press.

——— (1992b) "Seduced and Terrorized: AIDS and Network Television." *A Leap in the Dark: AIDS, Art and Contemporary Culture.* Ed Allan Klusacek and Ken Morrison. Montreal: Artexte.

——— (1992c) "AIDS, HIV, and the Cultural Construction of Reality." *The Time of AIDS: Social Analysis, Theory, and Method.* Ed. Gilbert H. Herdt and Shirley Lindenbaum. Newberry Park, CA: Sage Publications, pp. 65–98.

——— (1993) "AIDS Narratives on Television: Whose Story?" *Writing AIDS: Gay Literature, Language, and Analysis.* Ed. Timothy Murphy and Suzanne Poirier. New York: Columbia University Press.

"Urgent Responsibility Confronts Condom Marketers" (1987) *Marketing News* May 22, p. 20, 23.

Wallace-Whitaker, Virginia (1987) "You Did What? Using the AIDS/Condoms Advertising

396 Controversy in the Classroom," presented at the annual meeting of the Association for Education in Journalism and Mass Communication. Trinity University, San Antonio TX, August 1–4.

Warner, Leslie Maitland (1987) "Surgeon General Urges Ads on RV for Condoms in Combating AIDS." *New York Times*, February 11: 1,4.

Watney, Simon (1994) *Practices of Freedom: Selected Writings on HIV/AIDS*. Durham NC: Duke University Press.

Weller, S.C. (1993) "A Meta-Analysis of Condom Effectiveness in Reducing Sexually Transmitted HIV." *Social Science and Medicine* 36: 1635–1644.

Wentz, Laurel (1987) "AIDS: Condom Advertising Charts Broader Course Overseas." *Advertising Age* March 9, p. 62.

Whitehead, Tony L. (1992) "Expressions of Masculinity in a Jamaican Sugertown: Implications for Family Planning Programs." *Gender Constructs and Social Issues*. Ed. Tony L. Whitehead and Barbara V. Reid. Urbana: University of Illinois Press, pp. 103–141.

Wilkinson, Stephan (1985) "Selling Condoms to Women." *Working Woman* vol. 10 October, p. 68.

"Woman kills husband over condom packet" (1991) *Kenya Daily Nation* November 9, p. 8.

World Health Organization (1985) *Report on Women's Health and Development*. Geneva.

Lauren Berlant

17

THE FACE OF AMERICA AND THE STATE OF EMERGENCY

When can I go
into the supermarket
and buy what I
need with my good looks?

—Allen Ginsberg, "America"

I. The Political is the Personal

"The tradition of the oppressed teaches us that the 'state of emergency' in which we live is not the exception but the rule. We must attain to a conception of history that is in keeping with this insight. Then we shall clearly realize that it is our task to bring about a real state of emergency."[1] When Walter Benjamin urges his cohort of critical intellectuals to foment a state of political counter-emergency, he responds not only to the outrage of Fascism in general, but to a particularly brutal mode of what we might call *hygienic governmentality*[2]: this involves a ruling bloc's dramatic attempt to maintain its hegemony by asserting that an abject population threatens the common good and must be rigorously governed and monitored by all sectors of society. Especially horrifying to Benjamin are the ways the ruling bloc solicits mass support for such "governing": by using abjected populations as exemplary of all obstacles to national life; by wielding images and narratives of a threatened "good life" that a putative "we" have known; by promising relief from the struggles of the present through a felicitous image of a national future; and by claiming that, because the stability of the core image is the foundation of the narratives that characterize an intimate and secure national society, the nation must at all costs protect this image of a way of life, even against the happiness of some of its own citizens.

398 In the contemporary United States it is almost always the people at the bottom of the virtue/value scale—the adult poor, the non-white, the unmarried, the non-heterosexual, and the nonreproductive—who are said to be creating the crisis that is mobilizing the mainstream public sphere to fight the good fight on behalf of normal national culture, while those in power are left relatively immune. For example, while the public is incited to be scandalized by so-called "Welfare Queens," the refusal of many employers to recompense their workers with a living wage and decent workplace conditions engenders no scandal at all. Indeed, the exploitation of workers is encouraged and supported, while it is poor people who are vilified for their ill-gotten gains. The manufactured emergency on behalf of "core national values" advanced by people like William Bennett, magazines like the *National Review*, and organizations like FAIR (Federation for American Immigration Reform) masks a class war played out in ugly images and ridiculous stereotypes of racial and sexual identities and anti-normative cultures.[3] As Stephanie Coontz (1992) has argued, this core U.S. culture has never actually existed, except as an ideal or a dogma. But the cultural politics of this image of the normal has concrete effects, both on ordinary identity and the national life the state apparatus claims to be representing.

In this essay I am going to tell a story about the transformation of the normative citizenship paradigm from a public form into the abstracted time and space of intimate privacy. I will start with a reading of the film *Forrest Gump* (Robert Zemeckis, 1994) and other scenes of mass politics and end with the film of Michael Jackson's song "Black or White" (John Landis, 1991). In between, and comprising the crux of this essay, I will be engaging another fictitious citizen: the new "Face of America" who, gracing the covers of *Time*, *Mirabella*, and the *National Review*, has been cast as an imaginary solution to the problems of immigration, multiculturalism, sexuality, gender, and (trans)national identity that haunt the U.S. present tense.

This imaginary citizen or "woman" was invented in 1993 by *Time* magazine. She is a nameless, computer-generated heterosexual immigrant, and the figure of a future modal national population. Elsewhere (Berlant 1993, 1994), I have described the constriction of modal citizenship onto smaller and more powerless vehicles of human agency: fetuses and children. Joining this gallery of incipient citizens, the computer-generated female immigrant of our *Time* cannot act or speak on behalf of the citizenship she represents; she is more human than living Americans, yet less invested with qualities of personhood. With no capacity for agency, her value is also in her irrelevance to the concerns about achievement, intelligence, subjectivity, desire, demand, and courage that have recently sullied the image of the enfranchised American woman. Her pure isolation from lived history also responds to widespread debate about the value of working-class and proletarian immigrants to the American economy and American society. This essay will show how sectors of the mainstream public sphere link whatever positive value immigration has to the current obsessive desire for a revitalized national heterosexuality and a white, normal national culture.

Thus this is a story about official storytelling and the production of mass polit-

ical experience[4]; it is also an opportunity to ask what it means that, since "'68," the sphere of discipline and definition for proper citizenship in the United States has become progressively more private, more sexual and familial, and more concerned with personal morality. How and why have other relations of power and sociality—those, for example, traversing local, national, and global economic institutions—become less central to adjudicating ethical citizenship in the United States?[5] How and why have so many pundits of the bourgeois public sphere (which includes the popular media, the official discourses and practices of policy-making, and the law) come to see commitments to economic, racial, gender, and sexual justice as embarrassing and sentimental holdovers from another time? And how might the privatization of citizenship help to devalue political identification itself for U.S. citizens?

To begin to answer these questions, it might help first to see a bigger picture of the ways the spaces of national culture have recently changed, at least in the idealized self-descriptions of contemporary U.S. official culture. Conservative attempts to restrict citizenship have so successfully transformed scenes of privacy into the main public spheres of nationality that, for example, there is nothing extraordinary about a public figure's characterization of sexual and reproductive "immorality" as a species of "unAmerican" activity that requires drastic hygienic regulation. This general shift has at least three important implications for the attempt to understand the cultural politics of citizenship in the official U.S. present tense.

First, the transgressive logic of the feminist maxim "the personal is the political," which aimed radically to make the affects and acts of intimacy in everyday life the index of national/sexual politics and ethics, has now been reversed and redeployed on behalf of a staged crisis in the legitimacy of the most traditional, apolitical, sentimental patriarchal family values. Today, the primary guiding maxim might be "the political is the personal." Reversing the direction of the dictum's critique has resulted in an anti-political nationalist politics of sexuality whose concern is no longer what sex reveals about unethical power but what "abnormal" sex/reproduction/intimacy forms reveal about threats to the nation proper/the proper nation. As registered in the anti-gay-citizenship film *The Gay Agenda* (1993), the pro-gay response *One Nation Under God* (Teodoro Maniaci and Francine M. Rzeznik, 1994), and many pro-life pamphlets, the religious right calls the struggle to delegitimate gayness and return sexual identity to tacitness, privacy, and conjugal heterosexuality "The Second Civil War."[6] This general shift also informs the increasing personalization of politics, where "character" issues have come to dominate spaces of critique that might otherwise be occupied with ideological struggles about public life, and where the appearance of squeaky cleanness (read: independently wealthy conjugal heterosexuality) is marketed as an index of personal virtue (as in the recent cases of Michael Huffington in California and Mitt Romney in Massachusetts).

But personalizing citizenship as a scene of private acts involves more than designating and legislating sexual and familial practices as the main sites of civic ethics. Relevant here as well is an increasing tendency to designate political duty in

400 terms of individual acts of consumption and accumulation. Two major economic platforms in the last twenty years bear this out: (1) the increasing emphasis on boycotts to enforce conservative sexual morality in the mass media (often on behalf of "our youth"); and (2) the staggering contention, by Presidents Reagan, Bush, and Clinton and their cohorts, that receiving federal welfare funds so morally corrupts individuals that they are responsible for the quotidian violence and decay of the inner city, and indeed more generally for the decline of the nation as a whole. This assertion refuses to account for many things racial, gendered, and economic, including the dramatic drop in employment opportunities and wages in the metropolitan industrial sector over the last twenty years, and the social devastation that has taken place precisely in those defunded areas; its logic of displacement onto the consumer reveals how the personal morality citizenship card being played by ruling blocs is central to the ideology of unimpaired entrepreneurial activity that is sanctified as free-market patriotism during and after the Reagan regime.[7]

The second effect of citizenship's privatization has to do with the relation of mass media to national culture. If individual practice in and around the family is one nodal point of postmodern national identity, another intimate sphere of public citizenship has been created as sentimental nationality's technological mirror and complement: the mass-mediated national public sphere. As I will elaborate shortly, activism performed in civic spaces has become designated as a demonized, deranged, unclean (a)social mob activity[8]; in contrast, every article about the Internet shows us that accessing and mastering national/global mass media forms has become widely construed as the *other* most evolved or developed scene and practice of being American. While at other moments in U.S. history the mediations of mass culture have been seen as dangers to securing an ethical national life, the collective experiences of national mass culture now constitute a form of intimacy, like the family, whose national value is measured in its subjugation of embodied forms of public life.

Finally, there exists a dialectic between a privatized "normal" nation of heterosexual, reproductive family values and the public sphere of collective intimacy through which official mass nationality stays familiar, and I have suggested that these two domains now saturate what counts as mass community in the contemporary U.S. The compression of national life into these apparatuses of intimacy also advances the conservative desire to delegitimate the embodied public itself, both abstractly and in its concrete spatial forms. Michael Rogin has called this kind of wholesale deportation of certain embodied publics from national identity "American political demonology." This involves "the inflation, stigmatization, and dehumanization of political foes" by a cluster of populist, centrist, and right-wing politicians and thinkers (1987: xii). We see it happening in the right-wing and neoliberal loathing of a cluster of seemingly disparate national scenes: public urban spaces and populations; sexualities and affective existences that do not follow the privacy logic of the patriarchal family form; collectivities of the poor, whether of inner city gangs or workers at the bottom of the class structure; the most exploited (im)migrants; nonpaternal family forms; and racially-marked subjects who do not

seem to aspire to or identify with the privacy/property norms of the ostensibly core national culture. The "American way of life" against which these deviancies are measured is, needless to say, a fantasy norm, but this fantasy generates images of collective decay monstrous and powerful enough to shift voting patterns and justify the terms of cruel legislation and juridical decree.

Persons categorized as degenerate typically enter the national register through stereotype, scandal, or unusually horrible death: otherwise their lives are not timely, not news of what counts as the national present. That is, they are part of the present but are inassimilable to the national in its pure form. The disfiguring marks of disqualified U.S. citizenship are inscribed within the present tense by tactics ranging from the manufacture of scandal to strategies of throwaway representation, like jokes; and when collective contestation does happen, it is cast as a scene of silly and/or dangerous subrationality, superficiality, or hysteria.[9] But my aim in this essay is not solely to explicate the ways public lives uncontained by the family form and mass mediation have become bad objects in the political public sphere. It is also to seek out and explore the moments of world-building optimism within the normalizing discourse of national privacy, to better understand what kinds of life are being supported by the privatization of U.S. citizenship, and what kinds of good are being imagined in the ejection of entire populations from the national present and future.

II. On being Normal, Average, Common, Ordinary, Standard, Typical, and Usual in Contemporary America[10]

One of the most popular vehicles celebrating citizenship's extraction from public life is the film *Forrest Gump*, which uses spectacles of the nation in crisis to express a nostalgic desire for official national culture, and which retells the story of recent U.S. history as a story about the fragility of normal national personhood. Like the *Contract With America* that expresses the wish of the now mythic "angry white male" voter who feels that his destiny has been stolen from him by a coalition of feminists, people of color, and social radicals, *Forrest Gump* narrates the recent history of the United States using an image archive from contemporary rage at the radical movements of the 1960s and the culture of desire that borrowed their energy to challenge previously protected forms of American pro-family patriarchal pleasure and authority. To perform this act of rage as though it were a show of love, the film situates a politically illiterate citizen in the place of civic virtue, and reinvents through him a revitalized, reproductive, private, and pre-political national heterosexuality. It is telling, here, that Forrest Gump is named after Nathan Bedford Forrest, founder of the Ku Klux Klan, and that an early film clip from of the Klan with Tom Hanks in Klan drag cites *Birth of a Nation* as *Forrest Gump*'s earliest cinematic progenitor. What does it suggest that these nostalgic, familial references to nationally-sanctioned racial violence are translated through someone incapable of knowing what they mean?

Forrest Gump follows the youth and middle age of an infantile citizen, a man who retains his innocence because he is five points shy of normal intelligence. We

know he is such a statistical person because the principal of his school says so: to explain Forrest's horizon of life opportunity, the principal holds up a sign with statistics on it, which are clustered into the categories: Above Average, Normal, and Below Normal (fig. 1). Forrest has an IQ of 75, which would force him to attend what Mrs. Gump bitingly calls a "special" school: 80 is normal, and would give the child access to the standard pedagogical resources of the state. Forrest's mother refuses to submit to the rule of numbers, since she believes that people must make their own destinies. Therefore she fucks Forrest's way into normal culture by having sex with the principal of his school, her body in trade for five points of IQ and the privileged protections of normality.

Fig. 1.

Therein begins a simple story about gender, heterosexuality, and nationality that nonetheless articulates complicated ideas about how U.S. citizens inhabit national history. First, *Forrest Gump* seeks to eradicate women from public life and nonreproductive sex from the ideal nation. As Mrs. Gump demonstrates, a virtuous woman does her business at home and organizes her life around caretaking, leaving the domestic sphere only to honor her child. Even more insidious than this 1950's style gender fantasy is the way the film sifts through the detritus of national history since the protest movements of the 1960's and their challenge to what constitutes a national public. First, the narrative replays the history of post-'68 America as a split between the evil of intention, which is defined as a female trait, and the virtue of shallowness, which is generally a male trait (except if the man has lusted after women, in which case his passions are figured both as violent to women and

tainted by the cupidity/rapacity of feminine desire). Forrest Gump's "girl," Jenny 403
Curran, inherits Mrs. Gump's horizon of historical possibility, organizing with her libidinous body a narrative of the corrupted national public sphere. Like Mrs. Gump, Jenny is there to have sex and to be sexually exploited, humiliated, and physically endangered in every intimate encounter she has with a man. Between 1971 and 1982 Jenny goes through each form of public, sensual degradation available in the *Time*-mediated version of American culture: the sexual and political revolution of the '60's, the drugs and disco culture of the '70's, and then, finally, the AIDS pandemic of the '80's. (Although the disease goes unnamed, Jenny seems to die of a special strain of AIDS that makes you more beautiful as your immune system collapses.) To add insult to history, the film seems to locate the bad seed of the '60's in the sexual abuse of Jenny by her alcoholic father. It is as though, for the family to be redeemed as a site of quasi-apolitical nation-formation, the pervasiveness of abuse has to be projected out onto the metropolitan public: Jenny's private trauma comes to stand not for the toxicity of familial privacy or patriarchal control of children, but for a *public* ill whose remedy seems bizarrely to require a return to the family, albeit a kinder, gentler, more antiseptic one. Before Jenny dies she is redeemed from her place as an abject sexual and historical subject via an act of reproductive sex with Forrest. The family is then fully redeemed by Forrest's single fatherhood of his eponymous son: symbolically eradicated from the nasty public world, women and friends are ultimately separated from the family form as well, absent the way public history is, except as animating memory.

In his random way, Forrest enters the national narrative too. But he encounters history without becoming historical, which in this film means being becoming dead, gravely wounded, or degenerate. Because he is mentally incapable of making plans or thinking conceptually, he follows rules and orders literally. Someone says "Run, Forrest," he runs; someone says "shrimp," he shrimps. This is why he can become an "All-American" football hero and why, in the Army, Gump is considered a genius. This is why he can survive Vietnam while others around him fall and falter; why he endures when a hurricane obliterates every other shrimp boat in the south, (which produces "Bubba Gump," a financial empire made from shrimp and clothing tie-ins with the company logo); and why, when his friend Lt. Dan gambles on some "fruit" company called Apple, Gump is financially fixed for life. He takes risks but experiences nothing of their riskiness: a Vietnam with no Vietnamese, capitalism with no workers, and profit at a distance both from production and exploitation.[11] While Jenny deliberately seeks out the deteriorating political and aesthetic public culture of modern America, Gump notices nothing and excels at everything he decides to do. He is too stupid to be racist, sexist, and exploitative; this is his genius, and it is meant to be his virtue.

In addition to enjoying the patriarchal capitalist entitlements of American life as a man of football, war, and industry, and in addition to inventing the treasured and complexly linked national banalities "Have a Nice Day" and "Shit Happens," Gump makes three pilgrimages to the White House, where he meets Presidents Kennedy, Johnson, and Nixon. Each time he shakes a President's hand the President auto-

matically inquires as to his well-being, a question that conventionally seeks a generic citizen's response, such as "Fine, Mr. President." But to Kennedy, Gump says "I gotta pee." With Johnson, Gump pulls down his pants to show the war wound on his "buttocks." With Nixon, he discusses his discomfort in Washington: Nixon transfers him to his favorite place, the Watergate Hotel, where Gump sees flashlights in the Democratic National Committee headquarters and calls Frank Wells. Forrest notices that Nixon soon resigns, but this event is as random to him as the white feather that floats in the film's framing shots. "For no particular reason," he keeps saying, these nice Presidents are shot, assaulted, or disgraced, along with George Wallace, John Lennon, Bobby Kennedy, Gerald Ford, and Ronald Reagan. No mention of Martin Luther King, Medgar Evers, or Malcolm X is made in *Forrest Gump*.

Gump narrates the story of his unearned and therefore virtuous celebrity to a series of people who sit on a park bench next to him in Savannah, Georgia. They all assume he's stupid, partly because he repeats his mother's line "Stupid is as stupid does" so often it begins to make sense. But then the fact that this movie makes any sense at all is a tribute to two technologies of the gullible central to contemporary American life. First, the digital technology that makes it possible to insert Tom Hanks/Forrest Gump into nationally momentous newsreel footage from the past three decades. Using the technologies called "morphing" and bluescreen photography that enable computers to make impossible situations and imaginary bodies look realistic on film, *Forrest Gump* stages five national "historical" events.[12] In these moments the nation, often represented through the President's body, meets "the people," embodied by Gump, who has made a pilgrimage to Washington. Gump's clear anomalousness to the national norm, signalled in the explicit artificiality of Hanks' presence in the newsreel images, makes his successful infantile citizenship seem absurd, miraculous, or lucky; on the other hand, the narrative of his virtue makes him seem the ideal type of American. The technology's self-celebration in the film borrows the aura of Gump's virtuous incapacity to self-celebrate: the film seeks to make its audience want to rewrite recent U.S. history into a world that might have sustained a Forrest Gump. To effect the audience's desire for his exemption from the traumas of history, the writers and director broadly ironize and parody an already wildly oversimple version of what constituted the 1960's and beyond: but the intensity of the visual and aural maneuvers the film makes suggests a utopian desire for one political revolution (the Reaganite one) to have already happened in the '60s, and another (the counter-culture's) never to have begun at all.

The second technology of the gullible, then, available in the film's revisionary historicism, is the right-wing cultural agenda of the Reagan revolution, whose effects are everywhere present. The ex-president is literally represented for a minute, in one of the film's many scenes of national trauma. But Reagan's centrality to the historical imaginary of *Forrest Gump* is signalled as powerfully by the *People* Magazine his first interlocutor reads. This has Nancy Reagan on the cover,

standing in both for her presidential husband and for the grotesqueness of feminine ambition. Although it has the historical and technological opportunity, the film never shows Gump meeting, or even noticing, this President. Why should it? He *is* Reagan—Reagan, that is, as he sold himself, a person incapable of duplicity who operates according to a natural regime of justice and common sense in a national world that has little place for these virtues.[13]

With its claim to be without a political or sexual unconscious, and with its implied argument that to have an unconscious is to be an incompetent or dangerous American, *Forrest Gump* is a symptomatic product of the conservative national culture machine, with its desire to establish a simple, privacy-based model of normal America. This machine involves creating a sense of a traditional but also an urgently contemporary mass consent to an image/narrative archive of what a core national culture should look like: through an anti-political politics that claims to be protecting what it is promoting—a notion of citizenship preached in languages of moral, not political, accountability—the national culture industry seeks to stipulate that only certain kinds of people, practices, and property that are, at core, "American," deserve juridical and social legitimation. The modal normal American in this view sees her/his identity as something sustained in private, personal, intimate relations; in contrast, only the abjected, degraded, *lower* citizens of the United States will see themselves as sustained by public, coalitional, non-kin affiliations. *Forrest Gump* produces this political hierarchy too. For all its lightness and irony, there is something being wished-for when the film has Forrest "unconsciously" ridicule the Black Panthers and the left wing cultural and political imaginary, which is reduced to achieving the revolutionary liberation of the word "fuck" from the zone of "adult" language into public political discourse.[14] For all its idealization of Jenny Curran, the film is never more vicious about the desire to be and to have a public than when she leaves her terrible home to experiment in non-familial contexts. I have suggested that the crisis of the contemporary nation is registered in terms of threats to the imagined norm of privatized citizenship: *Gump* defines "normal" through the star's untraumatized survival of a traumatic national history, which effectively rewrites the traumas of mass unrest of the last few decades not as responses to systemic malaise, exploitation, or injustice, but as purely personal to the dead, the violent, and the violated.

Explicating this ejection of a non-conjugal and non-mass-mediated public life from the official/dominant present tense in the U.S. involves coordinating many different plateaus of privilege and experience. It also involves taking up Benjamin's challenge: to the state of emergency the official nation is now constantly staging about the ex-privilege of its elite representatives there must be a response, involving the creation of a state of counter-emergency. To do this will at least be to tell the story of a symbolic genocide within the U.S., a mass social death that takes place not just through the removal of entire populations from the future of national political life and resources but also through cruel methods of representation in the mainstream public sphere and in the law. This is to say that the United States that

406 the law recognizes is generated in representations of public opinion and custom; to take seriously the ordinary representations of the official public sphere is to enter a war of maneuver, an uncivil war that is currently raging everywhere around us.

III. Making Up Nations (1): Postmodern Mobocracy and Contemporary Protest

As anyone can see on the television news, a terrible state of political emergency exists on the streets of the contemporary U.S. There, ordinary conflicts among different publics about what the good life should entail are recast as menaces to national society, and images of political life "on the street" become evidence that a violent change threatens an idealized version of the national. Despite occasional attempts to caption images of public dissent respectfully, the typical modern T.V. news report represents the right and left through their most disorderly performances of resistance, to indicate that collective opposition is based not on principle, but on passions that are dangerous and destabilizing for the commonweal. Whether their acts are cast as naive, ridiculous, insipid, and shallow, or merely serious and unpragmatic, protesters are made to represent the frayed and fraying edges of national society.[15] Yet in news footage of police activity during feminist, abortion, antiwar, civil rights, and Yippie demonstrations, we see that violent disorder is in fact rather more likely to come from the actions of police.[16] Michael Warner (1992) has argued that media sensationalism around collective public citizenship acts is partly driven by a desire to increase ratings and to whet the consuming public's appetite for mass disaster. More important than that, though, is the chilling effect such framing has on conceptions of political activism. Nonetheless politicians and the dominant press tend to ascribe the disorder to the resisters and, more insidiously, to the world they want to bring into being.

The double humiliation of protest in the mainstream media, making it both silly and dangerous, subtracts personhood from activists, making their very gestures of citizenship seem proof that their claims are illegitimate. This is especially germane in the portrayal of pro-life and gay collective actions. In contrast, political suffering is still palatable when expressed as a trauma or injury to a particular person. This narrowing in the means for making a legitimate claim on public sympathy has had a significant effect in a certain strain of U.S. legal theory, where some are arguing that words and images can produce harms to a person as substantial as those made by physical acts of violence, such that violent and cruel talk should be actionable the way physical assault is (Matsuda 1993). But more than this, talk shows and other forms of gossip media have helped to make scenes of personal witnessing the only political testimony that counts. It is not that just everybody loves a good sob story. Trauma makes good storytelling and, as journalistic common sense constantly reminds us, it puts a "face" on an otherwise abstract issue.[17] Moreover, the sheer scale of the systematically brutal hierarchies that structure national capitalist culture can be overwhelming, leading to a kind of emotional and analytic paralysis in a public that cannot imagine a world without poverty or violence: here too, the facialization of U.S. injustice makes it manageable and enables further deferral of considerations that might force structural transformations of public life. In the

meantime, while the embodied activities of anonymous citizens have taken on the odor of the abject, the personal complaint form now bears a huge burden for vocalizing and embodying injustice in the United States.

Yet there *is* a kind of public and collective protest that the media honors. Take, for example, press reports of the 30th anniversary of Martin Luther King's March on Washington, and contrast them to reports on the gay and lesbian march on Washington on April 25, 1993. In 1963, the approach of King's march created panic and threats of racist counter-violence. But in retrospect, this event has been sanitized into a beautifully choreographed mass rationality, an auturist production of the eloquent, rhetorically masterful, and then martyred King. These solemn reports wax nostalgic for the days when protest was reasonable, and protestors were mainly men speaking decorously with their bodies, while asking for reasonable things like the ordinary necessities of life.[18]

This media legitimation of orderly national protest has a long history. The 1933 film *Gabriel Over the White House* (Gregory La Cava, 1933), for example, details with particular clarity the limited kind of citizenship activity a privacy-based mass democracy can bear, especially in times of economic crisis. Like other films of the depression,[19] *Gabriel* emplots the seeming fraudulence of the claim that democracy can exist in a capitalist society, by focusing on the "forgotten men" who had fought World War I for a United States that could not support them afterwards. To the "forgotten man" the depression broke a contract national-capitalism had made with national-patriotism: and the possibility of a legitimate *patriotic* class war among men was palpable everywhere in the U.S. In response to this decline in national-masculine prestige, the culture industry produced narratives that performed ways of sending rage into remission. I quote *Gabriel* at length to demonstrate Americans' longstanding ambivalence toward democracy's embodiment in collective struggle; but also to set up these images of collective dignity and sacrifice as the nostalgic horizon that official culture "remembers" in its scramble to codify the proprieties of mass national culture in the present tense.

Speaking on the radio during the depression is "John Bronson," leader of an army of unemployed men who are marching on their way to Washington from New York to find out whether the federal nation feels accountable to their suffering. As Bronson speaks, the film shows the President having a treasure hunt in the Oval office with his nephew and then eating the marshmallow treasures he has hidden. They are not attending to the disembodied and dignified voice coming from the radio: this difficult task is left to the viewers who hears it while their eyes are distracted by the President's play:

> People of America. This is John Bronson speaking, not for himself but for over a million men who are out of work who cannot earn money to buy food because those responsible for providing work have failed in their obligations. We ask no more than that which every citizen of the United States should be assured the right to live, the right to food in the mouths of our wives and children. Our underlying purpose is not revolutionary. We are not influenced by militant leaders. None of us are reds. We merely want work, and we

believe this great United States of America under proper leadership can provide work for everybody. I have appealed to the President for an interview and the President says he will not deal with us because we are dangerous anarchists. We are not. We are citizens of America with full confidence in the American democracy, if it is properly administered. The people of America are hopelessly [speech drowned out by conversation between an African-American valet and the President about what coat the President will wear]...prosperous and happy. I ask your President now if he has ever read the Constitution of the United States as it was laid out by those great men that day in Philadelphia long ago, a document which guarantees the American people the rights of life, liberty, property, and the pursuit of happiness. All we ask are to be given those rights. This country is sound. The right man in the White House can bring us out of despair into prosperity again. We ask him at least to try.

Almost instantly after this speech Bronson is murdered, and enters the pantheon of anti-national patriotic martyrs (the "army of the unemployed" sings the almost eponymous "John Brown's Body" as it marches from city to city); but there is no violence by the workers. Indeed, becoming by executive order an official reserve army for American capital, they trade rage for wages the government pays them (the President eventually sets up utopian boot camps for the working poor, in support of the men's prestige in the family). As in the case of King's March on Washington, this suggests that the only way Americans can claim both rights and mass sympathy is to demonstrate not panic, anger, demand, and desire, but ethical serenity, hyperpatriotism, and proper deference. Political emotions like anxiety, rage, and aggression turn out to be the feelings only privileged people are justified in having. America's breach of its contract with its subordinated peoples becomes in this model of mass politics an opportunity for elites to feel sorry for themselves, and sympathy for the well-behaved oppressed: but the cruelty of sympathy, the costs it extracts in fixing abject suffering as the only condition of social membership, is measured in the vast expanse between the scene of feeling and the effects that policies exert.

This distortion of the origins and aims of disorder is not just due to the confusion of the moment, nor merely to the traditionally grotesque representation of public bodies made by political elites and editorial cartoonists. As a force in framing the contemporary conditions of national power, the misattribution of public disorder is a strategy to delegitimate anti-privacy citizenship politics, especially where they seek to unsettle the domains of white patriarchal nationalism. The mainstream press's representation of the serious carnival of women's liberation and antiwar activity of the early 1970s is not, after all, so far from the representation of sexual politics in mainstream places like *Newsweek* and *The Gay Agenda*, which features graphic descriptions of sexual display in gay pride parades and the March on Washington to equate negatively the spectacular modalities of the parade with the utopian national imaginary of Queers (see Berlant 1995). Accusations that political activists on parade are animals unable to assimilate to the rational norms of civic life are crucial weapons in the denationalization of these populations.

There is no appreciation for the desire for continuity between everyday life and political activism behind these serious carnivals: as in Marlon Riggs's *Tongues Untied* (1989), where the specific beauty and self-pleasure of protestors in parades is a form of sexual *and* political happiness, a part of the erotics of public personhood that queer politics imagines as central to the world of unhumiliated sexual personhood (at least for gay men) it means to bring forth in America: "Black men loving Black men is the Revolutionary Act."

Finally, John Grisham's *The Pelican Brief* (1992) and the film of it (Alan J. Pakula, 1993) summarize strikingly how the fear of mobocracy both constitutes and threatens to efface the popular spaces and animate bodies of adult citizens in the contemporary nation. The film opens outside of the Supreme Court in the middle of a demonstration. This, the first of four major street/mob scenes in the film, means to measure a crisis of national power brought on, or so it seems, by the people who insist on being represented by it. The opening shot of the protestors quotes the iconic images from the 1968 Democratic Convention in Chicago: wild-haired youths and police in helmets struggling to move, to hit, to fall, and to remain standing; loud, incoherent, angry voices.

The camera pulls back to reveal a disorderly mob, the faces in which are obscured by the sheer number of people and the placards that are being brandished. What is the protest about? I catalogue the signs and slogans: "abortion is murder"; uncaptioned pictures of aborted fetuses; "handgun control"; "no justice no peace"; "save our cities"; "AIDS cure now"; "Silence=Death"; "Come out come out wherever you are"; "gun control now"; "fur is death"; "pass gun control"; "execution is no solution"; "Death to Rosenberg" (this uncannily anticommunist sign actually refers to a liberal judge who is shortly thereafter assassinated for political reasons that are not at all linked to this cluster of protests). From this mélange of complaints we can conclude that in the contemporary United States collective social life is constituted within a sublime expanse of nationally-sanctioned violent death, a condition that the animated mob breaks down to its discrete evidences and testifies to by shouting out.

At the end of the film, the camera rests happily on the smiling face of Julia Roberts, who is watching Denzel Washington on television reporting that "she's just too good to be true." By this time we have entirely lost the trace of the opening protest. It turns out that there is nothing important about the scene, it is entirely gratuitous to the narrative. The activist judge is killed because he threatens the property privilege of a fat capitalist; this capitalist, Victor Mattiece, has contributed millions to the campaign of the film's vacuous Reagan-style president; in contrast, we never see the criminal in the flesh, only a newspaper photo of him. In short, citizens acting en masse seem to be protesting *the wrong things*, and to have irrelevant views about what kinds of corruption constrain their free citizenship.

Yet the logic of the book/film is more complex. We see that when the state imagines popular resistance, its paranoia invents mass political entities like the "underground army," an underdefined institution of faceless and random radicals (Grisham 1992, 47, 55). But when the state itself is reimagined here as a corrupt

cabal of businessmen, lawyers, and politicians, the corruption is *personal* and does not rub off onto the institution, which apparently still works well when "good men" are in it. Likewise, Julia Roberts plays Darby Shaw, a sexy law student who writes the "Pelican Brief" not from a political motive, but out of love for her lover/law professor (whose mentor was Justice Rosenberg); Denzel Washington plays Gray Grantham, disinterested reporter for the *Washington Post*, out to get a story. Together they manage to create a non-subaltern-identified asexual, apolitical wedge of objective knowledge about the corrupt state: and in the end it is Roberts, with her guileless youth, her detached sexuality, her absolute privacy, her enormous smile, and her mass-mediated star aura, who becomes the horizon of the law's possibility and of a sanitized national fantasy, the new face of a remasculinized America where the boundaries are drawn in all the right places, and the personal is as vacuous as the political.[20]

IV. Making up Nations (2): "The Idea is Reckless. . . . A Melding of Cultures"[21]

In contrast to the zone of privacy where stars, white people, and citizens who don't make waves with their bodies can imagine they reside, the immigrant to the United States has no privacy, no power to incorporate automatically the linguistic and cultural practices of normal national culture that lubricate life for those who can pass as members of the core society. This is the case whether or not the immigrant has "papers": indeed, the emphasis placed on *cultural* citizenship by books like Bennett's *The De-Valuing of America*, Brimelow's *Alien Nation*, and Henry's *In Defense of Elitism* suggests that acquiring the formal trappings of legitimate residence in the country is never sufficient to guarantee full acceptance by the nation.

These books argue that, where immigrants are concerned, the only viable model for nation-building is a process of "Americanization." I have suggested that, even for birthright citizens, the process of identifying with an "American way of life" increasingly involves moral pressure to identify with a small cluster of privatized normal identities: but what kinds of special pressure does this process involve for immigrants? What kinds of self-erasure, self-transformation, and assimilation are being imagined by those who worry that even the successful "naturalization" of immigrants will equal the denaturalization of the U.S. nation? What does the project of making this incipient citizen "American" tell us about the ways national identity is being imagined and managed in the political public sphere?

When a periodical makes "special issue" out of a controversy, the controversy itself becomes a commodity whose value is in the intensity of identification and anxiety the journal can organize around it, and this is what is happening to immigration as a subject in the U.S. mainstream. Captioning *Time*'s first "special issue" on immigration, *Immigrants: the Changing Face of America* (July 8, 1985), is a sentence that describes what kinds of boundaries get crossed and problems raised when the immigrant enters the United States: "Special Issue: Immigrants. They come from everywhere, for all kinds of reasons, and they are rapidly and permanently changing the face of America. They are altering the nation's racial makeup, its cities, its tastes, its entire perception of itself and its way of life"(1). The empha-

sis on time and space in this framing passage—"they" come from everywhere, "they" incite rapid change—suggests that there is something "special" about the contemporary immigrant to the U.S. that ought to create intensified anxieties about social change, even despite the widely held axiom that the U.S. is fundamentally "a nation of immigrants." The something that the force and velocity of immigrant cultural practices is radically changing is people's everyday lives in the nation, but that something is underspecified. We see in particular a change in the default reference of the category "race," and concurrently the city and its dominant "tastes." These unsettlements, in turn, have forced alterations in what had ostensibly been a stable national self-concept, based on common affinities and ways of life.

Of course, every crisis of immigration in U.S. history has involved the claim that something essentially American is being threatened by alien cultural practices. In the 1985 *Time* Magazine variant on this national anxiety, however, immigrants to the United States are made stereotypical in newly ambivalent ways. *Time* first represents their challenge to the "us" and the "our" of its readership—everywhere implicitly native-born, white, male salaried citizens—through a cover that shows a classic huddled mass made up mostly of Latinos and Asians of all ages, with lined or worried faces (fig. 2). Their faces are in various stages of profile facing the reader's right, as though the "changing" face of America that the title declares is made

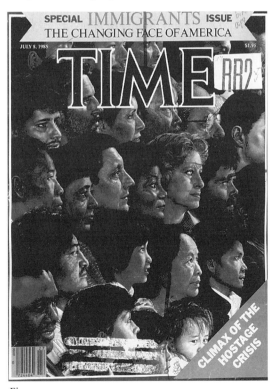

Fig. 2.

412 visible in the dynamism of their rotation. In the present tense of a new national life, they are looking off toward the edge of the page at something unidentified: their future, America's future, the scene of their prospects contained in the magazine whose pages are about to be opened. The diverted gaze of the immigrants frees the reader from identification with them: the readers too, from their side of the border, are positioned to open the magazine and see their future prophesied and plotted.

I overread this cover story in part to set up a frame for thinking about the 1993 special issue of *Time* on immigration and national life, but also to look at how national publics are characterized and made in an age of mass mediation. *Time* presents its immigrants in segmented populations, which are defined in relation to the totality "Americans": "Hispanics," "Asians," and "Blacks" each get their own article. But *Time*'s task is not merely to document changes: to name a racial or ethnic population is to name for the public a difficult problem it faces. Specifically, the issue responds to particular issues created by the 1965 Immigration and Nationality Act, which dissolved official preference given to European migration to the U.S (26): while some section headings confirm that immigrants like "Asians" as a class and talented individuals like the Cuban poet Heberto Padilla contribute superbly to the core U.S. national culture, alien cultures are mainly named because they seem to pose threats. For "Blacks" (said to be "left behind" by the wave of new races) and the rest of the U.S., "Hispanics" are the new "problem" population, so disturbing they get their own section and dominate several others, including "Business," "Policy," "The Border," "Religion," "Video," and "Behavior".

Yet the explicit rhetoric of the special issue is nothing if not optimistic: overall, the essays have a tinny and intense enthusiasm about immigration's effect on national life, and it is the ambivalent tone of voice they use to support optimism about the process of assimilation that is of interest here. An immigrant is defined by *Time* as a national alien who comes to America consciously willing to be exploited in exchange for an abstraction, "opportunity" (3, 57). But in lived terms opportunity is not abstract. If the immigrant's value is in her/his willingness to be economically exploited for freedom, *Time* also argues that the intense labor of mass assimilation into cultural literacy itself will further enrich the already existing indigenous "national culture" (33ff).

> The American schoolroom has traditionally provided a hopeful glimpse of the nation's future, and some people still imagine it to be a Rockwellian scene of mostly pink-cheeked children spelling out the adventures of Dick and Jane. But come for a moment to the playground of the Franklin elementary school in Oakland, where black girls like to chant their jump-rope numbers in Chinese. "See you *mañana*," one student shouts with a Vietnamese accent. "Ciao!" cries another, who has never been anywhere near Italy. And let it be noted that the boy who won the National Spelling Bee in Washington last month was Balu Natarajan, 13, who was born in India, now lives in a suburb of Chicago, and speaks Tamil at home. "Milieu" was the word with which he defeated 167 other competitors. Let it also be noted that Hung Vu and Jean Nguyen in May became the first

The Face of America and the State of Emergency

Vietnamese-born Americans to graduate from West Point. (29)

413

Like their parents, these child-immigrants are imagined as a heterogenous population that lives mainly outside and on the streets of America. They compose a population whose tastes in food and art and whose creative knowledges ("Spanglish" is featured elsewhere, 81) are easily assimilable to the urges for commodity variation and self-improvement that already saturate the existing indigenous mass national "milieu." There are also *three* essays on elite immigrants who have freely brought "wealth," "brain power," and "culture" to enrich the land of opportunity that is the United States. Children and the elite: these good immigrants are good, in *Time*'s view, because they are the gift that keeps giving, willing to assimilate and to contribute difference and variation to American culture.

Meanwhile, in separate articles on immigrant women and children we see that worthy migration is a not only determined by intercultural influence and economic activity, but also by its utility as symbolic evidence for the ongoing power of American democratic ideals. That is, immigration discourse is a central technology for the reproduction of patriotic nationalism: not just because the immigrant is seen as without a nation or resources and thus is deserving of pity or contempt, but because the immigrant is defined as *someone who desires America* (82–3). Immigrant women especially are valued for having the courage to grasp freedom. But what is freedom for women? *Time* defines it not as liberation from oppressive states and economic systems, but as release from patriarchal family constraints, such that the free choice of love object is the pure image of freedom itself. Indeed, an explicit analogy is drawn between the intimacy form of consensual marriage and the value of American national culture:

> Women migrate for the same reasons that men do: to survive, because money has become worthless at home, to find schooling and jobs. But they also have reasons of their own. Single women may leave to escape the domination of their old-fashioned families, who want them to stay in the house and accept an arranged marriage…[for] home, like parentage, must be legitimized through love; otherwise, it is only a fact of geography or biology. Most immigrants to America found their love of their old homes betrayed. Whether Ireland starved them, or Nazi Germany persecuted them, or Viet Nam drove them into the sea, they did not really abandon their countries; their countries abandoned them. In America, they found the possibility of a new love, the chance to nurture new selves…. [Americanization] occurs when the immigrant learns his ultimate lesson: above all countries, America, if loved, returns love. (82; 100f)

I will return to the utopian rhetoric of national love anon. Although *Time* admits that there are other reasons people come to the U.S.—for example, as part of the increasingly global proletarian workforce (82)—its optimism about immigration is most powerfully linked not to the economic and cultural *effects* of immigration on the U.S. or its current and incipient citizens, but on the symbolic implications immigration has on national vanity: it is proof that the U.S. is a country worthy of being loved. This is, after all, the only imaginable context in which the United States

414 can be coded as antipatriarchal: come to America and not only can you choose a lover and a specially personalized modern form of quotidian exploitation at work, but because you can and do choose them, they must be *prima facie* evidence that freedom and democracy exist in the U.S..

Meanwhile, for all its optimism about immigrant-American nation-formation, "The Changing Face of America" clearly emerges from a panic in national culture, and one motive for this issue is to substitute a new panic about change for an old one. Explicitly the issue responds to the kinds of nativist economic and cultural anxiety that helped shape the Immigration Reform and Control Act of 1986 and, more recently, California's Proposition 187. Three specific and self-contradictory worries predominate: the fear that immigrants, legal and illegal, absorb more resources than they produce, thus diverting the assets of national culture from legal citizens; the fear that immigrants, legal and illegal, are better capitalists than natal citizens, and thus extract more wealth and political prerogative than they by birthright should; and the fear that cities, once centers of cultural and economic capital, are becoming unlivable, as spatial boundaries between communities of the very poor, workers, and affluent residents have developed in a way that threatens the security of rich people and the authority of "the family."

The essay that most fully expresses this cluster of fears is the title essay, "The Changing Face of America," which provides a remarkable caption to the cover image. But what is striking about this essay, which equates "face" with place of national origin ("That guy is Indian, next to him is a Greek, next to him is a Thai," says one neighborhood tour guide, 26) is not the American xenophobia-style apprehension it expresses, acknowledges, and tries to manage. This panic of mistrust in the viability of a non-European-dominated "America" almost goes without saying in any contemporary mainstream discussion of the immigrant-effect: it is expressed in the chain of almost equivalent signs "immigrant," "alien," "minority," "illegal"; it is expressed in the ordinary phrase "wave of immigrants," which never quite explicitly details the specter of erosion and drowning it contains that has long haunted American concerns about the solidity of national economic and cultural property.

Instead, what distinguishes this special issue on immigration is the way it characterizes birthright American citizenship, and particularly how it codes the relationship between the animated corporeality of immigrant desire and the enervation of the native or assimilated American. The essay about America's changing face is illustrated by photographs of immigrants who have just landed within the hour at New York's Kennedy Airport. The photographs are not meant to tell stories about the immigrants' histories. Rather, *Time* claims that the captured image of the face in the picture records an immigrant's true feeling at the threshold, the feeling of anticipation that history is about to begin again, in the context of the new nation: "The moment of arrival stirs feelings of hope, anxiety, curiosity, pride. These emotions and many others show in the faces on the following pages" (26). (These phrases caption a picture of a sleeping baby.) The immigrant portraits are like fetal sonograms or baby pictures. The specific bod-

ies matter little. Their importance is in the ways they express how completely generic immigrant hopes and dreams might unfold from particular bodies: and they tell a secret story about a specific migrant's odds for survival—by which *Time* means successful Americanization.

The photographs of new immigrants are also made in an archaic style, often taking on the design of formal family daguerreotype portraits. Given *Time*'s explicit commitment, in this issue, to refurbishing Ellis Island, it is not surprising that these threshold images make the immigrants American ancestors before the process of living historically as an American has happened. What are the aims of this framing modality? First, to borrow the legitimating aura of American immigrants from past generations, with whom even Euro-Americans can still identify. Second, to signal without saying it that the "wave" is no mob, but actually a series of families, bringing their portable privacy to a land where privacy is protected. Third, the structure of generationality provides a strong model of natural change, evolutionary reproduction being the most unrevolutionary structure of collective transformation imaginable, even while worries about burgeoning new-ethnic populations (of color) seem to threaten the future of (white) modern nationality. Fourth, as Roland Barthes (1981) argues, the portrait photograph is a figure of displacement and a performance of loss or death: and as the immigrant has long been said to undergo a death and rebirth of identity in crossing the threshold to America, so too the picture might be said to record the "changing" over of the face as the subjects change the register of their existence.

Yet if death (of identities, identifications, national cultures) is everywhere in this issue of *Time*, and if these processes are linked complexly to the production of America, it is not simply the kind of death one associates with the iconic symbolics of national rebirth; nor its opposite, in the privileged classes' typical construction of ghetto violence and its specters as the end of America as "we" know it; nor in the standard depiction of an undervalued and exploited underclass with a false image of the *class's* undervaluation of "life"—although the special issue cues up this cruel translation periodically in essays on the unlivable city. Mainly, "The Changing Face of America" deploys images of national death to say something extraordinary about the logics by which the American desire for property and privacy makes citizenship itself a death-driven machine.

The essay on America's changing face captions its photographs with a story about what happens to the immigrant's sensuous body in the process of becoming American: "America is a country that endlessly reinvents itself, working the alchemy that turns 'them' into 'us.' That is the American secret: motion, new combinations, absorption. The process is wasteful, dangerous, messy, sometimes tragic. It is also inspiring." However the story, "in its ideal, is one of earthly redemption," the magazine proclaims (24). But the process of alchemy turns out to be virtually vampiric.

> It was America, really, that got the prize: the enormous energy unleashed by the immigrant dislocations. Being utterly at risk, moving into a new and dangerous land, makes

the immigrant alert and quick to learn. It livens reflexes, pumps adrenaline.... The immigrant who travels in both time and geographical space achieves a neat existential alertness. The dimensions of time and space collaborate. America, a place, becomes a time: the future.... In this special issue, *Time* describes the newest Americans and addresses the myriad ways in which they are carrying on an honored tradition: contributing their bloodlines, their spirit and their energy to preserve the nation's vitality and uniqueness. (25)

The immigrant is full of vitality, and he/she provides an energy of desire and labor that perpetually turns America into itself. What then of the native citizen? Throughout the text the problem of immigration turns into the problem of abject America: it turns out that to be an American citizen is to be anesthetized, complacent, unimaginative. "There is nothing deadened or smug about immigrants," the editors write. In contrast, U.S. citizenship is a form of annulment, for the attainment of safety and freedom from the anxiety for survival national-capitalism promises turns out, again and again, to make old and new citizens enervated, passive in the expectation that at some point their constitutionally-promised "happiness" will be delivered to them. This passivity is central to America's economic and cultural decline, implies *Time*; the metaphysics of "success" leads to the evacuation of ambition in the present tense, and threatens the national future.[22]

Thus along with the problem of cultural transformation that immigration presents to the anxious native public is a threatening, half-obscured question of national identification and identity: in 1985 *Time* proclaims the *new* immigrant as the only true American, while casting birthright and naturalized citizens as subject to enervation, decay, and dissolution. The very promise that lures persons to identify with their native or assumed U.S. national identity, the promise of freedom unearned and privacy enjoyed, is cast as an unmitigated economic disaster.

This is, perhaps, why "The Changing Face of America" emphasizes the difference between the economic and the ideal United States: if masses of immigrants are necessary to provide the proletarian and creative cultural energy for the nation's well-being, the essential nation itself must be untouched by the changing face of America, must be a theoretical nation where success is measured by civic abstractions and moral obligations: "love" of "home" turns out to be *Time*'s foundation for democratic American morality; American morality turns out to be the reality-effect of national culture. If America is constituted metaphysically, as an ethical space of faith or belief, then intimacy with the principles of American democratic culture—of property, privacy, and individuality—is the only ground for the true practice of nationhood. There are no immigrants or citizens there, in that zone of abstraction, it is a dead space, dead to the fluctuations of change. All the rest is just history.

V. Making up Nations (3): Another *New* Face of America

When in 1993 *Time* revised its earlier construction of the immigrant-effect, the magazine felt compelled to do so not only because of the conflictual economic and

cultural conditions of the present, but also because a new future was being assessed: it had just become common knowledge that "sometime during the second half of the 21st century the descendants of white Europeans, the arbiters of the core national culture for most of its existence, are likely to slip into minority status 'Without fully realizing it,' writes Martha Farnsworth Riche, director of policy studies at Washington's Population Reference Bureau."[23] The directionality of the earlier special issue on immigrants has reversed: whereas in the 1980's, the issue was immigration and the politics of assimilation (to Americanness), in the 1990's the issue seems to be the necessary adaptation all white Americans must make to the new multicultural citizenship norm, even the ones who don't live in New York, El Paso, and Los Angeles.

This special issue is thus a cultural *memento mori* for the white American statistical majority, but it is also a call to a mass action. But what kind of mass action? At the moment of its statistical decline, it becomes necessary to reinvent the image archive of the nation in a way that turns the loss of white cultural prestige into a gain for white cultural prestige. To perform this process of transfiguration, the cover of this issue is both more and less than a death mask; it is a new commercial stereotype advertising the future of national culture (fig. 3): "Take a good look at this woman. She was created by a computer from a mix of several races. What you see is a remarkable preview of The New Face of America."

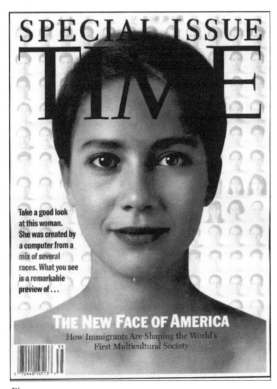

Fig. 3.

418 The changes this special issue rings on the citizen-energy crisis of the earlier issue is indicated in the facelift the newer version gives to the faciality of the immigrant cover. Two particular domains of assimilation that have framed immigrant representation in the past are importantly altered here: in the threat and allure of the immigrant's body, and its relation to the ways assimilation is imagined, whether through generational change or the relation of labor and education to citizenship. What will count as full citizenship in the future which is also the now of the new? Whereas the earlier cover depicts multiple living ethnic-faced persons apparently involved with imagining their own future lives in America, the second cover foregrounds a single, beautiful woman looking directly out of the page, at the reader, who is, in turn, invited to "Take a good look...." The earlier faces were lined—texts of history written on the body; the new face of America reveals only the labor of a faint smile on a generically youthful face. The earlier faces are clearly artificial, standing in for a "wave" of face-types that Americans, in their national anxiety, have difficulty seeing as human; the second image looks like a photograph of an actually existing human being who could come from anywhere, but she is actually a Frankenstein monster composed from other "ethnic" human images, through a process of morphing. The new face of America involves a melding of different faces with the sutures erased and the proportions made perfect; she is a national fantasy from the present representing a post-historical—that is, post-white—future.

The "new face of America," then, has been manifestly individuated and gendered, specified and symbolized in the eight years between *Time*'s special issues. Moreover, the contexts for the immigrant image have also changed in the interval: in the '80's immigrants are public, collective, constructed by the activity of changing nations and subjectivities on the way to becoming American; in the second, the background to the new girl in the polis is merely a phenotypic index, a subject-effect. Behind her is a field of other immigrant faces, barely visible: the matrix of blurry faces, barely intelligible dots, is the dominant image of mass immigrant life in this *Time*, which is dedicated to disaggregating, categorizing, and managing the circulation and value of the contemporary immigrant population. The dots declare the immigrant a weak or faded sign, real only as an abstract racial type rather than as persons distinguished by movement through concrete and abstract spaces of any sort. As they recede behind the face of the future that is also called the "new face of America" in a kind of whirl of temporalizing, the immigrant dots are also already being forgotten.

The new American face also has a body. In the first issue the changing faces sit atop clothed bodies, because these persons are figured as social agents, capable of making history; in the second issue, the bodies are still and naked, hidden demurely behind the screen of the text, but available for erotic fantasy and consumption. This again raises images of the national fetal person, but differently than in its first incarnation. In 1985, the immigrants photographed *in situ* of their transition into the status "foreign national" were fetal-style because they were officially or wishfully caught as persons prior to their incorporation within the American national story: that is, the potential of their unfolding history was indistinguishable from

their new identities as potential U.S. citizens. In 1993, the new face of America has the corporeality of a fetus, a body without history, an abstraction that mimes the abstraction of the American promise that retains power *because* it is unlived.

In short, the cover situates American post-history in prelapsarian time. Appropriately, where the first issue describes the "possibility of finding a new love" in the national context as a matter of collectively inhabiting lawful national spaces or "homes," the latter text proclaims, early on, a kind of carnal "love" for the computer-generated cover girl's new face of America.[24]

But what of love's role in the technology of assimilation and nation-building? What is the labor of love, if not to lose sight of the labor of the immigrant in the blinding bright light of patriotic gratitude for the possibility that there will be, if "we" do not slip unawares into multiracial society, an intelligible national future after all? In the previous special issue, the female immigrant fleeing an archaic patriarchal family represented the limits of what immigration could do to alter America: to repeat, the narrative image of the woman in flight from intimate authoritarian structures translates into a figure of and desire for America, not the abject lived-in United States where suffering takes place and survival is decided locally, but abstract America, which foundationally authorizes an elastic language of love and happiness that incorporates and makes claim on any aspiring citizen's intimate desire, as long as the citizen is, in a deep way, "legal." Likewise, in 1993, an image of a sexualized cyborg gendered female explicitly bears the burden of mature and natural national love, which involves representing and effacing the transition the privileged classes of the United States must make to a new logic of national identity and narrative.

But love amounts even to more than this when it comes to revitalizing the national narrative: desiring to read the immigrant like the fetus and the child, whose histories, if the world is "moral," are supposed to unfold from a genetic/ethical kernel or rhizome, *Time* in 1993 installs the future citizen not in a family that has come from somewhere else, but in a couple form begotten by a desire to reproduce in private, that is to say, in a post-political domain of privacy authorized by national culture and law. It further illustrates this future through a series of photographic images, which are organized into a 7x7 square according to visible ethnicities now procreating in the U.S. (fig. 4). The principles by which an American ethnic type is determined are very incoherent: "Middle Eastern," "Italian," "African," "Vietnamese," "Anglo-Saxon," "Chinese," "Hispanic." These images are organized on the page following the model of those multiplication squares children use to learn the multiplication tables: within these "reproduction squares" the images are morphed onto each other so that their future American "progeny" might be viewed in what is almost always its newly lightened form (66–67). The nationalist heterosexuality signified by this racial chain is suffused with nostalgia for the feeling of a stable and dominant collective identity: in the now of the American future *Time* sets forth, the loving heart is a closed-off border open only to what intimacy and intercourse produces, and even American strangers cannot enter the intimate national future, except by violence.[25]

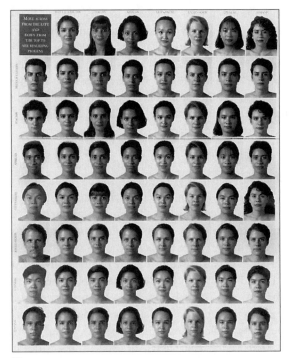

Fig. 4.

Love of the new face embodies three feelings less hopeful than the ones I've been following so far: disappointment in and disavowal of the cultural and economic violence of the present tense; a counter-insurgent rage at what has been called "the new cultural politics of difference"; and an ambition for the nation's future (West 1990). Let me briefly address each of these. First, *Time* reinvents the "new" but not yet achieved or experienced American future in the context of a more conventional engagement with issues of immigrant practice, never hesitating to trot out the same old categories (illegals, immigrant high culture, transformed metropolitan life, etc.) and the same old defensive bromides (de Toqueville and the *Federalist* papers are the real core of national identity that no immigrant culture can disturb). The ambition of the ex-privileged is to be able to narrate from the present a national scene of activity, accumulation, and reproduction that never becomes unintelligible, unmanageable: the wish of the dream cover is that American racial categories will have to be reinvented as tending toward whiteness or lightness, and whiteness will be reinvented as an ethnic minority (as in the story "III Cheers for the WASPS," which asserts that "Americanization has historically meant WASPification. It is the gift that keeps on giving"; moreover, it is the essence of America's "national character," which is in danger of "slipping into chronic malfunction"[26]).

Time, admitting the bad science of its imaging technologies, nonetheless makes a claim that cross-breeding, in the reproductive sense, will do the work of "melding" or "melting" that diverts energy from subcultural identification to what will

be the newly embodied national scene. "For all the talk of cultural separatism," it argues, "the races that make the U.S. are now crossbreeding at unprecedented rates" such that 'the huddled masses have already given way to the muddled masses'(64–65). "Marriage is the main assimilator," says Karen Stephenson, an anthropologist at UCLA. "If you really want to effect change, it's through marriage and child rearing." Finally, "Those who intermarry have perhaps the strongest sense of what it will take to return America to an unhyphenated whole" (65). This ambition about what "the ultimate cultural immersion of interethnic marriage" will do for the nation is an ambition about the natural narrative of the national future (9): the promise of this collective narrative depends on a eugenic program, enacted in the collective performance of private, intimate acts, acts of sex, and everyday childrearing. The American future has nothing to do with vital national world-making activities, nor public life: just technologies of reproduction that are, like all eugenic programs, destructive in their aim.

Of course you wouldn't discover this violent desire in the tone of the special issue, which demonstrates an overarching optimism about the culturally enriching effects of all kinds of reproduction: the intimate private kind, and its opposite, from within the mass mediated public sphere. You will remember that the special issue begins with the morpher's fantasy of cybersex with the fair lady's face he creates; it ends where "The Global Village Finally Arrives." *Time*'s excitement about globality is very specific: if the new national world of America will be embodied in private, the new global world will be public and abstract:

> It would be easy, seeing all this, to say that the world is moving toward the *Raza Cósmica* (Cosmic Race), predicted by the Mexican thinker José Vasconcelos in the '20s—a glorious blend of mongrels and mestizos. It may be more relevant to suppose that more and more of the world may come to resemble Hong Kong, a stateless special economic zone full of expatriates and exiles linked by the lingua franca of English and the global marketplace. (87)

In other words, the melding of races sexually is not a property of the new world order, which *Time* describes as "a wide-open frontier of polyglot terms and post-national trends." This global scene is economic and linguistic, it has no narrative of identity, it is the base of capitalist and cultural expansion that supports the contraction of the intra-national narrative into a space covered over by a humanoid face.

It remains to be asked why this national image of immigration without actual immigrants is marketed now, in the 1990's, and in a way that elides the optimism and anxiety about immigrant assimilation of the previous decade. To partly answer this, one must look at the essay by William A. Henry III, "The Politics of Separation," which summarizes much in his subsequent book *In Defense of Elitism*.[27] This essay blames multiculturalism, political correctness, and identity politics for the national fantasy *Time* promotes in this issue: "…one must be pro-feminist, pro-gay rights, pro-minority studies, mistrustful of tradition, scornful of Dead White European Males, and deeply skeptical toward the very idea of a 'mas-

terpiece,'" says Henry (74).

Henry equates the discord of identity politics and its pressures on the terms of cultural literacy and citizenship competence with something like an anti-assimila-tionist stance that might be taken by immigrants: indeed, he bemoans the ways the dominant narratives that marked competency at citizenship themselves have become "alien," thanks to the allegedly dominant fanatical multiculture that reduces the complexity of culture and power to authoritarian counter-cultural sim-plicities. As a result, "Patriotism and national pride are at stake," for "in effect, the movements demand that mainstream white Americans aged 35 and over clean out their personal psychic attics of nearly everything they were taught—and still fer-vently believe—about what made their country great" (75).

Henry's passionately committed essay is not merely cranky. It is also a sympto-matic moment in the struggle that motivates the "new Face of America" to be born. This is a culture war over whose race will be the national one for the policy-driven near future, and according to what terms. For example, if whites must be racialized in the new national order, racial identity must be turned into a national family value. If race is to be turned into a national family value, then the non-familial pop-ulations, the ones, say, where fathers are more loosely identified with the health of the family form, or affective collectivities not organized around the family, must be removed from the national archive, which is here organized around a future race of cyborgs, or mixed-race but still white-enough children. It is in this sense that the defensive racialization of national culture in this issue is genocidal. It sacrifices the centrality of African-American history to American culture by predicting its demise. It sacrifices attention to the concrete lives of exploited immigrant and native people of color by fantasizing the future as what will happen when white people intermarry, thus linking racial mixing to the continued, but masked, hege-mony of whiteness. It tacitly justifies the continued ejection of gays and lesbians and women from full citizenship, and deploys national heterosexuality to suppress the complex racial and class relations of exploitation and violence that have taken on the status of mere clichés—that is, accepted truths or facts of life too entrenched to imagine surpassing—by the panicked readership of *Time*. After all, the entire project of this issue is to teach citizens at the core culture to remain optimistic about the U.S. future, and this requires the "new face" the nation already is becom-ing not to have a memory.

This epidemic of amnesia was sponsored by the Chrysler corporation, a com-pany sure to benefit from the translation of the immigrant into an image of an immigrant's future racially mixed granddaughter from a nice family in a white American suburb. And it should not be surprising that the "new face of America" generated even more new faces: on the cover of the February 21, 1994, *National Review* (fig. 5), which shows a young African-American child running away from a graffiti mustache he has drawn on the "new face" of *Time*'s cover, accompanied by a story that blasts *Time*'s refusal to engage directly in the class and race war it is romancing away; on the cover of *Mirabella* (fig. 6), in which a picture of a mor-phed woman and a computer chip makes explicit the desire to love and aspire only

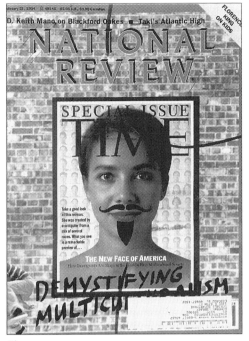

Fig. 5.

Fig. 6.

424 to faces that have never existed, unlike one's pitiful own; and in at least two marketing magazines,[28] which were directly inspired by *Time*'s "new face" to think of new ethnic markets in cosmetics, so that "ethnic" women might learn how simultaneously to draw on and erase the lines on their faces that distinguish them as having lived historically in a way that threatens their chances of making it in the new future present of America.

VI. Making up Nations (4): The New Face of the Old Race

In *Time* we have learned that the experience of the national future will be beautiful, will be administered by families, will involve intimate collective patriotic feelings, and will take place in the domestic private, or in foreign publics, places like Hong Kong or, say, CNN, the contemporary American post-nation. In reinventing the national icon, embodied but only as an abstraction, *Time* delinks its optimism about national culture from the negativity of contemporary public politics: in the abstract here and now of *Time*'s America, the rhetorics of victimhood and minority that identity politics and multiculturalism have deployed are given over to the previously unmarked or privileged sectors of the national population; in the abstract here and now of this America, people at the bottom are considered American only insofar as they identify with and desire the status of the unmarked.

In this light we can better see more motives for official America's embrace of heterosexuality for national culture. For one thing, *Time*'s fantasy logic of a tacitly white or white-ish national genetic system integrated by private acts of consensual sex that lead to reproduction provides a way of naturalizing its separation of especially African-American history and culture from the national future, and thus implicitly supports disinvestment in many contexts of African-American life in the present tense. In making the main established taxonomy of race in the U.S. an archaic formation with respect to the future it is projecting as already here or "new," the issue of *Time* makes core national subjectivity itself racial along the lines of scientific racism through images of what it calls "psychic genes" that mime the genes that splice during reproduction to produce new likenesses.

Second, heterosocial marriage is a model of assimilation like *e pluribus unum*, where sexual and individual "difference" is obscured through an ideology/ethics of consensual "melding" that involves channelling one's world-making desires and energy into a family institution through which the future of one's personhood is supposed to unfold effortlessly. So too the new face of America, having been bred through virtual sex acts, projects an image of American individuals cross-breeding a new citizenship-form that will ensure the political future of the core national culture. In sum, the nationalist ideology of marriage and the couple is now a central vehicle for the privatization of citizenship: first, via moralized issues around privacy, sex and reproduction that serve as alibis for white racism and patriarchal power; but also in the discourse of a United States that is not an effect of states, institutions, ideologies, and memories, but an effect of the private citizen's acts. The expulsion of embodied public spheres from the national future/present involves a process I have been describing as an orchestrated poli-

tics of nostalgia and sentimentality marketed by the official national culture industry, a politics that perfumes its cruelty in its claim to loathe the culture war it is waging, blaming social divisions in the U.S. on the peoples against whom the war is being conducted.

In itself, there is nothing cruel in using racial morphing to make up fantasy images of a new national identity, especially insofar as the purpose might be to counter the national/global traffic in stereotypes of nationality, race, sexuality, and gender. Indeed, this is what morphing was invented to do, to represent the unintelligibility of the visible body, and thus to subvert the formulaic visual economy of identity forms, which are almost always monuments to the negativity of national power. Yet the morphing technology *Time* uses to make its racial, sexual, economic, and national imaginary appear to be a visible reality is haunted by the process of amnesia/utopia that must accompany the seamlessness of these corporeal transformations. Nowhere is this haunting more manifest than in Michael Jackson's video for the song "Black or White." I say "haunted" because the ghosted forms of the bodies left behind by this mode of racial and sexual futurism are instructively and insistently visible in Jackson's fantasy. The visual scene of the video is at first located in public, collective, and historically-saturated spaces of dance and ends with Jackson's utter solitude: in this translation of space, this video seems to repeat the pattern of privatization I have been describing, which supports disinvesting in cultural, collective forms of personhood while promoting an image of the legitimate, authentic individual situated in the spaces of intimate privacy. Yet the video also disinvests in privatized citizenship, by representing in complicated and powerful ways the world of national, racial, sexual, and class injustice the politics of privacy ejects from the dominant national narrative.

The video is split into two. First, the song "Black or White," during which Jackson shuttles among a frenetic montage of national images. Neither the song's lyrics or its music refers to nationality: this mise en scène is invented for the visual text, which has its own narrative that meets up with, or morphs into, the song's love story in the section's final minutes. The story of the lyric is the story about love that modern sentimentality has long told: traditions of violence between people like us that might keep us apart do exist, but it doesn't matter, I can still love you; all the cruel forces of history could seek to hurt me for being with you and I would still love you. Absent the video, the pop lyric enters just enough into both the racial conflicts of contemporary U.S. life and the self-esteem pedagogies of much pop music, to tell the absent lover that as far as Jackson's concerned, "It doesn't matter if you're black or white": history is "history" and conceivably anyone who wants to can be his "baby" or his "brother."

But the visual story reorganizes the song's emphasis on love's transcendence of the violence of racism, locating itself in the stereotypes and forms of intelligibility that characterize *national* cultures, as though the nation form is racism's opposite and the solution to the problem of "black or white," a racial taxonomy which the visuals reveal as ridiculously oversimple by virtue of the multicultural casting of the national scenes. Each national image Jackson encounters gets its own pseudo-

authentic set, and each population is represented by the stereotyped version of itself that saturates the American popular cultural imaginary. National types from Africa, India, from Russia, from the Native American southwest, and from the U.S. inner city dance national dances in open, public spaces, and as Jackson migrates transglobally through these scenes, he dances improvisations on the dances of the other national cultures.

But then every context for a national dance becomes subverted by shots of the video's production apparatus. There is, apparently, nothing authentic about the dances themselves: they are valued *because* they are invented traditions and joyous expressions of a desire for national form, especially for the artificiality of form. Michael Jackson himself wears no stereotyped national costume, although in wearing black pants and white shirts he starkly represents what doesn't "matter" in the song. His decision to sing the chorus "It don't matter if you're black or white" while standing on an artificial image of the Statue of Liberty, however, suggests that his absence of a stereotyped national body *is* his performance of being American. In addition, the U.S. inner city scene is populated by the unmarked adult's symbolic other, a group of infantile citizens: and at a certain point, a black and a white baby in diapers sit atop the globe playing peacefully with a toy that contains and minimizes the hard history the song is telling. Indeed, as though it were advertising *Time*'s desire to eradicate multicultural citizenship politics, the video has the child actor Macaulay Culkin lip-synching, in the voice of an adult, male African-American rapper, the lines: "It's a turf war/on a global scale/I'd rather hear both sides of the tale; it's not about races, just places, faces…."

The final segment of the video's first half takes literally the lyric's assertion "I'm not going to spend my life being a color," by performing through computer morphing technology what the lover would like to perform with his will: the end of racial and gender boundaries. The video moves through the space marked by a series of differently sexed and multiply-raced faces. Their bodies are naked, stripped of the national costume: absent any "cultural" boundaries, the faces happily turn into each other while singing the words "It's black, it's white, yeah, yeah, yeah." Despite the politically-saturated differences of race and gender in their faces, all of them have shining eyes, great hair, and beautiful teeth.

But countering the frenetic glossing of the stereotype with a lyric about a star's refusal to live his intimate life and his public life within the American-style color-scheme, Jackson choreographs another segment, which created such a scandal that Jackson cut it from the video directly after its television premiere on November 14, 1991. It is now available in its complete state in video stores. The uncut video, from Jackson's *Dangerous: The Short Films*, opens with a tabloid-style montage of the sensation the second part of the video created. The scandal was mainly provoked by Jackson's masturbatory self-groping and destruction of property in this scene, which people took to imply an advocacy of these kinds of acts. Jackson issued a public apology that said that he had meant no harm, and that he had not intended to promote either violence or masturbation.

In the suppressed segment, Jackson is alone in a city. There are no other persons

there but himself—although it is not clear he *is* himself, for he enters the screen morphed into the body of a black panther—I mean the *Panthera pardus* kind. He enters the inner city scene as the panther, and his body emerges silently out of its body. Although this is part of the "Black and White" video, in this segment there is neither music nor song. There is no language either, but a series of screams, accompanied by dance. There is no happiness or optimism, but rage and destruction of property, property that displays the signs of white American racism by which Jackson, as a citizen, is always surrounded and endangered.

In the past, when Jackson has entered an imitation inner city—notably in the videos for "Beat It," "Thriller," and "The Way You Make Me Feel"—the inner city has been a place where a crumbling environment, a black public sphere, and heterosexual tension are entirely intertwined. The environment of "The Way You Make Me Feel" in particular predicts "Black or White" with its desolate and graffiti-laden surroundings: but the crisis "The Way You Make Me Feel" expresses is sexual. (In its first two lines someone says to Jackson, "You don't know about women. You don't have that kind of knowledge.") But in the suppressed segment of "Black or White" no one can question Jackson's sexual competence—he's a successful masturbator. Instead, the crisis here is racial.

On the walls and on the glass of the inner city he lives in we see the graffiti slogans "Nigger go home"; "No More Wet Backs"; "KKK Rules"; a swastika. Like the protest signs in *The Pelican Brief*, these epithets emanate from diverse sites and address different problems in American life: but if in *The Pelican Brief* slogans and rallies issue from the spaces of subordination, in "Black or White" the fighting words are uttered from the extremes of a contested racial/national privilege greedy for more domination. Screaming and dancing, Jackson breaks the windows that broadcast these messages. Amidst a cascade of sparks bursting in air from the sign of the "Royal Arms Hotel" that collapses from the sheer force of Jackson's rage, he howls a counter-national anthem beyond language and music. At one point he throws a trash can through a big generic storefront window. As when Mookie throws the trash can through the window of Sal's Famous Pizzeria to begin a riot in Spike Lee's *Do the Right Thing* (1989), Jackson's extraordinary violence performs the limit of what his or anyone's eloquence can do to change the routine violence of the core national culture. His act, isolated and symbolic, is almost as much a blow against a politically dissociated cultural studies.

One might say more about the films this segment quotes—*Singin' in the Rain*[29], *Do the Right Thing*, and *Risky Business*[30]. But I want to focus on the dominant political intertext: the black panther, the animal that is Jackson's technological origin and end. By this single sign he signals the amnesiac optimism or the absolute falseness of the utopian performative "It don't matter if you're black or white."

Most importantly, the eloquent dance Jackson dances in the second segment, which refuses syntactic language in a hailstorm of howling, performs the violence of the traffic in U.S. stereotypes, in order to show that *having an identity in the culture of the stereotype makes a citizen public, makes the citizen definitionally on the streets, not privileged by any privacy protections, constantly in danger,* and thus, here,

428 for a minute, dangerous. In other words, life on the streets in this video reminds us that the fantasy of a private, protected national space is a fantasy only a non-stigmatized person, a privileged person, can realistically imagine living. This is the kind of person who can freely use the waste and stereotype-laden languages of national culture, like jokes, graffiti, and gossip, and who can, without thinking, keep coaxing the stereotype's reference away from the cartoon it should mean, back to the real it does mean, thereby making unsafe the contexts in which the stereotyped peoples live. As the last shot of the video proclaims in large type, "Prejudice is ignorance."

"Black or White" seems to argue that the stigmatized person cannot use realism to imagine a world that will sustain her/him, for the materials of that world are saturated with a history of ordinary violence, violence so prosaic it would be possible to wield without knowing it, violence that feels like a fact of life. To break the frame of ordinariness, the stigmatized person seems to have two aesthetic choices: spare, howling, formalist minimalism, as in part two; or lush fantasy Diva activity, as in the broad oversimple wishfulness and technologically-supported impossibility of part one.[31]

And yet the processing of U.S. racism in this video goes on. In 1995, Jackson released a greatest hits album of sorts, titled *History*. With it he released a greatest hits video collection, which claims that it includes "Black or White." However, *History* dramatically changes the story this video tells. While the rereleased version follows *Dangerous* in returning the Black Panther segment to its rightful place next to "Black or White," it also sanitizes this segment, but in ways that should not, by now, surprise.

In the expurgated version of the Black Panther portion, all the masturbatory images of Jackson remain. But all the racist graffiti has been cleansed from the scene: no KKK, no "nigger," no swastika, no "wet-back" anywhere. The clip of Jackson captioned by "Prejudice is Ignorance" is also edited out. The destruction of racism by fantasy solutions, refused by the video's first edition, is now completed in the video called *History*: and it requires the self-destruction of Jackson's own text, which has had to further bury its memories through a kind of horrifying mnemoplasty. These memories seem to have been digitally lifted, following the same logic that had Forrest Gump digitally edited into spaces he could not have historically experienced. That is, Jackson continues to revise history, and particularly the history of national racism, by revising what its images tell you about what it takes him to survive in America.

In the re-edited version, Jackson's destruction of property and his howling appear to be solely the expression of his physical and sexual power, frustration, and self-consolation. This shift from racial to sexual corporeality might be explained by the immediate context in which *History* was marketed: accused of sexually abusing children after so long identifying himself with advancing their happiness in the hard world, Jackson attempts to use *History* to make himself appear safe, and in several ways. He includes a brochure with the record that contains images of his abuse as a child, assertions of spiritual and not sexual feelings for children, and testimonials to his rectitude by mainstream American celebrities like Steven Spielberg

and Elizabeth Taylor; he also draws attention to his very public heterosexual marriage to Lisa Marie Presley; and in the iconography of the *History* jacket cover, he casts himself as a heroic monument—to children and to "history." Thus in the re-edited version of "Black or White" Jackson attempts to assert conflicting views of himself: his safety to children; his self-contained sexuality; and his virile adult heterosexuality. To do this the signs of history, nationality, transnationality, racism, and the urban black public sphere are sacrificed from the Black Panther segment of "Black and White," remaining only in their smudged traces in the song's happy lyric: his struggle for citizenship becomes fully sexual, and Jackson now appears animated by a desire for an infinitely expanding zone of privacy.

Imagine what kind of scandal the latter part of "Black or White" would have created were there were dozens or hundreds of angry black men screaming, destroying, dancing, groping. Before the revision, both segments expressed a wish for a public, a collective culture, perhaps a movement culture (of the Black Panther kind): one that supports a world that no longer polices the way one inhabits race, gender, or the isolations of ordinary privatized sexuality. Absent collective struggle, Jackson's own very public and painful relation to sexual anomaly, to racial ambivalence, to animals, and to bodily transformation is everywhere visible. Watching any version of "Black or White," it is impossible not to think of the compulsive self-morphing Jackson's own body has undergone to try to erase his vulnerability to the nationally-supported violence of race, gender, class, and sexuality—at least from his face. We can see the ravages of this violence in their incomplete effacement.

When *Time* magazine deploys the immigrant morph it is not to provide any kind of lens through which the most banal forms of national violence can be viewed and reexperienced painfully. Its essay on the morph takes us back to where we began, in the universe of *Forrest Gump*: the special issue is introduced by the headline "Rebirth of a nation." Can it be an accident that the new face of America is captioned with a citation of D. W. Griffith's racist nationality? (An answer: sure, racist citation can be unconscious or unintentional, that is what makes the simple pun and other cruel and popular forms of dominant cultural privilege so hard to contest.) When the magazine next participates in the logic of the morph, in the summer of 1994, it is to darken the face of O. J. Simpson, accused of killing his wife and a friend of hers. *Time* was saying many things in translating Simpson into darker hues: not only had the celebrity allegedly killed two people, but he had seemed to do it while passing as someone who had transcended his "origin," a word used broadly in the Simpson literature to denote poverty while screaming "race." Even now, passing is a crime against white people's desire to dominate race through fantasy scenes and fixed definitions. Simpson had seemed successfully to morph himself, but his arrest and the revelations of battery and drug use that quickly followed peeled away the new face to reveal a "darker" kid from the ghetto who was inassimilable to the "lighter" game face he used in his cross-over career.[32]

When a human morphs himself without a computer, through ambition or plastic surgery or assimilation to a putatively normal lifestyle or, say, through interracial

marriage to a more racially and class-privileged person, that identification and that passing makes him more likely to be a member of the core national culture, according to the logic of normalization I have been describing. But when his passing up the hierarchy of value fails and falls into a narrative about the real trauma in which visible order is actually a screen over terrible misrule, he unsettles the visual discipline of the American identity form that makes white people feel comfortable, and thus fouls the space of abstract personhood, ostensibly the American ethical space. In Simpson, racial and class morphing comes to look like an abuse of the national privilege to be abstract, tacit, entitled, normal: or this is the view of *Time*, whose "optimistic" desire for the new face of America to create a post-historical future in which all acts take place in a private space of loving citizen discipline attempts and fails to screen out an ongoing race and class struggle of unbeautiful proportions; a sex war of outrageous exhibition; a global conflict about the ethics of labor and ideologies of freedom; and a political public sphere where adult citizens identify powerfully with living in the complex, jagged edges of a terrible and terribly national present tense.

Coda: A Scar Across the Face of America

"There is a terrible scar across the face of America the beautiful," said Pat Buchanan in 1992, as he ran for President of the United States.[33] The scarred face to which Buchanan refers seems unrelated to the hypothetical forms—fetal, normal, cyborg—around which so much fantasy of a revived American way of life is now being invested. It is nothing like the face of America that *Time* produced, a prosthetic image of a hopeful national future. It is nothing like the body of *Forrest Gump*, which transcends national trauma to produce beautiful children. And it is nothing like Michael Jackson's computer-generated (re)vision of a national body liberated from humiliation, strangeness, violence, and history. It is more like *Time*'s representation of the darkened face of O. J. Simpson, which is the current model moral image of what a damaged and veiled social subjectivity looks like, a once-beautiful thing whose degeneracy registers on the surface as a distortion, an eruption, a gash, or a scar, a brutal and unforgettable historicity that the body registers externally and eternally. Buchanan never represents what the face of America looked like before it was scarred; it was just beautiful, a luminous abstract image of the righteous body politic. It is as though the scar itself makes the face concrete, human, fallen, and representable. In any case, he argues, the once iconic face of American beauty has been scarred, and "terribly"—by "1.5 million abortions per year."

To Buchanan and many anti-abortion rhetoricians, the devastating violence of 1.5 million abortions per year by women in the United States destroys the natural beauty of America, a space which has nothing to do with anything remotely ecological. Instead, the beauty to which the presidential candidate alludes is an abstraction for a natural way of life that is also a specific version of American national culture. These days, identification with this natural, national way of life is cast as part of a holy nation-building project by much of the secular and religious right—

in considerable pro-life material, and also in the three volumes of the Republican and Christian *Contract with America*.[34] In the image archives of these reactionary movements the aborting or improperly sexual person is not only self-destructive, but destructive of nature, culture, and spirit as well. In Buchanan's rhetoric, the uterus is displaced to the unmarked face, and the abortion is a visible self-mutilation: this horrible image supports an allegory of wasted life, a wasted way of life, and a culture of degenerate citizenship in a declining nation.

As we have seen, one embodiment strategy of both the religious and the secular right, which has been adopted more fuzzily by the dominant media, is to produce a revitalized image of a future United States from the genetic material of what was dominant, and then to build a new national public sphere around this past/future image of the good life in the U.S. The pre-political child and other infantile and incipient citizens have become so important to public sphere politics partly because the image of futurity they convey helps to fend off more complex and troubling issues of equity and violence in the present. The recent book *Alien Nation* demonstrates this process, when the author, Peter Brimelow, explains his desire to bring into being a white, post-immigrant America: "My son, Alexander, is a white male with blue eyes and blond hair. He has never discriminated against anyone in his little life.... But public policy now discriminates against him" in favor of the "'protected classes' that are now politically favored, such as Hispanics," a population he sees lamentably expanding, pushing his innocent son to the margins from his rightful place in the center (11, 274). Yet while inciting racialist and nationalist panic in the present through images of white pain in the future, national sentimentalists like Brimelow claim that their politics are superior to politics as usual. Driven by ethical and spiritual commitments to natural justice, common sense, and a generic good, long, intimate life, they promote a mode of being they think is at once sacred, ahistorical, and national.

The fantasy of an American dream is an important one to learn from. It has long been the public form of private history: it promises that if you invest your world-building energies in work and making a family, the nation will take care of the social and economic conditions in which this labor will allow you to live out your life with dignity. Yet this promise, which links personal lives to capitalist subjectivity and the cultural forms of national life, sets the stage for imagining a national people unmarked by public history. The fear of being saturated and scarred by the complexities of the present produces the kinds of vicious symbolic, optimistic, and banal politics I have been describing, a politics brimming over with images and faces.

One response to this politics among progressive writers has been to represent or put "faces" on members of the "protected classes" too, so that those with prerogative in the formerly unmarked populations, those white, financially fixed, or heterosexually-identified people, for example, might recognize that people unlike them are humans worth full citizenship after all. Books in the important tradition of Studs Terkel's *Working*, Faye Ginsburg's *Contested Lives*, or Marilyn Davis's *Mexican Voices/American Dreams* might indeed teach the persons who read them

432 to break with their own xenophobia, misogyny, racism, sex bigotry, or aversion to the relatively and absolutely poor. Likewise, every time someone who has suffered makes the pilgrimage to Washington to testify before Congress about the hard effects of the law, it is surely possible that someone else might see it and imagine millions of people so testifying in a way that changes the kinds of nationally-sanctioned prejudice and harm they are willing to support. But the nation has witnessed Anita Hill, and many others, testifying without making an irrevocable difference that counts: one person, one image, one face can only symbolize (but never meet) the need for the radical transformation of national culture, whose sanitary self-conception these days seems to require a constant cleansing of the non-normal populations—immigrant, gay, sexually non-conjugal, poor, Hispanic, African-American—from the fantasy scene of private, protected, and sanctified "American" life.

The changes that would make such testimony central to an undefensive democratic culture in the U.S. can only be effected in collective and public ways: not simply by changing your feelings about something to which you used to be averse. To effect such a transformation requires sustained, long-term, collaborative, multiply-mediated agitation against the narrow, privatized version of the American way of life everywhere: in the political public sphere, in the courts, in the middlebrow media, at work, in the labor of living everyday, in all the avant-gardes, sub-cultures, and normal spaces we can imagine. This means not killing off the family or intimacy, but inventing new scenes of sociality that take the pressure off of the family form to organize history for everything from individuals to national cultures. Only by taking the risk to make demands that will render people vulnerable (first, to changing their minds) will it be possible to make the culture here called "national" adequate to any of the things for which it ought to stand in this current state of emergency.

Notes

Much thanks to Arjun Appadurai, Carol Breckenridge, Cary Nelson, and Candace Vogler for goading me on to do this competently; and to Roger Rouse for his archival help, vast knowledge, intensive debate, and heroic labor of reading.

1 Walter Benjamin, "Theses on the Philosophy of History," *Illuminations* (1969), 257.

2 See Michel Foucault, "Governmentality," in Graham Burchell (1991), esp. 100–104. Foucault argues that modern states substitute a relatively decentered economic model of population control for the familial model of the sovereign, pre-Enlightenment state, and at the same time become obsessed with maintaining intimacy and continuity with its governed populations, an obsession that results in a fetishism of the kinds of knowledge and feeling that support the security of the state. Thus the intimate identity form of national fantasy accompanies the increasing segmentation and dispersal of state force, violence, and capital.

3 The literature on the "culture wars" is extensive. Inspiration for the conservative war to make a core national culture continues to be derived from Allan Bloom (1987); its current figurehead is former Secretary of Education, Chairman of the National Endowment for the Humanities, and director of the Office of National Drug Control Policy, William J. Bennett. See Bennett (1992) and (1988), particularly the chapters "The Family as Teacher," 61–68;

"Public Education and Moral Education," 69–76; and the section "In Defense of the West," 191–218. Some samples of the anti-core culture side of the struggle (mainly over the content of educational curricula and youth culture entertainment) are: Richard Bolton, ed. (1992); Henry Louis Gates, (1992); Gerald Graff (1992); and Russell Jacoby (1994).

4 It is in this sense that this essay takes up the spirit of Ian Hacking's "Making up People," with its arguments about the mutual and dialectical constructedness of categories of identity and kinds of subjectivity, seeing nation-formation here as an institution of subjectification whose purpose is to install as a fact of life the verity of its own practice, and whose generation of *itself* as an area must always be a facet of understanding the motive force of its practice (Ian Hacking, 1986). See also Fredric Jameson (1988).

5 The literature on race, gender, migration, state formation, and transnational capital is extensive: for a start, see Teresa L. Amott and Julie A. Matthaei (1991); Lena Dominelli (1991); Paul Gilroy (1987); Saskia Sassen (1988).

6 Newt Gingrich has recently claimed "Republicans who oppose gays are "not representative of the future," and the GOP is open to homosexuals "in broad agreement with our effort to renew American civilization." This concession to queer American nationality is amazing. However, in the context of the radical right revitalization of the family as the nest for the future of national identity, it is clear that Gingrich has assimilated homosexuality to the project of reprivatizing sexual property in the person. See Gannett News Service wire report, "Gingrich: GOP must include Gays," (23 November, 1994).

7 A most succinct analysis of the violent state- and capital-prompted disinvestment in the city and the national poor can be found in a two-part essay by Mike Davis (1993). In addition, see the important anthology edited by Robert Gooding-Williams (1993), especially Ruth Wilson Gilmore, "Terror Austerity Race Gender Excess Theater"; Cedric J. Robinson, "Race, Capitalism and the Antidemocracy"; Rhonda M. Williams, "Accumulation as Evisceration: Urban Rebellion and the New Growth Dynamics"; Michael Omi and Howard Winant, "The Los Angeles 'Race Riot' and Contemporary U.S. Politics"; Melvin L. Oliver, James H. Johnson, Jr., and Walter C. Farrell, Jr., "Anatomy of a Rebellion: A Political-Economic Analysis"; *Covert Action Information Bulletin*, "An Interview with Mike Davis"; Thomas L. Dumm, "The New Enclosures: Racism in the Normalized Community"; and Elaine H. Kim, "Home is Where the *Han* Is: A Korean-American Perspective on the Los Angeles Upheavals".

8 Concepts of the protesting mass as a "mob" have even taken on Mafia-tones since the Supreme Court, at Clinton's behest, allowed RICO anti-mob statutes to be used against nonviolent pro-life protesters. See National Organization for Women Inc., et al. v. Joseph Scheidler, et al., 114 S.CT. 798. For discussions of the Court's decision to link organized protest to racketeering, see *The Connecticut Law Tribune* (12 June, 1995) and the *Chicago Daily Law Bulletin*, (7 February, 1995 and 25 July, 1995).

9 An apparent counter-example to the claim that public popular political activity has become a demonized and dominant form of containment for radical politics might be found in the *Washington Post* critique of *The New York Times* coverage of the 1994 Gay, Lesbian, and Bi-Sexual March on Washington, which, according to the *Post*, went out of its way to clean up the parade and edit out its powerfully sexual performances. But, as often, the inversion into the opposite reinforces the Law: Queer complexity must be suppressed. See Howard Kurtz (1993).

10 This list of synonyms for "normal" is brought to you by the thesaurus of WordPerfect 5.1.

11 In a long commercially-sold preview for the film of *Forrest Gump*, titled *Through the Eyes of Forrest Gump*, director Robert Zemeckis and actor Tom Hanks very clearly state their desire to write the history of the recent U.S. in a post/pre-political vein of cultural memory (the screenplay was actually written by Eric Roth). Zemeckis says that "Forrest is a metaphor

434 in the movie for a lot of what is constant and decent and good about America," and quite self-consciously goes on to show the film emerging from a revulsion at the culture of negativity that begins to mark the political public sphere in the sixties. Take what happens to Vietnam in *Forrest Gump*, for example. From the pilgrimage to Washington material we know that the director could have placed Hanks/Gump in newsreel footage from Vietnam. But in *Through the Eyes of Forrest Gump* Hanks says, "We wanted to capture the reality without playing the same images that we've seen over and over again. And what we don't want to do is make that be yet another editorial comment on how bad a place it was or why. It just was." Significantly, *Through the Eyes of Forrest Gump* shows an alternative take to Gump's speech at the anti-war March on Washington the film represents. In the unreleased version of the scene, Gump says "There's only one thing I can tell you about the war in Vietnam. In Vietnam your best good friend can get shot. That's all I have to say about that." This speech verbalizes the event from the novel: upset from thinking about his dead friend Bubba Blue, Forrest "heaves" his Congressional Medal of Honor at the crowd "as hard as he can." (Winston Groom, *Forrest Gump* [1986, 113]) In contrast, in the released film, Gump's speech against the war is silenced by a "pig" who sabotages his microphone: the one moment when Forrest's "virtue" might come into critical contact with the nation is deliberately expurgated by Zemeckis.

12 For a precise insider explanation of the technologies of corporeal transformation in the film of *Forrest Gump*, see Janine Pourroy (1994). Thanks much to Julian Bleeker for sending this to me.

13 See the chapter "*Ronald Reagan*, the Movie," in Rogin (1987). For another scene of infantile national politics that is a clear precedent both for Reagan and for *Forrest Gump*, see *Being There*. The novel is by Jerzy Kosinski (1970); the film was directed by Hal Ashby (1979).

14 While generally the novel of *Forrest Gump* is not nearly as reactionary as the film, it does predict the film's dismay at public political life. The novel represents the March against the War in Vietnam as "the most frightening thing I have seen since we was back at the rice paddy where Bubba was kilt" (78), and also describes a mass political movement for which Forrest is the political inspiration, called the "I Got To Pee" movement (Winston Groom [1986], 236).

15 Many examples of ridiculed protest representations against the left and the right abound at the present moment. Episodes from more liberal shows like *Roseanne, The Simpsons,* and *Murphy Brown,* for example, mock right-wing protest as the acts of yahoos. Cinematic instances tend to be more conservative and confused. A film less ambitious than the *Pelican Brief* and *Forrest Gump* reveals the sheer ordinariness of protest's debasement: *PCU* (dir. Hart Bochner; 1994), for example, looks at the plague of "cause-ism" on contemporary college campuses, and after much sarcastic and hyperbolic cataloguing of political activism by African-Americans, Gays and Lesbians, Vegetarians, Eco-radicals, and so on, the campus comes together in the end under the rubric "Americans," chanting "We won't protest! We won't protest!" The film *SFW* (dir. Jefery Levy, 1995) plays on three kinds of debased antinormative social movement activity: a "terrorist" group, "Split Image," whose politics is never defined, takes over a convenience store and, in exchange for not killing its youthful hostages, puts them on national television for 36 days, where the nation learns to heroize them. Next, a political movement sweeps the mass-mediated country, inspired by the courage of the captives, especially the surviving ones, the working class Cliff Babb (Steven Dorff) and the upper-crust Wendy Pfister (Reese Witherspoon). The movement's slogan is "SFW," for "So Fucking What!" Babb is at first alienated by the shallowness of this movement, but as his face and fame spread across television and the covers of many national magazines, and he comes to identify with his message, which is "that there is no message." Finally, Babb and Pfister are shot by a disgruntled leftist, "Babs" Wyler, whose slogan is "Everything Matters!" and who

is very politically correct in the liberal way. The movie ends with Wyler becoming the nation-
al youth heroine of the moment; at the same "moment," the two stars agree to get married,
and the movie ends. For yet a different set of contradictions, see the demonstration that
introduces us to the fictional "Columbus College" in John Singleton's *Higher Learning* (1995).
Starting with a shot of a crowd chanting "Fight! Fight! Fight!" and pointing their fists in the
air, the film obscures whether this is a sports event or a political rally. The person who leads
the rally, standing in front of a large American flag that provides the backdrop for the
extremely political events to follow, then asks the cheering crowd two questions: "How many
people came here to change the world?" and "How many people came here to learn to make
a lot of money?" The last shot of the film is the silent stark caption "Unlearn."

16 Archive: the 1970 ABC documentary on "women's liberation" (from the series *Now*);
the 1993 25th Anniversary Special commemorating "'1968" (Fox, 1993); footage from CNN
throughout the 1980's; footage from Chicago television news broadcasts during the 1990's. For
an impressive, if overoptimistic, general history of recent protest in the U.S. and police bru-
tality during it, see Terry H. Anderson (1995).

17 In the contemporary U.S. public sphere, the rhetoric of the "face" flourishes in dis-
courses of social justice: currently issues of welfare, AIDS, wife abuse, crime, racism, vio-
lence, war, and sexuality invoke this logic. Its function is a classically sentimental one, an
attempt to solicit mass sympathy for or commitment to difficult social changes via a logic of
personal identification. Some examples, culled from many: on welfare, Jennifer Wolff (text)
and Kristine Larsen (photo essay) (1995); Rachel Wildavsky and Daniel R. Levine (1995); on
AIDS, Bettijane Levine (1995); Lisa Frazier (1995); Douglas Crimp (1991); and Stuart Mar-
shall's video *Bright Eyes* (1984); on wife beating, Rheta Grimslsley Johnson (1995); on race,
Peter Watrous (1995) and Gilbert Price; on war, Catharine Reeve (1995); on the death penal-
ty, Linnet Myers (1995).

Yet, as Gilles Deleuze and Félix Guattari argue, "Faces are not basically individual; they
define zones of frequency or probability, delimit a field that neutralizes in advance any
expressions of connections amenable to the appropriate significations." The face, in their
view, is not evidence of the human, but a machine for producing tests for humanness at its
limits. Likewise, this trend in the public sphere to put "faces" on social problems has the
paradoxical effect of making the faces generic and not individual: thus the facializing ges-
ture that promotes identification across the spaces of alterity is, in effect, an equivocal chal-
lenge to shift the political and cultural boundaries of what will count politically as human.
Gilles Deleuze and Félix Guattari, "Year Zero: Faciality," in *A Thousand Plateaus: Capitalism
and Schizophrenia* (1987, 168, 167–91).

18 See, for example, *Chicago Sun-Times* (28 August, 1993): 3 and (29 August, 1993): 3; *Cleve-
land Plain Dealer* (29 August, 1993): sec. A:1; *The Los Angeles Times* (29 August 1993), sec A: 1;
New York Times (29 August, 1993), sec. 1: 18; *The Washington Post* (29 August, 1993): 1.

19 *Gabriel Over the White House* comes from an anonymous novel of 1925, which reads
American society as currently in a depression-style crisis mainly for the unemployed "for-
gotten men" who fought for the U.S. during World War I but reaped little prosperity from
that sacrifice. The film of it takes bizarre twists. The President, an appetite-driven, politics-as-
usual politician for the élite, drives too fast and dies in a car crash: but God, via the angel
Gabriel, brings him back to life as an "ethical" person, in order to complete a short mission:
the eradication of organized crime from the United States. To do this, he not only initiates a
populist war on poverty by fiat but proclaims martial law, suspending the Constitution and
all civil rights.

20 For the concept and the recent history of remasculinization, see Susan Jeffords (1989).

21 *Time* Magazine (8 July, 1985): 24, 36.

22 There continues to be a vociferous debate on the right as to whether the benefit the

436 United States might receive from immigrant "blood" is not less than the cost their practices and histories pose to the maintenance of normal national culture. See, for example, Peter Brimelow (1995); the issue of *National Review* titled "Demystifying Multiculturalism," (21 February, 1994); and William F. Buckley and John O'Sullivan, "Why Kemp and Bennett are Wrong on Immigration" (1994), 36–45, 76, 78.

23 *Time*, Special Issue (Fall 1993), vol. 142, no. 21: 5.

24 *Time* (8 July 1985): 100; *Time* (Fall 1993): 3.

25 *Time*'s impulse to taxonomize and therefore to make firmer borders around racial types in the U.S. prior to their "melding" was evident in many places in the early 1990's: another parallel example of the graphic unconscious is in the *Newsweek* cover story responding carefully to Richard Herrnstein and Charles Murray's reinvigoration of scientific racism in *The Bell Curve*, titled "What Color is Black?" and illustrated by a 4x5 square of differently-shaded African-American faces. As though randomly related, the three faces on the upper right hand corner are partly obscured by a yellow slash that reads "Bailing Out Mexico." *Newsweek* (13 February, 1995).

26 *Time*, Special Issue (Fall 1993): 79.

27 See also Henry's (1990) much less extreme prophecy of xenophobia to come.

28 See *Cosmetics and Toiletries*, vol. 109, no. 2: 75; *Ethnic Marketing* (18 January, 1993): 11.

29 On *Singin' in the Rain* and "Black or White," see Carol Clover (1995).

30 "Black or White" cites *Risky Business* (dir. Paul Brickman, 1983) in its frame narrative, which is also a part of the recorded song. In this scene, Macaulay Culkin gyrates and plays air guitar in his bedroom, like Tom Cruise in *Risky Business*, to libidinously pulsating rock and roll. Berated by his father (George Wendt) for playing the music too loud, Culkin retaliates with an electric guitar blast so loud that his father explodes, still in his armchair, out of his house and to the other side of the world (Africa). The phrase Culkin uses as he blasts his father is "Eat this." Culkin's body is thus deployed here to link white, male pubescent rock and roll excess to masturbation, awakening masculine heterosexuality, Oedipal rage, generational identity, commodity attachment, and a desire to inhabit the publics in which he *feels* himself at his happiest.

31 These two aesthetic horizons of possibility for a nationally minor literature are predicted by Gilles Deleuze and Félix Guattari (1990).

32 A few weeks later, (18 July 1994) *Time* no doubt unconsciously returned to the theme of racial/class passing in its cover story on "attention deficit disorder": it is illustrated by a caricature that looks uncannily like O. J.'s distorted icon, now the poster face both for distorted subjectivity and white despair over the alterity of darker faces.

33 Associated Press release, "Buchanan courts Michigan Baptists," *Chicago Sun-Times* (16 March, 1992): 14.

34 *Contract with America: The Bold Plan by Rep. Newt Gingrich, Rep. Dick Armey, and the House Republicans to Change the Nation*, ed. Ed Gillespie and Bob Schellhass (New York: Times Books, 1994); *Restoring the Dream: The Bold New Plan by House Republicans*, ed. Stephen Moore (New York: Times Books, 1995); *Contract with the American Family: A Bold Plan by the Christian Coalition to Strengthen the Family and Restore Common-Sense Values* (Nashville: Moorings, 1995).

References

Amott, Teresa L. and Julie A. Matthaei (1991) *Race, Gender, and Work: A Multicultural History of Women in the United States*. Boston: South End Press.

Anderson, Terry H. (1995) *The Movement and the Sixties: Protest in America from Greensboro to Wounded Knee*. New York: Oxford U.P.

Barthes, Roland (1981) *Camera Lucida*. New York: Hill and Wang.

Benjamin, Walter (1969) "Theses on the Philosophy of History." In *Illuminations.* Trans. H. 437 Arendt. New York: Shocken Books.

Bennett, William J. (1992) *The De-Valuing of America: The Fight for Our Culture and Our Children.* New York: Simon and Schuster.

—— (1988) *Our Children and Our Country: Improving America's Schools and Affirming Our Common Culture.* New York: Simon and Schuster.

Berlant, Lauren (1995) "'68: or, the Revolution of Little Queers." In Diane Elam and Robyn Wiegman (eds) *Feminism Beside Itself.* New York: Routledge.

—— (1994) "America, 'Fat,' the Fetus." *boundary 2* (21)3, pp. 145–195.

—— (1993) "The Theory of Infantile Citizenship." *Public Culture* (5)3, pp. 395–410.

Bloom, Allan (1987) *The Closing of the American Mind.* New York: Simon and Schuster.

Bolton, Richard (ed) (1992) *Culture Wars: Documents from the Recent Controversies in the Arts.* New York: New Press.

Brimelow, Peter (1995) *Alien Nation: Common Sense About America's Immigration Disaster.* New York: Random House.

Buckley, William F. and John O'Sullivan (1994) "Why Kemp and Bennett are Wrong on Immigration." *National Review,* 21 Nov., pp. 36–45;76;78.

Clover, Carol (1995) "Dancin' in the Rain." *Critical Inquiry* 21, pp. 722–747.

Contract With the American Family: A Bold Plan by the Christian Coalition to Strengthen the Family and Restore Common Sense Values. (1995) Nashville: Mooring.

Coontz, Stephanie (1992) *The Way We Never Were: American Families and the Nostalgia Trap.* New York: Basic Books.

Covert Action Information Bulletin (1993) "An Interview With Mike Davis." In *Reading Rodney King/Reading Urban Uprising.* Ed. R. Gooding-Williams. New York: Routledge.

Crimp, Douglas (1991) "Portraits of People with AIDS." In Grossberg, Lawrence, Cary Nelson and Paula Treichler, Eds. *Cultural Studies Now and In the Future.* New York: Routledge.

Davis, Marilyn (1990) *Mexican Voices/American Dreams: An Oral History of Mexican Immigration to the United States.* New York: Henry Holt.

Davis, Mike. (1993a) "Who Killed LA? A Political Autopsy." *New Left Review* 197: 3–28.

—— (1993b) "Who Killed Los Angeles? Part Two: The Verdict is Given." *New Left Review* 199: 29–54.

Deleuze, Gilles and Félix Guattari (1990) "What is a Minor Literature?" In Russell Ferguson, Martha Gever, Trinh T. Min-ha, and Cornel West, Eds. *Out There: Marginalization and Contemporary Cultures.* Cambridge: MIT Press.

—— (1987) "Year Zero: Faciality." In *A Thousand Plateaus: Capitalism and Schizophrenia.* Trans. Brian Massumi. Minnesota: University of Minnesota Press.

Dominelli, Lena (1991) *Women Across Continents: Feminist Comparative Social Policy.* New York: Harvester.

Dumm, Thomas L. (1993) "The New Enclosures: Racism in the Normalized Community." In *Reading Rodney King/Reading Urban Uprising.* In Ed. R. Gooding-Williams. New York: Routledge.

Foucault, Michel (1991) "Governmentality." In G. Burchell, C. Gordon, and P. Miller, eds. *The Foucault Effect: Studies in Governmentality.* Chicago: University of Chicago Press.

Frazier, Lisa (1995) "The Face of AIDS is Changing." *Times-Picayune* (8 March): B:1.

Gates, Henry Louis (1992) *Loose Canons: Notes on the Culture Wars.* New York: Oxford University Press.

Gillespie, Ed and Bob Schellhass, Eds. (1994) *Contract With America: The Bold Plan by Rep. Newt Gingrich, Rep. Dick Armey, and the House Republicans to Change the Nation.* New York: Times Books.

Gilmore, Ruth Wilson (1993) "Terror Austerity Race Gender Excess Theater." In *Reading Rod-*

438

ney King/Reading Urban Uprising, Ed. R. Gooding-Williams. New York: Routledge

Gilroy, Paul (1987) *There Ain't No Black in the Union Jack.* London: Hutchinson.

Ginsburg, Faye D. (1989) *Contested Lives: The Abortion Debate in an American Community.* Berkeley: University of California Press.

Gooding-Williams, Robert, Ed. (1993) *Reading Rodney King/Reading Urban Uprising.* New York: Routledge.

Graff, Gerald (1992) *Beyond the Culture Wars: How Teaching the Conflicts Can Revitalize American Education.* New York: Norton.

Grisham, John (1992) *The Pelican Brief.* New York: Dell.

Groom, Winston (1986) *Forrest Gump.* New York: Pocket Books.

Hacking, Ian (1986) "Making Up People." In T. C. Heller et al., Eds. *Reconstructing Individualism: Autonomy, Individuality, and the Self in Western Thought.* Stanford: Stanford University Press.

Henry III, William A. (1994) *In Defense of Elitism.* New York: Doubleday.

—— (1990) "America's Changing Colors." *Time* (9 April): 28–31.

Jameson, Fredric (1988) "Imaginary and Symbolic in Lacan." In *The Ideologies of Theory: Essays 1971–1986.* Vol. 1. Minneapolis: University of Minnesota Press.

Jacoby, Russell (1994) *Dogmatic Wisdom: How the Culture Wars Divert Education and Distract America.* New York: Doubleday.

Jeffords, Susan (1989) *The Remasculinization of America: Gender and the Vietnam War.* Bloomington: Indiana University Press.

Johnson, Rheta Grimsley (1995) "Nicole has given wife abuse a face." *Atlanta Constitution* (15 May): C:1.

Kim, Elaine H. (1993) "Home Is Where the *Han* Is: A Korean Perspective on the Los Angeles Upheavals." In *Reading Rodney King/Reading Urban Uprising,* Ed. R. Gooding-Williams. New York: Routledge.

Kosinski, Jerzy (1970) *Being There.* New York: Harcourt, Brace, Jovanovich.

Kurtz, Howard (1993) "Don't Read All About It! What We Didn't Say About the Gay March— And Why." *Washington Post* (9 May): C:1.

Levine, Bettijane (1995) "The Changing Face of AIDS." *Los Angeles Times* (16 June): E:1.

Matsuda, Mari J., Charles R. Lawrence III, Richard Delgado, and Kimberle Williams Crenshaw (1993) *Words That Wound: Critical Race Theory, Assaultive Speech, and the First Amendment.* Boulder CO: Westview Press.

Moore, Stephen (ed) (1995) *Restoring the Dream: The Bold New Plan by House Republicans.* New York: Times Books.

Myers, Linnet (1995) "Girl Puts Human Face on Death Penalty Debate." *Chicago Tribune* (5 February): 1:3.

Oliver, Melvin L., James H. Johnson, Jr. and Walter C. Farrell, Jr. (1993) "Anatomy of a Rebellion: A Political-Economic Analysis." In *Reading Rodney King/Reading Urban Uprisin,* Ed. R. Gooding-Williams. New York: Routledge.

Omi, Michael and Howard Winant (1993) "The Los Angeles 'Race Riot' and Contemporary U.S. Politics." In *Reading Rodney King/Reading Urban Uprising,* Ed. R. Gooding-Williams. New York: Routledge.

Pourroy, Janine (1994) "Making Gump Happen." *Cinefex* #60: 90–106.

Price, Gilbert (1994) "Conservatism: A New Face." *Call and Post:* A:4.

Reeve, Catharine (1995) "The Face of War." *Chicago Tribune* (7 May): 6:3.

Robinson, Cedric J. (1993) "Race, Capitalism, and the Antidemocracy." In *Reading Rodney King/Reading Urban Uprising,* Ed. R. Gooding-Williams. New York: Routledge.

Rogin, Michael Paul (1987) *Ronald Reagan, The Movie: and Other Episodes in Political Demonology.* Berkeley: University of California Press.

Sassen, Saskia (1988) *The Mobility of Capital and Labor*. Cambridge: Cambridge University Press.

Terkel, Studs (1974) *Working: People Talk About What They Do All Day and How They Feel About What They Do*. New York: Pantheon.

Warner, Michael (1992) "The Mass Public and the Mass Subject." In C. Calhoun, Ed. *Habermas and the Public Sphere*. Cambridge: MIT Press.

Watrous, Peter (1995) "The loss of a star [Selena] who put a face on a people's hopes." *New York Times* (4 April): C:15.

West, Cornel (1990) "The New Cultural Politics of Difference." In Russell Ferguson, Martha Gever, Trinh T. Min-ha, and Cornel West, Eds. *Out There: Marginalization and Contemporary Cultures*. Cambridge: MIT Press.

Wildavsky, Rachel and David R. Levine (1995) "True Faces of Welfare." *Reader's Digest* (March): 49–60.

Williams, Rhonda M. (1993) "Accumulation as Evisceration: Urban Rebellion and the New Growth Dynamics." In *Reading Rodney King/Reading Urban Uprising*, Ed. R. Gooding-Williams. New York: Routledge.

Wolff, Jennifer (text) and Kristine Larsen (photoessay) (1995) "The Real Faces of Welfare." *Glamour* (September): 250–53.

David A. H. Hirsch

18

DAHMER'S EFFECTS

GAY SERIAL KILLER GOES
TO MARKET

> We're
> only horny enough to see through
> things, not actually inside.
>
> —Dennis Cooper

> After having formed this determination, and having spent some
> months in successfully collecting and arranging my materials, I
> began.
>
> —Dr. Victor Frankenstein

1995. *The Dream Police*, p. 103. "If you hold the pages of my jour-
nal up to the light you'll see contrasting, interrelating images
dealing with him. If you hold this one up you'll find my head is full of the words
of another writer."

1987. *Tales of Love*, p. 26. "When the object that I incorporate is the speech of the
other—precisely a nonobject, a pattern, a model—I bind myself to him in a pri-
mary fusion, communion, unification.... I become like him: One. A subject of
enunciation. Through psychic osmosis/ identification. Through love." And with all
the radical ambivalence of paracitational love.

Variations on some themes by Benjamin:

I AM *unpacking my library. The books are not yet on the shelves, not yet touched by
the mild boredom of order. You need not fear any of that. I must ask you to join me in
the disorder of crates that have been wrenched open, the air saturated with the dust of
wood, the floor covered with torn paper, to join me among piles of pages that are seeing
daylight again after two years of darkness, so that you may be ready to share with me
a bit of the mood—certainly not only an elegiac mood but, also, one of anticipation—
which these texts, these tissues, arouse in a genuine collector. What I am really con-
cerned with is giving you some insight into the relationship of a collector to his*

442 *possessions which possess him, in a very mysterious relationship to ownership; as well as some insight into a* serial-logics *of media and mediation, a dead man's "effects" and their effects. My aim has been to produce a work that, rather than ask, "What is the* attitude *of a work to the relations of production and consumption of its time?" asks instead, "What is its* position *in them, what is the author/collector's position in them?"*

1983. "Reading an Archive," pp. 118, 122. "Clearly archives are not neutral; they embody the power inherent in accumulation, collection, and hoarding as well as that power inherent in the command of the lexicon and rules of a language.... Archival projects typically manifest a compulsive desire for completeness, a faith in an ultimate coherence imposed by the sheer quantity of acquisitions.... In retrieving a loose succession of fragmentary glimpses of the past, the spectator is flung into a condition of imaginary temporal and geographical mobility. In this dislocated and disoriented state, the only coherence offered is that provided by the constantly shifting position of the camera, which provides the spectator with a kind of powerless omniscience."

1992. "Postcolonial Authority and Postmodern Guilt," pp. 58–59. "[T]his arbitrary closure is also the cultural space for opening up *new* forms of agency and identification that confuse historical temporalities, confound sententious, continuist meanings, traumatize tradition, and may even render communities contingent.... Difficult though it is, we cannot understand what is being proposed for new times—politics at the site of cultural enunciation; culture in the place of political affiliation—if we do not see that the discourse of the language-metaphor suggests that in each achieved symbol of cultural/political identity or synchronicity there is always the repetition of the sign that represents the place of psychic ambivalence and social contingency."

It has been one of the decisive processes of the last ten years in the American academy that a considerable proportion of its productive minds, under the pressure of economic and political conditions, have passed through a revolutionary development in their attitudes productive of what have been called "cultural studies," without being able simultaneously to rethink their own work, their relation to the means of production-consumption, their technique, in a really revolutionary way. A rethinking of modes of relationality, articulation, and agency, this essay aspires toward the procedure of montage by cutting thought-fragments out of their familiar contexts and rearranging them in an experimental manner. The superimposed element disrupts the context in which it is inserted, with much of the "work" or meaning-formation occurring in the interruptive place between elements. These articulating interruptions will hopefully arrest the action in its course, for a moment, and thereby compel the reader to adopt an active attitude vis-à-vis the process, the intellectual flâneur vis-à-vis the marketplace s/he visits ostensibly to look around, yet in reality to find a buyer.

* * *

1968. "The Death of the Author," p. 146. "Succeeding the Author, the scriptor no

longer bears within him passions, humours, feelings, impressions, but rather this immense dictionary from which he draws a writing that can know no halt: life never does more than imitate the book, and the book itself is only a tissue of signs, an imitation that is lost, infinitely deferred."

Seriality's infinite deferral/transmission of authority, however, need not lead to the conclusion that "life lived as a succession of episodes is a life free from the worry about consequences": *for even if* "the postmodern world in which authorities spring up, unannounced, from nowhere, only to vanish instantly without notice, preaches *delay of payment*," *and precisely because* "the credit card is the paradigm of the postmodern" (1995, *Life in Fragments,* p. 5), *the serialogics of accumulation and chronic indebtedness, far from bringing about the death of the author, may call and recall into being an author* (AUCTOR) *compelled into active responsiveness and responsibility for the relation of effects.*

1991. *Close to the Knives,* p. 116. "I found that, after witnessing [—]'s death,... I tend to dismantle and discard any and all kinds of spiritual and psychic and physical words or concepts designed to make sense of the external world or designed to give momentary comfort. It's like stripping the body of flesh in order to see the skeleton, the structure. I want to know what the structure of all this is in the way only I can know it. All my notions of the machinations of the world have been built throughout my life on odd cannibalizations."

The collector as producer-consumer speaks only about himself, interruptively; yet he may prove on closer scrutiny to be speaking to you, as he runs discursively from himself, to himself, into a temporary site of residence which now he is going to disappear inside, as is only fitting.

I. Arts of Ex-sistence

1991. *Close to the Knives,* pp. 143–45. "If you look at newspapers you rarely see a representation of anything you believe to be the world you inhabit.... Susan Whatsername said something about photographs being like small deaths which is maybe true. Maybe not.... To me, photographs are like words and I generally will place many photographs together or print them one inside the other in order to construct a free-floating sentence that speaks about the world I witness."

8/3/91. "Art Tries to Distance Itself From Life." The filmmakers and distributors of *Silence of the Lambs* "'do not feel the events involving [Jeffrey] Dahmer are equatable' to those in the film," said a publicity executive at Orion Pictures. "'The parallels are not legitimately drawn.'" Likewise, a Paramount Pictures spokesman wants to make it clear that the film *Body Parts* is "'not a death and dismemberment movie, not a slasher movie and is totally unrelated to the tragedy in Milwaukee.'"

8/10/91. *New Republic,* "Choice cuts." "Don't believe the people at Paramount who say the story line of their new horror flick *Body Parts* is 'not related at all to what happened' in Milwaukee. Based on a novel called *Choice Cuts,* the movie bears more than just an unfortunate titular resemblance to the putative autobiography of Jeffrey Dahmer.... But what Paramount is probably most worried about is the

charge of pandering to the same lust for violence that in a more developed state motivated Dahmer to drug, dismember, and consume portions of a dozen or more men. Which is, of course, exactly what it is doing."

Don't believe the author of an article called "Choice cuts" (which bears more than just a titular resemblance to the novel *Choice Cuts*), who implicitly suggests that his own critical practice is "'not related at all to what happened.'" What the author might be worried about is criticism's inescapable incorporation within an economy charged by explosive pandering to the same lust for violence that in a more developed state motivates the film industry, the surgical psychiatric industry (among others), to drug, dismember, and consume portions of countless gay men. "In our exploitation-friendly society," writes Lance Loud in a 11/3/92 *Advocate* article called "No hatchet job," "Dahmer's grotesque tale—the booze, the boys, the body parts—seemed destined for the silver screen. Still, it came as a shock this September when, less than three months after Dahmer was sentenced for his grisly acts, *Variety* announced that the film *Jeffrey Dahmer: The Secret Life* was finished and seeking a distributor. A star was born," writes the star-struck Loud, whose article is illustrated with one photo from the sensational film and a glamor shot of Loud himself.

1953. *Querelle*, epigraph. "'I had the habit of following exciting court cases,' he said, 'and Ménesclou poisoned my mind. I am less guilty than he, having neither raped nor dismembered my victim. My photograph must certainly be superior to his....' Declaration before the Public Prosecutor, ...July 15, 1881."

4/27/34. "The Author as Producer," p. 226. "I am speaking, as you see, of the so-called left-wing intellectuals.... I shall...show with these examples that a political tendency, however revolutionary it may seem, has a counterrevolutionary function as the writer feels his solidarity with the proletariat only in his attitudes, not as a producer," not as a consumer.

8/10/91, cont.: "From various news reports, I gather that Dahmer picked up his victims in

gay bars. I say gather, *Hunters and gatherers* because hardly anyone has been willing to say this directly. *constitute societies that* Is this information being soft-pedaled...out of a paternalistic *have no permanent place* desire to protect gays from negative publicity? The average *of residence.* American journalist tends to assume that the average American non-journalist is the redneck occupant of a Midwestern trailer park who believes gays are sick people who would have each other for dinner more often if they

weren't so busy *Eating and drinking together* committing crimes against nature in the hope of *affirm a society's shared* catching AIDS. Of course, there is plenty of homophobia *means of support and* out there, and it may feed for a time on what most people *exchange of resources.* have already figured out about the Dahmer killings. But that's hardly an excuse for trimming the story. Besides, if journalists would drop their own biases, they might be surprised by how liberal the Midwestern masses are.... Who knows? People might even feel sympathy for gay men who ended up in a fridge."

Trimming and packaging a news product to make it more palatable, to best secure the proper objects for sympathetic identification and consumption; cutting out the politically offensive parts (gay/*bar*/sex-murder), while playing up those parts that can seduce the reader's easily distracted attention (buy this text). The author of "Choice cuts" calls for the cutting out of biased, journalistic choices. Does the packaging of gay meat make a difference outside the apparently closed-door economy of the gay bar? Can family-values consumers stomach choice cuts of gay male subculture offered up for sale in those magazines to be flipped through at the check-out counter of the grocery store, while the meat and potatoes are moving down the conveyer belt? Should a gay-positive reporter follow the social realism of the Lukácsian school of political aesthetics, and go for the sympathetic jugular of the masses; or is the possible impossibility of obtaining sympathy for a dismembered corpse already an exercise in Brechtian defamiliarization?

Fall 1992. "The Ethnographer's Tale," p. 70. "[E]motional reactions of such unfathomed strength…float in a sea of questions because they lack an interpretive frame within which they can be addressed…. Instead of comprehension, assimilation, and interpretation these reactions surge past the mind in a guise that allows expression to what remains ultimately repressed within the unconscious. They are ego-defensive and boundary-protective rather than catalysts to relationality and exchange."

Winter 1987. "The Spectacle of AIDS," pp. 79–80. "In these densely coded *tableaux mourants* the body is subjected to extremes of casual cruelty and violent indifference, like the bodies of aliens, sliced open to the frightened yet fascinated gaze of uncomprehending social pathologists. Here, where the signs of homosexual 'acts' have been entirely collapsed into the signs of death-as-the-deserts-of-depravity, there is still some chance that reflexive identification *with* the merely human fact of death might interrupt the last rites of psychic censorship, with the human body in extremis."

1985. *Killing for Company: The Case of Dennis Nilsen*, pp. 25–6, emphasis added. Gay British serial killer Nilsen writes, in his prison diaries, "The population at large is neither 'ordinary' or 'normal.' They seem to be bound together by a collective ignorance of themselves and what they really are. Their fascination with 'types' (rare types) like myself plagues them with the mystery of why and how a living person can actually do things which may be only those dark images and acts secretly within them. *I believe they can identify with these 'dark images and acts' and loathe anything which reminds them of this dark side of themselves.* The usual reaction is a flood of popular self-righteous condemnation but a willingness to, with friends and acquaintances, talk over and over again the appropriate bits of the case."

1913. *Totem and Taboo*, p. 33. "If the violation were not avenged by the other members they would become aware that they wanted to act in the same way as the transgressor." p. 30. "The instinctual desire is constantly shifting in order to escape from the impasse and endeavours to find substitutes—substitute objects and substitute acts—in place of the prohibited one."

1887. *On the Genealogy of Morals*, p. 49. "[B]etter to have it expressly described

David A. H. Hirsch446for us by an authority not to be underestimated in such matters, Thomas Aquinas, the great teacher and saint. '*Beati in regno coelesti,*' he says, meek as a lamb, '*videbunt poenas damnatorum,* **ut beatitudo illis magis complaceat.**'" ('The blessed in the kingdom of heaven will see the punishments of the damned, *in order that their bliss be more delightful for them.*')

3/24/94. "I Had No Other Thrill or Happiness," p. 56. "The serial killer's immersion in fantasy; his apparent helplessness in the face of his compulsion…; the ritualistic and totemic elements of his grotesque 'art'; the seemingly insatiable need to orchestrate, and reorchestrate, a drama of hallucinated control; the mystical-erotic 'high' released by the consummation, after a lengthy period of premeditation—all suggest a kinship, however distorted, with the artist."

Yes, "People might even feel sympathy for gay men who ended up in a fridge." But it will be a sympathetic nausea.

II. Disrecognizing Kinship: Let us break bread together

1947. *Monsieur Verdoux.* "Never, never in the history of jurisprudence, have such terrifying deeds been brought to light. Gentlemen of the jury, you have before you a cruel and cynical monster. Look at him."

1940. *Native Son,* p. 376. "Your Honor, for the sake of this boy and myself, I wish I could bring to this Court evidence of a morally worthier nature…. If I could honestly invest the hapless actor in this fateful drama with feelings of a loftier cast, my task would be easier and I would feel confident of the outcome…. But I have no choice in this matter."

People *might even feel sympathy for gay men who ended up in a fridge.*

8/12/91. *People,* "Door of Evil," p. 34. "Dahmer's mother, Joyce, and his father, Lionel, were in the throes of a bitter divorce…. 'Jeffrey was left all alone in the house with no money, no food, and a broken refrigerator,' said Shari, who married Lionel after his 1978 divorce."

12/12/94. *People,* p. 132. "And in a twist so ugly Jeffrey might have thought it up himself, Lionel and Joyce are fighting over their son's remains."

3/8/94. *Dateline NBC.* Voice-over): "As a teenager, there were many things Jeffrey, or Jeff as he prefers to be called, felt he couldn't share with his parents. But in Lionel Dahmer's home, one subject was particularly taboo." Stone Phillips) "Did you ever consider talking to your parents, to your dad, about [pause] homosexuality?" Jeff Dahmer) "No. All I knew was that it was something that was to be kept hush-hush, not talked about, not even thought about. So I just kept it all within me, and never, never, talked about sexual issues at all, really, with anybody." Voice-over) "Jeffrey's secret homosexuality was only one force that drove him into his own world. His parents' incessant fighting was another." JD) "I'd leave the house, go out in the woods and sulk, wondering why they had to have such a rough relationship…. I sort of lived in my own fantasy world when things got too heated. It was just my own little world where I had control, …where I could completely control a person, a person that I found physically attractive, and keep them with me as long as possible, even if it meant just keeping a part of them." Commercial break: "*Alpha-hydrox*

is going to turn everything you think about skin care on its head. Oh, and it's under ten dollars."

1985. *Killing for Company*, p. 143. "I was the forlorn seeker after a relationship which was always beyond my reach. I felt somehow inadequate as a human being."

1913. *Totem and Taboo*, pp. 134–35. "But why is this binding force attributed to eating and drinking together? In primitive societies there was only one kind of bond which was absolute and inviolable—that of kinship.... 'A kin was a group of persons whose lives were so bound up together, in what must be called a physical unity, that they could be treated as parts of one common life.... In Hebrew the phrase by which one claims kinship is "I am your bone and your flesh.""'"

3/8/94. *Dateline NBC.* "It made me feel that they were a permanent part of me."

8/5/91. *Newsweek*, "Killing Patterns," p. 40. "In one study of 30 serial killers, seven were involved in the food business, as cooks, bakers or owners. Experts have no explanation."

1913. *Totem and Taboo*, p. 137. "We have heard how in later times, whenever food is eaten in common, the participation in the same substance establishes a sacred bond between those who consume it."

8/12/91. *People*, "Evil," p. 34. "There was no food in apartment 213, only condiments. Inside the freezer were packed lungs, intestines, a kidney, a liver, a heart....."

3/8/94. *Dateline NBC.* Thanksgiving, 1990; home video. Lionel Dahmer) "Grandma was saying that she thought that you got quite a bit thinner. But you look fit...I don't know." JD) "Well, I've been surviving mostly on McDonalds' foods, it's so much easier just to pop into the restaurant. But like I've said before, it gets too expensive, and I have to start eating at home more."

1913. *Totem and Taboo*, p. 135. "In our own society the members of a family have their meals in common; but the sacrificial meal bears no relation to the family.... To this day, savages eat apart and alone and the religious food prohibitions of totemism often make it impossible for them to eat in common with their wives and children."

2/3/92. *Newsweek*, pp. 45–46. "Along the decaying Walker's Point strip in Milwaukee, the gay bars line up like tarts in the night, identical red neon signs extending their OPEN invitation to the restless in pursuit of easy comfort or casual sex.... At Club 219 he made friends with a onetime Lutheran minister. 'He talked openly about why he shouldn't be gay, that there was something wrong with it,' the confidant recalls."

3/8/94. *Dateline NBC.* SP) "If Jeff had come to you, and said, 'Dad, I'm a [pause] homosexual,' how would you have reacted?" LD) "I think I would have started in on a program to try to change his thinking." SP) "Do you believe to this day that he is, as a homosexual, living in a state of sin?" LD) "If you believe the inspired Word of God, which I do, that is sin. It's repugnant to God."

1989. *Tongues of Flame*, p. 115. "We fucked on the roof and in the boiler room and in alleys in the neighborhood in every season and any weather for a few years. I was afraid of being queer and almost murdered him after the first night so that no one would find out."

I was the forlorn seeker after a relationship which was always beyond my reach. I felt somehow inadequate as a human being

2/10/92. *Newsweek.* "He told the police that he ate only those young men he liked: he wanted them to become part of him."

8/12/91. *People,* "Evil," p. 34. "He was known as a mild-mannered man who worked, of all places, in a chocolate factory."

2/3/92. *Newsweek,* p. 46. "Most of the men Dahmer killed were dark-skinned gays. At the chocolate factory, people who worked with him remember that he constantly muttered about 'niggers.'"

8/12/91. *People,* "The *Lambs* connection." "Homophobia and racism are central to Dahmer's case…. 'Most serial killers…believe that they are doing good for society by killing certain types.'"

3/8/94. *Dateline NBC.* JD) "No, their race didn't matter to me. The first two young men were white, the third young man was American Indian, the fourth and fifth were Hispanic; so, no. Race had nothing to do with it. It was just [pause] their looks."

4/95. *Esquire,* "A Beer and Some Chips with Jeffrey Dahmer," p. 126. "He was the only white guy in the building, but he didn't appear to have any racial hang-ups, and that was one of the reasons I liked him. The only thing that made me wonder about him was the fact that I never saw him with a woman."

During his trial JD read newspapers and magazines about computer programming. Mild-mannered man talked to former minister about why he shouldn't be gay, that there was something wrong with it /minister/shouldn't be gay/*delete*/ something wrong; he ate only those young men he liked he muttered about 'niggers' he ate he hated he liked he muttered/mannered/murdered certain/*types*/; there was something/ wrong/ read magazines

III. Imitations of *Life*

2/3/92. *Newsweek,* p. 46. "Most of the men Dahmer killed were dark-skinned gays. At the chocolate factory, people who worked with him remember that he constantly muttered about 'niggers.'" *There was a story my sister once told me, about a white kid who walked up to a black kid in a supermarket, said, "Look, Mommy, a chocolate boy," and bit the black child. There's a song from the musical Hair, that goes something like "Black boys are delicious, chocolate-covered treats."* "Dahmer may have developed his modus operandi because he thought minorities were weaker, or perhaps because he thought racism could work in his favor. He selected 'more disposable' victims."

Hunters and gatherers /constitute societies/ that have no permanent place of residence, although they may return/ repeatedly to temporary sites/ for resources.

3/8/94. *Dateline NBC.* "I went to bath-houses, I went to bars, shopping malls."

2/10/92. *Newsweek*. "Searching for partners over whom he could have 'total control,' he stole a department-store mannequin, read newspaper obituaries of dead young men…. 'At one point they were human beings,' he said. 'Then they were reduced to four or five garbage bags.'"

8/12/91. *People*, "Evil," pp. 33–34. "He lured his victims—most of them black and homosexual—from shopping malls, bus stops and bars by offering them money to pose for pictures at his apartment."

12/12/94. *New Yorker*, "A Riddle Wrapped in a Mystery," p. 45. "So long as the serial killer chooses his victims from the ever-shifting population of drifters, prostitutes, and the disenfranchised of contemporary America—those who seem to lack identity—he can operate with impunity for a very long time."

Homophobia and racism are central to Dahmer's case: who but those without value, those occupying the otherwise unemployable bodies of "the Black," "the Asian," "the Hispanic," "the Homosexual," who else would swallow the lure of $50 for a few hours of nude photography and possibly the "small death" of an orgasm or two? Someone would actually *pay* to photograph *my* body? Susan Whatsername said something about photographs *Susan Whatsername said something about photographs being like small deaths which is maybe true.* Maybe not.

1991. *Close to the Knives*, p. 81: "I was ten years old and walking around times square looking for the weight of some man to lie across me to replace the nonexistent hugs and kisses from my mom and dad. I got picked up by some guy who took me to a remote area of the waterfront in his car and proceeded to beat the shit out of me because he was so afraid of the impulses of heat stirring in his belly."

at the bottom of the food chain an excess of embodiment devoid of cultural capital archivally semantically up for grabs *quick fuck make a buck can't afford to give a fuck* itinerant body mouldering not prettily of operatic consumption but homeless on the waterfront and he's no Marlon Brando outside the conservative economia with no reproductive use-value in the army now war-bond bodybag finally on the evening news as cannon-fodder advertising-fodder the so-called **colored body,** the so-called **castrated body,**

Winter 1987. "Spectacle," p. 80. **"the 'homosexual body'**…must be publicly seen to be humiliated, thrown around in zip-up plastic bags, fumigated, denied burial, lest there be any acknowledgment of the slightest sense of loss…devoid of value, unregretted, unlamented, and—final indignity—effaced into a mere anonymous statistic. The 'homosexual body' is 'disposed of,' like so much rubbish, like the trash it was in life."

…*He was known as a mild-mannered man who worked, of all places, in a chocolate factory. He selected* 'more disposable' *victims*

1944. *Dialectic of Enlightenment*, p. 137. "Amusement under late capitalism is the prolongation of work. It is sought after as an escape from the mechanized work process, and to recruit strength in order to be able to cope with it again. But at the same time mechanization has such power over a man's leisure and happiness, and so profoundly determines the manufacture of amusement goods, that his experi-

ences are inevitably after-images of the work process itself. The ostensible content is merely a faded foreground; what sinks in is the automatic succession of standardized operations. What happens at work, in the factory, or in the office can only be escaped from by approximation to it in one's leisure time."

1936. *Modern Times.* Charlie "The Little Tramp" Chaplin, a wrench in the machinery of the factory where he works, chases one woman after another, trying to unscrew her buttons. He squirts successive male co-workers with an oil can. Diagnosed as a communist and a lunatic, he undergoes several runs through the machinery of the police and psychiatrists, and works in a restaurant before becoming a drifter.

1947. *Monsieur Verdoux.* The Little Tramp as Bluebeard: "As for being a mass killer, does not the world encourage it? Is it not building weapons of destruction for the sole purpose of mass killing?... As a mass killer I am an amateur by comparison."

8/12/91. *People,* "Evil," p. 36. "While often keen, the minds of serial killers run in obsessive ruts."

...He was known as a mild-mannered man who worked, of all places, in a chocolate factory. The production line, the chorus line, the gay bars line up like tarts in the night, identical red neon signs, predigested clichés.

2/3/92. *Newsweek,* p. 45. "Stories about the serial killer who wouldn't hurt a fly have

become pulp clichés; *Look, up in the sky, it's* true to form, Dahmer appeared outwardly harmless to most *a bird, it's a plane, it's* people until the night he was caught."

> *Mild-mannered reporter steps out of office closet,*
> *into telephone booth closet, emerges as*
> *Underdog. Never identifying with Clark Kent*
> *when I was a kid, I remember coming out*
> *of the shower wrapping a towel tightly around*
> *my legs, walking knock-kneed around the room in imitation of*
> *Lois Lane walking knock-kneed in those ultra-confining*
> *late-'50s sheath skirts on TV.*

4/1/91. *People,* p. 68, on Ed Gein, upon whom Norman Bates in *Psycho* was based: "On the opening day of deer season in 1957, Gein...shot and killed Bernice Worden,... partially dismembered her and trussed her up like a deer.... He apparently liked to wear the skins of his victims and to look at his image in multiple mirrors."

Dear little Eve, formerly a worker in a Milwaukee beer factory, the type of fan Bette Davis calls "juvenile delinquents, mental defectives"; vaguely lesbian Eve is covering up her mannish suit with Bette's theater dress and bowing before an imaginary audience, no longer a backstage producer of stardom but a new improved product off the line./Series continues with *All About Eve's* unclosed ending, as Eve's assistant, the next ingenue, puts on her idol's high-priestess stole, her image reflect-

ing three times in a multiple mirror, these images then reflecting themselves and reproducing endlessly into the superficial void of the silvered screen, perpetually moving the market exchange onward, promising satisfaction but never delivering the goods of being, perpetuating lesbian desire, clutching the fetish of the Sarah Siddons theater award. Vaguely gay theater critic George Sanders: *he* can see through Eve's masquerade, he knows her type: like Cain, they both bear "the mark of a true killer." *All About Eve* will go on to win Best Picture 1950.

["You made one mistake. There is no such thing as lesbian desire. It is narcissism: the only desire is heterosexual. She kills the mother to become her, so she can have the father, the phallic award." *But I thought you said, 1913,* Totem and Taboo, *p. 141, "Psycho-analysis has revealed that the totem animal is in reality a substitute for the father"?* The Sarah Siddons Award is phallic, perhaps, but don't Eve and her clones serial kill other women as sacrificial totems? "I was talking about boys in *Totem.* May I recommend the 1929 Joan Riviere?" *Not to my taste; how about a nice Judith Butler, vintage 1990?* "Who?"]

1988. *The Silence of the Lambs*, p. 136. "Gumb toweled himself pink and applied a good skin emollient. His full-length mirror had a shower curtain on a bar in front of it.

"Gumb used the dishmop to tuck his penis and testicles back between his legs. He whipped the shower curtain aside *[he is Norman Bates]* and stood before the mirror, hitting a hipshot pose despite the grinding it caused in his private parts *[he is Janet Leigh]*."

["You see? He wants to be his mother." *But the sacrificial animal is a woman again.* "I was talking there about heterosexual boys." *If there's no such thing as homosexual desire, how can there be homosexual boys?* "You're confusing identification and desire." *I know. Let me try again.]*

Oh, to be Lana Turner, epitome of Hollywood suburban lust; to be the café-manager Poster Pin-Up, desired by John Garfield, glowing as she looks in her vanity mirror, fresh from a bath, wearing on her head a towel— a white, Americanized turban. To be the perfect imitation of life, to pass like the mulatto daughter of an Aunt Jemima mammy whose recipe for pancakes Lana the spokesmodel markets so successfully (or was that in the 1934 *Imitation?*). But script after script, role after role, husband after husband, poor Lana —in *Imitation* a white widow, a theatrical aura stealer who (a model consumer) compulsively needs "something different… a new experience"— poor Lana can't find love and intimacy. *I was the forlorn seeker after a relationship which was always beyond my reach.* Real-life lesbian daughter Cheryl (previously raped repeatedly by stepfather #2 Lex Barker, star of Tarzan films) stabs to death Johnny Stompanato after he screams at Lana, "I'll cut you up…. I'll mutilate you so you'll be repulsive" (1982. *Always, Lana*, p. 36), just as Sara Jane the little trampish mulatto tries in *Imitation* to steal and kill Lana's lover…or am I confusing Lana with Mommie Dearest, as the café manager in *Mildred Pierce*?

["Cheryl was never raped, that was her fantasy. Nor is she a lesbian, as such: say instead an incomplete heterosexual. Oedipus, Oedipus: she wanted Johnny—that's the rumor I heard. Mommie Dearest is only the phantasmatic castrating mother. I LOVED Joan in *Mildred Pierce*; she won the Academy Award." *Interesting…well at least with Cheryl the totemic animal does seem to be a substitute for the step-father-rapist.* "I was talking in *Totem* about heterosexual boys." **Narcissism.** *Is it possible that a gay boy's identification with straight women is the effect, rather than the cause, of his desire to have sex with men?*

"Nonsense. Tell me, why do you enjoy cutting my work into pieces?"]

Virtually every scene in *Imitation*, every other scene in *Mildred* or *Eve*, is shot in high melodramatic style through a mirror, or a clear pane of glass.

1982. *Always, Lana*, p. 38. "At first, Lana and Cheryl had to endure the predictable condemnation from religious quarters and from the press, not to mention every psychiatrist and bartender in view.... Though the headlines eventually faded, the question that lingers to this day is whether...Lana herself stabbed Johnny and convinced her daughter to stand trial for it."

Is the market for fresh-young things to blame, is the heterosexualized and white-bleached male or female producer-consumer to blame, or does the blame usually fall upon those rebellious underlings, upon "deviant" Juvenile Delinquents, make-a-killing starlets like Eve, Mildred's daughter Veda, Sara Jane, Norman and Cheryl, who won't stay restrained in their programmed places?

1936. *Modern Times*. Little Tramp: "Where do you live?" Trampette: "No place—anywhere." 1959. *Imitation*. Lana's daughter Susie: "Where do you live, Sara Jane?" SJ: "No place." *Hunters/gatherers constitute societies/ that have no/place.*

8/1/91. "17 Killed, and a Life Is Searched for Clues," p. 1. "Mr. Dahmer fell far short of honor society standards, but he sneaked into the photo session as if he belonged. No one said a word until long after the shutter had clicked."

4/27/34. "The Author as Producer," p. 230. "What we require of the photographer is the ability to give his picture the caption that wrenches it from modish commerce and gives it a revolutionary useful value."

1951. *Washington Confidential*, p. 123. "Foreign chancelleries long ago learned that homos are of value in espionage work.... According to Congressman Miller, who made a comprehensive study of the subject, young students are indoctrinated and given a course in homosexuality, then taught to infiltrate in perverted circles in other countries. Congressman Miller said:

"...'The homosexual is often a man of considerable intellect and ability. It is found that the cycle of these individuals' homosexual desires follows the cycle patterned to the menstrual period of women. There may be three or four days in each month that the homosexual's instincts break down and drive the individual into abnormal fields of sexual practice.'"

1988. *Serial Killers*, p. 93. The FBI Behavioral Science Unit "found that a serial killer's cycles are much like a menstrual cycle. He drifted between episodes based upon his arousal and the need he felt to satisfy it. Actually, what the Unit still hasn't discovered is that the cycles are not *like* menstrual cycles, they are *forms* of a menstrual cycle in which the hormones responsible for arousal, violence, fear, and anxiety are generated according to a rhythm established in the hypothalamus.... [*Recent dissection of corpses suggests that critical sections of the hypothalamus of /straight/ women and gay men are statistically identical in size/ the gay male serial killer is the 1980s and '90s avatar of the spoiled-rotten pubescent daughters of 1940s and '50s melodrama*] ...Since the menstrual cycle itself is controlled by hormones, it is natural that, if the area of the brain that controls normal hormonal function in the ductless glands is malfunctioning, the body's normal hormonal control system will malfunction as well."

1988. *Silence*, pp. 282–83. "The next item he'd taped off cable television…was the 453
loop film they run on seedy cable channels late at night as background for the sex
ads that crawl up the screen in print. The loops are made of junk film, fairly
innocuous naughty movies from the forties and fifties….

"There was nothing Mr. Gumb could do about the ads crawling up the screen.
He just had to put up with them."

11/17/92. I'm writing this during commercial breaks in the CBS made-for-TV
movie *Overkill*, about lesbian serial killer Aileen Wuornos. Despite the pre-airing
hype, it's more sympathetic, less sensationalistic than I anticipated, suggesting that
most serial killers are the endproducts of a physically-abusive, re-generational
series of "family values." *(Rumor has it that Jeffrey Dahmer was raped by good old dad.)*

3/21/94. *Time*, "Serial Chic." "Charles Manson has earned some $600 in royalties
from a line of caps, surfer pants, and T shirts adorned with his image and such stu-
diously ironic slogans as **SUPPORT FAMILY VALUES.**"

I've been trying to tune out the commercials while I type this, but it isn't easy:

9:25 pm EST. An Eveready Energizer ad that parodied those ubiquitous hetero-
sexual-male-oriented beer commercials. My sense of identification with Aileen is
quickly interrupted—but at the same time strengthened—once the beer-guzzling
breeder boys snap their fingers expecting the babes to appear on the beach. That
damned drum-beating wind-up rabbit breaks the illusion; this is an ad for batter-
ies, not beer and babes. "It keeps going, and going, and going…." Cut to an ad for
Dead Poets' Society, a film about an English Lit. teacher. New, improved: "Presented
with thirteen minutes of new footage"; every clip in this ad shows some type of
physical contact between boys or boys and teacher. Image in my head of the drama
teacher at Phillips Exeter Academy, recently convicted of photographing male stu-
dents in the nude and shipping across state lines doctored videos of *Dead Poets'
Society*, into which he had inserted graphic video sex scenes, making explicit what
had been only an erotic undertone to this film about an unmarried male teacher
and his beautifully scrubbed, ever-red-cheeked students.

10:25 commercial break. Again an Eveready ad (they reproduce like rabbits, like
batteries in series), again previews for a news story following the film at 11:00
("Overkill: The Real Story," with real-life footage of Wuornos), again ads for tomor-
row night's 11:00 news story ("Go Inside the Mind of a Killer"), an ad for this week's
episode of the series *In the Heat of the Night* (about a killer sniper) and *Top Cops*.
These ads running and rerunning in my mind, I realize that the term *series* is its
own plural.

11/16/92. I saw a large window advertisement tonight for Paul Verhoeven's *Basic
Instinct*. "See it again. And again. And again. And again," for rent at only $3 a copy.

But I *have* already seen it again. I've already gone "In the Deep Woods," a recent
serial-killer-of-the-week TV-movie, where the suspects include two promiscuous
males (one a cop), and Anthony Perkins in his last role before succumbing to that
other serial killer, AIDS. The real killer wasn't a promiscuous fag, though: it was a
sister-lover who wanted to be mother's favorite. But isn't it always the same story:
missionary-style only with your legally exogamous, intraracial, intergendered

454 spouse; and women (fags, dykes and other transsexuals included), please stay quietly in your domestic closet, otherwise you'll be the black, the black-and-blue, or the black-rooted blonde-haired *Black Widow*, who killingly "mates for life"? Herr Doktor, is there any difference between incest and other sorts of queer sexuality? Is it that they're all taboos of sameness? *Civilized critics must disavow any imputation of kinship with children and savages. The totemic animal of our culture is the serial-killer proxy for queer sexualities. "FBI Warning: Federal law provides severe civil and criminal penalties for the unauthorized reproduction, distribution, or exhibition, of copyrighted motion pictures and video tapes."*

 1944. *Dialectic.* "What happens…can only be escaped from by approximation to "What happens…can only be escaped from by approximation to "What happens…

 8/12/91. *People*, p. 32. Officer Mueller "headed for the bedroom where a Polaroid camera lay on the bed. He indeed discovered a butcher's knife underneath. But what caught Mueller's

eye were the photographs *Down the right hand margin of*
spilling out of the highboy. *pages 33 and 35 of this article*
They showed homosexual *are a series of head shots of*
sex acts, men in various stages *Dahmer's victims.*

of undress—and corpse after corpse, bodies mutilated and dismembered, including one eaten away from the nipples down, apparently by acid.

 "With a shock, Mueller realized the pictures had been taken in that very room. After scrutinizing another grisly photo, he ran to the kitchen area, prompting Dahmer to leap up from the living room sofa, screaming like a terrified animal. When Mueller opened the refrigerator, he made an unspeakable discovery:

[The cover of this issue of People *is a head shot of Jeffrey Dahmer. This cover story is called "The Door of Evil." Open this magazine and multiple advertisements for merchandise proliferate with images of other heads, like the faces of Dahmer's victims, smiling.]*

a human head, sitting on the bottom shelf next to a box of baking soda."

 With a shock, when I opened to page 173 of 1988's *Silence*, I made an unspeakable discovery: "*And when I opened the refrigerator, well, you know what I found. Klaus's head looking out from behind the orange juice.*" I leaped off my sofa and screamed like an animal, "You copy-cat! Federal law provides severe civil and criminal penalties for unauthorized reproduction."

 Gumb toweled himself pink and applied a good skin emollient.

 1988. *Detour*, pp. 168–69. "She could afford the world's costliest creams (and even endorsed one or two), but she herself used humble products bought in the five-and-dime. After bathing, she slathered her body with Nivea cream, and once a week, …she scrubbed her face with a paste made of Twenty Mule Team Boraxo, an industrial-strength scouring powder (for which Ronald Reagan was once the television spokesman)."

 Fall 1990. "The New Founding Fathers," p. 7. "Incredibly, just a few months after

['Son of Sam' David Berkowitz's 1977] arrest, Max Factor introduced a new face moisturizer called 'Self-Defense.' As the billboards throughout the city threatened: 'Warning! A Pretty Face Isn't Safe In This City. Fight Back With Self-Defense.'"

1991. *Close to the Knives*, p. 172. "Maybe it was that violence they'd witnessed on television during wartime had gotten completely confused with the seductive commercials that surround these images. I felt the whole landscape surrounded by media faces expounding how normal things were and how thoroughly wonderful life in america was and how well we all were doing and yet all my friends were doing a death dance in front of these surreal propped-up facades."

1944. *Dialectic*, p. 163. "In the most influential American magazines, *Life* and *Fortune*, a quick glance can now scarcely distinguish advertising from editorial picture and text. The latter features an enthusiastic and gratuitous account of the great man (with illustrations of his life and grooming habits) which will bring him new fans, while the advertisement pages use so many factual photographs and details that they represent the ideal of information which the editorial part has only begun to try to achieve. The assembly-line character of the culture industry, the synthetic, planned method of turning out its products (factory-like not only in the studio but, more or less, in the compilation of cheap biographies, pseudo-documentary novels, and hit songs) is very suited to advertising: the important individual points, by becoming detachable, interchangeable, and even technically alienated from any connected meaning, lend themselves to ends external to the work. The effect, the trick, the isolated repeatable device, have always been used to exhibit goods for advertising purposes, and today every monster close-up of a star is an advertisement."

2/10/92. *Newsweek.* "He used salt, pepper, [Adolph's?] meat tenderizer and A-1 steak sauce on three men."

IV. Hacking Up the Serial Killer

2/3/92. *Newsweek*, p. 45. "To reconstruct the life of a serial killer, *Newsweek* reporters interviewed...psychologists and legal experts."

9/18/95. "Dahmer's brain saved; his body is cremated." "His father...claimed his half of the ashes Sunday, while arrangements were being made for his mother...to receive the rest.... The brain has been preserved in formaldehyde since the autopsy. A court hearing regarding Dahmer's brain is scheduled Oct. 3, but his divorced parents chose cremation [of the body] in the meantime to save storage costs."

1913. *Totem*, p. 72. "The punishment will not infrequently give those who carry it out an opportunity of committing the same outrage under colour of an act of expiation. This is indeed one of the foundations of the human penal system."

1936. "The Work of Art in the Age of Mechanical Reproduction," p. 223. "Every day the urge grows stronger to get hold of an object at very close range by way of its likeness, its reproduction.... To pry an object from its shell, to destroy its aura, is the mark of a perception whose 'sense of the universal equality of things' has increased to such a degree that it extracts it even from a unique object by means of reproduction. Thus is manifested in the field of perception what in the theoretical

sphere is noticeable in the increasing importance of statistics."

"'At one point they were human beings,' he said. 'Then they were reduced to four or five garbage bags.'"devoid of value, unregretted, unlamented, and
—final indignity— *effaced to a mere anonymous statistic*
1988. *Serial Killers*, p. 88. "The killer may collect memorabilia from his victims, or he may have kept detailed records of each of his murders, in diary form." P. 93. The FBI Behavioral Science Unit "is still gathering information from interviews of apprehended serial killers and is computerizing their profiles and MOs."
12/30/91. *People*'s "25 Most Intriguing People for 1991." "Indeed, says FBI consultant A[—] B[——], a University of Pennsylvania professor of psychiatric nursing: 'Dress him in a suit and he looks like 10 other men.'"

FBI Warning: Federal, academic, and psychiatric law provides severe civil and criminal penalties for unauthorized reproduction, distribution, or exhibition

11/11/91. *New York Times*, "Doctor Is Allowed To Scan Dahmer's Brain." "Dr. Palermo said he would use a CAT scan, which uses X-rays of soft tissue to form an image of the brain, in his analysis of Mr. Dahmer's brain."
2/10/92. *Newsweek*. "Experimenting with ether and a drill, he performed amateur lobotomies on some of his victims."
Poor Elizabeth Taylor, threatened with lobotomy because she knows the ostensible secret of market reproduction—a process coded, as is often the case, as hommosexual cloning—in Suddenly Last Summer. *Poor little rich saint Sebastian, never shown as having a head, devoured by Third-World children he lures with money,* "Fed-up with dark ones, famished for light ones: That's how he talked about people, as if they were—items on a menu"; *poor Monty Clift, a fit subject for lobotomy himself.*
8/4/91. "17 Killed," p. 30. "Money was also on his mind. [His probation officer] wrote that Mr. Dahmer 'gets angry at people who make a lot of money, saying, "Why are they so lucky?" And he "hates" them for having so much.'"
3/10/91. *New York Times*, "Every era gets the psychos it deserves, at least in art.... And, unavoidably, there is Bret Easton Ellis' pea-brained novel *American Psycho*, the book that Simon & Schuster canceled on the grounds of bad taste and that Vintage Books has just published as a controversial cause celebre. More an up-to-the-minute media event than a novel, this story of a serial killer obsessed by designer labels should have been called *Killers Who Shop Too Much....*

[From where does the power of media criticism come? One way to become a celebrated critic is to consume objects of bad taste, savor their stupidity, and then expel them, which can be a closed economy of serial cannibalism. Citing news stories critical of a politically correct academy, a colleague says that "the media" misrepresent the academy. But this academic (an erstwhile champion of semantic indeterminacy) also writes in the New York Times. *Following Epimenides' logic: this academic media-star misrepresents; therefore the media does not misrepresent; therefore this mediacademic does not misrepresent; therefore the media misrepresent; therefore this mediacademic misrepresents...*
By professing through the media that one is

misrepresented by the media, one can authorize one's [T]o read *American Psycho* is to feel like

status as victim of a public relations con job. The the victim of a public relations con job....

sacrificial victim's robe is the preferred costume in Mr. Ellis wants readers to believe that

some academic circles, the designating label of success. cramming a dozen designer names in one

It may seem in sensationally bad taste to say, and sentence is the same as making a comment

cause nausea to realize, that there is a sadomasochistic on consumer culture."

power-play at work, deriving from an ability to market one's expertise as the controversially new and marginalized voice of the victim while

simultaneously constructing a more suitable victim in the all-powerful fantasy of a victimizing big-bad media. The acamedia critic, the

hacamedic, must deny any imputation of kinship, of collaboration, in order to rise intellectually above the common pulp of a pea-brained,

mass produced-consumed, mass culture. As if it were possible to escape serial culture, as if it were possible to not be a serial killer-producer-

consumer by turning to one's computer keyboard and hacking up the other. Silence of the Lambs made a sex-symbol out of Anthony Hopkins,

who plays Hannibal **Lecter**, *the X-ray psychologist* **reader** *who attempts to gain his own freedom from the prison-house by giving informa-*

tion about his serial-killer cohort Jame Gumb. Dr. Lecter is a cannibal. Hypocrite Lecter, mon/ton/ son semblable, mtson frère This leads me

to wonder why every era gets the psychos it deserves, or desires.]

The instinctual desire endeavours to find substitutes—substitute objects and substitute acts—in place of the prohibited ones//*character assassination of an assassinating character may be a denied act of substitutive identification, a regurgitation of the inability to stomach oneself, an auto-homo-phobic disavowal of likeness.*

Among others, I am speaking, among others, of the so-called left-wing intellectuals…

of hack critics

4/27/34. "The Author as Producer," p. 229. "I define the hack writer as the man who abstains in principle from alienating the productive apparatus from the ruling class by improving it in ways serving the interests of socialism. And I further maintain that a considerable proportion of so-called left-wing literature possessed no other social function than to wring from the political situation a continuous stream of novel effects for the entertainment of the public."

1938. *La Nausée*, p. 181 "When you suddenly realize it, it turns your heart/soul/ stomach/courage [*cœur*] and everything begins to drift, like the other evening at the 'Railroaders' Rendezvous': that's Nausea."

Hack it up.

V. The Making of Monsters

Hunters and gatherers /no permanent place of residence/ may return/repeatedly to cites/ for resources.

2/10/92. *Newsweek*. "He paid $100 for an 'Exorcist III' video and played it all the time —for victims before he murdered them."

1936. "The Work of Art," p. 223. "To pry an object from its shell, to destroy its aura, is the mark of a perception whose 'sense of the universal equality of things' has increased to such a degree that it extracts it even from a unique object by means of reproduction."

1988. *Serial Killers*, pp. 23–24. "The aura phase can also begin as a prolonged fantasy. In this mode, the killer acts out the thrill of the crime in his own mind. He progresses from one step to another step, exciting himself as the vision reaches its

458 climax.... The aura phase once entered, however, is like a portal between two real-ities. On the one side is the reality that all of us, even the most neurotic, react to and inhabit all our lives. This is a world of normalcy, of social convention in which laws are obeyed and rules observed. However, on the other side of the portal is the killer's reality. It is a world of compulsion, a world dominated by the replaying of the fan-tasy of violence in which there is no social convention or obedience to rules.... Passing through the aura stage, the serial murderer is translated into a different kind of creature. Whatever is human in him recedes for a while, and he enters into a shad-owy existence, a death in life in which laws and threats of death or punishment, morality, mores, taboos, or the importance of life itself hold no meaning."

1887. *Morals*, pp. 40–41. "[T]he same men who are held so sternly in check *inter pares* by custom, respect, usage, gratitude, and even more by mutual suspicion and jealousy...—once they go outside, where the strange, the *stranger* is found, they are not much better than uncaged beasts of prey. There they savor a freedom from all social constraints,... they go back to the innocent conscience of the beast of prey, as triumphant monsters who perhaps emerge from a disgusting procession of mur-der, arson, rape, and torture, exhilarated and undisturbed of soul, as if it were no more than a students' prank.... One cannot fail to see at the bottom of all these noble races the beast of prey."

...it turns your heart/soul/stomach/courage and everything begins to drift....

1959. *The Divided Self*, pp. 47–8. "The complaint he made all along was that he could not become a 'person.' He had 'no self.' 'I am only a response to other peo-ple, I have no identity of my own.' ...He felt he was becoming more and more 'a mythical person.' He felt he had no weight, no substance of his own. 'I am only a cork floating on the ocean.'"

1938. *La Nausée*, p. 113. "On the calm, black-speckled water, a cork was floating."

1871. *The Birth of Tragedy*, pp. 35–36. "[T]he words of Schopenhauer when he speaks of the man wrapped in the veil of *maya* (*Welt als Wille und Vorstellung...*): 'Just as in a stormy sea that, unbounded in all directions, raises and drops moun-tainous waves, howling, a sailor sits in a boat and trusts in his frail bark: so in the midst of a world of torments the individual human being sits quietly, supported by and trusting in the *principium individuationis*.' ...In the same work Schopenhauer has depicted for us the tremendous *terror* which seizes man when he is suddenly dumfounded by the cognitive form of phenomena because the prin-ciple of sufficient reason, in some of its manifestations, seems to suffer an excep-tion. If we add to this terror the blissful ecstasy that wells from the innermost depths of man, indeed of nature, at this collapse of the *principium individuationis*, we steal a glimpse into the nature of the *Dionysian*."

1973. *The Pleasure of the Text*, pp. 18–9. "*Dérive*/Drift." "My pleasure can very well take the form of a drift. *Drifting* occurs when I *do not respect the whole*, and when-ever, by dint of seeming driven about by language's illusions, seductions, and intim-idations, like a cork on the waves, I remain motionless, pivoting on the *intractable* bliss that binds me to the text (to the world). Drifting occurs whenever social lan-

guage, the sociolect, fails me (as we say: *my courage fails me*). Thus another name for drifting would be: *the Intractable*—or perhaps even: Stupidity.

"However, if one were to manage it, the very utterance of drifting today would be a suicidal discourse."

everything begins to drift, *to* float, *to* cruise, *like the other evening at the Ramrod*

1980. *Cruising.* "This film is not intended as an indictment of the homosexual world. It is set in one small segment of that world which is not meant to be representative of the whole."

Cruising occurs when *I do not respect the whole*

Opening shot: New York City as seen from a ship cruising the Hudson River. Severed arm floating *(like a cork)* in the water. Cut to coroner analyzing body parts. "It's obvious it's not suicide, and it's obvious it's not normal." Police Captain Edelson informs Steve Burns (Al Pacino) of his undercover role in tracking down a serial killer of at least two gay men. "Lucas and Vincent were not in the mainstream of gay life. They were into heavy leather, S&M. It's a world unto itself." Burns: "I love it."

1906. *The Secret Agent,* pp. 110–11. "[A]s a matter of fact, the mind and the instincts of a burglar are of the same kind as the mind and the instincts of a police officer.... They understand each other, which is advantageous to both, and establishes a sort of amenity in their relations. Products of the same machine, one classed as useful and the other as noxious, they take the machine for granted in different ways, but with a seriousness essentially the same."

1980. *Cruising.* Following the first murder portrayed in the film, cut to shot of coroner. Victim's anus dilated, presence of semen. No sperm in semen. "Maybe he has some physical aberration."

/the gay male serial killer is the 1980 avatar of the pubescent daughters of 1940s and '50s melodrama.
/The cycle of these individuals' homosexual desires follows the cycle patterned to the menstrual period/ Since the menstrual cycle itself is controlled by hormones, it is natural that, if the area of the brain that controls normal hormonal function in the ductless glands is malfunctioning, the body's normal hormonal control system will malfunction as well./
Subsequent murder in a porn movie house. Images of stray body parts fucking. Cut to shot of coroner dissecting another victim. Behind the coroner: a mural of a medical anatomy.

The prime suspect in the film is Stewart, the graduate student of a Columbia University professor who has just been killed. He is one of those academic *"monsters who emerge from a disgusting procession of murder, arson, rape, and torture, exhilarated and undisturbed of soul, as if it were no more than a students' prank.... One cannot fail to see at the bottom of all these noble races the beast of prey."* Yet Doctor-to-be Stew, a hacamedic homo-phobe, violently denies any imputation of kinship, of collaboration.

Noble cop Burns breaks into Stewart's apartment by pushing in a circular window fan, this architectural entry continuing the series of anal rapes. *The punishment will not infrequently give an opportunity of committing the same outrage.* Once inside, Burns enters

460 the student/killer's closet which is filled with leather and a box of never-mailed letters, letters which never reach their destination, *Drifting occurs whenever social language, the sociolect, fails me,* addressed to his father in St. Louis. A photo of the suspect as a little boy standing before his father; the top half of the photo, and the father's upper torso and head, have been ripped off.

Good student Stew has imaginary conversation with his dead father in Central Park: "I try to do everything you want but it's never good enough." Father-homophobe says to his son-likeness, "You know what you have to do. You know what you have to do." This incantation has been repeated by the killer throughout the film. In the first sex-murder scene, the ostensible bottom switches roles: Killer: "Turn over." Victim: "What are you gonna do?" Killer: "I know what I have to do." Killer backstabs victim. Camera cuts to victim's face (the agony and the ecstasy). Killer: "You made me do that."

"Psycho-analysis has revealed that the totem animal is in reality a substitute for the father." Psycho analysis reveals that the totem animal is a substitute for Norman's mother. Psycho-analysis suggests that child abuse is a child's fantasy that, like "homosexuality," denies the reality of Freud's myth of Oedipus, which ramrods the spoiled child and spares the parents. Cross-reference 1953, 1960 Devereux; 1972 Anti-Oedipus, esp. 274.

Burns, obviously enjoying his immersion in the shadowy underworld of gay S&M, traps the student by dressing just like him, in full leather regalia. Burns stabs Stewart in the abdomen (no backstabbing sissy here), Stewart is arrested. End of case.

Nov. 1992. Superman dies in Marvel Comics series, in attempt to jump-start a sluggish economy. Huge revenues expected; collectors in feeding frenzy. There are plans to resurrect him in future issues.

28 Nov. 1994. Inmate 177252 Jeffrey Dahmer is murdered by a fellow inmate in Wisconsin's Columbia Correctional Institution, while cleaning a prison bathroom.

Case closed, Beginning of case. Gay murderer Burns (it is ambiguous whether he is gay, whether he murders gays, or both) in an apartment bathroom. He has apparently just slaughtered his friendly gay neighbor. *I was afraid of being queer and almost murdered him after the first night so that no one would find out.* Cut to Burns's girlfriend Nancy (Karen Allen, a virtual copy of Margot Kidder/Lois Lane), walking into the apartment. Nancy/Lois, now in the living room, puts on Burns's leather costume and looks at herself in the mirror; she seems to enjoy how she looks. Burns, attempting to shave off his experience as an imitation of gay life, also looks at himself in a mirror. Technically a copy of so many in, say, *All About Eve,* this shot is framed so that the camera, and thus a viewer of the film, must seize with Burns (now a "nancy") his/her reflection in the mirror. Final image: the series continues with a shot of New York City as seen from a ship cruising the Hudson River. The film loops back upon itself: identification has been achieved. But, then again, this is only a pleasurable movie.

1973. *Pleasure,* pp. 20–21. "Is pleasure only a weakened, conformist bliss—a bliss deflected through a pattern of conciliations? Is bliss merely a brutal, immediate (without mediation) pleasure? ...But if I believe on the contrary that pleasure and

bliss are parallel forces, that they cannot meet, and that between them there is more than a struggle: an *incommunication*, then I must certainly believe that history, our history, is not peaceable and perhaps not intelligent, that the text of bliss always rises out of it like a scandal (an irregularity), that it is always the trace of a cut, [...] and that the subject of this history (this historical subject that I am among others), far from being possibly pacified by combining my taste for works of the past with my advocacy of modern works in a fine dialectical movement of synthesis—this subject is never anything but a 'living contradiction': a split subject, who simultaneously enjoys, through the text, the consistency of his selfhood and its collapse, its fall."

Shot is framed so that the camera, and thus viewers of the film, seize with Burns/ Nancy/Lana/Sara Jane/Mildred/Veda/Bette/Eve/Sartre/Barthes our reflection in the mirror. *I was the forlorn seeker after a relationship which was always beyond my reach. I felt somehow inadequate as a human being.* This subject is never anything but a 'living *contra*-diction': this is only a movie.

Cruising has not been justly recognized or reflected by
the gay critical mainstream.

1987. *The Celluloid Closet*, p. 259. "A turning point of sorts was reached in 1980 when there was a tremendous amount of controversy surrounding William Friedkin's *Cruising*, which many gay people correctly perceived to be deeply homophobic at the conceptual level. By the end of the film, ...we are led to believe that Pacino himself has become homosexual through his intimate contact with the gay world. In addition, the unavoidable conclusion is that Pacino also becomes a murderer of gays, having killed the gentle homosexual (Don Scardino) who lives in his building. The audience is left with the message that homosexuality is not only contagious but inescapably brutal." p. 91. "Violence comes with the territory—that point is stressed so often and exaggerated so far out of proportion to any other aspect of gay life that its inclusion in the script of the film version of Gerald Walker's *Cruising* brought a storm of *[violent?]* protest and rioting by gays in New York at the end of 1979." p. 238. "Gays who protested the making of the film maintained that it would show that when Pacino recognized his attraction to the homosexual world, he would become psychotic and begin to kill.... Protest leaflets against *Cruising* said, 'People will die because of this film.' In November 1980, outside the Ramrod Bar, the site of the filming of *Cruising*, a minister's son emerged from a car with an Israeli *[why is this important?]* submachine gun and killed two gay men." p. 261. Vincent Canby's review of the film: "*Cruising* is a homosexual horror film." Vito Russo's continuation: "The monster in Friedkin's horror film is homosexuality itself."

Russo's audience is left with the message that homosexuality is not only contagious but inescapably brutal. The monster in Russo's horror film is not **homophobia**, the violent disavowal of likeness, of kinship, of collaboration, of identification, of *I was afraid of being queer and almost murdered him after the first night so that no one would find out*; Russo's monster is brutal homosexuality itself. That point is

stressed so often that I am forced to wonder why I did not reach the same unavoidable conclusion as did Russo and the activists in 1979–80. *which leads me to wonder why every era gets the psychos it deserves, or desires.*

If there is a strength in *Cruising*, it is the strength of recognizing how critical cut-outs can serve as a disavowal of resemblance. Russo's *Cruising* occurs when *I do not respect the whole.*

1988. *Hiding in the Light,* p. 162. "The 'reader' is licensed to use whatever has been appropriated in whatever way and in whatever combination proves most useful and most satisfying…. By cruising, the 'reader' can take pleasure in a text without being obliged at the same time to take marriage vows and a mortgage on a house."

Cruising appreciates the fetishized pieces of the gay body in the market; cruising involves a challenge in the consensual gaze of predators, hunters and gatherers. The gay cruise often acknowledges that we desire what we see, but also that we see what we desire to see. To return a cruise is to advertise, in silence, bliss. It can be a teasing power-game—if there is one problem I have with *Cruising,* it is that it (like *Mildred Pierce*) begins and ends in the same place, I leave the screen in the same state (dead-endedly alone, in solitary) as I was when I entered: a pleasurably temporary diversion. *I was the forlorn seeker after a relationship which was always beyond my reach.* But Cruising can be a power-game which is the portal, the aura stage, the prelude to bliss; an invitation to Bataillean self-abandonment, a practice of joy before death, which is to say,

> *A cork was floating; pleasure can very well take the form of a drift, whenever, driven about by illusions, seductions, and intimidations, like a cork on the waves, I remain motionless, pivoting on the intractable bliss that binds me to the text (to the world)*

suicide as well as sacrificial homicide. *Cruising* as advertisement for a real negation of alienated being: not to be, "just a movie."

Schopenhauer has depicted the tremendous TERROR *which seizes a man when he is suddenly dumfounded,* THE BLISSFUL ECSTASY *that wells from the innermost depths of man, indeed of nature, at* THIS COLLAPSE OF THE PRINCIPIUM INDIVIDUATIONIS

Terrifying, terrorizing, deterritorializing? Well, how do ~~you~~ define ecstasy?

1985. *Killing for Company,* pp. 196–97, emphasis added. "In a moderate conventional world this is considered bizarre and alien…. I was a child of deep romanticism in a harsh plastic functioning materialism…. I am an odd personality for today. There never was *a place for me in the scheme* of things."

Or, if this is all too much, how do you spell relief?

1987. *Celluloid Closet,* p. 189. "Many gay activists wanted the film industry to 'skip a step' and omit the painful but necessary exploration of a once hidden subculture, especially if that exploration were to be conducted by a misinformed majority. But films with good or ill will toward gays, independent and commercial, explored the same ratty turf relentlessly throughout the Seventies, seeing only the readily visible poles of the gay community—the sissy at one end, the leather-jacketed macho

violence of the waterfront sex bar at the other. Gays who wanted films about people in the middle forgot that movies will not reflect what American cannot see. Lesbian couples living in a suburb of Denver and gay men who are corporate executives and share a townhouse in Boston are hardly visible in the fabric of the culture.

[*"Dress him in a suit and he looks like 10 other men."*]

"From the early 1970s, when the gay movement first began to formulate an ideology, middle class gays in America have sought to have it both ways. They do not want to see the sexual ghetto life of most large American cities portrayed as the only side of the gay world, but at the same time they are unwilling to affiliate themselves as homosexuals *[or with certain other types of homosexuals]* in order to demonstrate the reality to the rest of America." [*"Most serial killers…believe that they are doing good for society by killing certain types."*]

Russo's "Afterword" to the revised edition, p. 325. "It has become clear since the first edition of this book was published that what we need is no more films about homosexuality. Mainstream commercial films and made-for-television movies that have as their subject the allegedly controversial issue of my existence may be necessary evils but they're not for me. They're for mothers in New Jersey, aunts in Kansas City and frightened fifteen-year-old gay kids in Mississippi." /deny any imputation of kinship/ Drifting occurs whenever the sociolect fails me (as we say: *my courage fails me*). Thus another name for drifting would be: Stupidity. *The average American journalist tends to assume that the average American non-journalist is the redneck occupant of a Midwestern trailer park who believes gays are sick people who would have each other for dinner more often if they weren't so busy committing crimes against nature in the hope of catching AIDS.* BUT: "The aura phase can begin as a prolonged fantasy. In this mode, the killer acts out the thrill of the crime in his own mind…. Passing *through* the aura stage, the serial murderer is translated into a different kind of creature. Whatever is human in him recedes for a while, and he enters into a shadowy existence, a death in life…. He will not re-emerge into the world of the living until after the hallucination has broken *or the ritual has been acted out.*"

My question is whether we can imagine a work, a production, an opening (*œuvre, ouvrage, ouverture*) that could seduce one *through* aural pleasure and open one up *towards* bliss; whether there can be a mode of reproduction that will force the collector—more effectively than *Cruising* or its copy-cat-killer *Basic Instinct* was able to (my rented copy of *Basic Instinct* included a commercial trailer, advertising a *Basic Instinct* coffee mug)—*force* the collector to enter the aura phase, to be translated, to make it impossible for him or her to disavow kinship with monstrosity. How the silver screen might reflect and return X-rays back to irradiate their source. A mode of reproduction in which the hallucination will not fade out (this is not a one-night stand, a pleasurable movie from which the spectator can achieve catharsis and then leave the theater fundamentally unchanged), but one in which the imaginary pleasure of a historical "'living contradiction': a split subject, who simultaneously enjoys, through the text, the consistency of his selfhood and its collapse, its fall,"

464 can be shattered into bliss through the very force of that fall, into the gap of inescapable contradiction—the *recognition* of which will be an avowal of consensual sympath(olog)y. The text of bliss always rises like a scandal (an irregularity), it is always the trace of a cut: how might we *recognize* this scandalous potential, rather than pretend that it, like the violence and power within sex, does not, can not, or should not be suffered to exist ?

 3/24/94. "I Had No Other Thrill," p. 56. "Our fascination and revulsion for the 'monstrous' among us has to do with our uneasy sense that such persons are forms of ourselves."

VI. The Making of Monsters II: Let us break heads together

1990. *The Making of 'Monsters'*. "Between March, 1983 and December, 1985, four Toronto school teachers were murdered by anti-gay assailants.... In 1991, the CBC, Canada's national TV network, will be making a made-for-TV movie about one of the murders."

 John Greyson's proleptic film (#1) follows "Lotte Lenya's" documentary (#2) of the making of this TV re-enactment (#3) of a Toronto teacher's killing by five normal boys (dressed in hockey masks, like Jason of *Friday the 13th, parts 1 - ∞*). The two leftist "colleagues" making the TV film, director Bertolt Brecht and producer Georg Lukács, cannot agree on the politically correct aesthetic for the film. Lukács: "The purpose of this film, the political purpose, Bertolt, is precisely to confront that middle-class audience with their homophobia. My strategy of cross-cutting will force them to identify with the boys.... By making the boys into sympathetic realist characters, the audience will recognize themselves in the boys, and therefore recognize their complicity in Maguire's murder." Brecht: "Social realist ratshit. Instead of indicting and mobilizing viewers, straight and gay, the script classifies them. They watch this spectacle of murder with fascination, they wring their hands, they suddenly shed a few tears: through such catharsis they are resolved of any responsibility." After a particularly nasty fight between producer and director, Lukács takes over the direction of the murder scene, his eyes glazing sympathetically as he urges his "actors" to kick the gay actor-victim harder, to hate harder. In his excitement, Lukács kills Brecht, who, the "documentary" tells us, had recently taken Kurt Weill as a lover.

 We never see the final cut of the Lukács/Brecht collaboration. Greyson's film ends when the gay white actor who had played the victim Joe, and the creator of the pseudo-documentary of the TV movie (the black lesbian Lotte Lenya), drop their roles and become actors Lee MacDougall and Taborah Johnson. Real-life documentary footage of Queer Nation protests is intercut with Lee and Taborah singing collectively "Bash back baby, victims no more."

 Ante/Post Script to the proleptic *'Monsters'*: "October, 1990. During our production, one of our actors was gay-bashed by a gang of teenagers in a public park." And, to substantiate Lotte's critique within *Monsters* that Queer Nation meetings often seemed like "gay white men doing their macho bonding number" (she says this as she points her camera at the viewer): Queer Nation since 1990 has under-

gone severe internecine turf wars. Possessive individuals, Queer or not, know much more about collecting than collectivity.

VII. Real Life and Fortune: Each confirms a prison

During his trial, JD read newspapers and magazines. He subsequently received 15 consecutive life *sentences. In the most influential American magazines,* Life *and* Fortune, *a quick glance can now scarcely distinguish advertising from editorial picture and text.*

During his trial, he read magazines about computer programming.

5/18/92. *Time,* "Guilty! Call My Agent!" "The Milwaukee judge who sentenced serial killer Jeffrey Dahmer to 15 consecutive life terms appears to be rushing from the bench to the word processor. Laurence Gram's *The Jeffrey Dahmer Case: A Judge's Perspective* is in the works. And so is a film script titled *The Jeffrey Dahmer Confessions,* to be based on the judge's book but not written by him. 'The judge doesn't want a horror picture per se,' says agent Lew Breyer. 'But I have written in one or two horror scenes that are horrific in describing one of the murders.' While Gram says he will not pocket any profits from the book, New York University law professor Stephen Gillers points out that since judges are not bound by clear ethical guidelines, Gram 'could keep every cent.' Gillers, who teaches legal and judicial ethics, is 'skeptical' of a sitting judge who might 'view his or her docket as material for future popular exploitation.'"

5/4/92. *Time,* "Dealing from a Crooked Deck." "Jeffrey Dahmer. Ted Bundy. David ('Son of Sam') Berkowitz. Collect 'em, trade 'em, memorize their stats. It's hard for a mere baseball card to compete with the latest offering in candy stores and comic-book shops: 'killer cards' that feature notorious mass murderers, complete with gory drawings and graphic descriptions of their crimes…. Dean Mullaney, a Forestville, Calif., publisher of a line of cards featuring FBI agents and crooks, insists that such products do not exalt criminals. '*Silence of the Lambs* won the Academy Award,' he says, 'but it's not a glorification of cannibalism.'"

1989. *Todesking.* "Cheated by life, ~~this creature~~ is trying to give a final signal…. The frustration about ~~its~~ own existence and ~~its~~ neglect by a callously progressive society manifests itself in this universal act of vengeance."

12/19/94. *Jet,* "Why Jeffrey Dahmer Killed So Many Black Men," p. 16. "Dahmer…recently was attacked in prison and killed allegedly at the hands of a Black inmate, Christopher J. Scarver…[who was] reported to hate Whites and expressed such feelings at psychological interviews, blaming them for the loss of his job, his incarceration and an alleged government conspiracy to eliminate Black men."

What forms do a victim's pleasure take; from where do these forms come? To reconstruct a *serial killer,*

<div align="center">

reporters inter - viewed

victims,

psychologists and

legal

experts.

</div>

Jet magazine: 9/2/91, "Family Sues Dahmer For $3 Billion In Murder Case": "'I believe big bucks are going to be spent for the story rights to Jeff Dahmer's horrendous killing spree,' said attorney Tom Jakobson.... 'People feed on this stuff.'" 12/16/91, "Mother of Dahmer Victim Sues Police." 8/17/92, "Mother of Dahmer Victim Can Make $10 Mil. Claim on Serial Killer's Royalties." 8/31/92, "Kin of Dahmer Victims Sue Over Comic Book": "The comic book, 'Jeffrey Dahmer: An Unauthorized Biography of a Serial Killer,' was published by Hart Fisher and his Boneyard Press in Champaign, Ill. The comic book depicts in graphic detail how Dahmer murdered and dismembered his victims. Thomas Jacobson, an attorney for the victims' families said, 'It is a real exploitation of the grief of the families.'"

Schedule of Losses and Benefits

Loss	Percentage of Amount Insured
Life	100%
Two hands	100%
Two feet	100%
One hand and one foot	100%
One foot and sight of one eye	100%
One hand or one foot	50%

(*Loss of a hand or a foot shall mean severance at or above the wrist or ankle joint.)

12/12/94. *People*, p. 132. "...eight other families are hoping to hold an auction of some of Dahmer's possessions, including the refrigerator where he stored some body parts, a drill and pornographic videotapes. A lawyer representing the families—who has already won in excess of $80 million for them in civil lawsuits against Dahmer (money they will never see, as Dahmer had little money)—says he expects the auction to net more than $100,000. 'It's an investment that will increase in value,' insists the lawyer, Thomas Jacobson. 'And you can feel good about it, knowing the money is going to the right people.'...

"Theresa Smith, whose brother died at Dahmer's hands, says she wants no part of the grisly sideshow that has grown up around the killer. 'I don't want someone saying, "This is the ax that cut off Eddie's head,"' she says of the auction. 'It's blood money no matter how you look at it.'"

Fall 1990. "Cannibal Tours" p. 102. "I detect in all these reports on exchanges between tourists and others a certain mutual complicity, a co-production of a pseudo-conflict to obscure something deeper and more serious: namely, that the encounter between tourist and 'other' is the scene of **a shared utopian vision of profit without exploitation,** logically the **final goal of a kind of cannibal economics shared by ex-primitives and postmoderns alike.**"

Neither	Nor simply
"'I had the habit of following exciting court cases,' he said, 'and Ménesclou poisoned my mind. I am less guilty than he,	3/8/94. *Dateline NBC.* JD: "I think it's wrong for people who commit crimes to try to shift the blame onto somebody else, onto their

having neither raped nor dismembered my parents or onto their upbringing or living
victim. My photograph must certainly be circumstances. I think that's just a cop-out. I
superior to his."' take full responsibility."

4/29/36. "The Sacred Conspiracy," p. 181. "He is not a man. He is not a god either. He is not me but he is more than me: his stomach is the labyrinth in which he has lost himself, loses me with him, and in which I discover myself as him, in other words as a monster."

* * *

1991. *Close to the Knives,* p. 66. "So I'm watching this thing move around in my environment, among friends and strangers: something invisible and abstract and scary; some connect-the-dots version of hell only it's not as simple as hell. It's got no shape yet or else maybe I'm just blind to it or we're just blind to it or else it is just invisible until all the dots are connected. Draw a line from here to there to there to here with all the dots being people you see from miles up in the air or from the ledge of a tall building…but it's still not that easy, not that abstract because you can't shut out the smell of rotting."

During his trial, /*fill in name of so-called left-wing intellectual*/ read newspapers and magazines, rented videos, ate chocolate, and considered how best to take a stab at stardom in preparation for entering the job market, while James was living fighting dying in West Roxbury. These fragments I have shored against his ruins.

(Afterwords)

1983. "The Object of Post-Criticism," p. 86: "[T]he debates among Lukács, Brecht, Benjamin, Adorno, et al with respect to the value of montage experiments in literature will no doubt be reiterated now with respect to criticism. Will the collage/montage revolution in representation be admitted into the academic essay, into the discourse of knowledge, replacing the 'realist' criticism based on the notions of 'truth' as correspondence to or correct reproduction of a referent object of study?"

Spring 1995. *Radical History Review*, p. 52. "If these queer students were writing history books on their own, …they would prefer that insofar as persons were to be represented in history books, that the persons should be figured on the model of characters in late twentieth-century fiction rather than on the model of characters in mid-Victorian fiction."

I feel somehow inadequate. I can only begin to articulate a hope that the fragmentation characteristic of modernity, as of post-modernity, might provoke neither a defeatist acceptance of seemingly irresolvable, radical difference in which "each confirms a prison," nor an uncritically universalist disavowal of these differences, but instead a drive to relate those heterogeneous partialities produced by current conditions into provisional and tactically productive assemblages—(tactically productive for whom?)—along with a sense of responsibility for the partiality of these provisional effects. Of course I run many risks in acting upon this

468　drive. An attempt to imagine the economies that link critical practice with serial dismemberment could produce a false allegory that elides material differences as easily and quickly as a "drum full of hydrochloric acid" (1994. "The Postmodern Ethnic Brunch," p. 7). Yet taking such a risk, at this particular critical-cultural-political moment, seems not only worthwhile but necessary.

It is increasingly easy to recognize in our (academic) market fetishization of hypostatized "difference" a drive coextensive with the worldwide demise of demotic nationality and the revival of tribal nationalism—a movement that precludes any committed aspiration towards the de- and re-identificatory coalition-building of relationalities quite different from, and indeed opposed to, those characteristic of transnational corporate capitalism. Some might hold that the *unheimlich* self-estrangement induced by imagining "*new* forms of agency and identification that confuse historical temporalities, confound sententious, continuist meanings, traumatize tradition, and may even render communities contingent," is far too dangerous, self-shattering, too similar to self-hatred, to be effective in launching political intervention. I propose instead that it is too safe (and thus, too dangerous), too self-aggrandizing, to maintain a fantasy that the disturbing other works in an alien economy, distantly non-contingent with my (supposedly radical) difference. The recognition of difference within apparent sameness must be balanced by a recognition of similarity within apparent difference. This may be difficult, unpleasant, frightening, and yes, even dangerous. But not impossible.

1991. *Postmodernism*, p. 31. "The postmodernist viewer…is called upon to do the impossible, namely,… to rise somehow to a level at which the vivid perception of radical difference is in and of itself a new mode of grasping what used to be called relationship: something for which the word *collage* is still only a very feeble name."

What the archivist viewer must not be permitted escape from, in dealing with the futility of satisfying the classical compulsion for completeness, is the responsibility of acknowledging complicity with the very economy of the social text under critique. If a major failure of the Modern was its faith in the transformative nucleus of an elite creative mind (the sustaining definition of Superman, Wonderwoman, and other duplicitous clerks depends upon their critical distance from a seemingly ineffectual labor force, their transcendence of the filthy marketplace of *The Daily Planet*), what then would a truly post-Modern intellectual resemble? Certainly not an *übermensch*, nor an *unmensch*, nor even just a liberal-pluralist *mensch* ….

1989. *Repression and Recovery*, pp. 245–46, with my alterations. "I think it should now be apparent that what is at stake in the varied poetic discourses of modern American *criticism* is not only the aesthetics of an individual cultural domain but also the network of relations that define the nature and boundaries of that domain and grant it influence or irrelevance elsewhere in social life…. We need to recognize and interrogate our positions and investments in the struggle over whether criticism will offer readers subject positions that are reflective and self-critical, over

whether criticism can be a force for social change, over what discourses criticism can plausibly integrate or juxtapose, over what groups of readers will be considered valid audiences for criticism, over what role criticism and the interpretation of criticism can play in stabilizing or destabilizing the dominant values and existing power relations in the culture as a whole.... These are not merely questions, therefore, about the appropriate subject matter of criticism or about its aesthetics."

Far more important than debating the proper material for serious study (the work of art vs. the text) or the proper technique of committed analysis (cultural studies vs. postmodernism) is that we pause in our nomadic wanderings and attempt to consider the effects of our production-consumption, within a relational terrain too frequently disavowed, for auto-immunizing purposes, as not-home, not-me. Neither (1995, *Life in Fragments*, pp. 179–80) the "primitive" strategy of incorporating otherness (*anthropophagia*), nor the more Modern, "civilized" strategy of expulsive *anthropoemesis*, can sustain the health and integrity of the postmodern subject. We've been only horny enough to see through things, or even worse, *not* to see through things. We've not been horny enough to see things through. Other relations must be possible. Having formed this determination, and having spent some months collecting and arranging my materials, I once again find myself, losing myself, unpacking my library, the forlorn seeker after a relationship that is always beyond my reach.

References

Thank you, members of the Academy. I'd especially like to thank some of my kin who helped me gather these thoughts, and have supported me despite not sharing the same orientation on every issue: Mark Brodl; David Eng; Robert Fripp, whose *Exposure* I played repeatedly during the compositional process; Kathy Inman; Bob and Don Kinney; Bob McRuer; D. A. Miller; Sean Mills; Chris Pomiecko at the MIT Film Center; and my father, a single parent who always insisted that the family eat dinner together. This essay is dedicated to the *cœur* of James Assatly, whose disciplining of anger into strength, without lapsing into bitterness, has encouraged me to try to work past my own weakness.

1871. Friedrich Nietzsche *The Birth of Tragedy*. Trans. W. Kaufmann. New York: Vintage (1967).

1887. Friedrich Nietzsche *On the Genealogy of Morals*. Trans. W. Kaufmann and R. J. Hollingdale. New York: Vintage (1967).

1906. Joseph Conrad *The Secret Agent*. Middlesex: Penguin (1984).

1913. Sigmund Freud *Totem and Taboo*. Trans. J. Strachey. New York: W. W. Norton (1950).

1929. Joan Riviere "Womanliness as a Masquerade." In V. Burgin, J. Donald, and C. Kaplan, eds. *Formations of Fantasy*. London: Methuen (1986), 35–44.

4/27/34. Walter Benjamin "The Author as Producer." *Reflections*. Ed. P. Demetz. Trans. E. Jephcott. New York: Schocken (1978).

1936. Walter Benjamin "The Work of Art in the Age of Mechanical Reproduction." *Illuminations*. Ed. H. Arendt. Trans. H. Zohn. New York: Schocken (1969).

1936. *Modern Times*. Written, directed and scored by Charles Chaplin. With Paulette Goddard.

4/29/36. Georges Bataille "The Sacred Conspiracy." *Visions of Excess: Selected Writings, 1927-1939. (Theory and History of Literature, Volume 14)*. Ed. and trans. A. Stoekl, with C.

470 R. Lovitt and D. M. Leslie, Jr. Minneapolis: University of Minnesota Press (1985).

1938. Jean-Paul Sartre *La Nausée*. Paris: Gallimard (1970). My translations appear in the text.

1940. Richard Wright *Native Son*. New York: Signet (1950).

1944. Max Horkheimer and Theodor W. Adorno *Dialectic of Enlightenment*. Trans. John Cumming. New York: Continuum (1987).

1947. *Monsieur Verdoux*. Written, directed and produced by Charles Chaplin, from an idea by Orson Welles. With Martha Raye.

1950. *All About Eve*. Written and directed by Joseph L. Mankiewicz. Prod. Darryl F. Zanuck. With Bette Davis, Anne Baxter, and George Sanders.

1951. Jack Lait and Lee Mortimer *Washington Confidential*. New York: Dell.

1953. Jean Genet *Querelle*. Trans. Anselm Hollo. New York: Grove (1974).

1953. George Devereux "Why Oedipus Killed Laius." *International Journal of Psycho-Analysis*, 34: 132–41.

1957. Martin Freud *Glory Reflected: Sigmund Freud, Man and Father*. London: Angus and Robertson.

1959. R. D. Laing *The Divided Self*. New York: Penguin (1979).

1959. *Imitation of Life*. Dir. Douglas Sirk. With Lana Turner, Sandra Dee, Juanita Moore, and Susan Kohner.

1960. George Devereux "Retaliatory Homosexual Triumph Over the Father." *International Journal of Psycho-Analysis*, 41: 157–61.

1968. Roland Barthes "The Death of the Author." *Image-Music-Text*. Trans. S. Heath. New York: Farrar, Straus & Giroux.

1972. Gilles Deleuze and Félix Guattari *Anti-Oedipus*. Trans. R. Hurley, M. Seem, and H. R. Lane. New York: Viking, 1977.

1973. Roland Barthes *The Pleasure of the Text*. Trans. R. Miller. New York: Hill and Wang (1975).

1980. *Cruising*. Written and directed by William Friedkin. Prod. Jerry Weintraub. Based on the novel by Gerald Walker. With Al Pacino and Karen Allen.

1982. Taylor Pero and Jeff Rovin *Always, Lana*. New York: Bantam.

1983. Gregory L. Ulmer "The Object of Post-Criticism." In H. Foster, Ed. *Anti-Aesthetic: Essays on Postmodern Culture*. Port Townshend, WA: Bay Press, 83–110.

1983. Alan Sekula "Reading an Archive." In B. Wallis, Ed. *Blasted Allegories: An Anthology of Writings by Contemporary Artists*. Cambridge, MA: MIT Press (1987), 114–27.

1985. Brian Masters *Killing for Company: The Case of Dennis Nilsen*. London: Jonathan Cape.

1987. Vito Russo *The Celluloid Closet: Homosexuality in the Movies*. Revised edn. New York: Harper & Row.

1987. Julia Kristeva *Tales of Love*. Trans. L. S. Roudiez. New York: Columbia University Press.

Winter 1987. Simon Watney "The Spectacle of AIDS." *October*, 43: 71–86.

1988. Cheryl Crane, with Cliff Jahr *Detour: A Hollywood Story*. New York: Arbor House.

1988. Dick Hebdige *Hiding in the Light: On Images and Things*. London: Routledge.

1988. Thomas Harris *The Silence of the Lambs*. New York: St. Martin's Press.

1988. Joel Norris *Serial Killers: The Growing Menace*. New York: Doubleday.

1989. Cary Nelson *Repression and Recovery: Modern American Poetry and the Politics of Cultural Memory, 1910–1945*. Madison: University of Wisconsin Press.

1989. *Der Todesking*. Dir. Jorg Buttgereit. Written by Franz Rodenkirchen and J. Buttgereit.

1989. David Wojnarowicz *Tongues of Flame*. Ed. Barry Blinderman. Normal, IL: University Galleries of Illinois State University / New York: Distributed Art Publishers (1992).

1990. Judith Butler *Gender Trouble: Feminism and the Subversion of Identity*. New York: Routledge.

1990. *The Making of 'Monsters'*. Written and directed by John Greyson. Prod. Laurie Lynd.

With Taborah Johnson and Lee MacDougall.

Fall 1990. Dean MacCannell "Cannibal Tours." In L. Taylor, Ed. *Visualizing Theory: Selected Essays from V. A. R, 1994*. New York: Routledge.

Fall 1990. Jane Caputi "The New Founding Fathers: The Lore and Lure of the Serial Killer in Contemporary Culture." *Journal of American Culture*, 13(3): 1–12.

1991. David Wojnarowicz *Close to the Knives: A Memoir of Disintegration*. New York: Vintage.

1991. Fredric Jameson *Postmodernism, or the Cultural Logic of Late Capitalism*. Durham: Duke University Press.

3/10/91. Caryn James "Now Starring, Killers for the Chiller 90's." *New York Times*, sect. 2: 1, 20–21H.

4/1/91. Mark Goodman "Cops, Killers and Cannibals" *People*: 62–70.

8/3/91. Larry Richter "Art Tries to Distance Itself From Life." *New York Times* Local edition: 8.

8/4/91. James Barron and Mary B.W. Tabor "17 Killed, and a Life Is Searched for Clues." *New York Times*: 1, 30.

8/5/91. David Gelman, with Patrick Rogers, Karen Springen, Farai Chideya, and Mark Miller "The Secrets of Apt. 213," and "Killing Patterns" *Newsweek*: 40–42.

8/10/91. Jacob Weisberg "Choice cuts." *New Republic*: 43.

8/12/91. Paula Chin and Civia Tamarkin "The Door of Evil." *People*: 32–37.

8/12/91. John Tayman "The *Lambs* connection: fiction pales." *People*: 36.

9/2/91. "Family Sues Dahmer For $3 Billion In Murder Case." *Jet*: 36.

11/11/91. "Doctor Is Allowed To Scan Dahmer's Brain." *New York Times*: A11.

12/16/91. "Mother of Dahmer Victim Sues Police." *Jet*: 28.

12/30/91. "25 Most Intriguing People for 1991." *People*: No page.

1992. Homi K. Bhabha "Postcolonial Authority and Postmodern Guilt." In L. Grossberg, C. Nelson, and P. Treichler, Eds. *Cultural Studies*. New York: Routledge.

Fall 1992. Bill Nichols "The Ethnographer's Tale." In L. Taylor, Ed. *Visualizing Theory: Selected Essays from V. A. R, 1990–94*. New York: Routledge.

2/3/92. Tom Mathews, with Karen Springen, Patrick Rogers, and Gregory Cerio. "Secrets of a Serial Killer." *Newsweek*: 44–48.

2/10/92. Tom Mathews, with K. Springen "'He Wanted to Listen to My Heart.'" *Newsweek*: 31.

5/4/92. "Dealing from a Crooked Deck." *Time*: 20–21.

5/18/92. Sidney Urquhart "Guilty! Call My Agent!" *Time*: 17.

8/17/92. "Mother of Dahmer Victim Can Make $10 Mil. Claim On Serial Killer's Royalties." *Jet*: 36.

8/31/92. "Kin of Dahmer Victims Sue Over Comic Book." *Jet*: 17.

11/3/92. Lance Loud "No hatchet job." *Advocate*: 93.

1994. Lawrence Chua "The Postmodern Ethnic Brunch: Devouring Difference." *muæ: a journal of transcultural production*, 1(1): 4–11.

1994. Lucien Taylor, Ed. *Visualizing Theory: Selected Essays from V.A.R., 1990-94*. New York: Routledge.

3/8/94. *Dateline NBC*. "Dahmer." An interview conducted by Stone Phillips. Dir. Guy Pepper. Prod. Neal Shapiro, Colleen Halpin, and Eric Doreschneider.

3/21/94. "Serial Chic." *Time*: 23.

3/24/94. Joyce Carol Oates "I Had No Other Thrill or Happiness." *New York Review of Books*: 52–59.

12/12/94. Joyce Carol Oates "A Riddle Wrapped in a Mystery Inside an Enigma." *New Yorker*: 45–46.

12/12/94. Elizabeth Gleick, Bryan Alexander, Leah Eskin, Grant Pick, Sarah Skolnik, Johnny Dodd, and Jane Sugden "The Final Victim." *People*: 126–29, 131–32.

472 12/19/94. "Why Jeffrey Dahmer Killed So Many Black Men." *Jet*: 14–16.

1995. Dennis Cooper *The Dream Police*. New York: Grove.

1995. Zygmunt Bauman *Life in Fragments: Essays in Postmodern Morality*. Oxford: Blackwell.

Spring 1995. Henry Abelove "The Queering of Lesbian/Gay History." *Radical History Review* 63: 44–57.

4/95. Vernell Bass "A Beer and Some Chips with Jeffrey Dahmer." *Esquire*: 125–26.

9/18/95. "Dahmer's brain saved; his body is cremated." *News-Gazette* (Champaign-Urbana): A9.

CONTRIBUTORS

ACKBAR ABBAS teaches in the Department of Comparative Literature at the University of Hong Kong. His key essays include: "The Last Emporium: Verse and Cultural Space," *Positions* 1 (1993):1–23; "Building on Disappearance: Hong Kong Architecture and the City," *Public Culture* 6 (1994): 441–59. His recent work includes a book on Hong Kong Culture and a monograph on the modern Chinese painter Chen Danqing.

ARJUN APPADURAI is Barbara E. and Richard J. Franke Professor in the Humanities at the University of Chicago. He is also the director of the Chicago Humanities Institute. His books include: *Worship and Conflict Under Colonial Rule: A South Indian Case* (1981), *The Social Life of Things: Commodities in Cultural Perspective* (1986, edited volume), and *Modernity at Large: Cultural Dimensions of Globalization* (1996). He is one of the founding editors of *Public Culture*.

LAUREN BERLANT teaches in the Department of English at the University of Chicago. She is the author of *The Anatomy of National Fantasy: Hawthorne, Utopia, and Everyday Life* (1991). Her key essays include: "The Female Complaint," *Social Text* fall 1988; "The Theory of Infantile Citizenship," *Public Culture* 5 (1993): 395–410.

MICHAEL DENNING teaches in the American Studies Program at Yale University. He has studied the politics of popular culture in both the 19th and 20th centuries. His books include: *Cover Stories: Narrative and Ideology in the British Spy Thriller* (1987), *Mechanical Accents: Dime Novels and Working Class Culture in America* (1987), and the forthcoming *The Culture Front*.

VIRGINIA R. DOMINGUEZ is Professor of Anthropology and Director of the Center for International and Comparative Studies at the University of Iowa. She was born in Cuba, but spent much of her early life in and out of the U.S. She is the author of *White By Definition: Social Classification in Creole Louisiana* (1986), *People as Subject, People as Object: Selfhood and Peoplehood in Contemporary Israel* (1989), and *From Neighbor to Stranger: The Dilemma of Caribbean People in the United States* (1975), and the coauthor, with her brother Jorge I. Dominguez, of *The Caribbean and Its Implications for the U.S.* (1981). Among her most recent edited collections are a Special Issue of *Identities* (1995) entitled "(Multi)Culturalisms and the Baggage of 'Race,'" and a volume, coedited with Catherine Lewis, entitled *Questioning Otherness* (1995).

DILIP PARAMESHWAR GAONKAR teaches in the Department of Communications Studies at Northwestern University. He is also codirector of the Center for Transcultural Studies. His essay "The Idea of Rhetoric and the Rhetoric of Science"

is the subject of a book-length collection of commentaries, *Rhetorical Hermeneutics* (1996), edited by William Keith and Alan Gross.

HERMAN GRAY teaches courses on mass media, popular culture, and cultural studies in the Sociology Board of Studies at the University of California at Santa Cruz. He is the author of *Producing Jazz: the Experience of an Independent Record Company* (1988) and *Watching Race: Television and the Struggle for Blackness* (1995), and writes regularly on the issue of race in America.

LAWRENCE GROSSBERG is Morris Davis Professor of Communication Studies at the University of North Carolina. His books include *We gotta get out of this place: Popular conservatism and postmodern culture* (1992), the coedited collections *Marxism and the Interpretation of Culture* (1988) and *Cultural Studies* (1992), and two forthcoming volumes: *Dancing in Spite of Myself* and *It's a Sin and Other Essays*. He is also the coeditor of the journal *Cultural Studies*.

MICHAEL HANCHARD is an associate professor of Political Science and Afro-American Studies at Northwestern University. He is the author of *Orpheus and Power: The Movimento Negro of Rio de Janeiro and São Paulo, Brazil, 1945-1988* (1994) and numerous articles on racial politics, the African diaspora, and social theory.

DAVID A. H. HIRSCH teaches in the English Department at the University of Illinois at Urbana-Champaign. He is presently completing a book on fraternal relations in 19th- and 20th-century fiction.

BENJAMIN LEE teaches in the Anthropology Department at Rice University. He is also the codirector of the Center for Transcultural Studies. He writes regularly on area studies and the problematics of globalization.

CARY NELSON is Jubilee Professor of Liberal Arts and Sciences at the University of Illinois at Urbana-Champaign. He is the author of *The Incarnate Word: Literature as Verbal Space* (1973), *Our Last First Poets: Vision and History in Contemporary American Poetry* (1981), and *Repression and Recovery: Modern American Poetry and the Politics of Cultural Memory* (1989). Among his many edited or coedited books are *Theory in the Classroom* (1986), *Marxism and the Interpretation of Culture* (1988), *Cultural Studies* (1992), *Higher Education Under Fire: Politics, Economics, and the Crisis of the Humanities* (1994), *Madrid 1937: Letters of the Abraham Lincoln Brigade from the Spanish Civil War* (1996), and Edwin Rolfe's *Collected Poems* (1993).

CONSTANCE PENLEY teaches at the University of California at Santa Barbara. A founding editor of *Camera Obscura*, she is the author of *The Future of an Illusion: Film, Feminism, and Psychoanalysis* (1989), editor of *Feminism and Film Theory* (1988), and coeditor of *Technoculture* (1991) and other volumes.

BRUCE ROBBINS teaches English and Comparative Literature at Rutgers University. His books include: *The Servant's Hand: English Fiction from Below* (1986), *Intellectuals: Aesthetics, Politics, Academics* (ed. 1990), *The Phantom Public Sphere* (ed. 1993), and *Secular Vocations: Intellectuals, Professionalism Culture* (1993).

ANDREW ROSS is Professor and Director of the American Studies Program at New York University. He is the author of *The Failure of Modernism* (1986), *No Respect: Intellectuals and Popular Culture* (1989), *Strange Weather: Culture, Science and Technology in the Age of Limits* (1991), and *The Chicago Gangster Theory of Life:*

Nature's Debt to Society (1994). A columnist for *Artforum*, and coeditor of the journal *Social Text*, he is also the editor of *Universal Abandon?* (1988), *The Science Wars* (1996), and the coeditor of *Technoculture* (1990) and *Microphone Fiends* (1994).

LYNN SPIGEL teaches in the Division of Critical Studies, School of Cinema-Television at the University of Southern California. She is the author of *Make Room for TV: Television and the Family Ideal in Postwar America* (1992).

MICHAEL P. STEINBERG teaches in the Department of History at Cornell University. He is the author of *The Meaning of the Salzburg Festival: Austria as Theater and Ideology* (1990).

PAULA A. TREICHLER is a professor in the Institute for Communications Research, the College of Medicine, and Women's Studies at the University of Illinois at Urbana-Champaign. She has coauthored *A Feminist Dictionary* (1985) and *Language, Gender, and Professional Writing* (1989), and coedited *For Alma Mater: Theory and Practice in Feminist Scholarship* (1985), *Cultural Studies* (1992), and *The Visible Woman: Imaging Science, Gender, and Technology* (1996). She is the author of an extensive series of essays on the cultural meaning of AIDS which have been collected in a forthcoming book titled *How to Have Theory in an Epidemic: Cultural Chronicles of AIDS*.

GAIL GUTHRIE VALASKAKIS is Dean of Liberal Arts at Concordia University in Montreal. She often writes on Native American and Inuit culture and is active in Native American issues in Canada.